Currier's Price Guide to
EUROPEAN ARTISTS 1545-1945
at AUCTION

Current Price Ranges on the Original Art
of Over 13,000 European Artists at Auction

THIRD EDITION

Includes Latin American and Canadian Artists

Written and Compiled by
William T. Currier

ISBN 0-935277-15-3 Softcover
Library of Congress
Catalog Card Number 91-72575

Printed in the United States of America

COVER PHOTO:

Grand Boulevard, **Jean Beraud**, oil on canvas, 15" x 22", Courtesy of Wolf's Auction Gallery, Cleveland, OH

Additional copies of this book may be obtained from bookstores and selected antique dealers. To order directly from the publisher, remit $22.95 per copy, plus $3.50 shipping(book rate) and handling, or $4.50(first class). Massachusetts residents add 5% sales tax. For bulk order discounts (6 or more copies) please write, or call, for details to:

CURRIER PUBLICATIONS
P.O. Box 2098
Brockton, MA 02405
(508) 588-4509

[Make check or money order payable to CURRIER PUBLICATIONS]
(U.S. dollars only, please)

ACKNOWLEDGEMENTS

Many thanks for assistance with this Third Edition go out to:

Cynthia Tukis, for her expertise and valuable assistance in editing and proofreading everything I do.

James R. Bakker Antiques, Inc., and Skinner, Inc., for providing many of the photographs in this *Guide*.

Walt Reed of the Illustration House, Inc., New York City, for contributing photographs for this *Guide*.

Each individual who took the time during the past year to send in corrections and additions of which we would, otherwise, have never been aware.

Sara and Fred Keylor, Mike and Linda Joy, Nora Pires, and Wanda Alves for their invaluable assistance in keeping my projects accurate and on schedule.

My parents, Lillian and William, for their encouragement and support - as always.

My sister Sandra for her inspirational words and her unerring faith in me.

My wife, Donna, her mother, Lorraine, my daughter, Danielle, and my son, Christopher, who sacrificed so much month after month, to make each new edition possible. I thank you especially, with love.

William T. Currier

To Danielle and Christopher

About the Author

William T. Currier

William T. Currier, a graduate of Boston University, was an educator with the Boston Public Schools for over fifteen years. Although his knowledge of art history was not acquired through a "formal" education in art history, he spent thousands of hours during the past twenty years in intense independent study of both art history and the art market. Mr. Currier has been a guest speaker at adult education classes, lecturing on identifying original prints and paintings, and has attended many lectures and professional seminars on art history and art investment. He is presently president of *Currier Publications*, Director of *Currier's Fine Art*, a member of The New England Appraisers Association, and also works privately as an agent, market liaison, consultant, and dealer.

TABLE OF CONTENTS

CHAPTER TWO: Using This Guide

CHAPTER THREE: Period Frames

European Artists at Auction

Appendix

PREFACE

This companion *Guide* to *Currier's Price Guide to American Artists 1645-1945 at Auction* will fill the void created previously by only having price ranges for American artists available. Now, in the same inexpensive, compact, concise and easy to carry format as the American *Guide* you will have access to price ranges for European artists as well. This *Guide* will aid antique dealers, auctioneers, art collectors, appraisers, and art dealers in quickly checking the probable worth of fine examples of European, Latin American, and Canadian art from the 16th to the 20th century. There isn't another similar publication available which is as *accurate* and *useful* for the price.

This *Guide* is the most practical price guide to 500 years of European art [artists born 1545-1945] available today. The compilation of data here will be useful to even the most seasoned veteran of the European art marketplace:

▶ Accurate spellings of artists' names and their nationality.

▶ Accurate birth and death dates not easily found elsewhere.

▶ A "mnemonic" (meaning to assist the memory) list of subjects typical for each artist.

▶ An expanded section on important period frames, with many examples - more than double the previous number of illustrations.

▶ Current, accurate price ranges (compiled from thousands of auction results over the past ten years) for the world's most sought after artists - over 13,000 in this Third Edition.

Art collectors, art dealers, appraisers, and many others will find

both the American and European editions of our *Guide* continually useful for *quickly* checking the auction records of the many artists they may encounter.

Many auctioneers will use the price ranges to help establish a starting bid on the work of artists with whom they are unfamiliar, or help screen items for possible consignment.

Art collectors will find the *Guides* extremely interesting and especially helpful when hunting for artists whose work falls only within certain price ranges (e.g., $500-$7500) and/or who specialize in certain subjects (e.g., marines, landscapes, still life, etc.). Many collectors will want to keep a copy with them as they frequent yard sales, flea markets, thrift shops, or country auctions. Not infrequently, many "sleepers" can be uncovered.

Appraisers will use the *Guides* to quickly find what the highest price realized at auction has been on a particular artist's work. They will use this information as a starting point, then proceed to do further research on the actual auction results. For appraisers, knowing the highest price realized at auction for the work of a particular artist will help avoid the chance of being penalized by the IRS for overvaluation.

Estate lawyers working with appraisers will find it beneficial to know the *least* amount certain works by a particular artist have sold for, so they can justify a low valuation for estate tax purposes.

Because of information gleaned from our *Guides*, many estate executors will want to pursue a professional appraisal on certain works of art. It would not be unusual for someone running an estate "tag sale" to price something **well** below its true market value.

Antique dealers, who have occasion to buy and sell art, but who have very little knowledge of the art market will find our *Guides* to be the most important references books in their library. The *Guides* will help many dealers to avoid the problem of buying too high or selling too low. And help them to *quickly* assess the *potential* value of artwork in many situations: house calls, estate sales, etc. Dealers can quickly determine if a recent purchase needs more research before pricing it for resale. Obviously, if a dealer purchased a large land-

scape, signed Oswald Achenbach, at a yard sale for $100, and he found in our *Guide* that the highest price realized for the artist's work exceeds $110,000, he'd want to have it examined by an "expert"(more on that in Chapter One.)

Financial consultants will find our *Guides* very helpful in their efforts to help clients fulfill their financial goals. A client may have a fortune in artwork and not even realize it. A quick look in our *Guides* and the consultant will be aware if there is a need for further investigation.

Add to the list the many thrift shop owners, pickers, museum personnel, art framers, and yard sale and flea market fanatics who will find our *Guides* useful; and you can only agree that *Currier's Price Guide to American Artists 1645-1945 at Auction* and *Currier's Price Guide to European Artists 1545-1945 at Auction* will be the *first* place to look for values on works by artists worldwide.

One final note: You are welcome and encouraged to comment, make note of errors, and feel free to suggest changes or additions which will improve this *Guide*. Please write or call:

CURRIER PUBLICATIONS
William T. Currier
P.O. Box 2098
Brockton, MA 02405

(508) 588-4509

DISCLAIMER

Although every attempt, within reason, has been made to keep the price ranges herein as accurate as possible, there may be mistakes, both typographical and in content. Therefore, this guide should be used only as a general guide, not as the final or ultimate source of the only prices which may be realized at auction by any particular artist.

Special care must be exercised when examining the prices of contemporary artists. Because of the "dynamic" nature of the market as a whole, prices can rise and fall quickly. With living artists, it is best to check with those galleries that represent them for the "final" word on current values. Prices charged in the galleries for the works of living artists can be many times those realized at auction.

Also, the compilation of conservators, framers, auction houses and private galleries in the *Appendix* is only a representative sampling of the hundreds of other conservators, framers, auction houses and private galleries which I am sure may be of equal distinction.

The author and *Currier Publications* shall have neither liability nor responsibility to any person with respect to any loss or damage caused or alleged to be caused directly or indirectly by the information contained in this book.

CHAPTER ONE

Determining Value

Please Note: **Two assumptions are made throughout this Guide: that you are a novice in the art marketplace, and that we will always be talking about prices at fair market value (i.e., auction results both here and abroad).**

Those of you who have previously purchased my price guide to American artists and have thoroughly read the section on determining value, can consider skipping this section. Very little of the information contained in this chapter varies from that in the price guide to American artists. The factors important in determining the value of a work of art by a European, Latin American, or Canadian artist will be quite similar to those for American artists. The only *general* exception will be that American subjects, painted by foreign artists, will be more desirable than those that are not (e.g., a street scene in New York may be more desirable than a street scene in London by the same artist - other things being equal).

Until your work of art is sold, it has no real value (unlike stocks); only a subjective value based on many factors. No one can guarantee that your piece will bring a specified dollar amount at some future date. Factors influencing the price of a work of art may vary and, for that reason, you can expect a different price at each new auction. Let's look briefly at some of the direct factors and outside influences which, the author feels, most dramatically affect price.

Seven Important Factors

ARTIST The most important factor. When we can prove who the artist is, whether or not the piece is signed, it will most directly influence the price realized. Almost without exception, the first question you will get from any major auction house, or dealer, when you call them to look for price information, will be: "Who is the artist?" Once the name is known, everything else follows: "What's the subject matter?", "What's the condition?", etc.

If you buy a piece which is unsigned, but you have been told by the seller that it was painted by a well-known artist, obtaining a letter from an authority, which states without question that it is the particular artist the seller said it was, will help immensely in increasing its desirability and value.

Most would consider the signature to be exceedingly important. The truth is that it is of the very least value, until it can be proved without question that it is indeed the signature of the artist who painted the particular work.

Signatures can be added to an oil painting by anyone feeling it will increase its value. If you have a magnifying glass of at least 10-30x, examine the signature to be sure that "old" cracks running through the signature do indeed run through - that they are not filled with paint from a "recent" signature. If you suspect a forged signature, another way to check is to rub the signature gently with a little turpentine on a soft cloth - it will usually wash out a recent signature.

An authentic signature with a date is more desirable than one without.

MEDIUM There are many good books available which explain the peculiarities of the various mediums. The novice to the art market should endeavor to familiarize him/herself with several.

The most popular medium overall today is still oils. It should be mentioned that, in the case of many contemporary artists, mixed media is extremely popular - much to the chagrin of today's conservator. Also, with contemporary artists, it is their mixed media work which often brings the highest prices.

Try to remember, that the price ranges in this *Guide* which begin with an asterisk (*) denote: mixed media, watercolors, gouaches, pastels, and/or pencil and ink drawings. With such a variety of mediums, you can expect a price range often to start in the hun-

dreds (for drawings) and end in the hundreds of thousands of dollars (for contemporary mixed media.) Don't be mislead, though, in thinking all drawings will be of least value - *there are exceptions*. A drawing which is a preparatory study for a painting, which today is historically important, can have great value.

QUALITY Without question, the most exceptional pieces, regarding quality, in any medium, by any artist, will bring exceptionally high prices. Quality is the standard which distinguishes superior from mediocre achievements in a work of art. Every dealer will tell you that he has no problem quickly moving the pieces of the highest quality.

The work of a much sought-after artist will only bring a meager price, if it is of meager quality. Artists are human, of course, and have their good and bad days.

During an artist's lifetime, his/her work could have evolved through several style changes, and within each style change works of varying quality can be found. The months or years which represent a particular style change are called "periods." It may happen that a small work of great quality, from a much sought-after earlier,or later period, will be of more value than a much larger work from some other "period" which is not highly sought after.

There are many factors which the novice can consider in determining a "probable" value of a fine painting, but judging quality, style, and period is best left up to the "expert": university scholar, museum curator, art dealer, certain art consultants, qualified appraiser, or some independent author or connoisseur. For each period of art there are acknowledged experts and they alone can determine those pieces of the greatest quality - the masterpieces.

SUBJECT In a broad sense, this is the main theme of a work of art. In a narrower vein, it is the "subject matter" within the subject that can affect value. As an example, the subject of a painting might be a still life, but its "subject matter" might be dead game birds. The subject of another painting might be marine, and the "subject matter," a coastal harbor scene.

Most artists have one or two subjects for which they are best known. These particular subjects are the ones most sought after and bring the highest prices (see the section on Typical Subjects in Chap-

ter 2 for a list with an explanation.) Knowing the subject(s) most sought after for any particular artist is very important for you in determining the *potential* value of a piece. I have done most of that work for you in this *Guide* - more on that in Chapter 2.

After attending a number of art auctions, you will begin to note which subjects and subject matter are most and least desirable. In general, collectors today want bright colorful, non-offensive pieces for their walls. Let's look more closely at our subjects:

Avant-Garde: During this century, avant-garde art movements have sprung up on all parts of the globe. They were basically a departure from those traditional, established styles, with which we were so familiar prior to 1900. Much of the subject matter in this category is "non-representational" (e.g., abstraction). Every other avant-garde art movement during this century has been a bold and specialized field which is not easily or readily understood by the layperson. Typically, the first reaction to most avant-garde work is puzzlement.

—Since the 1940's, mixed media has became very popular in much of the avant-garde work, and can account for some of the highest prices realized at auction by any particular artist. During the past year, the market for the works of many 20th century artists has been very strong. Especially high have been the prices of the works of the leading Abstract Expressionists painting during the late 1940's, 50's, and 60's. Unfortunately, many of the contemporary avant-garde works today can fall into or out of vogue quickly and the prices realized for those works can vary accordingly. Please refer to the bibliography in the *Appendix* for further reading on many of the avant-garde art movements of this century.

Figures: Studio portraits, with the exception of historical figures, hold very little interest among collectors, unless done by a well- known artist. The most desirable figure paintings are those in a non-studio setting, e.g., groups of people in an interior or outdoor setting. Collectors often prefer women and children

over men in both portraits and figure studies. Religious figures are not very popular, unless they are old master paintings. To certain collectors, the nude figure is desirable.

Genre: Themes which can be considered genre probably number in the thousands. You will note that we have included in this *Guide* more photo examples of genre and figure painting than any other subject. During the 16th, 17th, 18th and 19th centuries most artists learned to paint the human figure with academic precision and there was a proliferation of paintings by European artists which almost always included figures engaged in some activity. Some of the more popular themes included: a public fete, a friendly conversation, the comedies of the household, or the little dramas of private life.

Illustrations: Because of the endless variety of both subjects and mediums in the field of illustration, it is very difficult to point out a most and least popular subject. The subject matter of illustrations can encompass all of the other subjects mentioned here. Many illustrators were highly creative outside their responsiblities as illustrators and executed many works which today can be both rare and valuable.

Landscapes: Collectors today prefer bright, colorful landscapes with identifiable landmarks - especially if the landmarks have local interest. Of the four seasons, winter scenes seem to draw the most attention. Landscapes with a "luminous" quality are popular. American scenes are usually more desirable than European scenes by the same artist.

Marines: Collectors of marine subjects can be very particular about their ship portraits. The rigging, the position of the sails, the flags that are being flown, and many other details can affect the desirability of a marine painting. American vessels, flying American flags, are always more desirable than a foreign equiv-

alent. From my own observations, the old side-wheelers and clipper ships under full sail enjoy considerable popularity. As with landscapes, collectors prefer coastal scenes in which there is an identifiable landmark - such as, a familiar lighthouse. Again, local interest increases value.

Still Life: All types of still life are eagerly collected. Floral pieces today are enjoying popularity, as are elaborate fruit and vegetable compositions. The "grander" the composition, the greater the value. When objects which are not essential to it are introduced into a composition, they are known as accessories and can often add interest and value to a still life.

Wildlife: Scenes with an abundance of blood will be least desirable and farm yard fowl don't enjoy much popularity today unless painted by a sought after old master. Of all the animals around the farm, horses are the most popular with collectors. British sporting paintings with horses and dogs (hounds) are currently very popular. Deer are always popular, if not shown being shot, and most hunting and fishing scenes will attract buyers, if there is no blood and gore.

STYLE Sir Joshua Reynolds (1723-1792) said,"In painting, style is the same as in writing: some are grand, others plain; some florid and others simple." Styles can be peculiar to a "school," or a master, in design, composition, coloring, expression, and execution, but not necessarily peculiar to the artist. In many instances, artists have changed their personal styles several times during their lifetime. As stated earlier, each new style change is considered a new period. Some periods, or styles, are more sought after than others because of a greater appeal. Leading the list would be the work of the American Impressionists.

When you're assessing the "probable" value of a painting, it may be necessary to let an "expert" determine the style of the work (see "Quality" above.)

CONDITION Although "condition" seems a long way down on our list of "factors determining value," it is really the one variable to which we must pay the most attention. No matter who the artist is, a painting in very poor condition, or one that has been heavily restored, will have very little value - at best, a fraction of the worth of a similar painting in pristine condition.

Before you buy a painting on canvas in need of conservation, consider the following:

- After you spend anywhere from $100-$1500 for the cost of restoration, will you be able to realize a profit?

- Are you willing to tie that painting up for what may take as long as six months?

- If there is paint loss, is any of it in critical areas which will affect value? For instance, you do not want the paint to be falling away from the faces and bodies of people in a figure painting.

- Is the overall paint loss greater than 25% ? If so, unless the painting is extremely valuable, pass on it!

- Besides restoration, will the painting need an appropriate frame to make it saleable - another expense?

- Is the painting covered with a very dark layer of dirt and varnish? Only a professional conservator will be able to ascertain if that painting will "clean up." If she/he says definitely not, you may never see a profit.

- Has the painting already had any "bad" restoration?

- The cost of restoration can be very high if the conservator has to do a relining and extensive "inpainting" in addition to a cleaning. Relinings are often necessary when the canvas is extremely wrinkled, torn, abraded, or too loose and floppy. Inpainting is an expensive and involved process of repainting damaged areas to their original condition.

Remember: Though cleaning may be useful to restore the

original brilliance of an old painting - though relining is sometimes needed to save it from imminent destruction - to let it be attempted by a non-professional is a sacrilege. ***Always make sure that the conservator has an impeccable reputation for quality work.*** Also, *never* use water to clean a painting - leave it alone until an expert can look at it.

To assist you in finding a conservator, I have compiled a representative list from around the country and have included it in the *Appendix* of this *Guide*. Your best source for a reputable conservator is the recommendation of an art museum or art gallery. Some of the latter are also listed in the *Appendix* - see if there is one near you.

For those of you who are only vaguely familiar with the use of a blacklight for assistance in finding previous restorations, added signatures, etc., and wish to become more "expert" in its use, there is information available. This past year, Karl Gabosh, an art dealer and researcher, assembled a guide, complete with samples and text, entitled: *The Collector's Blacklight Guide*. It is an important tool for the serious art dealer, collector, and others.

To obtain more information on the *The Collector's Blacklight Guide*, please write to:

Karl Gabosh
P.O. Box 142
Princeton, MA 01541

SIZE All it will take is one afternoon at an art auction to see that there is a definite correlation between size and price. This relation holds true only among paintings by the same artist, and among paintings that are similar in subject matter, quality, and style.

Prior to the 20th century when paintings were purchased for homes with ceilings which reached heights exceeding 15 feet, it was not unusual to see paintings executed on a massive scale - some greater than 5' x 8'. Today, dealers cannot find buyers for these large canvases as easily as a more manageable "sofa size" work.

You may never hear of a painting that is too small to be desirable, but you will likely hear of a painting being too big to be desirable. When a painting is larger than sofa size, you will find that your buying audience has shrunk considerably. Of course, there could

be exceptions to this, in cases where the artist is an acknowledged master.

Outside Influences on Value

As discussed above, when you purchase a painting for resale, there are inherent factors (e.g., artist, size, medium, condition, quality, subject, style) which can be quickly ascertained for determining an approximate value. There are other outside influences (e.g., historical importance, provenance, time and location of sale, competitive bidding, publicity and fads) which can have a positive or negative affect on value. Let's take a brief look at each.

HISTORICAL IMPORTANCE All preparatory studies (drawings, watercolors, oil sketches, etc.) for any major historical painting can be valuable. If you find, while researching your artist, that he/she painted many historically important paintings, check your piece or have an "expert" check your piece, to determine if it could be an important preparatory study. The likelihood of finding an actual canvas which is a major historical painting is slim. Most are either in museums, historical societies, or private corporate collections. Don't expect to find one in someone's attic next month.

PROVENANCE Provenance is simply a list of previous owners, analogous to a pedigree. It can be important to some collectors; not so important to others. Provenance works in reverse, for example, the present owner is listed first, the previous owner is listed second, and so on, until we are back, ideally, to the artist himself. This line of ownership can make the piece very desirable, particularly if the list has some important names on it. But there can be a problem since we sometimes have no way of checking the authenticity of a particular document. Most of the people on the list may be deceased, and therefore, not available to vouch for their prior ownership of the piece in question.

A provenance is not at all necessary to transact a sale, but if you have supportable evidence that the provenance is unquestionably genuine, then it can be even more important than the signature on the piece.

Sometimes, you will find that names have been filled in to complete a gap in its provenance. Be careful. Always try to judge the

piece first on its own merit as a fine work of art. If it turns out later that all the documentation included with it is authentic, then the value of the piece will increase immeasurably.

The topic of Provenance is closely related to a discussion of authentication. If you feel you have just bought an "important" painting and would like to have it properly authenticated, see the *Appendix* under "Appraisal Organizations" for a list of authentication services.

SELLING: TIME AND LOCATION OF SALE Some auction houses do better than others, selling the works of certain artists. It is valuable information to know at which auction house an artist continually commands the highest prices. Information of this type is not easily obtainable, unless you have been closely following the market all over the country. If you have a "potentially" valuable painting, I might suggest that you contact some art consultants in your area, to see if they provide that service. If they do not, the author can help you. Please call or write to William Currier, *Currier Publications* (the address is included in the front of this book.)

The worst months of the year in which to sell at auction are July and August; the best months are October thru May.

If you plan to send your art to auction at one of the major auction houses (a list can be found in the *Appendix*), and if you are in a hurry to see your money, then keep two things in mind:

1. From the day you send your piece to auction until the day of the actual sale, two to five months may pass. Auction officials need that time to research all the paintings, determine estimates, do the presale advertising, and photograph most of the paintings in the sale for placement in a catalog, which goes out (at a price) to the patrons of the sale.

2. Many of the major auction houses do not send you your money (less commission) until 35-40 days after the sale. They wait for buyers' checks to clear. [*Please Note*: Some *major* auction houses will advance you a loan up to a certain percentage of the low estimate on *very* important works of art. This *loan*, plus interest, will be subtracted from the net proceeds of the sale of your painting. When you are consigning your piece, inquire into the options available to you.]

28

Before you ship your piece to auction, check the offers of dealers who specialize in work by your artist - you may get an offer you can't refuse.

COMPETITIVE BIDDING At almost every major auction there are a number of fine paintings which sell well above the estimates - much to the delight of the consignor. Competitive bidding can drive the price up well above estimate. All that is needed are two or more people who want that piece desperately enough, that it seems money is no object.

PUBLICITY AND FADS The resale value of your work of art will leap, if it has appeared as an illustration in one or more pieces of literature. If the work of art also has a well-documented exhibition record, that will increase its desirability.

CHAPTER TWO

Using This Guide

An Overview

You will find the basic format of this price guide similar to that of our American price guide with any critical differences noted in the forthcoming text and examples.

The most noticeable difference is the exclusion of a *Record Prices* section. Because of the great number of atypical prices realized at auction for thousands of European artists we could easily have written a book which listed *only* record prices. To have included a list in the rear of the book would have made it unmanageable. In most instances, the high end of the price range will be the record price.

In the process of compiling the over 13,000 names of artists for this *Guide*, the one problem we consistently faced with European names, in many catalogs, was the deletion of portions of a long name, and slight variations in the spelling of many Russian, German, and Dutch names (e.g., Carl for Karl, Willem for William, etc.). There can be almost as many variations in the spelling of some European names as there are sources for checking them. The full and correct spelling of names was determined as accurately as possible by checking more than one dictionary of artists for each name.

Although we tried to place the names alphabetically where you would most likely expect them to appear, don't discount any possibility. Check *all* reasonable possibilities for a variation in the position of a name within the alphabetical list. For last names which are hyphenated, the first of the two hyphenated names always determined

position (e.g., the name Louise Abel-Truchet would be placed in the "*A's*").

The birth and death dates and nationality, when available, were researched for accuracy and recorded next to the name. In many instances, birth and death dates which could not be easily found elsewhere were recorded. If no dates were available, the century during which that artist is known to have worked was placed next to the name.

Let's Keep It Simple

The names and dates need no more explanation than presented above. It will be the "price ranges" and the "typical subjects" that need clarification.

The price ranges quoted in this edition were established in the same manner as our American price guide. They represent the range within which *most* of each artist's work would be expected to sell at auction based on previous prices realized. Price ranges and typical subjects were established by studying hundreds of thousands of actual auction sales records worldwide for the previous ten years.

Vast amounts of biographical data, from my own reference library and sources outside, were carefully reviewed, in an attempt to establish those subjects most typical for each artist in question. From that point, we ascertained, as accurately as possible, which subjects were most sought after by collectors and recorded them in our table - as explained below.

PRICE RANGES: You have to remember three things:

1. Most of the price ranges are simply low and high dollar amounts, indicating the range within which you would expect the artist's oils, acrylics, and/or tempera paintings to sell.

Example:

ARTIST	PRICES	SUBJECT
ADAM, EMIL (1843-1924) GERMAN	1500-25000	W,G

2. A number of the price ranges will be preceded by an asterisk (*), indicating a price range for that artist's drawings, watercolors, gouaches, pastels, and/or mixed media. If an artist's name was listed twice, he/she was prolific enough in all mediums to have two separate price ranges. When a name is listed twice, the "typical subject" follows the second price range and the birth and death dates also follow the second listing of the name.

Example:

ARTIST	PRICES	SUBJECT
ALT, FRANZ	*300-9400	
ALT, FRANZ (1821-1914) AUSTRIAN	700-12000	L

3. A good number of the price ranges will not show any prices at all on the high end of the range - only three pluses (+++). Those artists have had works which sold for over $250,000 and to quote a more exact high end would be useless. If any of our readers have a work by *any* artist whose high end might exceed that $250,000 figure, he/or she will need the assistance of an "expert" to accurately ascertain what value that work may have. Knowing it *could* possibly be worth more than $250,000 should be enough incentive to seek professional help.

Example:

ARTIST	PRICES	SUBJECT
DUBUFFET, JEAN (1901-1985) FRENCH	10000-+ + +	A

Typical Subjects:
"Mnemonic" Letters

"Mnemonic" (pronounced "ni-monic") means *assisting or designed to assist the memory.* In that respect, you will find after each artist, if the information was available, single letters corresponding to the subjects most typical for the artist. Each letter matches the following subjects:

A	Avant-Garde
F	Figures
G	Genre
I	Illustrations
L	Landscapes
M	Marines
S	Still Life
W	Wildlife
X	Unknown

In the section which follows, for the benefit of the novice, we will briefly explain, with photo examples, each of the subject areas.

TYPICAL SUBJECTS

AVANT-GARDE (A)

For our purposes,"Avant-Garde" will refer to all the art works which do not easily fit into any of the other categories herein because of their unconventional styles. Such works might typically include the "experimental" works of the 20th century - such as, Cubism, Dadaism, Surrealism, Abstract Expressionism, Minimal Art, Photorealism, and Pop Art.

Please Note: It is important to repeat here a statement made earlier in the "Disclaimer." When examining the prices of Contemporary artists (over 300 in this *Guide*),care must be exercised. Because of the "dynamic" nature of the contemporary market as a whole, prices rise and fall quickly. With regard to living artists,it is *always* best to check with those galleries that represent them for the "final" word on current values.

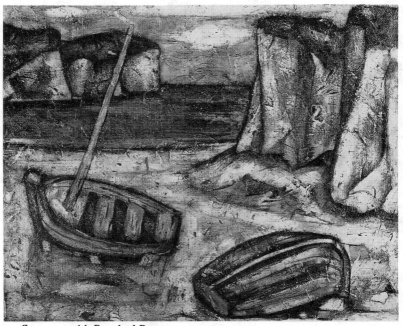

Seascape with Beached Boats
by Enrico Campagnola, oil on canvas, 19" x 24"
(Courtesy of James R. Bakker Antiques, Inc., Cambridge, MA)

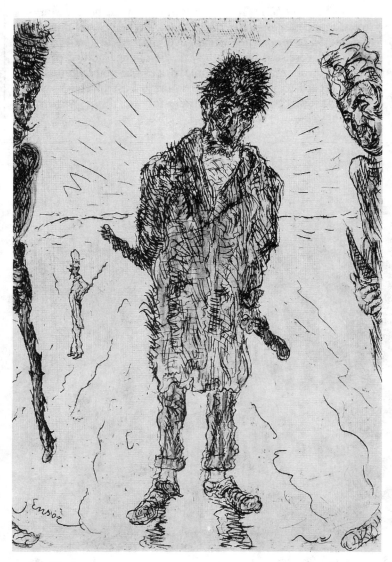

Untitled
by James Ensor, pen & ink wash, 8" x 6"
(Courtesy of a Private Collector)

FIGURES (F)

Most typically under this category are works which depict adults and/or children in various studio and non-studio settings. These figure studies may include: portraits (single and/or group), miniatures, historical figures, and people from all walks of life in settings typical of the period and location. Many "experts" will argue, with good reason , that many non-studio figure paintings are genre.

In figure painting, the artist usually is more interested in depicting the character of the individual, not so much the human situation, as in genre (see next topic.)

Religious, historical, and allegorical subjects will also be included in this category for our purposes.

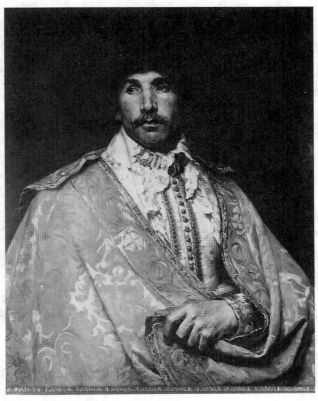

Portrait of a Young Gentleman
by Ferdinand Roybet, oil on panel, 32" x 25"
(Courtesy of Skinner, Inc., Bolton, MA)

37

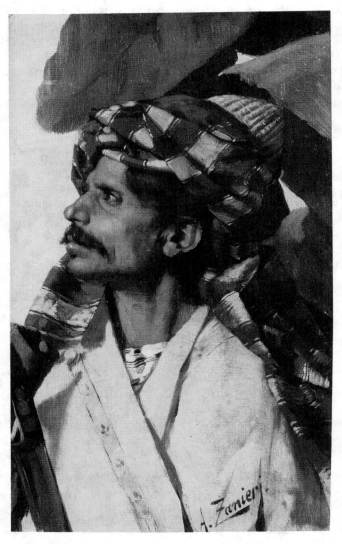

Man in Turban
by Arturo Zanieri, oil on panel, 9" x 6"
(Courtesy of James R. Bakker Antiques, Inc., Cambridge, MA)

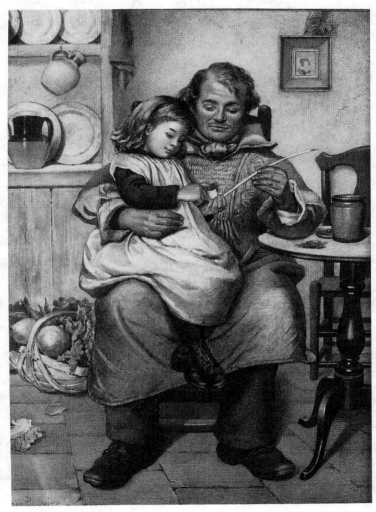

Filling Daddy's Pipe
by Agnes Bouvier, watercolor, 14" x 10"
(Courtesy of Skinner, Inc., Bolton, MA)

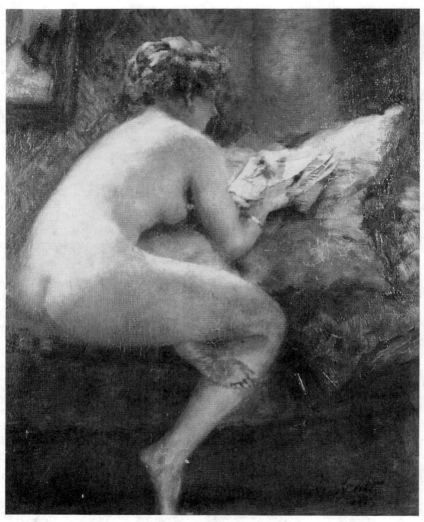

Nude Reading
by Ferdinand Max Bredt, oil on panel, 14" x 17"
(Courtesy of James R. Bakker Antiques, Inc., Cambridge, MA)

GENRE (G)

Genre refers to people of all ages engaged in everyday activities typical for the period and location. Genre differs from figure studies in that usually the activity in the composition is the main theme. Typical compositions might include: carnival, sporting, city, country, seafaring, or domestic subjects.

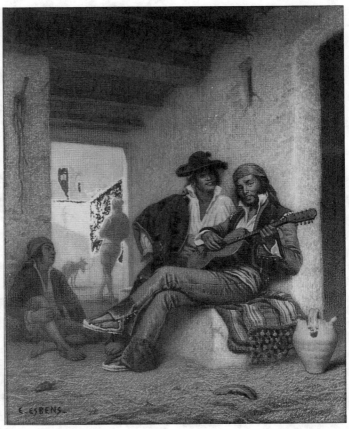

The Guitarist
by Emile Etienne Esbens, watercolor, 8" x 7"
(Courtesy of Skinner, Inc., Bolton, MA)

Zur Erinnerung – an den Weihnachts Abend 1921
by German School, watercolor, 13" x 18"
(Courtesy of James R. Bakker Antiques, Inc., Cambridge, MA)

It's Your Move
by J. Lepage, oil on canvas, 12" x 16"
(Courtesy of Skinner, Inc., Bolton, MA)

Genre Scene with Girl and Dog
by Albert Roosenboom, oil on canvas, 8" x 9"
(Courtesy of Skinner, Inc., Bolton, MA)

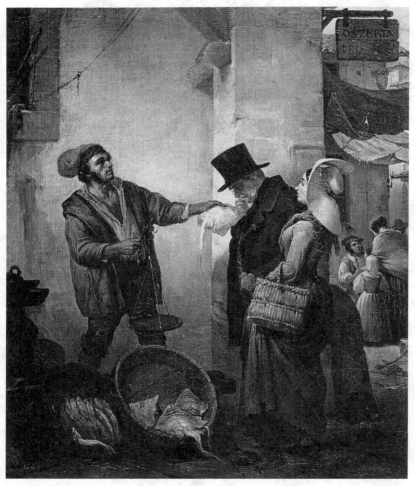

Fish Seller
by Niccolo Sanesi, oil on canvas, 17" x 14"
(Courtesy of James R. Bakker Antiques, Inc., Cambridge, MA)

ILLUSTRATIONS (I)

This is a broad category which typically involves works which were executed for the purpose of reinforcing an idea or theme of a publication and/or advertisement. In this category, you will find the greatest variety of mediums and subject matter.

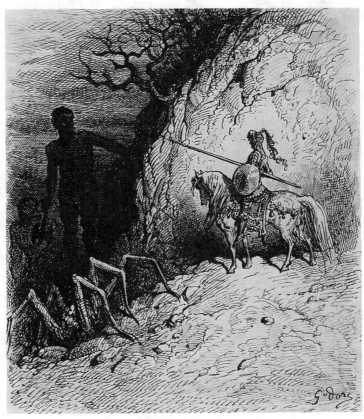

Unused Illustration by Paul Gustave Dore
The History of Don Quixote, pen & ink, 10" x 8"
(Courtesy of The Illustration House,Inc., New York, NY)

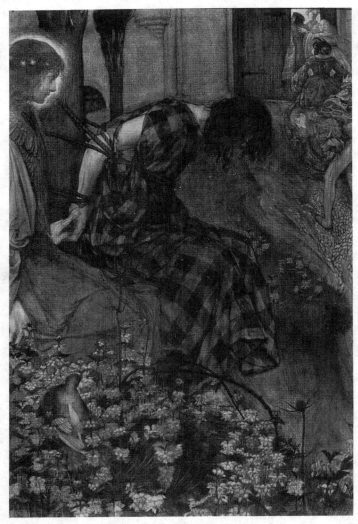

Love and Adversity, reproduced in *The Studio*
by Eleanor Fortescue Brickdale, watercolor, 20" x 13"
(Courtesy of The Illustration House,Inc., New York, NY)

LANDSCAPES (L)

In this category, you may find compositions which depict natural scenery, and which may or may not include figures and/or manmade objects. All seasons and all times of the day may be depicted, and views might include any of the following: cityscapes, seascapes (shoreline views), street scenes, mountains, river views, desert scenes, and lake scenes. *Genre* may often be combined with a landscape composition.

Figure on a Country Road
by Achille Francois Oudinot, oil on panel, 12" x 10"
(Courtesy of James R. Bakker Antiques, Inc., Cambridge, MA)

Landscape
by Ernest Meyer, oil on board, 20" x 16"
(Courtesy of Skinner, Inc., Bolton, MA)

Rest Along the Road
by German School, watercolor, 6" x 6"
(Courtesy of Skinner, Inc., Bolton, MA)

Marketplace, Piacenza
by Auguste Siegen, oil on panel, 21" x 16"
(Courtesy of Skinner, Inc., Bolton, MA)

MARINES (M)

This category will be used in instances where the artist's major output was nautical compositions, such as, drawings and/or paintings of vessels of all descriptions and sizes, Venetian canal scenes, marsh scenes, sea scenes, and coastal or harbor scenes.

Clearing Mists
by William A. Thornbery, oil on panel, 10" x 8"
(Courtesy of Skinner, Inc., Bolton, MA)

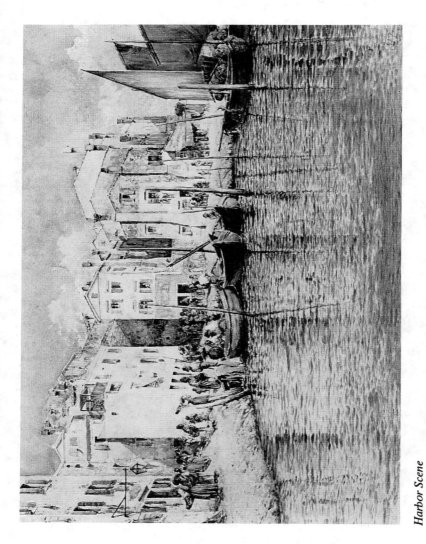

Harbor Scene
by Mariano De Franceschi, watercolor, 21" x 29"
(Courtesy of James R. Bakker Antiques, Inc., Cambridge, MA)

A Walk Along the Shore
by Continental School, oil on canvas, 24" x 36"
(Courtesy of Skinner, Inc., Bolton, MA)

STILL LIFE (S)

These are most often paintings of inanimate objects characterized by their beauty of color, line, or arrangement. These compositions were almost always set indoors and most typically depicted the following: fruit and/or vegetables, flowers, birds nests, fish and shellfish, or objects found around the home or farm.

When objects are introduced into a composition to add interest and color, they are usually called accessories.

Floral Still Life
by Charles Jean Briaudeau, oil on canvas, 29" x 21"
(Courtesy of James R. Bakker Antiques, Inc., Cambridge, MA)

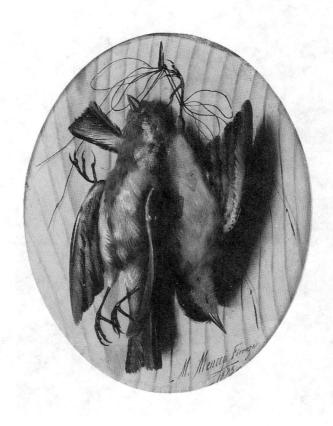

Lot of Two Still Lifes with Game
by Michelangelo Meucci, oil on panel, 9" x 7"
(Courtesy of Skinner, Inc., Bolton, MA)

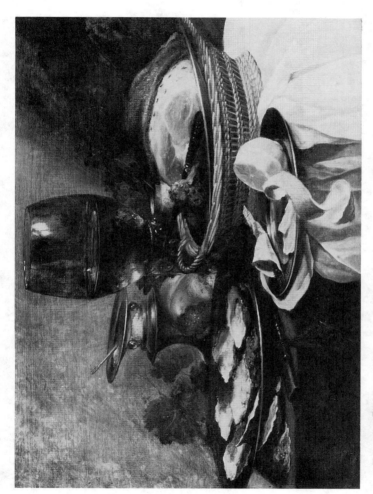

A Tempting Repast
by Pieter Claesz, oil on panel, 18" x 25"
(Courtesy of Skinner, Inc., Bolton, MA)

WILDLIFE (W)

Many artists made a career of drawing and painting wildlife subjects (animals, fish, and/or birds) set in their natural habitat. These subjects will be included in this category along with animal subjects in a domestic or farm setting - such as, horse portraits, family pets, farmyard animals and fowl. Also included are the sporting scenes which depict mainly the activity of the horses and the hounds.

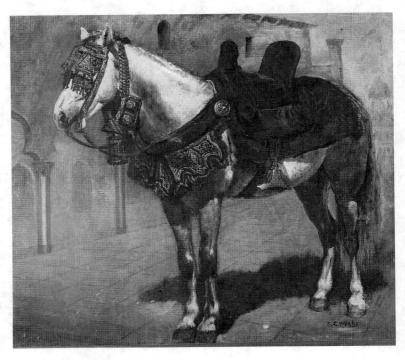

The Arabian Mount
by Edwin Lord Weeks, oil on canvas, 21" x 23"
(Courtesy of Skinner, Inc., Bolton, MA)

A Reluctance to Share
by Robert Physick, oil on canvas, 20" x 24"
(Courtesy of Skinner, Inc, Bolton, MA)

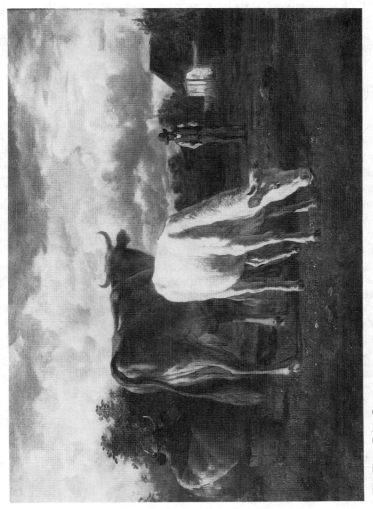

The Three Prize Cows
by Constant Troyan, oil on canvas, 32" x 46"
(Courtesy of Skinner, Inc., Boston and Bolton, MA)

Unknown (X)

An "X" was used when sufficient data were not available at the time, to determine the type of subject "most" typical for this artist. If the "X" is followed by any of the letters "A" thru "W" in parentheses, then that artist is known to have executed *some* works in that particular category. If you have verifiable information regarding prices or subjects for any artist listed here with an "X", please send it along to the address at the front of this *Guide*.

Expert or Sleuth?

Now that you are familiar with the use of this *Guide*, what next? When you want to quickly estimate the *potential* value of a certain work of art, you'll want to use this *Guide* and *Currier's Price Guide to American Artists at Auction* first. After determining that you may have a very valuable painting, and before you sell (privately, to a dealer, on consignment, through advertisement, or in your shop, etc.), you will want to determine more accurately what the painting may be worth (i.e., fair market value). You have two choices. Either you consult with an "expert" (e.g., art appraiser, qualified auctioneer, art dealer, art consultant), or you try to research it yourself. Whichever route you decide on, you will find help in the Appendix of this *Guide* under "Resources For Pricing", and "Appraisal Organizations".

One last comment. If you are a complete novice to the art market, I would recommend seeking the help of an expert. Only an expert will have the trained eye and the references on hand to make the most accurate estimate of the value of your piece. It is also helpful, and may eliminate later heartache, to keep in mind that you should consult with more than one expert if you feel your piece is very important!

CHAPTER THREE

Period Frames

The Frame: An Aesthetic Statement

The following essay was kindly contributed by **LOWY***, New York, New York.* **LOWY** *has served the art community around the world for many years with a complete line of fine art services, including: sales of antique frames from all periods, 20th century American frames, and complete conservation and restoration services for antique frames and furniture.*

At no time in the history of America has the awareness of the frame's importance been so great... both as an art object and as a vehicle for aesthetically and historically enhancing a work of art. Antique picture frames, while providing us with a wonderfully detailed and historical account of style and prevailing tastes, also dramatically illustrate the incredible craftsmanship and creativity called upon in the art of frame- making through the centuries.

In Europe there has been an awareness, appreciation, and even passion for antique picture frames for some time. More recently however, that same awareness, appreciation, and passion has captured the sensibility of the American collector and dealer as well. It is now common to find both European and American art connoisseurs vying for the same antique frames in the salesrooms of Paris, London, and now even occasionally in New York City. Indeed, many great European period frames now adorn paintings in most significant Old Master,

Impressionist, and Modern Master collections, whether abroad or in the United States.

A more uniquely American phenomenon however, is the most recent interest in and demand for 19th and 20th century American picture frames. Frames in particular demand from this era are those from the Arts and Crafts period.

American frame-making in the Arts and Crafts period of the late 19th and early 20th centuries was a period of extraordinary creativity. The aesthetic climate of the times signaled a move away from the more traditional ornate and complex cast frame styles being produced in the last half of the 19th century. This was a period of experimentation recalling earlier hand-crafted motifs with a greater collaborative effort between painter, sculptor, craftsman, and architect, resulting in an exuberant fusion of elements.

Artists of this era, such as James McNeill Whistler, Thomas Wilmer Dewing, Elihu Vedder, and Abbot Thayer frequently designed or worked with framers and architects to design their picture frames. These frames were often intended to be an integral part of their work. Frame-making firms of this era, such as Carrig-Rohane, Foster Brothers, Thulin, the Newcomb-Macklin Company, and Albert Mitch, among others, produced many such frames, thus developing a whole new vocabulary of framing styles and a new "American look".

Frames from the Arts and Crafts period not only represent a significant piece of frame history, but are frames which were very closely tied to the particular works of art for which they were designed and made. The specific relationship of frame to art work perhaps reached its height during this era.

The values of antique frames are bound to virtually the same set of criteria that govern the value of other antiquities, such as rarity, quality, historical significance, and condition. Although many antique picture frames can certainly be considered works of art unto themselves, and often are, their greatest value will always be realized when paired with the appropriate work of art to make an aesthetic and historical statement. This marriage of frame to art is the single consideration which will forever dominate the antique frame's utility, significance, and ultimately its value.

New York, New York, 1991
LOWY
(212) 861-8585

How Period Frames Are Affecting the Value of Paintings!

The following essay was kindly contributed by Edward P. LaBlue, of Duxbury, Massachusetts. Mr. LaBlue is a private frame dealer, consultant, and authority on period American and European frames.

Though the antique frame market has been with us for some time, the increased demand for period frames has been sparked by the keen interest and vision of art dealers and museum curators. Due to the heightened awareness of the value of quality period frames the number of establishments dealing exclusively in antique frames has also increased. Specialized exhibitions of antique frames around the United States and Europe have encouraged the development of a new sector for speculation in the field of art - that of frame collector and frame investors.

There seems to be a buyer for every type, size, color and shape frame, whether at a frame auction in London or a flea market in a small country town. The craze runs the gamut from the right frame for a painting to an interesting frame for a print or family photograph. The demand for a good frame is increasing, the supply diminishing and the prices skyrocketing.

Where does one locate antique frames? There are numerous frame dealers in America and abroad. Specialized frame sales occur at Bonham's in London two or three times a season. Antique dealers and art dealers occasionally have frames for purchase. Antique shows, particularly the large outdoor summer extravaganzas, can be a good source. Auctions, yard sales, flea markets, and attics, as well, can yield valuable frames.

Years ago, I began noting how period frames affected the price realized at auction on a number of paintings by obscure or little known American and European artists. Price estimates on these works ranged from a low of $200 up to $1,500. Many of the frames on these works were art objects in their own right, aesthetic statements, much in demand by frame dealers, art dealers, decorators, and frame collectors. Because of the demand for these quality period frames, the prices realized at auction for the work of many obscure artists were much higher than one would expect - sometimes two to three times the projected estimates.

The frame, an object which can have separate and substantial value, can compound the task of researching and assessing what a painting is worth. It is essential for buyers and sellers to be aware of what part the artwork and what part the frame play in determining price.

To acquire a valuable period frame I've sometimes paid premium prices for works by minor artists - surpassing private, dealer and auction records for those artists. As many others may have, on one occasion I drove over three hundred miles to bid on a painting. The 7' x 5' painting, a partially clad woman of french origin, rendered without too much anatomical consideration, was at best a piece of old unlined canvas. The frame, however, was a splendid French 1850's, 8 1/2" serpentine fluted cove, torus with imbricated egg and dart motif in a flawless French gold water gilt finish. The auction estimate for the painting was $500-$700; the price realized was $7,500.

That $7,500 price will be recorded as a new high for the artist when actually a substantial portion of the price realized was for the value of the frame - *all that glitters is gold*. Because of this sale a misleading price range for this artist may be established. In spite of this newly established high end of the range, at a later date this work of art could resurface at another auction stripped of its frame only to sell at a price substantially below $7,500.

Thus far, frame dealers have no firm guidelines for the purchase or selling price of period frames. You should be aware that most antique frames you're likely to encounter do not have a value exceeding several hundred dollars. How, then, do you price frames for purchase or resale? This is not an easy question to answer and several factors are important to consider:

Historical Significance	Is the frame, whether American or European, important in the history of the decorative arts?
Attribution	Was the frame produced by a specific firm or artisan whose work is much sought after by frame collectors and frame dealers?
Condition and Size	Does the frame require conservation which is time consuming and expensive? Value can be affected by restoration and necessary alterations of size.

To be able to recognize the more valuable frames requires con-

siderable study. If you intend to become familiar with the more valuable antique frames you should plan on studying frame history, go to several frame exhibitions, and visit frequently with a knowledgeable antique frame dealer. Please consult the *Appendix* for source information regarding antique frame dealers and books pertaining to frame history.

Illustrations of a few representative frames will follow. Retail values for these frames can range from $500 to $35,000 dependent on size, historical importance, attribution to a famous firm or artisan, and condition.

A statement by Edward P. LaBlue: *I would like to express my gratitude to William Currier for the opportunity herein and hope that his readers will become more aware of how period frames can affect the value of paintings.*

Duxbury, Massachusetts, 1991
Edward P. LaBlue
(617) 834-0392

Carrig-Rohane (Boston)
carved and gilt, (Ca 1915-1920)
(Courtesy of Lowy, New York, NY)

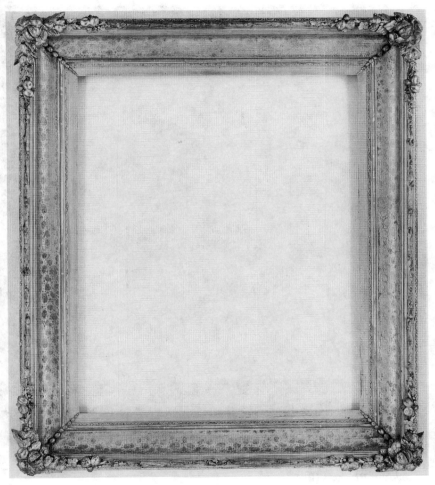

Cove (American)
gilt composition, (19th C.)
(Courtesy of Lowy, New York, NY)

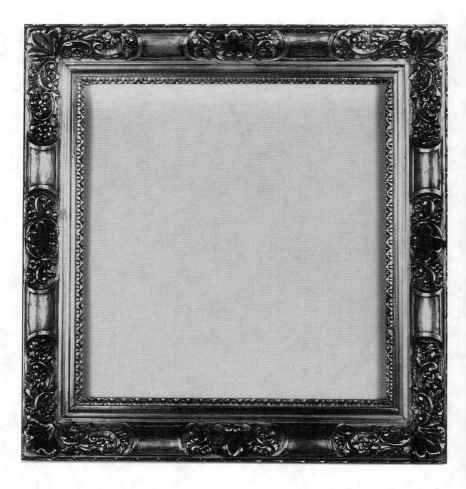

Foster Brothers (Boston)
carved and gilt, (Ca 1900-1910)
(Courtesy of Lowy, New York, NY)

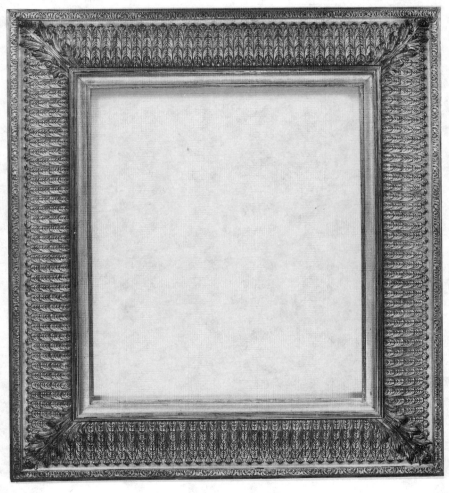

Stanford White Frame (American)
gilt composition, (19th C.)
(Courtesy of Lowy, New York, NY)

Stanford White Frame (American)
gilt composition, (19th C.)
(Courtesy of Lowy, New York, NY)

Fluted Cove (American)
gilt composition, (19th C.)
(Courtesy of Lowy, New York, NY)

Original Hassam Frame (American)
carved and gilt, (Ca 1910-1915)
(Courtesy of Lowy, New York, NY)

Albert Milch Frame (New York)
carved and gilt, (Ca 1900-1905)
(Courtesy of Lowy, New York, NY)

Albert Milch Frame (New York)
gilt composition, (Ca 1890-1895)
(Courtesy of Lowy, New York, NY)

Whistler Frame (American)
carved and gilt, (Ca 1870-1875)
(Courtesy of Lowy, New York, NY)

Greek Revival (American)
(from the Boston Firm of Jordan & Harberg)
gilt with applied carved corners, (Ca 1830)
(Courtesy of Lowy, New York, NY)

Arts and Crafts (American)
carved and gilt, (turn of the century)
(Courtesy of Lowy, New York, NY)

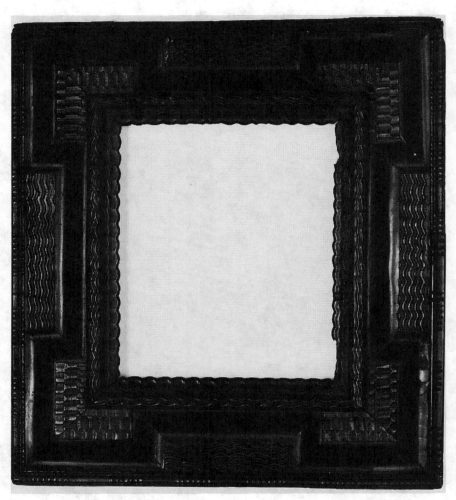

Dutch Ripple Frame (European)
carved and ebonized, (mid-17th C.)
(Courtesy of Lowy, New York, NY)

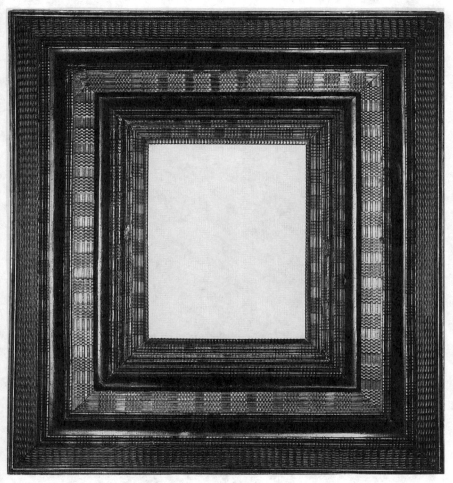

Dutch Ripple Frame (European)
carved and ebonized (mid-17th C.)
(Courtesy of Lowy, New York, NY)

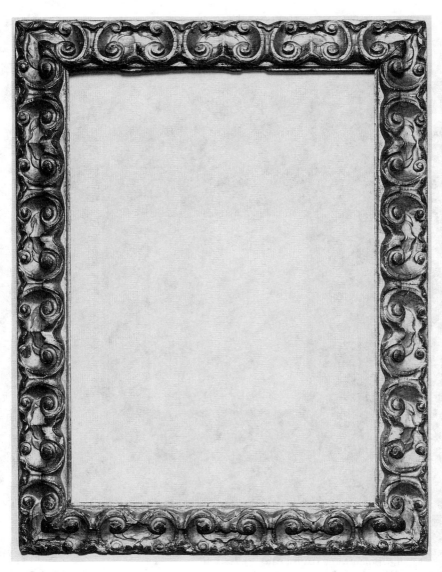

Spanish
carved and gilded, (17th C.)
(Courtesy of Lowy, New York, NY)

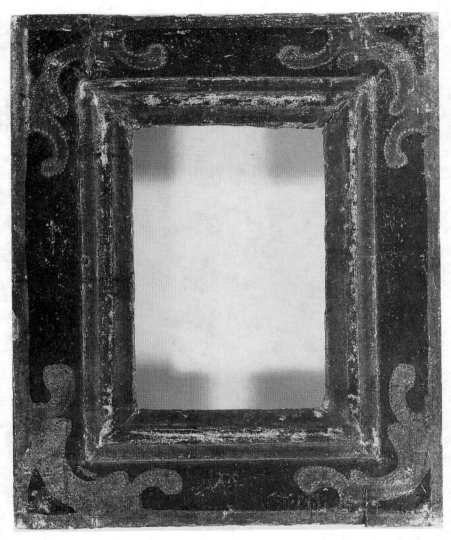

Reverse Profile Frame (Spanish)
gilt and polychrome, (early 17th C.)
(Courtesy of Lowy, New York, NY)

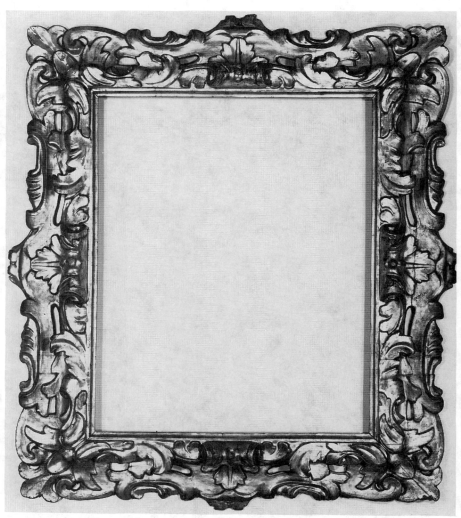

Florentine (European)
carved and gilt, (17th C.)
(Courtesy of Lowy, New York, NY)

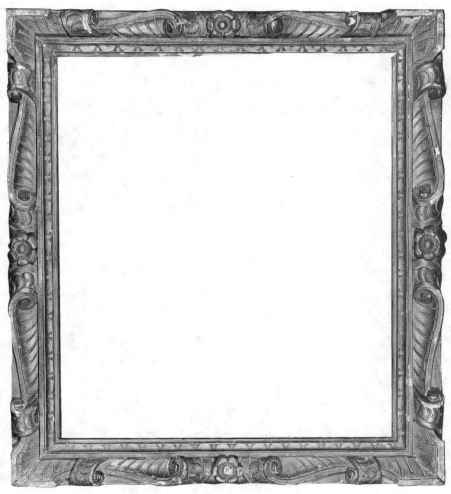

Sansovino Frame (Italian)
carved and gilt, (late 16th to early 17th C.)
(Courtesy of Lowy, New York, NY)

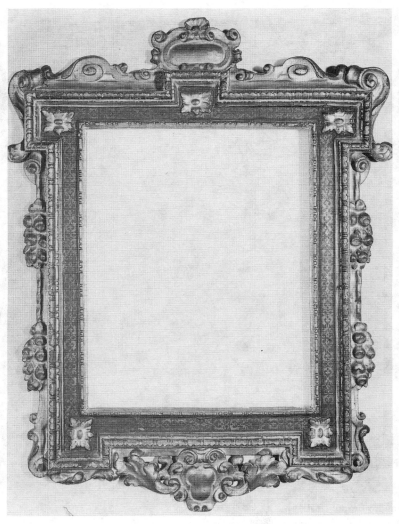

Cassetta Frame (Italian)
carved, gilt, and polychrome (early 17th C.)
(Courtesy of Lowy, New York, NY)

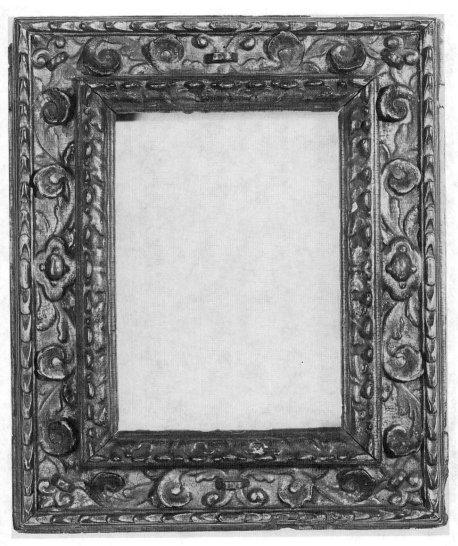

Tuscan (European)
carved and gilt, (mid/late 16th C.)
(Courtesy of Lowy, New York, NY)

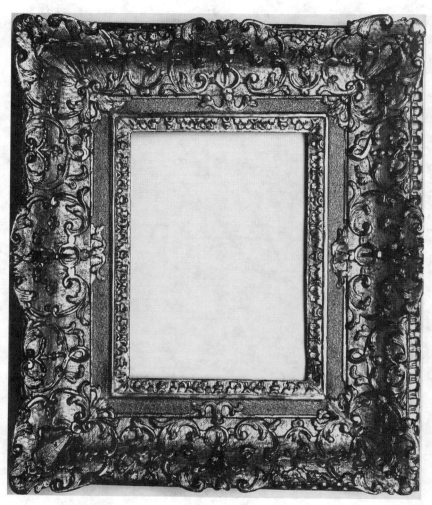

Louis XIV (French)
carved and gilt, (Ca 1720)
(Courtesy of Lowy, New York, NY)

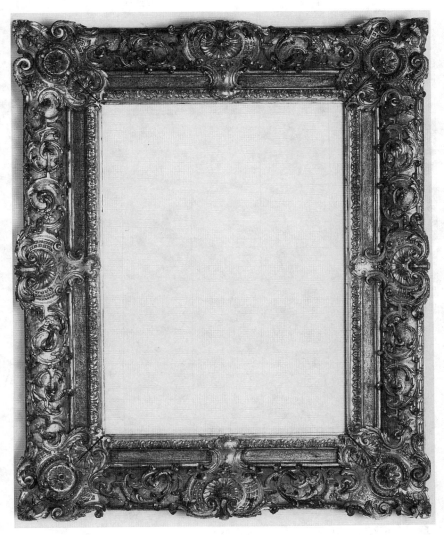

Regence (French)
carved and gilt, (Ca 1725-1730)
(Courtesy of Lowy, New York, NY)

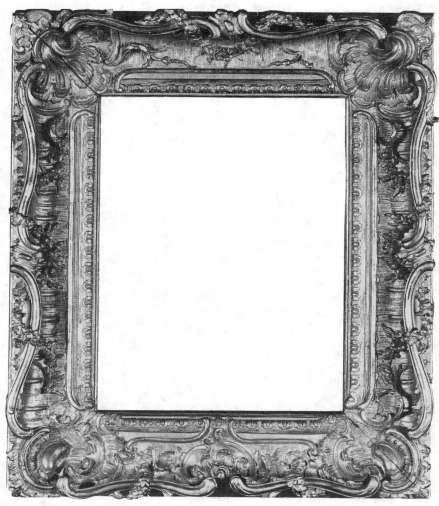

Louis XV (French)
carved and gilt, (mid-18th C.)
(Courtesy of Lowy, New York, NY)

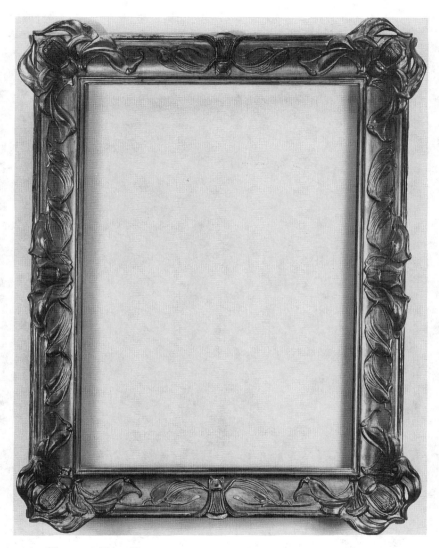

Art Nouveau (French)
(from the Atelier of Georges de Feure)
gilt composition, (Ca 1900)
(Courtesy of Lowy, New York, NY)

Carrig-Rohane (Boston)
carved and gilt, (1915)
(Courtesy of Lowy, New York, NY)

Foster Brothers (Boston)
carved and gilt, (1907)
(Courtesy of Lowy, New York, NY)

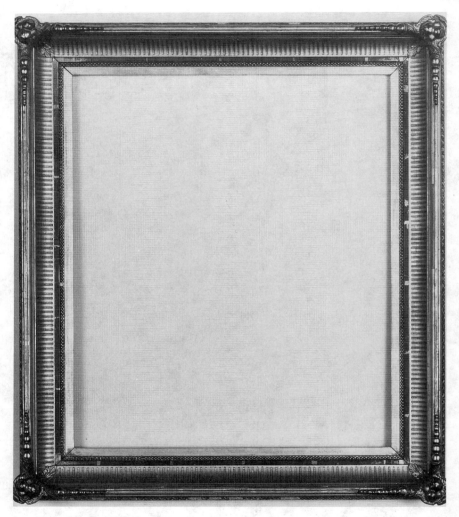

Fluted Cove (American)
gilt composition, (19th C.)
(Courtesy of Lowy, New York, NY)

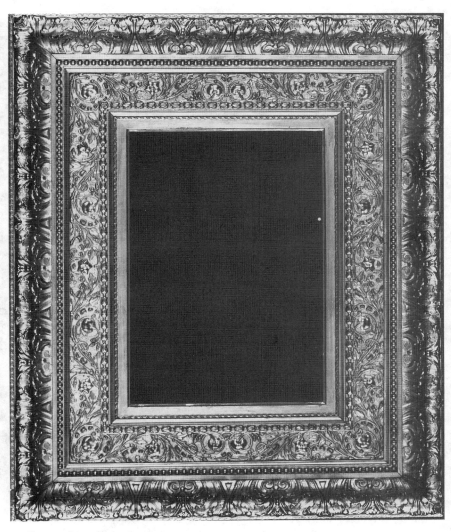

Composition (American)
gilt composition, (19th C.)
(Courtesy of Lowy, New York, NY)

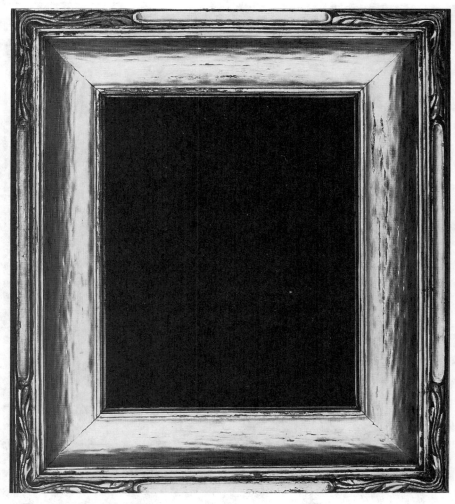

Foster Brothers (Boston)
carved and gilt, (Ca 1910-1915)
(Courtesy of Lowy, New York, NY)

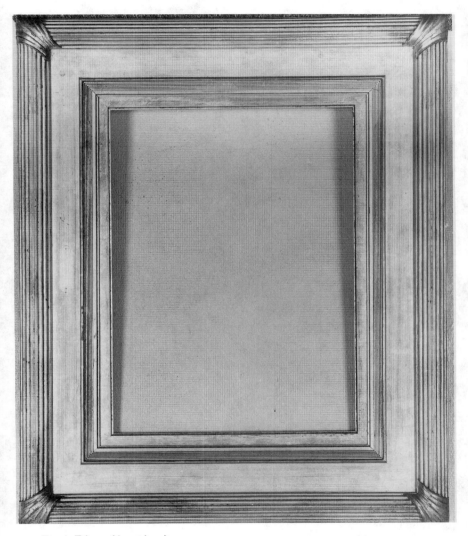

Denis Dinan (American)
cast and gilded, (Ca 1890)
(Courtesy of Eli Wilner & Co., New York, NY)

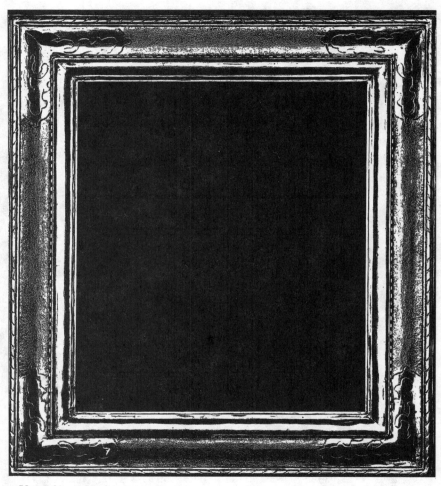

Yates (American)
carved and gilded, (Ca 1910)
(Courtesy of Eli Wilner & Co., New York, NY)

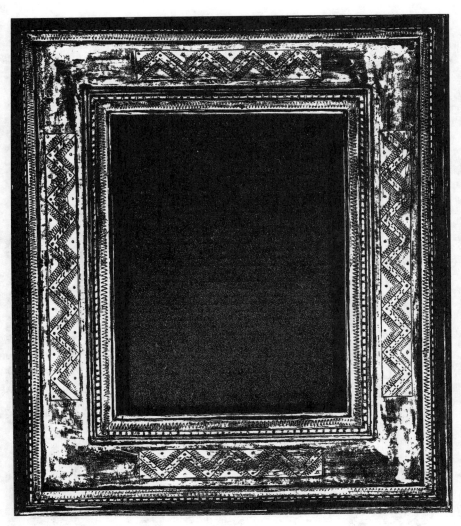

Harer (American)
carved, incised, gilded (Ca 1915)
(Courtesy of Eli Wilner & Co., New York, NY)

Foster Brothers (American)
carved and gilded, (Ca 1900)
(Courtesy of Eli Wilner & Co., New York, NY)

Newcomb-Macklin (American)
carved and gilded, (Ca 1910)
(Courtesy of Eli Wilner & Co., New York, NY)

Harer (American)
carved and gilded, (Ca 1910)
(Courtesy of Eli Wilner & Co., New York, NY)

Newcomb-Macklin (American)
carved and gilded (Ca 1910)
(Courtesy of Eli Wilner & Co., New York, NY)

Key to Subjects

A	Avant-Garde
F	Figures
G	Genre
I	Illustrations
L	Landscapes
M	Marines
S	Still Life
W	Wildlife
X	Unknown

EUROPEAN ARTISTS
AT AUCTION

ARTIST	PRICES	SUBJECT
AACHEN, (JOHANN) HANS VON (1552-1616) GERMAN	8500-140000	G,F
AAGAARD, CARL FREDERIC (1833-1895) DANISH	600-20000	L,W
AAGAARD, MARTIN (1863-1913) NORWEGIAN	400-10000	M
AALTONEN, WAINO (1894-1966) FINNISH	500-12000	F,L
ABADES, JUAN MARTINEX (20TH C) SPANISH	600-10000	M,F
ABATE, ALBERTO (B. 1946) ITALIAN	500-5500	X
ABBATE, NICCOLO DELL (1512-1571) ITALIAN	2500-+++	G,F
ABBATI, GIUSEPPE (1836-1868) ITALIAN	2000-120000	L,F
ABBATI, VINCENZO (19TH C) ITALIAN	700-20000	L
ABBEMA, LOUISE (1858-1927) FRENCH	350-8900	F,G,S
ABBIATI, FILIPPO (1640-1715) ITALIAN	2000-18000	X(F)
ABBOTT, JOHN WHITE (1763-1827) BRITISH	*900-20000	L
ABBOTT, LEMUEL FRANCIS (1760-1803) BRITISH	800-30000	F
ABEELE, ALBIJN VAN DEN	*300-6000	
ABEELE, ALBIJN VAN DEN (20TH C) BELGIAN	600-18000	L
ABEL-TRUCHET, LOUIS (1857-1918) FRENCH	800-12000	L,G
ABELA, EDUARDO (1892-1966) LATIN AMERICAN	600-8500	L,F
ABELARD, GESSNER (B. 1922) HAITIAN	200-2500	X(F)
ABELEN, PETER (1884-1962) GERMAN	200-2000	F,G
ABELS, JACOBUS THEODORUS (1803-1866) DUTCH	400-9000	L
ABERDAM, ALFRED (1894-1963) POLISH	500-8500	L,F,S
ABERG, BENGT (20TH C) SWEDISH	400-4000	M
ABERG, EMIL (1864-1940) SWEDISH	300-7200	L,I
ABERG, GUNNAR (1869-1894) SWEDISH	300-4500	L
ABERG, PELLE (1909-1964) SWEDISH	400-20500	F,G,L
ABERG, PELLE (1909-1964) SWEDISH	*400-12000	
ABERRY, J (18TH C) BRITISH	900-18000	F
ABESCH, JOHAN PETER (1666-1740) SWISS	400-4500	F
ABLETT, WILLIAM ALBERT (1877-1937) BRITISH	*400-4500	F,L
ABRAHAM, ROBERT J (19TH C) BRITISH	*100-2000	F,G
ABRAHAMSSON, ERIK (1871-1907) SWEDISH	400-6000	L
ABRAMOVITSCH, S (1903-1953) FRENCH	300-3000	X(F,S)

ABSOLON, JOHN	*200-7500	
ABSOLON, JOHN (1815-1895) BRITISH	900-12000	G,L,F
ABSOLON, LOUIS (19TH C) BRITISH	*100-1500	L
ABULARACH, RODOLFO	*150-2000	
ABULARACH, RODOLFO (B. 1934) MEXICAN	500-7000	X
ACCARD, EUGENE (1824-1888) FRENCH	700-8500	G,F
ACCARDI, CARLA (B.1924) ITALIAN	400-16000	X
ACHEN, GEORG NICOLAJ (B. 1860) DANISH	700-24500	M,L,F
ACHENBACH, ANDREAS	*300-3500	
ACHENBACH, ANDREAS (1815-1910) GERMAN	1000-47000	M,G,L
ACHENBACH, OSWALD	*500-5000	
ACHENBACH, OSWALD (1827-1905) GERMAN	3500-110000	L,M
ACHILLE-FOULD, GEORGES (1865-1951) FRENCH	200-2000	X
ACHINI, ANGELO (1850-1930) ITALIAN	*200-3000	F
ACHTENHAGEN, AUGUST (B. 1865) GERMAN	100-1500	X
ACHTSCHELLINCK, LUCAS (1626-1699) FLEMISH	500-6000	L
ACKE, J AXEL G (1859-1924) SWEDISH	900-28000	F,G,L
ACKER, FLORI-MARIE VAN (B.1858) FLEMISH	400-3000	L,W
ACKERMAN, PAUL	*300-5500	
ACKERMAN, PAUL (1908-1981) RUMANIAN/FRENCH	500-12000	A,G,F
ACKERMANN, GERALD (B.1876) BRITISH	*300-3400	L
ACKERMANN, MAX	*500-9500	
ACKERMANN, MAX (1887-1973) GERMAN	1000-50000	A
ACKERMANN, OTTO (B.1872) GERMAN	300-1800	G,L,F
ACKLAND, T.G. (19TH C) BRITISH	*150-1800	X
ACOQUAT, LOUISE-MARIE (19TH-20TH C) FRENCH	200-1800	L
ACOSTA, A. (19TH C) SPANISH	100-6100	F
ACS, AGOSTOS (19TH/20TH C) HUNGARIAN	300-6800	L
ACUNA, LOUIS ALBERTO (B. 1905) COLUMBIAN	200-1200	G
ADAM, ALBRECHT	*300-5900	
ADAM, ALBRECHT (1786-1862) GERMAN	2000-45000	L,W
ADAM, BENNO (1812-1892) GERMAN	400-15000	W,L
ADAM, EDOUARD (1847-1922) FRENCH	500-5600	M
ADAM, EMIL (1843-1924) GERMAN	1500-25000	W,G
ADAM, EMMY (B. 1871) GERMAN/AMERICAN	100-700	X
ADAM, FRANZ (1815-1886) GERMAN	100-45000	G,F,L
ADAM, HEINRICH (1787-1886) GERMAN	950-35000	L,W
ADAM, JOSEPH DENOVAN (1842-1896) BRITISH	300-6000	L,W
ADAM, JULIUS (1852-1913) GERMAN	2000-45000	W

* Denotes watercolors, pastels, drawings, and/or mixed media

ADAM, PATRICK WILLIAM (B. 1854) BRITISH	250-7500	L
ADAM, RICHARD BENNO (B. 1873) GERMAN	300-3200	L,W
ADAM, ROBERT (1728-1792) SCOTTISH	*300-25000	L
ADAM, VICTOR (1801-1866) FRENCH	500-3500	F
ADAM-KUNZ, L. (19TH-20TH C) GERMAN	200-1800	X
ADAMI, PIETRO (18TH C) ITALIAN	*350-1800	L
ADAMI, VALERIO	*800-98000	
ADAMI, VALERIO (B. 1935) ITALIAN	1000-89000	A
ADAMOFF, HELENA (B. 1906) RUSSIAN	100-1000	G
ADAMS, CHARLES JAMES (1857-1931) BRITISH	*300-5400	G,L
ADAMS, DOUGLAS (1853-1920) BRITISH	300-4800	L
ADAMS, HARRY W (1868-1947) BRITISH	300-6000	L
ADAMS, JOHN CLAYTON (1840-1906) BRITISH	450-7800	L,W
ADAMS, JOHN TALBOT (19TH/20TH C) BRITISH	400-5000	X (G)
ADAMS, WILLIAM D. (1864-1951) BRITISH	200-1800	G,L
ADAN, LOUIS EMILE	*400-2500	
ADAN, LOUIS EMILE (1839-1937) FRENCH	1000-72000	G,L,F
ADCOCK, J. WILTON	*100-400	
ADCOCK, J. WILTON (1886-1891) BRITISH	100-1200	M
ADEMOLLO, CARLO (B. 1825) ITALIAN	400-6000	
ADLER, EDMUND (1871-1957) GERMAN	1000-18000	G,F,W
ADLER, JANKEL	*500-12000	
ADLER, JANKEL (1895-1949) POLISH	800-40000	A,S,F
ADLER, JULES	*300-3200	
ADLER, JULES (1865-1952) FRENCH	700-35000	G,F
ADNET, FRANCOISE (B. 1924) FRENCH	100-1200	G
ADOLPH, CARL (18TH C) AUSTRIAN	1000-6000	X(S)
ADRIAENSSEN, ALEXANDER (1587-1661) FLEMISH	600-29000	S,W
ADRIAN-NILSSON, GOSTA	*400-13200	
ADRIAN-NILSSON, GOSTA (1884-1965) SWEDISH	2000-80000	X
ADRIENSENCE, HENRIETTE (20TH C) FRENCH	400-3500	X
ADRION, LUCIEN	*200-1500	
ADRION, LUCIEN (1889-1953) FRENCH	500-16000	L,S
ADVIER, VICTOR-ANDRE (20TH C) FRENCH	100-750	S
AEGERTER, KARL (1888-1969) SWISS	300-4000	F,L
AELST, EVERT VAN (1602-1657) DUTCH	500-15000	S
AELST, PIETER COECKE VAN (1502-1550) FLEMISH	*3000-85000	
AELST, WILLEM VAN (1625-1683) DUTCH	1000-98000	S
AERNI, FRANZ THEODOR (1853-1918) GERMAN	400-16000	F,L

AFFLECK, ANDREW F (20TH C) BRITISH	300-5000	F
AFFLECK, WILLIAM (1869-1909) BRITISH	*300-15000	G,L
AGAR, CHARLES D' (1669-1723) FRENCH	200-1800	F
AGAR, EILEEN (B. 1904) BRITISH	700-15000	X
AGARD, CHARLES (B. 1866) FRENCH	100-4000	X
AGASSE, JACQUES LAURENT (1767-1849) SWISS	2500-+++	L,W
AGAZZI, RINALDO (1866-1945) ITALIAN	400-3500	F
AGNETTI, VINCENZO (B. 1926) ITALIAN	*800-20000	X
AGOSTINI, GUIDO (19TH C) ITALIAN	800-9000	L
AGRASOT Y JUAN, JOAQUIN (1836-1907) SPANISH	1200-137000	G
AGRESTI, LIVIO (1508-1580) ITALIAN	*300-6500	F
AGRICOLA, CARL (1779-1852) GERMAN	500-6500	F
AGRICOLA, EDUARD (B. 1800) GERMAN	900-20000	L
AGUELI, IVAN (1869-1917) SWEDISH	1500-25000	L,F
AGUILA, A. (19TH C) SPANISH	100-1700	X
AGUILAR, M.(B.1919) SAN SALVADOR	100-800	X
AGUILAR MORE, RAMON (B. 1924) SPANISH	800-14000	X(F)
AGUIRRE, IGNACIO (B.1902) MEXICAN	200-2500	G
AHGUPUK, GEORGE A. (20TH C) ESKIMO	*100-600	X
AHLBERG, ARVID MAGNUS (1851-1932) SWEDISH	500-9500	X(M)
AHRENS, CARL (1863-1936) CANADIAN	100-1700	G,L
AHRWEILER, KARL (1888-1962) GERMAN	300-3000	L
AIGEN, KARL (1684-1764) AUSTRIAN	200-3500	L
AIKMAN, GEORGE W (1831-1906) BRITISH	400-4000	G,F,M
AIKMAN, WILLIAM (1682-1731) BRITISH	1500-85000	F
AIRY, ANNA (20TH C) BRITISH	*900-8500	X
AITCHISO6, CRAIGIE (20TH C) BRITISH	5000-40000	X
AITKEN, JOHN ERNEST (1881-1957) BRITISH	*300-1800	G,L
AIVAZOFFSKI, IVAN CONSTANTINOWITSCH	*600-6000	
AIVAZOFFSKI, IVAN CONSTANTINOWITSCH (1817-1900) RUSSIAN	3000-128000	L,M
AIZPIRI, PAUL	*300-12000	
AIZPIRI, PAUL (B.1919) FRENCH	2000-130000	F,M,S
AJDUKIEWICZ, SIGISMUND VON (1861-1917) AUSTRIAN	1000-15000	F,L
AJDUKIEWICZ, THADDEUS VON (1852-1916) POLISH	900-18000	G,W
AJMONE, GIUSEPPE (B. 1923) ITALIAN	200-5000	L,S
AKEN, LEO VAN (1857-1904) BELGIAN	250-3200	X
AKKERINGA, JOHANNES EVERT (1894-1942) DUTCH	600-23000	G,L
AKKERSDIJK, JACOB (1815-1862) DUTCH	400-6500	G
ALAJOS, MAYER (19TH/20TH C) HUNGARIAN	100-700	X

* Denotes watercolors, pastels, drawings, and/or mixed media

ALARCON, FELIX (19TH C) SPANISH	250-3800	G,F
ALAUX, GUILLAUME (D. 1913) FRENCH	200-2000	F
ALAUX, GUSTAVE (1887-1965) FRENCH	450-25000	F
ALAUX, JEAN PIERRE (B. 1925) FRENCH	150-2500	L,M
ALBANI, FRANCESCO (1578-1660) ITALIAN	1000-64000	F
ALBERT, ADOLPHE (20TH C) FRENCH	100-600	G,M
ALBERT, JOS (B. 1866) BELGIAN	900-32000	S,L,F
ALBERTI, CARL (B.1800) GERMAN	300-2500	G
ALBERTI, CHERUBINO (1553-1615) ITALIAN	*1000-15000	F
ALBERTI, HENRI (B. 1868) FRENCH	150-2400	G
ALBERTIS, SEBASTIANO DE	*200-1800	
ALBERTIS, SEBASTIANO DE (1828-1897) ITALIAN	1500-47000	G
ALBERTS, W.J. (20TH C) DUTCH	100-700	X
ALBINO, J. (20TH C) ITALIAN	100-700	X
ALBOY-REBOUET, ALFRED (1841-1875) FRENCH	300-4300	X
ALBRIZZI, ENRICO (OR ALBRICCI) (1714-1775) ITALIAN	1100-21000	G
ALDER, EDMUND (1871-1957) AUSTRIAN	500-6000	X
ALDI, PIETRO (1852-1888) ITALIAN	300-3500	X
ALDIN, CECIL CHARLES WINDSOR (1870-1935) BRITISH	*350-15000	G
ALDINE, MARC (B. 1917) FRENCH	300-13000	L,M
ALDRIDGE, FREDERICK JAMES	*100-3000	
ALDRIDGE, FREDERICK JAMES (1850-1933) BRITISH	150-3000	M
ALDRIDGE, JOHN (20TH C) BRITISH	1000-6500	L
ALECHINSKY, PIERRE	*2500-+++	
ALECHINSKY, PIERRE (B.1927) BELGIAN	3500-+++	A
ALEGIANI, FRANCESCO (19TH C) ITALIAN	250-3200	G,F
ALEXANDER, EDWIN (1870-1926) BRITISH	400-6000	X(M)
ALEXANDER, ROBERT (1896-1940) BRITISH	400-7000	
ALEXANDER, ROBERT L. (1840-1923) BRITISH	200-1500	G,W
ALEXANDER, WILLIAM (1767-1816) BRITISH	*600-30000	L,F
ALFARO, JOSE (18TH C) MEXICAN	2500-35000	G,L
ALFELT, ELSE (1919-1975) DANISH	600-3500	X
ALFONSO, J. (19TH C) CUBAN	150-1500	X
ALHORI, V. (19TH/20TH C) ITALIAN	200-1200	G,F
ALIGNY, CLAUDE FELIX THEODORE (1798-1871) FRENCH	600-7500	L,W
ALINARI, LUCA (20TH C) ITALIAN?	800-5000	A
ALIX, YVES (B. 1890) FRENCH	300-9000	L
ALIZARD, JEAN PAUL (19TH C) FRENCH	300-2500	X
ALIZON, H. (19TH/20TH C) FRENCH	100-800	L

ALIZON, HIPOLITE (19TH C) FRENCH	100-1000	X
ALKEN, HENRY GORDON (SAMUEL HENRY)	*1000-12000	
ALKEN, HENRY GORDON (SAMUEL HENRY)(1810-1894) BRITISH	800-45000	G
ALKEN, HENRY THOMAS (1785-1851) BRITISH	2700-75000	W,G
ALLAN, ARCHIBALD RUSSELL WATSON (1878-1959) BRITISH	400-3000	L,W
ALLAN, ROBERT WEIR (1852-1942) BRITISH	*400-3200	M,L,G
ALLBON, CHARLES FREDERICH (1858-1926) BRITISH	*100-2000	L,W
ALLCOT, JOHN (1888-1973) AUSTRALIAN	400-6000	M,L
ALLEAUME, LUDOVIC (B. 1859) FRENCH	500-6000	F
ALLEBE, AUGUSTUS (1838-1927) DUTCH	350-11000	X
ALLEGRAIN, ETIENNE (1653-1736) FRENCH	900-30000	L
ALLEN, A.C. (19TH C) BRITISH	100-500	F,S
ALLEN, HARRY EPWORTH	*400-8000	
ALLEN, HARRY EPWORTH (1894-1958) BRITISH	1000-30000	L,G,F
ALLEN, JOSEPH WILLIAM (1803-1852) BRITISH	350-3800	L,W
ALLERSTON, JOHN TAYLOR (19TH C) BRITISH	100-900	X
ALLFREY, E W (19TH-20TH C)	300-3200	G,L
ALLINGHAM, HELEN (1848-1926) BRITISH	*900-62000	G,F
ALLINSON, ADRIAN (1890-1959) BRITISH	500-7500	F,L
ALLONGE, AUGUSTE (1833-1898) FRENCH	300-4500	G,L
ALLORI, ALESSANDRO (1535-1607) ITALIAN	2000-100000	F
ALLORI, CHRISTOFANO (1577-1621)ITALIAN	1500-52000	G,F
ALMA-TADEMA, SIR LAWRENCE	*1000-25000	
ALMA-TADEMA, SIR LAWRENCE (1836-1912) BRITISH	3500-+++	G,F
ALMA-TADEMA, LADY LAURA (LAURA EPPS) (1852-1909) BRITISH	1000-20000	G,F
ALONSO-PEREZ, MARIANO (1857-1930) SPANISH	800-28000	F,G
ALONZO, ANGEL (20TH C) FRENCH	1000-8500	A
ALOTT, ROBERT (19TH C) AUSTRIAN	200-6500	L,M
ALPERIZ, NICHOLAS (B.1869) SPANISH	400-22500	G
ALSINA, J. (19TH/20TH C) FRENCH	300-7000	G,F
ALSLOOT, DENIS VAN (1570-1628) FLEMISH	3000-110000	L
ALSOP, FREDERIC (19TH C) BRITISH	100-700	L
ALT, FRANZ	*300-9400	
ALT, FRANZ (1821-1914) AUSTRIAN	700-12000	L
ALT, JACOB (1789-1872) GERMAN	2000-34000	L
ALT, RUDOLF VON (1812-1905) AUSTRIAN	*1500-34000	L,S
ALT, THEODOR (1846-1901) AUSTRIAN	800-5000	L,W
ALTAMURA, SAVERIO (1826-1897) ITALIAN	250-3400	L,F

* Denotes watercolors, pastels, drawings, and/or mixed media

ALTENKIRCH, OTTO (B.1875) GERMAN	100-1000	X(L)
ALTHAUS, FRITZ (19TH-20TH C) BRITISH	*400-3000	L
ALTHERR, HEINRICH (1878-1947) SWISS	500-4000	F,G
ALTMANN, ALEXANDRE (1885-1932) RUSSIAN	700-14000	L,S
ALTMANN, ALEXANDRE (B. 1885) RUSSIAN	400-11000	X(L,F)
ALTMANN JR, ANTON (1808-1871) AUSTRIAN	1000-7000	L
ALTSON, ABBEY (B.1864) BRITISH	1200-22000	L,F
ALTZAR, ANDERS (1886-1939) SWEDISH	400-3500	L
ALVAREZ, CATALA LUIS	*600-3500	
ALVAREZ, CATALA LUIS (1836-1901) SPANISH	3500-70000	F,G
ALVAREZ, GIAN (19TH C) SPANISH	2000-20000	X
ALVAREZ-DUMONT, EUGENIO (1864-1927) SPANISH	700-36000	G,F
ALVARO, JORGE (B.1949) ARGENTINIAN	*250-2500	G,F
AMADO Y BERNARDET, RAMON (1844-1888) SPANISH	300-11000	X(F,G)
AMAN-JEAN, EDMOND FRANCOIS	*1200-143000	
AMAN-JEAN, EDMOND FRANCOIS (1860-1935) FRENCH	850-44000	G,F
AMARAL, ANTONIO HENRIQUE ABEU (B.1935) BRAZILIAN	500-6000	X(G)
AMBERG, AUGUST WILHELM (1822-1899) GERMAN	300-3800	G,F
AMBERGER, CHRISTOPH (1490-1562) GERMAN	2500-36000	F
AMBILLE, PAUL (B. 1930) FRENCH	800-7500	X
AMBROGIANI, PIERRE	*200-4000	
AMBROGIANI, PIERRE (1907-1985) FRENCH	500-14000	G,L,S
AMBROS, RAPHAEL VON (19TH C) CZECHOSLOVAKIAN	400-10000	X(G)
AMEGLIO, MERIO (1897-1970) FRENCH	250-8000	L,M
AMELIN, ALBIN (1902-1975) SWEDISH	1000-21000	S
AMELIN, ALBIN (1902-1975) SWEDISH	*500-15000	S,F
AMERLING, FRIEDRICH VON (1803-1887) GERMAN	300-11000	F
AMESEDER, EDOUARD (1856-1938) AUSTRIAN	200-3000	X(M,F)
AMICUS, CRISTOFORO DE (B. 1902) ITALIAN	900-15000	L,S
AMIET, CUNO (1868-1961) SWISS	1200-132000	L,S
AMIET, CUNO (1868-1961) SWISS	*600-20000	
AMIGONI, JACOPO (1682-1752) ITALIAN	1500-121000	F
AMOROSI, ANTONIO (1660-1738) ITALIAN	900-44000	G,F
AMORSOLO, FERNANDO (Active 1925-1935) PHILLIPINO	400-7500	G,F
ANASTASI, AUGUSTE	*100-3000	
ANASTASI, AUGUSTE (1820-1889) FRENCH	250-4000	L,M
ANBURU, MANUEL DE (18TH C) MEXICAN	100-1500	F
ANCCHER, MICHAEL (1849-1927) DANISH	$1000	
ANCHER, ANNA (B.1859) DANISH	2000-32000	G,F

ANCHER, MICHAEL P. (1849-1927) DANISH	2500-+++	M,F,
ANDERS, ERNST (1845-1911) GERMAN	500-11000	X
ANDERSEN, MOGENS (20TH C) DANISH	500-5000	A
ANDERSEN, WILHELM (1867-1945) DANISH	500-5000	X(S)
ANDERSEN-LUNDBY, A (1841-1923) DANISH	800-16000	L
ANDERSON, CHARLES GOLDSBOROUGH (1865-1936) BRITISH	1000-15000	F
ANDERSON, CILIUS (1865-1913) DANISH	800-6500	G,F
ANDERSON, JAMES BELL (1886-1931) SCOTTISH	100-1000	F,S
ANDERSON, JOHN (19TH) BRITISH	500-20000	L
ANDERSON, NILS (1817-1866) SWEDISH	400-6000	L
ANDERSON, ROBERT (1842-1885) BRITISH	*400-4000	M
ANDERSON, SOPHIE (1823-1903) BRITISH	1500-20000	F
ANDERSON, STANLEY (19TH-20TH C) BRITISH	*400-6000	G,L
ANDERSON, W.LIVINGSTON	*100-500	
ANDERSON, W.LIVINGSTON (Late 19TH C) BRITISH	300-5000	G,L
ANDERSON, WILLIAM	*1000-10000	
ANDERSON, WILLIAM (1757-1837) BRITISH	1000-25000	G,M,F
ANDERSSON, AKE WILHELM (B. 1922) SWEDISH	400-2000	L
ANDERTON, C.W. (19TH C) BRITISH	*100-600	X
ANDRE, ALBERT	*800-9000	
ANDRE, ALBERT (1869-1954) FRENCH	1000-45000	G,S
ANDRE, CHARLES (19TH/20TH C) FRENCH	*400-12000	X
ANDRE, JULES (1807-1869) FRENCH	250-5000	G
ANDREASSON, FOLKE (1902-1948) SWEDISH	600-7500	M,S
ANDREENKO, MIKHAIL (1895-1982) RUSSIAN	*350-8500	F,L
ANDREIS, ALEX DE (19TH C) BELGIAN	1000-8500	F,G
ANDREIS, ALEX DE (19TH C) EUROPEAN	400-9500	G
ANDREJEVIC, MILET (B. 1925) YUGOSLAVIAN	800-9000	X
ANDREOTTI, FEDERICO (1847-1930) ITALIAN	66000	
ANDREOTTI, FEDERIGO (1847-1930)ITALIAN	2500-60000	G,F,L
ANDRESEN, JENS CHRISTIAN (1865-1949) SWEDISH	300-3500	M
ANDREU, MARIANO	*100-800	
ANDREU, MARIANO (B.1901) SPANISH	550-23000	F,S
ANDREWS, GEORGE HENRY (1816-1898) BRITISH	350-7500	G,M
ANDREWS, HENRY (1816-1869) BRITISH	1500-18000	F,G
ANDRI, FERDINAND (1871-1956) AUSTRIAN	1000-12000	
ANDRIESSEN, ANTHONY (1746-1813) DUTCH	*500-3500	L
ANDRIEU, MATHURAN ARTHUR (D.1896) FRENCH	100-750	X
ANDRIEU, PIERRE (1821-1892) FRENCH	*400-2500	F,W

* Denotes watercolors, pastels, drawings, and/or mixed media

ANDRIEUX, CLEMENT AUGUSTE (B.1829) FRENCH	*350-5000	G,W
ANDRINGA, TJEERD (1806-1827) DUTCH	300-2500	G
ANEDEE, VESNUS (1831-1909) FRENCH	300-2800	X
ANELAY, HENRY (1817-1883) BRITISH	150-850	F
ANESI, PAOLO (1700-1761) ITALIAN	600-32000	L,S
ANGAS, GEORGE (1822-1886) BRITISH	1800-22000	X
ANGELI, FRANCO	*700-25000	
ANGELI, FRANCO (B. 1935) ITALIAN	1000-25000	A
ANGELI, GIUSEPPE (1709-1798) ITALIAN	1000-12000	F
ANGELI, HEINRICH VON (1840-1925) AUSTRIAN	350-4500	G,F
ANGELIS, DESIDERIO DE	*100-800	
ANGELIS, DESIDERIO DE (19TH C) ITALIAN	500-7500	X
ANGELLI, FILIPPO (1600-1640) ITALIAN	2000-26000	L,F
ANGILLIS, PIETER (1685-1734) FLEMISH	4000-150000	G,F
ANGLADA-CANMARASA, HERMAN (1873-1959) SPANISH	3500-+++	X
ANGLADE, GASTON (1854-1926) FRENCH	300-2500	L,S
ANGO, JEAN ROBERT (Late 18TH C) FRENCH	*150-5100	X
ANGQVIST, OLLE (B. 1922)	800-5000	A
ANGRAND, CHARLES	*800-40000	
ANGRAND, CHARLES (1854-1926) FRENCH	3500-200000	G,F,L
ANGUIANO, RAUL	*200-3800	
ANGUIANO, RAUL (B.1915) MEXICAN	600-6500	F,W
ANIVITTI, FILIPPO (1876-1955) ITALIAN	450-5000	L,W
ANKARCRONA, ALEXIA (1825-1901) SWEDISH	200-2500	L
ANKARCRONA, GUSTAF (1869-1933) SWEDISH	1000-14000	L
ANKARCRONA, HENRIK AUGUST	*300-1500	
ANKARCRONA, HENRIK AUGUST (1839-1919) SWEDISH	1200-15000	L,G
ANKER, ALBERT	*700-90000	
ANKER, ALBERT (1831-1910) SWISS	*5000-225000	F,S,G,L
ANNA, ALESSANDRO DE (1560-1640) ITALIAN	*900-6500	G,F
ANNENKOFF, GEORGES (1890-1971) RUSSIAN	300-2000	F
ANNENKOFF, YURI (1890-1974) RUSSIAN	*400-157000	X
ANNIGONI, PIETRO	*400-24000	
ANNIGONI, PIETRO (B.1910) ITALIAN	1000-32000	L,F
ANQUETIN, LOUIS (1861-1932) FRENCH	*400-5000	X
ANRROY, ANTON VAN (1870-1949) DUTCH	800-5000	L
ANSDELL, RICHARD (1815-1885) BRITISH	1000-180000	G,L,W
ANSELMI, MICHELANGELO (1491-1554) ITALIAN	2000-86000	F
ANSINGH, LIZZY (B.1875) DUTCH	500-9500	G,S

ANSON, MARK (19TH C) BRITISH	300-2800	X(L)
ANTCHER, ISAAC (20TH C) RUMANIAN	800-6000	L
ANTES, HORST	*1200-57000	
ANTES, HORST (B.1936) GERMAN	1500-240000	A
ANTHONISSEN, HENDRICK VAN (1606-1660) DUTCH	1000-40000	M
ANTIGNA, ALEXANDRE (1817-1878) FRENCH	900-12000	X(G)
ANTIGNA, MARC (19TH/20TH C) FRENCH	100-800	X
ANTOINE, MONTAS (20TH C) LATIN AMERICAN	100-900	X
ANTONIANI, PIETRO (1740-1805) ITALIAN	1200-181000	L,M
ANTONISSEN, HENRI J. (1737-1794) FLEMISH	800-15000	W,L
ANTRAL, ROBERT (1895-1940) FRENCH	500-6000	L
ANTROS, A. VAN (19TH C) EUROPEAN	250-1200	X
ANTUNEZ, NEMESIO (B.1918) CHILEAN	250-4500	G
ANVILLE, HUBERT FRANCOIS BOURGUIGNON D' (1699-1773) FRENCH	400-2000	X
APOL, ARMAND (1879-1950) BELGIAN	300-4900	F,M
APOL, LOUIS	*100-3900	
APOL, LOUIS (1850-1936) DUTCH	800-23000	X
APPEL, KAREL	*900-106000	
APPEL, KAREL (B.1921) DUTCH/AMERICAN	1500-+++	A
APPERLEY, GEORGE OMEN WYNNE (1884-1960) BRITISH	*400-5000	F
APPERT, EUGENE (1814-1867) FRENCH	300-4500	G
APPERT, G. (19TH C) FRENCH	200-2200	G,F
APPIAN, JACQUES BARTHOLOMY (Called ADOLPHE)	*100-2000	
APPIAN, JACQUES BARTHOLOMY (Called ADOLPHE) (1818-1898) FRENCH	300-5500	L,F
APPIAN, LOUIS (1862-1896) FRENCH	800-6500	M
APPLETON, HONOR CHARLOTTE (1879-1951) BRITISH	*500-5500	G,F,I
APPLEYARD, FREDERICK (1874-1963) BRITISH	400-3000	X(L)
APSHOVEN, THOMAS VAN (1622-1664) FLEMISH	1000-50000	G,L
AQUINO, EDMUNDO (B.1939) MEXICAN/AMERICAN	150-1500	X
ARAKAWA, SHUSAKU	*1200-140000	
ARAKAWA, SHUSAKU (B.1936) JAPANESE	2000-160000	A
ARBO, PETER NICOLAI (1831-1892) NORWEGIAN	800-6000	G,F
ARBORELIUS, OLOF (1842-1915) SWEDISH	700-12000	L,G,F
ARBUCKLE, GEORGE FRANKLIN (B. 1909) CANADIAN	700-10000	L
ARCHER, CHARLES (19TH C) BRITISH	900-6000	S
ARCHIPENKO, ALEXANDER	*1000-40000	
ARCHIPENKO, ALEXANDER (1887-1964) RUSSIAN	1500-102000	F,S
ARDEN-QUIN, CARMELO (B. 1913) URUGUAYAN	2000-32000	A

* Denotes watercolors, pastels, drawings, and/or mixed media

ARDISSONE, YOLANDE (B.1872) FRENCH	*200-4500	F
ARDIZZONE, EDWARD (1900-1978) BRITISH	*900-12000	F,G
ARDON, MORDECHAI (B. 1896) ISRAELI	10000-140000	L
ARELLANO, JUAN DE (1614-1676) SPANISH	3500-+++	S
AREN, OLOF (B. 1918) SWEDISH	400-5000	L,S
AREND, G. (19TH/20TH C) DUTCH	100-650	X
ARENDSEN, ARENTINA HENDRICA (1836-1915) DUTCH	900-7000	S
ARGOV, MICHAEL (20TH C) ISRAELI	300-2000	X
ARIAS, MIGUEL (19TH C) CUBAN	300-5000	X
ARIZA, GONZALO (B. 1912) COLUMBIAN	600-25500	X
ARLINGSSON, ERLING (1904-1982) SWEDISH	900-12000	G,S,L
ARMAN, (ARMAN FERNANDEZ)	*600-70000	
ARMAN, (ARMAN FERNANDEZ) (B. 1928) FRENCH	900-75000	F
ARMAND-DUMARESQ, EDOUARD CHARLES (1826-1895) FRENCH	500-5000	W
ARMANET, FRANCOIS (20TH C) FRENCH	800-6000	X
ARMENISE, RAFFAELLO (1852-1932) ITALIAN	400-12000	G,F
ARMES, THOMAS (20TH C) BRITISH	*300-1800	M,L
ARMET Y PORTANEL, JOSE (1843-1911) SPANISH	1000-40000	X(L)
ARMFIELD, EDWARD (19TH C) BRITISH	450-6800	G,W
ARMFIELD, G SMITH (19TH C) BRITISH	400-3500	X(W)
ARMFIELD, GEORGE (Active 1840-1875) BRITISH	1000-16000	L,W
ARMFIELD, MAXWELL (1882-1972) BRITISH	700-20000	X
ARMFIELD, STUART (B. 1916) BRITISH	400-3000	X
ARMINGTON, FRANK MILTON	*100-1000	
ARMINGTON, FRANK MILTON (1876-1941) CANADIAN	500-5000	L,F
ARMINGTON, FRANK MILTON (1876-1941) CANADIAN	250-4000	F,G
ARMLEDER, JOHN M (20TH C) SWISS	2000-30000	A
ARMOUR, GEORGE DENHOLM (1864-1949) BRITISH	*300-4200	G,L
ARMOUR, GEORGE DENHOLM (1864-1949) BRITISH	*450-21000	G,W
ARMOUR, MARY (B. 1902) BRITISH	700-9500	S,L
ARMSTRONG, JEAN SHEARER (20TH C) BRITISH	200-1500	X
ARMSTRONG, JOHN (1893-1973) BRITISH	800-47000	X(A)
ARMSTRONG, THOMAS (1835-1911) BRITISH	600-10000	F
ARNAL, FRANCOIS	*500-9000	
ARNAL, FRANCOIS (B. 1924) FRENCH	3000-65000	A
ARNALD, GEORGE (1763-1841) BRITISH	700-6500	L,F
ARNEGGER, ALOIS (1879-1967) AUSTRIAN	300-3500	L
ARNEGGER, ALWIN (1883-1916) EUROPEAN	300-4300	L
ARNEGGER, GOTTFRIED (B. 1905) AUSTRIAN	200-2000	L,F

ARNESEN, VILHELM (B. 1865) DANISH	250-7000	M
ARNOLD, G. (20TH C) CANADIAN	100-750	X
ARNOLD, REGINALD ERNST (1853-1938) BRITISH	300-3200	G,F
ARNOLD, S. (19TH C) BRITISH	100-700	X
ARNOULD DE COOL, DELPHINE (B. 1830) FRENCH	300-4800	X
ARNOUX, CHARLES ALBERT (1820-1863) FRENCH	400-5500	G,F
ARNSBURG, MARIE (B. 1862) AUSTRIAN	300-2500	X(L)
ARNTZENIUS, FLORIS (1864-1925) DUTCH	500-6500	L,F
ARNTZENIUS, H. (19TH C) DUTCH	100-600	X
ARNZ, ALBERT (B. 1832) EUROPEAN	100-2500	M
AROSENIUS, IVAR (1878-1919) SWEDISH	*300-13000	G,F
ARP, JEAN	*900-78000	
ARP, JEAN (1887-1966) FRENCH	2000-+++	A
ARRANGO, RAMIRO B. (20TH C) COLOMBIA	200-1200	S
ARROYO, EDOUARD	*1000-12000	
ARROYO, EDOUARD (B. 1937) SPANISH	3000-100000	A
ARSENIUS, JOHN (1818-1903) SWEDISH	500-7500	L,W
ARSENIUS, KARL GEORG (1855-1908) SWEDISH	600-2500	W,L
ART, BERTHE (B. 1857) BELGIAN	*600-2000	S
ARTAN, LOUIS (1837-1890) BELGIAN	700-6000	L,M
ARTHOIS, JACQUES D'	*200-1500	
ARTHOIS, JACQUES D' (1613-1686) FLEMISH	1200-25000	L,W
ARTHUR, REGINALD (Late 19TH C) BRITISH	550-27500	G,F
ARTS, THEODORUS JOHANNES (1901-1961) DUTCH	100-2500	G
ARTZ, CONSTANT	*500-5000	
ARTZ, CONSTANT (1870-1951) DUTCH	700-12000	W
ARTZ, DAVID ADOLF CONSTANT	*200-2500	
ARTZ, DAVID ADOLF CONSTANT (1837-1890) DUTCH	350-15000	M,W
ARUNDALE, FRANCIS VYVYAN JAGO (1807-1853) BRITISH	*600-6200	I
ARUS, JEAN MARIE JOSEPH (B. 1846) FRENCH	100-900	X
ARUS, JOSEPH RAOUL (1848-1921) FRENCH	400-6000	G
ASCH, PIETER JANSZ VAN (1603-1678) DUTCH	1500-15000	L,W
ASCHENBACH, ERNST (1872-1954) NORWEGIAN	200-3000	L
ASCHENBRENNER, LENNART (20TH C) SWEDISH	800-7500	A
ASHBURNER, WILLIAM F (19TH-20TH C) BRITISH	*500-6000	L
ASHFORD, LEONARD (19TH/20TH C) BRITISH	300-2800	X
ASHTON, HOWARD (19TH C) BRITISH	700-3500	L
ASHTON, JULIAN HOWARD (1877-1964) AUSTRIALIAN	500-15000	M
ASHTON, JULIAN ROSSI (1851-1942) BRITISH	800-40000	F,M

* Denotes watercolors, pastels, drawings, and/or mixed media

ASHTON, SIR JOHN WILLIAM (1881-1963) BRITISH/AUSTRALIAN	600-15000	L,F
ASHTON, WILLIAM (18TH C) BRITISH	150-7000	L,G
ASHWORTH, L. (19TH C) BRITISH	100-800	X
ASIS, ANTONIO (B. 1932) ARGENTINIAN	800-9000	A
ASKEVOLD, ANDERS MONSEN (1834-1900) SWEDISH	600-25000	L,F,G
ASLUND, ACKE	*400-5000	
ASLUND, ACKE (1881-1958) SWEDISH	400-4000	
ASLUND, ELIS (1872-1956) SWEDISH	300-3500	L,M
ASMUSSEN, CHRISTIAN (1873-1940) DANISH	900-18000	W
ASPERTINI, AMICO (1474-1552) ITALIAN	5000-+++	F
ASPETTATI, ANTONIO MARIO (B. 1880) ITALIAN	350-5000	X
ASPINWALL, REGINALD (1858-1921) BRITISH	*300-3200	L
ASPLUND, NILS (1874-1958) SWEDISH	100-700	X
ASSE, GENEVIEVE (B. 1923) FRENCH	800-20000	A
ASSELBERGS, ALPHONSE (1839-1916) BELGIAN	500-2500	L
ASSELIN, MAURICE	*100-1300	
ASSELIN, MAURICE (1882-1947) FRENCH	300-7000	G,L
ASSELYN, JAN	*300-5000	
ASSELYN, JAN (1610-1652) DUTCH	1000-78000	L,M
ASSERETO, GIOACCHINO (1600-1649) ITALIAN	2500-110000	L,F
ASSETTO, FRANCO (B. 1911) ITALIAN	100-600	X
ASSMUS, ROBERT (B. 1837) GERMAN	400-10000	G,L
ASSTEYN, BARTHOLOMEUS (1628-1662) AUSTRIAN	2000-127000	S
ASSUS, ARMAND JACQUES (B. 1892) FRENCH	400-5500	X
AST, BALTHASAR VAN DER (1590-1656) DUTCH	3000-+++	S
ASTE, JEAN LOUIS (B. 1864) FRENCH	*100-12000	F
ASTI, ANGELO (1847-1903) FRENCH	300-7700	L
ASTRUP, NIKOLAI (1880-1928) NORWEGIAN	3000-+++	S,L
ATAMIAN, CHARLES GARABED	*100-2100	
ATAMIAN, CHARLES GARABED (Active 1913-1945) TURKISH	700-22000	G,M
ATCHERLEY, ETHEL (19TH-20TH C) BRITISH	*200-2000	L,F
ATKINS, M E (19TH-20TH C) BRITISH	200-2000	L
ATKINS, SAMUEL (Active 1787-1808) BRITISH	*1200-18000	G,M
ATKINS, WILLIAM EDWARD (1842-1910) BRITISH	300-2000	M
ATKINSON, GEORGE MOUNSEY WHEATLEY (19TH C) BRITISH	600-8700	M
ATKINSON, JOHN (19TH/20TH C) BRITISH	*400-9000	G,F,M
ATKINSON, JOHN AUGUSTUS (1775-1831) BRITISH	400-4500	F
ATKINSON, ROBERT (1863-1898) AUSTRALIAN	500-15000	M
ATKINSON, WILLIAM EDWIN (1862-1926) CANADIAN	300-2500	L

ATL, DR.(GERALDO MURILLO)	*2000-35000	
ATL, DR.(GERALDO MURILLO) (1875-1964) MEXICAN	2000-53000	L,F
ATLAN, JEAN MICHEL (1913-1960) FRENCH	2500-+++	A
ATSARA, VIVES (20TH C) MEXICAN	100-700	X
ATTANASIO, NATALE (B. 1846) ITALIAN	800-18000	G,F
ATTARDI, UGO	*300-3000	
ATTARDI, UGO (B. 1923) ITALIAN	800-11000	A
ATTERSEE, CHRISTIAN LUDWIG (B. 1940) GERMAN	*500-4500	A
ATTWELL, MABEL LUCIE (1879-1964) BRITISH	*800-4500	G,F
AUBERJONOIS, RENE (1872-1957) SWISS	4000-52000	F
AUBERT, JEAN ERNEST (1824-1906) FRENCH	1000-18000	G,S
AUBERTIN, BERNARD (20TH C) ?	2000-15000	A
AUBLET, ALBERT (1851-1938) FRENCH	2500-100000	G,F
AUBRAY, C.F. (19TH C) FRENCH	200-1500	X
AUBREY, CHRISTOPHER (19TH C) NEW ZEALANDER	*800-7500	L
AUBRY, ETIENNE (1745-1781) FRENCH	900-15000	F,G
AUCLAIR, ANDRE (20TH C) FRENCH	100-900	F
AUDGREM, W. LIVINGSTONE (19TH/20TH C) BRITISH	100-600	W
AUDY, JONNY	*100-750	
AUDY, JONNY (Active 1872-1876) FRENCH	200-4000	W
AUER, GRIGOR (1882-1967) FINNISH	400-3500	L,M
AUER, ROBERT (1873-1952) AUSTRIAN	150-850	G
AUFORT, JEAN (19TH C) FRENCH	100-2000	L,G
AUFRAY, JOSEPH ATHANASE (B. 1836) FRENCH	500-7500	G
AUFSANDAN, F. (19TH C) GERMAN	250-1500	G
AUGE, PHILIPPE (B. 1935) FRENCH	300-2800	G
AUGUSTE, SALNAVE PHILIPPE (20TH C?) HAITIAN	200-1500	X
AUGUSTIN, L. (20TH C) FRENCH	300-2000	X
AUGUSTIN, LUDWIG (20TH C) GERMAN	150-1000	X
AUGUSTSON, GORAN	*1000-8000	
AUGUSTSON, GORAN (B. 1936) FINNISH?	2500-35000	A
AUJAME, JEAN (1905-1965) FRENCH	400-7000	G,F
AULD, PATRICK C (19TH C) BRITISH	500-2500	M
AULIE, REIDAR (1904-1977) NORWEGIAN	800-20000	L,F
AULT, CHARLES H. (19TH C) CANADIAN	100-650	X
AUMONIER, JAMES (1832-1911) BRITISH	200-2500	L,W
AUMONT, LOUIS (1805-1979) DANISH	900-10000	F
AURELI, GIKUSEPPE (1858-1929) ITALIAN	*400-3000	G,F
AURELI, GIUSEPPE	*400-8500	

* Denotes watercolors, pastels, drawings, and/or mixed media

AURELI, GIUSEPPE (1858-1929) ITALIAN	1000-15000	G
AURELI, RAMIELO (1885-?) ITALIAN	*400-3200	F
AUSTEN, ALEXANDER (19TH/20TH C) BRITISH	250-2800	G
AUSTEN, ANTON J. (B. 1865) POLISH	150-800	X
AUSTEN, WINIFRED (1876-1964) BRITISH	*700-7500	W
AUSTIN, HENRY (19TH C) BRITISH	300-2200	L,F
AUSTIN, SAMUEL (1796-1834) BRITISH	*300-5000	L
AUSTIN, SAMUEL (1796-1834) BRITISH	*600-6000	L,F
AVENDANO, SERAFIN DE (1838-1916) SPANISH	500-7800	L,M
AVERCAMP, HENDRICK (1585-1663) DUTCH	5000-+++	L
AVIGDOR, RENE (B. 1891) FRENCH	250-2000	X
AVISSAR, SIMON (B. 1938) ISRAELI	600-4000	X
AVNI, AARON (20TH C) ISRAELI	500-3500	L
AVONT, PIETER VON (1600-1632) FLEMISH	800-24000	F
AVROLL, JAMES (19TH C) BRITISH	100-800	X
AVY, JOSEPH MARIUS (B. 1871) FRENCH	800-38000	G,F,I
AXELSON, VICTOR (1883-1953) SWEDISH	500-2400	L
AYLING, GEORGE	*400-3200	
AYLING, GEORGE (20TH C) BRITISH	800-9000	L,M
AYLMER, THOMAS BRABAZON (19TH C) BRITISH	*500-2500	G,L
AYOTTE, LEO (1909-1976) CANADIAN	800-4000	K,F,S
AYRES, GILLIAN (B. 1930) BRITISH	1000-20000	X
AYRTON, MICHAEL (1921-1975) BRITISH	900-18000	X(A)
AZEGLIO, MASSIMO DE (1798-1866) ITALIAN	250-3200	F,L,M
AZNAR, JUAN CARLOS (B. 1937) ARGENTINIAN	200-2000	X
AZUZ, DAVID (B. 1942) ISRAELI	*800-5500	X(F)

B

ARTIST	PRICES	SUBJECT
BAADE, KNUD-ANDREASSEN (1808-1879) NORWEGIAN	600-16000	L,M
BAADER, LOUIS MARIE (1828-1919) FRENCH	800-4500	X(F)
BAADSGAARD, ALFRIDA (1839-1912) DANISH	900-6000	S
BAAGOE, CARL (1829-1902) DANISH	800-11000	M
BAAGOE, CARL EMIL (1829-1902) DANISH	400-16000	L,M
BAAR, HUGO (1873-1912) GERMAN?	800-6000	L
BAARLE, H.M. (19TH C) BELGIUM	250-1800	G

BABB, CHARLOTTE E. (1830-1900) BRITISH	*200-1200	F
BABOT, JOAQUIN CANETE (20TH C) EUROPEAN	100-700	G,F
BABOULENE, EUGENE (B. 1905) FRENCH	1000-38000	G,L,F
BABOULET, FRANCOIS (B. 1915) FRENCH	250-3200	L,S
BAC, FERNAND (1859-1952) FRENCH	*200-1800	F
BACCANI, ATTILIO (19TH C) ITALIAN	450-6000	G,F
BACCI, BACCIO MARIA (B, 1888) ITALIAN	1500-30000	X
BACH, ALOIS (1809-1893) GERMAN	1000-11000	L,G
BACH, GUIDO (1828-1905) GERMAN	350-3200	G
BACH, WILLIAM HENRY (19TH C) BRITISH	400-2500	L
BACHE, OTTO (1839-1914) DANISH	700-22000	F,G
BACHELET, EMILE JUST (B. 1892) FRENCH	2000-28000	F
BACHELIER, JEAN JACQUES (1724-1806) FRENCH	1500-55000	G,S
BACHELIN, AUGUSTE (1830-1890) SWISS	800-14000	L,S
BACHG, FRANSISCUS HERMANUS (1865-1956) DUTCH	400-3000	L
BACHMANN, ADOLPHE (19TH-20TH C) SWISS	500-6500	L
BACHMANN, ALFRED (B. 1863) GERMAN	100-15000	L
BACHMANN, HANS (B. 1852) SWISS	900-18000	G,L
BACHMANN, KARL (1874-1924) HUNGARIAN	500-3200	S
BACHMANN, OTTO (B. 1915) SWISS	800-12000	G,F
BACHRACH-BARRE, HELMUT (1898-?) GERMAN	400-3000	F,W
BACHTA, JOHANN (1782-1856) GERMAN	700-6000	G,F,L
BACHUR, ANTHONY (20TH C) FRENCH	900-3500	A
BACK, YNGVE (B. 1904) FINNISH	800-18000	F,L
BACKER, HARRIET (1845-1932) GERMAN	67000	X(L)
BACKER, JACOB ADRIAENSZ (1608-1651) DUTCH	900-18000	F
BACKER, JACOB DE (1560-1591)	850-34000	F
BACKHUYSEN, LUDOLF (THE ELDER)	*400-3500	
BACKHUYSEN, LUDOLF (THE ELDER) (1631-1708) DUTCH	1500-44000	X
BACKMANSSON, HUGO	*600-7500	
BACKMANSSON, HUGO (1860-1953) FINNISH	900-8000	L,F
BACKVIS, FRANCOIS (19TH C) FRENCH	400-5200	S,W,L
BACON, FRANCIS (B. 1909) IRISH	20000-+++	A
BACON OF CULFORD, SIR NATHANIEL J. (17TH C) BRITISH	600-6500	X
BADEN, HANS J.V. (1604-1663) DUTCH	2500-20000	G,F
BADHAM, HERBERT EDWARD (1899-1961) AUSTRALIAN	1000-18000	M,L,F
BADIA, JUAN (B. 1938) MEXICAN	100-500	X(G)
BADIN, JEAN JULES (B. 1843) FRENCH	350-4500	G,F
BADIN, JULES (19TH/20TH C) FRENCH	150-3300	X

* Denotes watercolors, pastels, drawings, and/or mixed media

BADMIN, STANLEY ROY (B. 1906) BRITISH	*900-6000	L,G
BADUE, DANIEL SERRA (B. 1914) LATIN AMERICAN	300-4500	G
BAEN, JAN DE (1633-1702) DUTCH	1200-22000	F
BAERDEMAEKER, FELIX DE (1836-1878) BELGIAN	300-2500	L
BAERTLING, OLLE (1911-1981) SWEDISH	1500-132000	X
BAES, EDGAR ALFRED (1837-1909) BELGIAN	300-2800	G,F
BAES, EMILE (1879-1953) BELGIAN	350-12000	G,F
BAES, FIRMIN (1874-1945) BELGIAN	*300-1500	S,L
BAES, LIONEL OSCAR (1839-1913) BELGIAN	150-1400	X
BAGDATOPOULOS, WILLIAM SPENCER (1888-?) GREEK	*400-2000	L
BAGER, JOHANN DANIEL (1734-1815) GERMAN	900-18000	G,S
BAGGALLY, OSBORN J. (19TH C) BRITISH	100-700	X
BAGGE, MAGNUS THULSTRUP VON (1825-1890) NORWEGIAN	100-1500	L
BAGLIONE, CAVALIERE GIOVANNI (1571-1644) ITALIAN	*1000-8200	F
BAHIEU, JULES G. (19TH C) BELGIAN	300-6000	X (W)
BAHRE, HANS EBERHARD (B. 1882) GERMAN	100-700	G
BAHUNEK, BRANKO (B. 1935) YUGOSLAVIAN	100-700	X
BAIERL, THEODOR (1881-1932) GERMAN	300-3500	L,F
BAIGLER, ARISTODEMO (B. 1928) ITALIAN	100-800	G
BAIL, FRANCK ANTOINE (1858-1924) FRENCH	900-25000	L,G,S
BAIL, JOSEPH CLAUDE (1862-1921) FRENCH	500-34000	G,S
BAILEY, HENRY V. (20TH C) BRITISH	250-1800	L,G
BAILLY, ALICE (1872-1938) SWISS	*400-4000	X
BAILLY, F.V. (19TH/20TH C) DUTCH	300-7500	X
BAIN, DONALD (B. 1904) BRITISH	900-7500	S,L
BAIN, MARCEL ADOLPHE (1878-1937) FRENCH	350-9000	G,L
BAINES, THOMAS (1822-1875) BRITISH	5000-75000	G,F,L
BAIRD, NATHANIEL HUGHES JOHN (B. 1865) SCOTTISH	250-6000	L,F
BAISCH, HERMANN (1846-1894) GERMAN	900-19000	L,G,W
BAIXAS, JUAN (19TH C) SPANISH	350-3500	X
BAIXERAS Y VERDAGUER, DIONISIO (1862-1943) SPANISH	48000	X(G)
BAJ, ENRICO	*600-55000	
BAJ, ENRICO (B. 1924) ITALIAN	1000-25000	X
BAKALOWICZ, LADISLAUS (1833-1904) POLISH	450-7800	G,F
BAKALOWICZ, STEPHAN WLADISLAWOWITSCH (B. 1857) RUSSIAN	500-19000	G
BAKER, ALAN DOUGLAS (1914-1987) AUSTRALIAN	800-5000	S
BAKER, K. SIEGFRIED (B. 1922) GERMAN	100-900	X
BAKER, THOMAS (1809-1869) BRITISH	1200-15000	L,W

BAKHUIZEM, W. VAN DE SANDE (20TH C) DUTCH	150-900	X
BAKHUYZEN, ALEXANDRE H. (1826-1878) DUTCH	500-5000	G,F,L
BAKHUYZEN, G. J. VAN DE SANDE (1826-1895) DUTCH	600-29000	S
BAKHUYZEN, HENDRIK VAN DE SANDE	*400-4500	
BAKHUYZEN, HENDRIK VAN DE SANDE (1795-1860) DUTCH	1000-28000	L,W
BAKHUYZEN, JULIUS JACOBUS VAN DE SANDE (1835-1925) DUTCH	400-8000	L,F
BAKHUYZEN, LUDOLF	*400-5000	
BAKHUYZEN, LUDOLF (1631-1708) DUTCH	3000-+++	L,M
BAKKER-KORFF, ALEXANDER HUGO (1824-1882) DUTCH	1500-18000	G,F
BAKST, LEON	*1100-140000	
BAKST, LEON (1866-1924) RUSSIAN	1000-15000	F,A
BALAN, EUGENE (1809-1858) FRENCH	500-3000	L,F
BALDI, LAZZARO (1624-1703) ITALIAN	700-25000	X(G)
BALDOCH, JAMES WALSHAM (19TH C) BRITISH	*400-3000	G,F,W
BALDRY, HARRY (B. 1890) BRITISH	100-1500	X(F)
BALDWIN, SAMUEL (19TH C) BRITISH	400-3500	G
BALDWYN, CHARLES H C (19TH C) BRITISH	*800-7500	X(W)
BALE, CHARLES THOMAS (Active 1868-1875) BRITISH	400-7600	S
BALE, EDWIN (1838-1923) BRITISH	200-12000	G,L,F
BALEN, HENDRIK VAN (THE ELDER)	*700-4800	
BALEN, HENDRIK VAN (THE ELDER) (1575-1632) FLEMISH	2000-45000	L,F
BALEN, MATTYS (1684-1766) FLEMISH	750-14000	L,F
BALESTRA, ANTONIO (1660-1740) ITALIAN	2000-90000	G,F
BALESTRIERI, LIONELLO (1872-1958) ITALIAN	400-17000	G
BALFOUR-BROWNE, VINCENT (1880-1963) BRITISH	*800-9500	W
BALKE, PEDER (1804-1887) NORWEGIAN	5000-+++	L
BALL, WILFRED WILLIAMS (1853-1917) BRITISH	200-1500	L
BALLA, GIACOMO	*1000-+++	
BALLA, GIACOMO (1871-1958) ITALIAN	10000-+++	A
BALLANGER, RENE (1895-1964) FRENCH	250-1500	X
BALLANTYNE, EDITH (Late 19TH C) BRITISH	200-1200	F,G
BALLANTYNE, JOHN (1815-1897) BRITISH	400-7000	F,G
BALLARD, BRIAN (20TH C) BRITISH	800-6000	S,F
BALLAVOINE, JULES FREDERIC	*200-4500	
BALLAVOINE, JULES FREDERIC (19TH C) FRENCH	800-62000	F
BALLE, MOGENS (20TH C) SCANDINAVIAN	900-11000	A
BALLESIO, FEDERICO	*700-20000	
BALLESIO, FEDERICO (19TH C) ITALIAN	1000-15000	G,M

* Denotes watercolors, pastels, drawings, and/or mixed media

BALLESIO, GIUSEPPE (19TH C) ITALIAN	400-4000	G,F
BALLIN, AUGUSTE (B. 1842) FRENCH	400-5000	L,M
BALLINGALL, ALEXANDER (19TH C)	*400-2500	M,L
BALLUE, PIERRE ERNEST (1855-1928) FRENCH	300-6500	G,L
BALMETTE, JULES JEAN (19TH C) FRENCH	250-3000	X
BALMFORD, HURST (B. 1871) BRITISH	400-3500	M,G,F
BALOUZET, ARMAND (1858-1905) FRENCH	150-950	L
BALSGAARD, CARL VILHELM (1812-1893) DANISH	500-25000	S
BALTEN, PIETER (1552-1598) FLEMISH	2500-187000	X
BALTHUS, JEAN	*1500-+++	
BALTHUS, JEAN (B. 1908) POLISH/FRENCH	15000-+++	F
BALWE, ARNOLD (1898-1983) GERMAN	800-24000	L,M
BAMBER, BESSIE (19TH/20TH C) BRITISH	400-4000	W
BAMBERGER, FRITZ (1814-1873) GERMAN	1000-24000	L,M
BAMBERGER, GUSTAVE (B. 1860) GERMAN	300-1800	G
BANCK, JOHAN VAN DER (1686-1739) DUTCH	350-4500	X
BANDEIRA, ANTONIO (1922-1967) BRAZILIAN	450-20000	L
BANDERA, MENDEZ (19TH/20TH C) SPANISH	100-800	W
BANDIERI, C. (19TH C) ITALIAN	300-3200	G,S
BANDINELLI, BACCIO (1493-1560) ITALIAN	*800-70000	F
BANDO, TOSHIO (B. 1890) JAPANESE	700-15000	S,L
BANKS, THOMAS J. (19TH C) BRITISH	100-2400	G,L,W
BANNATYNE, JOHN JAMES (1835-1911) BRITISH	100-4400	L,M
BANNER, DELMAR HARMOOD (B. 1896) BRITISH	*100-1100	L
BANNER, JOSEPH (19TH C) BRITISH	100-950	G
BANTING, SIR FREDERICK GRANT (1891-1941) CANADIAN	600-3500	L
BANTZER, CARL (B. 1857) GERMAN	750-24000	G,L
BAPTISTE, JEAN (17TH C) FRENCH	900-19000	S
BAR, BONAVENTURE DE (1700-1729) FRENCH	1500-12000	G,L
BARADUC, JEANNE (20TH C) FRENCH	200-1500	X(S)
BARAT, PIERRE-MARTIN (18TH C) FRENCH	*600-5000	F
BARATTI, FILIPPO (PHILIP) (19TH/20TH C) ITALIAN	2000-280000	G,L
BARBARINI, EMIL (1855-1930) AUSTRIAN	600-13000	L
BARBARINI, FRANZ (1804-1873) AUSTRIAN	600-15200	L,F
BARBARINI, GUSTAV (1840-1909) AUSTRIAN	500-6500	L
BARBARO, GIOVANNI (20TH C) ITALIAN	*100-1200	G,S
BARBEIRI, GIOVANNI (1780-1864) ITALIAN	700-24000	X(G)
BARBER, CHARLES BURTON (1845-1894) BRITISH	1500-35000	F
BARBER, THOMAS (1768-1843) BRITISH	450-12400	L

BARBERIS, EUGENE DE (B. 1851) FRENCH	400-5400	G,F
BARBEY, JEANNE MARIE (1882-1960) FRENCH	150-1500	L,F
BARBIER, JEAN JACQUES LE (1738-1826) FRENCH	5000-+++	F
BARBIER, ANDRE (20TH C) FRENCH	1000-15000	L
BARBIER, GEORGES	*200-2000	
BARBIER, GEORGES (1882-1932) FRENCH	300-7500	G,F,I
BARBIERS, PIETER (II) (1749-1842) DUTCH	350-3500	L
BARBUDO, SALVADOR SANCHEZ (1858-1917) SPANISH	900-210000	G,F
BARCELO, MIGUEL (17TH C) SPANISH	2000-175000	F
BARCLAY, EDGAR (1842-1913) BRITISH	400-7000	G,L
BARCLAY, J. EDWARD (20TH C) BRITISH	200-1200	L
BARDERY, LOUIS ARMAND (20TH C) FRENCH	150-750	X
BARDIN, M. (19TH C) EUROPEAN	150-800	X
BARDONE, GUY (B. 1927) FRENCH	200-5000	L
BARDOU, PAUL JOSEPH (1745-1814) BRITISH	*350-3600	F
BARE, E. (19TH C) FRENCH	250-5300	G,F
BARENGER, JAMES (1745-1813) BRITISH	400-18000	L,G,W
BARENGER, JAMES (JR.) (1780-1831) BRITISH	900-22000	G,L,W
BARGUE, CHARLES (D. 1883) FRENCH	*150-2200	G,F
BARILLOT, LEON (1844-1929) FRENCH	300-2400	L,M,W
BARISON, GIUSEPPE (1853-1930) ITALIAN	500-15000	G
BARKER, JOHN JOSEPH (1835-1866) BRITISH	2000-18000	L,M
BARKER, THOMAS JONES	*200-1200	
BARKER, THOMAS JONES (1815-1882) BRITISH	900-18000	G,L
BARKER, WRIGHT (D. 1941) BRITISH	1200-32000	G,L,W
BARKER OF BATH, BENJAMIN (1776-1838) BRITISH	600-5000	L
BARKER OF BATH, THOMAS (1769-1847) BRITISH	800-7000	F,L
BARLACH, ERNST (1870-1938) GERMAN	*1500-16000	G,F,L
BARLAG, PHILIP (1840-1913) NORWEGIAN	700-3000	F,L
BARLAND, ADAM (B. 1843) BRITISH	350-24000	L,W
BARLE, MAURICE (B. 1903) FRENCH	150-1200	M
BARLEAN, A. (20TH C) FRENCH	150-850	X
BARLOW, FRANCIS (1626-1702) BRITISH	1000-125000	F,L,W
BARLOW, JOHN NOBLE (1861-1917) BRITISH	800-12000	L
BARNABE, DUILIO	*200-1800	
BARNABE, DUILIO (1914-1961) ITALIAN	450-13000	A?
BARNES, ARCHIBALD GEORGE (B. 1887) BRITISH	400-6000	F,S
BARNES, EDWARD CHARLES (19TH C) BRITISH	850-34000	F,L
BARNES, JAMES (19TH/20TH C) BRITISH	*250-11000	L

* Denotes watercolors, pastels, drawings, and/or mixed media

BARNES, JOSEPH H (19TH/20TH C) BRITISH	*300-2400	G,F
BARNES, ROBERT (1840-1895) BRITISH	*400-3500	G,I
BARNES, SAMUEL J. (19TH C) BRITISH	100-1200	G,S,L
BARNEY, CAROLINE RICHMOND (19TH C) BRITISH	*100-650	X
BARNOIN, HENRI ALPHONSE	*150-6500	
BARNOIN, HENRI ALPHONSE (1882-1935) FRENCH	650-350000	M,G
BARNSLEY, JAMES MACDONALD	*150-3000	
BARNSLEY, JAMES MACDONALD (1861-1929) CANADIAN	250-3000	L
BAROCCI, FEDERICO (1526-1612) ITALIAN	*2000-+++	F
BARON, HENRI CHARLES ANTOINE (1816-1885) FRENCH	600-6200	G,F,L
BARON, THEODORE (1840-1899) FRENCH	350-3200	L,M
BARON DE CEDERSTROM, TURE NIKOLAUS (1843-1924) SWEDISH	400-3200	X
BARRABLE, GEORGE H (19TH C) BRITISH	900-10000	G,F
BARRAGAN, JULIO (B. 1928) ARGENTINIAN	200-2500	L
BARRALET, JOHN (1747-1815) IRISH	300-9000	G,F,I
BARRAU BUNOL, LAUREANO (1864-1957) SPANISH	1200-150000	G
BARRAUD, AIME (1902-1954) SWISS	500-5500	F,S
BARRAUD, ALFRED THOMAS (1849-1925) CANADIAN	*150-1600	M,I
BARRAUD, FRANCOIS (1899-1934) SWISS	500-6500	F,L,S
BARRAUD, GUSTAVE FRANCOIS	*500-1000	
BARRAUD, GUSTAVE FRANCOIS (1883-1964) SWISS	900-6000	F,L
BARRAUD, HENRY (1811-1874) BRITISH	1300-90000	W,G,F
BARRAUD, MAURICE (1889-1954) SWISS	1500-25000	F
BARRAUD, WILLIAM (1810-1850) BRITISH	1800-+++	W,L
BARRE, ELIZABETH (19TH/20TH C) FRENCH	250-3500	G
BARRERA, ANTONIO (B. 1889) ITALIAN	350-12000	X
BARRET, GEORGE (18TH/19TH C) BRITISH	1000-25000	L,W
BARRET, GEORGE (SNR) (1728-1784) BRITISH	1000-12000	L,W
BARRETT, JERRY (1814-1906) BRITISH	400-4000	F,L
BARRIER, GUSTAVE (20TH C) FRENCH	300-2000	F,G,S
BARRON Y CABRILLO, MANUEL (19TH C) SPANISH	400-4800	L
BARRY, C. M. (19TH C) BRITISH	150-800	X
BARRY, CLAUDE-FRANCIS (19TH/20TH C) FRENCH	600-35000	L,G
BARRY, GERARD (B. 1864) IRISH/AMERICAN	150-1200	X(F)
BARRY, JAMES (1741-1806) BRITISH	900-22000	F
BARRY, JOHN (20TH C) BRITISH	150-800	X
BARTEAU, ANDRE (20TH C) FRENCH	150-700	X
BARTELS, HANS VON	*400-11000	
BARTELS, HANS VON (1856-1913) GERMAN	350-9000	G,F,L

BARTENBACH, HANS (B. 1908) GERMAN	400-5200	X
BARTH, CARL WILHELM (1847-1919) NORWEGIAN	800-8500	M,L
BARTH, PAUL BASILIUS (1881-1955) SWISS	1000-25000	F,L,S
BARTHALOT, MARIUS (B. 1861) FRENCH	200-1500	S
BARTHEL, PAUL (B. 1862) GERMAN	*400-1800	F,L
BARTHOLOMEW, F. W. (19TH/20TH C) BRITISH	150-850	M,L
BARTLETT, CHARLES WILLIAM (1860-1940) BRITISH	*250-2600	G,F
BARTLETT, WILLIAM HENRY (1809-1954) BRITISH	1000-15000	L,I
BARTOLENA, GIOVANNI (1866-1942) ITALIAN	600-12000	X (G)
BARTOLINI, FREDERICO (19TH/20TH C) ITALIAN	*1200-20000	F,G
BARTOLINI, LORENZO (1777-1850) ITALIAN	*1500-5000	F,W
BARTOLOMMEO, FRA (14TH C) ITALIAN	*1200-+++	F
BARTOLOZZI, FRANCESCO (1727-1815) ITALIAN	*300-2800	F
BARTON, ROSE M. (1856-1929) BRITISH	*350-23000	L,G
BARTONEK, ADALABERT (B. 1859) CZECHOSLOVAKIAN	300-4000	L
BARTTENBACH, HANS (B. 1908) GERMAN	200-2000	X
BARUCCI, PIETRO (1845-1917) ITALIAN	800-32000	G,F
BARVITIUS, VICTOR (1834-1902) CZECHOSLOVAKIAN	2000-45000	G,L
BARWICK, JOHN (1798-1876) BRITISH	450-10000	F,L,W
BARYE, ANTOINE LOUIS (1796-1875) FRENCH	*600-20000	F,W
BAS, EDWARD LE (1904-1966) BRITISH	1000-20000	L,F,S
BASALDUA, HECTOR (B. 1895) ARGENTINIAN	250-2500	G,I
BASCHENIS, EVARISTO (1617-1677) ITALIAN	2500-115000	S
BASDEN, T. (19TH/20TH C) EUROPEAN	150-950	X
BASELITZ, GEORG	*700-36000	
BASELITZ, GEORG (B. 1938) GERMAN	3000-+++	A
BASILE, CASTERA (20TH C) LATIN AMERICAN	200-1200	X
BASKETT, CHARLES E (19TH C) BRITISH	800-4000	S
BASQUE, HENRI LE (1865-1937) FRENCH	900-15000	S
BASSANI, LUIGI (B. 1825) ITALIAN	400-5500	G
BASSANO, (JACOBO DE PONTE) (1515-1592) ITALIAN	3000-75000	F,G
BASSANO, FRANCESCO (15TH/16THC) ITALIAN	500-40000	F
BASSANO, LEANDRO DA PONTE (Called LEANDRO) (1557-1622) ITALIAN	1500-51000	L,F
BASSEN, BARTHOLOMEUS VAN (1590-1652) DUTCH	500-17000	F,L
BASSETTI, MARCANTONIO	*300-3800	
BASSETTI, MARCANTONIO (1588-1630) ITALIAN	2000-66000	F,L
BASTERT, NICHOLAAS	*300-3500	
BASTERT, NICHOLAAS (1854-1939) DUTCH	400-6500	L,G

* Denotes watercolors, pastels, drawings, and/or mixed media

BASTIEN, ALFRED	*100-800	
BASTIEN, ALFRED (1873-1955) FRENCH	400-5200	L,S
BASTIEN-LEPAGE, JULES (1848-1884) FRENCH	1500-130000	F,G
BATCHELDER, STEPHEN (1849-1932) BRITISH	*800-5500	L,M,F
BATEMAN, HENRY MAYO (1887-197) BRITISH	*500-6500	I
BATEMAN, JAMES (1815-1849) BRITISH	400-5500	G
BATEMAN, SAMUEL (19TH C) BRITISH	300-3500	L
BATES, DAVID	*200-5000	
BATES, DAVID (1840-1921) BRITISH	800-20000	G,L,F
BATES, FREDERICK DAVENPORT (1867-1930) BRITISH	1000-15000	L,F
BATET, FRANCOIS (B. 1923) SPANISH/FRENCH	1000-11000	X(F)
BATONI, POMPEO GIROLAMO	*500-6500	
BATONI, POMPEO GIROLAMO (1708-1787) ITALIAN	5000-+++	F
BATT, J. ARTHUR (Late 19TH C) BRITISH	400-6000	L,W
BATTAGLIA, DOMENICO (B. 1846) ITALIAN	200-2000	X(L)
BATTEM, GERARD VAN	*400-12000	
BATTEM, GERARD VAN (1650-1690) DUTCH	1000-15000	L
BATTISTA, GIOVANNI (1858-1925) ITALIAN	400-4400	L,F
BATTY, LT COL ROBERT (1789-1848) BRITISH	800-7500	L
BATURIN, VIKTOR PAVLOVICH (1863-1938) RUSSIAN	300-10000	X
BAUCHANT, ANDRE (1873-1958) FRENCH	1800-168000	A
BAUCK, JEANNA MARIA CHARLOTTA (1840-1926) SWEDISH	300-5000	F,G,L
BAUDESSON, NICOLAS (1611-1680) FRENCH	1200-32000	S
BAUDIN, JEAN BAPTISTE (19TH C) FRENCH	350-3200	W
BAUDOT, EDOUARD H. (20TH C) FRENCH	100-1000	L,W
BAUDOUIN, PIERRE ANTOINE	*300-7000	
BAUDOUIN, PIERRE ANTOINE (1723-1769) FRENCH	400-6500	G,F
BAUDRY, PAUL (1828-1886) FRENCH	300-6800	F
BAUER, ANTON (19TH C) GERMAN	300-4800	L
BAUER, JOHN (1882-1918) SWEDISH	*1000-16000	F,L
BAUER, MARIUS A. J.	*200-4500	
BAUER, MARIUS A. J. (1864-1932) DUTCH	350-6500	L,M,G
BAUER, RUDOLF	*900-22000	
BAUER, RUDOLF (1889-1953) GERMAN	2500-85000	X
BAUER, WILLI (B. 1923) GERMAN	200-1500	X
BAUERLE, CARL WILHELM FRIEDRICH (1831-1912) GERMAN	1000-50000	F,G
BAUERNFEIND, GUSTAV (1848-1904) AUSTRIAN	2500-+++	F
BAUFFE, VICTOR	*100-1400	
BAUFFE, VICTOR (19TH C) DUTCH	100-2000	L,W

BAUGH, SAM (1822-1878) BRITISH	300-1500	X
BAUGNIET, CHARLES (1814-1886) FLEMISH	1200-26000	F,G
BAUM, PAUL	*200-3200	
BAUM, PAUL (1859-1932) GERMAN	500-32000	L,M
BAUMEISTER, WILLI	*800-170000	
BAUMEISTER, WILLI (1889-1955) GERMAN	2500-195000	A
BAUMER, LEWIS (1870-1963) BRITISH	*400-3000	F,G,S
BAUMGARTNER, ADOLF (1850-1924) AUSTRIAN	800-3500	G,L
BAUMGARTNER, H. (19TH C) GERMAN	450-11000	L
BAUMGARTNER, JOHANN WOLFGANG (1712-1761) AUSTRIAN	1200-20000	G,F
BAUMGARTNER, PETER (1834-1911) GERMAN	3500-65000	G
BAUMGARTNER, THOMAS (1892-1962) GERMAN	1000-9500	F
BAUR, FERDINAND (1760-1826) AUSTRIAN	*300-1500	X
BAUR, JOHANN WILHELM	*300-16000	
BAUR, JOHANN WILHELM (1600-1640) FRENCH	500-7500	G,M
BAWDEN, EDWARD (B. 1903) BRITISH	*500-11000	L
BAXTER, CHARLES (1809-1879) BRITISH	700-4000	F,G
BAYARD, EMILE ANTOINE (1837-1891) FRENCH	1500-20000	G,F,S
BAYER, ANTON (19TH C) AUSTRIAN	350-4200	L,G
BAYER, HERBERT	*300-3000	
BAYER, HERBERT (20TH C) GERMAN	800-15000	A
BAYERLEIN, FRITZ (B. 1872) GERMAN	350-7000	X
BAYEU Y SUBIAS, FRANCISCO (1734-1795) SPANISH	1000-15000	G,F
BAYNES, FREDERICK THOMAS (19TH C) BRITISH	*400-3500	S,F
BAYROS, FRANZ VON (1866-1924) AUSTRIAN	*800-6000	F
BAZAINE, JEAN RENE	*400-16000	
BAZAINE, JEAN RENE (B. 1904) FRENCH	1200-210000	A
BAZHIN, NICOLAI NIKOLAEVICH (1856-1917) RUSSIAN	500-7000	X
BAZILE, ALBEROI (20TH C) HAITIAN	150-850	S
BAZILE, CASTERA (1928-1965) HAITIAN	1500-28000	G,L,S
BAZZANI, LUIGI	*200-1800	
BAZZANI, LUIGI (1836-1927) ITALIAN	800-12000	G,F
BAZZARO, LEONARDO (1853-1937) ITALIAN	1000-15000	X(L)
BAZZICALUVA, ERCOLE (1600-1640) ITALIAN	*500-4100	L
BEACH, E. J. (19TH C) BRITISH	100-800	F,G,L
BEACH, THOMAS (1738-1806) BRITISH	1200-74000	F,G
BEAL, FRANZ DE (Late 19TH C) BRITISH	200-2800	X
BEALE, MARY (1632-1699) BRITISH	500-5500	F
BEAN, AINSLIE (Late 19TH C) BRITISH	*100-750	L

* Denotes watercolors, pastels, drawings, and/or mixed media

BEARDSLEY, AUBREY (1872-1898) BRITISH	*800-66000	F,I
BEATON, SIR CECIL (1904-1980) BRITISH	*300-12000	A
BEATTIE-BROWN, WILLIAM (1831-1909) BRITISH	300-2600	G,L
BEAUDIN, ANDRE	*300-12000	
BEAUDIN, ANDRE (1895-1980) FRENCH	600-63000	X
BEAUDUIN, JEAN (1851-1916) BELGIAN	300-8500	L,F
BEAUFRERE, ADOLPHE (1876-1960) FRENCH	1000-20000	X(L)
BEAULIEU, GUSTAVE DE (1801-1860) FRENCH	150-800	X
BEAUME, JOSEPH (1796-1885) FRENCH	300-3200	F,G,W
BEAUMONT, AUGUSTE BOUTHILLIER DE (1842-1899) GERMAN	200-1200	L
BEAUMONT, HUGUES DE (1874-1947) FRENCH	150-1000	X(F)
BEAUMONT, JEAN (20TH C) FRENCH	100-700	X
BEAUQUESNE, WILFRID CONSTANT (1847-1913) FRENCH	350-5000	G,F
BEAUVERIE, CHARLES JOSEPH (1839-1924) FRENCH	300-5000	F,L
BEAVIS, RICHARD	*200-3200	
BEAVIS, RICHARD (1824-1896) BRITISH	2000-38000	L,F,W
BECHI, LUIGI (1830-1919) ITALIAN	1000-40000	G,F
BECHMANN, MAX (1884-1950) GERMAN	*500-60000	G,F
BECKENKAMP, KASPAR BENEDIKT (1747-1828) GERMAN	900-12000	F
BECKER, ALBERT (1830-1896) GERMAN	400-4600	G,L,W
BECKER, AUGUST (1822-1887) GERMAN	400-6800	L
BECKER, CARL LUDWIG FRIEDRICH	*150-600	
BECKER, CARL LUDWIG FRIEDRICH (1829-1900) GERMAN	450-9200	G,F
BECKER, ERNST AUGUST (19TH C) GERMAN	350-3200	X
BECKER, JOHANN WILHELM (1744-1782) GERMAN	400-3500	G
BECKERATH, MORITZ VAN (1838-1896) GERMAN	300-3500	G
BECKERS, FRANS (1898-1983) DUTCH	300-3500	L,W
BECKETT, CLARICE (20TH C) AUSTRALIAN	900-7500	F,L
BECKMAN, HANS (1809-1882) GERMAN	300-3200	X
BECKMANN, CONRAD (1846-1902) GERMAN	1500-24000	G
BEDA, FRANCESCO (1840-1900) ITALIAN	1500-45000	G
BEDINI, GIOVANNI PAOLO (1844-1924) ITALIAN	600-9500	G
BEECHEY, RICHARD BRYDGES (1808-1895) BRITISH	2000-75000	M
BEECHEY, SIR WILLIAM (1753-1839) BRITISH	1800-87000	F,L
BEEK, BERNARDUS ANTONIE VAN (B. 1875) DUTCH	150-1200	X(M)
BEELDEMAKER, ADRIAEN C. (1625-1701) DUTCH	800-24000	L,F,W
BEELT, CORNELIS (1660-1702) DUTCH	1000-22000	L,F
BEER, DICK (1893-1938) SWEDISH	1000-35000	L
BEER, JOHN (1853-1906) BRITISH	300-5500	W,F

BEERBOHM, SIR MAX	*350-10000	
BEERBOHM, SIR MAX (1872-1956) BRITISH	900-22000	A,I
BEERS, JAN VAN (1852-1927) BELGIAN	400-14000	A,G,L,F
BEERSTRATEN, ANTHONIE VAN (17H C) DUTCH	3000-55000	L,F
BEERSTRATEN, JAN ABRAHAMSZ (1622-1666) DUTCH	3000-145000	L,M,F
BEERT, OSIAS (1622-1678) FLEMISH	10000-250000	S
BEERT, OSIAS I (1570-1624) FLEMISH	5000-+++	S
BEEST, ALBERTUS VAN (1820-1860) DUTCH	1000-16000	M,F
BEEST, SYBRANDT VAN (1610-1674) DUTCH	1200-30000	L,F,S
BEETHOLME, GEORGE LAW (Active 1847-1878) BRITISH	300-2500	L
BEFANI, ACHILLE FORMIS (1832-1906) ITALIAN	2000-35000	G,L,F
BEGA, CORNELIS PIETERSZ (1620-1664) DUTCH	3000-61000	G
BEGAS, OSKAR (1828-1883) GERMAN	600-8500	F,G
BEHEYN, ABRAHAM C. JANSZ (1637-1697) DUTCH	1200-95000	L,W
BEHM, VILHELM (1859-1934) SWEDISH	300-4100	L
BEHRENS, AUGUST FREDERICK (B. 1821) DANISH	800-10000	L
BEICH, JOACHIM FRANZ (1665-1748) GERMAN	900-4500	L,F
BEINKE, FRITZ (1842-1907) GERMAN	500-25000	F,G
BEISCHLAGER, EMIL (B. 1897) AUSTRIAN	500-6000	L,S
BELANGER, FRANCOIS JOSEPH (1744-1818) FRENCH	*600-49000	X(F)
BELANGER, LOUIS (1736-1816) FRENCH	1000-95000	G,L
BELAY, PIERRE DE	*200-14000	
BELAY, PIERRE DE (1890-1947) FRENCH	750-46000	F,M
BELIMBAU, ADOLFO (B. 1845) ITALIAN	400-11000	G,L
BELKIN, ARNOLD	*100-650	
BELKIN, ARNOLD (B. 1930) MEXIACN	400-3500	A
BELL, GEORGE HENRY (1878-1966) AUSTRALIAN	400-14000	G,L
BELL, GRAHAM (1910-1943) BRITISH	300-5000	L,F
BELL, JOHN CLEMENT (1811-1895) BRITISH	1500-32000	L,W
BELL, STUART HENRY (19TH C) BRITISH	350-4200	X(M)
BELL, TREVOR (20TH C) BRITISH	1000-10000	A
BELL, VANESSA (1879-1961) BRITISH	900-25000	F,L,S
BELL, WILLIAM (1740-1804) BRITISH	250-1800	F
BELL-SMITH, FREDERICK MARLETT	*400-8500	
BELL-SMITH, FREDERICK MARLETT (1846-1923) CANADIAN	450-10000	L,M
BELLA, STEFANO DELLA (1610-1664) ITALIAN	*1000-18000	G,L,W
BELLANDI, ERNESTO (B. 1842) ITALIAN	200-1500	F
BELLANGE, JOSEPH LOUIS HIPPOLYTE	*200-1100	
BELLANGE, JOSEPH LOUIS HIPPOLYTE (1800-1866) FRENCH	900-53000	F

BELLANGER, CAMILLE FELIX (1853-1923) FRENCH	1500-138000	G,F
BELLANGER, RENE-CHARLES (1895-1964) FRENCH	900-6000	L
BELLAVOINE, CLAUDE (19TH C) FRENCH	150-800	X
BELLE, ALEXIS SIMON (1674-1734) FRENCH	1200-46000	F
BELLE, CHARLES ERNEST DE (1873-1937) CANADIAN	*100-1300	L,G
BELLE, KAREL VAN (B. 1884) BELGIAN	400-3500	F,G
BELLE, MARCEL (19TH/20TH C) FRENCH	100-3000	G,L
BELLEFLEUR, LEON (B. 1910) CANADIAN	1500-20000	A
BELLEGARDE, CLAUDE (B. 1927) FRENCH	1000-12000	A
BELLEI, GAETANO (1857-1922) ITALIAN	500-53000	G,F
BELLERMANN, FERDINAND (1814-1889) GERMAN	3500-68000	L
BELLET, PIERRE (19TH/20TH C) FRENCH	150-900	X
BELLEVOIS, JACOB ADRIAENSZ (1621-1675) DUTCH	2000-32000	M
BELLI, ENRICO (19TH C) ITALIAN	100-750	G,F
BELLIAS, RICHARD (B. 1921) FRENCH	100-2000	G,S
BELLINGHAM-SMITH, ELINOR (20TH C) BRITISH	400-3000	L,F
BELLINI, GIOVANNI (1430-1516) ITALIAN	10000-+++	F
BELLIS, ANTONIO DE (D. 1656) ITALIAN	900-10000	F
BELLIS, HUBERT (1831-1902) BELGIAN	500-18000	S
BELLMER, HANS (1902-1975) FRENCH	*800-25000	A,F
BELLMER, HANS (B. 1902) FRENCH	3000-47000	F
BELLONI, GIORGIO (1861-1944) ITALIAN	900-45000	G,L,M
BELLOTTI, DINA (19TH/20TH C) ITALIAN	200-1000	X
BELLOTTO, BERNARDO	*1000-58000	
BELLOTTO, BERNARDO (1724-1780) ITALIAN	5000-+++	L
BELLUCCI, ANTONIO (1654-1726) ITALIAN	700-55000	F,L
BELLYNCK, HUBERT EMILE (B. 1859) FRENCH	300-4100	G,F
BELOFF, ANGELICA (B. 1905) RUSSIAN	*200-1100	F
BELTRAN-MASSES, FEDERICO (1885-1949) SPANISH	800-60000	G,F
BELVEDERE, ABATE ANDREA) (1642-1732) ITALIAN	2500-80000	S
BEMMEL, CHRISTOPH V. (1707-1783) GERMAN	550-30000	G,W
BEMMEL, KARL SEBASTIAN VON (1743-1796) GERMAN	*300-2800	L
BEMMEL, PETER VON (1685-1754) GERMAN	600-7500	L
BENASCHI, GIOVANNI BATTISTA (1636-1688) ITALIAN	600-4500	F
BENASSIT, LOUIS EMILE (1833-1902) FRENCH	200-6000	F
BENAVENT Y ROCAMORA, CAYETANO (19TH/20TH C) SPANISH	400-3500	X
BENCOVICH, FEDERICO (1670-1753) ITALIAN	500-8500	F
BENCZUR, GYULA (1844-1920) HUNGARIAN	400-4800	F,I
BENEDICTER, ALOIS JOSEF (B. 1843) GERMAN	250-3000	F

BENEDIT, LUIS F. (B. 1937) ARGENTINIAN	*300-4000	X
BENELLI, GUISEPPE (1819-1861) ITALIAN	300-3800	G,F
BENES, R. H. (19TH/20TH C) FRENCH	150-1500	X(L)
BENFORD, ELNORA (19TH C) FRENCH	150-900	S
BENLLIURE Y GIL, JOSE (1855-1914) SPANISH	1500-193000	G,F
BENLLIURE Y GIL, MARIANO (B. 1862) SPANISH	*500-18000	G,F
BENNER, EMMANUEL (1836-1909) FRENCH	500-11000	F,L
BENNER, GERRIT (B. 1897) DUTCH	3000-28000	L
BENNETT, ARTHUR (19TH C) BRITISH	100-850	X
BENNETT, FRANK MOSS (1874-1953) BRITISH	1800-27000	G,F,L,S
BENNETT, WILLIAM RUBERY (B. 1893) AUSTRALIAN	900-68000	L
BENNETTER, JOHAN JAKOB (1822-1904) NORWEGIAN	350-7000	M
BENNI, ENDI (19TH C) ITALIAN	100-700	X
BENOIS, ALBERT NIKOLAJEWITCH (B. 1852) RUSSIAN	*150-2300	A
BENOIS, ALEXANDER NIKOLAIVITCH (1870-1960) RUSSIAN	*900-14000	L
BENOIS, NICOLAI (B. 1902) RUSSIAN	300-1800	X(F)
BENOIST, J. (19TH C) FRENCH	250-1200	S
BENOIT, RIGAUD (B. 1911) HAITIAN	2000-18000	F,S
BENOUVILLE, JEAN ACHILLE	*400-2300	
BENOUVILLE, JEAN ACHILLE (1815-1891) FRENCH	900-19000	F,L
BENRATH, FREDERIC (B. 1930) FRENCH	1800-7500	A
BENSA, ALEXANDER VON RITTER (1820-1902) AUSTRALIAN	500-9500	G,L,W
BENSO, GIULIO (1601-1668) ITALIAN	*500-15000	F
BENSON, AMBROSIUS (1495-1550) FLEMISH	2500-60000	F
BENT, JOHANNES VAN DER (1650-1690) DUTCH	500-16000	G,L,W
BENTABOLE, LOUIS (1827-1880) FRENCH	1500-18000	M
BENTELI, WILHELM BERNHARD (B.1839) SWISS	800-15000	L
BENTHAM-DINSDAL, JOHN (B. 1927) BRITISH	300-1800	G,L
BENTLEY, CHARLES (1806-1854) BRITISH	*1000-8500	M,G
BENTLEY, CHARLES E. (1806-1854) BRITISH	350-7600	M,L
BENTZEN, AXEL (1893-1952) DANISH	400-2000	F,S
BENVENUTI, EUGENIO (19TH C) ITALIAN	*250-1200	M,L
BENWELL, JOSEPH AUSTIN (19TH C) BRITISH	*400-5500	W,L
BENZ, SEVERIN (1834-1898) SWISS	150-900	F
BERAIN, JEAN (THE ELDER) (1640-1709) FRENCH	*500-7500	F,I
BERANGER, CHARLES (1816-1853) FRENCH	*500-6800	G,W
BERANGER, JEAN BAPTISTE ANTOINE EMILE (1814-1883) FRENCH	500-6400	X
BERARD, CHRISTIAN	*300-8300	

* Denotes watercolors, pastels, drawings, and/or mixed media

BERARD, CHRISTIAN (1902-1949) FRENCH	900-12000	I,F
BERAUD, JEAN	*1000-25000	
BERAUD, JEAN (1849-1936) FRENCH	3500-+++	G,F
BERCHEM, NICOLAES (1620-1683) DUTCH	2000-+++	L,M
BERCHERE, NARCISSE (1819-1891) FRENCH	1000-29000	G,F,S
BERCHMANS, EMILE (B. 1867) BELGIAN	*400-8500	X(F)
BERCKHEYDE, GERRIT ADRIAENSZ. (1638-1698) DUTCH	3200-135000	L,G,S
BERCKHEYDE, JOB (1630-1693) DUTCH	1500-42000	G,L
BEREA, DEMETRE DE (1908-1975) RUMANIAN/AMERICAN	150-8300	S,F,M
BERENDT, MORITZ (B. 1803) GERMAN	300-3500	F
BERENTZ, CHRISTIAN (1658-1722) GERMAN	900-15000	S
BERG, ALBERT (1825-1884) GERMAN	300-6500	L
BERG, FRANS (1892-1949) SWEDISH	400-4500	S,L
BERG, SIMON VAN DEN (1812-1891) DUTCH	250-3500	L,W
BERG, SVANTE (1885-1946) SWEDISH	400-3500	X(F)
BERG, WILLEM VAN DEN (1886-1970) DUTCH	250-2800	L,F
BERGAMINI, FRANCESCO (1815-1883) ITALIAN	900-21000	G,F,L
BERGEN, CLAUS VON (1885-1964) GERMAN	500-24000	M,F
BERGEN, DIRCK T. VAN (1645-1690) DUTCH	500-12000	L,W,F
BERGER, GIACOMO (1754-1822) FRENCH	500-2500	F
BERGER, HANS (B. 1882) SWISS	400-7500	F,S
BERGERET, DENIS PIERRE (1846-1910) FRENCH	350-13000	S
BERGH, EDVARD (1828-1880) SWEDISH	800-34000	L
BERGH, GILLIS DE (1600-1669) DUTCH	2500-60000	S
BERGHE, FRITZ VAN DEN (1883-1939) BELGIAN	2000-104000	A
BERGMAN, ANNA-EVA (B. 1909) SWEDISH/FRENCH	900-6500	A
BERGMAN, KARL (1891-1965) SWEDISH	800-4500	L
BERGMAN, OSKAR	*300-14000	
BERGMAN, OSKAR (1879-1963) SWEDISH	600-25000	L
BERGMANN, CHARLES PIERRE (20TH C) FRENCH	150-1000	G
BERGMANN, GEORG (1819-1870) GERMAN	2000-35000	G
BERGMANN, JULIUS HUGO (1861-1940) GERMAN	500-4500	G,F
BERGMANN, MAX (1884-1955) GERMAN	500-7800	G,W,L
BERGMANN, OTTO (19TH C) GERMAN	350-4000	F
BERGNER, YOSL	*150-1000	
BERGNER, YOSL (B. 1920) ISRAELI	800-20000	X
BERGSLEIN, KNUD LARSEN (1827-1908) NORWEGIAN	800-24000	G,W,F
BERGSLIEN, NILS (1853-1928) NORWEGIAN	1000-35000	F,L,G
BERGSOE, JOHAN FREDERICK (1841-1897) DANISH	500-6500	S

BERGSTROM, ALFRED (1869-1930) SWEDISH	800-6000	L
BERJON, ANTOINE	*500-18000	
BERJON, ANTOINE (1754-1893) FRENCH	1200-107000	S
BERKE, HUBERT (20TH C) GERMAN	*400-6500	A
BERKES, ANTAL (B.1874) HUNGARIAN	400-8000	G,L
BERLEWI, HENRYK (1894-1967) POLISH	*500-15000	X
BERLIN, SVEN PAUL (B. 1911) BRITISH	*300-2500	M,G
BERLIT, RUDIGER (1883-1939) GERMAN	1000-28000	L
BERMAN, EUGENE (1899-1972) RUSSIAN	*300-10000	I,F
BERMAN, LEONID	*100-600	
BERMAN, LEONID (1898-1976) RUSSIAN	400-6800	F,L
BERMUDEZ, CUNDO (B. 1914) CUBAN	700-30000	G,F,S
BERMUDEZ, JORGE (1883-1926) ARGENTINIAN	300-4500	L,S
BERNAGOZZI, FEDERICO (B. 1859) ITALIAN	300-3200	G
BERNALDO, ALLAN T (B. 1900) AUSTRALIAN	*900-15000	X(S)
BERNALDO DE QUIROS, CESAREO (20TH C) ARGENTINIAN	300-2000	X
BERNARD, EMILE	*500-35000	
BERNARD, EMILE (1868-1941) FRENCH	2000-+++	A,L,F,S
BERNARD, JEAN CLEMENT (B. 1761) FRENCH	600-6500	X
BERNARD, JEAN JOSEPH (Called BERNARD DE PARIS) (1740-1809) FRENCH	*400-3800	F
BERNARD, JOSEPH (1864-1933) FRENCH	400-6500	G,F
BERNARD, JULES FRANCOIS (20TH C) FRENCH	400-5400	G,F,L
BERNARD, LOUIS MICHEL (B. 1885) FRENCH	200-2500	G
BERNARDI, DOMENICO DE (20TH C) ITALIAN	400-2400	X
BERNATZIK, WILHELM (1853-1906) AUSTRIAN	800-7000	F,L
BERNE-BELLECOUR, ETIENNE PROSPER (1838-1910) FRENCH	1500-66000	F,G
BERNE-BELLECOUR, JEAN JACQUES (B. 1874) FRENCH	500-6500	L,F
BERNHARDT, SARAH (1844-1923) FRENCH	400-8000	F
BERNI, ANTONIO	*500-7000	
BERNI, ANTONIO (B. 1905) ARGENTINIAN	400-30000	A
BERNIER, GEORGE (1862-1918) BELGIAN	300-7000	L,W
BERNINGER, EDMUND (B. 1843) GERMAN	500-28000	L,M
BERNT, RUDOLF (B. 1844) AUSTRIAN	*900-6000	L
BEROLDINGEN, AMARIE VON (1853-1911) GERMAN	400-3500	L,W
BEROUD, LOUIS (1852-1910) FRENCH	450-170000	G,F
BERRE, JEAN BAPTISTE (1777-1838) BELGIAN	800-8000	L,S
BERRES, JOSEPH VON (1821-1921) AUSTRIAN	400-3000	X(F,W)
BERRETTONI, NICCOLO (1637-1682) ITALIAN	400-5200	F

* Denotes watercolors, pastels, drawings, and/or mixed media

BERROETA, PIERRE DE (20TH C) FRENCH	1000-11000	A
BERTEAUX, RUDOLPH S. (19TH C) FRENCH	200-1000	G,F
BERTEL-NORDSTROM, BERTEL (20TH C) SWEDISH?	500-3200	L,S
BERTHELON, EUGENE	*200-3200	
BERTHELON, EUGENE (1829-1914) FRENCH	400-14000	L,M
BERTHELSEN, CHRISTIAN (1839-1909) SCANDINAVIAN	200-4000	L
BERTHOLLE, JEAN (B. 1909) FRENCH	1000-32000	A
BERTHOME-SAINT-ANDRE, LOUIS (1905-1977) FRENCH	800-14000	F
BERTHOUD, AUGUSTE HENRI (1829-1887) SWISS	300-4500	X(W)
BERTIER, CHARLES ALEXANDRE (1860-1924) FRENCH	300-110000	L,M
BERTIN, JEAN VICTOR	*400-3000	
BERTIN, JEAN VICTOR (1775-1842) FRENCH	1000-28000	L
BERTIN, NICOLAS (1668-1736) FRENCH	900-24000	F
BERTIN, ROGER (B. 1915) FRENCH	150-800	X
BERTINI, GIANNI	*1000-28000	
BERTINI, GIANNI (B. 1913) ITALIAN	1000-40000	A
BERTINI, L. (20TH C) ITALIAN	200-9600	X(L)
BERTOJA, JACOPO (Called JACOPO ZANGUIDI) (1544-1574) ITALIAN	*1500-35000	F
BERTON, ARMAND (1854-1927) FRENCH	250-50000	F
BERTONCELLI, G. (19TH C) ITALIAN	150-2200	F
BERTRAM, ABEL	*150-2500	
BERTRAM, ABEL (1871-1954) FRENCH	350-14000	G,L
BERTRAND, GASTON (20TH C) BELGIAN	500-10000	X (A)
BERTRAND, GEORGES JULES (1849-1929) FRENCH	300-5000	G
BERTRAND, JEAN BAPTISTE (19TH C) FRENCH	350-7000	F
BERTRAND, PAULIN (1852-1940) FRENCH	500-12000	L,M,S
BERUETE Y MORET, AURELIANO DE (1845-1911) SPANISH	600-54000	L
BESCHEY, BALTHASAR (1708-1776) FLEMISH	1100-42000	F,L
BESCHEY, JACOB ANDRIES (1710-1786) FLEMISH	500-125000	F
BESNARD, ALBERT	*900-15000	F
BESNARD, ALBERT (1849-1934) FRENCH	900-22000	F
BESNARD, PAUL ALBERT	*300-13000	
BESNARD, PAUL ALBERT (1849-1934) FRENCH	500-19000	G,F
BESNUS, AMEDEE (1831-1909) FRENCH	400-3000	G,W
BESSE, RAYMOND (1871-1969) FRENCH	150-2000	L
BESSON, FAUSTIN (1821-1882) FRENCH	450-9000	G,L
BESSONOF, BORIS (20TH C) RUSSIAN	200-1800	X
BEST, HANS (1874-1942) GERMAN	300-5200	G,F,L

BEST, JOHN (Active 1750-1791) BRITISH	1000-18000	L,W
BEST, MARY ELLEN (1809-1891) BRITISH	*900-20000	F,S,L
BETHKE, HERMANN (1825-1895) GERMAN	600-15000	G,F
BETTERA, BARTOLOMEO (1639-1700) ITALIAN	1800-36000	S
BETTIJAI, G. (19TH C) ITALIAN	300-2800	X(G)
BEUL, FRANS DE (1849-1919) DUTCH	300-5200	G,L,W
BEUL, HENRI DE (1845-1900) BELGIAN	400-5500	G,L,W
BEUL, LAURENT DE (1821-1872) BELGIAN	350-5200	L,W
BEURDEN, ALFONS VAN (B. 1878) FLEMISH	800-20000	F,L
BEUYS, JOSEF (1921-1986) GERMAN	*800-110000	A
BEVAN, ROBERT (1865-1925) BRITISH	1000-25000	L,F
BEVERLEY, WILLIAM ROXBY (1811-1889) BRITISH	*300-8100	M
BEYER, EUGENE (1817-1893) GERMAN	350-15000	X
BEYER, JAN DE (1705-1768) SWISS	350-4500	L
BEYEREN, ABRAHAM HENDRICKSZ VAN (1620-1690) DUTCH	2000-+++	S,M
BEYLARD, LOUIS CHARLES (D. 1925) FRENCH	200-1500	F,L
BEYLE, PIERRE MARIE (1838-1902) FRENCH	600-55000	G,F
BEZARD, JEAN LOUIS	*100-900	
BEZARD, JEAN LOUIS (B. 1799) FRENCH	300-3500	F
BEZZI, BARTOLOMEO (1851-1925) ITALIAN	1000-18000	L,M
BEZZUOLI, GIUSEPPE (1784-1855) ITALIAN	600-12000	F
BIALINITSKI-BIROULIA, VITOLD (1872-1957) RUSSIAN	600-7500	L
BIANCA, ANGELO D. (1858-1942) ITALIAN	800-24000	G,F
BIANCHI, GAETANO (1819-1892) ITALIAN	300-4800	X(G)
BIANCHI, MOSE DI GIOSUE (1840-1904) ITALIAN	1000-137000	F,W
BIANCHI, P.O. (19TH C) ITALIAN	100-600	X
BIARD, FRANCOIS AUGUSTE (1799-1882) FRENCH	1200-150000	G,F
BIBIENA, CARLO GALLI (1728-1778) ITALIAN	500-6500	I,F
BIBIENA, GIUSEPPE GALLI (1696-1756) ITALIAN	*500-17000	L
BICCHI, FERRARI (19TH/20TH C) ITALIAN	200-1500	X
BICCI, LORENZO DI (1373-1450) ITALIAN	2500-225000	F
BICCI, NERI DI (1419-1491) ITALIAN	4500-125000	F
BIDA, ALEXANDRE	*100-1700	
BIDA, ALEXANDRE (1823-1895) FRENCH	100-1500	S
BIDAU, EUGENE (19TH C) FRENCH	800-18000	X
BIDAULD, JEAN JOSEPH XAVIER (1758-1846) FRENCH	3000-95000	L,M
BIDDLE, LAURENCE (B. 1888) BRITISH	350-4500	S
BIDO, CANDIDO (B. 1936) DOMINICAN	300-4600	G
BIE, CORNELIS DE (1621-1654) DUTCH	400-8000	F

* Denotes watercolors, pastels, drawings, and/or mixed media

BIELER, ANDRE CHARLES (B. 1896) CANADIAN	600-3800	L
BIELER, ERNEST	*1000-30000	
BIELER, ERNEST (1863-1948) SWISS	2000-25000	X(F)
BIELER, ERNEST (B. 1863) SWISS	*500-35000	F,G
BIELING, HERMANN FRIEDRICH (1887-1964) DUTCH	800-9000	X(L)
BIERHALS, OTTO (B. 1879) GERMAN	100-700	I,F
BIERMANN, EDOUARD KARL (1803-1892) GERMAN	300-3000	X
BIERNACKA, ANIELA DE (19TH C) POLISH	150-700	X
BIESE, HELMI (1867-1933) FINNISH	1500-32000	L
BIESE, KARL (1863-1930) GERMAN	*150-2800	L
BIESEBROECK, JULES VAN (1873-1965) BELGIAN	600-4000	F,L
BIEVRE, MARIE DE (B. 1865) BELGIAN	600-475000	S
BIGARI, VITTORIO (1692-1776) ITALIAN	*800-45000	L
BIGAUD, WILSON (B. 1931) HAITIAN	400-5800	X(G)
BIGG, WILLIAM REDMORE (1755-1828) BRITISH	800-12000	G,F
BIGGI, FELICE FORTUNATO (17TH C) ITALIAN	1000-72000	S
BIGOT, TROPHIME (OR THEOPHISME) (Active 1620-1635) FRENCH	1800-50000	G,F,L
BILBIE, JAMES LEES (1860-1945) BRITISH	300-1500	L
BILCOQ, MARIE MARC ANTOINE (1755-1838) FRENCH	700-12000	G
BILDERS, ALBERT GERARD (1838-1865) DUTCH	300-5500	L
BILDERS, JOHANNES WERNARDUS (1811-1890) DUTCH	500-9000	L,W
BILL, OLIVER (19TH C) BRITISH	150-1000	M
BILLE, CARL LUDWIG (1815-1898) DANISH	650-28000	M
BILLE, VILHELM (1889-1944) DANISH	500-3800	M
BILLE, WILHELM VICTOR (1864-1908) DANISH	300-3800	M
BILLET, ETIENNE (1821-1881) FRENCH	400-8500	G,W
BILLET, PIERRE	*200-1500	
BILLET, PIERRE (1837-1922) FRENCH	400-35000	G
BILLGREN, OLA (B. 1940) SPANISH	1500-45000	A
BILLING, TEODOR (1817-1892) SWEDISH	400-4300	L
BILLINGHURST, ALFRED JOHN (1880-1963) BRITISH	500-15000	G,L,F
BILLOTTE, LEON JOSEPH (B. 1815) FRENCH	400-3500	G,F
BILTIUS, JACOBUS VAN DER (1633-1681) DUTCH	500-88000	S
BIMBI, BARTOLOMEO (1648-1725) ITALIAN	2000-70000	S
BIMMERMANN, CAESAR (19TH C) GERMAN	600-14000	L,F,W
BINDEMAN, G. (19TH C) BRITISH	200-800	X
BINDER, ALOIS (B. 1857) GERMAN	300-4200	G,F,S
BINDER, TONY (1868-1944) GERMAN	200-2000	G,F
BINET, ADOLPHE GUSTAVE (1854-1897) FRENCH	400-6000	G,F,M

BINET, GEORGES (1865-1949) FRENCH	500-16500	F,M
BINET, VICTOR JEAN BAPTISTE BARTHELEMY (1849-1924) FRENCH	400-6500	L,W
BINKS, REUBEN WARD (20TH C) BRITISH	*450-24000	W,F
BINOIT, PETER (1590-1632) GERMAN	3000-139000	S
BIORO, GUSTAVE (19TH/20TH C) FRENCH	*200-1500	X(F)
BIOULES, VINCENT (B. 1938) FRENCH	1000-16000	A
BIRCH, JOHN (1807-1857) BRITISH	150-1500	F,M,L
BIRCH, SAMUEL JOHN LAMORNA	*400-5700	
BIRCH, SAMUEL JOHN LAMORNA (1869-1955) BRITISH	650-35000	L,W
BIRCHALL, WILLIAM MINSHALL (19TH/20TH C) BRITISH	*300-3700	M
BIRD, HARRINGTON	*300-8000	
BIRD, HARRINGTON (Late 19TH C) BRITISH	1000-18000	G,W
BIRD, JOHN ALEXANDER HARINGTON (1846-1936) BRITISH	*1000-16000	G,F,W
BIRD, SAMUEL (Late 19TH C) BRITISH	150-900	S
BIRLEY, OSWALD (1880-1979) NEW ZEALAND	1200-22000	F,L
BIRMANN, PETER (1758-1844) SWISS	*200-9400	L
BIROLLI, RENATO (1906-1959) ITALIAN	400-31000	X
BIRTLES, HARRY (19TH C) BRITISH	800-3500	W,L,F
BIRZER, EUGEN (1847-1905) GERMAN	600-5000	L,F
BISCHOFF, FREDERICH (1819-1873) GERMAN	450-10000	G
BISCHOFF, THEOFILE (B. 1847) SWISS	300-4000	G
BISHOP, ALFRED S. (19TH C) BRITISH	300-2200	G,W
BISHOP, E.W. (19TH C) BRITISH	150-700	X
BISON, GIUSEPPE BERNARDINO (1762-1844) ITALIAN	1000-56000	G,F
BISSCHOP, JAN DE (1628-1671) DUTCH	*400-8000	L,F
BISSIER, JULES	*400-24000	
BISSIER, JULES (1893-1965) GERMAN/SWISS	900-49000	G,L,S
BISSIERE, ROGER	*900-50000	
BISSIERE, ROGER (1884-1964) FRENCH	1000-120000	A
BISSON, EDOUARD (B. 1856) FRENCH	400-6500	L,F
BISSON, PIERRE (19TH C) FRENCH	300-2200	F
BISTAGNE, PAUL (1850-1886) FRENCH	1200-132000	M
BITRAN, ALBERT (B.1929) ISRALI	300-6500	X
BIVA, HENRI (1848-1928) FRENCH	400-14000	L,S
BIVEL, FERNAND ACHILLE LUCIEN (1888-1950) FRENCH	900-25000	G,F
BJERHE-PETERSEN, VILHELM (1909-1957) DANISH	600-28000	A
BJULF, SOREN CHRISTIAN (1890-1958) DANISH	300-13000	G,L,M
BJURSTROM, TOR (1888-1966) SWEDISH	1000-15000	L,S

* Denotes watercolors, pastels, drawings, and/or mixed media

BLAAS, CARL VON (1815-1894) AUSTRIAN	1500-45000	G,F
BLAAS, EUGEN RITTER VON	*500-4800	
BLAAS, EUGEN RITTER VON (1843-1931) AUSTRIAN	3000-+++	G,F
BLAAS, JULIUS VON (1845-1922) AUSTRIAN	1800-30000	G,L
BLACADDER, ELIZABETH (B. 1931) BRITISH	*600-7500	A,S,L
BLACHE, CHR (1838-1920) DANISH	500-5000	M,L
BLACK, ANDREW	*100-2000	
BLACK, ANDREW (1850-1916) BRITISH	200-2500	M
BLACKLOCK, WILLIAM KAY (B. 1872) BRITISH	1000-34000	G,L,F
BLACKMAN, CHARLES	*500-10000	
BLACKMAN, CHARLES (B. 1928) AUSTRALIAN	1000-40000	F,L
BLAIKLEY, ALEXANDER (1816-1903) BRITISH	400-3000	G,F,L
BLAKE, BENJAMIN (1780-1830) BRITISH	400-6500	S,F
BLAKE, T. (Active 1829-1839) BRITISH	2000-35000	X
BLAKE, WILLIAM	*800-60000	
BLAKE, WILLIAM (1757-1827) BRITISH	3000-75000	G,F
BLAMPIED, EDMUND	*100-8000	
BLAMPIED, EDMUND (1886-1966) BRITISH	500-18000	A,G,M
BLANCH, VENTURA (19TH/20TH C) SPANISH	100-700	X
BLANCHARD, ANTOINE (B. 1910) FRENCH	400-6000	F
BLANCHARD, MARIA	*1200-69000	
BLANCHARD, MARIA (1881-1932) SPANISH/FRENCH	1800-+++	A,F,S
BLANCHE, JACQUES EMILE	*500-16000	
BLANCHE, JACQUES EMILE (1861-1942) FRENCH	1400-142000	L,F,S
BLANCHET, ALEXANDRE (1882-1961) SWISS	500-7500	X (G)
BLANCHET, LOUIS GABRIEL (1705-1772) FRENCH	1500-27000	F
BLANCPAIN, JULES (1860-1914) SWISS	400-5400	L
BLAND, EMILY BEATRICE (1864-1951) BRITISH	500-4500	X (L)
BLANDY, L.V. (19TH C) BRITISH	100-700	S
BLANES, JUAN M. (1830-1901) URUGUAYAN	400-4500	X(F)
BLANKE, WILHELM (B. 1873) GERMAN	400-4000	F,S
BLANKERHOFF, JAN THEUNISZ (1628-1669) DUTCH	1000-18000	M
BLARENBERGHE, HENRI DESIRE VAN (1734-1812) FRENCH	*500-21000	X(L)
BLARENBERGHE, JACQUES W. (1669-1742) DUTCH	500-34000	G,F
BLARENBERGHE, LOUIS NICOLAS VAN	*2500-48000	
BLARENBERGHE, LOUIS NICOLAS VAN (1716-1794) FRENCH	2000-82000	G,F,L
BLAS, L.O. (19TH C) ITALIAN	*300-1500	M
BLASS, GUILIO DA (1880-1934) ITALIAN/AMERICAN	200-1200	X
BLASSET, E. (19TH C) FRENCH	300-6000	G

BLATAS, ARBIT	*100-500	
BLATAS, ARBIT (B. 1908) LITHUANIAN	400-5500	X(L,F)
BLATTER, BRUNO (19TH C) GERMAN	300-1500	G
BLAU, TINA (1845-1916) AUSTRIAN	1000-35000	L
BLAU-LANG, TINA (1845-1937) AUSTRIAN	400-8500	L
BLAUENSTEINER, LEOPOLD	*500-5000	
BLAUENSTEINER, LEOPOLD (1880-1947) AUSTRIAN	1000-15000	G,L
BLAZEBY, JAMES (19TH C) BRITISH	250-3500	W
BLEECK, PETER DE (1700-1764) DUTCH	400-2500	X
BLEIBTREU, GEORG (1828-1892) GERMAN	800-18000	F,L
BLES, DAVID JOSEPH (1821-1899) DUTCH	800-12000	G,F
BLES, HENDRIK MET DE CIVETTA (1480-1550) FLEMISH	20000-+++	L,F
BLES, JOSEPH (1792-1883) DUTCH	450-15000	L,F
BLEULER, JOHANN LUDWIG (1792-1850) SWISS	*1000-12000	L
BLEULER, LOUIS (19TH C) SWISS	*500-16000	L
BLEYFUS, LUCIEN (20TH C) FRENCH	200-1200	X(L)
BLIECK, DANIEL DE (1620-1673) DUTCH	1800-25000	G,L
BLIGNY, ALBERT (1849-1908) FRENCH	200-900	G,W
BLIN, FRANCIS (1827-1866) FRENCH	200-1800	L,M
BLINKS, THOMAS (1860-1912) BRITISH	800-72000	L,W
BLOCH, ALEXANDRE (20TH C) FRENCH	200-3000	G
BLOCH, CARL (1834-1890) DANISH	900-15000	G,F
BLOCK, EUGENIUS FRANZ DE (1812-1893) BELGIAN	500-16000	G,F
BLOCK, JOSEPH (B. 1863) GERMAN	400-5000	G
BLOCKLANDT, ANTHONIE VAN MONTFOORT (1532-1583) DUTCH	400-7200	L,F
BLOEM, MATHIAS (17TH C) DUTCH	250-3900	F
BLOEMAERT, ABRAHAM	*500-110000	
BLOEMAERT, ABRAHAM (1564-1651) DUTCH	2500-+++	F,L
BLOEMAERT, ADRIAEN (1610-1666) DUTCH	2000-18000	L,F
BLOEMAERT, HENDRICK (1601-1672) DUTCH	800-40000	G,F,L
BLOEMEN, JAN FRANS VAN (Called ORIZZONTE) (1662-1749) FLEMISH	1000-99000	L
BLOEMEN, PIETER VAN	*150-7500	
BLOEMEN, PIETER VAN (Called STANDAART)(1657-1720) FLEMISH	800-52000	L,G
BLOEMERS, ARNOLDUS (1786-1844) DUTCH	2500-45000	S
BLOM, GUSTAV-VILHELM (1853-1942) DANISH	800-11000	F
BLOM, JAN (1622-1685) DUTCH	500-12000	L
BLOMFIELD, CHARLES (1856-1920) BRITISH	450-34000	L
BLOMMAERT, MAXIMILIAN (17TH/18TH C) FLEMISH	1000-10000	L,G

• Denotes watercolors, pastels, drawings, and/or mixed media

BLOMME, ALPHONS (1845-1923) BELGIAN	300-2800	X(F)
BLOMMERS, BERNARDUS JOHANNES	*400-12000	
BLOMMERS, BERNARDUS JOHANNES (1845-1914) DUTCH	1000-60000	G,F
BLOMSTEDT, VALNO (B. 1871) FINNISH	900-12000	L
BLOND, MAURICE (B. 1899) FRENCH	800-9500	X(F)
BLONDEAU, PAUL	*100-700	
BLONDEAU, PAUL (19TH C) FRENCH	300-4500	G,F
BLONDEL, JACQUES FRANCOIS (1705-1774) DUTCH	*300-8500	F,L
BLONDIN, CHARLES (20TH C) FRENCH	150-900	X(F)
BLONDIN, MARIE LOUISE (20TH C) FRENCH	100-650	X
BLOODGOOD, MORRIS SEYMOUR (1845-1920) BRITISH	150-800	L
BLOOT, PIETER DE (1602-1658) DUTCH	2000-92000	G,L
BLOT, JACQUES EMILE (1885-1960) FRENCH	150-850	X(F)
BLUM, LUDWIG (20TH C) ISRAELI	200-9000	X(F)
BLUM, MAURICE (B. 1832) FRENCH	250-15000	G,F
BLUME, EDMUND (B. 1844) BRITISH	350-9000	G,F
BLUME-SIEBERT, LUDWIG (B. 1853) GERMAN	800-8500	G,L,F
BOBAREWSKI, N. (19TH C) RUSSIAN	300-2800	X
BOBERG, ANNA (1864-1935) SWEDISH	*250-8800	X(L)
BOCCHI, FAUSTINO (1659-1742) ITALIAN	1000-41000	G
BOCCIONI, UMBERTO (1882-1916) ITALIAN	10000-+++	X (F)
BOCHMANN, GREGOR ALEXANDER VON (SR.) (1850-1930) GERMAN	1000-24000	F,L,W
BOCION, FRANCOIS LOUIS DAVID (1828-1890) SWISS	1000-170000	M,L
BOCK, ADOLF	*900-7500	
BOCK, ADOLF (1854-1917) GERMAN	2000-20000	M
BOCK, THEOPHILE EMILE ACHILLE DE	*300-3200	
BOCK, THEOPHILE EMILE ACHILLE DE (1851-1904) DUTCH	700-22000	L,W
BOCKLIN, ARNOLD (1827-1901) SWISS	3000-+++	F,L
BOCKLIN, CARLO (B. 1870) SWISS	400-3500	X
BOCKSBERGER, JOHANN MELCHIOR (1540-1589) GERMAN	*450-7000	W
BOCKSTIEGEL, PETER AUGUST (1889-1951) GERMAN	2000-42000	L,S
BOCQUET, PAUL (B.1868) FRENCH	700-17000	L
BODAN, ANDREAS (THE YOUNGER) (1656-1696) GERMAN	350-1800	F
BODDINGTON, EDWIN H. (1836-1905) BRITISH	400-7000	L,W
BODDINGTON, HENRY JOHN (1811-1865) BRITISH	1000-30000	L,F
BODENHAUSEN, CUNO VON (B. 1852) GERMAN	200-1200	G,F
BODENMULLER, FRIEDRICH (1845-1913) GERMAN	350-4000	G,F
BODLEY, JOSSELIN (B. 1893) BRITISH	400-8000	L

BODMER, KARL	*200-3000	
BODMER, KARL (1809-1893) SWISS	450-5000	L,G
BOE, FRANZ DIDRIK (1820-1891) NORWEGIAN	1000-6500	S
BOECK, FELIX DE (B. 1898) ?	800-9500	X(F)
BOECKHORST, JAN VAN (1661-1724) GERMAN	500-5000	X
BOEHM, EDUARD (B.1830) GERMAN	600-3000	L,F,G
BOEHN, WOLFGANG (19TH C) BRITISH	300-2500	F,G
BOETTI, ALIGHIERO (B. 1940) ITALIAN	*1000-52000	A
BOEYERMENS, THEODOR (1620-1678) FLEMISH	900-15000	F
BOGAERT, BRAM (B. 1921) DUTCH	*900-20000	A
BOGAERT, HENDRICKSZ (1626-1672?) DUTCH	500-4500	G,F
BOGAIEVSKAIA, OLGA (B. 1916) RUSSIAN	800-7500	X(F)
BOGDANOFF-BJELSKI, NIKOLAI PETROWITSCH (1868-1945) RUSSIAN	1000-37000	L,F
BOGDANY, JAKOB (1660-1724) HUNGARIAN	2500-110000	L,S
BOGGIO, EMILIO (1857-1920) FRENCH	2500-82000	L
BOGH, HENRIK CARL (1827-1893) DANISH	700-13000	L,W,G
BOGOLIUBOV, ALEXEI (1824-1896) RUSSIAN	900-32000	L,M
BOGOMAZOV, ALEXANDER	*400-9200	
BOGOMAZOV, ALEXANDER (B. 1880) RUSSIAN	800-51000	X(F)
BOHEMEN, KEES VAN (20TH C) DUTCH	1000-15000	A
BOHM, PAL (1839-1905) HUNGARIAN	1000-18000	G,F,L
BOHME, KARL (1866-1939) GERMAN	400-3500	X
BOHRDT, HANS (B. 1857) GERMAN	*800-6000	M
BOICHARD, GEORGES LUCIEN (19TH C) FRENCH	300-3000	G,F
BOILAUGES, FERNAND	*250-3500	
BOILAUGES, FERNAND (B. 1891) FRENCH	300-1800	G
BOILEAU, PHILIP	*150-1000	
BOILEAU, PHILIP (1864-1917) CANADIAN	300-3000	F,I
BOILLY, LOUIS LEOPOLD	*900-38000	
BOILLY, LOUIS LEOPOLD (1761-1845) FRENCH	5000-+++	G,F,L
BOISGONTIER, HENRI (1850-1940) FRENCH	200-1000	X
BOISSELIER, ANTOINE FELIX	*250-1200	
BOISSELIER, ANTOINE FELIX (1790-1857) FRENCH	350-6500	L
BOISSIEU, JEAN JACQUES DE (1736-1810) FRENCH	*300-4900	X
BOITARD, FRANCOIS (1670-1715) DUTCH	300-2500	G,F
BOITEL, MAURICE (B. 1919) FRENCH	150-900	X(L)
BOIZOT, SIMON LOUIS (1743-1809) FRENCH	*200-1500	G,F
BOKELMANN, CHRISTIAN LUDWIG (1844-1894) GERMAN	1000-42000	F,G

* Denotes watercolors, pastels, drawings, and/or mixed media

BOKER, CARL (1836-1905) GERMAN	1800-20000	G
BOKER, EDMUND (19TH C) GERMAN	100-750	X
BOKHORST, H.G. (Early 20TH C) GERMAN	100-700	X
BOKHUYZEN, LIDOLF (1631-1708) DUTCH	300-3200	X
BOKS, EVERT JAN (1838-1914) DUTCH	2500-+++	G
BOL, FERDINAND	*450-11000	
BOL, FERDINAND (1616-1680) DUTCH	1200-38000	F
BOLDINI, GIOVANNI	*2800-+++	
BOLDINI, GIOVANNI (1842-1931) ITALIAN	10000-+++	G,F
BOLIN, GUSTAVE (B. 1920) SWEDISH	1000-22000	A
BOLLONGIER, HANS (1600-1644) DUTCH	2000-60000	S
BOLSI, U. (19TH C) ITALIAN	250-1000	X
BOMBERG, DAVID	*400-40000	
BOMBERG, DAVID (1890-1957) BRITISH	1600-125000	L,F
BOMBLED, KAREL FREDERIK (1822-1902) DUTCH	100-800	L,G
BOMBLED, LOUIS CHARLES	*100-600	
BOMBLED, LOUIS CHARLES (1862-1927) FRENCH	300-6000	G,L
BOMBOIS, CAMILLE (1883-1970?) FRENCH	2200-121000	G,L
BOMMEL, ELIAS PIETER VAN (1819-]890) DUTCH	600-30000	L
BOMPARD, MAURICE (1857-1936) FRENCH	300-14000	L,S
BOMPIANI, ROBERTO (1821-1908) ITALIAN	300-6000	G
BOMPIANI-BATTAGLIA, CECELIA (1847-1927) ITALIAN	*100-1800	X
BONACINO, G. (19TH C) ITALIAN	200-1200	X
BONALUMI, AGOSTINO	*1000-20000	
BONALUMI, AGOSTINO (B. 1935) ITALIAN	1500-25000	A
BONAMICI, A. (20TH C) ITALIAN	200-800	X
BONAMICI, LOUIS (20TH C) FRENCH	100-600	G
BONANNI, E. (19TH C) ITALIAN	*300-2000	G,F
BONAVIA, CARLO (Active 1740-1756) ITALIAN	800-160000	L,M
BOND, RICHARD SEBASTIAN (1808-1866) BRITISH	400-3500	L,M
BOND, WILLIAM J.	*100-1500	
BOND, WILLIAM J. (1833-1926) BRITISH	300-11000	L,M
BONDOUX, JULES GEORGE (D. 1920) EUROPEAN	250-2600	G
BONE, SIR DAVID MUIRHEAD (1876-1953) SCOTTISH	*150-3400	L
BONELLI, GIUSEPPE (B. 1898) ITALIAN	200-1200	G
BONEVARDI, MARCELO	*400-22000	
BONEVARDI, MARCELO (B. 1929) ARGENTINIAN	800-14000	X
BONFILS, GUSTAVE (19TH C) FRENCH	400-3000	G,F
BONGART, SERGEI R. (1918-1981) RUSSIAN/AMERICAN	150-1000	L,S

BONGEY, H. (19TH C) FRENCH	100-700	X
BONHEUR, AUGUSTE (1824-1884) FRENCH	800-12000	G,W,L
BONHEUR, FERDINAND (19TH C) FRENCH	200-4000	S,F
BONHEUR, JULIETTE (1830-1891) FRENCH	500-7000	F,W
BONHEUR, ROSA	*600-210000	
BONHEUR, ROSA (1822-1899) FRENCH	2000-58000	W,F
BONHOMME, LEON	*300-4000	
BONHOMME, LEON (1870-1924) FRENCH	1000-38000	F,G
BONI, E. (19TH C) ITALIAN	100-700	X
BONIFANTI, DECOROSO (1860-1941) ITALIAN	150-1000	L
BONIFAZI, ADRIANO (19TH C) ITALIAN	350-2200	G,F
BONINGTON, RICHARD PARKES	*900-160000	
BONINGTON, RICHARD PARKES (1801-1828) BRITISH	8000-+++	M,L,F
BONITO, GIUSEPPE (1705-1789) ITALIAN	2200-+++	G,F
BONJOUR, DAVID (19TH C) SWISS	100-800	X
BONJOUR, JEAN-BAPTISTE (1897-1967) BRITISH	500-5000	F
BONNARD, PIERRE	*1500-168000	
BONNARD, PIERRE (1867-1947) FRENCH	10000-+++	F,G,L
BONNAT, LEON JOSEPH FLORENTIN (1834-1922) FRENCH	700-20000	G,F
BONNECHOSE, R. (19TH C) FRENCH	200-1200	X
BONNEFOY, HENRI ARTHUR (1839-1917) FRENCH	650-8000	L,F
BONNENCONTRE, ERNEST COURTOIS (19TH C) LATIN AMERICAN	*300-1500	F,L
BONNIER, EVA (1857-1909) SWEDISH	2500-38000	F,L
BONNIER, G. (19TH C) FRENCH	250-3200	X(G)
BONNIER, OLLE	*900-7500	
BONNIER, OLLE (B. 1925) SCANDINAVIAN	3000-36000	A
BONOME, ADOLPHINE (19TH C) FRENCH	100-700	X
BONONI, CARLO (1569-1632) ITALIAN	2000-110000	F,G
BONSI, GIOVANNI (14TH C) ITALIAN	1000-50000	F
BONVIN, FRANCOIS	*500-27000	
BONVIN, FRANCOIS (1817-1887) FRENCH	1000-15000	G,L,S
BONZI, PIETRO PAOLO (16TH C) ITALIAN	1000-39000	L,S
BOOG, CARLE MICHEL (B. 1877) SWISS/AMERICAN	500-9000	G,L
BOOGAARD, WILLEM JACOBUS (1842-1887) DUTCH	900-28000	G,W
BOONEN, ARNOLD (1669-1729) DUTCH	500-9500	F,W
BOOTH, PETER (B. 1940) AUSTRALIAN	*800-9500	A
BOOTH, S. L. (19TH/20TH C) BRITISH	200-14000	L,M
BOOTY, FREDERICK WILLIAM (20TH C) BRITISH?	*300-3200	L

* Denotes watercolors, pastels, drawings, and/or mixed media

BORBINO, J. (1905-1964) ITALIAN/AMERICAN	200-1200	X
BORDENAVE, PIERRE (19TH/20TH C) FRENCH	100-2000	X
BORDONE, PARIS (1500-1571) ITALIAN	2500-125000	F
BORDUAS, PAUL EMILE (1905-1960) CANADIAN	5000-+++	A
BORELY, JEAN BAPTISTE (1776-1823) FRENCH	450-4800	L
BORENSTEIN, SAMUEL (1908-1969) CANADIAN	800-11000	L,S
BORES, FRANCISCO	*500-21000	
BORES, FRANCISCO (1898-1972) SPANISH	1000-120000	A
BORG, AXEL LEONARD	*100-500	
BORG, AXEL LEONARD (1847-1916) SWEDISH	900-38000	L
BORGELLA, FREDERIC (19TH C) FRENCH	100-900	G,F
BORGEN, HANS FREDRIK (1852-1907) NORWEGIAN	800-6000	L
BORGES, JACOB (B. 1931) VENEZUELAN	1500-30000	F
BORGMANN, PAUL (1851-1893) GERMAN	600-18000	G
BORIONE, BERNARD LOUIS	*200-3500	
BORIONE, BERNARD LOUIS (B. 1865) FRENCH	250-6300	G,F
BORJE, GIDEON (1891-1969) SWEDISH	400-12000	L,S,F
BORNFRIEND, JACOB (B. 1904) BRITISH	400-4000	X(F)
BORNOIN, HENRI ALPHONSE (20TH C) FRENCH	300-1800	X
BOROVIKOVSKY, VLADIMIR-LUKITSCH (1757-1825) RUSSIAN	500-7700	F
BORRANI, ODOARDO (1834-1905) ITALIAN	10000-+++	L,F
BORRAS Y ABELLA, VICENTE (19TH C) SPANISH	450-19500	X
BORRERO, R. (19TH C) SPANISH	150-700	X
BORSELEN, JAN WILLEM VAN (1825-1892) DUTCH	500-38000	G,L,W
BORTOLUZZI, CAMILLO (1868-1933) ITALIAN	350-18500	M
BOS, GERARD VAN DEN (1825-1898) DUTCH	350-7500	G
BOS, HENK (B. 1901) DUTCH	300-3800	S
BOS, PIETER VAN DEN (1613-1663) DUTCH	3000-31000	G,S
BOSBOOM, JOHANNES	*400-18000	
BOSBOOM, JOHANNES (1817-1891) DUTCH	1200-34000	F,G
BOSCH, EDOUARD VAN DEN (1828-1878) BELGIAN	600-5400	S
BOSCH, HENDRICK (17TH C) DUTCH	500-3500	X
BOSCHER, FERDINAND JEAN EDOUARD (B. 1888) FRENCH	100-700	X
BOSCHETTO, GIUSEPPE (1841-1918) ITALIAN	300-2400	G
BOSCHI, FABRIZIO (1570-1642) ITALIAN	650-10000	F
BOSELLI, FELICE (1650-1732) ITALIAN	1500-38000	G,D
BOSER, KARL FRIEDRICH ADOLF (1809-1881) GERMAN	800-12000	G,F
BOSHAMER, JAN HENDIRK (B. 1775) DUTCH	400-4800	X
BOSSCHAERT, AMBROSIUS (THE ELDER) (1573-1621) FLEMISH	8000-+++	S

BOSSCHAERT, AMBROSIUS (THE YOUNGER) (1609-1645) FLEMISH	5000-+++	S
BOSSCHAERT, JAN BAPTISTE (1667-1746) FLEMISH	2000-52000	S
BOSSCHE, BALTHASAR VAN DEN (1681-1715) FLEMISH	500-16000	X
BOSSHARD, RODOLPHE-THEOPHILE (1889-1959) SWISS	800-20000	L,F
BOSSI, DOMENICO (1765-1853) ITALIAN	*350-15000	X
BOSSOLI, CARLO (1815-1884) ITALIAN	*800-25000	L
BOSSUET, FRANCOIS ANTOINE (1800-1889) BELGIAN	800-18000	L
BOTERO, FERNANDO	*3000-210000	
BOTERO, FERNANDO (B. 1932) COLOMBIAN	10000-+++	A,L,F
BOTH, JAN DIRKZ (1618-1652) DUTCH	2000-120000	L,F,W
BOTT, FRANCIS (B. 1904) GERMAN	400-18000	X(S)
BOTT, R.T. (19TH C) BRITISH	2000-20000	G,F
BOTTANI, GIUSEPPE (1717-1784) ITALIAN	2000-24000	F
BOTTI, A. (20TH C) ITALIAN	100-850	X
BOTTI, ITALO (20TH C) ITALIAN	100-850	X
BOTTICELLI, SANDRO (1440-1510) ITALIAN	10000-+++	F
BOTTICINI, FRANCESCO (1446-1497) ITALIAN	4000-49000	F
BOTTINI, GEORGES	*400-5800	
BOTTINI, GEORGES (1874-1907) FRENCH	350-7000	G,F
BOTTON, JEAN ISY DE	*100-2500	
BOTTON, JEAN ISY DE (1898-1978) FRENCH	300-4200	G,F
BOTTONI, E. ITALIAN	100-900	X
BOUCART, GASTON H. (B. 1878) FRENCH	150-3600	M
BOUCHARD, LORNE HOLLAND (1913-1978) CANADIAN	600-3500	L,S
BOUCHARD, PIERRE LOUIS (1831-1889) FRENCH	200-8800	G,F
BOUCHARDON, EDME (1698-1762) FRENCH	*250-13000	G,F
BOUCHE, GEORGES (1874-1941) FRENCH	500-7400	S
BOUCHE, LOUIS ALEXANDRE (1838-1911) FRENCH	400-9000	M,L
BOUCHER, FRANCOIS	*1000-+++	
BOUCHER, FRANCOIS (1703-1770) FRENCH	3000-+++	F,G
BOUCHERVILLE, ADRIEN DE (D. 1912) FRENCH	700-12000	G
BOUCKHORST, JAN PHILIPSZ (1588-1631) DUTCH	*300-15000	F
BOUCQUET, VICTOR (1619-1677) FLEMISH	600-5800	F
BOUDEWYNS, ADRIAEN FRANS (1644-1711) FLEMISH	1000-20000	L,M
BOUDEWYNVE, A. (19TH C) DUTCH	250-1200	X
BOUDIN, EUGENE	*1500-+++	
BOUDIN, EUGENE (1824-1898) FRENCH	3500-+++	L,M,W
BOUET, PIERRE HENRI (1828-1889) FRENCH	100-900	X

* Denotes watercolors, pastels, drawings, and/or mixed media

BOUGH, SAMUEL	*300-12000	
BOUGH, SAMUEL (1822-1878) SCOTTISH	1200-36000	M,L
BOUGUEREAU, WILLIAM ADOLPHE	*800-15000	
BOUGUEREAU, WILLIAM ADOLPHE (1825-1905) FRENCH	10000-+++	F,G
BOUILLATS, B. (Early 18TH C) FRENCH	400-2400	X
BOULAN, E. (19TH C) FRENCH	100-700	X
BOULANGER, CLEMENT (1805-1842) FRENCH	250-14000	G
BOULANGER, FRANCOIS JEAN LOUIS (1819-1873) FRENCH	300-14000	L
BOULANGER, GUSTAVE CLARENCE RODOLPHE (1824-1888) FRENCH	500-33000	G,F
BOULANGER, LOUIS (1806-1867) FRENCH	*150-650	X
BOULANGER, S.L. (19TH C) FRENCH	400-4000	X(G)
BOULARD, AUGUSTE (1852-1927) FRENCH	400-5500	L,G
BOULARD, AUGUSTE (SR.) (1819-1873) FRENCH	350-2000	X
BOULAYE, PAUL DE LA (19TH C) FRENCH	150-1800	F
BOULENGER, HIPPOLYTE (1837-1874) BELGIAN	900-4000	L
BOULET, CYPRIEN EUGENE (1877-1927) FRENCH	350-3800	F
BOULIARD, MARIE GENEVIEVE (1772-1819) FRENCH	450-4500	X
BOULIER, LUCIEN (1890-1964) FRENCH	600-3400	F,S
BOULINEAU, ARISTIDE (19TH C) FRENCH	250-2400	X
BOULOGNE, LOUIS DE (1654-1733) FRENCH	*650-30000	G,F
BOULTBEE, JOHN (1753-1812) BRITISH	1500-28000	L,W
BOUMAN, ADRIANUS (19TH/20TH C) DUTCH	150-750	X
BOUMAN, JOHAN (1602-1635) DUTCH	2500-100000	S
BOUMEESTER, CHRISTINE (1904-1971) DUTCH	1000-11000	A
BOUNIEU, MICHEL HONORE (1740-1814) FRENCH	700-4500	S
BOUQUET, ANDRE (B. 1897) FRENCH	1000-15000	L
BOURDELLE, EMILE ANTOINE (1861-1929) FRENCH	*350-4900	F,G
BOURDON, SEBASTIEN (1616-1671) FRENCH	2500-242000	F,G
BOURGAIN, GUSTAVE (B. 1921) FRENCH	*150-4400	F
BOURGEOIS, EUGENE (1855-1909) FRENCH	300-4200	L,M
BOURGEOIS DU CASTELET, FLORENT FIDELE CONSTANT (1767-1836) FRENCH	*250-5000	L
BOURGES, PAULINE ELISE LEONIDE (1838-1910) FRENCH	250-7500	G,F
BOURGONNIER-CLAUDE, BERTHE (D. 1922) FRENCH	*150-1200	X
BOURLARD, ANTOINE JOSEPH (1826-1899) BELGIAN	500-12000	G,L
BOUT, PIETER (1658-1702) FLEMISH	1500-28000	X(L,W)
BOUTCHKINE, PIOTR (1886-1965) RUSSIAN	600-4000	X(F)
BOUTER, CORNELIS WOUTER (Called COR) (1888-1966) DUTCH	500-8500	G,L
BOUTET DE MONVEL, BERNARD (1884-1949) FRENCH	700-34000	G,F

BOUTH, G. (19TH C) FRENCH	300-1400	X
BOUTIBONNE, CHARLES-EDOUARD (1816-1897) HUNGARIAN	3000-42000	F
BOUTIGNY, PAUL EMILE (1854-1895) FRENCH	400-6600	G
BOUTT, PIERRE DE (19TH C) EUROPEAN	150-900	X
BOUVARD, ANTOINE (D. 1956) FRENCH	600-12500	M
BOUVARD, AUGUSTE (19TH C) FRENCH	350-5600	M
BOUVARD, HUGHES DE (1879-1959) AUSTRIAN	350-4500	M,W
BOUVARD, NOEL (1912-1975) FRENCH	150-3200	M
BOUVIER, ARMAND (B. 1913) FRENCH	100-1900	L
BOUVIER, ARTHUR (1837-1921) BELGIAN	150-1200	X
BOUVIER, AUGUSTUS JULES (1837-1881) FRENCH	*250-2500	G,L,F
BOUVY, FIRMIN GASTON (1822-1891) BELGIAN	300-1400	G
BOUY, GASTON (B. 1866) FRENCH	*100-3600	X(S)
BOUYS, ANDRE (1656-1740) FRENCH	400-4600	G,S
BOWEN, OWEN (1873-1967) BRITISH	650-19000	G,L
BOWERS, STEPHEN (Late 19TH C) BRITISH	*100-1200	L
BOWKETT, JANE MARIA (B. 1885) BRITISH	350-8000	G,L
BOWLER, THOMAS W. (D.1869) BRITISH	*900-7500	L
BOXALL, ARTHUR D'AUVERGNE (1895-1943) AUSTRALIAN	800-6000	M
BOYCE, WILLIAM THOMAS NICHOLAS (1858-1911) BRITISH	*400-2400	M
BOYD, THEODORE PENLEIGH (1890-1923) AUSTRALIAN	700-65000	L,M
BOYDELL, CRESWICK (19TH C) BRITISH	*400-4000	X(L,F)
BOYE, ABEL DOMINIQUE	*200-1000	
BOYE, ABEL DOMINIQUE (1864-1934) FRENCH	500-8700	G,F
BOYER, EMILE (B. 1877) FRENCH	150-2500	F
BOYLE, ELEANOR (1825-1916) BRITISH	*600-16000	F
BOYS, THOMAS SHOTTER (1803-1874) BRITISH	*900-65000	L,W
BOZNANSKA, OLGA (1865-1945) POLISH	400-4500	G
BOZZOLINI, SILVANO (B. 1911) ITALIAN	900-11000	A
BRAAKMAN, ANTHONIE (B. 1811) DUTCH	300-3800	X(F,W)
BRABAZON, HERCULES BRABAZON (1821-1906) BRITISH	*500-12000	G,F
BRACHO, ANGEL	100-700	
BRACHO, ANGEL (B. 1911) MEXICAN	250-2000	L
BRACHT, EUGEN (1842-1921) SWISS	500-32000	L
BRACK, EMIL	*150-2600	
BRACK, EMIL (1860-1905) GERMAN	1500-26000	G,F
BRACKLE, JAKOB (1897-1987) GERMAN	1000-21000	L
BRADLEY, BASIL (1842-1904) BRITISH	*500-6200	G,L,W
BRADLEY, HELEN	*300-11000	

BRADLEY, HELEN (20TH C) BRITISH	2000-42000	G,L,F
BRADLEY, MARTIN (20TH C) BRITISH	700-9000	A
BRAECKELEER, ADRIEN FERDINAND DE (1818-1904) BELGIAN	1200-23000	G
BRAEKELEER, FERDINAND DE (1792-1883) BELGIAN	2000-36000	G,F
BRAEKELEER, HENRI DE (1840-1888) BELGIAN	600-58000	G,F
BRAGARD, CHARLES DE (19TH/20TH C) FRENCH	150-1000	X
BRAGG, CHARLES WILLIAM (19TH C) BRITISH	150-800	X(G)
BRAITH, ANTON	*500-4500	
BRAITH, ANTON (1836-1905) GERMAN	3000-68000	L,W
BRAKENBURG, RICHARD (1650-1702) DUTCH	5000-75000	G,F
BRAMER, LEONAERT	*300-1800	
BRAMER, LEONAERT (1596-1674) DUTCH	400-33000	G,F
BRAMMER, R. (19TH C) DUTCH	150-900	L
BRANCACCIO, CARLO (1861-1920) ITALIAN	1200-110000	M,S
BRANCUSI, CONSTANTIN (1876-1957) RUMANIAN	*2500-+++	A
BRAND, JOHANN CHRISTIAN (1722-1795) AUSTRIAN	1500-12000	L
BRANDEIS, ANTONIETTA	*250-1000	
BRANDEIS, ANTONIETTA (1849-1920) AUSTRIAN	500-18000	L,F
BRANDEIS, JOHANN (19TH/20TH C) FRENCH	400-2800	F
BRANDES, WILLY	*150-750	
BRANDES, WILLY (B. 1876) GERMAN	300-2800	G,W
BRANDI, DOMENICO (1683-1736) ITALIAN	400-14000	L,W
BRANDI, GIACINTO (1623-1691) ITALIAN	500-19000	F
BRANDIS, AUGUST VON (1862-1947) GERMAN	400-3500	F
BRANDS, EUGENE	*350-12000	
BRANDS, EUGENE (B. 1913) DUTCH	1200-75000	F,L
BRANDT, CARL (D. 1930) SWEDISH	400-16000	L
BRANDT, JOSEF VON	*200-4300	
BRANDT, JOSEF VON (1841-1928) POLISH	2000-48000	G,F
BRANDT, OTTO (1828-1892) GERMAN	500-4500	G,F
BRANGWYN, SIR FRANK	*650-11000	
BRANGWYN, SIR FRANK (1867-1956) BRITISH	1200-143000	A,G,F,L
BRANSCOMBE, CHARLES H. (1817-1880) BRITISH	200-8900	G,L
BRANWHITE, CHARLES (1851-1929) BRITISH	250-5800	L
BRAQUAVAL, LOUIS (1856-1919) FRENCH	400-5000	X(G)
BRAQUE, GEORGES	*5000-+++	
BRAQUE, GEORGES (1882-1963) FRENCH	10000-+++	A
BRASCASSAT, JACQUES RAYMOND (1804-1867) FRENCH	800-18000	L,W
BRASCH, MORTEN (17TH C) DANISH	*350-14000	X(F)

BRASCH, WENZEL IGNAZ (D. 1761) GERMAN	500-8200	X
BRASEN, HANS (1849-1930) DANISH	600-11000	G,F
BRASILIER, ANDRE	*400-3500	
BRASILIER, ANDRE (B. 1929) FRENCH	1200-210000	L,S
BRASSAUW, MELCHIOR (1709-1757) FLEMISH	600-7500	G,W,F
BRATBY, JOHN (B. 1928) BRITISH	350-4500	A
BRATE, FANNY (1861-1940) SWEDISH	1000-15000	L,M,S
BRATLAND, JACOB (1859-1906) NORWEGIAN	1000-15000	F
BRAUER, ERICH	*300-5200	
BRAUER, ERICH (B. 1929) AUSTRIAN	900-14000	A
BRAUN, LOUIS (1836-1916) GERMAN	300-2500	X
BRAUNER, VICTOR	*1000-227000	
BRAUNER, VICTOR (1903-1966) RUMANIAN	5000-+++	A
BRAVO, CLAUDIO	*1200-60000	
BRAVO, CLAUDIO (B. 1936) CHILEAN	3000-+++	X(F)
BRAVURA, DENYSE (20TH C) FRENCH	*300-2400	F
BRAY, JAN DE	*300-3200	
BRAY, JAN DE (1626-1697) DUTCH	2000-35000	G,F
BRAYER, YVES	*400-20000	
BRAYER, YVES (B. 1907) FRENCH	2000-46000	G,L,F
BREACH, JOHN L. (19TH C) BRITISH	150-700	X
BREAKSPEARE, WILLIAM A. (1855-1914) BRITISH	900-12000	G,F
BREANSKI, ALFRED DE (19TH C.) BRITISH	600-48000	L
BREANSKI, ALFRED DE (SR.) (1852-1928) BRITISH	500-34500	L
BREANSKI, ALFRED FONTEVILLE DE (JR.) (1877-1945) BRITISH	900-12000	L,W
BREANSKI, GUSTAVE DE (1856-1898) BRITISH	350-4600	M,L,G
BREANSKI, WILLIAM (19TH/20TH C) BRITISH	250-2400	X(L)
BREDA, CARL FREDRIK VON (1759-1818) SWEDISH	7000-125000	F
BREDAEL, JAN FRANS VAN (1686-1750) FLEMISH	1200-116000	G,L
BREDAEL, JOSEF VAN (1688-1739) FLEMISH	3500-146000	G,L
BREDAEL, PEETER VAN (1629-1719)DUTCH	600-51000	G,L
BREDT, FERDINAND MAX (1860-1921) GERMAN	700-14000	L
BREITBACH, CARL (1833-1904) GERMAN	400-3200	G,L
BREITENBACH, FRANZ SCHMID (19TH/20TH C) GERMAN	400-3800	G
BREITENSTEIN, CARL AUGUST (1864-1979) DUTCH	300-1000	M
BREITNER, GEORG HENDRIK	*900-37000	
BREITNER, GEORG HENDRIK (1857-1923) DUTCH	2000-85000	G,F
BREKELENKAM, QUIRYN GERRITSZ VAN (1620-1668)	1800-150000	G,F
BRELING, HEINRICH (1849-1900) GERMAN	1500-12000	G,L

BREMAN, CO (1865-1938) DUTCH	1000-30000	L
BREMEN, JOHANM GEORGE MEYER VON (1813-1886)	1500-44000	G,F
BREMEN, MEYER VON (1813-1886) GERMAN	1000-45000	F
BREMOND, HENRI (B. 1875) FRENCH	450-4000	F,W
BRENAN, JAMES BUTLER (1825-1889) BRITISH	150-5000	X(F)
BRENAN, JOHN J. (19TH C) BRITISH	150-800	X
BRENDEKILDE, HANS ANDERSEN (1857-1920) DANISH	600-160000	G,L,F
BRENDEL, ALBERT (1827-1895) GERMAN	350-9500	L,F
BRENNER, ADAM (1800-1891) AUSTRIAN	300-2000	X
BRENNIR, CARL (1850-1920) BRITISH	300-2800	L
BRENTANO, FRANS (ANTON) (1840-1888) GERMAN	300-1000	X
BRESCIANINO, ANDREA DEL (Active 1506-1545) ITALIAN	1000-36000	F
BRESLAU, MARIE LOUISE CATHERINE (1856-1928) SWISS	500-7500	X
BRESSLER, EMILE (1886-1966) SWISS	600-10000	A
BREST, GERMAIN-FABIUS	*300-2800	
BREST, GERMAIN-FABIUS (1823-1900) FRENCH	900-24000	M,S
BRETLAND, THOMAS W. (1802-1874) BRITISH	1200-15000	X(W,L)
BRETON, EMILE ADELARD (1831-1902) FRENCH	250-4000	L
BRETON, JULES	*300-8900	
BRETON, JULES (1827-1906) FRENCH	8500-+++	G,L
BRETON, VIRGINIE DEMONT (1859-1935) FRENCH	400-5000	X(F)
BRETT, JOHN (1830-1902) BRITISH	500-21000	L,M
BREU, M. (19TH C) GERMAN	300-1500	W
BREUKELAAR, HENRICK (1809-1839) DUTCH	400-10000	G
BREUL, FRANZ DE (19TH C) BELGIAN	250-1500	X
BREUNINGER, HELMUT (B. 1921) GERMAN	100-800	X
BREWTNALL, EDWARD FREDERICK (1846-1902) BRITISH	*150-1000	G,F
BREYDAEL, KAREL (1678-1733) FLEMISH	1800-28000	G,F
BREYER, ROBERT (1866-1941) GERMAN	1000-18000	L,F,S
BRIANCHON, MAURICE	*500-8000	
BRIANCHON, MAURICE (B. 1899) FRENCH	3000-168000	A
BRIANTE, EZELINO (1901-1970) ITALIAN	250-4500	G,M,L
BRICARD, C. (19TH/20TH C) FRENCH	150-1000	X
BRICHARD, GABRIELLE JEANNE (Early 20TH C) FRENCH	350-2800	G
BRICKDALE, ELEANOR FORTESCUE (1871-1945) BRITISH	*400-22000	A
BRIDELL, FREDERICK LEE (1831-1863) BRITISH	450-5200	L
BRIDGES, JOHN (19TH C) BRITISH	400-3200	G,L
BRIERLY, SIR OSWALD WALTER (1817-1894) BRITISH	*400-9400	M
BRIET, ARTHUR (B. 1867) DUTCH	400-3200	X(F)

BRIGDEN, FREDERICK H. (1871-1956) CANADIAN	*100-2100	G
BRIGGS, WILLIAM KEIGHLEY (19TH C) BRITISH	300-1800	F
BRIGHT, ALFRED (20TH C) BRITISH	*350-3800	W,G
BRIGHT, HARRY (Late 19TH C) BRITISH	*200-3600	W,L,A
BRIGHT, HENRY	*300-5000	
BRIGHT, HENRY (1814-1873) BRITISH	800-15000	L,M
BRIGLIA, GIOVANNI FRANCESCO (1737-1794) ITALIAN	600-27000	G,S
BRIGNONI, SERGIO (B. 1903) SWISS	1000-30000	A
BRIL, PAUL (1554-1626) FLEMISH	3000-88000	L,F,W
BRILLOUIN, LOUIS GEORGES	*300-2500	
BRILLOUIN, LOUIS GEORGES (1817-1893) FRENCH	700-7500	G,L
BRIMANT, JULES RUINART DE (1838-1898) FRENCH	400-3500	G
BRIMMER, H. (19TH C) EUROPEAN	250-1000	G
BRINCKMANN, PHILIPP HIERONYMOUS (1709-1761) GERMAN	600-14000	L,F
BRINDISI, REMO (B. 1918) ITALIAN	1000-15000	A
BRIOSCHI, ANTON (1854-1912) ITALIAN	250-7700	X
BRISARD, FERDINAND (B. 1870) FRENCH	200-900	X
BRISCOE, ARTHUR JOHN TREVOR (B. 1873) BRITISH	400-9500	M
BRISPOT, HENRI (1846-1928) FRENCH	500-6500	G,F,W
BRISSAUD, PIERRE (B. 1885) FRENCH	*100-1700	I
BRISSET, EMILE (19TH C) FRENCH	350-2400	G
BRISSON, MAURICE (20TH C) FRENCH	100-800	X
BRISSOT DE WARVILLE, FELIX SATURNIN	*250-800	
BRISSOT DE WARVILLE, FELIX SATURNIN (1818-1892) FRENCH	350-9500	F,G,W
BRISTOW, EDMUND (1787-1876) BRITISH	1200-29000	G,W,L
BRIT, E. LA (19TH C) FRENCH	100-700	X
BRITTAN, CHARLES EDWARD (B. 1870) BRITISH	*300-2500	L,W
BRIULOV, KARL PAVLOVICH (1799-1852) RUSSIAN	*1500-26000	G
BRIZZI, ARY (B. 1930) ARGENTINIAN	200-1800	G
BROCHOCKI, WALERY (1849-1923) POLISH	250-1400	X
BROCK, CHARLES EDMOND (1870-1938) BRITISH	250-6300	F,G,I
BROCK, ERNEST (19TH C) BRITISH	300-2000	X
BROCK, HENRY MATTHEW (B. 1875) BRITISH	*400-6000	G,F
BROCKBANK, ALBERT ERNEST (1862-1958) BRITISH	*800-9200	L,F
BROCKHURST, GERALD L.	*250-15000	
BROCKHURST, GERALD L. (B. 1890) BRITISH	400-8500	F
BROCZIK, WENCELAS (1851-1901) HUNGARIAN	450-15000	X
BRODSKY, ISAAC (1883-1939) RUSSIAN	300-16000	F,W
BRODZKY, HORACE (1885-1969) AUSTRALIAN	800-7500	F

BROECK, CLEMENCE VAN DEN (1843-1922) BELGIAN	300-2800	G
BROECK, ELIAS VAN DEN (1650-1709) DUTCH	1500-111000	S
BROECKER, A. (19TH C) GERMAN	100-900	X
BROERS, GASPOR (1682-1716) EUROPEAN	*200-2200	X(F)
BROGE, ALFRED (B. 1870) DANISH	800-18000	G,F,L
BROISAT, A. (19TH C) BELGIAN	100-600	X
BROMLEY, HENRY THOMAS (19TH/20TH C) BRITISH	100-750	X(G,W)
BROMLEY, VALENTINE WALTER (1848-1877) BRITISH	900-8500	G,F
BROMLEY, WILLIAM (Active 1835-1888) BRITISH	900-21000	F,G
BRONNIKOV, FEODOR ANDREIEVICH (1827-1902) RUSSIAN	300-16000	X(F)
BRONTE, CHARLOTTE (1816-1855) BRITISH	150-800	X
BROOK, MARIA BURNHAM (Late 19TH C) BRITISH	300-3100	G,S
BROOKER, HARRY (Late 19TH C) BRITISH	800-20000	G
BROOKING, CHARLES (1723-1759) BRITISH	900-14000	M
BROOKS, MARIA (Active 1869-1890) BRITISH	1200-110000	G,S
BROOKS, THOMAS (1818-1892) BRITISH	400-65000	G,F,L
BROOME, WILLIAM (19TH C) BRITISH	700-6000	M
BROOS, JEAN JACQUES ZUIDEMA (Late 19TH C) BELGIAN	400-5200	G
BROTAT, JOAN VILANOVA (B. 1920) SPANISH	100-1400	X
BROUGIER, ADOLF (1870-1926) GERMAN/BRITISH	250-1800	F,L
BROUILLARD, EUGENE (B. 1870) FRENCH	100-700	L
BROUILLET, PIERRE ANDRE ARISTIDE (1857-1914) FRENCH	400-24000	G,F
BROUWER, ADRIAEN (1606-1638) FLEMISH	2000-55000	G
BROUWER, BAREND (1872-1936) DUTCH	150-1200	L,W
BROUX, S. (19TH C) FRENCH	100-600	X
BROWN, ALEXANDER KELLOCK (1849-1922) BRITISH	300-4500	L
BROWN, ARTHUR WILLIAM (1881-1966) CANADIAN/AMER.	*150-2000	I,G
BROWN, CECIL (19TH/20TH C) BRITISH	500-3500	X(L)
BROWN, FORD MADOX	*500-38000	
BROWN, FORD MADOX (1821-1893) BRITISH	1000-164000	G,F
BROWN, GEORGE HENRY ALAN (B. 1862) BRITISH	*150-2700	G,S
BROWN, HARLEY	*150-800	
BROWN, HARLEY (B. 1939) CANADIAN	400-8000	F
BROWN, HUGH BOYCOTT (B. 1909) BRITISH	500-3500	M
BROWN, JOHN ARNESBY (B. 1866) BRITISH	1000-70000	L
BROWN, JOHN LEWIS	*400-3300	
BROWN, JOHN LEWIS (1829-1890) FRENCH	800-25000	G,F
BROWN, ROBERT WOODLEY (19TH C) BRITISH	150-1500	L
BROWN, THOMAS AUSTEN (1859-1924) SCOTTISH	450-11000	G,L

BROWN, W. WARREN (B. 1881) CANADIAN	100-1500	F
BROWN, WILLIAM BEATTIE (1831-1909) BRITISH	400-7500	L
BROWN, WILLIAM MARSHALL (1863-1936) BRITISH	600-27000	M,G
BROWNE, ALFRED J. WARNE	*100-500	
BROWNE, ALFRED J. WARNE (D. 1915) BRITISH	100-900	M,L
BROWNE, HARBLOT KNIGHT (1815-1892) BRITISH	250-2500	X(I)
BROWNE, HENRIETTE (1829-1901) FRENCH	500-14000	G
BROWNE, ROBERT (19TH C) BRITISH	100-1000	G
BROWNELL, PELEG FRANKLIN (1857-1946) CANADIAN	400-4000	L
BROWNLOW, GEORGE WASHINGTON (19TH C) BRITISH	900-14000	L
BROZIK, WENCESLAS VON VACSLAW	*100-800	
BROZIK, WENCESLAS VON VACSLAW (1851-1901) BOHEMIAN	1200-40000	G,W
BRUBIER, W. (19TH C) BRITISH	350-3800	X
BRUCE, WILLIAM BLAIR (1857-1906) CANADIAN	450-11000	L,G
BRUCK-LAJOS, L. (1846-1910) HUNGARIAN	400-5000	F,G
BRUCKE, WIHELM (19TH C) GERMAN	600-7800	M,F
BRUCKER, ERNST (1893-1963) GERMAN	100-2000	G,L,M
BRUCKMANN, LODEWIJK (B. 1903) DUTCH/AMERICAN	200-2500	S
BRUCKNER, K. (20TH C) GERMAN	100-700	X
BRUCKNER, THEODOR (1870-1921) AUSTRIAN	100-1200	X(F)
BRUEGHEL, AMBROSIUS (1617-1675) FLEMISH	2500-+++	S
BRUEGHEL, JAN (THE ELDER) (1568-1625) FLEMISH	10000-+++	G,L,F
BRUEGHEL, JAN (THE YOUNGER) (1601-1678) FLEMISH	1500-165000	G,F
BRUGAIROLLES, VICTOR (1867-1936) FRENCH	300-2800	L
BRUGES, PAULINE ALICE LEONIDE (1833-1910) FRENCH	100-850	X
BRUGNER, COLESTIN (19TH C) GERMAN	400-3200	L,M
BRUGNOLI, EMMANUELE (19TH C) ITALIAN	*300-2200	M
BRUHLMANN, HANS ERNST (19TH/20TH C) SWISS	4000-30000	X (S)
BRUJANDET, LAZARE (1755-1804) FRENCH	1500-18000	L,F
BRULLOFF, ALEXANDRE (1798-1877) RUSSIAN	*400-3000	F
BRUN, EDME GUSTAVE FREDERIC (1817-1881) FRENCH	350-3600	F,G
BRUN, RENEE EUGENIE CAMILLE (20TH C) FRENCH	500-6500	F
BRUNAIS, AUGUSTIN (18TH C) BRITISH	5000-95000	G,F
BRUNEL DE NEUVILLE, ALFRED ARTHUR (19TH C) FRENCH	400-11000	F,S,W
BRUNELLESCHI, UMBERTO (20TH C) ITALIAN	*300-1600	G,I
BRUNERY, FRANCOIS (B. 1845) ITALIAN	1500-46000	G,F
BRUNERY, MARCEL (20TH C) FRENCH	800-27000	G,F
BRUNET-DESBAINES, ALFRED LOUIS (B. 1845) FRENCH	400-1600	L,W
BRUNIAS, AUGUSTIN (1735-1810) BRITISH	400-2800	X

BRUNIN, LEON DE MEUTER (1861-1949) BELGIAN	800-14000	G,S
BRUNKAL, ERICH (B. 1859) GERMAN	300-1500	G
BRUNNER, FERDINAND (1870-1945) AUSTRIAN	800-24000	L
BRUNNER, HANS (1813-1888) GERMAM	600-9900	G,L
BRUNNER, JOSEF (1826-1893) GERMAN	250-4600	L,W
BRUNNER, LEOPOLD (1788-1849) AUSTRIAN	500-6500	S,L
BRUS, GUNTER (B. 1938) AUSTRIAN	*900-9500	A
BRUSSEL, PAUL THEODOR VAN (1754-1795) DUTCH	4000-150000	S
BRUSSELMANS, JEAN	*400-2500	
BRUSSELMANS, JEAN (1884-1953) BELGIAN	600-191000	L,F,S
BRUYCKER, FRANCOIS ANTOINE DE (1816-1882) BELGIAN	2000-35000	G,S
BRUYCKER, FRANCOIS ANTOINE DE (1816-1882) BELGIAN	600-6000	F,G
BRUYERE, ELISE (1776-1842) FRENCH	450-30000	S
BRUYN, CHRIS DE (20TH C) DUTCH	150-800	X
BRUYN, CORNELIS JOHANNES DE (19TH C) DUTCH	800-6000	S
BRUYN, JAN DE (Late 18TH C) DUTCH	500-7800	F
BRUZZI, STEFANO (1835-1911) ITALIAN	2000-70000	G,L,F
BRYANS, ALICE MAUDE (19TH C) BRITISH	200-1500	W
BRYANT, ANN (20TH C) BRITISH	100-600	X
BRYANT, CHARLES (1883-1937) AUSTRALIAN	600-15000	M,L
BRYEN, CAMILLE	*1000-15000	
BRYEN, CAMILLE (B. 1907) FRENCH	3000-125000	A
BRYMNER, WILLIAM (1855-1925) CANADIAN	1000-48000	L
BRZOZOWSKI, TADEUSZ (B. 1918) POLISH	100-700	X
BUCCI, LORENZO (18TH/19TH C) ITALIAN	100-800	F
BUCCIARELLI, DANIELE (19TH C) ITALIAN	*100-2000	G,L
BUCHANAN, GEORGES F. (Active 1848-1864) SCOTTISH	300-3300	L
BUCHANAN, PETER (19TH C) BRITISH	100-6200	L,W
BUCHBINDER, SIMON (1853-1900) POLISH	250-7200	F
BUCHE, JOSEF (1848-1917) AUSTRIAN	150-3800	G,F,S
BUCHET, GUSTAVE (1888-1963) SWISS	*700-28000	X
BUCHHEISTER, CARL (KARL) (1890-1964) GERMAN	*100-27000	A
BUCHNER, GEORG (1858-1914) GERMAN	250-8000	G,F
BUCHNER, RUDOLF JOSEF JOHAN (1894-1962) AUSTRIAN	150-1500	S
BUCHSER, FRANK (1828-1890) SWISS	4000-95000	F,L,M
BUCK, ADAM (1759-1883) IRISH	250-1500	G,F,M
BUCKLER, JOHN CHESSEL	*100-8800	
BUCKLER, JOHN CHESSEL (1770-1851) BRITISH	200-2500	L
BUCKLER, WILLIAM (1814-1884) BRITISH	200-3500	G,F

BUCKLEY, CHARLES F. (19TH C) BRITISH	*200-6000	G,L
BUCKLEY, STEPHEN (B. 1944) BRITISH	300-15000	L
BUCKMASTER, ERNEST (1897-1968) AUSTRALIAN	600-13000	L,F,S
BUCKNALL, ERNEST PILE (B. 1861) BRITISH	150-1500	L,W
BUCKNER, RICHARD (19TH C) BRITISH	600-45000	G,F
BUDELOT, PHILIPPE (Early 19TH C) FRENCH	400-10000	F,L
BUDGEN, FRANK SPENCER CURTIS (20TH C) BRITISH	150-800	X
BUECKELAER, JOACHIM (1530-1573) FLEMISH	1800-34000	G,F
BUEHR, KARL ALBERT (1866-1952) GERMAN/AMERICAN	1500-22000	G,F,L
BUEL, FRANZ DE (19TH C) BELGIAN	250-2400	X(G)
BUEL, HENRI DE (19TH C) BELGIAN	250-2400	X(W)
BUEL, L. DE (19TH C) BELGIAN	250-2000	X(L)
BUENO, ANTONIO (1918-1984) ITALIAN	900-47800	A
BUENO, XAVIER S. (1915-1979) ITALIAN	500-8900	L,G,S
BUFFET, BERNARD	*900-229000	
BUFFET, BERNARD (B. 1928) FRENCH	5000-+++	A
BUFFET, L'ABBE PAUL	*100-450	
BUFFET, L'ABBE PAUL (B. 1864) FRENCH	150-1700	L
BUFFIN, CARLOS (19TH C) FRENCH	500-40000	X(F)
BUGATTI, CARLO (B. 1855) ITALIAN	*250-2700	X(G)
BUGATTI, REMBRANDT (1885-1916)	*250-5400	F,W
BUGGION, M. (20TH C) FRENCH	100-600	X
BUHLER, ROBERT (1916-1989) BRITISH	800-9500	L,F
BUHLMAN, R. (19TH C) SWISS	100-800	L
BUHLMANN, JOHANN RUDOLF (1802-1890) SWISS	450-33000	L,W
BUHLMAYER, CONRAD (1835-1883) AUSTRIAN	400-14000	G,L,W
BUHOT, FELIX HILAIRE (1847-1898) FRENCH	*350-14000	G,L
BUKLAND, ELSA (19TH C) EUROPEAN	150-900	G
BUKOVAC, VLACHO (1855-1923) YUGOSLAVIAN	500-7200	F
BULFIELD, J. (19TH C) BRITISH	250-2400	F
BULLEID, GEORGE LAWRENCE (B.1858) BRITISH	*500-3500	F
BULLERKOLLER, L. (19TH C) BELGIAN	200-2400	X
BULMAN, ORVILLE (20TH C) LATIN AMERICAN	150-750	X
BUNCE, KATE E. (1858-1927) BRITISH	1000-23000	G
BUNDEL, WILLEM VAN DEN (1577-1655) DUTCH	1500-55000	L
BUNDY, EDGAR (1862-1922) BRITISH	400-10000	G,F
BUNING, B. (19TH C) DUTCH	150-800	X
BUNNEY, JOHN WHARLTON (1828-1882) BRITISH	*100-3500	L
BUNNY, RUPERT (19TH/20TH C) BRITISH	1000-190000	F,M,L

* Denotes watercolors, pastels, drawings, and/or mixed media

BUNTZEN, HEINRICH (1802-1892) DANISH	300-2400	L
BUONACCORSI, PIETRO (Called PIERINO DEL VAGA) (1500-1547) ITALIAN	*1500-+++	F,W
BUONGIORNO, DONATUS (B. 1865) ITALIAN	100-1200	G,F
BUONTALENTI, BERNARDO (Called DALLE GIRANDOLE) (1536-1608) ITALIAN	*650-3500	S,F
BURBURE, LOUIS DE (B. 1837) BELGIAN	350-5000	X
BURCHARTZ, A. (19TH C) GERMAN	100-650	X
BURFIELD, JAMES M. (Late 19TH C) BRITISH	350-3500	G,F
BURFORD, THOMAS (1710-1774) BRITISH	1000-22000	X
BURGADE, LOUIS (B. 1803) FRENCH	450-7800	M
BURGE, MAUDE	*900-11000	
BURGE, MAUDE (20TH C) NEW ZEALANDER	1000-20000	L,F,S
BURGER, ANTON	*300-4000	
BURGER, ANTON (1824-1905) GERMAN	1200-87000	G,F,L
BURGER, JOSEF (B. 1887) GERMAN	900-11000	S,L
BURGER, LEOPOLD (1861-1903) AUSTRIAN	*250-2000	F
BURGERS, HENDRICUS JACOBUS (1834-1899) DUTCH	400-17000	G,F
BURGESS, ARTHUR J. W. (B. 1879) AUSTRALIAN	300-12000	M
BURGESS, HENRY WILLIAM (Active 1809-1844) BRITISH	*300-2700	X
BURGESS, JOHN BAGNOLD (1830-1897) BRITISH	650-42000	G,F
BURKEL, HEINRICH	*600-7000	
BURKEL, HEINRICH (1802-1869) GERMAN	1200-160000	G,L,W
BURKHARDT, K. (19TH C) SWISS	100-700	X
BURLE-MARX, ROBERTO (B. 1909) BRAZILIAN	*150-800	X
BURLER, DE (19TH C) AUSTRIAN	200-1200	X
BURMANN, FRITZ (1892-1945) GERMAN	500-12000	W,F
BURMEISTER, PAUL (B. 1847) GERMAN	500-9000	X(G)
BURMUDEZ, CUNDO (B. 1914) CUBA	350-3800	A
BURN, E. (19TH C) BRITISH	100-800	X
BURNE-JONES, SIR EDWARD COLEY	*2500-+++	
BURNE-JONES, SIR EDWARD COLEY (1833-1898) BRITISH	3000-+++	G,F
BURNE-JONES, SIR PHILIP (1861-1926) BRITISH	200-4200	F,L
BURNET, JOHN (1784-1868) SCOTTISH	150-900	G,W,L
BURNEY, EDWARD FRANCIS	*400-24000	
BURNEY, EDWARD FRANCIS (1760-1848) BRITISH	600-8000	X
BURNIER, RICHARD (1826-1884) DUTCH	400-5200	G,F,W
BURNITZ, KARL-PETER (1824-1886) GERMAN	600-7000	L
BURNS, MILTON J. (19TH/20TH C) BRITISH	*150-850	G,M
BURNS, ROBERT (1869-1941) BRITISH	400-5500	G,L,F

BURON, HENRI LUCIEN JOSEPH (1880-1969) FRENCH	150-2600	L
BURR, ALEXANDER HOHENLOHE (1835-1899) SCOTTISH	900-18000	G,F
BURR, JOHN P. (1831-1893) SCOTTISH/BRITISH	600-8000	G
BURRA, EDWARD (1905-1976) BRITISH	*1000-56000	A
BURRAS, THOMAS OF LEEDS (19TH C) BRITISH	500-12000	G,W
BURRELL, JAMES (19TH C) BRITISH	400-6000	G,L,M
BURRI, ALBERTA (1915) ITALIAN	*6000-95000	A
BURRI, ALBERTO (B. 1915) ITALIAN	*4500-+++	A
BURROUGHS, LEICESTER (19TH C) BRITISH	150-2600	G,F,L
BURROWS, ROBERT (1851-1855) BRITISH	400-7700	X(G,F)
BURSSENS, JAN (20TH C) BELGIAN	1000-7000	A
BURT, CHARLES THOMAS (1823-1902) BRITISH	350-4800	F
BURTHE, LEOPOLD (19TH C) FRENCH	350-4200	G,F
BURTON, MARY R. HILL (19TH C) BRITISH	*400-3500	F,G,L
BURTON, WILLIAM SHAKESPEARE (1830-1916) BRITISH	450-24000	L,F
BUSCH, HENDRIK (19TH C) DUTCH	500-5000	X(M)
BUSCH, PETER (19TH C) DANISH	100-800	L
BUSCH, WILHELM (1832-1908) GERMAN	2000-65000	G,F,L
BUSCOLANO, VINCENZO (B. 1851) ITALIAN	300-2500	G
BUSH, JACK	*1100-48000	
BUSH, JACK H. (1909-1977) CANADIAN	2000-60000	A,I
BUSIRI, GIOVANNI BATTISTA (1698-1757) ITALIAN	*700-3500	L
BUSON, D. (19TH C) EUROPEAN	150-1200	X(G)
BUSON, PETER NIKOLAUS (18TH/19TH C) GERMAN	300-2000	S
BUSQUETS, JEAN (1895-1962) FRENCH	150-1200	L
BUSSEY, REUBEN (1818-1893) BRITISH	300-1800	M,L
BUSSIERE, GASTON (1862-1929) FRENCH	400-19000	G
BUSSON, CHARLES (1822-1908) FRENCH	350-5500	L,F
BUSSON, GEORGES (1859-1933) FRENCH	*200-4500	X(L,G)
BUSTOS, HERMENEGILDO (1832-1907) SOUTH AMERICAN	300-3500	F
BUTHAUD, RENE (B. 1886) FRENCH	*400-6500	G,F
BUTLER, CHARLES ERNEST (B. 1864) BRITISH	400-5000	F,L
BUTLER, ELIZABETH (1846-1933) BRITISH	800-15000	F,G
BUTLER, GEORGE E. (B. 1872) BRITISH	400-15000	G,F
BUTLER, JOSEF (1822-1885) SWISS	400-17000	X(G)
BUTLER, MILDRED ANNE (B.1858) BRITISH	*700-40000	G,F,L
BUTLER, THOMAS (Active 1750-1759) BRITISH	*6000-143000	W
BUTTERSACH, BERNHARD (1858-1909) GERMAN	500-5000	L
BUTTERSWORTH, THOMAS	*400-7500	

* Denotes watercolors, pastels, drawings, and/or mixed media

BUTTERSWORTH, THOMAS (1798-1827) BRITISH	1000-52000	M
BUTTLER, H. (19TH C) BRITISH	150-1200	X
BUTTNER, HANS (19TH C) GERMAN	1000-18000	G,F
BUTTNER, HELENA (B. 1861) HUNGARIAN	400-4000	X
BUVELOT, ABRAM LOUIS (1814-1888) SWISS/AUSTRALIAN	1000-75000	L
BUXTON, ROBERT HUGH (B. 1871) BRITISH	150-2200	W
BUYKO, BOLESLAS (19TH C) POLISH	250-2400	X
BYLANDT, ALFRED EDOUARD VAN (1829-1890) DUTCH	550-11000	L,M,F
BYLERT, JAN VAN (1603-1671) DUTCH	900-110000	G,F,W
BYLES, WILLIAM HOUNSON (B. 1872) BRITISH	300-3000	G,L
BYNG, ROBERT (D. 1850) BRITISH	800-27000	W,F
BYRNE, SAMUEL (B. 1883) AUSTRALIAN	400-6400	L,G
BYRON, BOURMOND (B. 1923) HAITIAN	300-2400	G
BYSS, JOHANN RUDOLPH (1660-1738) SWISS	600-57000	F,S

C

ARTIST	PRICES	SUBJECT
CABAILLOT, CAMILLE LEOPOLD (Called LASALLE) (B. 1839) FRENCH	300-26000	G,F
CABAILLOT, LOUIS-SIMON (Called LASSALLE) (B. 1810) FRENCH	400-15000	G,F
CABALLERO, LUIS	*350-12000	
CABALLERO, LUIS (B. 1943) SPANISH	300-9100	G,F
CABALLERO, MAXIMO (1867-1951) SPANISH	1500-32000	G,F
CABANE, EDOUARD (B. 1857) FRENCH	900-15000	G,F
CABANEL, ALEXANDRE	*400-5000	
CABANEL, ALEXANDRE (1823-1889) FRENCH	5000-78000	F
CABAT, NICHOLAS LOUIS (1812-1893) FRENCH	300-4200	L,W
CABEL, ADRIAN VAN DER (1631-1705) DUTCH	900-20000	G,M
CABIANCA, VINCENZO (1827-1902) ITALIAN	*500-6300	G,F
CABIE, LOUIS ALEXANDRE (1853-1939) FRENCH	600-6500	L
CABLE, LOUIS ALEXANDRE (1853-1939) FRENCH	500-6000	L
CABRERA, MIGUEL (1695-1768) MEXICAN	1500-48000	F
CACCIA, GUGLIELMO (Called IL MONCALVO)	*900-12000	
CACCIA, GUGLIELMO (Called IL MONCALVO) (1568-1625) ITALIAN	1500-78000	F
CACCIARELLI, VICTOR (19TH C) ITALIAN	600-12000	G
CACHET, CAREL LION (1864-1945) DUTCH	200-1200	X
CACHOUD, FRANCOIS CHARLES	*100-800	

CACHOUD, FRANCOIS CHARLES (1866-1943) FRENCH	350-13200	L
CADEL, EUGENE (19TH/20TH C) FRENCH	150-6200	G
CADELL, FLORENCE ST JOHN (20TH C) BRITISH	500-6500	F,L
CADELL, FRANCIS CAMPBELL BOILEAU (B. 1883) BRITISH	2000-+++	L,S,F
CADENASSO, GIUSEPPE	*100-450	
CADENASSO, GIUSEPPE (1854-1918) ITALIAN/AMERICAN	150-2500	L
CADES, GIUSEPPE (1750-1799) ITALIAN	600-12000	F
CADORET, MICHEL (20TH C) FRENCH	400-17000	X
CAFE, THOMAS WATT (1856-1925) BRITISH	350-3800	G,F
CAFFE, NINO (B. 1909) ITALIAN	500-11000	G,F
CAFFI, IPPOLITO (1809-1866) ITALIAN	1200-24000	L
CAFFI, MARGHERITA (Active 1660-1700) ITALIAN	1500-48000	S
CAFFIERI, HECTOR	*400-20000	
CAFFIERI, HECTOR (1847-1932) BRITISH	700-35000	M,G,L
CAFFYN, WALTER WALLOR (B. 1898) BRITISH	400-9500	L
CAGLI, CORRADO (1910-1976) ITALIAN	500-25000	G,F
CAGLI, CORRADO (B. 1910) ITALIAN	*400-4000	X
CAGNIART, EMILE (1851-1911) FRENCH	300-4500	L
CAHOURS, HENRY MAURICE (B. 1889) FRENCH	300-2200	L
CAILLARD, CHRISTIAN (B. 1899) FRENCH	600-9000	X (F,S)
CAILLE, LEON EMILE	*100-800	
CAILLE, LEON EMILE (1836-1907) FRENCH	400-13000	G,F
CAILLEBOTTE, GUSTAVE (1848-1894) FRENCH	10000-+++	L,F,S
CAIN, GEORGES JULES AUGUSTE (1856-1919) FRENCH	400-6500	G
CAIRO, FRANCESCO DEL (Called IL CAVALIERE DEL CAIRO) (1598-1674) ITALIAN	800-72000	F
CALAME, ALEXANDRE	*400-6500	
CALAME, ALEXANDRE (1810-1864) SWISS	2000-38000	L
CALANO, T. (19TH C) ITALIAN	*150-800	X
CALBET, ANTOINE (1860-1944) FRENCH	*300-9000	L,F
CALCOTT, A.W. (1799-1844) BRITISH	100-600	X
CALDERARA, ANTONIO (1903-) ITALIAN	1000-9900	L
CALDERON, CHARLES CLEMENT (19TH/20TH C) FRENCH	300-6200	M
CALDERON, PHILIP HERMOGENES (1833-1898) FRENCH/BRITISH	500-30000	G,F
CALDWELL, EDMUND (1852-1930) BRITISH	250-4800	W
CALEGARI, VITTORIO (B. 1861) ITALIAN	*100-600	X
CALES, ABBE PIERRE (1870-1961) FRENCH	1000-5000	L
CALIARI, CARLO (1570-1596) ITALIAN	*400-7500	F,G
CALIFANO, MUNDO (1875-1930) ITALIAN	100-900	X

* Denotes watercolors, pastels, drawings, and/or mixed media

CALLADINE, WILLIAM (20TH C) DUTCH	100-900	M
CALLCOTT, SIR AUGUSTUS WALL	*100-1700	
CALLCOTT, SIR AUGUSTUS WALL (1779-1844) BRITISH	1800-36000	L
CALLIAS, HORACE DE (D. 1921) FRENCH	350-8000	L
CALLOT, JACQUES (1592-L635) FRENCH	*10000-+++	F,G
CALLOW, GEORGE D. (19TH C) BRITISH	250-5200	M
CALLOW, JOHN	*500-7340	
CALLOW, JOHN (1822-1878) BRITISH	500-21000	M
CALLOW, WILLIAM	*400-42000	
CALLOW, WILLIAM (1812-1908) BRITISH	600-7500	M
CALLOWHILL, JAMES (19TH C) BRITISH	400-3500	L
CALOGERO, JEAN (B. 1922) ITALIAN	300-5200	L,F
CALOSCI, ARTURO (1855-1926) ITALIAN	400-3800	G
CALRAET, ABRAHAM VAN (1642-1721) DUTCH	1500-35000	L,F,S
CALS, ADOLPHE FELIX	*200-850	
CALS, ADOLPHE FELIX (1810-1880) FRENCH	500-12000	G,S,L
CALVAERT, DIONISIO (1540-1619) FLEMISH	2000-29000	X (F)
CALVERT, EDWIN SHERWOOD	*100-400	
CALVERT, EDWIN SHERWOOD (1844-1898) BRITISH	100-1600	L
CALVERT, FREDERICK (Early 19TH C) IRISH/BRITISH	350-11000	L,M
CALVERT, HENRY (B. 1798) BRITISH	350-10000	W
CALVERT, SAMUEL (Late 19TH C) BRITISH	350-2500	L,F
CALVES, LEON GEORGES (B. 1848) FRENCH	650-24000	G
CALVET, HENRI BERNARD (B. 1868) FRENCH	600-2000	S
CALVI, ERCOLE (1824-1900) ITALIAN	500-35000	M,L
CALZADA, HUMBERTO (B. 1944) CUBAN	400-6000	G
CAMACHO, JORGE	*100-800	
CAMACHO, JORGE (B. 1934) CUBAN	400-9000	X(I)
CAMARENA, JORGE GONZALEZ (B. 1908) MEXICAN	450-6000	X
CAMARGO, SERGIO DE (B. 1930) BRAZILIAN	300-6600	F
CAMASSEI, ANDREA (1601-1648) ITALIAN	*500-3500	F,G
CAMBIASO, LUCA	*500-14000	
CAMBIASO, LUCA (1527-1585) ITALIAN	1000-24000	F
CAMBIER, LOUIS G (1874-1949) BELGIAN	600-5500	X(L)
CAMERON, ANGUS (20TH C) BRITISH	200-1200	G,W
CAMERON, DUNCAN (19th C) SCOTTISH	350-9500	L
CAMERON, HUGH (B. 1835) BRITISH	1000-28000	F,L
CAMERON, KATHERINE (1874-1965) BRITISH	*400-6400	X
CAMERON, MARIE GELON (19TH C) FRENCH	100-900	F

CAMERON, SIR DAVID YOUNG	*200-5400	
CAMERON, SIR DAVID YOUNG (1865-1945) BRITISH	500-27000	L
CAMM, ROBERT (B. 1847) AUSTRALIAN	600-6000	F,W,L
CAMOIN, CHARLES	*500-17000	
CAMOIN, CHARLES (1879-1965) FRENCH	2300-125000	A,G,L,S
CAMPANA, PEDRO (Called KEMPENER) (1503-1580) SPANISH	300-2400	F
CAMPBELL, GEORGE	*600-5500	
CAMPBELL, GEORGE (1917-1979) BRITISH	1000-30000	M,S,F
CAMPBELL, HAY (Late 19TH C) BRITISH	100-750	F
CAMPBELL, JOHN HENRY (1757-1828) BRITISH	950-10000	L,M
CAMPBELL, ROBERT RICHMOND (1902-1972) AUSTRALIAN	800-16000	M,L
CAMPENDONK, HEINRICH	*1000-85000	
CAMPENDONK, HEINRICH (1889-1957) GERMAN	2500-+++	A
CAMPHAUSEN, WILHELM (1818-1885)	2000-24000	F,G
CAMPHUYSEN, GOVAERT D. (1624-1672) DUTCH	500-7800	F,L,W
CAMPI,-BERNARDINO (1522-1595) ITALIAN	2500-62000	G,F
CAMPI, GIACOMO (1846-1921) ITALIAN	400-4500	G,F
CAMPIGLI, MASSIMO (1895-1971) ITALIAN	4000-+++	A
CAMPIGLIA, GIOVANNI DOMENICO (1692-1768) ITALIAAN	*700-3000	F
CAMPION, GEORGE B. (1796-1870) BRITISH	*300-8100	L
CAMPO, FEDERICO DEL (19TH C) PERUVIAN	2000-180000	M,L,S
CAMPOREALE, SERGIO	*150-700	
CAMPOREALE, SERGIO (B. 1937) ARGENTINIAN	400-4500	G
CAMPOTOSTO, HENRY	*150-900	
CAMPOTOSTO, HENRY (1798-1910) BELGIAN	500-9800	G,L,W
CAMPRIANI, ALCESTE (1848-1933) ITALIAN	600-37000	M,F
CAMRADT, JOHANNES LUDVIG (1779-1849) DANISH	1500-25000	S
CAMUS, BLANCHE (19TH/20TH C) FRENCH	800-10000	X (F)
CAMUS, GEORGE (19TH C) FRENCH	100-700	X
CAMUS, GUSTAVE (20TH C) BELGIAN	400-3000	F,S
CANAL, GILBERT VON (1849-1927) AUSTRIAN	350-4200	L
CANALETTO, (GIOVANNI ANTONIO)	*3000-+++	
CANALETTO, (GIOVANNI ANTONIO)(1697-1768) ITALIAN	10000-+++	M
CANAS, BENJAMIN (B. 1933) BRAZILIAN	400-8200	G,F
CANCHOIS, HENRI (19TH C) FRENCH	350-3000	X
CANE, LOUIS	*1000-30000	
CANE, LOUIS (B. 1943) FRENCH	1000-28000	X(A,F)
CANELLA, ANTONIO (19TH C) ITALIAN	*300-1800	G,F
CANELLA, CARLO (19TH C) ITALIAN	1000-24000	X

* Denotes watercolors, pastels, drawings, and/or mixed media

CANELLA, GEORGIO (19TH C) ITALIAN	*150-13000	X
CANELLA, GIUSEPPE (1788-1847) ITALIAN	1500-26000	L,M
CANEVARI, CARLO (B. 1922) ITALIAN	400-3200	A,F,L
CANNICCI, NICOLO	*300-3200	
CANNICCI, NICOLO (1846-1906) ITALIAN	500-110000	G,L,W
CANO, ALONSO (1601-1667) SPANISH	750-35500	F
CANOGAR, RAFAEL (B. 1934) SPANISH	300-48000	X
CANON, HANS VON STRASCHIRIPKA (1829-1885) AUSTRIAN	200-2000	F,L
CANTA, JOHANNES ANTONIUS (1816-1888) DUTCH	500-19000	G,F
CANTAGALLINA, REMIGIO (1582-1630) ITALIAN	*600-5000	G,L
CANTARINI, SIMONE (1612-1648) ITALIAN	500-38000	F
CANTIS, FEDERICO (20TH C) SPANISH	*100-850	F
CANTU, FREDERICO (B. 1908) MEXICAN	300-2500	G,F
CANU, YVONNE (B. 1921) FRENCH	350-10000	L,M,F
CANZIANI, ESTELLA (1887-1964) BRITISH	*200-900	G
CAP, CONSTANT AIME MARIE (1842-1915) BELGIAN	500-9000	G
CAPEINICK, JEAN (1838-1890) BELGIAN	550-60000	S
CAPELLE, ALFRED EUGENE (1834-1887) FRENCH	300-2000	G
CAPELLE, JAN VAN DE (1624-1679) DUTCH	15000-+++	M,L
CAPMANY MUNTANER, RAMON (B. 1899) SPANISH	1000-30000	L,M
CAPOBIANCHI, VINCENTE (Late 19TH C) ITALIAN	2000-16000	G
CAPOGROSSI, GIUSEPPE	*900-77000	
CAPOGROSSI, GIUSEPPE (1900-1972) ITALIAN	3000-161000	X
CAPON, GEORGES EMILE (B. 1890) FRENCH	800-11000	X(F)
CAPONE, GAETANO	*150-650	
CAPONE, GAETANO (1845-1924) ITALIAN	250-4300	G,M,L
CAPORILE, J. (20TH C) ITALIAN	400-9000	X
CAPPIELLO, LEONETTO (1875-1942) FRENCH	*300-2400	F
CAPRILE, VINCENZO (1856-1936) ITALIAN	3000-42000	F
CAPRON, JEAN PIERRE (B. 1921) FRENCH	100-1700	M,L
CAPUANO, FRANCESCO (B. 1854) ITALIAN	250-2800	M,F
CAPULETTI, JOSE MANUEL	*100-500	
CAPULETTI, JOSE MANUEL (B. 1925) SPANISH	100-900	X(S)
CAPUTO, ULISSE (1872-1948) ITALIAN	500-25000	F,M
CARABAIN, JACQUES FRANCOIS (1834-1892) BELGIAN	2500-57000	G,L
CARABAIN, VICTOR (19TH C) BELGIAN	300-4500	X(M)
CARAUD, JOSEPH (1821-1905) FRENCH	1500-65000	G
CARBONERO, JOSE MORENO (B. 1860) SPANISH	400-11000	G
CARBONI, GIOVANNI BERNARDO (1614-1683) ITALIAN	600-42000	X(F)

CARCANO, FILIPPO (1840-1910) ITALIAN	500-21000	L,F
CARDI, LUDOVICO (Called IL CIGOLI)	*500-11000	
CARDI, LUDOVICO (Called IL CIGOLI) (1559-1613) ITALIAN	600-120000	G,F
CARDINAL, EMILE VALENTIN (19TH-20TH C) FRENCH	600-4000	S,F
CARDINAUX, EMILE (1877-1936) SWISS	800-4000	L
CARDON, CLAUDE (19TH C) BRITISH	400-12000	W,G
CARDUCHO, VINCENTE (1578-1638) ITALIAN	2000-21000	G
CARELLI, CONSLAVE	*350-6500	
CARELLI, CONSLAVE (1818-1900) ITALIAN	1200-85000	G,L,M
CARELLI, GABRIELLI (1820-1880) ITALIAN	*400-6600	L,F
CARELLI, GIUSEPPE (1858-1921) ITALIAN	550-15000	M,L
CARELLI, RAFFAELE (1795-1864) ITALIAN	2000-180000	L
CARENA, FELICE	*8500-4000	
CARENA, FELICE (B. 1880) ITALIAN	1000-32000	F,S
CARESME, JACQUES PHILIPPE	*300-8700	
CARESME, JACQUES PHILIPPE (1734-1796) FRENCH	500-9000	F
CAREY, HENRY (19TH C) BRITISH	100-700	L,M
CAREY, JOSEPH WILLIAM (19TH-20TH C) BRITISH	*400-2000	M,L
CARGNEL, VITTORE ANTONIO (1872-1931) ITALIAN	200-7000	G,L
CARLANDI, ONORATO (1848-1939) ITALIAN	400-3500	L
CARLAW, WILLIAM (1847-1889) BRITISH	250-1400	F
CARLBERG, HUGO (1880-1943) SWEDISH	300-4000	G,L
CARLEBUR, FRANCOIS (1821-1893) DUTCH	900-6000	L,M
CARLETTI, ALICIA (B. 1946) ARGENTINIAN	250-2400	X(G)
CARLEVARIS, LUCA (1665-1731) ITALIAN	5000-+++	F
CARLIER, MODESTE (1820-1878) BELGIAN	900-18000	S
CARLINI, GIULIO (1830-1887) ITALIAN	900-20000	F,L
CARLO, CHIOSTRI (19TH C) ITALIAN	400-3500	G
CARLONE, CARLO INNOCENZO (1686-1775) ITALIAN	1500-+++	F
CARLONI, P. (19TH C) ITALIAN	100-800	X
CARLSEN, CARL (1853-1917) DANISH	450-17500	G,S,L
CARLSON, PAUL H. (B. 1860) SWEDISH	200-2000	X
CARLSTEDT, MIKKO (1892-1964) FINNISH	1000-14000	X(L,S)
CARLSTROM, GUSTAF (1896-1964) SWEDISH	900-16000	L,S
CARLSUND, OTTO (1897-1948) SWEDISH	*1000-65000	A
CARLTON, FREDERICK (19TH/20TH C) BRITISH	150-2400	L
CARLTON, H. (19TH C) BRITISH	*100-700	X
CARLTON, HENRY (19TH C) BRITISH	100-700	X
CARLYLE, MAY (19TH/20TH C) BRITISH	300-2200	L

CARMASSI, ARTURO (B. 1925) ITALIAN	500-4500	A
CARMICHAEL, FRANKLIN (1890-1945) CANADIAN	1000-24000	L
CARMICHAEL, HERBERT (B. 1856) BRITISH	350-5000	F
CARMICHAEL, JAMES WILSON (JOHN)(1800-1868) BRITISH	1200-45000	M,L
CARMICHAEL, STEWART (B. 1867) SCOTTISH	*100-600	X
CARMIGNANI, GUIDO (1838-1909) ITALIAN	400-5000	X
CARMONTELLE, LOUIS CARROGIS (1717-1806) FRENCH	*2000-32000	F
CARNEO, ANTONIO (1637-1692) ITALIAN	1000-32000	F
CARNERO, G. (19TH C) ITALIAN	150-1800	G
CARNIER, H. (19TH C) FRENCH	300-2400	L
CARNOVALI, GIOVANNI (1804-1873) ITALIAN	1000-20000	F
CARO, ANTHONY (B. 1924) BRITISH	*200-5000	A
CARO, BALDASSARE DE (1689-1750) ITALIAN	500-27000	L,S
CARO, BILL (B. 1949) PERUVIAN	350-4200	X
CAROLIS, NINO (20TH C) ITALIAN	100-600	F
CAROLUS, JEAN (Late 19TH C) BELGIAN	1000-20000	G
CAROLUS-DURAN, EMILE AUGUSTE	*250-1600	
CAROLUS-DURAN, EMILE AUGUSTE (1838-1917) FRENCH	1000-+++	F
CARON, PAUL ARCHIBALD (1874-1941) CANADIAN	700-8000	X (L)
CARPACCIO, VITTORE (1450-1522) ITALIAN	*20000-+++	F
CARPEAUX, JEAN BAPTISTE (1827-1875) FRENCH	*700-13000	L,F
CARPENTER, KATE HOLSTON (B. 1866) BRITISH	100-700	X
CARPENTER, MARGARET SARAH	*200-1800	
CARPENTER, MARGARET SARAH (1793-1872) BRITISH	600-7500	G,F
CARPENTERO, HENRI JOSEPH GOMMARUS (1820-1874) BELGIAN	500-9500	G,L
CARPENTERO, JEAN CHARLES (1774-1823) BELGIAN	400-5600	X
CARPENTIER, EVARISTE (1845-1922) BELGIAN	1000-26000	F,G,L
CARPENTIER, MADELEINE (B. 1865) FRENCH	400-5400	L
CARPIONI, GIULIO (1611-1674) ITALIAN	*400-3500	F
CARR, EMILY	*500-52000	
CARR, EMILY (1875-1945) CANADIAN	1000-110000	L
CARR, TOM (20TH C) BRITISH	*300-3500	L
CARRA, CARLO (1881-1966) ITALIAN	3500-+++	A
CARRACCI, AGOSTINO (1557-1602) ITALIAN	*1500-+++	G,F,L,W
CARRACCI, ANNIBALE (1560-1609) ITALIAN	3000-+++	F
CARRACCI, LODOVICO (1555-1619) ITALIAN	10000-175000	F
CARRE, FRANCIS (1636-1669) DUTCH	1200-15000	L,G
CARRE, LEON GEORGES JEAN BAPTISTE (1882-1962) FRENCH	100-700	G
CARREE, JOHANNES (1698-1772) DUTCH	350-5000	L,W

CARREE, MICHIEL (1657-1747) DUTCH	400-6700	X
CARRENO, MARIO	*900-12000	
CARRENO, MARIO (B. 1913) CUBAN	2500-+++	A
CARRENTON, VICTOR (1864-1937) FRENCH	250-2000	X
CARRICK, JOHN MULCASTER (Active 1854-1878) BRITISH	800-44000	L
CARRIER-BELLEUSE, LOUIS ROBERT (1851-1913) FRENCH	*400-16000	G,F
CARRIER-BELLEUSE, PIERRE (B. 1851) FRENCH	*800-90000	F
CARRIERA, ROSALBA G.	*2500-165000	
CARRIERA, ROSALBA G. (1675-1757) ITALIAN	1000-15000	G,L,F
CARRIERE, EUGENE	*400-5800	
CARRIERE, EUGENE (1849-1906) FRENCH	500-25000	G,F
CARRILLO, LILIA (1930-1974)	500-6000	G
CARRINGTON, DORA (1893-1932) BRITISH	*800-5500	S,F
CARRINGTON, LEONORA	*1200-20000	
CARRINGTON, LEONORA (B. 1917) BRITISH	3500-120000	G,F,L
CARRINGTON, LEONORA (B. 1917) BRITISH	10000-95000	A
CARRUCCI DA PONTORMO, JACOPO (1493-1558) ITALIAN	*10000-+++	F
CARSE, JAMES HOWE (19TH C) BRITISH	300-10000	L,M
CARSON, TAYLOR (19TH/20TH C) IRISH	100-600	X
CARTE, ANTOINE (1886-1954) BELGIAN	600-155000	G,F
CARTER, FRANK T. (1853-1934) BRITISH	100-1000	G,L
CARTER, HENRY BARLOW (1803-1867) BRITISH	*100-3800	M
CARTER, HENRY W (19TH C) BRITISH	1000-10000	W
CARTER, JOSEPH N	*500-3000	
CARTER, JOSEPH N (1835-1871) BRITISH	600-4000	M,L,G
CARTER, SAMUEL JOHN (1835-1892) BRITISH	600-15000	W,L
CARTER, SYDNEY (19TH/20TH C) BRITISH	200-3900	L,F,S
CARUSO, BRUNO (B. 1927) ITALIAN	150-5700	A
CARUSO, ENRICO (1873-1921) ITALIAN	400-3200	F
CARVALLO, MARIA TERESA (B. 1903) PERUVIAN	200-1600	X
CARYBE, HECTOR JULIO BERNABO (B. 1911) LATIN AMERICAN	400-6000	X(G)
CARZOU, JEAN (B. 1907) FRENCH	600-36000	A
CASALI, ANDREA (B. 1720) ITALIAN	1500-28000	F
CASANOVA, DOMIGO A. (19TH C) SPANISH	200-2900	X
CASANOVA, FRANCESCO GIUSEPPE (1729-1802) ITALIAN	*500-7500	G,F
CASANOVA Y ESTORACH, ANTONIO	*100-5100	
CASANOVA Y ESTORACH, ANTONIO (1847-1896) SPANISH	1000-18000	G,F
CASAS, RAMON (1866-1932) SPANISH	*1000-40000	F
CASCELLA, MICHELE	*200-42000	

* Denotes watercolors, pastels, drawings, and/or mixed media

CASCELLA, MICHELE (B. 1892) ITALIAN	400-49000	L,S
CASCIARO, GIUSEPPE	*200-12000	
CASCIARO, GIUSEPPE (1863-1945) ITALIAN	400-11000	G,L
CASENTINO, JACOPO DEL (1297-1358) ITALIAN	2000-28000	F
CASILE, ALFRED (1847-1909) FRENCH	500-5500	L,F
CASISSA, NICOLA (D. 1730) ITALIAN	2000-40000	S,L,F
CASO, L.G. (19TH/20TH C) ITALIAN	300-2000	X(W)
CASORATI, FELICE (1886-1963) ITALIAN	3000-+++	X (F)
CASSAB, JUDY (B. 1920) AUSTRALIAN	300-3000	X(F,S)
CASSANA, ABATE GIOVANNI AGOSTINO (1658-1720) ITALIAN	1000-19000	W,S,L
CASSANI, A. PHILLIP (19TH C) ITALIAN	150-1000	X
CASSARD, PIERRE LEON (19TH/20TH C) FRENCH	100-700	X
CASSAS, LOUIS-FRANCOIS (1756-1827) FRENCH	*2000-20000	L,F
CASSELL, FRANK (19TH C) BRITISH	250-2200	X(W)
CASSELLARI, VINCENZO (B. 1841) ITALIAN	300-2600	G
CASSIE, JAMES (1819-1879) BRITISH	300-7000	M,L
CASSIERS, HENRY	*200-3000	
CASSIERS, HENRY (1858-1944) BELGIAN	200-4000	G,M
CASSIGNEUL, JEAN PIERRE (20TH C) FRENCH	2000-+++	F,S
CASSINARI, BRUNO (B.1912) ITALIAN	1000-39000	X
CASSON, ALFRED JOSEPH (B. 1898) CANADIAN	1500-124000	L,M
CASTAGNOLA, GABRIELE (1828-1883) ITALIAN	350-13000	G
CASTAIGNE, CARLOS (19TH/20TH C) ARGENTINIAN	100-800	X
CASTAIGNE, JEAN ANDRE (19TH/20TH C) FRENCH	500-6000	F,G
CASTAN, GUSTAVE EUGENE (1823-1892) SWISS	700-17000	L
CASTAN, PIERRE JEAN EDMOND (1817-1892) FRENCH	900-24000	G,W,F
CASTANEDA, ALFREDO	*300-9000	
CASTANEDA, ALFREDO (B. 1938) SPANISH	1500-40000	X(G)
CASTEELS, PETER	*600-6000	
CASTEELS, PETER (1684-1749) FLEMISH	2000-120000	L,S
CASTEL, MOSHE (B. 1909) ISRAELI	1200-22000	L,F
CASTELL, ANTON (1810-1867) GERMAN	800-9500	L
CASTELLANI, ENRICO (B. 1930) ITALIAN	*400-79000	X
CASTELLANO, FILIPPO (18TH C) ITALIAN	400-3500	X
CASTELLO, BERNARDO (1557-1629) ITALIAN	*250-3000	F
CASTELLO, GIACOMO DI (16TH C) ITALIAN	2000-20000	S
CASTELUCHO, CLAUDIO (1870-1927) SPANISH	350-16000	G,F
CASTEX-DEGRANGE, ADOLPHE LOUIS (B. 1840) FRENCH	1000-16000	S
CASTIGLIONE, GIOVANNI BENEDETTO	*5000-110000	

CASTIGLIONE, GIOVANNI BENEDETTO (1616-1670) ITALIAN	4000-75000	F,L
CASTIGLIONE, GUISEPPE (1829-1908) ITALIAN	400-29000	G
CASTILLO, ANTONIO DEL (1616-1668) SPANISH	*300-5000	F
CASTILLO, JORGE (20TH C) SPANISH	600-36000	X (G)
CASTILLO, MARCOS (B. 1899) VENEZUELAN	1000-18000	F
CASTOLDI, GUGLIELMO (B. 1852) ITALIAN	350-4500	G,F
CASTRES, EDOUARD (1838-1902) SWISS	2000-32000	G,L
CATALAN, RAMOS (20TH C) CHILEAN	200-3400	L
CATANO, F. (19TH C) ITALIAN	*100-900	X(L)
CATHELIN, BERNARD (B. 1919) FRENCH	550-25000	X(L)
CATHERWOOD, FREDERICK (1799-1854) BRITISH	*1200-45000	L
CATS, JACOB (1741-1799) DUTCH	*1000-25000	L,F
CATTANEO, ACHILLE (1872-1931) ITALIAN	300-3900	G,L
CATTERMOLE, CHARLES (1832-1900) BRITISH	*300-3200	G,F
CATTERMOLE, GEORGE (1800-1868) BRITISH	*100-1500	G,F
CAUCHOIS, EUGENE HENRI (1850-1911) FRENCH	400-21000	S,L
CAULAERT, JEAN DOMINIQUE VAN	*100-750	
CAULAERT, JEAN DOMINIQUE VAN (20TH C) FRENCH	200-1800	F
CAULFIELD, PATRICK (B. 1936) BRITISH	1500-16000	A
CAULLERY, LOUIS DE (Active 1595-1620) FLEMISH	2000-72000	F,G
CAUVY, LEON (1874-1933) FRENCH	1200-24000	M,L
CAUWER, EMILE PIERRE JOSEPH DE (1828-1873) BELGIAN	400-8500	L
CAUWER, LEOPOLD DE (19TH C) GERMAN	350-3600	W
CAVAEL, ROLF (20TH C) GERMAN	1000-15000	A
CAVAILLES, JEAN JULES LOUIS (1901-1977) FRENCH	400-32000	X(L,S)
CAVALCANTE, JAYME (20TH C) BRAZILIAN	100-700	X
CAVALCANTI, EMILIANO DE (B. 1897) BRAZILIAN	10000-75000	X(F)
CAVALIERI, LUDOVICO (1867-1942) ITALIAN	500-18000	X
CAVALLERI, FERNANDO (1794-1865) ITALIAN	300-5000	G
CAVALLINO, BERNARDO (1622-1654) ITALIAN	1800-58000	F
CAVAZZA, AZZO (19TH C) ITALIAN	150-900	X
CAVE, JULES CYRILLE (B. 1859) FRENCH	300-3000	X(F,G)
CAVE, PETER LE (18TH C) BRITISH	1000-15000	L,F
CAVEDONE, GIACOMO (1577-1660) ITALIAN	*300-6200	F
CAWSE, JOHN (1779-1862) BRITISH	250-6000	G,F
CAYLEY, NEVILLE HENRY PENISTON (1853-1903) AUSTRALIAN	*800-7000	S,W
CAYRON, JULES (1868-1940) FRENCH	1000-15000	F,G
CAZIN, JEAN CHARLES	*150-1700	
CAZIN, JEAN CHARLES (1841-1901) FRENCH	1200-33000	L

CECCHI, ADRIANO (B. 1850) ITALIAN	500-14000	G
CECCHI, AUGUSTO (19TH C) ITALIAN	700-9000	G,F
CECCHI, GAETANO (20TH C) ITALIAN	150-2500	L
CECCHINI, GUILIO (B. 1832) ITALIAN	350-3800	X(G)
CECCHINI-PRICHARD, EUGENIO (B. 1831) ITALIAN	400-3000	M
CECCONI, EUGENIO (1842-1903) ITALIAN	900-12000	X (F)
CEDERGREN, PER VILHELM (1823-1896Y) SWEDISH	400-3000	M
CEDERSTROM, GUSTAF (1845-1933) SWEDISH	700-22000	G,F
CEDERSTROM, THURE NIKOLAUS VON (1843-1924) SWEDISH	1800-20000	G,F
CEDOR, DIEUDONNE (B. 1925) HAITIAN	200-1800	F
CEI, CIPRIANO (1864-1922) ITALIAN	300-4800	G,F
CELEBRANO, FRANCESCO (1729-1814) ITALIAN	800-20000	G,F
CELOMMI, PASQUALE (1860-1928) ITALIAN	500-12000	L
CELOMMI, RAFFAELLO (B. 1883) ITALIAN	250-3500	X(W)
CELS, ALBERT F. (1883-1953) DUTCH	150-900	X(F,L)
CELS, EMANUEL ANTOINE JOSEPH (1821-1894) BELGIAN	250-3500	M
CERAMANO, CHARLES FERDINAND (1829-1909) BELGIAN	400-8600	L,W
CERESA, CARLO	*200-2500	
CERESA, CARLO (1609-1679) ITALIAN	500-18500	F
CERIA, EDMOND (1884-1955) FRENCH	200-8900	M,S,F
CERQUOZZI, MICHELANGELO (1602-1660) ITALIAN	2500-43000	L,S,F
CERRA, MIRTA (B. 1908) LATIN AMERICAN	400-3000	X
CERRINI, GIANDOMENICO (1609-1681) ITALIAN	1000-35000	F
CERUTI, GIACOMO (Called IL PITOCCHETTO) (Early 18TH C) ITALIAN	6000-126000	F,S,W
CESAR, BALDACCINI (B. 1921) FRENCH	*1000-28000	A
CESARI, GIUSEPPE (1580-1640) ITALIAN	*800-8000	F
CESETTI, GIUSEPPE (B.1902) ITALIAN	800-8500	X (S)
CEULEN, CORNELIS JONSON VAN (1593-1664) DUTCH	2000-32000	F
CEZANNE, PAUL	*7500-+++	
CEZANNE, PAUL (1839-1906) FRENCH	20000-+++	A,L,S,F
CHAB, VICTOR	*100-400	
CHAB, VICTOR (B. 1930) ARGENTINIAN	100-4200	A
CHABANIAN, ARSENE	*100-2500	
CHABANIAN, ARSENE (1864-1949) FRENCH	100-1200	M,L,S
CHABAS, MAURICE (1862-1947) FRENCH	600-26000	A,F,L
CHABAS, PAUL EMILE (1869-1937) FRENCH	1300-42000	F,G,L
CHABAUD, AUGUSTE (1882-1955) FRENCH	600-28000	F,L
CHABLIS, E. MARTIN (20TH C) FRENCH	250-6000	X(L)

CHABOT, E. (19TH C) FRENCH	250-1400	X
CHABOT, HENDRIK (B. 1894) DUTCH	400-3500	L
CHABRIER, GEORGE (19TH/20TH C) FRENCH	300-5000	X
CHADWICK, ERNEST ALBERT (1876-1955) BRITISH	*900-6500	L
CHADWICK, LYNN (B. 1914) BRITISH	*150-3300	F
CHAGALL, MARC	*1500-+++	
CHAGALL, MARC (1887-1985) RUSSIAN/FRENCH	20000-+++	A
CHAGNOUX, CHRISTINE (20TH C) FRENCH	100-700	X
CHAHINE, EDGAR (1874-1947) FRENCH	*300-3000	L,M
CHAIGNEAU, JEAN FERDINAND (1830-1906) FRENCH	400-4700	G,L,W
CHAILLOUX, ROBERT (B. 1913) FRENCH	300-3000	X(F)
CHAISSAC, GASTON	*600-171000	
CHAISSAC, GASTON (1910-1964) FRENCH	1200-96000	X (A)
CHALAPIN, BORIS	*100-600	
CHALAPIN, BORIS (1904-1979) RUSSIAN	200-1600	F
CHALEYE, JEAN (1878-1960) FRENCH	600-8500	X(S,L)
CHALLE, CHARLES MICHELANGE (1718-1778) FRENCH	*300-3500	G,L
CHALMERS, GEORGE PAUL (1833-1878) BRITISH	400-2000	F,L,M
CHALON, ALFRED EDWARD (1780-1860) SWISS	*300-2400	G,F,L
CHALON, HENRY BERNARD (1770-1849) BRITISH	2800-128000	L,W,F
CHALON, JOHN JAMES (1778-1854) BRITISH	*600-5500	F,L
CHALON, KINGSLEY S. (19TH C) BRITISH	100-2400	W
CHALON, LOUIS (B. 1866) FRENCH	900-20000	X
CHAMAILLARD, ERNEST (1862-1930) FRENCH	900-17500	M,L
CHAMBERLIN, MASON (THE ELDER) (B. 1787) BRITISH	750-60000	F
CHAMBERS, GEORGE (SR.)	*300-2500	
CHAMBERS, GEORGE (SR.) (1803-1840) BRITISH	1000-22000	M
CHAMBERS, GEORGE W. (JR.) (19TH C) BRITISH	600-28000	M
CHAMBERS, JOHN (19TH-20TH C) BRITISH	*400-2000	M,L
CHAMBON, EMILE FRANCOIS (B. 1905) SWISS	400-23000	X (S)
CHAMPAIGNE, JEAN BAPTISTE DE (1631-1681) FLEMISH	800-15000	F
CHAMPAIGNE, PHILLIPPE DE (1602-1674) FRENCH	2500-187000	F
CHAMPION, EDME THEODORE (Late 19TH C) FRENCH	300-7100	L
CHANCO, ROLAND (B. 1914) FRENCH	500-6700	S
CHANDLER, ROSE M. (19TH C) BRITISH	200-1200	L,F
CHANET, HENRI (19TH C) FRENCH	150-900	X
CHANISLINSKA, H.C. (19TH C) POLISH	150-2000	G
CHANTRELLE, LUCIEN (B. 1890) FRENCH	200-1200	X
CHANTRON, ALEXANDRE JACQUES (1842-1918) FRENCH	250-3000	L,S

* Denotes watercolors, pastels, drawings, and/or mixed media

CHAPELAIN-MIDY, ROGER	*100-600	
CHAPELAIN-MIDY, ROGER (B. 1904) FRENCH	400-12000	A
CHAPELLE, SUZANNE J (20TH C) FRENCH	800-4000	X(F)
CHAPERON, EUGENE (B. 1857) FRENCH	3000-70000	G,F
CHAPIRO, JACQUES (B. 1887) RUSSIAN	900-11000	L,F,S
CHAPLIN, CHARLES	*500-5500	
CHAPLIN, CHARLES (1825-1891) FRENCH	1400-65000	F
CHAPMAN, JOHN WATKINS (Active 1853-1903) BRITISH	500-11000	G,F
CHAPMAN, W. (19TH C) BRITISH	100-800	F,L
CHAPOTON, GREGOIRE (B. 1845) FRENCH	200-10000	X(S)
CHAPOVAL, YOUA (1919-1951) FRENCH/RUSSIAN	1000-38000	A
CHAPPEL, L. (19TH C) FRENCH	150-900	X(S)
CHAPPELL, REUBEN	*100-1400	
CHAPPELL, REUBEN (1870-1940) BRITISH	300-2500	M,F
CHAPPELL, WILLIAM (19TH C) BRITISH	200-2400	X(G)
CHARCHOUNE, SERGE (1888-1975) RUSSIAN	900-104000	X
CHARDIGNY, JULES (D. 1892) FRENCH	150-900	X
CHARDIN, JEAN BAPTISTE SIMEON (1699-1779) FRENCH	3000-+++	S,G,F
CHARETTE-DUVAL, FRANCOIS (Active 1836-1878) BELGIAN	350-4000	X(S)
CHARLAMOFF, ALEXEI	*400-2000	
CHARLAMOFF, ALEXEI (B. 1842) RUSSIAN	2000-35000	G,L
CHARLEMONT, EDUARD (1848-1906) AUSTRIAN	550-16000	F
CHARLEMONT, HUGO (1850-1939) AUSTRIAN	1000-28000	X(S,G)
CHARLES, JAMES (1851-1906) BRITISH	800-12000	G,L
CHARLET, FRANTZ (1862-1928) BELGIAN	500-26000	F,G
CHARLIER, EMILE (19TH C) BELGIAN	250-1400	X
CHARLOT, JEAN	*300-4500	
CHARLOT, JEAN (1898-1979) FRENCH	1500-29000	F,G
CHARLTON, JOHN (1849-1910) BRITISH	1100-90000	X(W,F)
CHARMY, EMILIE (1877-1974) FRENCH	1000-7000	X(F)
CHARPENTIER, JEAN BAPTISTE (1728-1806) FRENCH	3000-45000	G,F
CHARPIN, ALBERT (1842-1924) FRENCH	500-3800	X(W,L)
CHARRETON, VICTOR (1864-1936) FRENCH	500-101000	L
CHARTIER, HENRI GEORGES JACQUES	*150-600	
CHARTIER, HENRI GEORGES JACQUES (1859-1924) FRENCH	300-3800	F
CHARTON, ERNEST (1813-1905) FRENCH	1500-60000	L
CHARTRAN, THEOBALD (1849-1907) FRENCH	500-10000	F
CHARTRAND, ESTEBAN S.(1825-1889) SPANISH	400-10000	X(L)
CHASE, MARIAN (1844-1905) BRITISH	*400-3500	X (S)

CHASSELAT, HENRI JEAN SAINT ANGE (1813-1880) FRENCH	600-4500	F,G
CHASSERIAU, THEODORE	*1000-+++	
CHASSERIAU, THEODORE (1819-1856) FRENCH	4000-+++	F
CHATAUD, MARC-ALFRED (1833-1908) FRENCH	900-5000	F,G
CHATEIGNON, ERNEST (19TH C) FRENCH	450-6000	L,G
CHATELET, CLAUDE LOUIS	*400-20000	
CHATELET, CLAUDE LOUIS (1753-1794) FRENCH	1800-75000	L,G
CHAUVIN, PIERRE ATHANASE (1774-1832) FRENCH	2000-32000	G,F
CHAVES, GLAUCO (20TH C) BRAZILIAN	100-700	X
CHAVET, VICTOR JOSEPH (1822-1906) FRENCH	400-6500	X
CHAYLLERY, EUGENE LOUIS (Active 1894-1906) FRENCH	250-3000	G,F
CHECA Y SANZ, ULPIANO	*250-8500	
CHECA Y SANZ, ULPIANO (1860-1916) SPANISH	1000-+++	F,G
CHELMINSKI, JAN VAN (1851-1925) POLISH	1500-10000	F
CHELMONSKI, JOSEF (1849-1914) POLISH	1500-24000	G
CHELMONSKI, JOSEF (1850-1914) POLISH	800-9500	G,F
CHEMIAKIN, REBECCA (B. 1934) RUSSIAN	*800-2200	X(F)
CHENARD-HUCHE, GEORGE (1864-1937) FRENCH	400-4500	X(M,L)
CHEREAU, CLAUDE (B. 1883) FRENCH	*400-9000	X
CHERET, JULES	500-22000	
CHERET, JULES (1836-1932) FRENCH	1200-125000	F,G
CHERKAS, CONSTANTINE (20TH C) RUSSIAN/AMERICAN	100-700	X
CHEROVEL, PAUL (20TH C) FRENCH	100-700	X
CHERUBINI, ANDREA (19TH C) ITALIAN	300-16000	X(L,W)
CHERY, JEAN RENE (B. 1929) HAITIAN	250-2000	X
CHESTER, GEORGE F. (19TH C) BRITISH	300-6300	L
CHEUNG LEE, CHEE CHIN S. (20TH C) CHINESE/AMERICAN	100-700	X
CHEVALA, A. (19TH C) AUSTRIAN	200-1200	X
CHEVALIER, NICHOLAS	*1100-68000	L
CHEVALIER, NICHOLAS (1828-1902) AUSTRALIAN	600-160000	L
CHEVALIER, ROBERT MAGNUS (19TH C) BRITISH	350-7000	X(F)
CHEVILLIARD, VINCENT JEAN BAPTISTE	*400-5000	
CHEVILLIARD, VINCENT JEAN BAPTISTE (1841-1904) FRENCH	700-12000	X(G,W)
CHEVIOT, LILIAN (20TH C) BRITISH	600-8200	X(W,L)
CHEVOLLEAU, JEAN (B. 1924) FRENCH	800-6000	X(L)
CHIALIVA, LUIGI	*400-15000	
CHIALIVA, LUIGI (1842-1914) SWISS/ITALIAN	600-20000	F,G
CHIBAUH, AIMEE (19TH C) FRENCH	100-800	X
CHICLANERO, R. (19TH C) SPANISH	*300-2500	G,F

* Denotes watercolors, pastels, drawings, and/or mixed media

CHIERICI, ALFONSO (1816-1873) ITALIAN	300-1500	X(G)
CHIERICI, GAETANO (1838-1920) ITALIAN	3000-+++	G,F
CHIGHINE, ALFREDO (B. 1914) ITALIAN	1000-32000	A
CHIGOT, EUGENE HENRI ALEXANDRE (1860-1923) FRENCH	300-7000	M,L
CHILD, LOUISE (19TH C) BRITISH	300-1600	X(S)
CHILDE, ELIAS (19TH C) BRITISH	300-4000	G,F,M
CHILONE, VINCENZO (1758-1839) ITALIAN	3000-70000	L
CHINI, GALILEO (1873-1956) ITALIAN	500-33000	G
CHINNERY, GEORGE	*650-21000	
CHINNERY, GEORGE (1774-1852) BRITISH	3500-125000	F,L
CHINTREUIL, ANTOINE (1816-1873) FRENCH	650-12000	L
CHIRICO, GIORGIO DE	*2500-+++	
CHIRICO, GIORGIO DE (1888-1978) ITALIAN	5000-+++	A
CHLEBOWSKI, STANISLAS VON (1835-1884) POLISH	3000-35000	X(G)
CHMIELINSKI, W.T. (19TH/20TH C) POLISH	300-1900	X
CHOCARNE-MOREAU, PAUL CHARLES (1855-1931) FRENCH	900-19000	G,F
CHOCHON, ANDRE EUGENE LOUIS (20TH C) FRENCH	150-8000	X(G)
CHODOWIECKI, DANIEL (1726-1801) GERMAN	*800-7500	F
CHONE, GEORGES (B. 1819) FRENCH	400-2500	X(S)
CHOULANT, LUDWIG THEODOR (1827-1900) GERMAN	200-3000	L,F
CHOULTSE, IVAN F. (20TH C) RUSSIAN	1000-14000	L
CHRISTENSEN, ANTONORE (1849-1926) DANISH	800-20000	S,F
CHRISTENSEN, GODFRED (B. 1845) DANISH	800-7500	L
CHRISTENSEN, HAY (B. 1899) DANISH	500-4000	
CHRISTENSEN, KAY (B. 1899) DANISH	900-15000	X(A)
CHRISTIANSEN, NILS HANS (1873-1960) DANISH	300-2000	L
CHRISTIANSEN, RASMUS (B. 1863) DANISH	800-20000	G,F,L
CHRISTIE, JAMES ELDER (1847-1914) BRITISH	400-8000	X(G)
CHRISTO, (CHRISTO JAVACHEFF)	*2000-151000	
CHRISTO, (CHRISTO JAVACHEFF) (B. 1935) BULGARIAN	2000-88000	A
CHU TEH CHUN (B. 1922) CHINESE	2000-36000	A
CHUBLEY, HENRY HADFIELD (19TH/20TH C) BRITISH	150-800	X
CHUIKOV, IVAN (B. 1935) RUSSIAN	*10000-95000	A
CHURCH, FRANCIS (19TH C) BELGIAN	*150-900	X
CHURCHILL, SIR WINSTON (1874-1965) BRITISH	4000-85000	L,G
CHURCHYARD, THOMAS (1798-1865) BRITISH	400-3500	L
CHUTEAU, JACQUELINE (20TH C) FRENCH	100-700	S
CHWALA, ADOLF (1836-1900) CZECHOSLOVAKIAN	400-6500	L
CIAMPELLI, AGOSTINO (1578-1640) ITALIAN	600-7500	F,G

CIANI, CESARE (1854-1925) ITALIAN	500-7200	M,L,F
CIAPPA, V. (20TH C) ITALIAN	300-1800	X(G)
CIARDI, BEPPE GIUSEPPE (1875-1932) ITALIAN	1000-48000	G,L
CIARDI, EMMA (1879-1933) ITALIAN	700-17000	G,L,F
CIARDI, GUGLIELMO (1842-1917) ITALIAN	1000-70000	L,M
CIBOT, MARIE (19TH C) FRENCH	*100-600	X
CICERI, EUGENE	*400-11500	
CICERI, EUGENE (1813-1890) FRENCH	500-8500	G,L
CICOGNA, GIAMMARIA (1813-1849) ITALIAN	150-1200	X
CIESZKOWSKI, HENRYK (1835-1895) POLISH	350-6000	X(M)
CIFRONDI, ANTONIO (1657-1730) ITALIAN	900-24000	X
CIGNANI, CARLO (1628-1719) ITALIAN	1100-28500	F
CIGNAROLI, GIANBETTINO (1706-1770) ITALIAN	900-10000	F
CIMAGLIA, GIUSEPPE (1849-1905) ITALIAN	300-4000	G,F,S
CIMAROLI, GIOVANNI BATTISTA (17TH/18TH C) ITALIAN	1000-20000	L
CINCINNATO, ROMULO F.(1502-1600) ITALIAN	*1500-15000	F
CINFUEGOS, GONZALO (20TH C) LATIN AMERICAN	400-4500	X(F)
CIONE, JACOPO DI (1308-1394) ITALIAN	20000-+++	F
CIOPPA, CARLO (EARLY 20TH C.) ITALIAN	100-900	X(M)
CIPOLLA, FABIO (B. 1854) ITALIAN	300-3800	G,L
CIPPER, GIACOMO FRANCESCO (Called IL TODESCHINI) (18TH C) ITALIAN	1200-35000	G,S,F
CIPRIANI, GIOVANNI BATTISTA	*400-2500	
CIPRIANI, GIOVANNI BATTISTA (1727-1790) ITALIAN	500-196000	G
CIPRIANI, NAZZARRENO (1843-1925) ITALIAN	700-15000	X(G,W)
CIRCIGNANI, NICOLO (Called DO POMARANCE) (1519-1591) ITALIAN	*2000-20000	F
CIRY, MICHEL	*300-3500	
CIRY, MICHEL (B. 1919) FRENCH	400-11000	X(G,F)
CISERI, ANTONIO (1821-1891) ITALIAN	400-6000	X(L)
CITREON, PAUL (B. 1896) GERMAN	450-27000	L
CITTADINI, PIER FRANCESCO (1616-1681) ITALIAN	2000-140000	G,L,F,S
CIUSA-ROMAGNA, GIOVANNI (20TH C) ITALIAN	100-700	X(L)
CLACK, ARTHUR BAKER (20TH C) BRITISH	500-6000	X(L)
CLAES, CONSTANT GUILLAUME (1826-1905) BELGIAN	300-1500	X
CLAESSENS, ANTHONIE (1536-1613) FLEMISH	800-9500	F
CLAESZ, ANTHONY (THE ELDER) (1590-1636) DUTCH	4000-75000	S
CLAESZ, PIETER VAN HARLEM (1597-1661) DUTCH	7000-+++	S
CLAEUW, JACQUES DE (D. 1676) DUTCH	2500-204000	S
CLAEYS, ALBERT (1883-1967) DUTCH	900-8500	L,W

CLAGG, T. (Early 20TH C) BRITISH	100-700	X
CLAIR, CHARLES (1860-1930) FRENCH	400-5000	G,W
CLAIRIN, GEORGES JULES VICTOR	*500-8900	
CLAIRIN, GEORGES JULES VICTOR (1843-1919) FRENCH	2500-50000	L,G,F
CLAIRIN, PIERRE EUGENE (B. 1897) FRENCH	800-4500	X(M)
CLAPP, WILLIAM H. (1859-1954) CANADIAN	400-6000	F,L
CLARE, GEORGE	*100-600	
CLARE, GEORGE (19TH C) BRITISH	400-7000	S
CLARE, OLIVER (19TH C) BRITISH	700-14000	S
CLARE, VINCENT (1855-1930) BRITISH	500-8000	S
CLARENBACH, MAX (1880-1952) GERMAN	500-19000	G,M
CLARK, DIXON (20TH C) BRITISH	300-4500	L,W
CLARK, FREDERICK ALBERT (20TH C) BRITISH	800-3000	W
CLARK, JAMES (1858-1943) BRITISH	750-32000	G,W
CLARK, JAMES (SNR) (1884-1909) BRITISH	600-6000	W
CLARK, JOSEPH (B. 1835) BRITISH	900-32000	G,W
CLARK, JOSEPH BENWELL (B. 1857) BRITISH	250-3700	X(G)
CLARK, LILLIAN GERTRUDE (19TH C) BRITISH	300-3200	X(L)
CLARK, OCTAVIUS T. (1850-1921) BRITISH	250-3200	G,L,F,W
CLARK, S. JOSEPH (19TH C) BRITISH	500-7000	X
CLARK, THOMAS (1820-1876) BRITISH	2500-87000	F,L,W
CLARK, THOMAS (18TH C) IRISH	800-10000	X
CLARK, WILLIAM ALBERT (19TH-20TH C) BRITISH	800-5000	W
CLARKE, SAMUEL BARLING (19TH C) BRITISH	400-3800	G,W
CLARKE, WILLIAM HANNA (19TH/20TH C) BRITISH	300-8100	G,F,L
CLARY-BAROUX, ALBERT ADOLPHE (D. 1933) FRENCH	1000-18000	X(F,L)
CLAUDE, EUGENE (1841-1923) FRENCH	1000-16000	X (S)
CLAUDE, JEAN MAXIME (1823-1904) FRENCH	500-8000	L,M
CLAUDOT, JEAN BAPTISTE CHARLES (1733-1805) FRENCH	2500-64000	L,S
CLAUS, EMILE (1849-1924) BELGIAN	2200-120000	X(L,F)
CLAUSADES, PIERRE DE (B. 1910) FRENCH	450-8000	L
CLAUSELL, JOAQUIN (1866-1935) MEXICAN	3500-100000	X(L,F)
CLAUSEN, SIR GEORGE (1852-1944) BRITISH	4000-130000	G,F,L,A
CLAVE, ANTONI	*500-186000	
CLAVE, ANTONI (B. 1913) SPANISH	3000-+++	A
CLAVERIE, JULES JUSTIN (1859-1932) FRENCH	350-7100	L
CLAVIERE, BERNARD DE (20TH C) FRENCH	100-4500	X
CLAYES, ALICE DES (B. 1890) CANADIAN	400-3500	L
CLAYES, BERTHE DES (1877-1968) CANADIAN	500-6800	L,F

CLAYES, GERTRUDE DES (1879-1949) CANADIAN	1000-35000	F
CLAYS, PAUL JEAN	*400-2600	
CLAYS, PAUL JEAN (1819-1900) BELGIAN	900-15000	M
CLAYTON, HAROLD (1896-1979) BRITISH	500-42000	X (S)
CLAYTON, JAMES HUGUES (20TH C) BRITISH	*200-3400	X(L,M)
CLEEMPUT, J. VAN (20TH C) BELGIAN	100-750	X(L)
CLEENEWERCK, HENRY (19TH C) BELGIAN	1500-20000	X(L)
CLEMENS, CURT (1911-1947) SWEDISH	600-6000	F,G,L
CLEMENT, CHARLES (B. 1889) SWISS	*400-6800	F,L,S
CLEMENT, FELIX AUGUSTE (1826-1888) FRENCH	500-6500	X(F)
CLEMENT, MAXIME (20TH C) FRENCH	*150-900	X(F)
CLEMENT, SERGE (20TH C) EUROPEAN	400-2800	X(F)
CLEMENTS, A.H. (1818-1896) BRITISH	250-6000	X
CLEMENTZ, HERMANN (B. 1852) GERMAN	350-3500	G,L,F
CLEMINSON, ROBERT (19TH C) BRITISH	400-6500	W
CLERC, PIERRE (20TH C) FRENCH	1000-9500	A
CLERCK, HENDRICK DE (1570-1629) FLEMISH	2000-110000	F
CLERCQ, ALPHONSE (B. 1868) BELGIAN	300-7000	L
CLERISSEAU, CHARLES LOUIS	*300-16000	
CLERISSEAU, CHARLES LOUIS (1721-1820) FRENCH	600-22000	L,F
CLESINGER, JEAN-BAPTISTE (1814-1883) FRENCH	400-4000	L,W
CLESSE, LOUIS (1889-1961) BELGIAN	900-7000	L,F
CLEVE, CORNELIS VAN (1520-1567) FRENCH	900-36000	F
CLEVE, JOOS VAN DER (THE ELDER) (1495-1540) DUTCH	6000-125000	F
CLEVELEY, JOHN SR (18TH/19TH C) BRITISH	1500-58000	M
CLEVELEY, ROBERT (1747-1809) BRITISH	400-6800	M
CLIFFORD, EDWARD (1844-1907) BRITISH	*900-12000	X(F)
CLINT, ALFRED (1807-1883) BRITISH	400-6500	M,L
CLOSTERMAN, JOHN BAPTIST (1660-1713) GERMAN	1200-36000	X(F)
CLOUGH, PRUNELLA (B. 1919) BRITISH	1000-18000	F,L,M
CLOUGH, TOM (B. 1903) BRITISH	*700-5500	M,G
CLOWES, DANIEL (Early 19TH C) BRITISH	2000-57000	W,G,L
CLUVER, BERNT (1897-1941) NORWEGIAN	600-4000	F,L
COBBETT, EDWARD JOHN (1815-1899) BRITISH	400-9500	X(L)
COBLITZ, L. (19TH C) FRENCH	100-900	X
COBURN, FREDERICK SIMPSON (1871-1960) CANADIAN	400-25000	L,G,F
COBURN, JOHN (B. 1925) AUSTRALIAN	*800-7000	X(A)
COCCORANTE, LEONARDO (1700-1750) ITALIAN	1000-50000	M,L
COCHIN, CHARLES-NICOLAS (18TH C) FRENCH	*1000-10000	F

COCHRANE, HELEN L. (20TH C) BRITISH	*100-700	L,G
COCK, CESAR DE (1823-1904) FLEMISH	450-17000	L,G
COCK, GILBERT DE (20TH C) BELGIAN	800-3500	A
COCK, XAVIER DE (1818-1896) BELGIAN	700-38000	G,W
COCKBURN, MAJOR GENERAL JAMES PATTISON (1778-1847) BRITISH	*1000-7500	L
COCKERELL, CHARLES ROBERT (1788-1863) BRITISH	*2000-35000	L
COCKERELL, FREDERICK PEPYS (19TH C) BRITISH	*2000-32000	L
COCKRAM, GEORGE (1861-1950) BRITISH	*400-2000	M,L,F
COCTEAU, JEAN (1889-1963) FRENCH	*600-132000	F
CODAZZI, NICCOLO VIRIANI (1648-1693) ITALIAN	1000-20000	X(F)
CODAZZI, VIVIANO (1603-1672) ITALIAN	900-40000	X(L)
CODDE, PIETER JACOBS (1599-1678) DUTCH	2500-110000	G,F
CODDRON, OSCAR (1881-1960) BELGIAN	1000-50000	F,M
COECKE VAN AELST, PIETER	*5000-90000	
COECKE VAN AELST, PIETER (1502-1550) FLEMISH	10000-105000	F
COEFFIER, MARIE PAULINE ADRIENNE (1814-1900) FRENCH	200-1500	X
COENE, CONSTANTINUS FIDELIO (1780-1840) FLEMISH	900-18000	G,F
COENE, JEAN-HENRI DE (1798-1866) FLEMISH	1000-14200	X(L,F)
COESSIN DE LA FOSSE, CHARLES ALEXANDRE	*300-1800	
COESSIN DE LA FOSSE, CHARLES ALEXANDRE (1829-1900) FRENCH	500-6200	G
COEYLAS, HENRI (19TH/20TH C) FRENCH	650-15000	X
COFFERMANS, MARCELLUS (1535-1575) FLEMISH	1000-73000	F
COHEN, EDWARD (1838-1910) GERMAN	1000-20000	X(F)
COIGNARD, JAMES	*350-9600	
COIGNARD, JAMES (B. 1925) FRENCH	350-29000	X
COIGNARD, LOUIS (1810-1883) FRENCH	400-10000	L
COIGNET, JULES (1798-1860) FRENCH	250-9500	M,L,W
COL, JAN DAVID	*400-1000	
COL, JAN DAVID (1822-1900) BELGIAN	2500-36000	G,L,W
COLBERT, JACQUES (19TH C) FRENCH	100-1500	X
COLDER, FRANK (19TH/20TH C) SCOTTISH	100-750	X
COLDSTREAM, SIR WILLIAM (20TH C) BRITISH	400-3800	F,L
COLE, A. (B. 1830) BRITISH	250-5000	L
COLE, CHISLOM (Active 1837-1868) BRITISH	100-1000	L
COLE, F. (JR.) (19TH C) BRITISH	100-800	X
COLE, GEORGE (1810-1883) BRITISH	500-121000	G,L,W
COLE, GEORGE VICAT	*150-24000	
COLE, GEORGE VICAT (1833-1893) BRITISH	1300-42000	L

COLE, JAMES (19TH C) BRITISH	800-6500	G,F
COLE, REX VICAT (1870-1940) BRITISH	300-3200	L
COLEMAN, CHARLES (B. 1874) BRITISH	400-6500	L,W
COLEMAN, ENRICO (1846-1911) ITALIAN	*500-9000	L,W
COLEMAN, FRANCESCO (B. 1851) ITALIAN	*1000-24000	G,F
COLEMAN, WILLIAM (B. 1922) AUSTRALIAN	600-5000	F,S,L
COLEMAN, WILLIAM STEPHEN (1829-1904) BRITISH	800-12000	L,F
COLIN, ALEXANDRE MARIE (1798-1873) FRENCH	400-8300	L,S,F
COLIN, GUSTAVE HENRI (1828-1910) FRENCH	300-9800	M,G
COLIN, PAUL EMILE (1892-1984) FRENCH	*1000-38000	G
COLKETT, SAMUEL DAVID (1806-1863) BRITISH	500-15000	G,F,L
COLKETT, VICTORIA SUSANNA (B. 1840) BRITISH	350-3200	X(L)
COLLAR, J. (B. 1941) SPANISH	100-900	X
COLLART, MARIE (1842-1911) DUTCH	400-5500	X(G,L)
COLLIER, EVERT (17TH/18TH C) DUTCH	1500-95000	S
COLLIER, JOHN (1708-1786) BRITISH	600-26000	F
COLLIER, THOMAS FREDERICK (1840-1891) BRITISH	*250-7000	S
COLLIGNON, GEORGES (B. 1923) BELGIAN	2000-30000	A
COLLIN, A. (19TH C) BRITISH	100-800	X
COLLIN, LOUIS JOSEPH RAPHAEL (1850-1916) FRENCH	1000-38000	G,F
COLLIN DE VERMONT, HYACINTHE (1693-1761) FRENCH	5000-45000	F
COLLINGWOOD, WILLIAM GERSHAM (1854-1932) BRITISH	*1000-4500	L,F
COLLINS, CECIL (B. 1900) BRITISH	500-13000	A
COLLINS, CHARLES	*300-2500	
COLLINS, CHARLES (D. 1744) BRITISH	350-11000	G,L
COLLINS, HUGH (19TH C) BRITISH	300-2500	X(G)
COLLINS, REGINALD (19TH/20TH C) BRITISH	100-600	S
COLLINS, WILLIAM (1788-1847) BRITISH	900-22000	X(G,M)
COLLS, EBENEZER (MID 19TH C) BRITISH	250-2600	L,M
COLNOT, ARNOUT (B. 1887) DUTCH	400-3000	L
COLOMBEL, NICOLAS (1644-1717) FRENCH	1000-24000	F
COLOMBO, D. (19TH C) ITALIAN	*100-700	X
COLOMBO, VIRGILIO (19TH C) ITALIAN	*350-4200	G
COLQUHOUN, ROBERT	*300-8900	
COLQUHOUN, ROBERT (1914-1962) BRITISH	800-22000	F,G
COLSON, JEAN FRANCOIS GILLE (1733-1803) FRENCH	*350-2200	F
COLSON, P. (19TH C) BRITISH	100-700	L
COLYNS, DAVID (1582-1668) DUTCH	550-10000	X
COMERRE, LEON (1850-1916) FRENCH	900-46000	F,L

* Denotes watercolors, pastels, drawings, and/or mixed media

COMERRE, LEON FRANCOIS (1850-1916) FRENCH	1500-32000	X
COMINICIS, ACHILLE DE (19TH C) ITALIAN	*100-800	X
COMMERE, JEAN (B. 1920) FRENCH	500-15500	G,L,W
COMMERE, YVES (20TH C) FRENCH	250-2500	M
COMPAGNO, SCIPIONE (1624-1680) ITALIAN	1000-15000	F
COMPARD, EMILE (B. 1900) FRENCH	800-8000	X(F)
COMPTE, A. (19TH C) FRENCH	*150-2000	X
COMPTE, PIERRE CHARLES (1823-1895) FRENCH	500-8500	F
COMPTE-CALIX, FRANCOIS CLAUDIUS (1813-1880) FRENCH	500-26000	G,F
COMPTON, EDWARD HARRISON (1881-1960) BRITISH	250-11000	L
COMPTON, EDWARD THEODORE	*400-15000	
COMPTON, EDWARD THEODORE (1849-1921) BRITISH	800-24000	L
COMTE, PIERRE CHARLES (1823-1895) FRENCH	400-25000	F,G
CONCA, SEBASTIANO (1676-1764) ITALIAN	500-27000	G,F
CONCONI, LUIGI (1852-1917) ITALIAN	800-4000	F
CONDAMY, CHARLES FERNAND DE (Late 19TH C) FRENCH	*300-2800	G,F
CONDER, CHARLES EDWARD	*600-45000	
CONDER, CHARLES EDWARD (1868-1909) BRITISH	1200-210000	G,F
CONDON, ANDRE (B. 1943) FRENCH	150-1600	X(W)
CONDY, NICHOLAS MATTHEW (1816-1851) BRITISH	600-45000	M
CONDY, NICHOLAS MATTHEW SR (1793-1857) BRITISH	1500-25000	M
CONFORTINI, JACOPO (17TH C) ITALIAN	*500-8000	F
CONGERS, C. (Late 19TH C) EUROPEAN	100-700	X
CONINCK, DAVID DE (OR KONINCK) (Called ROMELAER) (1636-1699) FLEMISH	2500-195000	L,S,W
CONINCK, PIERRE JOSEPH LOUIS DE (1828-1910) FRENCH	250-4800	G,F
CONINXLOO, ISAAK VAN (1580-1634) DUTCH	1000-25000	G,F
CONNARD, PHILIP (1875-1958) BRITISH	1000-40000	M,L
CONNEAU, E. (19TH C) FRENCH	300-1600	X(L)
CONNELLY, A. (19TH C) BRITISH	*100-600	X
CONNOR, KEVIN (B. 1932) AUSTRALIAN	800-6500	X(F)
CONOR, WILLIAM	*800-19000	
CONOR, WILLIAM (1881-1968) IRISH	1000-41000	G,F
CONRADE, ALFRED CHARLES (1863-1955) BRITISH	*200-2500	L
CONSTABLE, GEORGE (19TH C) BRITISH	300-4000	X(G)
CONSTABLE, JOHN	*2000-+ + +	
CONSTABLE, JOHN (1776-1837) BRITISH	8000-+ + +	F,L
CONSTABLE, WILLIAM GEORGE (19TH C) BRITISH	*300-2000	L
CONSTANS, LOUIS ARISTIDE LEON (19TH C) FRENCH	1500-61000	X

CONSTANT, JEAN JOSEPH BENJAMIN	*2000-38000	
CONSTANT, JEAN JOSEPH BENJAMIN (1845-1902) FRENCH	8000-+++	F
CONSTANTIN, JEAN ANTOINE (1756-1844) FRENCH	*800-9500	F,L
CONSTANTIN, MARIE (1895-1903) FRENCH	100-800	X
CONSTANTIN, S. (19TH C) ITALIAN	300-2000	X
CONSTANTINE, G HAMILTON (B. 1878) BRITISH	*300-3500	L
CONSTANTINI, GIOVANNI (19TH C) ITALIAN	300-2000	G
CONSTANTINI, GIUSEPPE (19TH/20TH C) ITALIAN	450-9000	G
CONSUEGRA, HUGO (B. 1929) CUBAN	350-7500	X(G)
CONTE, JACOPO DEL (1510-1598) ITALIAN	800-15000	F
CONTI, TITO (1842-1924) ITALIAN	600-38000	F,G
CONTICH, KAREL VAN (19TH C) DUTCH	100-700	X
COOGHEN, LEENDERT VAN DER (1610-1681) DUTCH	5000-46000	G,F
COOK, CHARLES HENRY (1830-1906) BRITISH	150-4900	G,L
COOK, EBENEZER WAKE	*300-4800	
COOK, EBENEZER WAKE (1843-1926) BRITISH	600-12000	M,L,G
COOKE, EDWARD WILLIAM	*300-6300	
COOKE, EDWARD WILLIAM (1811-1880) BRITISH	900-123000	M,G
COOKESLEY, MARGARET MURRAY (D. 1927) BRITISH	250-9000	X(G)
COOLWIJK, J. SCHREUDER VAN DE (20TH C) DUTCH	100-700	X
COOMANS, AUGUSTE (B. 1855) BELGIAN	700-10000	G,L,W
COOMANS, DIANA (19TH C) BELGIAN	600-15000	G,F
COOMANS, HEVA	*200-700	
COOMANS, HEVA (19TH C) BELGIAN	400-6500	X(G)
COOMANS, PIERRE OLIVIER JOSEPH (1816-1889) BELGIAN	800-38000	F
COOP, HUBERT (1872-1953) BRITISH	*400-3800	M
COOPER, ABRAHAM (1787-1868) BRITISH	1800-125000	F,L
COOPER, ALEXANDER DAVIS (1837-1888) BRITISH	300-3000	G
COOPER, ALFRED EGERTON	*400-4000	
COOPER, ALFRED EGERTON (1883-1974) BRITISH	500-8500	L,G
COOPER, ALFRED HEATON (1864-1929) BRITISH	*200-2000	M,L
COOPER, EDWIN (1785-1833) BRITISH	900-45000	W,L
COOPER, GERALD (20TH C) BRITISH	500-11000	S
COOPER, HENRY (20TH C) BRITISH	100-1200	L,W
COOPER, J. SAVAGE (19TH C) BRITISH	250-6700	F
COOPER, R. (19TH C) BRITISH	*200-3300	F
COOPER, THOMAS GEORGE (B. 1832) BRITISH	600-9500	L,M,W
COOPER, THOMAS SIDNEY	*400-6000	
COOPER, THOMAS SIDNEY (1803-1902) BRITISH	1500-75000	L,W

* Denotes watercolors, pastels, drawings, and/or mixed media

COOPER, WILLIAM HEATON (B. 1903) BRITISH	*300-2500	X(L)
COOPER, WILLIAM SIDNEY (19TH C) BRITISH	400-6000	L
COOSEMANS, ALEXANDER (1627-1689) FLEMISH	3000-55000	S
COOTER, RAMMA J. (19TH C) BRITISH	100-800	X
COPE, CHARLES WEST (JR.) (1811-1890) BRITISH	900-12000	G,F
COPETTI, A. (19TH/20TH C) ITALIAN	100-700	X
COPNALL, FRANK T. (B. 1870) BRITISH	100-1200	X(F,W)
COQUES, GONZALES (Called LE PETIT VAN DYCK) (1614-1684) FLEMISH	1000-230000	G,F
CORBELLINI, LUIGI (1901-1968) ITALIAN	500-12000	F
CORBET, PHILIP (19TH C) BRITISH	150-2000	X(F)
CORBIN, J B (20TH C) FRENCH	400-4000	X
CORBOULD, ALFRED (Mid 19TH C) BRITISH	450-7500	G,W,F
CORBOULD, EDWARD HENRY	*300-8200	
CORBOULD, EDWARD HENRY (1815-1905) BRITISH	500-20000	G,F
CORBUSIER, LE	*800-99000	
CORBUSIER, LE (1887-1965) FRENCH	8000-107000	A
CORCHON Y DIAQUE, FEDERICO (Late 19TH C) SPANISH	300-6000	X(L)
CORCOS, VITTORIO MATTEO (1859-1933) ITALIAN	900-60000	G,F
CORDEY, FREDERIC (1854-1911) FRENCH	900-12000	L
CORELLI, AUGUSTO	*100-2100	
CORELLI, AUGUSTO (1853-1910) ITALIAN	250-5500	L,F
CORENZIO, BELISSARIO (1558-1640) GREEK	*200-8000	F
CORETTI, G. (19TH C) ITALIAN	*400-1800	F,L,W
CORINTH, LOVIS	*900-32000	
CORINTH, LOVIS (1858-1925) GERMAN	1700-190000	G,F,L,M
CORMERY, LOUIS (19TH C) BRITISH	100-700	X
CORMON, FERNAND ANNE PIESTRE (1854-1924) FRENCH	650-28000	F
CORNEILLE, (CORNELIUS GUILLAUME BEVERLOO)	*500-39000	
CORNEILLE, (CORNELIUS GUILLAUME BEVERLOO) (B. 1922) SPANISH	1500-155000	A
CORNEILLE, MICHEL (1602-1664) FRENCH	*500-16000	F,L
CORNEILLE, MICHEL (THE YOUNGER) (1641-1708) FRENCH	*600-25000	X
CORNEILLE, PIERRE (1580-1616) ITALIAN	*500-4500	X
CORNEILLE DE LYON, CLAUDE (1500-1574) FLEMISH	8000-80000	F
CORNELISZ VAN HAARLEM, CORNELIS	*2000-45000	
CORNELISZ VAN HAARLEM, CORNELIS (1562-1638) DUTCH	5000-55000	X
CORNU,PIERRE (B. 1895) FRENCH	400-11000	F,S
CORNUT, LOUIS (20TH C) FRENCH	100-1200	X(L)
CORNWALLIS, BROWNELL (19TH/20TH C) BRITISH	150-800	X

CORONEL,PEDRO (1923-1985) MEXICAN	1500-88000	A
CORONEL, RAFAEL	*300-5000	
CORONEL, RAFAEL (B. 1932) MEXICAN	1000-130000	A
COROT, JEAN BAPTISTE CAMILLE	*900-146000	
COROT, JEAN BAPTISTE CAMILLE (1796-1875) FRENCH	7500-+++	L,G,F
CORPER, M. (19TH C) BRITISH	100-700	X(G)
CORPORA, ANTONIO (B. 1909) ITALIAN	400-29000	X(L)
CORRADETTI, ROMANO (20TH C) ITALIAN	100-1200	X
CORRADI, KONRAD (1813-1878) SWISS	*400-4000	L
CORREGGIO, JOSEPH (1810-1891) GERMAN	350-4800	X(S)
CORREGGIO, LUDWIG (B. 1846) GERMAN	350-4500	L,F,W
CORRENS, ERICH (1821-1877) GERMAN	400-3500	X(F)
CORRI, F. J. (19TH C) BRITISH	*150-3500	X
CORRIGLIA, G.B. (19TH C) ITALIAN	800-18000	G,F
CORRODI, ARNOLD (1846-1874) ITALIAN	600-12000	X
CORRODI, HERMANN DAVID SALOMON	*500-3200	
CORRODI, HERMANN DAVID SALOMON (1844-1905) ITALIAN	900-30000	L,F
CORRODI, SALOMON (1810-1892) ITALIAN	*400-11000	L,M
CORSI,NICOLAS DE (1882-1956) ITALIAN	400-8100	M,L
CORSINI, RAFFAEL (MID 19TH C) ITALIAN	*700-15000	X(M,F)
CORT, HENDRIK FRANS DE (1742-1810) DUTCH	2000-26000	L
CORTAZZO, ORESTE	*400-2500	
CORTAZZO, ORESTE (B. 1836) ITALIAN	3500-48000	X(G)
CORTELLINI Y HERNANDEZ, ANGEL-MARIA (B. 1820) SPANISH	300-2800	X
CORTER, P. R. (19TH C) DUTCH	400-1800	X(W)
CORTES, ANTONIO M. (19TH C) SPANISH	350-5500	L,W
CORTES, EDOUARD	*300-7000	
CORTES, EDOUARD (1882-1969) FRENCH	1200-63000	G,F
CORTEZ, ANDRE (19TH C) SPANISH	100-800	X
CORTIER, AMEDEE (1921-1976) FRENCH?	900-4500	X(A)
CORTONA, PIETRO DA (1596-1669) ITALIAN	*5000-65000	
CORZAS, FRANCISCO	*900-18000	
CORZAS, FRANCISCO (B. 1936) MEXICAN	1100-65000	G,F
COSGROVE, STANLEY MOREL (B. 1911) CANADIAN	800-14000	L
COSSAAR, JACOBUS CORNELIUS WYAND	*100-400	
COSSAAR, JACOBUS CORNELIUS WYAND (1874-1966) DUTCH	350-1800	X
COSSIERS, JAN (1600-1671) FLEMISH	*900-25000	F,G
COSSIO, FRANCISCO (B. 1894) SPANISH	600-9500	L,S
COSSMANN, MAURICE (1821-1890) FRENCH	250-3000	G,F

* Denotes watercolors, pastels, drawings, and/or mixed media

COSSON, JEAN LOUIS MARCEL (1878-1956) FRENCH	650-30000	G
COSTA, CLAUDIO (B. 1942) ITALIAN	*200-2000	A
COSTA, EMANUELE (B. 1875) ITALIAN	350-9200	X(G)
COSTA, GIOVANNI	*600-5500	
COSTA, GIOVANNI (1833-1903) ITALIAN	1300-65000	L,G,F
COSTA, GUISEPPE (1852-1912) ITALIAN	300-9500	F,G
COSTA, JOHN DA (1867-1931) BRITISH	800-11000	F
COSTA, LUIGI DA (Late 19TH)	600-6000	G
COSTA, OLGA (B. 1913) MEXICAN	300-30000	X
COSTA, ORESTE (1851-1901) ITALIAN	1500-18000	G,S,F
COSTAIGNE, J. ANDREA (1860-1930) GERMAN	*100-900	X
COSTANTINI, GIOVANNI (B. 1872) ITALIAN	350-3000	X
COSTANTINI, GIUSEPPE (1850-1894) ITALIAN	1000-15000	X(G,L)
COSTANZI, PLACIDO (1690-1759) ITALIAN	1500-28000	F
COSTER, ADAM DE (1586-1643) FLEMISH	600-38000	X(G)
COSTER, C. DE (19TH C) FRENCH	150-900	X
COSWAY, RICHARD	*300-3500	
COSWAY, RICHARD (1742-1821) BRITISH	600-31000	F
COSYN, PIETER (1630-1666) DUTCH	400-6000	L
COTES, FRANCIS (1725-1770) BRITISH	3000-200000	G,F
COTMAN, FREDERICK GEORGE (1850-1920) BRITISH	*400-4500	G,F,L
COTMAN, JOHN JOSEPH (1814-1878) BRITISH	*800-16000	L
COTMAN, JOHN SELL	*400-34000	
COTMAN, JOHN SELL (1782-1842) BRITISH	500-9900	M,L
COTTAVOZ, ANDRE (B. 1922) FRENCH	400-20000	F
COTTET, CHARLES F. (1863-1925) FRENCH	400-9000	G,M,W
COTTON, JOHN W. (B. 1868) CANADIAN	150-1000	I,L
COUBINE, OTHON (1883-1959) CZECHOSLOVAKIAN	300-6300	L,S
COUDER, JEAN ALEXANDRE REMY (1808-1879) FRENCH	300-4500	S
COUDER, LOUIS C. AUGUST (1790-1873) FRENCH	300-22000	X(F)
COUDOUR, HENRI (19TH/20TH C) FRENCH	100-1500	X(S)
COULANGE-LAUTREC, EMMANUEL (Late 19TH C) FRENCH	300-18000	S
COULAUD, MARTIN (D. 1906) FRENCH	300-6000	L
COULDERY, HORATIO H. (1832-1893) BRITISH	700-16000	W,G
COULET, PIERRE GUILLAUME (18TH C) FRENCH	100-800	X
COULON, RENEE (20TH C) FRENCH	150-2000	M
COULSON, GERALD D. (Early 20TH C) BRITISH	350-3200	X
COUNIS, SALOMON GUILLAUME (1785-1859) SWISS	*400-4000	X
COUR, JANUS LA (1837-1909) DANISH	400-7000	L,M

COURBET, GUSTAVE	*2500-60000	
COURBET, GUSTAVE (1819-1877) FRENCH	10000-+++	L,G,W,S
COURDOUAN, VINCENT-JOSEPH-FRANCOIS (1810-1893) FRENCH	1000-9000	F,L
COURMES, ALFRED (B. 1908) FRENCH	600-10000	L,G,M
COURNAULT, ETIENNE (1891-1948) FRENCH	400-6500	X(F)
COURTAT, LOUIS (D. 1909) FRENCH	400-14000	X(F)
COURTEILLE, EUGENE (Active 1790-1820) FRENCH	300-3000	G
COURTEN, ANGELODE (B. 1848) ITALIAN	200-7100	G,F
COURTEN, LODOVICO DE (19TH C) ITALIAN	*100-800	X
COURTENS, FRANZ (1854-1943) BELGIAN	600-26000	L,G,S
COURTENS, HERMAN (1884-1956) BELGIUM	650-15000	S
COURTIN, CAROLINE (19TH C) FRENCH	400-5000	L,W
COURTOIS, GUSTAVE CLAUDE ETIENNE (1853-1923) FRENCH	1000-33000	F,G
COURTOIS, JACQUES (1621-1676) FRENCH	1000-33000	F,G
COUSIN, CHARLES LOUIS AUGUSTE (1807-1887) FRENCH	400-5500	X
COUSSAINT, PIERRE JOSEPH (1822-1888) BELGIAN	400-5800	X
COUSTURIER, LUCIE (1870-1925) FRENCH	1500-70000	L,F,S
COUTAN, AMABLE PAUL (1792-1837) FRENCH	*100-800	X
COUTAUD, LUCIEN (B. 1904) FRENCH	500-23000	F
COUTURE, THOMAS	*900-15000	
COUTURE, THOMAS (1815-1879) FRENCH	1500-98000	G,F
COUTURIER, PHILIBERT LEON (1823-1901) FRENCH	400-15000	G,W
COUTY, JEAN FREDERIC (1829-1904) FRENCH	*500-18000	F
COUVER, JAN VAN (1836-1909) DUTCH	300-6000	M
COVARRUBIAS, MIGUEL	*700-18000	
COVARRUBIAS, MIGUEL (1904-1957) MEXICAN	600-24000	X(F,M)
COVENTRY, ROBERT MCGOWAN (1855-1914) BRITISH	*400-3600	M
COWEN, LIONEL J. (19TH C) BRITISH	100-2500	X(G)
COWPER, FRANK CADOGAN (1877-1958) BRITISH	2000-140000	G,F
COX, DAVID	*500-15000	
COX, DAVID (19TH C) BRITISH	*500-75000	L,F,G
COX, DAVID (JR) (THE YOUNGER) (1809-1885) BRITISH	400-9000	L,W
COX, DAVID (SR) (THE ELDER) (1783-1859) BRITISH	*500-6000	
COX, PALMER (1840-1924) CANADIAN/AMERICAN	*150-1000	F,G,I
COXON, ERNEST JAMES (19TH C) BRITISH	100-1200	X(F)
COYPEL, ANTOINE (1661-1722) FRENCH	*800-+++	F
COYPEL, CHARLES ANTOINE	*900-12500	
COYPEL, CHARLES ANTOINE (1694-1752) FRENCH	4000-115000	F
COYPEL, NOEL NICOLAS	*800-6000	

* Denotes watercolors, pastels, drawings, and/or mixed media

COYPEL, NOEL NICOLAS (1690-1734) FRENCH	2000-46000	F
COZENS, ALEXANDER	*300-132000	
COZENS, ALEXANDER (1700-1786) ENGLAND	1000-15000	L
COZZI, M. (19TH C) ITALIAN	100-800	X
COZZOLINO, CIRO (19TH C) ITALIAN	100-1500	M,L
CRABEELS, FLORENT NICOLAS (1829-1896) BELGIAN	900-15000	X(G) G
CRADDOCK, MARMADUKE (1660-1717) BRITISH	1000-26500	L,W
CRAESBEECK, JOOS VAN (1606-1661) FLEMISH	3000-18000	G
CRAIG, JAMES HUMBERT (D. 1944) BRITISH	450-16000	M,L,W
CRAMER, CARL CESAR ADELBERT (1822-1889) DANISH	300-2000	L,S
CRAMPEL, PAUL (Late 19TH C) FRENCH	*100-2000	G,F
CRANACH, LUCAS (THE ELDER) (1472-1553) GERMAN	8000-+++	F,G
CRANE, WALTER	*1200-135000	
CRANE, WALTER (1845-1915) BRITISH	700-+++	M,L
CRANS, JOHANNES MARINUS SCHMIDT (1830-1908) DUTCH	200-4000	X(G,F)
CRAPELET, LOUIS AMABLE (1822-1867) FRENCH	800-14000	L
CRAWFORD, EDMUND THORNTON (1806-1885) BRITISH	900-30000	L
CRAWFORD, WILLIAM (1825-1869) BRITISH	250-6500	G
CRAXTON, JOHN (B. 1922) BRITISH	600-8000	G,F
CRAYER, GASPAR DE (1584-1669) FLEMISH	1000-50000	F,G
CREEFT, JOSE DE (B. 1884) SPANISH	*150-1000	F
CREIXAMS, PIERRE (1893-1965) SPANISH	400-17000	A
CREMIEUX, EDOUARD (B. 1856) FRENCH	450-15000	X(L)
CREPIN, LOUIS PHILIPPE (1772-1851) FRENCH	300-6500	L,M
CRESPI, GIUSEPPE MARIA (1665-1747) ITALIAN	1500-220000	F
CRESPI, LUIGI (1710-1779) ITALIAN	500-77000	X(F)
CRESWICK, THOMAS (1811-1869) BRITISH	1000-30000	L,W,F
CRETI, DONATO (1671-1749) ITALIAN	*800-17000	F
CRETI, GIUSEPPE (1840-1914) ITALIAN	150-4000	L,W
CRIPPA, ROBERTO	*400-57000	
CRIPPA, ROBERTO (1921-1972) ITALIAN	400-25000	X
CRIPPENDORF, WILLIAM (19TH C) AUSTRIAN	200-2000	S
CRIVELLI, ANGELO MARIA (Called LE CRIVELLONE) (17TH/18TH C) ITALIAN	1000-18000	L,W
CROCHEPIERRE, ANDRE ANTOINE (B. 1860) FRENCH	300-4500	G,F
CROEGAERT, GEORGES (B. 1848) DUTCH	1200-80000	G,F,S
CROFT, ARTHUR (B. 1828) BRITISH	*400-6500	M,L
CROFT, C. W. (19TH/20TH C) BRITISH	100-700	X(L)
CROFTS, ERNEST (1847-1911) BRITISH	500-8600	G,W

CROISSANT, AUGUST (1870-1949) GERMAN	150-4500	L
CROME, JOHN (1768-1821) BRITISH	2000-44000	L,F
CROME, JOHN BERNEY (1794-1842) BRITISH	900-30000	G,L,M
CROMEK, THOMAS HARTLEY (1809-1873) BRITISH	900-12000	L
CROMPTON, JAMES SHAW (1853-1916) BRITISH	*300-5000	G,L
CROOKE, RAY AUSTIN (B. 1922) AUSTRALIAN	600-9200	F,L
CROOKE, STEPHEN (20TH C) BRITISH	300-2400	X
CROOS, ANTHONY JANSZ VAN DER (1601-1662) DUTCH	4000-90000	L,G
CROOS, JACOB VAN DER (Active 1690-1700) DUTCH	2000-52000	L,M
CROOS, PIETER VAN DER (B. 1610) DUTCH	2000-19000	M
CROSBY, WILLIAM (19TH C) BRITISH	1000-12000	G
CROSIO, LUIGI (1835-1915) ITALIAN	600-9500	X
CROSNIER, JULES (1843-1917) SWISS	*200-1000	X(L)
CROSS, HENRI EDMOND (HENRI EDMOND DELACROIX)	*900-55000	
CROSS, HENRI EDMOND (HENRI EDMOND DELACROIX) (1856-1910) FRENCH	4000-+++	M,F,L,A
CROTIN, H. (20TH C) FRENCH	100-700	X
CROTTI, JEAN	*750-88000	
CROTTI, JEAN (1878-1958) FRENCH	900-98000	A
CROUCH, WILLIAM (Active 1817-1840) BRITISH	*100-3000	L
CROUSE, M. (19TH C) BRITISH	100-700	M
CROW, B. (19TH C) BRITISH	100-600	X
CROWE, EYRE (1824-1910) BRITISH	800-12000	X(F,G)
CRUICKSHANK, WILLIAM	*300-2600	
CRUICKSHANK, WILLIAM (Active 1866-1877) BRITISH	400-3500	S,G
CRUIKSHANK, GEORGE (1792-1878) BRITISH	*300-3800	L,F
CRUIKSHANK, ISAAC (1756-1811) BRITISH	*500-5000	X(I)
CRUZ-DIEZ, CARLOS	*400-21000	
CRUZ-DIEZ, CARLOS (B. 1923) VENEZUELAN	500-20000	A
CRUZ-HERRERA, JOSE HERREILLA (B. 1890) SPANISH	400-4000	F
CSAPO, G. (20TH C) HUNGARIAN	100-600	X
CSOK, ISTVAN (1865-1961) HUNGARIAN	300-4500	X(F)
CUARTAS VELASQUEZ, GREGORIO	*400-2000	
CUARTAS VELASQUEZ, GREGORIO (B. 1938) COLOMBIAN	500-7500	X(S,F)
CUBLEY, HENRY HADFIELD (Late 19TH C) BRITISH	100-2300	L
CUEVAS, JOSE LUIS	*600-12000	
CUEVAS, JOSE LUIS (B. 1934) MEXICAN	700-3500	F,G
CUGAT, DELIA	*300-1000	
CUGAT, DELIA (20TH C) ARGENTINIAN	400-6000	A

* Denotes watercolors, pastels, drawings, and/or mixed media

CUGAT, XAVIER (20TH C) CUBAN	150-1000	F,G
CUGNIART, EMILE (B. 1851) FRENCH	100-600	X
CUITT, GEORGE (THE YOUNGER) (1779-1854) BRITISH	2000-28000	L
CULL, JAMES ALLENSON (19TH C) BRITISH	300-2500	F
CULLEN, MAURICE GALBRAITH (1866-1934) CANADIAN	2000-60000	M,L
CULVERHOUSE, JOHANN MONGELS (B. 1820) DUTCH	3000-26000	G,L
CUNDALL, CHARLES ERNEST (1890-1971) BRITISH	400-19000	G,L
CUNDELL, NORA LUCY MOWBRAY (1889-1948) BRITISH	1200-30000	F,L
CUNEO, JOSE	*100-900	
CUNEO, JOSE (B. 1889) URUGUAY	300-11000	G,L
CUNLIFFE, DAVID (19TH C) BRITISH	400-13000	G
CUNNINGTON, A. (19TH C) BRITISH	100-700	X
CUREL-SYLVESTRE, ROGER (B. 1884) FRENCH	100-800	X
CURNOCK, JAMES JACKSON (1839-1891) BRITISH	*300-3200	G,L,F,W
CURRADI, FRANCESCO (1570-1661) ITALIAN	*900-12000	F
CURRIE, WILLIAM (19TH C) BRITISH	150-1000	L
CURRIER, R. W. (Early 19TH C) BRITISH	200-1200	X
CURSITER, STANLEY (B. 1887) BRITISH	600-50000	F,L
CURTIS, JAMES WALTHAM (19TH/20TH C) AUSTRALIAN	900-32000	L
CUSACHS Y CUSACHS, JOSE (1851-1908) SPANISH	1500-188000	X(F)
CUVILLON, LOUIS ROBERT DE (B. 1848) FRENCH	*100-900	X
CUYLENBORCH, ABRAHAM VAN (1620-1658) DUTCH	700-12000	L,F
CUYP, AELBERT (1620-1691) DUTCH	4000-+++	L,F,S,W
CUYP, BENJAMIN GERRITSZ (1612-1652) DUTCH	1200-35500	G,F
CUYP, JACOB GERRITZ (1594-1651) DUTCH	3000-+++	X(F,W)
CZACHORSKI, WLADYSLAW VON (1850-1911) POLISH	1000-20000	F
CZEDEKOWSKI, BOLESLAW JAN (1885-1969) POLISH	350-7000	G,F
CZERNICKI, M. (19TH C) POLISH	100-600	X
CZERNOTZKY, ERNST (1869-1939) AUSTRIAN	350-2500	X(S)
CZOBEL, BELA A. (1883-1974) HUNGARIAN	600-9000	X(F,W)

D

ARTIST	PRICES	SUBJECT
D'ANCONA, VITO (1825-1884) ITALIAN	2000-45000	F
D'ANTONIO, FRANCESCO (15TH C) ITALIAN	10000-125000	F
D'ANTY, HENRY (B. 1910) FRENCH	400-5000	X(L)
D'ARLES, HENRI (1734-1784) FRENCH	2000-50000	M,L
D'ARTHOIS, JACQUES (1613-1686) FLEMISH	1000-33000	L
D'EGVILLE, JAMES T. HERVE (D. 1880) BRITISH	*150-700	M
D'ENTRAYGUES, CHARLES BERTRAND (B. 1851) FRENCH	1000-77000	G,F
D'ESPAGNAT, GEORGES (1870-1950) FRENCH	5000-180000	F,S
DA COSTA, JULIO (B. 1855) PORTUGESE	200-1200	X
DADD, FRANK (1851-1929) BRITISH	*500-10000	G,F
DADD, RICHARD (1819-1887) BRITISH	*900-32000	X
DADO (B. 1933) YUGOSLAV	2000-50000	A
DAEL, JAN FRANS VAN (1764-1840) FLEMISH	2500-+++	S,G
DAELE, CHARLES VAN DEN (1818-1880) BELGIAN	700-9500	G
DAELEN, EDWARD (B. 1848) GERMAN	400-3500	G,F
DAEYE, HIPPOLYTE (1873-1952) BELGIAN	1000-30000	F
DAGNAC-RIVIERE, CHARLES (1864-1945) FRENCH	150-3600	S
DAGNAN-BOUVERET, PASCAL ADOLPHE JEAN	*200-6900	
DAGNAN-BOUVERET, PASCAL ADOLPHE JEAN (1852-1929) FRENCH	2000-30000	G,F
DAHL, HANS A. (1849-1937) NORWEGIAN	1500-32000	G,L,F
DAHL, JOHAN CHRISTIAN CLAUSEN (1788-1857) NORWEGIAN	2000-89000	L,M
DAHL, MICHAEL (1656-1742) SWEDISH	600-22000	F
DAHL, PETER (B. 1934) SWEDISH	600-26000	L,S
DAHL, SIGWALD (1827-1902) NORWEGIAN	600-9000	W,M,L
DAHLMAN, HELGE (1924-1979) FINNISH	700-8000	L,M
DAHLSKOG, EVALD (1894-1950) SWEDISH	400-22000	F,L
DAHMEN, KARL-FRED	*600-25000	
DAHMEN, KARL-FRED (B. 1917) GERMAN	300-49000	A
DAIWAILLE, ALEXANDER JOSEPH (1818-1888) DUTCH	1500-42000	L
DAKE, CAREL LODEWYK (19TH-20TH C) DUTCH	300-3500	L
DALBONO, EDUARDO	*300-6000	
DALBONO, EDUARDO (1841-1915) ITALIAN	500-55000	A
DALBY, DAVID (Called DALBY OF YORK) (1790-1850) BRITISH	1500-35000	G,W
DALBY, JOHN (1826-1853) BRITISH	2000-39000	L,W
DALI, LOUIS (20TH C) FRENCH	200-1000	X(L)
DALI, SALVADOR	*1200-+++	
DALI, SALVADOR (B. 1904) SPANISH	8000-+++	A

* Denotes watercolors, pastels, drawings, and/or mixed media

DALIN, LOUIS (20TH C) FRENCH	100-700	X
DALLAIRE, JEAN PHILIPPE (1916-1965) CANADIAN	1000-50000	A
DALLEMAGNE, ADOLPHE (B. 1811) FRENCH	200-2500	G,L
DALLEMAGNE, LEON (19TH C) FRENCH	100-2000	L
DALLINGER, FRANTZ THEODOR (1710-1771) CZECHOSLOVAKIAN	400-6000	L,W,S
DALLINGER VON DALLING, JOHN BAPTIST (1782-1868) AUSTRIAN	7000-9500	L
DALOU, AIME JULES (1838-1902) FRENCH	500-6500	F
DALRINCON Y TRIVES, MARTINEZ (1840-1892) SPANISH	300-1200	X
DALSGAARD, CHRISTEN (1824-1907) DANISH	700-7900	G,F,L
DALSGAARD, SVEN (B. 1914) DANISH	500-6500	X
DAMAS, EUGENE (1848-1917) FRENCH	200-2500	G,L
DAMERON, EMILE CHARLES (1848-1908) FRENCH	400-6200	L,F
DAMERON, EMILE CHARLES (1848-1908) FRENCH	600-6000	L,F
DAMME, FRANS VAN (B. 1860) FLEMISH	500-15000	M,L
DAMME-SYLA, EMILE VAN (1853-1935) BELGIAN	300-4200	W,L
DAMOYE, PIERRE EMMANUEL (1847-1916) FRENCH	1000-36000	L
DAMSCHROEDER, JAN JAC MATTHYS (1825-1905) GERMAN	500-8200	F,G
DANBY, FRANCIS	*800-8500	
DANBY, FRANCIS (1793-1861) BRITISH	750-65000	L,F
DANBY, G. (19TH C) BRITISH	150-900	X
DANBY, JAMES FRANCIS (1816-1875) BRITISH	500-12000	M,G
DANBY, M. (19TH C) FRENCH	100-700	X
DANBY, THOMAS (1817-1886) BRITISH	200-5000	M,L
DANCE, GEORGE (1741-1825) BRITISH	*500-4000	F
DANCE, SIR NATHANIEL (DANCE-HOLLAND) (1734-1811) BRITISH	2000-96500	G,F
DANCKERTS, HENDRICK (1625-1679) DUTCH	3000-87000	L
DANCKERTS, JOHAN HENRY (1615-1687) DUTCH	400-7000	X(L)
DANDINI, CESARE (1595-1658) ITALIAN	600-86000	F
DANDINI, PIETRO (1646-1712) ITALIAN	1000-35000	F
DANDINI, VINCENZO (1607-1675) ITALIAN	1500-20000	F
DANDRIDGE, BARTHOLOMEW (1691-1751) BRITISH	2500-52000	F,W
DANFORTH, CHARLES (19TH C) BRITISH	200-1500	X
DANGER, HENRI CAMILLE (1857-1937) FRENCH	250-2800	X(G)
DANHAUSER, JOSEF (1805-1845) AUSTRIAN	550-30000	F,G
DANIELL, SAMUEL (1775-1811) BRITISH	*700-7000	L
DANIELL, WILLIAM (1769-1837) BRITISH	1000-+++	L,G,F
DANIELS, ANDRIES (1580-1640) FLEMISH	3500-+++	X
DANIELSON-GAMBOGI, ELIN (1861-1919) FRENCH	3000-75000	L,F

DANILOWATZ, JOSEPH (1877-1945) AUSTRIAN	300-3500	F
DANIOTH, HEINRICH (1896-1953) GERMAN	*1000-20000	X (F)
DANKMEYER, CAREL BERNARDUS (1861-1923) DUTCH	300-2500	L
DANKWORTH, AUGUST (1813-1854) GERMAN	300-3500	G
DANLOUX, HENRI PIERRE	*800-6500	
DANLOUX, HENRI PIERRE (1753-1809) FRENCH	2500-200000	G,F
DANSAERT, LEON MARIE CONSTANT (1830-1909) BELGIAN	300-6500	G
DANTON, A. F. (20TH C) BRITISH	500-4500	I
DANZ, ROBERT	*100-400	
DANZ, ROBERT (B. 1841) GERMAN	100-32000	X
DARAGNES, JEAN GABRIEL (1886-1950) FRENCH	200-1500	L,S
DARDEL, FRITZ VON (1817-1901) SWEDISH	*600-4500	G,F
DARDEL, NILS (1888-1942) SWEDISH	1500-+++	F,M
DARGELAS, ANDRE HENRI (1828-1906) FRENCH	2000-25000	M,G
DARNAUT, HUGO (1851-1937) AUSTRIAN	600-14000	L,W
DARWIN, SIR ROBIN (B.1910) BRITISH	500-3000	F,L
DASTUGUE, MAXIME (1851-1909) FRENCH	200-2000	X(F)
DAUBIGNY, CHARLES (1740-1830) FRENCH	1500-35000	G
DAUBIGNY, CHARLES FRANCOIS	*400-20000	
DAUBIGNY, CHARLES FRANCOIS (1817-1878) FRENCH	3000-128000	L,W,F
DAUBIGNY, KARL PIERRE (1846-1886) FRENCH	500-19000	L,W
DAUCHOT, GABRIEL (B. 1927) FRENCH	400-5000	F,G
DAUMIER, HONORE	*3500-+++	
DAUMIER, HONORE (1808-1879) FRENCH	5000-+++	G,F
DAUMIER, JEAN (20TH C) FRENCH	400-5000	L,F
DAUX, CHARLES EDMOND (B. 1855) FRENCH	1500-20000	G,L
DAUZATS, ADRIEN (1804-1868) FRENCH	*300-4500	G
DAVID, GIOVANNI (1743-1790) ITALIAN	400-4500	L
DAVID, GUSTAVE (1824-1891) FRENCH	*300-3200	G,F
DAVID, HERMINE	*200-1800	
DAVID, HERMINE (1886-1971) FRENCH	300-8400	L,F
DAVID, JACQUES LOUIS	*2500-98000	
DAVID, JACQUES LOUIS (1748-1825) FRENCH	10000-+++	G,F
DAVID, JULES (1808-1892) FRENCH	*300-3500	F
DAVID-NILLET, GERMAIN (1861-1932) FRENCH	100-900	L
DAVIDSON, ALLAN DOUGLAS (1874-1932) BRITISH	100-6500	G,F
DAVIDSON, BESSIE (B. 1880) BRITISH	4000-42000	S,L
DAVIDSON, CHARLES GRANT	*300-7200	
DAVIDSON, CHARLES GRANT (1820-1902) BRITISH	200-1500	L

* Denotes watercolors, pastels, drawings, and/or mixed media

DAVIDSON, J. A. (19TH C) BRITISH	100-1200	X
DAVIDSON, JEREMIAH (1695-1745) BRITISH	300-31000	F
DAVIDSON, LILIAN (20TH C) BRITISH	900-8500	G,L,F
DAVIDSON, ROWLAND (20TH C) BRITISH	400-5000	G,F
DAVIDSON, THOMAS (Late 19TH C) BRITISH	300-8500	G,F
DAVIE, ALAN	*300-13000	
DAVIE, ALAN (B. 1920) BRITISH	1000-85000	A
DAVIES, ARTHUR E (B. 1893) BRITISH	*100-3000	M,L,F
DAVIES, DAVID (1862-1939) AUSTRALIAN	*600-7500	M,L,F
DAVIES, JAMES HEY (1848-1901) BRITISH	200-3000	G,L
DAVIES, NORMAN PRESCOTT (1862-1915) BRITISH	400-20000	G,F
DAVIES, WILLIAM (1826-1901) BRITISH	300-4500	M,L
DAVIS, ARTHUR H. (Late 19TH C) BRITISH	500-10000	L
DAVIS, EDWARD T. (1833-1867) BRITISH	400-14000	G,L
DAVIS, FLOYD MACMILLAN (1896-1966) BRITISH	*150-900	I
DAVIS, FREDERICK WILLIAM (1862-1919) BRITISH	350-10000	G
DAVIS, HENRY WILLIAM BANKS (1833-1914) BRITISH	600-26000	L,W
DAVIS, RICHARD BARRETT (1782-1854) BRITISH	1500-36000	W,L
DAVIS, VAL (1854-1930) BRITISH	*300-1500	L,F,W
DAVIS, WILLIAM HENRY (D. 1865) BRITISH	600-15000	L,W
DAVISON, THOMAS RAFFLES (1853-1937) BRITISH	200-2000	X
DAWE, GEORGE (1781-1829) BRITISH	300-21000	F
DAWSON, ALFRED (1860-1894) BRITISH	250-4500	L
DAWSON, HENRY	*150-800	
DAWSON, HENRY (1811-1878) BRITISH	1000-18000	L,M
DAWSON, HENRY THOMAS (19TH C) BRITISH	1000-16000	M
DAWSON, MONTAGUE J.	*900-37000	
DAWSON, MONTAGUE J. (1895-1973) BRITISH	2500-145000	M
DAWSON, S. (19TH C) BRITISH	200-1200	X(G)
DAY, EDWIN (19TH C) BRITISH	100-700	X
DAYES, EDWARD (1763-1804) BRITISH	*500-50000	L
DAYEZ, GEORGES (B. 1907) FRENCH	450-11000	X (L)
DAYRELL, B. (19TH C) BRITISH	300-6000	W
DEAK, EBNER LAJOS (1850-1934) EUROPEAN	300-1800	L
DEAN, FRANK (1865-1947) BRITISH	300-2400	L,G
DEANE, DENNIS WOOD (19TH C) BRITISH	200-2500	F,G
DEANES, EDWARD (19TH C) BRITISH	300-4000	G,F
DEARMAN, JOHN (D. 1857) BRITISH	400-5000	G,L,W
DEBAINS, THERESE (B. 1907) FRENCH	100-1100	X(S)

DEBAT-PONSAN, EDOUARD BERNARD (1847-1913) FRENCH	800-25000	G,W,L
DEBEUL, LAURENT (19TH C) BELGIAN	300-2400	X
DEBLOIS, FRANCOIS B. (1829-1913) CANADIAN	300-5800	S
DEBRE, OLIVIER (B. 1920) FRENCH	1000-134000	X
DEBUCOURT, PHILIBERT LOUIS (1755-1832) FRENCH	600-18000	G,L
DEBUELL, J. (19TH C) EUROPEAN	100-700	X
DECAISNE, HENRI (1799-1852) BELGIAN	250-4000	G
DECAMPS, ALEXANDRE GABRIEL	*1000-22000	
DECAMPS, ALEXANDRE GABRIEL (1803-1860) FRENCH	1500-24000	G,F,W
DECKER, CORNELIS (1651-1709) DUTCH	1000-25000	G,F,L
DECKER, CORNELIS GERRITSZ (1643-1678) DUTCH	1000-23000	L,F
DECOENE, HENRI (1798-1866) BELGIAN	300-5000	X
DEFAUX, ALEXANDRE (1826-1900) FRENCH	500-8200	G,L,W
DEFFNER, LUDWIG (19TH/20TH C) GERMAN	400-5000	S
DEFRANCE, LEONARD (1735-1805) FLEMISH	1500-36000	F,S
DEFREES, T. (Late 19TH C) BRITISH	150-800	X
DEFREGGER, FRANZ VON (1835-1921) GERMAN	4000-140000	F,G
DEFSUALAVY, J. (19TH C) EUROPEAN	200-1500	X
DEGAS, EDGAR	*2500-+++	
DEGAS, EDGAR (1834-1917) FRENCH	15000-+++	F,G
DEGER, ERNST (1809-1885) GERMAN	300-3200	F
DEGOTTEX, JEAN	*800-21000	
DEGOTTEX, JEAN (20TH C) FRENCH	1000-187000	A
DEGOUVE DE NUNCQUES, WILLIAM (1867-1935) BELGIAN	5000-+++	L
DEGRAIN, ANTONIO MUNOZ (19TH C) SPANISH	1000-18000	L
DEHAUSSY, JULES JEAN BAPTISTE (1812-1891) FRENCH	400-4500	F
DEHN, GEORG (1843-1904) GERMAN	500-6000	G,F,L
DEHODENCQ, EDME ALEXIS ALFRED (1822-1882) FRENCH	900-92000	F,G
DEIBL, ANTON (1833-1883) GERMAN	450-6000	G,F
DEIKER, CARL FREIDRICH (1836-1892) GERMAN	400-6500	L,W
DEIKER, JOHANNE-CHRISTAIN (1822-1895) GERMAN	400-6500	W,L
DEIRA, ERNESTO (B. 1928) ARGENTINIAN	200-1500	A
DELACHAUX, LEON (1850-1919) SWISS	400-10000	G,F
DELACOUR, WILLIAM (1700-1768) FRENCH	*400-3500	L
DELACROIX, AUGUSTE (1809-1868) FRENCH	800-28000	G,L,M,W
DELACROIX, EMILIENNE (B. 1893) FRENCH	100-700	X
DELACROIX, EUGENE	*800-136000	
DELACROIX, EUGENE (1798-1863) FRENCH	10000-+++	F
DELACROIX, HENRI EUGENE (1845-1930) FRENCH	500-6500	X(G)

DELACROIX, PAUL (19TH/20TH C) FRENCH	100-1400	X
DELAFOSSE, JEAN CHARLES DE (1734-1789) FRENCH	*400-9500	G,F
DELAHOGUE, ALEXIS AUGUSTE (1867-1930) FRENCH	300-3500	G,L
DELAMAIN, PAUL (1821-1882) FRENCH	500-11000	G
DELAN, J. (19TH C) EUROPEAN	100-700	X
DELANCE, PAUL LOUIS (1848-1924) FRENCH	400-4500	M
DELANOY, HIPPOLYTE PIERRE (1849-1899) FRENCH	300-3500	G,S
DELAPORTE, ROGER (1907-1972) FRENCH	150-900	X
DELAROCHE, PAUL (HIPPOLYTE DELAROCHE)	*400-9500	
DELAROCHE, PAUL (HIPPOLYTE DELAROCHE) (1797-1856) FRENCH	600-37000	G,F
DELASALLE, ANGELE (B. 1867) FRENCH	150-2400	X(G)
DELATTRE, HENRI (1801-1876) FRENCH	1500-90000	G,L,W
DELATTRE, MATHILDE H. (B. 1871) EUROPEAN	150-1200	X(L)
DELAUNAY, JULES (D. 1906) FRENCH	200-1500	X
DELAUNAY, JULES ELIE (Called DUVAL) (1828-1891) FRENCH	350-7000	G,F
DELAUNAY, ROBERT	*4000-+++	
DELAUNAY, ROBERT (1885-1941) FRENCH	10000-+++	A
DELAUNAY, SONIA	*1500-104000	
DELAUNAY, SONIA (1885-1979) RUSSIAN/FRENCH	8000-+++	A
DELAVALLEE, HENRI (20TH C) FRENCH	2000-65000	L
DELAYE, ALICE (1884-1963) FRENCH	150-900	X
DELBECKE, LOUIS AUGUSTE CORNEILLE (1821-1891) BELGIAN	1000-15000	G,W
DELCOUR, PIERRE (19TH C) FRENCH	250-1500	X
DELDERENNE, LEON (19TH/20TH C) BELGIAN	100-1200	X(W)
DELECLUSE, AUGUSTE JOSEPH (1855-1928) FRENCH	500-6500	F
DELEHAYE, F. (B. 1843) FLEMISH	100-900	X
DELEN, DIRK VAN (1605-1671) DUTCH	2000-80000	G,L
DELERIVE, NICOLAS LOUIS ALBERT (18TH C) FRENCH	600-9000	G,W
DELESTRE, ADOLPHE ALEXANDRE (19TH C) FRENCH	2000-22000	L,G
DELFAU, ANDRE (20TH C) FRENCH	*100-900	X(G,L)
DELFGAAUW, GERARD JOHANNES (1882-1947) DUTCH	350-4000	L
DELFOSSE, AUGUSTE (Mid 19TH C) BELGIUM	300-2800	F
DELFT, CORNELIS JACOBSZ (1571-1643) DUTCH	2000-34000	S
DELISSER, R. LIONEL (19TH/20TH C) BRITISH	*100-700	X
DELL, ADOLF (1890-1977) GERMAN	400-4500	L,S
DELL'ACQUA, CESARE FELIX GEORGES (1821-1904) AUSTRIAN	400-5800	G,F
DELLA GATTA, SAVERIO (18TH/19TH C) ITALIAN	*400-3500	X
DELLEANI, LORENZO (1840-1908) ITALIAN	1500-25000	X (L)

DELLGRUEN, FRANZISKUS (1901-1984) GERMAN	600-6400	X
DELMOTTE, MARCEL (B. 1901) FRENCH	400-8200	F,S
DELOBBE, FRANCOIS ALFRED (1835-1920) FRENCH	450-5500	G,F
DELORME, ANTHONIE (D. 1673) DUTCH	1500-20000	X
DELORME, BERTHE (19TH-20TH C) SWISS	400-6000	X(F)
DELORME, MARGUERITE ANNE ROSE (1876-1946) FRENCH	300-7200	X(G,F)
DELORME, RAPHAEL (20TH C) FRENCH	1200-55000	F,G
DELORT, CHARLES EDOUARD	*400-4500	
DELORT, CHARLES EDOUARD (1841-1895) FRENCH	1500-42000	G,F
DELPECH, JEAN (20TH C) FRENCH	*150-900	X
DELPY, HIPPOLYTE CAMILLE (1842-1910) FRENCH	1000-50000	M,L
DELPY, JACQUES HENRY (1877-1957) FRENCH	500-6200	L,M
DELVAUX, PAUL	*2000-212000	
DELVAUX, PAUL (B. 1898) BELGIAN	8000-+++	G,L,M,A
DELYEN, JACQUES FRANCOIS (1684-1761) FRENCH	300-4200	F
DEMACHY, PIERRE ANTOINE (1723-1807) FRENCH	2000-62000	L
DEMAN, ALBERT (20TH C) FRENCH	400-2000	X (S)
DEMAREST, GUILLAUME ALBERT (1848-1906) FRENCH	300-4000	X(G)
DEMARNE, JEAN LOUIS (1744-1829) FRENCH	1200-85000	G,L,W
DEMETZ, KARL (B. 1909) GERMAN	300-3500	F,L
DEMONCHY, ANDRE (B. 1914) FRENCH	150-1500	X(L)
DEMONT-BRETON, VIRGINIE (1859-1935) FRENCH	500-9000	G
DENAVE, GERARD BOR (19TH/20TH C) DUTCH	300-2500	L
DENEUX, GABRIEL CHARLES	*150-800	
DENEUX, GABRIEL CHARLES (B. 1856) FRENCH	500-9000	G
DENIS, MAURICE	*500-170000	
DENIS, MAURICE (1870-1943) FRENCH	2500-+++	L,F
DENISOFF-URALSKY, A. K. (19TH/20TH C) RUSSIAN	500-10000	G,L,F
DENNER, BALTHASAR (1685-1749) GERMAN	500-7000	G,F,S
DENNEULIN, JULES (1835-1904) FRENCH	300-3500	M,F,L
DENONNE, ALEXANDER (1879-1953) BELGIAN	1000-20000	G,L
DENTMANN, F. (19TH C) EUROPEAN	100-700	X
DEPAUW, ROBERT (19th C) EUROPEAN	300-2500	G
DEPERO, FORTUNATO	*200-26000	
DEPERO, FORTUNATO (1892-1960) ITALIAN	1200-42000	A
DEPLECHIN, EUGENE (B. 1852) FRENCH	500-3000	F
DERAIN, ANDRE	*1000-165000	
DERAIN, ANDRE (1880-1954) FRENCH	60000-+++	L,F,S,A
DERAUX, MARCHAND (20TH C) FRENCH	150-700	X

* Denotes watercolors, pastels, drawings, and/or mixed media

DERI, KALMAN (B. 1859) HUNGARIAN	300-5500	G
DERKERT, SIRI (1888-1973) SWEDISH	400-13000	L
DERREY, JACQUES CHARLES (B. 1907) FRENCH	*100-600	X(L)
DES CLAYES, BERTHE (B. 1877) CANADIAN	*150-1000	L
DES FONTAINES, ANDRE (B. 1869) FRENCH	*150-1500	L
DES ISNARD, LOUIS MARQUIS (1805-1888) FRENCH	300-2400	L
DESAN, CHARLES (19TH C) BELGIAN	100-1000	W
DESANDRE, JULES MARIE (19TH C) FRENCH	400-3500	L
DESCAMPS, ALEXANDRE GABRIEL (1803-1860) FRENCH	400-3500	L
DESCHAMPS, GABRIEL (B. 1919) FRENCH	200-6000	X(F)
DESCHAMPS, LOUIS HENRI (1846-1902) FRENCH	400-6500	G,F
DESCHAMPS, P. (20TH C) FRENCH	100-600	X
DESCOURS, GEORGES (1889-1964) FRENCH	150-1200	X(L)
DESGOFFE, BLAISE A. (1830-1901) FRENCH	400-18000	S
DESHAYES, CELESTIN (1817-1884) FRENCH	200-1400	L,F
DESHAYES, CHARLES FELIX EDOUARD (B. 1831) FRENCH	500-5500	L,W
DESHAYES, EUGENE (1828-1890) FRENCH	400-7500	M,L
DESHAYS, JEAN BAPTISTE	*400-16000	
DESHAYS, JEAN BAPTISTE (1729-1765) FRENCH	500-17500	F,G
DESIDERIO, MONSU (16TH/17TH C) FRENCH	2500-75000	F,L
DESIRE-LUCAS, LOUIS-MARIE (B. 1869) FRENCH	600-5700	L
DESMAREES, GEORGES (1697-1776) SWEDISH	500-5500	F
DESNOS, FERDINAND (1901-1958) FRENCH	600-5000	X
DESNOYER, FRANCOIS (1894-1972) FRENCH	1000-40000	A
DESPIAU, CHARLES (1874-1946) FRENCH	*300-8900	F
DESPIERRE, JACQUES CERIA (B. 1912) FRENCH	300-11000	L
DESPORTES, ALEXANDRE FRANCOIS (1661-1743) FRENCH	5000-+++	F,L,S
DESPORTES, CLAUDE-FRANCOIS (1695-1774) FRENCH	3000-35000	W,L
DESPUJOLS, JEAN (B. 1886) FRENCH	2000-18000	F
DESRAIS, CLAUDE LOUIS (1746-1816) FRENCH	500-4500	G,F
DESSOULAVY, THOMAS (19TH C) BRITISH	4000-25000	L,M
DESTOUCHES, JOHANNA VON (1869-1956) GERMAN	400-7200	S
DESVARREUX, RAYMOND (1876-1961) FRENCH	300-4000	F,G
DESVIGNES, HERBERT CLAYTON (19TH C) BRITISH	450-12000	W
DETAILLE, EDOUARD	*500-12000	
DETAILLE, EDOUARD (1848-1912) FRENCH	2000-55000	G,F
DETAILLE, JEAN BAPTISTE EDOUARD (1848-1912) FRENCH	1500-55000	F
DETAILLE, JEAN BAPTISTE EDUOARD	*400-55000	
DETJENS, H. (19TH C) DUTCH	100-700	X

DETMOLD, CHARLES MAURICE (1883-1908) BRITISH	*150-5500	W,I
DETMOLD, EDWARD JULIAN (1883-1957) BRITISH	*500-4800	X (S)
DETMOLD, HENRY E. (B. 1854) BRITISH	350-4500	X(F)
DETROY, LEON (1857-1955) FRENCH	500-9500	L,S,F
DETTHOW, ERIC (1888-1952) SWEDISH	400-6500	L,S
DETTI, CESARE AUGUSTE	*300-2500	
DETTI, CESARE AUGUSTE (1847-1914) ITALIAN	3000-42000	G,F
DETTMANN, LUDWIG JULIUS CHRISTIAN (1865-1944) EUROPEAN	*350-18000	L
DETTMER, A. (19TH C) GERMAN	100-900	X
DEULLY, EUGENE AUGUSTE FRANCOIS (B. 1860) FRENCH	550-30000	G,F
DEURER, PETER FERDINAND (1777-1884) GERMAN	300-3000	F
DEUTSCH, BORIS	*100-600	
DEUTSCH, BORIS (1892-1978) RUSSIAN/AMERICAN	300-2500	F,G
DEUTSCH, LUDWIG (1855-1935) AUSTRIAN	8000-225000	G,F
DEUUS, JESUS (20TH C) MEXICAN	100-900	X
DEVAL, PIERRE (B. 1897) FRENCH	*400-6000	F,S
DEVAMBEZ, ANDRE VICTOR EDOUARD (1867-1943) FRENCH	300-5000	G
DEVAUX, JULES ERNEST (B. 1837) FRENCH	200-3200	G,F
DEVEDEUX, LOUIS (1820-1874) FRENCH	300-4900	G,L
DEVEIQUE, J. (19TH C) BRITISH	5000-25000	G,W
DEVEREAUX, CHARLES (19TH C) FRENCH	300-3000	X(G)
DEVERIA, ACHILLE JACQUES JEAN MARIE (1800-1857) FRENCH	*400-5300	F,G
DEVERIA, EUGENE FRANCOIS MARIE JOSEPH (1808-1865) FRENCH	*300-8800	F,G
DEVERIN, ROGER (B. 1884) FRENCH	100-600	X
DEVEUX, T. (19TH C) EUROPEAN	150-900	X
DEVIS, ANTHONY (1729-1817) BRITISH	*400-3500	L
DEVIS, ARTHUR (1711-1787) BRITISH	8000-+++	F
DEVOS, LEON (1897-1974) BELGIUM	300-7400	F,S
DEVOS, VINCENT (1829-1875) BELGIAN	300-3200	X(W)
DEWASNE, JEAN (B. 1921) FRENCH	*500-8400	A
DEWHURST, WYNFORD (B. 1864) BRITISH	200-17000	L
DEWILDE, J. (19TH C) DUTCH	150-800	X
DEWITT, JACOB (19TH C) DUTCH	300-3500	X
DEWOLF, JOHANNES PETRUS (19TH C) DUTCH	100-1000	X(L)
DEXEL, WALTER (B. 1890) GERMAN	*2000-13000	A
DEYROLLE, JEAN (1911-1967) FRENCH	1000-21000	A
DEZARATE, MANUEL ORITZ (1886-1946) FRENCH	*100-700	X
DEZAUNAY, EMILE (1854-1940) FRENCH	1200-27000	M,G

* Denotes watercolors, pastels, drawings, and/or mixed media

DHURMER, LUCIEN LEVY (1865-1953) FRENCH	*550-33000	X
DI CAVALCANTI, EMILIANO	*500-20000	
DI CAVALCANTI, EMILIANO (B. 1897) BRAZILIAN	2500-68000	X
DI VOLO, SILVIO (B. 1907) ITALIAN	300-2000	X
DIART, JULES EDOUARD (19TH C) FRENCH	500-5200	S
DIAZ DE LA PENA, NARCISSE VIRGILE	*300-2000	
DIAZ DE LA PENA, NARCISSE VIRGILE (1807-1876) FRENCH	400-94000	G,L,F
DIBDIN, THOMAS COLMAN (1810-1876) BRITISH	250-2400	G,M,L
DICKINSON, JOHN REED (Late 19TH C) BRITISH	*100-900	F,L
DICKSEE, FRANK BERNARD (1853-1928) BRITISH	4000-175000	G,L
DIDAY, FRANCOIS (1802-1877) SWISS	2500-32000	F,L,W
DIDIER, CLOVIS FRANCOIS AUGUSTE (B. 1858) FRENCH	500-9000	G,F
DIDIER, JULES (1831-1892) FRENCH	300-7500	L,F,W
DIDIER-POUGET, WILLIAM (1864-1959) FRENCH	250-3500	M,L
DIDIONI, FRANCESCO (1859-1895) ITALIAN	*200-1800	F,G
DIEFFENBACH, ANTON H. (1831-1914) GERMAN	400-12500	F
DIEGHEM, A. VAN (Active 1865-1910) DUTCH	200-2800	W,L
DIEGHEM, JACOB VAN (19TH C) DUTCH	350-4200	W,L
DIEHL-WALLENDORF, HANS (B. 1877) GERMAN	100-800	X(L)
DIELMAN, PIERRE EMMANUEL (1800-1858) BELGIAN	400-9500	W,L
DIELMANN, JACOB FURCHTEGOTT	*200-3500	
DIELMANN, JACOB FURCHTEGOTT (1809-1885) GERMAN	400-8000	G,F,L
DIEMER, MICHAEL ZENO (1867-1939) GERMAN	1400-88000	M
DIEPRAEM, ABRAHAM (1622-1670) DUTCH	500-10000	G
DIEST, ADRIAEN VAN (1656-1704) DUTCH	700-20000	M
DIEST, JERONYMUS VAN (1631-1672) DUTCH	7000-32000	M
DIEST, JOHAN VAN (17TH/18TH C) DUTCH	600-6500	F
DIEST, WILLEM VAN (1610-1673) DUTCH	1200-57000	M,L
DIETERLE, MARIE (1856-1935) FRENCH	300-16000	L,W
DIETLER, JOHANN FRIEDRICH (1804-1874) SWISS	*500-12000	G,F
DIETMAR, OSCAR (19TH C) GERMAN	150-900	X
DIETRICH, ADELHEID (B. 1827) GERMAN	6000-80000	S
DIETRICH, ADOLF (1877-1957) SWISS	3500-92000	S,L
DIETRICH, CHRISTIAN WILHELM ERNST	*300-3500	
DIETRICH, CHRISTIAN WILHELM ERNST (1712-1774) GERMAN	700-32000	F,G,L
DIETZSCH, BARBARA REGINA (1706-1783) GERMAN	*400-15000	W,S
DIEY, YVES (B. 1892) FRENCH	150-1700	F
DIGHTON, RICHARD (1785-1880) BRITISH	*250-2500	F,G,I
DIGNIMONT, ANDRE (1891-1965) FRENCH	*400-5900	F

DIJSSEHOF, GERRIT W. (1856-1924) EUROPEAN	400-4000	M
DILL, BRYAN (19TH C) BRITISH	100-700	X
DILL, LUDWIG	*300-6000	
DILL, LUDWIG (1848-1940) GERMAN	1000-13000	M,G,L
DILL, OTTO	*400-4500	
DILL, OTTO (1884-1957) GERMAN	1500-32000	L,W,F
DILL-MALBURG, J. (19TH/20TH C) GERMAN	100-900	L
DILLENS, ADOLPHE (1821-1877) BELGIAN	400-15000	G,L
DILLENS, HENDRICK JOSEPH (1812-1872) BELGIAN	500-3800	F
DILLIS, JOHANN GEORG VON (1759-1841) GERMAN	500-5000	L
DILLON, FRANK (1823-1909) BRITISH	100-38000	G,L
DINET, ETIENNE (1861-1929) FRENCH	800-102000	F
DINGER, OTTO (B. 1860) GERMAN	100-1000	F,G,I
DIRANIAN, SERKIS (19TH C) TURKISH	350-8800	G,F,L
DISCHLER, HERMANN (1866-1935) GERMAN	500-9400	F,G,L
DISPO, J. L. (20TH C) DUTCH	100-700	X
DITSCHEINER, ADOLF GUSTAVE (1846-1904) GERMAN	550-20000	L,W
DITTEN, JOHANNES VAN (19TH C) SCANDINAVIAN	200-4000	M,L
DITTMANN, JOHANN (D. 1847) AUSTRIAN	300-1500	X
DIULGHEROFF, NICOLAY	*300-12000	
DIULGHEROFF, NICOLAY (1901-1982) ITALIAN	1200-25000	G,L,F
DIX, OTTO (1891-1969) GERMAN	*900-148000	
DIX, OTTO (1891-1969) GERMAN	3500-+++	A
DIXON, ARTHUR A. (D. 1927) BRITISH	*250-2500	F,G
DIXON, CHARLES	*300-13000	
DIXON, CHARLES (1872-1934) BRITISH	300-9200	M
DIXON, PERCY (1862-1924) BRITISH	*100-750	X(L)
DIZIANI, GASPARE (1689-1767) ITALIAN	2000-90000	F
DMITRIEV-ORENBURGSKY, NIKOLAI DMITRIEVICH (1838-1898) RUSSIAN	400-5000	X(F)
DOBBIN, JOHN (1815-1884) BRITISH	*100-1600	L,W
DOBELL, SIR WILLIAM (1899-1970) AUSTRALIAN	1000-107000	F,L
DOBOUJINSKY, MSTISLAV	*300-4000	
DOBOUJINSKY, MSTISLAV (1875-1957) RUSSIAN	400-4500	F
DOBROWSKY, JOSEF (1889-1962) AUSTRALIAN	*900-3900	L,F
DOBSON, FRANK (1888-1963) BRITISH	*500-6800	F
DOBSON, HENRY JOHN (1858-1928) SCOTTISH	150-4000	G,F,W
DOBSON, ROBERT (19TH/20TH C) BRITISH	*100-900	L
DOBSON, WILLIAM CHARLES THOMAS	*200-8000	

* Denotes watercolors, pastels, drawings, and/or mixed media

DOBSON, WILLIAM CHARLES THOMAS (1817-1898) GERMAN/BRITISH	600-21000	F,W
DOCHARTY, ALEXANDER BROWNLIE (B. 1862) BRITISH	300-4000	L,W
DOCHARTY, JAMES (1829-1878) SCOTTISH	200-2500	L
DOCHLEIN, ELSIE (19TH C) GERMAN	300-2400	X
DOCKREE, MARK EDWIN (19TH C) BRITISH	200-1200	G,L,W
DODD, ARTHUR CHARLES (19TH C) BRITISH	300-6900	G,L,W
DODD, LOUIS (19TH C) BRITISH	500-6500	M
DODD, ROBERT (1748-1816) BRITISH	2000-81000	M
DODGE, J. F. (19TH C) BRITISH	*150-1200	X
DODGSON, GEORGE HAYDOCK (1811-1880) BRITISH	*200-4000	G,L
DOES, SIMON VAN DER (1653-1717) DUTCH	600-11000	W,L
DOESBURG, THEO VAN (1883-1931) DUTCH	500-150000	X
DOIGNEAU, EDOUARD EDMOND DE (1865-1954) FRENCH	400-2000	X
DOLCI, CARLO (1616-1686) ITALIAN	5000-+++	F
DOLGAN, FELIKS (20TH C) POLISH	100-700	X
DOLL, ANTON (1826-1887) GERMAN	1500-31000	G,L,F
DOLLMAN, JOHN CHARLES	*100-4600	
DOLLMAN, JOHN CHARLES (1851-1934) BRITISH	850-41000	G,W,L
DOLLOND, W ANSTEY	*400-3500	
DOLLOND, W ANSTEY (19TH/20TH C) BRITISH	700-5000	F,G
DOMBROWSKI, CARL RITTER VON (B. 1872) AUSTRIAN	150-1200	W
DOMELA, CESAR (B. 1900) DUTCH	*450-35000	A
DOMENICHINO, (Called DOMENICO ZAMPIERI)	*500-9500	
DOMENICHINO, (Called DOMENICO ZAMPIERI) (1581-1641) ITALIAN	7000-+++	F,L
DOMENICI, CARLO (B. 1898) ITALIAN	200-2300	L,F,W
DOMERGUE, JEAN GABRIEL	*200-25000	
DOMERGUE, JEAN GABRIEL (1889-1962) FRENCH	1500-56000	A
DOMICENT, MARTIN (B. 1823) FLEMISH	300-2300	X(G)
DOMINGO Y FALLOLA, ROBERTO	*500-24000	
DOMINGO Y FALLOLA, ROBERTO (1867-1956) SPANISH	500-10000	G,F,W
DOMINGO Y MARQUES, FRANCISCO (1842-1920) SPANISH	1500-34000	G,W
DOMINGO Y MUNOZ, JOSE (1815-1894) SPANISH	350-4500	G,F
DOMINGUEZ, OSCAR (1906-1958) SPANISH	2000-+++	A
DOMINICIS, ACHILLE DE (19TH C) ITALIAN	300-5200	G,F
DOMINIQUE, A. (Late 19TH C) EUROPEAN	250-2500	X
DOMINIUZ, A. DE (19TH C) ITALIAN	*100-1800	X(F)
DOMMERS, WILLIAM (19TH C) EUROPEAN	250-2400	X
DOMMERSEN, PIETER CORNELIUS CHRISTIAN (1842-1928) DUTCH	1000-22000	L,M,F

DOMMERSEN, WILLIAM RAYMOND (D. 1927) DUTCH	500-10000	L
DOMMERSHUIZEN, CORNELIS CHRISTIAN (1842-1928) DUTCH	1000-38000	X
DOMOND, WILMINO (B. 1925) HAITIAN	300-3200	G,L,S
DOMOTO, HISAO (B. 1928) JAPANESE	400-54000	A
DONADONI, STEFANO	*150-1500	
DONADONI, STEFANO (1844-1911) ITALIAN	300-4500	L
DONALDSON, ANDREW BENJAMIN (1840-1919) BRITISH	200-4300	G
DONAT, M. (Mid 19TH C) BELGIAN	200-1400	X
DONATI, LAZZARO (B. 1926) ITALIAN	150-1500	X(F)
DONCKER, HERMAN MIGNERTS (1620-1660) DUTCH	3000-52000	F,L
DONCRE, GUILLAUME DOMINIQUE JACQUES (1743-1820) FRENCH	1500-18000	S
DONGEN, HENDRICK VAN (20TH C) DUTCH	150-800	X
DONGEN, KEES VAN	*2500-222000	
DONGEN, KEES VAN (1877-1968) DUTCH/FRENCH	6000-+++	A,F
DONNE, J. M. (19TH C) BRITISH	100-1000	L
DONOVAN, J. (19TH C) BRITISH	150-900	X(G)
DONZEL, CHARLES (1824-1889) FRENCH	*200-1500	L
DOOIJEWARD, JACOB (B. 1876) DUTCH	100-800	X
DORAZIO, PIERO	*500-15000	
DORAZIO, PIERO (B. 1927) ITALIAN	900-118000	A
DORE, GUSTAVE	*800-50000	
DORE, GUSTAVE (1832-1883) FRENCH	5000-+++	F,G,L
DORIEL, L. (19TH C) FRENCH	100-700	X
DORIES, L. (19TH C) FRENCH	200-1200	X(G)
DORN, ALOIS (Late 19TH C) AUSTRIAN	150-800	X
DORN, ERNST (B. 1889) GERMAN	200-1500	L
DORNE, MARTIN VAN (1736-1808) FLEMISH	600-12000	S
DORNER, JOHANN JAKOB (THE YOUNGER) (1775-1852) GERMAN	600-28000	G,L
DORNMERSER, C. (19TH C) DUTCH	150-1200	X
DORP, MORITZ VAN (19TH C) DUTCH	150-1400	G
DOSAMENTES, FRANCISCO (B. 1911) MEXICAN	250-3200	G,F
DOSSIEKIN, NICOLAI WASSILIEVITCH (B. 1863) RUSSIAN	300-3600	G,F
DOTTORI, GERARDO	*1000-35000	
DOTTORI, GERARDO (1889-1977) ITALIAN	1500-25000	G,L
DOU, GERRIT (GERARD) (1613-1675) DUTCH	2500-230000	G,F,S
DOUCET, HENRI LUCIEN (1856-1895) FRENCH	600-15000	G
DOUCET, JACQUES (20TH C) FRENCH	2000-35000	A
DOUGLAS, ANDREW (1871-1935) BRITISH	*200-3000	X(L)

* Denotes watercolors, pastels, drawings, and/or mixed media

DOUGLAS, EDWARD ALGERNON STUART	*200-4000	
DOUGLAS, EDWARD ALGERNON STUART (19TH C) BRITISH	700-18000	W,G
DOUGLAS, EDWIN (1848-1914) BRITISH	500-36000	W
DOUGLAS, JAMES (1753-1819) BRITISH	*100-2600	X(L)
DOUGLAS-HAMILTON, A. M. R. (19TH C) BRITISH	*100-700	X
DOUMET, ZACHARIE FELIX (1761-1818) FRENCH	*200-3300	X
DOUST, JAN VAN (19TH/20TH C) DUTCH	350-6500	S
DOUTHERS, M. (19TH C) GERMAN	100-700	X
DOUVEN, JAN FRANS (1656-1727) DUTCH	400-4500	F
DOUW, SIMON JOHANNES VAN (1630-1677) FLEMISH	1000-14000	G,L,F
DOUWES, GABRIEL (20TH C) DUTCH	150-1000	X
DOUZETTE, LOUIS (1834-1924) GERMAN	500-12000	M,L,W
DOVA, GIANNI (B. 1925) ITALIAN	800-25000	X (A)
DOVASTON, MARIE (20TH C) BRITISH	600-12000	X(M)
DOWLING, ROBERT (1827-1886) AUSTRIAN	400-3600	G,F
DOWNIE, PATRICK (1854-1945) SCOTTISH	200-5000	G,L,M
DOWNING, CHARLES PALMER (19TH C) BRITISH	100-4700	G
DOWNING, DELAPOER (19TH/20TH C) BRITISH	450-14000	G
DOWNMAN, JOHN	*200-3600	
DOWNMAN, JOHN (1750-1824) BRITISH	300-6500	F
DQUARTREMAIN, WILLIAM WELLS (19TH C) BRITISH	*300-2000	L
DRACHMANN, HOLGER (1846-1908) DANISH	850-52000	M,L,F
DRAHONET, ALEXANDRE JEAN DUBOIS (1791-1834) FRENCH	400-5000	F,L
DRAMBURG, A. (19TH C) BRITISH	200-2500	X
DRECHSLER, ALEXANDRE (Late 19TH C) GERMAN	200-1500	X
DRECHSLER, JOHANN BAPTIST (1756-1811) AUSTRIAN	4000-90000	S
DREHER, R. (19TH C) GERMAN	100-700	X
DREUX, ALFRED DE	*900-12000	
DREUX, ALFRED DE (1810-1860) FRENCH	3000-168000	G,F,W
DREYFUS, BERNARDO	*300-4800	
DREYFUS, BERNARDO (B. 1940) NICARAGUAN	300-4000	X
DRIELST, EGBERT VAN (1746-1818) DUTCH	1500-81000	G,L
DRING, WILLIAM (B. 1904) BRITISH	600-16000	F
DROLLING, MARTIN (1752-1817) FRENCH	1500-20000	G,F
DROLLING, MICHEL MARTIN (1786-1851) FRENCH	500-9500	G,F
DROOCHSLOOT, CORNELIS (1630-1673) DUTCH	3000-16000	L,G
DROOCHSLOOT, JOOST CORNELISZ (1586-1666) DUTCH	5000-85000	G,F,L
DROUAIS, FRANCOIS HUBERT (1727-1775) FRENCH	4000-137000	F
DROUAIS, HUBERT (1699-1767) FRENCH	700-9000	F

DROUET, JEAN GILLAUME (1764-1836) FRENCH	150-800	X
DRUCK, HERMANN (B. 1856) GERMAN	400-5000	L
DRULMAN, MARINUS JOHANNES (Called M. DE JONGERE) (B. 1912) DUTCH	200-1500	M
DRUMMOND, ARTHUR (1871-1951) CANADIAN	300-7000	G
DRUMMOND, E. S. (19TH C) BRITISH	*100-1400	X
DRUMMOND, H. (19TH/20TH C) BRITISH	150-1000	M,F
DRUMMOND, JAMES	*300-1600	
DRUMMOND, JAMES (1816-1877) BRITISH	500-6500	G,F
DRUMMOND, MALCOLM (1880-1945) BRITISH	300-2500	F
DRYSDALE, SIR GEORGE RUSSELL (B. 1912) AUSTRALIAN	*400-5900	F,G
DUBAN, A. (Early 19TH C) FRENCH	*400-2000	X
DUBAUT, PIERRE (1886-1968) FRENCH	600-3000	G
DUBBELS, HENDRIK (1621-1676) DUTCH	4000-65000	M,L
DUBLIN, JACQUES (1901-1978) SWISS	800-8000	G,F,L
DUBOIS, CATHERINA (D. 1776) DUTCH	*400-2000	X
DUBOIS, HENRI PIERRE HIPPOLYTE (1837-1909) FRENCH	1500-25000	G
DUBOIS, LOUIS (1830-1880) FRENCH	300-4500	G,L,W
DUBOIS, P. (19TH C) FRENCH	300-3200	X
DUBOIS, PAUL (1829-1905) FRENCH	150-1000	F
DUBOIS, WILLEM (1622-1680) DUTCH	4000-48000	G,L
DUBOIS-PILLET, ALBERT	*1000-98000	
DUBOIS-PILLET, ALBERT (1845-1890) FRENCH	2000-150000	L,S,F
DUBOURG, LOUIS ALEXANDRE (1825-1891) FRENCH	700-16000	M,G,F
DUBOURG, LOUIS FABRICIUS (1693-1775) DUTCH	350-38000	F,L
DUBOVSKOI, NIKOLAI NIKANOROVICH (1859-1918) RUSSIAN	900-14000	M,L
DUBUFE, EDOUARD LOUIS(1820-1883) FRENCH	900-64000	F,G
DUBUFE, EDOUARD MARIE GUILLAUME (1853-1909) FRENCH	400-6500	F,G,
DUBUFFET, JEAN	*3000-+++	
DUBUFFET, JEAN (1901-1985) FRENCH	10000-+++	A
DUCAIRE-ROQUE, MARYSE (20TH C) FRENCH	100-700	X(F)
DUCASSE, G. EMMANUEL (B. 1903) HAITIAN	100-700	X
DUCATEL, LOUIS (B. 1902) FRENCH	1000-15000	X
DUCHAMP, MARCEL (1887-1968) FRENCH/AMERICAN	*1000-75000	A
DUCHAMP, SUZANNA (1898-1963) FRENCH	*400-12000	F,G
DUCHESNE, CHARLES (D. 1823) FRENCH	400-4000	W
DUCK, JACOB (1600-1660) DUTCH	3000-220000	F,G
DUCKER, EUGENE GUSTAV (1841-1912) GERMAN	500-6500	M,L
DUCKER, JAMES (19TH C) BRITISH	150-1000	L,F

* Denotes watercolors, pastels, drawings, and/or mixed media

DUCREUX, JOSEPH (1735-1802) FRENCH	900-60000	G,F
DUCROS, ABRAHAM LOUIS RUDOLPHE (1748-1810) SWISS	500-18000	L
DUDOUET, MARCEL GEORGES (B. 1924) FRENCH	100-700	X
DUEZ, ERNEST ANGE (1846-1896) FRENCH	500-103000	F,G,L
DUFAUX, FREDERIC (1852-1943) SWISS	400-14000	F,M
DUFEU, EDOUARD JACQUES	*100-1200	
DUFEU, EDOUARD JACQUES (1840-1900) FRENCH	350-6600	M,S
DUFFAUD, JEAN BAPTISTE (1853-1927) FRENCH	200-2500	G,F
DUFFAUT, PREFETE	*200-1200	
DUFFAUT, PREFETE (B. 1929) HAITIAN	500-10000	X(F,M)
DUFOUR, A. (19TH C) FRENCH	100-700	X
DUFOUR, CAMILLE (B. 1841) FRENCH	250-1800	L
DUFRANC, CHARLES (20TH C) HAITIAN	100-600	X
DUFRENE, FRANCOIS (20TH C) FRENCH	*800-11000	A
DUFRESNE, CHARLES GEORGES	*100-8800	
DUFRESNE, CHARLES GEORGES (1876-1938) FRENCH	700-77000	A,F,S
DUFY, JEAN	*400-34000	
DUFY, JEAN (1888-1964) FRENCH	1500-68000	A
DUFY, RAOUL	*1100-+++	
DUFY, RAOUL (1877-1953) FRENCH	15000-+++	A
DUGHET, GASPARD (Called GASPARD POUSSIN) (1615-1675) FRENCH	1500-72000	L,F,W
DUGOURC, JEAN DEMOSTHENE (1749-1825) FRENCH	*700-27000	G,F,S
DUGUID, HENRY G. (19TH C) BRITISH	250-2000	L
DUJARDIN, KAREL	*1000-17000	
DUJARDIN, KAREL (1622-1678) DUTCH	5000-+++	L,W,F
DUKE, ALFRED (19TH/20TH C) BRITISH	200-10000	G,L,W
DULAC, EDMUND	*1000-75000	
DULAC, EDMUND (1882-1953) FRENCH	800-14000	A,I,F,G
DULUARD, HIPPOLYTE FRANCOIS LEON (B. 1871) FRENCH	300-4200	G,F
DUMELLE, LEON (19TH C) FRENCH	100-600	X
DUMITRESCO, NATALIA (B. 1915) FRENCH	500-18000	A
DUMONT, CESAR ALVAREZ (19TH C) FRENCH	150-3000	X
DUMONT, FRANCOIS (1752-1831) BELGIAN	300-2700	G,F
DUMONT, JACQUES (1701-1781) FRENCH	3000-20000	F
DUMONT, PIERRE (1884-1936) FRENCH	600-49000	S,L
DUNCAN, EDWARD (1803-1882) BRITISH	*750-26000	L,M,W
DUNCAN, JOHN (1866-1945) BRITISH	*600-12000	M,G
DUNCAN, LAURENCE (D. 1891) BRITISH	*100-1800	G,F

DUNCAN, THOMAS (1807-1845) BRITISH	400-5000	F
DUNKER, BALTHASAR ANTON (1746-1807) GERMAN	*300-4500	G,F,L
DUNLOP, RONALD OSSORY (1894-1973) BRITISH	250-4400	L,M,F
DUNN, JOSEPH (OF WORCESTER) (19TH C) BRITISH	250-3500	W,L
DUNNINGTON, ALBERT (Late 19TH C) BRITISH	200-2600	L,W
DUNOUY, ALEXANDRE HYACINTHE (1757-1841) FRENCH	900-32000	L
DUNOYER DE SEGONZAC, ANDRE	*1000-48000	
DUNOYER DE SEGONZAC, ANDRE (1884-1974) FRENCH	2000-68000	A,L,S,F
DUNSTAN, BERNARD (B. 1920) BRITISH	600-12000	F,S,G
DUNTZE, JOHANN BARTHOLOMAUS (1823-1895) GERMAN	1000-32000	L
DUPAS, JEAN THEODORE	*900-35000	
DUPAS, JEAN THEODORE (1882-1964) FRENCH	2000-85000	G,F
DUPERRE, GABRIEL (19TH C) FRENCH	900-16000	L
DUPERRON, ADOLPHE (19TH C) FRENCH	*100-700	X
DUPLESSIS, JOSEPH SIFFREIN	*600-5000	
DUPLESSIS, JOSEPH SIFFREIN (1725-1802) FRENCH	1500-65000	F
DUPLESSIS, MICHEL (18TH C) FRENCH	700-18000	F,G,L
DUPONT, GAINSBOROUGH (1754-1797) BRITISH	900-15000	F,L,W
DUPONT, JACQUES (1909-1978) FRENCH	*100-900	X(G)
DUPONT, NICHOLAS (D. 1768) FRENCH	500-4500	G,F
DUPRAT, ALBERT-FERDINAND (B. 1882) ITALIAN	200-2300	M
DUPRAY, HENRY LOUIS (1841-1909) FRENCH	200-6000	F,G
DUPRE, FRANCOIS (1803-1871) FRENCH	300-3200	W
DUPRE, GUSTAVE (B. 1827) FRENCH	150-1200	G,L
DUPRE, JULES (1811-1889) FRENCH	1500-30000	L,M,W
DUPRE, JULIEN	*200-2500	
DUPRE, JULIEN (1851-1910) FRENCH	1500-155000	G,F,L
DUPRE, LEON VICTOR (1816-1879) FRENCH	500-29000	L,W
DUPRE, LOUIS (1789-1837) FRENCH	*900-12000	F,G
DUPRE, VICTOR (1816-1879) FRENCH	1200-35000	L,W,G
DUPUY, PAUL MICHEL (B. 1869) FRENCH	500-30000	G,F
DURA, GAETANO (19TH C) ITALIAN	*100-900	L,F
DURAN, JULES (19TH C) FRENCH	100-700	X
DURAND, GUSTAVE (19TH/20TH C) FRENCH	400-3800	X(F)
DURAND-BRAGER, JEAN BAPTISTE HENRI (1814-1879) FRENCH	400-10000	M
DURANTI, FORTUNATO (1787-1863)ITALIAN	*300-1500	G,F
DURCK, FREIDRICH (1809-1884) GERMAN	350-4500	G,F
DURENNE, EUGENE ANTOINE (1860-1944) FRENCH	300-16000	G,F
DUREUIL, MICHEL (20TH C) FRENCH	100-1000	X(M,S)

DURIG, ROLF (B. 1926) SWISS	400-4800	M,L
DURING, SEBASTIAN (1671-1723) SWISS	300-3500	F
DURR, LOUIS (1896-1973) SWISS	400-3500	L
DURUN, F. (19TH C) GERMAN	150-1000	X
DUSART, CORNELIUS	*900-25000	
DUSART, CORNELIUS (1660-1704) DUTCH	2000-130000	G,F
DUTHOIT, PAUL (B. 1858) FRENCH	100-700	X
DUVAL, CHARLES ALLEN (1808-1872) BRITISH	250-2600	F
DUVAL, EDWARD J. (19TH C) BRITISH	150-900	L,M,W
DUVAL, GOZLAN L. (1853-1941) FRENCH	250-4800	G,L,F,S
DUVAL, PIERRE (19TH C) FRENCH	150-1200	F
DUVAL, VICTOR (19TH C) FRENCH	350-5200	L
DUVALL, ETIENNE (1824-1914) FRENCH	300-3000	X
DUVALL, JOHN (1834-1881) BRITISH	400-4000	W,L,M,F
DUVENT, CHARLES JULES (1867-1940) FRENCH	850-50000	X(L)
DUVERGER, PAUL (19TH C) FRENCH	150-1600	M
DUVERGER, THEOPHILE EMMANUEL (1821-1901) FRENCH	1200-28000	G,F
DUVIEUX, HENRI (19TH C) FRENCH	300-9500	L
DUXA, KARL (1871-1937) AUSTRIAN	250-7000	G,F
DUYSTER, WILLEM CORNELISZ (1600-1635) DUTCH	5000-98000	G,F
DUYTS, GUSTAVE DEN (1850-1897) BELGIAN	350-12000	G,S
DYCK, ABRAHAM VAN (Called D'ALKMAAR) (1635-1672) DUTCH	1500-38000	G,F
DYCK, SIR ANTHONY VAN	*2000-+++	
DYCK, SIR ANTHONY VAN (1599-1641) FLEMISH	5000-+++	F
DYF, MARCEL DREYFUS (1899-1985) FRENCH	500-27000	A
DYK, PHILIP VAN (Called LITTLE VAN DYCK) (1679-1753) DUTCH	2000-48000	F
DYKSTRA, JOHAN (B. 1896) DUTCH	300-5900	F,L
DYXHOORN, PIETER ARNOUT (1810-1839) DUTCH	200-2500	M

E

ARTIST	PRICES	SUBJECT
EADIE, ROBERT (1877-1954) BRITISH	*300-5700	L,M
EADIE, WILLIAM (19TH C) BRITISH	400-3000	G,F
EAMERSON, SAMUEL (19TH C) BRITISH	100-700	X
EARDLEY, JOAN	*600-21000	
EARDLEY, JOAN (1921-1963) BRITISH	900-75000	G,F,L

EARL, GEORGE (19TH C) BRITISH	2500-+++	G,L,F,W
EARL, MAUD (Active 1884-1934) BRITISH	450-26000	G,L,W
EARL, PERCY (20TH C) BRITISH	900-18000	X
EARL, THOMAS (19TH C) BRITISH	700-8500	W
EARLE, CHARLES (D. 1893) BRITISH	*400-4500	G,L,F
EARP, HENRY	*100-3200	
EARP, HENRY (1831-1914) BRITISH	200-2500	G,L,W
EAST, SIR ALFRED	*300-4000	
EAST, SIR ALFRED (1849-1913) BRITISH	400-16500	L,W
EBEL, FRITZ (1835-1895) GERMAN	500-13000	L
EBERL, FRANCOIS (1887-1962) FRENCH	1000-40000	F,L
EBERLE, ADOLF (1843-1914) GERMAN	3000-72000	G,W
EBERSBERGER, MAX (B. 1852) GERMAN	400-7000	S
EBERT, ANTON (1845-1896) CZECHOSLOVAKIAN	500-15000	G,F
EBERT, CARL (1821-1885) GERMAN	2500-36000	G,L
EBERT, LEO (20TH C) EUROPEAN	100-1200	G,F
EBERZ, JOSEF (B. 1830) GERMAN	800-20000	F,L
EBIHARA, KINOSUKE (1904-1970) JAPANESE	200-3500	X(G)
ECHENA, JOSE (1845-1908) SPANISH	1400-20000	G,F
ECHEVARRIA, ENRIQUE (1923-1972) SPANISH	250-2800	G,S
ECHTLER, ADOLF (1843-1914) GERMAN	600-14000	G,F
ECKARDT, CHRISTIAN (1832-1914) DANISH	500-14000	M,L
ECKENBRECHER, THEMISTOCLES VON	*200-1800	
ECKENBRECHER, THEMISTOCLES VON (1842-1921) GERMAN	400-14000	L,M
ECKENFELDER, FREDERICH (1861-1938) GERMAN	1000-20000	G,L
ECKERSBERG, CHRISTOPHER WILHELM (1783-1853) DANISH	2000-78000	G,L,M
ECKHARDT VON ECKHARDSBURG, VICTOR (1864-1946) GERMAN	300-3000	F,W
EDDIS, EDEN UPTON (1812-1901) BRITISH	300-14000	G,F
EDELFELT, ALBERT GUSTAF ARISTIDES	*600-64000	
EDELFELT, ALBERT GUSTAF ARISTIDES (1854-1905) FINNISH	3000-+++	L,M,F
EDEMB, GERARD VAN (1652-1700) DUTCH	2000-28000	M,L
EDER Y GATTENS, FREDERICO MARIA (19TH C) SPANISH	450-23000	X(L)
EDERER, CARL (B. 1875) AUSTRIAN	*400-29000	X
EDOUARD, ALBERT JULES (B. 1845) FRENCH	200-3600	G,F,L
EDRIDGE, HENRY (1769-1821) BRITISH	*400-3000	F,L
EDSON, ALLAN (1846-1888) CANADIAN	700-14000	G,L,M
EDWARDS, LIONEL	*500-36000	
EDWARDS, LIONEL (1877-1966) BRITISH	1500-74000	G,F,W
EDWARDS, SYDENHAM TEAST (1768-1819) BRITISH	800-14000	W

* Denotes watercolors, pastels, drawings, and/or mixed media

EDWARDS-HOROWITZ, (19TH C) FRENCH	200-2000	X(M)
EDY-LEGRAND, EDWARD LEON LOUIS	*100-2500	
EDY-LEGRAND, EDWARD LEON LOUIS (1892-1970) FRENCH	100-3500	X
EDZARD, DIETZ (1893-1963) GERMAN	600-19000	F,M,S,I
EECKHOUT, GERBRAND VAN DEN (1621-1674) DUTCH	1200-88000	G,F
EECKHOUT, VICTOR (1821-1879) FLEMISH	*300-3800	G,F
EERDEN, E. VAN (20TH C) DUTCH	100-600	X
EERELMAN, OTTO	*300-19000	
EERELMAN, OTTO (1839-1926) DUTCH	700-23000	W
EGAZ, CAMILLE (20TH C) SOUTH AMERICAN	150-1000	X(F)
EGEA, Z. (19TH C) SPANISH	100-600	X
EGERTON, DANIEL THOMAS (Early 19TH C) BRITISH	800-28000	L
EGG, AUGUSTUS LEOPOLD (1816-1863) BRITISH	750-15000	F,G
EGGEL, EMMA (1848-1890) GERMAN	150-900	L,W
EGGENA, GUSTAV (B. 1850) GERMAN	200-1800	X(W)
EGGER-LIENZ, ALBIN (1868-1926) SWISS	2000-72000	G,L
EGGERT, SIGMUND (1839-1896) GERMAN	1000-12000	G
EGGINGTON, WYCLIFFE (1875-1951)	*400-3000	W,L
EGGINTON, FRANK (B. 1908) BRITISH	*100-3800	L,M
EGLEY, WILLIAM MAW (19TH C) BRITISH	500-8500	G,F
EGNER, MARIE (1850-1940) AUSTRIAN	500-9400	L
EGORNOV, ALEKSANDR SIMIONOVICH (1858-1902) RUSSIAN	100-1000	X
EGUSQUIZA, ROGELIO (19TH C) SPANISH	1500-95000	X(G)
EHCOSTYM, L. (19TH C) BRITISH	250-4000	G,F
EHLINGER, MAURICE AMBROSE (1896-1981) FRENCH	400-9300	X
EHMSEN, HEINRICH (B. 1886) GERMAN	600-8000	F
EHRENBERG, PAUL (1876-1949) GERMAN	150-900	X
EHRET, GEORG DYONIS (1710-1770) GERMAN/BRITISH	800-15000	X(S)
EICHINGER, ERWIN (1892-1950) GERMAN	100-3300	G,F
EICHINGER, OTTO (B. 1922) AUSTRIAN	250-3500	G,F
EICHLER, ANTOINE (19TH C) GERMAN	100-1500	F
EICKELBERG, WILLEM HENDRIK (1845-1920) DUTCH	400-6500	L,W,M
EICKEN, ELIZABETH VON (B. 1862) GERMAN	200-2200	L
EISEN, CHARLES DOMINIQUE JOSEPH (1720-1778) FRENCH	300-8500	G,F,W
EISEN, FRANCOIS (1695-1778) FLEMISH	300-5200	G,F
EISENDIECK, SUZANNE	*250-3200	
EISENDIECK, SUZANNE (B. 1908) GERMAN	300-11000	A
EISENHUT, FERENCZ (1857-1903) HUNGARIAN	1200-30000	G,F
EISENLOHR, L. W. (Late 19TH C) EUROPEAN	150-1500	X(F)

EISENSCHITZ, WILLY (1889-1974) FRENCH	*200-4200	L
EISMANN, JOHANN ANTON (1604-1698) GERMAN	900-14000	L,F
EKBLAD, FELIX (19TH C) EUROPEAN	100-600	X(L)
EKELAND, ARNE (B. 1908) NORWEGIAN	900-18000	X(A,F)
EKENAES, JAHN	*200-4100	
EKENAES, JAHN (1847-1920) NORWEGIAN	1000-20000	G,F,L
EKMAN, EMIL (1880-1951) SWEDISH	800-14000	M
EKSTROM, PER (1844-1935) SWEDISH	1000-101000	L,M
EKVALL, EMMA (1838-1925) SWEDISH	800-18000	F,G
EKWALL, KNUT (1843-1912) SWEDISH	1000-49000	G,L,M,A
ELEN, PHILIPPE-WEST (19TH C) BRITISH	*100-700	X
ELENA, GIUSEPPE (1801-1867) ITALIAN	1000-25000	G,L
ELGOOD, GEORGE SAMUEL (1851-1943) BRITISH	*250-7400	X(L)
ELI, CHRISTEL JOHANN HEINRICH (1800-1881) GERMAN	4000-24000	S
ELIASZ, NICOLAES (Called PICKENOY) (1590-1956) DUTCH	900-18000	F
ELIM, FREDERICK (20TH C) FRENCH	400-5200	G,W
ELLIGER, OTTMAR (THE YOUNGER) (1666-1735) GERMAN	2500-55000	S
ELLIOT, JAMES (Active 1848-1873) BRITISH	*300-5500	L
ELLIOT, JOHN (1858-1925) BRITISH	300-6200	F,I
ELLIS, EDWIN JOHN	*100-2100	
ELLIS, EDWIN JOHN (1841-1895) BRITISH	150-3800	F,L,M
ELLIS, TRISTRAM (1844-1922) BRITISH	*300-2800	G,F,L
ELLIS, WALTER E. (19TH C) BRITISH	100-1200	X(G)
ELLMINGER, IGNAZ (1843-1894) AUSTRIAN	900-32000	G,F,L
ELMBLAD, H. (19TH C) NORWEGIAN	150-2200	M
ELMER, STEPHEN (1714-1796) BRITISH	1000-30000	L,S,W
ELMIGER, FRANZ JACOB (1882-1934) SWISS	200-3400	F
ELOUT, FRANCHOYS (1597-1641) DUTCH	2000-35000	S
ELSASSER, FREDERICK AUGUSTE (1810-1845) GERMAN	300-2400	L
ELSHEIMER, ADAM 91574-1620) GERMAN	20000-+++	F
ELSHOLTZ, LUDWIG (1805-1850) GERMAN	300-4000	G
ELSLEY, ARTHUR JOHN (19TH/20TH C) BRITISH	1200-110000	G,F,W
ELWELL, FREDERICK W. (1870-1958) BRITISH	500-18000	G
EMANUEL, FRANK LEWIS	*100-500	
EMANUEL, FRANK LEWIS (1865-1948) BRITISH	100-1800	G,F,I
EMANUELOV, VICTOR (1884-1940) RUSSIAN	100-1500	L
EMBRO, L. (19TH C) ITALIAN	100-700	X
EMELE, WILHELM (1830-1905) GERMAN	1500-15000	F,W
EMELEN, ADOLF VAN (19TH/20TH C) DUTCH	100-600	X

EMMENEGGER, HANS (B. 1866) SWISS	800-11000	X(F,L)
EMMER, F. (Early 20TH C) GERMAN	100-700	X
EMMERIK, GOVERT VAN (1808-1882) DUTCH	350-6800	M
EMMS, JOHN (1843-1912) BRITISH	1000-74000	F,W,L
EMSLIE, ALFRED (1848-1917) BRITISH	400-4500	G
ENAULT, ALIX LOUISE (D. 1913) FRENCH	1500-20000	G
ENDE, HANS AM (1864-1918) GERMAN	800-32000	F,L
ENDER, AXEL H. (1853-1920) NORWEGIAN	400-43000	L,G
ENDER, EDOUARD (1822-1883) AUSTRIAN	1000-16000	F,L
ENDER, JOHANN N. (1793-1854) AUSTRIAN	*200-2000	X(F)
ENDER, THOMAS (1793-1875) AUSTRIAN	1000-25000	L,M
ENDLER, ENRY (19TH C) GERMAN	350-2500	L,W
ENDLICH, H. (20TH C) DUTCH	100-900	G,F
ENDOGOUROV, IVAN IVANOVICH (1861-1898) RUSSIAN	350-7500	G,F
ENGELHARD, FRIEDRICH WILHELM (1813-1902) GERMAN	350-5500	X
ENGELHARDT, GEORG (1823-1883) GERMAN	500-11000	L,W
ENGELHARDT, HERMANN VON (1858-1914) GERMAN	250-2000	X
ENGELHART, CATHERINE C. (B. 1845) DANISH	*800-10000	G
ENGELS, ROBERT (1866-1926) GERMAN	150-2400	X(G)
ENGELUND, SVEND (B. 1908) DANISH	400-7700	L,F
ENGER, ERLING (B. 1899) NORWEGIAN	1000-16000	L
ENGLAND, E. S. (19TH C) BRITISH	100-1300	X(W,L)
ENGLER, E. (19TH C) EUROPEAN	100-1600	X(L)
ENGSTROM, ALBERT (1869-1940) SWEDISH	*400-6400	L,G
ENGSTROM, LEANDER	*500-6500	
ENGSTROM, LEANDER (1886-1927) SWEDISH	800-94000	F,L
ENHUBER, KARL VON (1811-1867) GERMAN	1000-16000	G
ENJOLRAS, DELPHIN	*200-17000	
ENJOLRAS, DELPHIN (B. 1857) FRENCH	650-28000	G,F
ENNESS, AUGUSTUS WILLIAM (19TH C) BRITISH	400-4500	L,S,M
ENRIQUEZ, ANTONIO (18TH C) MEXICAN	400-7500	G,F
ENRIQUEZ, CARLOS	*200-3800	
ENRIQUEZ, CARLOS (1901-1955) CUBAN	400-6000	G,F
ENSOR, JAMES	*1500-69000	
ENSOR, JAMES (1860-1949) BELGIAN	8000-+++	A
ENSOR, MARY (Late 19TH C) BRITISH	150-2400	S
ENTRAYGUES, CHARLES BERTRAND D' (B. 1851) FRENCH	500-8000	G
EPERRIE, B. (19TH/20TH C) FRENCH	100-600	X
EPINAY, MARIE D' (19TH C) FRENCH	150-1500	X

EPP, RUDOLF (1834-1910) GERMAN	1000-48000	G,F
EPPER, IGNAZ (B. 1892) GERMAN	400-5000	F
EPSTEIN, HENRI	*200-1800	
EPSTEIN, HENRI (1892-1944) POLISH	500-8800	L,F
EPSTEIN, JEHUDO (1870-1946) POLISH	350-5200	G,F,L
EPSTEIN, SIR JACOB (1880-1959) BRITISH	*300-11000	A
ERDMANN, HEINRICH EDUARD MORITZ (1845-1919) GERMAN	1000-22000	L
ERDMANN, OTTO (1834-1905) GERMAN	500-38000	G,F
ERDTMANN, ELIAS (1862-1945) SWEDISH	250-10000	L,M
ERICHSEN, THORVALD (1868-1939) NORWEGIAN	2000-95000	L
ERICSON, JOHAN (1849-1925) SWEDISH	1000-18000	L,M
ERIKSEN, BJARNE (1882-1970) NORWEGIAN?	800-11000	L,F
ERIKSEN, SIGURD (1884-1976) NORWEGIAN?	700-8000	M,L,F
ERISTOFF-KASAK, PRINCESS MARIE (B. 19TH C) RUSSIAN	800-16000	F
ERIXSON, SVEN (1899-1970) SCANDINAVIAN	700-80000	L,M,A
ERLER, ERICH (1870-1946) GERMAN	500-5200	L,F
ERNI, HANS	*500-18000	
ERNI, HANS (B. 1909) SWISS	1000-25000	G,F,W
ERNST, HELGE (B. 1916) DANISH	1000-9000	X(A,S)
ERNST, MAX	*2000-+++	
ERNST, MAX (1891-1976) FRENCH	10000-+++	A
ERNST, RUDOLF	*700-26000	
ERNST, RUDOLF (1854-1920) AUSTRIAN	2500-150000	G,F,A
ERRO, GUDMUNDUR	*400-28500	
ERRO, GUDMUNDUR (B. 1932) ICELANDIC	500-62000	X(F)
ERTE, (ROMAIN DE TIRTOFF)	*300-29000	
ERTE, (ROMAIN DE TIRTOFF) (B. 1892) RUSSIAN	250-4600	F,I
ES, JACOB VAN (1617-1666) FLEMISH	4000-150000	S
ESCARS, YVES EDGARD MULLER D' (1876-1958) FRENCH	300-3500	X
ESCHBACH, PAUL A. (1881-1961) FRENCH	200-3200	L,M
ESCHER, MAURITS CORNELIS (B. 1898) DUTCH	*500-12000	I
ESCHWEGE, ELMER VON (B. 1856) GERMAN	2000-50000	G,F,L
ESCOSURA, IGNACIO LEON Y (1834-1901) SPANISH	3000-25000	X
ESKILSON, PETER (1820-1872) SWEDISH	300-5000	G,L,F
ESPAGNAT, GEORGES D' (1870-1950) FRENCH	2000-77000	F,L,M
ESPOSITO, GAETANO	*300-2200	
ESPOSITO, GAETANO (1858-1911) ITALIAN	1000-26000	L,F
ESPOSITO, V. (19TH/20TH C) ITALIAN	*100-700	X
ESSELENS, JACOB	*200-4400	

* Denotes watercolors, pastels, drawings, and/or mixed media

ESSELENS, JACOB (1626-1687) DUTCH	900-32000	M,L
ESSEN, JOHANNES CORNELIS (JAN) VAN	*150-4000	
ESSEN, JOHANNES CORNELIS (JAN) VAN (1854-1936) DUTCH	500-9500	L,F,W
ESTEVE, AUGUSTIN (1753-1809) SPANISH	2000-69000	F
ESTEVE, MAURICE	*1000-89000	
ESTEVE, MAURICE (B. 1904) FRENCH	6000-+++	A
ESTIENNE, GIOVANNI (B. 1870) ITALIAN	300-2400	G,F,S
ETCHELLS, FREDERICK (1886-1973) BRITISH	*1000-48000	G,L
ETCHEVERRY, HUBERT DENIS (1867-1950) FRENCH	600-36000	F,G
ETIENNE, RENE (19TH C) FRENCH	300-4000	X(F)
ETTY, WILLIAM	*150-3000	
ETTY, WILLIAM SIR (1787-1849) BRITISH	1500-28000	G,F,L
EUGEN, NAPOLEAN (1865-1947) SWEDISH	1200-42000	L
EURICH, RICHARD (B. 1903) BRITISH	400-21000	M,L,S
EVANS, BERNARD WALTER (1848-1922) BRITISH	*200-2700	L
EVANS, FRED M. (19TH C) BRITISH	*100-2600	X
EVANS, POWYS A. L. (B. 1899) BRITISH	*100-1800	I,F
EVANS, WILLIAM (OF ETON) (1798-1877) BRITISH	*200-4900	L
EVE, JEAN (1900-1968) FRENCH	300-7000	L,M
EVENPOEL, HENRI (1872-1899) BELGIAN	1000-20000	F,G
EVERARD, J.J. (20TH C) EUROPEAN	100-800	X(M)
EVERBROECK, FRANS VAN (1638-1672) FLEMISH	900-18000	F,S
EVERDING, WILHELM B. (B. 1863) GERMAN	200-2400	X
EVERDINGEN, ADRIAEN VAN (1823-1910) DUTCH	350-4600	L,M,W
EVERDINGEN, ALLART VAN	*900-25000	
EVERDINGEN, ALLART VAN (1621-1675) DUTCH	1500-43000	L,M,W
EVERSDYCK, WILLEM VAN (D. 1671) DUTCH	900-14000	G,W
EVERSEN, ADRIANUS (1818-1897) DUTCH	1500-59000	G,L
EVRARD, ADELE (1792-1889) FLEMISH	2000-25000	S
EWERS, HEINRICH (1817-1885) GERMAN	300-3800	G
EWERT, PIETER (20TH C) DUTCH	100-700	L
EXNER, JOHAN JULIUS (1825-1910) DANISH	400-22000	G,F,L
EXTER, ALEXANDRA	*500-+++	
EXTER, ALEXANDRA (1884-1949) RUSSIAN	2000-+++	I
EYBL, FRANZ (1806-1880) AUSTRIAN	400-5500	G,L
EYCK, GASPAR VAN (1613-1673) FLEMISH	500-15000	M
EYCK, NICHOLAS VAN (1617-1679) FLEMISH	450-7500	X(G)
EYCKEN, CHARLES VAN DEN (1859-1923) BELGIAN	1000-48000	G,W
EYCKEN, FELIX VAN DEN (19TH C) BELGIAN	400-7500	G,W

EYK, ABRAHAM VAN DER (19TH C) DUTCH	350-6500	F
EYKENS, FRANS (1627-1673) FLEMISH	900-10000	S
EYMER, ARNOLDUS JOHANNES (1803-1863) DUTCH	400-7500	L

F

ARTIST	PRICES	SUBJECT
FABBI, FABIO	*200-3000	
FABBI, FABIO (1861-1946) ITALIAN	700-42000	F,G
FABER DU FAUR, HANS VON (B. 1863) GERMAN	1500-32000	F,G,W
FABER DU FAUR, OTTO VON	*200-2400	
FABER DU FAUR, OTTO VON (1828-1901) GERMAN	800-13500	F,W
FABERT, JEAN (20TH C) FRENCH	100-600	X
FABIEN, LOUIS (B. 1924) FRENCH	150-2000	X(F)
FABIJANSKI, ERASMUS RUDOLF (1829-1891) RUSSIAN	200-3000	X(L)
FABRE, H. (19TH C) EUROPEAN	100-850	X
FABRES Y COSTA, ANTONIO MARIA	*900-12000	
FABRES Y COSTA, ANTONIO MARIA (B. 1854) SPANISH	3000-75000	G,F
FABRI, GIULIO (19TH C) ITALIAN	250-3600	X(F)
FABRIS, GIOVANNI (18TH/19TH C) ITALIAN	300-3000	X
FABRIS, PIETRO (18TH C) ITALIAN	1500-189000	G,L
FABRITIUS DE TENGNAGEL, FREDERIK MICHAEL ERNST (1781-1849) DANISH	400-8800	L,M
FACCIOLA, GIOVANNI (1729-1809) ITALIAN	200-1800	G,L
FACCIOLI, SILVIO (19TH C) ITALIAN	150-1000	G
FACHINETTI, C. (19TH C) ITALIAN	250-1800	X
FADER, FERNANDO (1882-1935) ARGENTINIAN	1500-34000	F
FAED, JAMES (JR) (19TH C) BRITISH	400-6000	L
FAED, JOHN (1820-1902) BRITISH	2000-48000	G,L,F
FAED, THOMAS (1826-1900) SCOTTISH	2100-158000	G,F,L
FAES, PIETER (1750-1814) FLEMISH	2000-123000	S
FAGERLIN, FERDINAND (1825-1907) SWEDISH	900-30000	G,F
FAHLCRANTZ, CARL JOHAN (1774-1861) SWEDISH	800-11000	L,F
FAHLGREN, CARL AUGUST (1819-1905) SWEDISH	300-5500	M,L
FAHRBACH, CARL LUDWIG (1835-1902) GERMAN	500-7200	L,W
FAIRMAN, FRANCES C (1836-1923) BRITISH	900-11000	W
FAIRWEATHER, IAN (1891-1974) AUSTRALIAN	*1000-43000	X
FAITHFULL, LEILA (19TH/20TH C) BRITISH	350-3200	G

* Denotes watercolors, pastels, drawings, and/or mixed media

FAIVRE, JULES ABEL (1867-1945) FRENCH	450-12000	G,L,F
FAIVRE, LEON MAXIM (1856-1914) FRENCH	900-6000	L
FAIVRE-DUFFER, LOUIS STANISLAS (1818-1897) FRENCH	200-1800	L
FALANGAR, S. (19TH/20TH C) EUROPEAN	100-600	X
FALAT, JULIAN	*400-7800	
FALAT, JULIAN (1853-1929) POLISH	500-8500	G
FALCHETTI, GIUSEPPE (1843-1918) ITALIAN	250-3500	L,S
FALCONE, ANIELLO (1607-1656) ITALIAN	1500-25000	L,F
FALDI, ARTURO (1856-1911) ITALIAN	550-17000	G,L
FALENA, P. (19TH C) ITALIAN	*100-700	X
FALENS, CAREL VAN (1683-1733) FLEMISH	2000-26000	G,L,F
FALERO, A. (19TH C) ITALIAN	200-2300	G
FALERO, LUIS RICCARDO (1851-1896) SPANISH	1000-35000	G,F
FALGUIERE, JEAN ALEXANDRE JOSEPH (1831-1900) FRENCH	*300-5000	F
FALK, LAR-ERIK (B. 1922) SCANDINAVIAN	900-3500	A
FALK, ROBERT (1886-1958) RUSSIAN	750-21000	F,S
FANFANI, ENRICO (19TH C) ITALIAN	150-2800	G,W,M
FANGEY, DANIEL (20TH C) FRENCH	100-600	X
FANTIN-LATOUR, IGNACE HENRI JEAN THEODORE	*800-24000	
FANTIN-LATOUR, IGNACE HENRI JEAN THEODORE (1836-1904) FRENCH	2000-+++	F,L,S
FANTIN-LATOUR, THEODORE (1805-1872) FRENCH	*1000-21000	F
FANTIN-LATOUR-DUBOURG, VICTORIA (1840-1926) FRENCH	800-32000	G,S
FANTINI, MATTEO (18TH/19TH C?) ITALIAN	200-1500	X
FARAI, GENNARO (B. 1882) ITALIAN	100-700	X
FARASYN, EDWARD (1858-1938) BELGIAN	500-35000	G,F,L
FARFA (1881-1964) ITALIAN	*500-5000	X(A)
FARGUE, JACOB ELIAS LA (1738-1771) DUTCH	*800-4200	L
FARGUE, PAULUS CONSTANTIN LA (1732-1782) DUTCH	1000-8500	L
FARINATI, PAOLO	*500-28000	
FARINATI, PAOLO (1524-1606) ITALIAN	700-25000	G,F
FARINGTON, JOSEPH (1747-1821) BRITISH	900-13000	L,F
FARMER, HENRY (20TH C) BRITISH	200-1500	S
FARNSWORTH, ALFRED V. (1858-1908) BRITISH	*100-900	L,M
FARQUHARSON, DAVID (1839-1907) BRITISH	450-18000	L,M,W
FARQUHARSON, JOSEPH (1846-1935) BRITISH	1000-75000	G,L
FARRER, THOMAS CHARLES (1839-1891) BRITISH	450-7500	L
FARRKY, C. (Early 20TH C) GERMAN	100-700	X
FARROTY, H. A. (19TH C) ITALIAN	250-2000	W,L

FASANOTTI, GAETANO (1831-1882) ITALIAN	1000-22000	L,M
FASCE, F. (19TH C) ITALIAN	*350-27000	X
FASS, OLIVER (B. 1920) FRENCH	100-600	X
FATTORI, GIOVANNI	*1000-60000	
FATTORI, GIOVANNI (1825-1908) ITALIAN	2000-80000	G,F,L,W
FAUCONNIER, EMILE EUGENE (1857-1920) FRENCH	200-1500	W,L,A
FAUCONNIER, HENRI LE	*400-46000	
FAUCONNIER, HENRI LE (1881-1946) FRENCH	600-16000	L,F
FAUERHOLDT, VIGGO (1832-1883) DUTCH	900-8500	M
FAULKNER, BENJAMIN R. (1787-1849) BRITISH	250-2600	F
FAULKNER, CHARLES (Late 19TH C) BRITISH	250-4000	X(G)
FAULKNER, FRANK (20TH C) BRITISH	*400-8000	A
FAULKNER, JOHN	*300-5200	
FAULKNER, JOHN (1803-1888) IRISH	300-17000	G,L
FAURE, AMANDUS (1874-1931) GERMAN	300-3400	S,F
FAUST, HEINRICH (B. 1843) GERMAN	450-6500	G,S
FAUSTINI, MODESTO (1839-1893) ITALIAN	350-4500	G
FAUTRIER, JEAN	*1200-+++	
FAUTRIER, JEAN (1898-1964) FRENCH	2000-+++	A
FAUVELET, JEAN BAPTISTE (1819-1883) FRENCH	250-3500	G,F
FAUX-FROIDURE, EUGENIE JULIETTE (B. 1886) FRENCH	*200-3100	X(S)
FAVAI, GENNARO	*100-700	
FAVAI, GENNARO (1882-1958) ITALIAN	350-12500	L
FAVORIN, ELLEN (1853-1919) FINNISH	1000-15000	L
FAVORY, ANDRE (1888-1937) FRENCH	300-6200	F
FAVRE DE THIERRENS, JACQUES (1895-1973) FRENCH	300-2600	F
FAVRETTO, GIACOMO	*300-29000	
FAVRETTO, GIACOMO (1849-1887) ITALIAN	1500-+++	G,F
FAVRY, ABEL (19TH C) FRENCH	250-3600	X
FAXSON, RICHARD (19TH C) FRENCH	200-2600	M
FAY, JOSEPH (1813-1875) GERMAN	350-5500	G,L
FAY, LUDWIG BENNO (1859-1906) GERMAN	400-9500	G,L,W
FAZZINI, PERICLE (B. 1913) ITALIAN	*100-1600	F
FEARNLEY, THOMAS (1802-1842) NORWEGIAN	2000-72000 L,F	
FECHTER, EMERICH (1854-1912) AUSTRIAN	100-1500	L
FEDDEN, MARY (B. 1915) BRITISH	1000-15000	S,L
FEDDER, OTTO (1873-1919) GERMAN	300-6500	L,F,W
FEDELER, CARL (1837-1897) GERMAN	400-5500	M

* Denotes watercolors, pastels, drawings, and/or mixed media

FEDER, ADOLPHE	*300-2000	
FEDER, ADOLPHE (1886-1945) FRENCH	500-8800	S,F,A
FEDERICO, CAVALIER MICHELE (B. 1884) ITALIAN	200-6000	M
FEDERZOLI, F. (19TH C) ITALIAN	100-700	X
FEHR, FRIEDRICH (B. 1862) GERMAN	*100-600	X(M)
FEININGER, LYONEL	*600-44000	
FEININGER, LYONEL (1871-1956) GERMAN	20000-+++	A
FEINT, ADRIAN (B. 1894) AUSTRALIAN	800-8500	S
FEITO, LUIS	*1000-18000	
FEITO, LUIS (B. 1919) SPANISH	5000-75000	A
FEJES, EMERIK (1904-1969) YUGOSLAVIAN	200-2500	X
FELARIK, A. (20TH C) DUTCH	100-600	X
FELBER, CARL FRIEDRICH (1880-1932) SWISS	150-3200	L
FELBINGER, FRANZ VON (1844-1906) AUSTRIAN	150-1000	X
FELDHUTTER, FERDINAND (1842-1898) GERMAN	350-9000	L,W
FELDMANN, KONAN (B. 1870) RUSSIAN	*400-7500	X
FELDTRAPPE, HENRI (19TH C) FRENCH	300-3500	G,F
FELGENTREFF, PAUL (1854-1933) GERMAN	300-10000	G,F
FELIX, K. EUGENE (1837-1906) AUSTRIAN	400-12000	M,F,S
FELIXMULLER, CONRAD (B. 1897)	7000-225000	F,G,S
FELNER, K. (Early 20TH C) GERMAN	100-700	X
FELS, A. J. (19TH/20TH C) DUTCH	100-600	X
FENSON, R (19TH C) BRITISH	300-3500	L
FENYES, ADOLF (1867-1945) HUNGARIAN	400-6000	G,L
FER, EDOUARD DE	*600-10000	
FER, EDOUARD DE (1887-1959) FRENCH	600-6500	X
FERANTI, C. (19TH C) ITALIAN	150-1200	X
FERAT, SERGE	*300-9500	
FERAT, SERGE (1881-1958) FRENCH	900-20000	X
FEREY, PROSPER (19TH C) FRENCH	250-3500	L,F
FERG, FRANZ DE PAULA (1689-1740) AUSTRIAN	1200-60000	G,L,F
FERGOLA, SALVATORE (1799-1877) ITALIAN	1500-15000	L
FERGUSON, WILLIAM GOWE (1632-1695) BRITISH	1200-16000	S
FERGUSSON, JOHN DUNCAN	*500-11000	
FERGUSSON, JOHN DUNCAN (1874-1961) BRITISH	1500-+++	L,F
FERNAND-TROCHAIN, JEAN (1879-1969) FRENCH	300-5700	X(F,G)
FERNANDEZ, JESSE (20TH C) PUERTO RICAN	*100-1200	G
FERNANDEZ, JOSE (19TH C) SPANISH	300-3600	G
FERNANDEZ, RAFA (B. 1935) LATIN AMERICAN	200-3500	G

FERNANDEZ CAVADA, FEDERICO (1831-1871) CUBAN	350-4500	L
FERNANDEZ-MURO, JOSE ANTONIO (B. 1920) ARGENTINIAN	*400-2500	A
FERNANDI, FRANCESCO (18TH C) ITALIAN	400-11000	G
FERNELEY, CLAUDE LORRAINE	*100-700	
FERNELEY, CLAUDE LORRAINE (1822-1892) BRITISH	400-10000	W,L
FERNELEY, JOHN (JR.) (1815-1862) BRITISH	1500-40000	G,L,W
FERNELEY, JOHN (SR.) (1782-1860) BRITISH	2500-+++	L,W,F
FERON, JULIEN HIPPOLYTE (B. 1864) FRENCH	200-4000	X
FERRAGUTI, ARNALDO (1862-1925) ITALIAN	*1000-16000	F
FERRANDIZ Y BADENES, BERNARDO (1835-1890) SPANISH	400-10000	G,F
FERRANTI, CARLO (19TH C) ITALIAN	250-5000	G,M
FERRARESI, F. (19TH C) ITALIAN	*200-4000	G
FERRARI, CARLO (1813-1871) ITALIAN	400-12000	X
FERRARI, GAUDENZIO M. (1484-1546) ITALIAN	*2000-20000	F
FERRARIS, ARTHUR VON (B. 1856) AUSTRIAN	800-14000	F
FERREIRA, JESUS REYES (CHUCHO) (1884-1977) MEXICAN	*100-1000	W,F,S
FERREIRA, MANUEL (20TH C) PORTUGESE	*100-600	X
FERRI, CIRO	*500-15000	
FERRI, CIRO (1634-1689) ITALIAN	800-47000	F
FERRIER, GABRIEL (1847-1914) FRENCH	400-40000	X
FERRIER, GEORGE STRATTON (D. 1912) BRITISH	*100-1200	M
FERRIER, JAMES (19TH C) BRITISH	*150-1600	M
FERRIER, JOSEPH MARIE AUGUSTIN GABRIEL (1847-1914) FRENCH	400-4500	G,F
FERRO-LAGREE, GEORGES (20TH C) FRENCH	150-3000	X(G)
FERRONI, EGISTO (1835-1912) ITALIAN	350-7200	G,L,F
FERSTEL, L. (19TH/20TH C) AUSTRIAN	100-2100	X
FESTA, TANO	*900-28000	
FESTA, TANO (B. 1938) ITALIAN	1000-20000	A
FEUERBACH, ANSLEM	*300-11000	
FEUERBACH, ANSLEM (1829-1880) GERMAN	800-25000	G,F,L
FEUILLET, RENE (19TH C) FRENCH	100-700	X
FEURE, GEORGES DE	*650-66000	
FEURE, GEORGES DE (1868-1943) FRENCH	750-78000	L,M,F
FEYEN, JACQUES EUGENE (1815-1908) FRENCH	350-7500	G,M,F
FEYEN-PERRIN, FRANCOIS NICOLAS AUGUSTIN (1826-1888) FRENCH	300-10000	G,F
FIALA, EMMANUEL (B. 1892) AUSTRIAN	100-700	X
FIASELLA, DOMENICO (1589-1669) ITALIAN	2000-18000	F
FICHEL, BENJAMIN EUGENE	*100-1000	

* Denotes watercolors, pastels, drawings, and/or mixed media

FICHEL, BENJAMIN EUGENE (1826-1895) FRENCH	1200-32000	G,F
FICHERELLI, FELICE (Called IL RIPOSO) (1605-1660) ITALIAN	400-17500	F
FIDANZA, FRANCESCO (1747-1819) ITALIAN	1000-12000	L
FIDLER, HARRY (D. 1935) BRITISH	500-12000	G,F,W
FIEDLER, BERNHARD (1816-1904) GERMAN	350-3800	L,M,F
FIELDING, ANTHONY VANDYKE COPLEY	*300-13000	
FIELDING, ANTHONY VANDYKE COPLEY (1787-1855) BRITISH	800-22000	L,M,F
FIELDING, GEORGE (19TH C) BRITISH	150-1000	L
FIELDING, THALES (1793-1837) BRITISH	*100-1500	L,W
FIERAVINO, FRANCESCO (IL MALTESE) (1640-1680) ITALIAN	1000-42000	S
FIGARET, L. (19TH C) FRENCH	*100-1000	X
FIGARI, PEDRO (1861-1938) URUGAYAN	3000-90000	X(G)
FILARSKI, DIRK HERMAN WILLEM (B. 1885) FLEMISH	300-7700	L,S
FILCER, LUIS (20TH C) MEXICAN	150-144000	X(F)
FILDES, SIR LUKE (1843-1927) BRITISH	500-5000	F,S
FILIBERTI, GEORGES GUIDO (1881-1970) FRENCH	400-3500	G,F
FILLA, EMIL (1882-1953) CZECHOSLOVAKIAN	900-41000	S,W
FILLIA, LUIGI COLOMBO (1904-1936) ITALIAN	1000-39000	A
FILLIARD, ERNEST (1868-1933) FRENCH	*100-6100	S
FILLON, ARTHUR (1900-1974) FRENCH	200-4800	L,F
FILONOV, PAVEL	*200-31000	
FILONOV, PAVEL (1883-1941) RUSSIAN	2000-35000	X
FILORI, G. (19TH C) ITALIAN	150-900	X
FILOSA, GIOVANNI B. (1850-1935) ITALIAN	*300-8500	G,L
FINART, NOEL DIEUDONNE (1797-1852) FRENCH	*200-1600	G,W
FINCH, ALFRED WILLIAM (WILLY)	*200-4500	
FINCH, ALFRED WILLIAM (WILLY) (1854-1930) BELGIAN	600-39000	X(L)
FINCKE, HERMANN (B. 1845) GERMAN	200-800	X
FINEZ, GREGOIRE NICOLAS (Late 19TH C) FRENCH	150-800	X
FINI, LEONOR	*600-15000	
FINI, LEONOR (B. 1918) ITALIAN	3000-155000	A
FINI, UMBERTO (19TH C) ITALIAN	150-1000	X(F)
FINK, AUGUST (1846-1916) GERMAN	450-14000	L,W
FINLAYSON, E. C. (19TH/20TH C) FRENCH	100-700	X
FIORE, JACOBELLO DEL (1394-1439) ITALIAN	2000-72000	F
FIRANGE, RINALD (19TH C) EUROPEAN	100-700	X
FIRARDOS, L. A. (19TH/20TH C) FRENCH	*100-600	X
FIRLE, WALTER (1859-1929) GERMAN	350-20000	G,F
FIRMIN-GERARD, MARIE FRANCOIS (1838-1921) FRENCH	1500-140000	G,F

FIRSCH, JOHANN CHRISTOPH (1738-1815) GERMAN	300-1500	X
FISCHBACH, JOHANN (1797-1871) AUSTRIAN	1000-18000	G,L
FISCHER, ERNST (1815-1874) GERMAN	400-7500	G
FISCHER, ERNST ALBERT (B. 1853) GERMAN	*200-5000	X
FISCHER, GOTTLOB (1829-1905) GERMAN	200-3000	G
FISCHER, HEINRICH (1820-1886) SWISS	150-4200	L
FISCHER, PAUL GUSTAVE (1860-1934) DANISH	1800-225000	G,L,F,W
FISCHETTI, FEDELE (1734-1789) ITALIAN	500-19000	F
FISCHHOF, GEORG (1849-1920) AUSTRIAN	250-5400	L,M
FISHER, SAMUEL MELTON (1859-1939) BRITISH	250-14000	F,G
FITZ, JOHN (Early 20TH C) BRITISH	*100-600	X
FITZ, WILLIAM (Late 19TH C) BRITISH	100-600	G,F,S
FIUME, SALVATORE (B. 1915) ITALIAN	1500-26000	A
FJAESTAD, GUSTAF (1868-1948) SWEDISH	2000-51000	M,G,L
FLAHAUT, LEON CHARLES (B. 1831) FRENCH	100-700	X
FLAMENG, FRANCOIS (1856-1923) FRENCH	1500-60000	G,F,W
FLANAGAN, JOHN RICHARD (1895-1964) AUSTRALIAN	*100-800	X
FLANDRIN, JEAN HIPPOLYTE (1809-1864) FRENCH	200-8400	G,F
FLANDRIN, JULES (1871-1947) FRENCH	250-9900	G,L,S
FLAUGIER, JOSE (1760-1812) SPANISH	450-4500	X(F)
FLAXMAN, JOHN (1755-1826) BRITISH	*300-5500	F
FLEISCHER, MAX (1861-1930) GERMAN	*400-6000	X
FLEISCHMANN, ADOLF (1892-1969) GERMAN	200-38000	X
FLERS, CAMILLE (1802-1868) FRENCH	350-7000	L,S
FLETCHER, BLANDFORD (19TH/20TH C) BRITISH	200-7200	X
FLETCHER, EDWIN (1857-1945) BRITISH	200-3500	L,M
FLETCHER, FRANK MORLEY (1866-1949) BRITISH/AMERICAN	150-600	X
FLETCHER, WILLIAM BLANFORD (1858-1936) BRITISH	*300-1500	
FLEURENT, ROBERT (1904-1981) FRENCH	400-2000	L,F
FLEURY, FANNY (B. 1848) FRENCH	200-3900	G,F
FLEURY, FRANCOIS ANTOINE LEON (1804-1858) FRENCH	300-4500	G,L,W
FLEURY, J.VIVIEN DE	*100-500	
FLEURY, J.VIVIEN DE (Active 1845-1870) BRITISH	200-6600	L,M
FLIEHER, KARL	*200-1500	
FLIEHER, KARL (1881-1958) AUSTRIAN	300-4500	G,L
FLIER, HELMERT RICHARD VAN DER (1827-1899) DUTCH	250-3500	L,W
FLINCK, GOVAERT	*1000-45000	
FLINCK, GOVAERT (1615-1660) DUTCH	6000-+++	F,W
FLINT, SIR WILLIAM RUSSELL	*900-95000	

* Denotes watercolors, pastels, drawings, and/or mixed media

FLINT, SIR WILLIAM RUSSELL (1880-1969) BRITISH	1000-80000	F,M
FLOGNY, EUGENE VICTOR DE (B. 1825) FRENCH	300-4200	G
FLOQUET, LUCAS (17TH C) FLEMISH	800-15000	F
FLORES, PEDRO (1897-1967) SPANISH	300-11000	L,S
FLORIS, FRANS (?)	5000-160000	F,E,G
FOLEY, HENRY (1818-1874) BRITISH	200-2200	L,F
FOLLI, LUIGI (19TH C) ITALIAN	250-3500	G
FOLLINI, CARLO (1848-1938) ITALIAN	300-19000	L,F,W
FONG, LAI (19TH/20TH C) CHINESE/AMERICAN	400-11000	M
FONSECA, REINALDO DE AQUINO (B. 1925) BRAZILIAN	400-10000	G
FONTANA, ERNESTO (1837-1918) ITALIAN	350-9600	G
FONTANA, GIUSEPPI (1821-1893) ITALIAN	200-1600	G
FONTANA, LAVINIA (1552-1614) ITALIAN	800-27000	F
FONTANA, LUCIO	*900-+++	
FONTANA, LUCIO (1899-1968) ITALIAN	2000-+++	A
FONTANE, A. LEONARD (20TH C) EUROPEAN	150-1400	X(F)
FONTEBASSO, FRANCESCO (1709-1769) ITALIAN	*800-22000	F
FONTENAY, ALEXIS DALEGI DE (1815-1892) FRENCH	300-2400	L,M
FONTENAY, ANDRE (B. 1913) FRENCH	100-4500	X(F)
FONTENAY, EUGENE (B. 1824) FRENCH	400-3500	L
FONTVILLE, ALFRED (Late 19TH C) BRITISH	150-900	L
FOOTE, EDWARD KILBOURNE (19TH C) BRITISH	*300-3000	G,F
FOPPIANI, GUSTAVO (B. 1925) ITALIAN	100-700	X
FORAIN, JEAN LOUIS	*900-100000	
FORAIN, JEAN LOUIS (1852-1931) FRENCH	1500-60000	G,F,A
FORBES, ELIZABETH ADELA	*500-49000	
FORBES, ELIZABETH ADELA (1859-1912) CANADIAN	1000-36000	G,F
FORBES, STANHOPE ALEXANDER (1857-1947) IRISH	1000-163000	G,L,F,W
FORBES, STEWART L. (19TH C) BRITISH	*100-1000	X
FORD, HENRY JUSTICE (1860-1941) BRITISH	*250-3000	L,W
FORD, JOHN (D. 1885) BRITISH	*200-2000	G
FORD, RUDOLPH ONSLOW (20TH C) BRITISH	300-2400	X(F)
FOREAU, LOUIS HENRI	*200-1500	
FOREAU, LOUIS HENRI (1866-1938) FRENCH	250-2500	G,M,L
FORIEN, J. (19TH C) FRENCH	100-600	X
FORLENZA, D. (19TH C) ITALIAN	150-1200	X
FORMILLI, CESARE (19TH C) ITALIAN	*300-3800	X(G)
FORMIS, ACHILLE (1832-1906) ITALIAN	350-5800	L,F
FORNARA, CARLO (1871-1968) ITALIAN	5000-100000	X

FORNASETTI, PIERRO (B. 1913) ITALIAN	1500-35000	X
FORNENBURGH, JAN BAPTIST VAN (1608-1656) DUTCH	5000-62000	S
FORNER, RAQUEL (B. 1902) ARGENTINIAN	350-3500	G
FORREST, CAPTAIN J. HAUGHTON (1825-1924) BRITISH	500-15000	M,L
FORREST, HAUGHTON (1825-1924) BRITISH	350-10500	M
FORSBERG, CARL JOHAN (1868-1938) SWEDISH	*800-6500	M
FORSSELL, VICTOR (1846-1931) SWEDISH	1000-25000	X (G)
FORSTER, BERTHOLD PAUL (1851-1928) GERMAN	100-1600	X
FORT, THEODORE (19TH C) FRENCH	*100-2200	F,W
FORTE, LUCA (18TH C) ITALIAN	3000-50000	S
FORTE, VINCENTE (B. 1912) ARGENTINIAN	300-5000	S,M
FORTESCUE, WILLIAM BANKS (19TH C) BRITISH	900-23000	G,M,F
FORTI, ETTORE (Late 19TH C) ITALIAN	600-41000	G,L
FORTIER, MARIE LOUISE (20TH C) FRENCH	200-2200	X
FORTIN, CHARLES (1815-1865) FRENCH	300-3500	X
FORTIN, MARC-AURELE	*800-13000	
FORTIN, MARC-AURELE (1888-1970) CANADIAN	600-120000	L
FORTINI, A. (19TH/20TH C) ITALIAN	200-3000	X
FORTUNY, LUCIA (20TH C) FRENCH	150-2400	G,M
FORTUNY Y CARBO, MARIANO	*200-11000	
FORTUNY Y CARBO, MARIANO (1838-1874) SPANISH	1000-220000	G,L,F
FORTUNY Y MADRAZO, MARIANO (1871-1949) SPANISH	350-15000	G,L
FOSCHI, PIER FRANCESCO (1502-1567) ITALIAN	2000-25000	F
FOSSATI, EMILIO (20TH C) ITALIAN	150-1500	M
FOSTER, HERBERT WILSON (Active 1870-1917) BRITISH	250-3500	G
FOSTER, KATE E. (19TH C) BRITISH	100-600	X
FOSTER, MYLES BIRKET (1825-1899) BRITISH	*900-72000	G,L,W
FOSTER, WILLIAM GILBERT (1855-1906) BRITISH	400-4200	G
FOUBERT, C. (19TH C) FRENCH	150-1500	G
FOUBERT, EMILE LOUIS (D. 1910) FRENCH	200-6000	G,L,F
FOUJITA, TSUGUHARU	*1000-+++	
FOUJITA, TSUGUHARU (1886-1968) JAPANESE	8000-+++	G,F
FOUQUET, ANATOLE (19TH C) FRENCH	250-3600	G,F
FOUQUIER, JACQUES (1580-1659) FRENCH	2500-35000	L,F,W
FOUREAU, LOUIS-HENRI (1866-1938) FRENCH	150-1500	X
FOURIE, ALBERT AUGUSTE (B. 1854) FRENCH	400-10000	G
FOURMOIS, THEODORE (1814-1871) BELGIAN	800-9000	L
FOURMOND, CORALYDE (1803-1853) FRENCH	100-1200	X
FOURNIER, ALFRED VICTOR (1872-1924) FRENCH	500-12000	G

* Denotes watercolors, pastels, drawings, and/or mixed media

FOURNIER, JEAN BAPTISTE FORTUNE DE (1798-1864) FRENCH	*200-2500	F
FOURNIER, JEAN SIMON (18TH C) FRENCH	600-8500	X
FOURNIER, LOUIS EDOUARD PAUL (B. 1857) FRENCH	400-10000	G
FOUS, JEAN (1901-1971) FRENCH	450-4200	G,L
FOWERAKER, A MOULTON	*300-2700	
FOWERAKER, A MOULTON (1873-1942) BRITISH	600-4200	L,M
FOWLER, DANIEL (1810-1894) BRITISH	*400-7500	X(L)
FOWLER, GEORGE (19TH/20TH C) BRITISH	100-1500	M
FOWLER, ROBERT	*150-3000	
FOWLER, ROBERT (1853-1926) BRITISH	400-32000	G,F
FOWLER, WILLIAM (1761-1832) BRITISH	900-18000	X(L)
FOX, EDWARD (19TH C) BRITISH	300-4500	X(G)
FOX, EMANUEL PHILLIPS (1865-1915) AUSTRALIAN	1200-54000	M,L,F
FOX, ETHEL CARRICK (1876-1952) AUSTRALIAN	500-35000	S,L,F
FOX, GEORGE (19TH C) BRITISH	100-1900	G
FOX, HENRY CHARLES	*200-3500	
FOX, HENRY CHARLES (B. 1860) BRITISH	150-1800	L,W
FOX, WILLIAM EDWARD (B. 1872) BRITISH	300-4500	X(L)
FRACANZANO, FRANCESCO (1612-1656) ITALIAN	900-35000	G,F
FRACASSI, CESARE (1838-1868) ITALIAN	200-2500	X
FRADEL, HENRI JOSEPH (1778-1865) FRENCH	200-1500	X(L)
FRAGIACOMO, PIETRO (1856-1922) ITALIAN	800-70000	M,L
FRAGONARD, ALEXANDRE EVARISTE	*500-40000	
FRAGONARD, ALEXANDRE EVARISTE (1780-1850) FRENCH	2000-144000	G,F
FRAGONARD, JEAN HONORE	*800-+++	
FRAGONARD, JEAN HONORE (1732-1806) FRENCH	15000-+++	G,F,L
FRAGONARD, THEOPHILE EVARISTE HIPPOLYTE ETIENNE (1806-1876) FRENCH	300-3200	G
FRAILE, ALFONSO (B. 1930) SPANISH	150-3000	X
FRANCAIS, FRANCOIS LOUIS	*200-6700	
FRANCAIS, FRANCOIS LOUIS (1814-1897) FRENCH	400-44000	G,L
FRANCESCHI, MARIANO DE	*200-4000	
FRANCESCHI, MARIANO DE (1849-1896) ITALIAN	300-7000	G
FRANCESCHINI, BALDASSARE (1611-1689) ITALIAN	*1000-30000	F
FRANCESE, FRANCO (B. 1920) ITALIAN	500-5500	G
FRANCHI, ANTONIO (1639-1709) ITALIAN	500-12000	F
FRANCHI, ROSSELLO DI JACOPO (1377-1456) ITALIAN	5000-82000	F
FRANCIA, ALEXANDRE T. (1820-1884) FRENCH/BELGIAN	900-12000	G,L,M
FRANCIA, FRANCOIS THOMAS LOUIS (1772-1839) FRENCH	*400-10000	M,L,F

FRANCIA, GIACOMO (1486-1557) ITALIAN	1200-50000	F
FRANCISCO, PIETRO DE (20TH C) ITALIAN	200-3500	F,L
FRANCK, PAUWELS (Called PAOLO FIAMMINGO) (1540-1596) FLEMISH	1000-26000	F
FRANCK, PHILIPP (1860-1944) GERMAN	400-23000	L,M
FRANCKEN, CONSTANTINUS (1661-1717) FLEMISH	800-9500	X
FRANCKEN, FRANS (III) (1607-1667) FLEMISH	500-56000	F
FRANCKEN, FRANS I (1542-1616) FLEMISH	1500-24000	F
FRANCKEN, FRANS II (1581-1642) FLEMISH	1000-45000	F,G
FRANCKEN, HIERONYMUS I (1540-1628) FLEMISH	800-48000	G
FRANCKI, GUSTAVE DE E. (19TH C) FRENCH	100-600	X
FRANCO, GIOVANNI BATTISTA (1510-1580) ITALIAN	*800-7000	F
FRANCOIS, ALEXANDER (1824-1912) BELGIAN	100-1000	X
FRANCOIS, ANGE (1800-1869) FLEMISH	400-11000	G
FRANCOIS, GUSTAVE (20TH C) SWISS	400-3000	F
FRANCOIS, GUSTAVE (B. 1883) SWISS	*400-8500	G,F
FRANCOIS, JOSEPH (1759-1851) BELGIAN	350-12000	X
FRANCOIS, RAYMOND (20TH C) FRENCH	100-1400	X
FRANCUCCI, INOCENZA (Called INOCENZA DA IMOLI) (1490-1545) ITALIAN	900-18000	F
FRANGIAMORE, SALVATORE (1853-1915) BRITISH	550-18000	G,F
FRANK, FRIEDRICH (1627-1687) GERMAN	*300-2500	F,L
FRANK, JOHANN ANDREAS JOSEPH (1756-1804) GERMAN	200-1800	X
FRANK, JOSEPH EGON (20TH C) GERMAN	500-4200	X(G)
FRANK-WILL	*500-32000	
FRANK-WILL (1900-1951) FRENCH	300-22000	L
FRANKE, ALBERT JOSEPH (1860-1924) GERMAN	1000-28000	G,F
FRANKEN, PAUL VON (1818-1884) GERMAN	100-4200	G,F
FRANKFORT, EDUARD	*100-500	
FRANKFORT, EDUARD (1864-1920) DUTCH	200-2500	G,F
FRANQUELIN, JEAN AUGUSTIN (1798-1839) FRENCH	650-94000	G
FRANQUELINE, M. (19TH C) FRENCH	200-2400	X
FRANZ, ETTORE ROESLER (1845-1907) ITALIAN	*800-8000	L
FRAPPA, JOSE (1854-1904) FRENCH	400-6500	G,F
FRASER, ALEXANDER (JR.) (1828-1899) BRITISH	400-7000	L
FRASER, ALEXANDER (SR.) (1786-1865) BRITISH	350-7500	G,W,F
FRASER, DONALD HAMILTON (B. 1929) BRITISH	200-8400	L,M
FRASER, JOHN (1858-1927) BRITISH	*100-3000	M,F
FRASER, JOHN ARTHUR (1838-1898) CANADIAN	1200-25000	L,F
FRASER, ROBERT WINTER (D. 1899) BRITISH	*100-5000	L,F,W

* Denotes watercolors, pastels, drawings, and/or mixed media

FRATER, WILLIAM (B. 1890) BRITISH/AUSTRALIAN	500-24000	G,F,L
FRAUENFELDER, F. J. (20TH C) DUTCH	150-1400	L,F,W
FRAZER, WILLIAM MILLER (19TH/20TH C) BRITISH	500-8500	L,W,F
FRECSKAY, LASZLO VON (1844-1916) AUSTRIAN	350-3800	G
FREDDIE, WILHELM (B. 1909) DANISH	600-49000	F,L,S
FREDERIC, LEON (1856-1940) BELGIAN	800-26000	G,L,F
FREDOU, JEAN MARTIAL (1711-1795) FRENCH	*300-4500	F
FREEMAN, J. (19TH/20TH C) BRITISH	*100-1400	X
FREEMAN, WILLIAM PHILIP BARNES (1813-1897) BRITISH	100-1900	L,W
FREGEVIZE, FREDERIC (1770-1849) SWISS	1000-16000	G,L
FREMIET, EMMANUEL (1824-1910) FRENCH	200-3600	X(W,F)
FRENCH, ANNIE (1872-1965) SCOTTISH	*300-5800	G,L
FRENCH, PERCY (1854-1920) IRISH	*300-6000	L,M
FRENTZ, RUDOLF (1831-1888) GERMAN	400-5800	X
FRENZENY, PAUL	*150-1200	
FRENZENY, PAUL (1840-1902) CANADIAN	400-8500	I,F
FRERE, CHARLES EDOUARD	*100-1000	
FRERE, CHARLES EDOUARD (1837-1894) FRENCH	1000-18000	G,L
FRERE, CHARLES THEODORE	*300-2500	
FRERE, CHARLES THEODORE (1814-1888) FRENCH	1200-82500	G,F
FRERE, H. (20TH C) FRENCH	100-600	X
FRERE, PIERRE EDOUARD (1819-1886) FRENCH	900-32000	G,F
FRERE, SAMUEL (20TH C) FRENCH	200-1800	X(L)
FRERE, THEODORE (20TH C) FRENCH	1000-30000	X
FRESNAYE, ROGER DE LA	*800-59000	
FRESNAYE, ROGER DE LA (1885-1925) FRENCH	3000-65000	X (A)
FREUD, LUCIAN (B. 1922) BRITISH	6000-+++	X
FREUDENBERGER, SIGMUND (1745-1801) SWISS	*800-10000	G,F,L
FREUND, FRITZ (1859-1942) GERMAN	400-5200	G,L
FREUNDLICH, OTTO (20TH C) GERMAN	*2000-63000	A
FREY, ALICE (20TH C) BELGIAN	400-3500	X
FREY, JOHANN JAKOB (1813-1865) SWISS	600-9700	G,L,F
FREY, JOHANN WILHELM (1826-1911) GERMAN	400-5500	X(L)
FREYBERG, CONRAD (B. 1842) GERMAN	1000-20000	G,L
FRICK, PAUL DE (1864-1935) FRENCH	300-4000	L,M,F
FRIED, OTTO (20TH C) DUTCH	100-1900	X
FRIED, PAL	*100-600	
FRIED, PAL (1893-1976) HUNGARIAN	750-6000	F
FRIEDEBERG, PEDRO (B. 1937) MEXICAN	*150-2000	G

FRIEDENSON, ARTHUR A. (1872-1955) BRITISH	150-3900	L
FRIEDLAENDER, ALFRED (B. 1860) GERMAN	350-4800	G,F
FRIEDLAENDER, JULIUS (1810-1861) DANISH	350-7800	G,M,F
FRIEDLANDER, FRIEDRICH (1825-1901) AUSTRIAN	500-16000	G,F
FRIEDLANDER, HEDWIG (B. 1863) AUSTRIAN	500-7500	G,F,S
FRIEDLANDER VON MALHEIM, CAMILLA (1856-1928) AUSTRIAN	500-8000	S
FRIEDRICH, ADOLF (1750-1803) SWEDISH	300-4000	X
FRIEDRICH, CASPAR DAVID (1774-1840) GERMAN	4000-181000	F,L
FRIEDRICH, JOHANN HEINRICH AUGUST (1789-1843) GERMAN	*500-7500	X(S)
FRIEDRICH, JOHANN NEPOMUK (1817-1895) GERMAN	250-2400	F
FRIEDRICH, OTTO (1862-1937) HUNGARIAN	600-18000	X(G)
FRIEDRICHSEN, ERNESTINE (1824-1892) GERMAN	300-9000	G
FRIEND, DONALD STUART LESLIE	*400-17000	
FRIEND, DONALD STUART LESLIE (B. 1914) AUSTRALIAN	500-20000	L,F
FRIESZ, ACHILLE EMILE OTHON	*400-17000	
FRIESZ, ACHILLE EMILE OTHON (1879-1949) FRENCH	3000-+++	A,L,M,F
FRIIS, HANS GABRIEL (1838-1892) DANISH	1000-20000	G,L,M
FRINK, ELIZABETH (B. 1930) BRITISH	*100-8200	F,W
FRIPP, ALFRED DOWNING (1822-1895) BRITISH	*200-4500	G,F
FRIPP, GEORGE ARTHUR (1813-1896) BRITISH	*200-12000	L
FRIPP, THOMAS W. (1864-1931) CANADIAN	*200-1800	L
FRISCH, JOHANN CHRISTOPH (1738-1815) GERMAN	300-4000	L
FRISTON, DAVID HENRY (Active 1853-1869) BRITISH	200-3800	X(G)
FRITH, WILLIAM POWELL	*150-1600	
FRITH, WILLIAM POWELL (1819-1909) BRITISH	1000-102500	G,F
FROHLICH, ERNEST (1810-1882) GERMAN	800-7000	X
FROHLICH, LORENZ (1820-1908) DANISH	150-13000	G,L
FROHLICHER, OTTO (1840-1890) SWEDISH	800-15000	L,W
FROMANTIOU, HENDRICK DE (1633-1694) DUTCH	1000-22000	G
FROMENTIN, EUGENE	*400-6000	
FROMENTIN, EUGENE (1820-1876) FRENCH	5000-130000	G,F
FROOD, HESTER (20TH C) BRITISH	*100-600	X
FROST, TERRY	*600-4400	
FROST, TERRY (B. 1915) BRITISH	900-24000	A
FROST, WILLIAM EDWARD	*200-3000	
FROST, WILLIAM EDWARD (1810-1877) BRITISH	1500-20000	F,M,W
FUCHS,-ERNST	*200-6500	
FUCHS, ERNST (B.1930) AUSTRIAN	2000-35000	G,F,L
FUCHS, LUDWIJK JULIAAN (1814-1873) DUTCH	150-1500	L

* Denotes watercolors, pastels, drawings, and/or mixed media

FUCHS, THERESE (B. 1849) GERMAN	100-1800	L
FUES, CHRISTIAN FRIEDRICH (1772-1836) GERMAN	150-2000	X
FUGER, FRIEDRICH HEINRICH (1751-1818) GERMAN	200-3500	F
FUITON, H. (19TH C) FRENCH	150-1400	X(G)
FUKUI, RYONOSUKE (B. 1922) JAPANESE	1000-12000	L,F
FULLWOOD, ALBERT HENRY	*400-6100	
FULLWOOD, ALBERT HENRY (1864-1930) BRITISH	1000-18000	M,L
FULLWOOD, JOHN (D. 1931) BRITISH	*100-1200	L
FULLYLOVE, JOHN (1845-1908) BRITISH	600-12000	L
FULOP, KAROLY (1898-1963) HUNGARIAN	*200-2000	X(F)
FULOR, ELISABETH WEBER (19TH/20TH C) AUSTRIAN	100-1200	X
FULTON, DAVID (1848-1930) SCOTTISH	500-19000	G,L
FULTON, SAMUEL (1855-1941) BRITISH	500-6500	W
FULVIS, DE (20TH C) ITALIAN	100-800	X
FUMIANI, GIOVANNI ANTONIO (1643-1710) ITALIAN	600-9500	F
FUNGAI, BERNARDINO (1460-1516) ITALIAN	2000-32000	F
FUNI, ACHILLE (1890-1972) ITALIAN	1200-55000	X (A)
FUNKE, BERNARD A. (19TH C) DUTCH	100-900	S
FURCY DE LAVAULT, ALBERT TIBULE (19TH C) FRENCH	800-16000	S,L
FURET, FRANCOIS (1842-1919) SWISS	250-4300	L,F,S
FURINI, FRANCESCO (1604-1646) ITALIAN	1000-49000	G,F
FUSSLI, JOHANN HENRY (1741-1825) SWISS	*600-62000	G,F
FUSSMAN, KLAUS (B. 1938) GERMAN	500-30000	X(S,M)
FUSTER, A. TORRES (19TH C) SPANISH	200-1600	X
FYFE, WILLIAM B. (1836-1882) BRITISH	450-18000	G,F,L
FYT, JAN	*400-5500	
FYT, JAN (1609-1661) FLEMISH	1400-+++	L,S

G

ARTIST	PRICES	SUBJECT
GABANI, GUISEPPE	*300-5500	
GABANI, GUISEPPE (1846-1899) ITALIAN	600-33000	G
GABBIANI, ANTONIO DOMENICO (1652-1726) ITALIAN	300-4200	F
GABE, NICHOLAS EDWARD (1814-1865) FRENCH	400-6500	L
GABL, ALOIS (1845-1893) SWISS	400-10000	G
GABRIEL, PAUL JOSEPH CONSTANTIN (1828-1903) DUTCH	900-18000	L,S

GABRINI, PIETRO	*300-10000	
GABRINI, PIETRO (1856-1926) ITALIAN	700-18000	G,M
GABRIS, B. (B. 1912) HUNGARIAN	100-700	X
GABRON, GUILLIAM (1619-1678) BELGIAN	1000-20000	S
GAEL, BARENT (OR BEREND GAAL) (1620-1703) DUTCH	1500-29000	L,F
GAELEN, ALEXANDER VAN (1670-1728) DUTCH	400-24000	X
GAGARIN, PRINCE GRIGORI GRIGORIEVICH (1810-1893) RUSSIAN	*300-7000	F,G
GAGEL, BEMIT (20TH C) DUTCH	200-1600	M
GAGLIARDINI, JULIEN GUSTAVE (1846-1927) FRENCH	300-5400	M
GAGNI, P. (19TH C?) EUROPEAN	100-1200	X
GAGNON, CLARENCE A (1882-1942) CANADIAN	1500-88000	L
GAIGNERON, JEAN DE (B. 1890) FRENCH	100-800	S
GAILLARD, FRANCOIS (1861-1932) FRENCH	1200-84000	G,L,I
GAINSBOROUGH, THOMAS	*1700-121000	
GAINSBOROUGH, THOMAS (1727-1788) BRITISH	8000-+++	F,L,W
GAISER, RAIMOND (19TH C) FRENCH	150-1400	F
GAISSER, JAKOB EMMANUEL (1825-1899) GERMAN	1000-19000	G,F
GAISSER, MAX (1857-1922) GERMAN	1200-75000	G,F
GALAN, JULIO (20TH C) LATIN AMERICAN	400-8500	F,G
GALANT, RENE (20TH C) FRENCH	100-700	F,G
GALBUSERA, GIOVACCHINO (B. 1871) ITALIAN	500-14000	G,S,L
GALE, WILLIAM (1823-1909) BRITISH	300-7600	F,G,S
GALIARDI, GIOVANNI (19TH C) ITALIAN	100-600	X
GALIEN-LALOUE, EUGENE	*1000-65000	
GALIEN-LALOUE, EUGENE (1854-1941) FRENCH	1000-50000	L
GALIMBERTI, SILVIO (B. 1878) ITALIAN	100-1000	X
GALL, FRANCOIS	*200-2400	
GALL, FRANCOIS (1912-1945) FRENCH	500-20000	F,G,M
GALLAGAN, H.R. (19TH C) AUSTRALIAN	200-2000	M
GALLAIT, LOUIS (1810-1887) BELGIAN	350-8600	G,F
GALLAND, PIERRE VICTOR	*100-400	
GALLAND, PIERRE VICTOR (1822-1892) FRENCH	100-1500	X
GALLARD-LEPINAY, PAUL CHARLES EMMANUEL (1842-1885) FRENCH	500-7500	M
GALLE, HIERONYMUS (THE ELDER) (1625-1679) FLEMISH	1000-54000	X(F)
GALLEGOS Y ARNOSA, JOSE (1859-1902) SPANISH	1500-204000	G,L
GALLELLI, MASSIMILIANO (B. 1863) ITALIAN	300-5500	L
GALLEN-KALLELA, AKSELI VALDEMAR	*400-10000	
GALLEN-KALLELA, AKSELI VALDEMAR (1865-1931) FINNISH	600-93000	F,L,I

GALLI, ALDO (1906-1981) ITALIAN	2000-15000	A
GALLI, GIACOMO (Called LO SPADARINO) (18TH C) ITALIAN	3000-58000	G
GALLI, GIUSEPPE (1866-1953) ITALIAN	*400-3800	G
GALLI, LEOPOLDO (19TH C) ITALIAN	100-700	X
GALLIAC, LOUIS (1849-1934) FRENCH	400-15000	G
GALLIARI, BERNARDINO (1704-1794) ITALIAN	*300-3600	L,I
GALLIARI, GASPARE (1760-1823) ITALIAN	*100-1100	I
GALLICE, A. (19TH C) MEXICAN	*500-3500	X
GALLIS, PIETER (1633-1697) DUTCH	900-110000	S
GALLIZIO, PINOT (B. 1902) ITALIAN	1000-8500	A
GALLON, ROBERT (1845-1925) BRITISH	500-23000	L,W
GALLOWAY, J (19TH C) BRITISH	200-3500	L
GALOFRE Y GIMENEZ, BALDOMERO	*700-19000	
GALOFRE Y GIMENEZ, BALDOMERO (1849-1902) SPANISH	3000-45000	G,F,L,M
GALSWORTHY, FRANK (B. 1863) BRITISH	*100-1800	X(L)
GALTON, S.A. (19TH C) BRITISH	150-1500	M,L
GALVAN, JESUS GUERRERO	*300-4500	
GALVAN, JESUS GUERRERO (1910-Early 1970'S) MEXICAN	1000-29000	L,F
GAMBA, ENRICO (1831-1883) ITALIAN	*300-3000	G,L,F
GAMBARINI, GIUSEPPE (1680-1725) ITALIAN	2000-46000	G,F
GAMBINO, GUISEPPE (20TH C) ITALIAN	100-2400	X(F)
GAMELIN, JACQUES (1738-1803) FRENCH	*400-6500	F,G
GAMPERT, OTTO (B. 1842) SWISS	500-6000	F,L,M
GANDOLFI, GAETANO	*400-8500	
GANDOLFI, GAETANO (1734-1802) ITALIAN	2000-141000	F,L
GANDOLFI, MAURO (1764-1834) ITALIAN	500-18000	F
GANDOLFI, UBALDO	*500-14000	
GANDOLFI, UBALDO (1728-1781) ITALIAN	1000-51000	F,G
GANDY, HERBERT (19TH/20TH C) BRITISH	400-18000	F,A
GANDY, JOSEPH MICHAEL (1771-1843) BRITISH	*1000-16000	X(L)
GANGERFELT, WILHELM VON (1844-1920) SWISS	300-2400	X
GANT, JAMES Y. (D. 1841) BRITISH	250-3800	F,L
GANTNER, BERNARD	*200-1800	
GANTNER, BERNARD (B. 1930) FRENCH	300-13000	L
GARAND, GUSTAVE CESARE (1847-1914) FRENCH	100-700	X
GARBELL, ALEXANDRE (1903-1970) LATVIAN/FRENCH	300-6700	L,M,S
GARCIA, GAY (B. 1928) CUBA	*100-1000	X
GARCIA, JOAQUIN TORRES (1874-1949) URAGUAYAN	1500-40000	G
GARCIA Y MENCIA, ANTONIO (Active 1871-1915) SPANISH	1000-16000	M,F

GARCIA Y RAMOS, JOSE (1852-1912) SPANISH	2000-55000	F,G
GARCIA Y RODRIGUEZ, MANUEL (1863-1925) SPANISH	1100-35000	L
GARDELL-ERICSON, ANNA (1853-1939) SWEDISH	*400-20000	L,G,M
GARDEN, WILLIAM FRASER (19TH C) BRITISH	*800-6500	L
GARDI, EMMA (19TH/20TH C) ITALIAN	300-4000	X(F)
GARDINER, STANLEY (B. 1887) BRITISH	400-3500	L
GARDNER, DANIEL	*900-23000	
GARDNER, DANIEL (1750-1805) BRITISH	900-13000	F,G,W
GARDNER, SIDNEY (19TH/20TH C) BRITISH	100-700	L
GAREIS, FRANCIS (19TH/20TH C) FRENCH	100-700	L,F
GARGIULO,-DOMENICO	*200-6600	
GARGIULO, DOMENICO (1612-1679) ITALIAN	5000-214000	F,L
GARIBALDI, JOSEPH (B. 1863) FRENCH	500-6500	L
GARINO, ANGELO (B. 1860) ITALIAN	1000-15000	X (W)
GARLAND, HENRY (Late 19TH C) BRITISH	550-14200	G,W,L
GARLAND, R. (19TH C) BRITISH	200-1500	X
GARLAND, VALENTINE THOMAS (19TH/20TH C) BRITISH	500-8000	G,L
GARNERAY, HIPPOLYTE JEAN BAPTISTE (1787-1858) FRENCH	400-3500	G,F,M,L
GARNIER, JULES A. (1847-1889) FRENCH	1000-40000	G
GAROLI, PIETRO FRANCESCO (1638-1716) ITALIAN	400-6500	X
GARRARD, GEORGE (1760-1826) BRITISH	900-60000	L
GARRETT, THOMAS BALFOUR (1874-1952) AUSTRALIAN	*500-22000	F,L
GARRIDO, EDUARDO LEON (1856-1906) SPANISH	1500-70000	G,F
GARRIDO, LEANDRO RAMON (B. 1868) SPANISH	500-12000	F,L
GARRY, CHARLEY (B. 1891) FRENCH	100-700	F,G
GARSIDE, THOMAS H. (1906-1980) CANADIAN	300-6400	L
GARSTIN, NORMAN	*400-3000	
GARSTIN, NORMAN (19TH C) BRITISH	700-20000	L,F
GARTMEIR, HANS (B. 1910) SWISS	400-6000	F,L
GARTNER, FRITZ (1882-1958) GERMAN	100-1100	G
GARTNER, L. (19TH C) EUROPEAN	150-4200	M
GARZI, LUIGI (1638-1721) ITALIAN	1000-99000	F,G
GASCOYNE, GEORGE (1862-1953) BRITISH	500-6500	L
GASKE, F.J. (19TH/20TH C) EUROPEAN	*100-900	X(G)
GASKELL, GEORGE ARTHUR (Late 19TH C) BRITISH	150-2200	F
GASKINS, ARTHUR JOSEPH (1862-1928) BRITISH	450-26000	G,F
GASPARD, LEON (1882-1964) FRENCH	2000-250000	L,F
GASSON, LEO (1860-1944) FRENCH	150-1000	X

* Denotes watercolors, pastels, drawings, and/or mixed media

GASTINEAU, HENRY G. (1791-1876) BRITISH	*350-14000	G,L,M
GATTA, SAVERIO DELLA (18TH/19TH C) ITALIAN	*700-28000	L,G,F
GATTORNO, ANTONIO (B. 1904) CUBAN	200-2000	X(G)
GAUBAULT, ALFRED EMILE (D. 1895) FRENCH	250-5000	F
GAUDGROY, FERNAND (1885-1964) BELGIAN	400-6800	G
GAUDI, ANTONIO (1852-1926) SPANISH	800-16000	X
GAUDIER-BRZESKA, HENRI (1891-1915) FRENCH	*600-15000	G,F,W,A
GAUERMANN, FRIEDRICH (1807-1862) AUSTRIAN	3000-+++	L,W
GAUFFIER, LOUIS (1761-1801) FRENCH	4000-200000	F
GAUGUIN, PAUL	*3000-+++	
GAUGUIN, PAUL (1848-1903) FRENCH	15000-+++	F,L,S
GAUGUIN, POLA (1883-1961) DANISH	1000-48000	X(A,F,L)
GAULD, DAVID (1866-1936) SCOTTISH	650-18000	X(W,L)
GAULLI, GIOVANNI BATTISTA (1639-1709) ITALIAN	*2000-40000	F
GAUSSEN, ADOLPHE-LOUIS (B. 1871) FRENCH	400-6500	L
GAUSSON, LEO (1860-1944) FRENCH	900-26000	L
GAUTHERIN, JACQUES (19TH C?) FRENCH	400-7000	L
GAVAGNIN, NATALE (B. 1851) ITALIAN	200-3500	M,L
GAVANI, GIUSEPPE (1849-1899) ITALIAN	*200-1400	W,L
GAVARDIE, JEAN DE (1909-1956) FRENCH	350-4200	X
GAVARNI, SULPICE-GUILLAUME CHEVALIER (Called PAUL) (1804-1866) FRENCH	*300-8000	F,G,I
GAVREL, GENEVIEVE (B. 1909) FRENCH	500-4000	X(S,L)
GEAR, WILLIAM (B. 1915) BRITISH	1000-11000	A
GEBAUER, CHRISTIAN DAVID (1777-1831) GERMAN	100-2500	L,F
GEBHARDT, EDUARD VON (1838-1925) GERMAN	150-4100	G,F
GEBHARDT, JOHANN (20TH C) GERMAN	150-700	X
GEBHARDT, LUDWIG (1830-1908) GERMAN	300-3500	G,L
GEBLER, FRIEDRICH OTTO (1838-1917) GERMAN	3000-65000	L,W
GEDLEK, LUDWIG (B. 1847) POLISH	400-9600	G,L,F
GEENS, LOUIS (19TH C) BELGIAN	500-7000	X
GEERAERTS, MARTEN	*100-900	
GEERAERTS, MARTEN (1709-1791) FLEMISH	900-50000	G,F
GEERTS, JULIUS (1837-1902) GERMAN	400-4500	X
GEEST, JULIEN FRANCISCUS DE (D. 1699) FLEMISH	400-8400	F
GEFFCKEN, WALTHER (1872-1950) GERMAN	150-3000	X(F)
GEGERFELT, WILHELM VON (1844-1920) SWEDISH	1000-34000	M,L
GEIBEL, CASIMIR (1839-1896) GERMAN	900-16000	F
GEIBEL, H. (19TH C) GERMAN	100-800	X

GEIGER, CONRAD (1751-1808) GERMAN	300-3200	F
GEIGER, RICHARD (B. 1870) AUSTRIAN	300-4000	F,G
GEIGER, WILLI (1878-1971) GERMAN	800-12000	X (L,S)
GEIRNAERT, JOZEF (1791-1859) BELGIAN	1500-15000	W,G
GEISSER, T. E. (19TH C) GERMAN	150-1400	G
GEITNER, OTTO (19TH C) GERMAN	*100-700	X
GELANZE, GIUSEPPE (B. 1876) ITALIAN	100-1000	G
GELDORP, GORTZIUS (1553-1618) FLEMISH	900-8500	F
GELHAY, EDOUARD (B. 1856) FRENCH	600-9500	G,L
GELIBERT, JULES BERTRAND (B. 1834) FRENCH	400-6500	G,L
GELLEE, CLAUDE (1600-1682) FRENCH	*2000-+++	
GELLI, EDOARDO (1852-1933) ITALIAN	350-8000	F,G
GEMIN, LOUISE ADELE (1817-1897) FRENCH	200-1200	X(S)
GEMITO, VINCENZO (1852-1929) ITALIAN	*300-9600	F,G
GEMPT, BERNARD DE (1826-1879) DUTCH	800-8500	W
GEN, LUCIEN (1894-1958) FRENCH	*100-700	X
GEN-PAUL	*800-35000	
GEN-PAUL (1895-1975) FRENCH	1200-88000	A,F
GENBERG, ANTON (1862-1939) SWEDISH	500-53000	L,F
GENERALIC, IVAN (B. 1914) YUGOSLAVIAN	400-10000	G
GENERALIC, JOSIP (B. 1936) YUGOSLAV	600-3500	F,G,L
GENEVE, C. BARRIOT (19TH C) AUSTRIAN	100-600	X
GENIN, LUCIEN	*300-12000	
GENIN, LUCIEN (1894-1958) FRENCH	300-53000	A
GENIS, RENE (20TH C) FRENCH	300-5000	X(L)
GENISSON, JULES VICTOR (1805-1860) BELGIAN	500-8500	X(L)
GENNARI, BENEDETTO (THE YOUNGER) (1633-1715) ITALIAN	500-100000	F
GENNARI, CESARE (1637-1688) ITALIAN	1500-45000	F,G
GENNARI, G. (19TH C) ITALIAN	150-1000	X
GENOD, MICHEL PHILIBERT (1795-1862) FRENCH	400-3500	X(G)
GENOELS, ABRAHAM (1640-1723) FLEMISH	900-15000	L,W,F
GENTILESCHI, ARTEMISIA (1597-1651) ITALIAN	800-63000	G,F
GENTILI, ANGELO (D. 1840) GERMAN	*100-800	F
GENTILINI, FRANCO (B. 1909) ITALIAN	1500-63000	X
GENTZ, ISMAEL (1862-1914) GERMAN	150-1000	F,G
GEOFFROY, HENRI JULES JEAN (1853-1924) FRENCH	1000-55000	X(G)
GEORGE, ADRIAN (20TH C) SWISS	100-800	L
GEORGE-JULLIARD, JEAN PHILIPPE (1818-1888) SWISS	600-12000	L

* Denotes watercolors, pastels, drawings, and/or mixed media

GEORGES, CLAUDE (B. 1929) FRENCH	900-8000	A
GEORGES, JOANNES (19TH C) FRENCH	400-7500	F
GEORGET, CHARLES JEAN (D. 1895) FRENCH	100-800	L
GEORGI, TRAUGOTT (1783-1838) GERMAN	400-4000	G,F
GERA, ZORAD (20TH C) HUNGARIAN	100-700	X
GERARD, FRANCOIS PASCAL SIMON BARON (1770-1837) FRENCH	400-140000	F,G,L
GERARD, LUCIEN (1852-1935) BELGIAN	500-4200	F,G
GERARD, MARGUERITE (1761-1837) FRENCH	2000-250000	G,F
GERARD, THEODORE (1829-1895) BELGIAN	2000-40000	G,L,S
GERARD, Z. A. (19TH C) FRENCH	100-1000	X
GERASCH, AUGUST (1822-1894) AUSTRIAN	300-3800	L,G
GERBAUD, ABEL (1888-1954) FRENCH	150-3300	M,L
GERBOUX, AUGUSTE CHARLES (1838-1878) BELGIAN	300-2000	L
GERCHMAN, RUBENS (B. 1942) BRAZILIAN	*300-1800	A
GERDERES, JEANNE (19TH/20TH C) FRENCH	150-900	X(F)
GERELL, GRETA (1898-1982) SWEDISH	800-12000	G,F,M,S
GERHARD, GEORGE (1830-1902) GERMAN	200-1600	F
GERHARDINGER, CONSTANTIN (1888-1970) GERMAN	500-7500	L
GERICAULT, JEAN LOUIS ANDRE THEODORE	*3000-80000	
GERICAULT, JEAN LOUIS ANDRE THEODORE (1791-1824) FRENCH	5000-+++	G,L,F
GERINI, LORENZO DI NICCOLO (14TH/15TH C) ITALIAN	6000-181000	F
GERINI, NICCOLO DI PIETRO (D. 1415) ITALIAN	4000-200000	F
GERMAIN, JACQUES (20TH C) FRENCH	900-17000	A
GERMAIN, LOUIS (19TH C) FRENCH	100-1000	G,L
GERMANA, MIMMO (B. 1944) ITALIAN	800-7500	X(F)
GERNEZ, PAUL ELIE (1888-1948) FRENCH	1200-49000	X
GERNON, V. (20TH C) FRENCH	100-700	X
GEROME, JEAN LEON	*800-12000	
GEROME, JEAN LEON (1824-1904) FRENCH	7000-+++	G,F
GERONE, F. (19TH/20TH C) FRENCH	150-1500	X
GERSHAL, G. J. (19TH C) EUROPEAN	100-700	X
GERTLER, MARK (1892-1939) BRITISH	5000-70000	A
GERTNER, JOHAN VILHELM (1818-1871) DANISH	600-5000	F
GERVAIS, PAUL JEAN LOUIS (1859-1936) FRENCH	400-27000	F
GERVEX, HENRI	*300-6000	
GERVEX, HENRI (1852-1929) FRENCH	1000-45000	F,L
GERZSO, GUNTHER	*900-25000	
GERZSO, GUNTHER (B. 1915) MEXICAN	1500-51000	A

GESSING, ROLAND (1895-1967) CANADIAN	200-1600	L
GESSNER, JOHANN CONRAD (1764-1826) SWISS	*250-3500	L,F
GESTEL, LEO VAN (1881-1941) EUROPEAN	1000-+++	G,F,L,S
GEVERS, HELENE (19TH C) FLEMISH	150-1900	F,G
GEYER, ALEXIUS (1816-1883) GERMAN	400-6000	L
GEYP, ANDRIAAN MARINUS (1855-1926) DUTCH	250-3200	L,W
GHEDUZZI, GIUSEPPE (1889-1957) ITALIAN	300-6600	G,M,L
GHERARDI, GIUSEPPE (Mid 19TH C) ITALIAN	300-4200	L
GHERARDINI, MILCHIORRE (D. 1675) ITALIAN	5000-18000	F
GHEZZI, PIER LEONE	*400-6500	
GHEZZI, PIER LEONE (1674-1755) ITALIAN	1000-50000	F,L
GHIRLANDAIO, RIDOLFI DI DOMENICO (1483-1561) ITALIAN	2500-30000	F
GHISLANDI, VITTORE (Called FRA GALGARIO) (1655-1743) ITALIAN	1500-71000	F
GHISOLFI, GIOVANNI (1632-1683) ITALIAN	1200-62000	F,L
GIACHI, E. (19TH C) ITALIAN	250-3500	X
GIACOMELLI, VINCENCO (1841-1890) ITALIAN	150-1200	F,G
GIACOMETTI, ALBERTO	*1500-219000	
GIACOMETTI, ALBERTO (1901-1966) SWISS	10000-+++	G,F,S
GIACOMETTI, AUGUSTO (1877-1947) SWISS	10000-240000	X(L)
GIACOMETTI, GIOVANNI	*2000-29000	
GIACOMETTI, GIOVANNI (1868-1934) ITALIAN	3000-125000	L,M
GIALLINA, ANGELOS (B. 1857) ITALIAN	*750-33000	L,M
GIAMPIETRI, SETTIMIO (1852-1924) ITALIAN	*100-2000	G
GIANI, FELICE (1760-1823) ITALIAN	*200-9000	F
GIANI, UGO (19TH/20TH C) ITALIAN	100-700	X
GIANNELLI, ENRICO (B. 1854) ITALIAN	400-5200	X(G)
GIANNETTI, RAFFAELE (1832-1916) ITALIAN	500-9500	F
GIANNI, GEROLAMO (B. 1837) ITALIAN	2000-40000	M,L
GIANNI, GIAN	*100-950	
GIANNI, GIAN (B. 1866) ITALIAN	400-14000	M,L
GIANNI, GIUSEPPE (1829-1885) ITALIAN	300-5200	M,L
GIANNI, R. (19TH C) ITALIAN	200-2400	G
GIANNI, U. (18TH C) ITALIAN	*100-700	X(L)
GIANOLI, LOUIS (1868-1957) SWISS	*100-2200	L
GIAQUINTO, CORRADO (1690-1765) ITALIAN	2000-+++	F,G
GIARDIELLO, GIOVANNI (19TH/20TH C) ITALIAN	200-3200	X
GIBBARD, JOHN (19TH C) BRITISH	250-3400	W
GIBBS, PERCY W (19TH-20TH C) BRITISH	300-6200	G,F,L

* Denotes watercolors, pastels, drawings, and/or mixed media

GIBSON, THOMAS (1680-1751) BRITISH	1000-12000	F
GIBSON, WILLIAM ALFRED (1866-1931) BRITISH	300-9500	L,M,W
GIERYMSKI, ALEXANDRE (1849-1901) POLISH	150-1800	X(L)
GIERYMSKI, MAXIMILIAM (1846-1874) POLISH	200-2500	F,G
GIETL, JOSUA VON (1847-1922) GERMAN	300-4500	L
GIFFORD, JOHN (19TH C) BRITISH	400-6200	L,W
GIFFORD, W. B. (Late 19TH C) BRITISH	100-600	X
GIGANTE, ERCOLE (19TH C) ITALIAN	500-3500	L
GIGANTE, GIACINTO (1806-1876) ITALIAN	800-39000	G,L,M
GIGLIO, CARLO (1804-1840) ITALIAN	*100-1200	L
GIGNOUS, EUGENIO	*1000-12000	
GIGNOUS, EUGENIO (1850-1906) ITALIAN	2000-60000	L,G,F
GILARDI, PIER CELESTINO (1837-1905) ITALIAN	500-8000	G,F
GILBAULT, JOSEPH EUGENE (19TH/20TH C) FRENCH	450-9200	S
GILBERT, ALFRED (1854-1934) BRITISH	*200-7200	F
GILBERT, ARTHUR (1819-1895) BRITISH	300-4200	L
GILBERT, FRANCIS (19TH C) BRITISH	*100-500	X
GILBERT, FRANK (19TH C) BRITISH	100-1000	X(M)
GILBERT, JOSIAH	*100-400	
GILBERT, JOSIAH (1814-1892) BRITISH	150-1200	F
GILBERT, SIR JOHN (1817-1897) BRITISH	*200-3500	F,G
GILBERT, STEPHEN (B. 1910) BRITISH	1000-12000	A
GILBERT, VICTOR GABRIEL (1847-1933) FRENCH	1500-102000	G,M
GILBERT, W. B. (19TH C) BRITISH	100-750	X(M)
GILBERT, WILLIAM J.	*100-1900	
GILBERT, WILLIAM J. (19TH C) BRITISH	300-5000	L,W
GILCHRIST, HERBERT H. (Active 1880-1914) BRITISH	300-4500	G
GILES, GEOFFREY DOUGLAS (1857-1923) BRITISH	1500-52000	W,F
GILES, JAMES WILLIAM (1801-1870) BRITISH	700-14000	W
GILIOLI, EMILE (1911-1977) FRENCH	*500-4500	A
GILL, EDMUND W. (1820-1894) BRITISH	650-8800	L,S
GILL, ERIC (1882-1940) BRITISH	*350-13000	F
GILL, SAMUEL THOMAS (1818-1890) AUSTRALIAN	*900-35000	G,L
GILLE, R. (19TH C) GERMAN	100-500	X
GILLEMANS, JAN PAUWEL (17TH C) FLEMISH	2000-30000	S
GILLES, J. J. (20TH C) HAITIAN	250-2600	L
GILLES, NICOLAS (B. 1870) GERMAN	*100-700	I,F
GILLES, WERNER (1894-1961) GERMAN	*400-17000	L,M,F
GILLESPIE, GEORGE K (B. 1924) BRITISH	400-5000	L,M

GILLET, ROGER EDGAR	*600-4500	
GILLET, ROGER EDGAR (B. 1924) FRENCH	800-10000	A
GILLIES, SIR WILLIAM GEORGE	*800-9500	
GILLIES, SIR WILLIAM GEORGE (1898-1973) BRITISH	1000-32000	S,M,L
GILLOT, EUGENE-LOUIS (1868-1925) FRENCH	200-6300	L
GILMAN, HAROLD	*200-3400	
GILMAN, HAROLD (1876-1919) BRITISH	900-46000	G,F,L,S
GILOT, FRANCOISE	*150-12000	
GILOT, FRANCOISE (B. 1921) FRENCH	150-3100	G,F
GILPIN, SAWREY (1733-1807) BRITISH	2500-90000	W,L
GILROY, JOHN (B. 1898) BRITISH	*150-1000	W
GILSOUL, VICTOR (B. 1867) BELGIAN	800-16000	L,F
GIMENO Y ARASA, FRANCISCO (1858-1927) SPANISH	2000-140000	X(F,G)
GIMINEZ Y MARTIN, JUAN	*150-2000	
GIMINEZ Y MARTIN, JUAN (B. 1858) SPANISH	500-53000	G
GIMMI, WILHELM	*700-6500	
GIMMI, WILHELM (1886-1960) SWISS	1000-25000	L,F
GINGELIN, JACQUES VAN (B. 1801) BELGIAN	400-6500	M
GINNER, CHARLES	*700-12000	
GINNER, CHARLES (1878-1952) BRITISH	4000-28000	M,L
GINNETT, LOUIS (1875-1946) BRITISH	100-4500	G,F
GINNTOTARDI, F. (Early 19TH C) ITALIAN	*100-400	X
GINTSENBERG, KARL YAKOVIEVICH (19TH C) RUSSIAN	300-2500	W
GIOJA, BELISARIO	*200-3200	
GIOJA, BELISARIO (1829-1906) ITALIAN	1200-88000	G
GIOLFINO, NICCOLO (1476-1555) ITALIAN	5000-125000	F
GIOLI, LUIGI (1854-1947) ITALIAN	1500-57000	L,G
GIONIMO, ANTONIO	*300-4200	
GIONIMO, ANTONIO (1697-1732) ITALIAN	900-16000	G,F
GIORDANO, FELICE (1880-1964) ITALIAN	200-2400	L,F
GIORDANO, LUCA	*300-12000	
GIORDANO, LUCA (1632-1705) ITALIAN	3000-122000	F,G
GIORELLI, LUIGI (1880-1913) ITALIAN	200-1600	X(F)
GIORGETTI, ANGELO (1899-1952) SWISS	150-1500	F
GIOVENNETTI, RAFAEL (19TH C) ITALIAN	300-3500	X(F)
GIRAN, EMILE GEORGES (1870-1902) FRENCH	100-600	X
GIRAN-MAX, LEON (1867-1927) FRENCH	500-4000	X
GIRARD, MARIE FRANCOIS FIRMIN (1838-1921) FRENCH	1000-125000	G,L,M
GIRARD, PAUL ALBERT (1839-1920) FRENCH	500-8500	L,G

* Denotes watercolors, pastels, drawings, and/or mixed media

GIRARD, THEODORE (19TH C) FRENCH	300-3500	M
GIRARDET, EDOUARD HENRI (1819-1880) SWISS	800-18000	F,L,G
GIRARDET, EUGENE ALEXIS (1853-1907) FRENCH	1200-78000	L,F
GIRARDET, JULES (B. 1856) FRENCH	1000-15000	G,L,W
GIRARDET, KARL (1813-1871) SWISS	3600-95000	L,G
GIRARDOT, ERNEST GUSTAVE (19TH/20TH C) BRITISH	350-6000	G,L,F
GIRARDOT, LOUIS AUGUSTE	*100-500	
GIRARDOT, LOUIS AUGUSTE (1856-1933) FRENCH	200-1600	X(F)
GIRAUD, PIERRE FRANCOIS EUGENE	*500-6500	
GIRAUD, PIERRE FRANCOIS EUGENE (1806-1881) FRENCH	1500-175000	G,F,L
GIRL, HELISENA (1831-1916) GERMAN	1000-14000	G
GIRODET DE ROUCY TRIOSON, ANNE LOUIS (1767-1824) FRENCH	5000-+++	
GIRON, CHARLES (1850-1914) SWISS	800-14000	F,L
GIROTTO, N. (19TH C) ITALIAN	*100-500	X
GIROUX, ERNEST (B. 1851) FRENCH/ITALIAN	400-7200	L
GIRTIN, THOMAS (1775-1802) BRITISH	*10000-+++	L,M
GISBERT, ANTONIO (1835-1901) SPANISH	300-48000	G
GISCHIA, LEON (B. 1903) FRENCH	1000-32000	X(A)
GISELLE, H. (19TH C) AUSTRIAN	200-2000	X(L)
GISLANDER, WILLIAM (1890-1937) SWEDISH	800-9000	W,M,L
GISSING, ROLAND (1895-1967) CANADIAN	400-5000	L
GISSON, ANDRE (B. 1910) FRENCH	300-4800	F,L,S
GISZINGER, IMRE (1895-1935) AUSTRIAN	200-2000	X(S)
GITTARD, ALEXANDRE CHARLES JOSEPH (1832-1904) FRENCH	200-3400	G,L
GIUDICI, RINALDO (19TH C) ITALIAN	300-6000	S
GIULIANO, BARTHOLOMEO (1825-1909) ITALIAN	500-53000	F,G
GIULLI, L. (19TH C) ITALIAN	*100-600	X
GIUSTI, GUGLIELMO (1824-1916) ITALIAN	*100-4200	G,L
GIUSTO, FAUSTO (19TH C) ITALIAN	350-12000	X(G)
GLADBEECK, JAN VAN (Active 1630-1653) DUTCH	1000-15000	S
GLAIZE, PIERRE PAUL LEON (1842-1932) FRENCH	1000-20000	G,F
GLANSDORFF, HUBERT (20TH C) BELGIAN	600-14000	S
GLASS, WILLIAM MERVYN (1885-1965) BRITISH	900-6500	X(L)
GLATTE, ADOLF (1866-1920) GERMAN	200-2400	G,L
GLATZ, OSCAR (1872-1958) HUNGARIAN	200-2000	G
GLEHN, WILFRID GABRIEL VON (B. 1870) GERMAN	1600-118000	F,L
GLEIZES, ALBERT	*800-135000	
GLEIZES, ALBERT (1881-1953) FRENCH	3000-+++	A
GLEN, MALCOM (19TH C) BRITISH	100-800	X

GLENDENING, ALFRED AUGUSTUS (Jr)	*500-15000	
GLENDENING, ALFRED AUGUSTUS (Jr) (D. 1907 BRITISH	900-56000	L,W
GLENDENING, ALFRED AUGUSTUS (Sr)	*500-12000	
GLENDENING, ALFRED AUGUSTUS (Sr) (19TH C) BRITISH	900-30000	M,L,W
GLINDONI, HENRY GILLARD	*100-500	
GLINDONI, HENRY GILLARD (1852-1913) BRITISH	450-8500	G,L
GLISENTI, ACHILLE (1848-1906) ITALIAN	200-2400	G,L
GLIUETTI, LUIGI (Early 20TH C) ITALIAN	*100-500	X
GLOVER, JOHN	*500-15000	
GLOVER, JOHN (1767-1849) BRITISH	1100-215000	L,W
GLUCKMANN, GRIGORY	*300-5200	
GLUCKMANN, GRIGORY (B. 1898) RUSSIAN	1000-14000	G,F,L
GNOLI, DOMENICO	*600-24000	
GNOLI, DOMENICO (1933-1970) ITALIAN	2000-+++	G,L
GOBAUT, GASPARD (1814-1882) FRENCH	*100-3000	L,F
GOBBIS, GIUSEPPE DE (18TH C) ITALIAN	1000-30000	G
GOBELL, GERRIT HENDRIK (1786-1833) DUTCH	2000-12000	F,G,L
GOBL, CAMILLA (B. 1871) AUSTRIAN	200-4300	G,S
GOBLE, WARWICK (D. 1943) BRITISH	*200-2000	F
GOBLET, J. R. (19TH C) FRENCH	100-1500	F
GODBOLD, SAMUEL BARRY (19TH C) BRITISH	900-20000	G,F
GODDARD, GEORGE BOUVERIE (1832-1886) BRITISH	1000-25000	G,L,W
GODERIS, HANS (Active 1625-1645) DUTCH	1000-15000	M,L
GODFREY, JOHN (1817-1889) BRITISH	150-2600	L
GODIN, M. (19TH C) FRENCH	100-1000	X(G)
GODWARD, JOHN WILLIAM (1858-1922) BRITISH	1500-141000	G,F
GODWIN, KARL (B. 1893) CANADIAN/AMERICAN	100-600	X
GOEBEL, CARL	*400-14000	
GOEBEL, CARL (1824-1899) AUSTRIAN	500-4000	G,M
GOEBEL, HERMAN (1885-1945) GERMAN	100-3000	X
GOENEUTTE, NORBERT	*200-4500	
GOENEUTTE, NORBERT (1854-1894) FRENCH	1500-125000	G,F,L
GOERG, EDOUARD (1893-1969) FRENCH	800-43000	A
GOERG, EDUOARD	*200-5700	
GOFF, COL. ROBERT CHARLES (1837-1922) BRITISH	*150-1100	X(L)
GOFF, FREDERICK EDWARD (1855-1931) BRITISH	*150-4900	L,M
GOGEIFELDT, W. DE (19TH C) FRENCH	300-4800	M
GOGH, VINCENT VAN	*20000-+++	
GOGH, VINCENT VAN (1853-1890) DUTCH	60000-+++	S,F,G,L

GOGLER, L. (19TH C) GERMAN	100-800	X
GOITIA, FRANCISCO (1884-1960) SPANISH	800-18000	G,F
GOLA, EMILIO (1852-1923) ITALIAN	500-29000	X
GOLD, E. (19TH C) BRITISH	150-1600	M
GOLDING, TOMAS (B. 1909) VENEZUELAN	150-1800	X(L)
GOLDSMITH, WALTER H. (Late 19TH C) BRITISH	200-3100	L
GOLDTHWAITE, HAROLD (19TH C) BRITISH	150-1000	L
GOLTZ, ALEXANDRE DEMETRIUS (1857-1944) HUNGARIAN	300-5600	X(F)
GOLTZIUS, HENDRIK	*2000-+++	
GOLTZIUS, HENDRIK (1558-1616) DUTCH	3000-+++	F
GOLTZLOFF, KARL W. (1799-1866) GERMAN	*100-700	X
GOLWIG, T. (19TH C) GERMAN	200-2400	G
GOMEZ, H. (19TH C) SPANISH	100-950	M,F
GOMEZ, MARCO ANTONIO (1910-1972) MEXICAN/AMERICAN	100-700	G,F
GOMIEN, PAUL (1799-1846) FRENCH	*100-4000	F
GOMUCHIAN, K. M. (19TH/20TH C) FRENCH	150-1200	F
GONCALVES, FRANCISCO REBOLO (B. 1902) PORTUGESE	350-5000	G,L
GONDOUIN, EMMANUEL (1883-1934) FRENCH	600-10000	X
GONGORA, LEONEL	*100-1000	
GONGORA, LEONEL (B. 1932) COLUMBIAN	200-2000	F
GONORO, ISABEL (19TH C) SPANISH	100-600	X
GONTCHAROVA, NATALIA	*1000-40000	
GONTCHAROVA, NATALIA (1881-1962) RUSSIAN	2000-190000	A
GONZAGA, PIETRO DI GOTTARDO (1751-1831) ITALIAN	*400-12500	I,L
GONZALES, EVA (1849-1883) FRENCH	*1500-200000	F
GONZALES, JULIO (1876-1942) SPANISH	*500-38000	G,F
GONZALEZ, JUAN ANTONIO (B. 1842) SPANISH	900-18000	G,F
GOOCH, JAMES (JOHN) (D. 1837) BRITISH	100-1000	X(F)
GOOCH, THOMAS (1750-1802) BRITISH	800-14000	G,F
GOODALL, EDWARD ALFRED (1819-1908) BRITISH	*400-5300	L,M
GOODALL, FREDERICK	*300-4200	
GOODALL, FREDERICK (1822-1904) BRITISH	1000-240000	G,W,M
GOODMAN, MAUDE (20TH C) BRITISH	500-8500	G,F
GOODMAN, ROBERT GWELO (1871-1939) BRITISH	1000-31000	L
GOODWIN, ALBERT	*500-25000	
GOODWIN, ALBERT (1845-1932) BRITISH	500-43000	L
GOODWIN, HARRY (D. 1925) BRITISH	*150-1200	G,L
GOODWIN, L. G. (19TH C) BRITISH	100-1000	X
GOOKINS, T. F. (19TH/20TH C) EUROPEAN	100-600	X

GOOL, JAN VAN (1685-1763) DUTCH	1500-13000	G,W,L
GORA, J. (19TH C) ITALIAN	250-3000	X(G)
GORANSSON, AKE (1902-1942) SWEDISH	800-47000	F,L
GORBATOV, CONSTANTIN (B. 1876) RUSSIAN	650-42000	L,M
GORDIGIANI, MICHELE (1835-1909) ITALIAN	200-9000	G,F,L
GORDON, JOHN S. (20TH C) CANADIAN	*100-500	X
GORDON, SIR JOHN WATSON (1788-1864) BRITISH	800-21000	F
GORDON-CRAIG, EDWARD (1872-1966) IRISH	*300-1200	X
GORE, FREDERICK (20TH C) BRITISH	500-11000	X
GORE, SPENCER (1878-1914) BRITISH	2000-65000	L
GORE, WILLIAM HENRY (20TH C) BRITISH	1000-12000	X (L)
GORGET-FAURE, HENRI (Early 20TH C) FRENCH	100-600	X
GORGUET, AUGUSTE FRANCOIS (1862-1927) FRENCH	350-10000	M,F
GORRA, GIULIO (1832-1884) ITALIAN	300-5000	G,L,I
GORSTKIN-WYWIORSKY, MICHAL (1861-1926) POLISH	900-16000	X(G)
GORTER, ARNOLD MARC	*400-3200	
GORTER, ARNOLD MARC (1866-1933) DUTCH	600-27000	L,W
GOS, ALBERT (1852-1942) SWISS	500-15000	L
GOSER, J. (Late 19TH C) GERMAN	150-1000	X
GOSLING, WILLIAM (1824-1883) BRITISH	400-21000	L,M
GOSSAERT, JAN (1478-1533) FLEMISH	6000-+ + +	F
GOSSE, SYLVIA (1881-1968) BRITISH	400-5700	F,G,L
GOSSELIN, CHARLES (1834-1892) FRENCH	250-3000	L
GOTCH, CAROLINE BURLAND YATES (19TH C) BRITISH	100-1500	G
GOTCH, THOMAS COOPER (1854-1931) BRITISH	500-+ + +	F
GOTSCH, FRIEDRICH KARL (20TH C) SWISS	2000-61000	L,S
GOTT, J. VAN (18TH C) DUTCH	500-5200	X
GOTTLIEB, LEOPOLD	*100-3000	
GOTTLIEB, LEOPOLD (1883-1930) POLISH	300-6200	G
GOTTLIEB, MORITZ (1856-1879) POLISH	1500-55000	F
GOTZELMANN, EDWARD (19TH C) AUSTRIAN	200-2800	L,W
GOTZINGER, HANS (1867-1947) AUSTRIAN	*100-1700	L,S
GOUBAUD, INNOCENT LOUIS (1780-1847) FRENCH	2000-24000	F
GOUBIE, JEAN RICHARD (1842-1899) FRENCH	3000-95000	M,F
GOUPIL, F. (D. 1878) FRENCH	200-2500	F
GOUPIL, JULES ADOLPHE (1839-1883) FRENCH	600-26000	G,F
GOURDON, RENE (19TH C) FRENCH	200-2400	L
GOURGUE, JACQUES ENGUERRAND (B. 1930) HAITIAN	1000-30000	G,L,S
GOVAERTS, ABRAHAM (1589-1626) FLEMISH	2000-159000	F,L

* Denotes watercolors, pastels, drawings, and/or mixed media

GOVAERTS, JAN BABTIST (1701-1746) FLEMISH	2000-28000	F
GOYA, FRANCISO JOSE DE	*2500-+++	
GOYA, FRANCISO JOSE DE (1746-1828) SPANISH	7000-+++	G,F,L
GOYEN, JAN JOSEFSZ VAN	*1500-60000	
GOYEN, JAN JOSEFSZ VAN (1596-1656) DUTCH	5000-+++	L,G,F
GRAAF, JOSUA DE (1660-1712) DUTCH	400-7500	L,G
GRAAT, BAREND (1628-1709) FLEMISH	2000-15000	F,G,W
GRABAR, IGOR (B. 1872) RUSSIAN	450-18000	L
GRABONE, ARNOLD (B. 1895) GERMAN	150-2400	L
GRACE, A. L. (20TH C) BRITISH	150-2500	G,F
GRADA, RAFFAELE DE	*300-2000	
GRADA, RAFFAELE DE (B. 1885) ITALIAN	600-10000	L,F,G
GRAEF, GUSTAV (1821-1895) GERMAN	200-3500	X(F,L)
GRAEME, COLIN (19TH C) BRITISH	400-9000	L,W
GRAESSEL, FRANZ (B. 1861) GERMAN	500-16000	L,W
GRAF, GERHARD (1883-1960) GERMAN	100-1400	L,F
GRAF, HERMANN (B. 1873) AUSTRIAN	100-1500	L
GRAF, PAUL EDMUND (1866-1903) SWEDISH	450-23000	G,F
GRAF, PHILIP (B. 1874) GERMAN	500-22000	L
GRAFSTROM, OLOF JONAS (1855-1933) SWEDISH	400-3500	L
GRAHAM, COLIN (19TH C) BRITISH	200-2700	X
GRAHAM, GEORGE (18TH C) BRITISH	400-9600	L,F,W
GRAHAM, J. S. (19TH C) BRITISH	100-700	X
GRAHAM, JAMES LILLIE (B. 1873) CANADIAN	200-2800	X(L)
GRAHAM, JOHN (18TH/19TH C) BRITISH	1000-130000	G,F
GRAHAM, PETER (1836-1921) BRITISH	500-15000	L,M,W
GRAHN, HJALMAR (1882-1949) SWEDISH	600-5000	L
GRAILLY, VICTOR DE (1804-1899) FRENCH	400-6900	L,W
GRAINGER, TH. (19TH C) BRITISH	100-800	L
GRAM, GEORGE (19TH C) EUROPEAN	*150-1200	G
GRANBERY, V. (19TH C) BRITISH	100-800	X
GRANDCHAMP, PINEL DE (1873-1955) BELGIAN	1000-20000	F
GRANDI, FRANCESCO (1831-1891) ITALIAN	*100-1200	X
GRANDIN, EUGENE (18TH/19TH C) FRENCH	*100-4200	X(M)
GRANDJEAN, EDMOND GEORGES (1844-1908) FRENCH	5000-125000	F,G
GRANDPRE, PIERRE EMILE GIGOUX DE (B. 1826) FRENCH	200-1200	X
GRANER Y ARRUFI, LUIS (1867-1929) SPANISH	550-22000	G,L,M,S
GRANET, FRANCOIS MARIUS (1775-1849) FRENCH	1500-26000	G,F
GRANT, COLIN (19TH C) SCOTTISH	100-600	X

GRANT, DUNCAN	*150-15000	
GRANT, DUNCAN (1885-1978) BRITISH	1500-137000	A
GRANT, SIR FRANCIS (1803-1878) BRITISH	3000-115000	F,W
GRANT, THEODORE (19TH C) EUROPEAN	150-900	X
GRASDORP, WILLEM (1678-1723) DUTCH	800-16000	S
GRASHOF, OTTO (1812-1876) RUSSIAN	400-12000	G
GRASSEL, FRANZ (1861-1948) GERMAN	800-48000	W
GRASSI, NICOLA (1662-1748) ITALIAN	1500-15000	F
GRAU, ENRIQUE	*400-25000	
GRAU, ENRIQUE (B. 1920) COLUMBIAN	1500-39000	G,F
GRAU-SALA, EMILE	*400-22000	
GRAU-SALA, EMILE (1911-1975) SPANISH	1500-86000	F,M,L,I
GRAVELOT, HUBERT F. (Called BOURGUIGNON D' ANVILLE) (1699-1773) FRENCH	*250-22000	L
GRAVES, HENRY RICHARD (1818-1882) BRITISH	250-24000	F
GRAY, ALPHONSE (19TH C) BRITISH	300-2400	X
GRAY, GEORGE (Late 19TH C) BRITISH	100-2000	X
GRAY, JACK L. (B. 1927) CANADIAN	500-20000	M,F
GRAY, JOHN (D. 1957) BRITISH	200-1800	S,F
GRAY, JOHN W. (1824-1912) BRITISH	100-1000	L
GRAY, KATE (19TH C) BRITISH	400-3200	F,G,L
GRAY, NICHOLAS HENRY DE (B. 1822) FRENCH	200-1000	G,F
GRAY, TOM (19TH C) BRITISH	*100-2100	G,L
GRAZIANI, ERCOLE (1651-1726) ITALIAN	500-19000	F
GRAZIANI, FRANCESCO (17TH C) ITALIAN	1000-28000	F
GREAVES, WALTER	*200-6500	
GREAVES, WALTER (1846-1930) BRITISH	500-9500	L,F
GREAVES, WILLIAM (1885-1920) BRITISH	100-4600	G,L
GREBBER, PIETER DE (1600-1692) DUTCH	1500-32000	F
GRECHOV, IVANOVITCH (Late 19TH C) RUSSIAN	100-600	X
GRECO, EL (1547-1614) SPANISH	10000-+++	F
GRECO, EMILIO (B. 1913) ITALIAN	*200-6800	F
GREEN, ALFRED H. (19TH C) BRITISH	100-7700	G,L,M
GREEN, CHARLES	*300-17000	
GREEN, CHARLES (1840-1898) BRITISH	1000-25000	G,F
GREEN, DENISE (B. 1946) AUSTRIAN/AMERICAN	500-6500	X(G)
GREEN, ROLAND	*100-2600	
GREEN, ROLAND (1896-1971) BRITISH	250-3000	L
GREENAWAY, KATE (1846-1901) BRITISH	*300-5200	G,F,I

* Denotes watercolors, pastels, drawings, and/or mixed media

GREGOIRE, PAUL (Active 1781-1823) FRENCH	*200-900	G,F
GREGORITSCH, TONI (ANTON) (B. 1868) AUSTRIAN	100-1400	X
GREGORY, CHARLES	*700-7500	
GREGORY, CHARLES (19TH/20TH C) BRITISH	500-25000	M,S
GREGORY, GEORGE	*100-1600	
GREGORY, GEORGE (1849-1938) BRITISH	500-3500	M
GREIFFENHAGEN, MAURICE	*100-5000	
GREIFFENHAGEN, MAURICE (1862-1931) BRITISH	300-4500	F
GREINER, OTTO (1869-1916) GERMAN	*150-1000	F
GRENDEL, GERRIT DE (1719-1741) DUTCH	300-3500	X(F)
GRENIER, P. (19TH/20TH C) FRENCH	100-1000	L,M
GRESELY, GASPARD (1712-1756) FRENCH	500-16000	F,S
GRETHE, CARLOS (1864-1913) GERMAN	200-3000	G,F,M
GREUZE, JEAN BAPTISTE	*800-87000	
GREUZE, JEAN BAPTISTE (1725-1805) FRENCH	3000-+++	G,F
GREVENBROECK, ORAZIO (Active 1670-1730) DUTCH	900-17000	M
GREY, GREGOR (Active 1880-1911) BRITISH	400-8000	L,W
GRIBBLE, BERNARD FINEGAN (1873-1962) BRITISH	800-12000	G,F
GRIERSON, CHARLES IVER (1864-1939) BRITISH	250-3000	G,F
GRIFFIER, JAN (ELDER) (1652-1718) DUTCH	6000-125000	L,F
GRIFFIER, ROBERT (1688-1750) DUTCH	2000-55000	L,F
GRIFFITH, MOISE (1747-1819) BRITISH	*100-1200	L,I,W
GRIFFITHS, JOHN (1837-1918) BRITISH	500-12000	L
GRIFFON, GABRIEL (B. 1866) FRENCH	200-2000	L,F
GRIGNARD, G. (19TH C) FRENCH	100-600	X
GRIGORIEV, BORIS	*100-15000	
GRIGORIEV, BORIS (1886-1939) RUSSIAN	1200-44000	G,L,F,A
GRILL, OSWALD (1878-1969) AUSTRIAN	150-4500	L
GRILO, SARAH (B. 1921) ARGENTINIAN	200-8000	X(F)
GRIM, MAURICE (B. 1890)	300-1800	X(L)
GRIMALDI, GIOVANNI FRANCESCO	*400-16000	
GRIMALDI, GIOVANNI FRANCESCO (1606-1680) ITALIAN	700-20000	G,F,L
GRIMELUND, JOHANNES MARTIN (1842-1917) NORWEGIAN	200-9200	L,M
GRIMER, JACOB (1526-1589) FLEMISH	3000-50000	G,F,L
GRIMM, SAMUEL HIERONYMUS (1733-1794) SWISS	*600-3000	L,F
GRIMMER, ABEL (1573-1619) FLEMISH	5000-+++	G,F,L
GRIMSHAW, JOHN ATKINSON (1836-1893) BRITISH	1700-82000	G,F,M
GRIPS, CHARLES JOSEPH (1852-1920) BELGIAN	2000-36000	G
GRIS, JUAN	*2000-+++	

GRIS, JUAN (1887-1927) SPANISH	20000-+++	A
GRISET, ERNEST HENRY (1844-1907) FRENCH/BRITISH	*150-1800	F,I,W
GRISON, FRANCOIS ADOLPHE (1845-1914) FRENCH	1800-40000	G,L,S
GRISOT, PIERRE (19TH C) FRENCH	300-4000	X(G)
GRITCHENKO, ALEXIS	*100-600	
GRITCHENKO, ALEXIS (1883-1977) RUSSIAN	100-2200	L
GRIVAZ, EUGENE	*100-3600	
GRIVAZ, EUGENE (1852-1915) FRENCH	100-900	G
GRIVELLI, A. (20TH C) ITALIAN	100-600	G
GROB, KONRAD (1828-1904) SWISS	1000-24000	G,F
GROBE (1857-1939) GERMAN	250-2400	G,M,L
GROENEVELD, TARMINE (1871-1938) DUTCH	150-1000	G,M
GROENEWEGEN, ADRIANUS JOHANNES (1874-1963) DUTCH	*400-1900	G,W
GROGLER, WILHELM (1830-1897) GERMAN	500-6500	X(G)
GROLLERON, PAUL LOUIS NARCISSE	*100-900	
GROLLERON, PAUL LOUIS NARCISSE (1848-1901) FRENCH	300-7000	G,F
GROMAIRE, MARCEL	*400-27000	
GROMAIRE, MARCEL (1892-1971) FRENCH	3000-+++	A
GRONLAND, RENE (B. 1849) GERMAN	*200-2200	S
GRONLAND, THEUDE (1817-1876) GERMAN	1200-32000	L,S
GRONVOLD, MARCUS (B. 1845) NORWEGIAN	1000-20000	G,L
GROOT, FRANS BREUHAUS DE (1796-1875) DUTCH	600-7500	L,F,M
GROOT, JOSEPH DE (B. 1840) DUTCH	400-6000	G,F
GROOT, M. DE (19TH/20TH C) DUTCH	150-1000	L,M
GROOTVELT, JAN HENDRICK VAN (1808-1865) DUTCH	800-12000	G
GROS, ANTOINE JEAN BARON (1771-1835) FRENCH	3500-+++	F,M
GROS, BARON JEAN LOUIS (1793-1879) FRENCH	4000-55000	G,F
GROS, ERNEST M. (19TH C) FRENCH	250-2200	L
GROS, LUCIEN ALPHONSE (1845-1913) FRENCH	250-12000	F
GROSCHOLSKY, STANISLAUS (19TH C) POLISH	100-700	X
GROSCLAUDE, LOUIS A. (1788-1869) FRENCH	300-4500	G
GROSPIETSCH, FLORIAN (1789-1830) GERMAN	450-8000	F
GROSZ, GEORGE	*500-133000	
GROSZ, GEORGE (1893-1959) GERMAN	1000-53000	F,A
GROUX, HENRI-JULES DE (1867-1930) BELGIAN	*100-2000	G,F
GROUZINSKY, P. (19TH C) RUSSIAN	250-3000	X
GROVE, NORDHAEL PETER FREDERICK (1822-1885) DANISH	500-12000	L,M
GRUBACS, CARLO (19TH C) GERMAN	1000-32000	M,L
GRUBACS, GIOVANNI (1829-1919) ITALAIAN	400-7800	X(M,L)

* Denotes watercolors, pastels, drawings, and/or mixed media

GRUBER, FRANCIS (1912-1948) FRENCH	1000-159000	A
GRUBER, FRANZ XAVER (1801-1862) AUSTRIAN	500-6000	S,F
GRUBER, R. W. (19TH/20TH C) GERMAN	100-800	X
GRUGER, FREDERIC RODERIGO (1871-1953) AUSTRIAN	*100-900	G,F
GRUN, JULES ALEXANDRE (1868-1934) FRENCH	600-30000	G,L,S
GRUN, MAURICE (B. 1869) FRENCH	150-3300	G,L
GRUND, JOHANN (1808-1887) AUSTRIAN	500-11000	G,F
GRUNENWALD, JACOB (1822-1896) GERMAN	1000-50000	G
GRUNER, ELIOTH (1882-1939) AUSTRALIAN	700-73000	L
GRUNEWALD, ISAAC	*500-13000	
GRUNEWALD, ISAAC (1889-1946) SWEDISH	1500-131000	L,F,S
GRUNLER, LOUIS (B. 1809) GERMAN	800-15000	F
GRUTZNER, E. J. (19TH C) GERMAN	150-2000	X
GRUTZNER, EDUARD VON	*400-5000	
GRUTZNER, EDUARD VON (1846-1925) GERMAN	2400-75000	G,F
GRUYTER, JACOB WILLEM	*100-800	
GRUYTER, JACOB WILLEM (1817-1880) DUTCH	350-14000	M
GRYEFF, ADRIAEN DE (1670-1715) FLEMISH	800-16000	G,L,F,S
GSCHOSMANN, LUDWIG (B. 1901) GERMAN	100-2400	G,F
GSELL, LAURENT LUCIEN (1860-1944) FRENCH	400-12000	M,F,L
GSUR, KARL FRIEDRICH (1871-1939) AUSTRIAN	200-3600	X(I,L)
GUACCIMANNI, VITTORIO	*100-750	
GUACCIMANNI, VITTORIO (1864-1927) ITALIAN	250-2500	G,F
GUALDI, PEDRO (1810-1859) ITALIAN/AMERICAN	1500-28000	X(L)
GUARANA, JACOPO (1720-1808) ITALIAN	2000-32000	F
GUARDABASSI, GUERRINO	*100-1400	
GUARDABASSI, GUERRINO (B. 1841) ITALIAN	250-7800	G,W
GUARDERAS, SERGIO (20TH C) MEXICAN	100-600	L
GUARDI, FRANCESCO	*3000-+++	
GUARDI, FRANCESCO (1712-1793) ITALIAN	5000-+++	G,F,L
GUARDI, GIACOMO	*900-26000	
GUARDI, GIACOMO (1764-1835) ITALIAN	5000-80000	L
GUARDI, GIOVANNI ANTONIO (1698-1760) ITALIAN	1500-32000	F
GUARDIA, WENCESLAO DE LA (B. 1861) SPANISH	300-4800	G
GUARINI, ANTONIO (1846-1881) ITALIAN	400-3500	G
GUARINO DA SOLOFRA, FRANCESCO (1611-1654) ITALIAN	600-15000	F
GUAY, GABRIEL (B. 1848) FRENCH	450-10000	G,L
GUAYASAMIN, OSWALDO	*300-6500	
GUAYASAMIN, OSWALDO (B. 1919) ECUADORIAN	1000-36000	G,F,L

GUBANI, G. (19TH C) ITALIAN	*100-600	X
GUDE, HANS FREDRIK	*300-12000	
GUDE, HANS FREDRIK (1825-1903) NORWEGIAN	1500-105000	L,M
GUDIN, HENRIETTE (19TH C) FRENCH	400-8000	M
GUDIN, THEODORE JEAN ANTOINE (1802-1880) FRENCH	300-4600	M,F,W
GUELDRY, FERDINAND JOSEPH (B. 1858) FRENCH	800-60000	L,M
GUELPA, CLELIO (B. 1900) ITALIAN	100-600	X
GUERARD, EUGENE VON (1811-1901) GERMAN	5000-+++	
GUERCINO, GIOVANNI FRANCESCO	*2000-171000	
GUERCINO, GIOVANNI FRANCESCO (1591-1666) ITALIAN	3000-+++	
GUERIN, ARMAND (B. 1913) FRENCH	250-3200	L,M
GUERIN, CHARLES (1875-1939) FRENCH	300-3600	F
GUERIN, ERNEST (19TH C) FRENCH	*400-8300	G,L
GUERIN, PIERRE NARCISSE (1774-1833) FRENCH	1500-36000	F
GUERMACHEFF, MICHEL (B. 1867) RUSSIAN	300-4200	L
GUERRA, ACHILLE (B. 1832) ITALIAN	400-15000	F
GUERRERO, JOSE (B. 1914) SPANISH/AMERICAN	600-50000	G,L
GUERRERO, MANUEL RUIZ (19TH C) SPANISH	350-4500	G
GUERRERO, XAVIER (B. 1896) MEXICAN	*150-1000	X(L)
GUERRERO GALVAN, JESUS	*200-2500	
GUERRERO GALVAN, JESUS (1910-1973) MEXICAN	600-65000	G,F
GUERRIER, RAYMOND (B. 1920) FRENCH	100-4100	F,S
GUGGENBERGER, THOMAS (1815-1882) GERMAN	300-2800	L
GUICHARD, JOSEPH B. (1806-1880) FRENCH	200-4500	L,G
GUIDI, GUISEPPE	*400-10000	
GUIDI, GUISEPPE (1881-1931) ITALIAN	400-6000	G,F
GUIDI, VIRGILIO (B. 1892) ITALIAN	1500-35000	F,L,S
GUIDOTTI, A. (19TH C) ITALIAN	100-600	X
GUIETTE, RENE	*300-15000	
GUIETTE, RENE (20TH C) BELGIAN	600-33000	A
GUIGNARD, ALBERTO DA VEIGA (1893-1962) BRAZILIAN	1000-15000	F,L
GUIGNARD, ALEXANDRE GASTON (1848-1922) FRENCH	400-6500	G,L,M,W
GUIGNET, JEAN ADRIEN (1816-1854) FRENCH	*200-1500	F,L
GUIGOU, PAUL CAMILLE (1834-1871) FRENCH	1000-230000	L,F
GUILBERT, ERNEST (B. 1848) FRENCH	*100-650	F
GUILBERT, NARCISSE (1876-1942) FRENCH	800-41000	L,S
GUILBERT, OCTAVE (20TH C) FRENCH	150-3800	X(L)
GUILLAUME, ALBERT (1873-1942) FRNCH	600-35000	G
GUILLAUME, P. (B. 1908) DUTCH	100-600	X

* Denotes watercolors, pastels, drawings, and/or mixed media

GUILLAUMET, GUSTAVE ACHILLE	*300-12000	
GUILLAUMET, GUSTAVE ACHILLE (1840-1887) FRENCH	1500-33000	L,W
GUILLAUMIN, JEAN BAPTISTE ARMAND	*800-65000	
GUILLAUMIN, JEAN BAPTISTE ARMAND (1841-1927) FRENCH	1500-142000	G,L,F
GUILLEMET, JEAN BAPTISTE ANTOINE (1842-1918) FRENCH	400-5500	L,M
GUILLEMIN, ALEXANDRE MARIE	*150-700	
GUILLEMIN, ALEXANDRE MARIE (1817-1880) FRENCH	450-8500	G,L
GUILLEMINET, CLAUDE (1821-1860) FRENCH	300-4600	L,S,W
GUILLERMIC, YVES (20TH C) FRENCH	100-600	X
GUILLERMOT, G. T. (19TH/20TH C) FRENCH	1000-26000	G
GUILLOD, THOMAS WALKER (Active 1839-1860) BRITISH	350-5400	L
GUILLON, ADOLPHE IRENEE (1829-1896) FRENCH	200-2600	L
GUILLON, ALFRED (19TH C) FRENCH	150-2000	X
GUILLON, EUGENE ANTOINE (B. 1834) FRENCH	200-2800	G
GUILLONNET, OCTAVE DENIS VICTOR (1872-1967) FRENCH	750-87000	G,F
GUILLOT, DONAT (19TH C) FRENCH	150-900	X
GUILLOU, ALFRED (19TH C) FRENCH	1000-18000	F,G
GUILLOUX, CHARLES VICTOR (20TH C) FRENCH	100-5300	G,L
GUILMANT, FELIX (19TH C) FRENCH	100-700	X
GUIRAND DE SCEVOLA, LUCIEN	*500-10000	
GUIRAND DE SCEVOLA, LUCIEN (1871-1950) FRENCH	300-15000	G,F
GUISTI, GIROLAMO (19TH C) ITALIAN	*100-600	X(M,L)
GULDI, G. (19TH C) ITALIAN	*100-800	X
GUNISCHEIM, J. (19TH C) GERMAN	150-1200	G
GUNN, ARCHIBALD (1849-1871) BRITISH	150-1500	G
GUNN, HERBERT JAMES (1893-1964) BRITISH	400-63000	F,M
GUNNEWEG, HERMANUS PETRUS ANTONIUS (1846-1904) DUTCH	150-1200	X
GUNTHER, ERWIN (1864-1927) GERMAN	150-1800	L,M
GURLITT, LOUIS (1812-1897) EUROPEAN	1000-14000	L,M,W
GUTERSLOH, ALBERT PARIS (B. 1887) AUSTRIAN	*600-6500	F,L,S
GUTFREUND, OTTO (1889-1927) CZECHOSLOVAKIAN	*200-1700	F,S
GUTIERREZ, ERNESTO (19TH/20TH C) SPANISH	250-17500	G,L
GUTMANN, IDA (19TH C) GERMAN	100-800	F
GUTTUSO, RENATO	*900-55000	
GUTTUSO, RENATO (B. 1912) ITALIAN	2500-137000	A,F
GUY, JEAN BAPTISTE LOUIS (1824-1888) FRENCH	600-7500	G,L,F
GUYET, J. LOUISE (19TH C) FRENCH	150-1700	X
GUYILLAN, D. (19TH C) EUROPEAN	100-800	X(G)
GUYON-GUEPP, MAXIMILIENNE (1868-1903) FRENCH	*200-1200	F

GUYOT, LOUISE (19TH C) FRENCH	300-4500	L,F,W
GUYS, CONSTANTIN (1802-1892) FRENCH	*900-24000	G,F
GUZZARDI, GIUSEPPE (1845-1914) ITALIAN	200-3200	G,L,F
GYSBRECHTS, FRANCISCUS (Late 17TH C) DUTCH	1000-21000	G,S
GYSELINCKX, JOSEPH (19TH C) BELGIAN	400-9000	G,W
GYSELS, PIETER (1621-1690) FLEMISH	4000-55000	L
GYSIS, NICOLAS	*350-12500	
GYSIS, NICOLAS (1842-1901) GREEK	1000-42000	G,F

H

ARTIST	PRICES	SUBJECT
HAAG, CARL	*500-45500	
HAAG, CARL (1820-1915) SWEDISH	400-6500	G,L,F,I
HAAG, JEAN PAUL (19TH C) FRENCH	400-6500	G,F
HAAGEN, JORIS VAN DER (1615-1669) DUTCH	600-19000	X(G)
HAALAND, LARS LAURITS (1855-1938) NORWEGIAN	1200-28000	M
HAANEN, ADRIANA JOHANNA (1814-1895) DUTCH	600-9000	S
HAANEN, CECIL VAN (1844-1885) DUTCH	400-7800	G,F
HAANEN, GEORG GILLIS VAN (1807-1876) DUTCH	1000-14000	F,L,M
HAANEN, REMI VAN (1812-1894) DUTCH	600-21000	M,L
HAARLEM, CORNELIS VAN (CORNELIS CORNELISZ)	*1000-45000	
HAARLEM, CORNELIS VAN (CORNELIS CORNELISZ) (1562-1638) DUTCH	3000-55000	G,F
HAAS, JOHANNES HUBERTUS (1832-1908) FLEMISH	300-4500	L,W
HAAXMAN, PIETER (1854-1937) DUTCH	400-12000	G,L
HABERMANN, HUGO VON	*100-1000	
HABERMANN, HUGO VON (1849-1921) GERMAN	400-4500	F
HABERT, EUGENE (D. 1916) FRENCH	200-2400	G,F
HACKAERT, JAN (17TH C) DUTCH	*500-6000	F,L
HACKER, ARTHUR	*1000-36000	
HACKER, ARTHUR (1858-1919) BRITISH	1000-56000	G,L,F
HACKER, HORST (1842-1906) GERMAN	500-9500	F,M,L
HACKERT, CARL LUDWIG	*200-5000	
HACKERT, CARL LUDWIG (1740-1796) GERMAN	400-5500	L,M,W
HACKERT, JACOB PHILIPPE	*400-20000	
HACKERT, JACOB PHILIPPE (1737-1807) GERMAN	2000-+ + +	L,M
HADAMARD, AUGUSTE (1823-1886) FRENCH	300-3000	G

* Denotes watercolors, pastels, drawings, and/or mixed media

HADDELSEY, VINCENT (B. 1829) BRITISH	100-2800	X
HADDON, ARTHUR TREVOR	*200-2000	
HADDON, ARTHUR TREVOR (1864-1941) BRITISH	1200-15000	G,L,F
HADLER, ROBERT (20TH C) HUNGARIAN	150-1200	X
HAECHT, TOBIAS VAN (1561-1631) FLEMISH	5000-85000	L
HAEFLIGER, LEOPOLD (1929-1989) SWISS	600-7000	F,S,L,M
HAEFLIGER, PAUL (1914-1982) AUSTRALIAN/GERMAN	600-15000	F,S,L
HAENSBERGEN, JAN VAN (17TH C) DUTCH	400-5000	F
HAESAERT, PAUL (1813-1893) BELGIAN	400-5500	G,S
HAFSTROM, JAN (B. 1937) SWEDISH	900-12000	A
HAGARTY, PARKER (1859-1934) BRITISH	150-2200	L,W
HAGBORG, AUGUST WILHELM NIKOLAUS (1852-1925) SWEDISH	1000-121000	G,M,F
HAGEDORN, FRIEDRICH	*300-11000	
HAGEDORN, FRIEDRICH (1814-1889) GERMAN	1000-14000	G,L,M
HAGEDORN, KARL (B. 1889) BRITISH	1000-18000	F,S
HAGEMANN, GODEFROY DE (D. 1877) FRENCH	300-11000	L,W
HAGEMANN, OSKAR H. (B. 1888) GERMAN	150-1200	G,F
HAGEMANS, MAURICE	*400-3500	
HAGEMANS, MAURICE (1852-1917) BELGIAN	600-9500	F,L
HAGEMANS, PAUL (1884-1959) BELGIAN	1000-9000	F,S,L
HAGEMEISTER, KARL (1848-1933) GERMAN	1000-18000	L,M,S,F
HAGEN, THEODOR JOSEF (1842-1919) GERMAN	300-11000	L,M
HAGERMANS, MAURICE (1852-1917) BELGIAN	*100-900	X
HAGHE, LOUIS	*400-17000	
HAGHE, LOUIS (1806-1885) BELGIAN	650-22000	F,L,G
HAGIWARA, T. (20TH C) JAPANESE	*100-1200	X(L)
HAGUE, JOSHUA ANDERSON (1850-1916) BRITISH	300-6000	L,S
HAHN, GUSTAV ADOLPH (1811-1872) GERMAN	100-3300	L
HAIGH, ALFRED G (19TH/20TH C) BRITISH	500-5500	W
HAINES, WILLIAM HENRY	*100-1000	
HAINES, WILLIAM HENRY (1812-1884) BRITISH	300-4500	L,G,F
HAINS, RAYMOND (B. 1926) FRENCH	*1000-50000	A
HAINZ, JOHANN GEORG (17TH-18TH C) GERMAN	5000-30000	S
HALBERG-KRAUSS, FRITZ (1874-1951) GERMAN	800-12000	L,W
HALICA, ALICE (B. 1895) POLISH	300-8000	X
HALL, FREDERICK (1860-1948) BRITISH	1000-69000	L,G,F,W
HALL, GEORGE LOTHIAN (1825-1888) BRITISH	*150-800	X
HALL, HARRY (1814-1882) BRITISH	1500-150000	G,W
HALL, HENRY R. (D. 1902) BRITISH	750-43000	W,G,L

HALL, THOMAS P. (19TH C) BRITISH	600-9500	G,L
HALL, W. HONYWILL (19TH C) BRITISH	150-1500	G,L
HALLE, CHARLES EDWARD (1846-1914) BRITISH	300-26000	G,W
HALLE, NOEL	*400-3200	
HALLE, NOEL (1711-1781) FRENCH	900-28000	F
HALLE, SAMUEL BARUCH (1824-1889) BRITISH	400-19000	G
HALLER, G. (20TH C) GERMAN	100-700	X(L)
HALLER, TONY (19TH C) AUSTRIAN	100-1500	L
HALLER, WILHELM (B. 1873) GERMAN	100-800	L
HALLSTROM, ERIC (1893-1946) SWEDISH	1000-51000	L,F,S
HALLSTROM, STAFFAN (1914-1976) SWEDISH	1000-32000	X(A)
HALPEN, FRANCIS (19TH C) BRITISH	500-3000	F
HALPERN, E. (19TH C) BRITISH	100-900	X
HALS, DIRCK (1591-1656) DUTCH	5000-+++	G,F,L
HALS, FRANS (16TH/17TH C) DUTCH	5000-+++	F
HALS, JAN (D. 1650) DUTCH	800-12000	G,F
HALSTON, H. (19TH C) BRITISH	100-700	X
HALSWELLE, KEELEY (1832-1891) BRITISH	500-8000	G,L,W
HALVOET, H. (19TH C) BELGIAN	100-800	X
HALZ, VAN DER (19TH C) DUTCH	100-600	X
HAM, A. (19TH C) BRITISH	100-500	X
HAMACHER, WILLY (1865-1909) GERMAN	100-1200	L,F,M
HAMALAINEN, VAINO 91876-1940) FINNISH	2000-26000	G,F,L
HAMBOURG, ANDRE	*100-3800	
HAMBOURG, ANDRE (B. 1909) FRENCH	400-67000	G,M,F,L
HAME, E. (Late 19TH C) EUROPE	100-600	X
HAMEL, OTTO (1866-1950) GERMAN	300-2400	L,W
HAMEN Y LEON, JUAN VAN DER (1596-1632) SPANISH	5000-+++	S
HAMILTON, CARL WILHELM DE (1668-1754) AUSTRIAN	900-18000	L,W,S
HAMILTON, FERDINAND PHILIPP DE (1664-1750) BELGIAN	600-9000	S
HAMILTON, FRANZ DE (17TH C) GERMAN	400-6000	W,F,S
HAMILTON, HUGH DOUGLAS	*300-15000	
HAMILTON, HUGH DOUGLAS (1739-1808) IRISH	1500-20000	G,F
HAMILTON, PHILIPP FERDINAND DE (1664-1750) FLEMISH	1500-72000	W,L,S
HAMILTON, ROBERT (20TH C) IRISH	100-600	X
HAMILTON, WILLIAM (1751-1801) BRITISH	300-5900	F,W
HAMMAN, EDOUARD JEAN CONRAD (1819-1888) BELGIAN	400-5100	G
HAMME, A. L. VAN (19TH C) DUTCH	150-1400	X
HAMME, ALEXIS VAN (1818-1875) BELGIAN	1000-32000	G,F

* Denotes watercolors, pastels, drawings, and/or mixed media

HAMME, G. DE (17TH C) FLEMISH	500-8500	X
HAMMER, CHRISTIAN GOTTLOB (1779-1864) GERMAN	*400-3000	F,L
HAMMER, JOHANN J.	*100-500	
HAMMER, JOHANN J. (1842-1906) GERMAN/AMERICAN	200-4500	G,L
HAMMER, WILLIAM (1821-1889) GERMAN	1100-22000	S
HAMMERL, MAX (1856-1886) GERMAN	400-7600	X(G,F)
HAMMERSHOI, VILHELM (1846-1916) DANISH	4000-+++	L,F
HAMMOND, JOHN (1843-1939) CANADIAN	350-6800	M,L,F
HAMMOND, ROBERT JOHN (19TH/20TH C) BRITISH	200-5900	L,F,W
HAMON, JEAN LOUIS (1821-1874) FRENCH	1100-69000	X(G)
HAMPE, GUIDO (B. 1839) GERMAN	300-4500	L,F
HAMPEL, SIGMUND WALTER	*500-12000	
HAMPEL, SIGMUND WALTER (1868-1949) AUSTRIAN	400-4500	F,S
HAMZA, JOHANN (1850-1927) AUSTRIAN	1000-20000	L,G,F
HANCOCK, CHARLES (1795-1868) BRITISH	700-27500	W,L,F
HAND, THOMAS (D.1804) BRITISH	600-13000	L,F,G
HANGER, MAX (B. 1874) GERMAN	400-4200	W,L
HANKE, HANS (19TH/20TH C) AUSTRIAN	150-2700	X(L,G)
HANKEY, WILLIAM LEE	*300-5200	
HANKEY, WILLIAM LEE (1869-1952) BRITISH	300-16500	M,G,S
HANNAFORD, CHARLES E. (1865-1955) BRITISH	*100-1800	W,L,M
HANNEMAN, ADRIAEN (1601-1671) DUTCH	700-33000	F
HANNEMANN, WALTER (B. 1863) GERMAN	150-1400	X(F)
HANNLEY, T. (19TH C) BRITISH	100-700	X
HANSCH, ANTON (1813-1876) AUSTRIAN	1000-14000	G,L
HANSEN, CARL LODEWYK (1765-1840) DUTCH	400-4500	L,F
HANSEN, HANS PETER	*100-400	
HANSEN, HANS PETER (1829-1899) DANISH	200-3000	X(F)
HANSEN, JOSEF THEODOR (1848-1912) DANISH	500-16000	L
HANSEN, LAMBERTUS JOHANNES (1803-1859) DUTCH	400-4500	G,F
HANSEN, NIELS (1880-1946) DANISH	400-3700	M,G,F
HANSEN, SIGVARD MARIUS	*350-3400	
HANSEN, SIGVARD MARIUS (1859-1938) DANISH	600-25000	L,F
HANSEN, THEODOR (20TH C) GERMAN	100-600	X
HAQUETTE, GEORGES JEAN MARIE (1854-1906) FRENCH	*100-1200	M
HARBORGER, C. W. (19TH/20TH C) DUTCH	150-1000	G
HARBUTT, W. (19TH C) BRITISH	150-1600	X
HARDEGG, L. (19TH C) GERMAN	100-1500	X
HARDIE, CHARLES MARTIN (1858-1917) SCOTTISH	400-6500	F,G,L

HARDIE, MARTIN (1875-1952) BRITISH	*100-800	X(L)
HARDIME, PIETER (1677-1758) FLEMISH	2000-32000	S
HARDING, GEORGE PERFECT (1777-1853) BRITISH	*150-1200	X(F)
HARDING, JAMES DUFFIELD	*400-2800	
HARDING, JAMES DUFFIELD (1798-1863) BRITISH	500-14000	L,M,G
HARDING, JOSHUA (1880-1940) BRITISH	200-2000	X
HARDT, ERNST (1869-1917) GERMAN	200-1800	L,M
HARDY, C. G. (19TH C) BRITISH	100- 950	X(G)
HARDY, DUDLEY (1865-1922) BRITISH	*300-2600	G,F,I
HARDY, FREDERICK DANIEL (1826-1911) BRITISH	2000-46000	G,F
HARDY, GEORGE (1822-1909) BRITISH	350-4500	G
HARDY, HEYWOOD (1843-1933) BRITISH	1500-81000	G,W
HARDY, JAMES (JNR)	*400-33000	
HARDY, JAMES (JNR) (1832-1889) BRITISH	500-56000	F,W
HARDY, THOMAS BUSH	*300-7700	
HARDY, THOMAS BUSH (1842-1897) BRITISH	200-8600	M,L
HARDY, WILLIAM J. (Active 1845-1856) BRITISH	150-2100	X(G)
HARDY JR, JAMES	*500-16000	
HARDY JR, JAMES (1832-1889) BRITISH	800-16000	G,W,S
HARE, JULIUS (1859-1932) BRITISH	300-5300	M,L
HARENCZ, JOSEF (1899-1969) HUNGARIAN	200-2000	X(L)
HARGITT, EDWARD	*100-2000	
HARGITT, EDWARD (1835-1895) BRITISH	400-13000	G,L
HARI, JOHANNES (1772-1849) DUTCH	400-5000	F
HARINGH, DANIEL (1636-1706) FLEMISH	400-42000	F
HARLAMOFF, ALEXIS (B. 1842) RUSSIAN	1500-115000	G,F
HARLOFF, GUY (B. 1933) DUTCH	*100-600	X
HARLOW, GEORGE HENRY (1787-1819) BRITISH	900-16000	G,F
HARPER, HENRY ANDREW (1835-1900) BRITISH	*200-4500	G,L,F
HARPER, THOMAS P. (19TH C) BRITISH	100-2000	M,G
HARPIGNIES, HENRI JOSEPH	*300-27000	
HARPIGNIES, HENRI JOSEPH (1819-1916) FRENCH	1400-60000	L
HARRADEN, RICHARD BANKS (1778-1862) BRITISH	500-8500	G,L
HARRIS, EDWIN (B. 1891) BRITISH	1000-40000	F
HARRIS, HENRY (1805-1865) BRITISH	200-2000	L,M,W
HARRIS, LAWREN STEWART (1885-1970) CANADIAN	1000-+++	L
HARRIS, WILLIAM E (19TH C) BRITISH	500-7800	L
HARRISON, CHARLES HARMONY (1842-1902) BRITISH	*600-4900	L,M
HARRISON, JOHN C. (1898-1985) BRITISH	*300-10000	L

* Denotes watercolors, pastels, drawings, and/or mixed media

HARRY, PHILIP (Active 1833-1857) CANADIAN	1200-22000	L
HARSBURG, CARL (19TH C) DUTCH	150-1500	X
HART, ADRIAN (20TH C) GERMAN	100-1000	G
HART, SOLOMON ALEXANDER (1806-1881) BRITISH	600-15000	G
HART, THOMAS	*100-2300	
HART, THOMAS (B. 1820) BRITISH	200-2400	X(L)
HARTE, LEON (20TH C) FRENCH	100-700	X
HARTFORD, WILLIAM (Active 1874-1878) BRITISH	*100-700	X
HARTLAND, ALBERT HENRY (1840-1893) BRITISH	200-2500	L
HARTMANN, BERTRAM (B. 1882) GERMAN	150-1000	X
HARTMANN, JOHANN JOSEPH (1753-1830) GERMAN	*1000-7500	M,L
HARTMANN, KARL (B. 1861) GERMAN	100-1000	X
HARTMANN, LUDWIG (1835-1902) GERMAN	3000-78000	W,G
HARTSON, WALTER C.	*100-950	
HARTSON, WALTER C. (B. 1866) GERMAN	100-900	L
HARTUNG, HANS	*600-169000	
HARTUNG, HANS (B. 1904) GERMAN	2000-+++	A
HARTUNG, HEINRICH (1851-1919) GERMAN	500-8000	L,W
HARTUNG, JOHANN (19TH C) GERMAN	250-3000	G
HARVEY, ELISABETH (Active 1802-1812) BRITISH	*100-900	X
HARVEY, HAROLD (1874-1941) BRITISH	1400-89000	G,M,F,L
HARVEY, HENRY T. (19TH/20TH C) BRITISH	100-1500	L
HARVEY, SIR GEORGE (1806-1876) SCOTTISH	350-4500	L,S
HARVEY, W. (20TH C) BRITISH	100-600	X
HASCH, CARL (1834-1897) AUSTRIAN	400-6500	L,G
HASEGAWA, KIYOSHI (B. 1891) JAPANESE	1500-118000	S,L
HASELEER, FRANS (1804-1869) BELGIAN	350-5600	G,F
HASENCLEVER, JOHANN PETER (1810-1853) GERMAN	700-20000	G,W
HASSALL, JOHN (1868-1948) BRITISH	*200-1200	G,I
HASTINGS, GEORGE (19TH C) BRITISH	100-1500	L,W,M
HASTINGS, RAFAEL (B. 1945) PERUVIAN	*200-7000	X
HATANO, TAMAJIRO (20TH C) JAPANESE	100-1200	X
HATFIELD, JOSEPH HENRY (1863-1928) CANADIAN	*150-1300	F,L
HAUBTMANN, MICHAEL (1843-1921) CZECHOSLOVAKIAN	350-3400	L,F
HAUCK, AUGUSTE C. (1742-1801) GERMAN	100-900	X
HAUEISEN, ALBERT (B. 1872) GERMAN	200-15000	F,S
HAUPTMANN, IVO	*400-8000	
HAUPTMANN, IVO (1886-1973) GERMAN	500-9500	M,L,S
HAUSER, KARL LUDWIG (1810-1873) GERMAN	200-4500	G,S,L

HAUTRIVE, MATHILDE MARGUERITE (1881-1963) FRENCH	300-7000	X(F)
HAVELL, ALFRED CHARLES (Late 19TH C) BRITISH	500-16000	G,W
HAVELL, WILLIAM (1782-1857) BRITISH	2000-15000	L
HAVELL (JR), EDMUND (1819-1894) BRITISH	950-43000	W
HAVERMAN, HENDRICK JOHANNES (1857-1928) DUTCH	200-2200	F
HAVERTY, JOSEPH PATRICK (1794-1864) BRITISH	200-3500	G,F
HAWKER, THOMAS (1640-1725) BRITISH	400-2200	G,F
HAWKINS, HENRY (Active 1820-1881) BRITISH	400-6500	F,W
HAWKINS, JANE (D. 1874) BRITISH	500-20000	F
HAWKINS, LEWIS WELDON	*450-30000	
HAWKINS, LEWIS WELDON (1849-1910) BRITISH	600-19000	G,L,F
HAWORTH, T. (19TH C) BRITISH	300-2500	M
HAY, BERNARDO (B. 1864) BRITISH	300-9500	M
HAYDEN, HENRI	*400-32000	
HAYDEN, HENRI (1883-1970) FRENCH	1500-+++	A,F
HAYDON, BENJAMIN ROBERT (1786-1846) BRITISH	500-18000	F
HAYES, CLAUDE (1852-1922) IRISH	*200-5000	W,G,M
HAYES, EDWIN	*100-2500	
HAYES, EDWIN (1819-1904) IRISH	450-24000	M,G
HAYES, MICHAEL ANGELO (1820-1877) IRISH	*100-5000	F,G
HAYES, WILLIAM (18TH C) BRITISH	*400-1500	W
HAYET, LOUIS (1854-1940) FRENCH	1900-118000	L
HAYEZ, FRANCESCO (1791-1881) ITALIAN	3000-138000	F
HAYLLAR, JAMES (B. 1829) BRITISH	1000-41000	G,F
HAYNES, JOHN WILLIAM (1836-1908) BRITISH	400-6200	G,F
HAYTER, SIR GEORGE (1792-1871) BRITISH	1500-22000	G,F
HAYTER, STANLEY WILLIAM	*200-11000	
HAYTER, STANLEY WILLIAM (B. 1901) BRITISH	500-42000	A
HAYWARD, ALFRED (19TH C) BRITISH	500-3500	L,M
HAYWARD, ARTHUR (B. 1889) BRITISH	800-7600	M
HAYWOOD, W. C. (19TH C) BRITISH	100-800	X(L,W)
HAZARD, WILLIAM G. (B. 1903) CANADIAN	*100-800	L,S
HEARD, JAMES (1799-1859) BRITISH	400-4200	M
HEARNE, THOMAS (1744-1817) BRITISH	*400-6800	F,L
HEATH, WILLIAM (Called PAUL PRY) (1795-1840) BRITISH	1500-20000	F,I
HEBERT, GEORGES (1837-1884) FRENCH	150-3500	G,F
HEBERT, JULES	*200-2500	
HEBERT, JULES (1812-1897) SWISS	300-5200	G,L,F
HECKEL, AUGUST VON (1824-1883) GERMAN	300-3500	G

* Denotes watercolors, pastels, drawings, and/or mixed media

HECKEL, ERICH	*500-45500	
HECKEL, ERICH (1883-1970) GERMAN	4500-+++	A,G,F,L
HECKENDORF, FRANZ (1888-1962) GERMAN	500-19000	L,M,S
HEDA, GERRIT WILLEMSZ (1642-1702) DUTCH	5000-143000	S
HEDA, WILLEM CLAESZ (1594-1682) DUTCH	8000-+++	S
HEDBERG, KALLE (1894-1959) SWEDISH	500-5400	F,L
HEDLEY, RALPH (1851-1913) BRITISH	450-20000	W,G
HEDOUIN, EDMOND (1820-1889) FRENCH	150-1800	G,L
HEDQUIST, TAGE (B. 1909) SWEDISH	400-6500	M
HEEM, CORNELIS DE (1631-1695) DUTCH	5000-+++	S,F
HEEM, JAN DAVIDSZ DE (1606-1684) DUTCH	5000-+++	S
HEEMSKERCK, EGBERT VAN (THE YOUNGER) (1634-1704) DUTCH	800-43000	G,F
HEEMSKERCK, JACOB EDUARD VAN BEEST (1828-1894) DUTCH	400-22000	M
HEEMSKERK, MARTEN VAN (17TH C) DUTCH	4000-46000	F
HEEREMANS, THOMAS (1640-1697) DUTCH	1500-53000	L
HEEREN, MINNA (1823-1898) GERMAN	400-9500	X(G)
HEERSCHOP, HENDRIK (1620-1672) FLEMISH	200-4500	G,F
HEERUP, HENRY (B. 1907) DANISH	500-17000	X
HEES, GERRIT VAN (1629-1702) FLEMISH	900-33000	G,L
HEFFNER, KARL (1849-1925) GERMAN	900-30000	L,M,W
HEGENBARTH, EMANUEL (1868-1923) GERMAN	300-6400	F,S,W
HEGENBARTH, JOSEF (1884-1962) GERMAN	500-8000	X
HEGER, HEINRICH ANTON (1832-1888) GERMAN	300-3500	L,G
HEILBUTH, FERDINAND	*400-11000	
HEILBUTH, FERDINAND (1826-1889) FRENCH	500-35000	G,L,M,F
HEILMAYER, KARL (1829-1908) GERMAN	400-6200	L,M
HEIM, HEINZ (1859-1895) GERMAN	200-2200	M
HEIMER, C. (19TH C) GERMAN	100-900	X
HEIMERDINGER, FRIEDRICH (1817-1882) GERMAN	400-4500	G,S,W
HEIMERL, JOSEF (1867-1918) AUSTRIAN	100-1200	W
HEIMIG, WALTER (1881-1955) GERMAN	400-11000	G,F
HEIN, ALOIS RAIMOND (B. 1852) AUSTRIAN	100-1400	X(F)
HEIN, EDWARD (B. 1875) DANISH	100-900	F,L
HEIN, HEINDRIK JAN (1822-1866) DUTCH	500-16000	S
HEINE, FRIEDRICH WILHELM (1845-1921) GERMAN/AMER.	*100-800	X(G)
HEINE, JOHANN ADALBERT (19TH C) GERMAN	300-3500	G,F,L
HEINE, WILHELM JOSEF (1813-1839) GERMAN	300-3200	G
HEINEFETTER, JOHANNN (1815-1902) GERMAN	300-5300	G,L

HEINEKEN, MARIA (19TH/20TH C) DUTCH	100-2500	S
HEINEL, EDUARD (1835-1895) GERMAN	400-7600	G,F,W
HEINISCH, KARL ADAM (1847-1927) GERMAN	600-10000	L,F
HEINRICH, FRANZ (1802-1890) AUSTRIAN	*500-12000	L,F
HEINS, D. (Mid 18TH C) ?	1000-18000	F
HEINZ, BRUNO (19TH/20TH C) BRITISH	150-800	S
HEISS, G. (19TH C) GERMAN	100-800	X
HEISS, JOHANN (1640-1704) GERMAN	1200-42000	G,F
HELDER, JOHANNES (1842-1913) DUTCH	100-700	X
HELION, JEAN	*700-164000	
HELION, JEAN (B. 1904) FRENCH	3000-+++	G,F
HELL, LOUIS (19TH/20TH C) FRENCH	*150-1200	L,F
HELLEMANS, PIERRE JEAN (1787-1845) BELGIAN	400-8000	F,L
HELLEN, CARL VON DER (1843-1902) DUTCH	200-4000	L
HELLER, EDWARD (19TH C) EUROPEAN	100-700	X
HELLESEN, THORWALD (1888-1937) SCANDINAVIAN	5000-30000	A
HELLEU, PAUL CESAR	*1000-140000	
HELLEU, PAUL CESAR (1859-1927) FRENCH	4000-+++	F,L
HELLNER, J. (19TH C) GERMAN	100-800	X
HELLWAG, RUDOLF (1867-1942) GERMAN	200-4900	L,M
HELMONT, LUCAS VAN GASSEL (1480-1570) FLEMISH	4000-82000	F
HELMONT, MATHEUS VAN (1623-1679) FLEMISH	1500-26000	G,F
HELSBY, ALFREDO (1862-1936) CHILEAN	400-9500	L,M
HELST, BATHOLOMEUS VAN DER (1613-1670) DUTCH	3500-220000	F
HELYI, VASAR (B. 1908) HUNGARIAN	100-700	X
HEMESSEN, JAN VAN (1504-1566) FLEMISH	5000-+++	G,F
HEMING, ARTHUR (1870-1940) CANADIAN	300-38000	W,F,L
HEMSLEY, WILLIAM (B. 1819) BRITISH	400-7000	G
HEMY, BERNARD BENEDICT (1855-1913) BRITISH	400-7500	M
HEMY, CHARLES NAPIER	*100-4500	
HEMY, CHARLES NAPIER (1841-1917) BRITISH	1000-42000	M
HENDERSON, ARTHUR E. (B. 1870) BRITISH	400-6200	G
HENDERSON, CHARLES COOPER	*400-5000	
HENDERSON, CHARLES COOPER (1803-1877) BRITISH	1000-25000	L,G,W
HENDERSON, JOSEPH MORRIS (1863-1936) BRITISH	400-4700	L
HENDERSON, W. S. P. (19TH C) BRITISH	200-3000	G
HENDRICH, HERMANN (1856-1931) GERMAN	200-2000	L
HENDRICKS, T. (19TH C) DUTCH	100-600	X
HENDRIKS, GERARDUS (19TH C) DUTCH	400-10000	M

HENDRIKS, JOHANNES (19TH C) DUTCH	200-2000	X
HENDRIKS, WILLEM (1828-1891) DUTCH	300-4200	L,W
HENDRIKS, WYBRAND (1744-1831) DUTCH	10000-90000	S
HENDSCHEL, OTTOMAR (B. 1845) GERMAN	250-4600	X
HENLEY, HENRY W. (Late 19TH C) BRITISH	100-900	L,F
HENLEY, W. B. (Mid 19TH C) BRITISH	100-900	X(G,F)
HENNEBICQ, ANDRE (1836-1904) BELGIAN	500-9000	G,F,L
HENNER, JEAN JACQUES	*200-1500	
HENNER, JEAN JACQUES (1829-1905) FRENCH	1200-36000	F,L
HENNESSY, WILLIAM JOHN (1840-1917) BRITISH	600-7000	G,F
HENNINGS, JOHANN FRIEDRICH (1838-1899) GERMAN	1200-26000	G,L
HENNINGSEN, FRANTS (1850-1908) DANISH	500-10000	G,F,L
HENRI, JULES (20TH C) FRENCH	100-900	X(F)
HENRICHSEN, CARSTEN (1824-1897) DANISH	300-2400	L
HENRION, ARMAND FRANCOIS JOSEPH (B. 1875) FRENCH	200-4700	G,F
HENRY, BERNARD BENEDICT (Late 19TH C) BRITISH	300-2800	X
HENRY, D. M. (20TH C) BRITISH	*300-2600	M,L
HENRY, GEORGE (1859-1943) BRITISH	700-27000	G,F
HENRY, MICHEL (B. 1928) FRENCH	400-2900	S,M
HENRY, PAUL (1877-1958) IRISH	1000-94000	L,F
HENRY, WILLIAM (1812-1884) BRITISH	200-2600	G,F
HENSHAW, FREDERICK HENRY (1807-1891) BRITISH	500-3500	L,W
HENZELL, ISAAC (19TH C) BRITISH	300-4600	G,L,F,W
HEPPER, GEORGE (19TH C) BRITISH	150-3400	G,W
HEPPLE, WILSON (1854-1937) BRITISH	250-6300	W,F
HEPWORTH, BARBARA (1903-1975) BRITISH	*1200-40000	A
HERALD, JAMES WATTERSON (1859-1914) BRITISH	*500-7000	L,F,M
HERBE, TIM (19TH C) BELGIAN	150-1200	X(F)
HERBERT, ALFRED (D. 1861) BRITISH	*200-4200	M
HERBERT, HAROLD B. (20TH C) AUSTRALIAN	*200-4600	L,M
HERBERT, JOHN ROGERS (1810-1890) BRITISH	300-17000	F,G,L
HERBERTE, EDWARD B.	*100-700	
HERBERTE, EDWARD B. (1857-1893) BRITISH	600-18500	G,L
HERBIG, OTTO (1889-1971) GERMAN	250-3500	X(G)
HERBIN, AUGUSTE	*400-53000	
HERBIN, AUGUSTE (1882-1960) FRENCH	1500-+++	A
HERBO, LEON (1850-1907) BELGIAN	350-23000	G,M,F
HERBSTHOFFER, PETER RUDOLPH KARL (1821-1876) AUSTRIAN	400-6800	G,F
HEREAU, JULES	*100-500	

HEREAU, JULES (1839-1879) FRENCH	300-3400	G,M,W
HERGER, EDMUND (1860-1907) GERMAN	500-8600	F,L
HERING, GEORGE EDWARDS (1805-1879) BRITISH	900-20000	L,G
HERING, W. H. (19TH C) BRITISH	200-1800	L,W
HERKELMAN, RUDOLF (20TH C) DUTCH	150-1400	X(F)
HERKOMER, HUBERT VON	*300-6500	
HERKOMER, HUBERT VON (1849-1914) BRITISH	500-28000	G,F
HERMAN, SALI (B. 1898) SWISS	500-50000	L,F
HERMANN, HANS (1813-1890) GERMAN	300-7000	F,S
HERMANN, HEINRICH (B. 1831) GERMAN	200-2400	X
HERMANN, LEO (1853-1927) FRENCH	900-12000	G,F
HERMANN, LUDWIG (1812-1881) GERMAN	500-27000	M,L
HERMANNS, HEINRICH	*300-9000	
HERMANNS, HEINRICH (1862-1942) GERMAN	1000-18000	L
HERMANS, CHARLES (1839-1924) BELGIAN	500-63000	G,F
HERMELIN, OLAF (1820-1913) SWEDISH	950-60000	G,L,M,S
HERMISTON, HAIG J. (19TH C) FRENCH	100-800	X(L)
HERNANDEZ, DANIEL (1856-1932) PERUVIAN	2000-26000	F
HERNANDEZ, MANUEL (B.1928) SOUTH AMERICAN	300-3500	X
HERNANDEZ CRUZ, LUIS (B. 1936) PUERTO RICAN	150-1000	X
HEROLD, WILHELM (B. 1865) DANISH	150-900	X(L)
HERON, PATRICK	*100-6500	
HERON, PATRICK (B. 1920) BRITISH	900-46000	A
HERP, WILLEM VAN (17TH/18TH C) FLEMISH	800-12000	F
HERPFER, CARL (1836-1897) GERMAN	1500-30000	G
HERRAN, PEDRO ALCANTARA (20TH C) LATIN AMERICAN	*150-1200	X(G)
HERRAN, SATURNINO (1887-1918) MEXICAN	300-4500	G,F
HERREROS, C. (19TH/20TH C) SPANISH	400-3600	X(L)
HERRING, ADOLF (B. 1863) GERMAN	100-700	X
HERRING, BENJAMIN JR. (1830-1871) BRITISH	2000-24000	W,G,F
HERRING, JOHN FREDERICK (JR.) (1815-1907) BRITISH	1200-58000	G,F,W,L
HERRING, JOHN FREDERICK (SR.) (1795-1865) BRITISH	4000-+ + +	W,L
HERRLEIN, JOHANN ANDREAS (1720-1796) GERMAN	900-11500	F,L
HERRMANN, HANS (1858-1942) DUTCH	500-16000	L,G,F
HERRMANN, KARL GUSTAV (B. 1857) GERMAN	200-3500	G
HERRMANN-LEON, CHARLES (1838-1908) FRENCH	250-3500	G,W
HERRMANSTORFER, JOSEPH (1817-1901) GERMAN	500-21000	G,F,M
HERSCHEL, OTTO (1871-1937) GERMAN	300-2800	F,S
HERVE, JULES R.	*200-3500	

* Denotes watercolors, pastels, drawings, and/or mixed media

HERVE, JULES R. (1887-1981) FRENCH	500-20000	F,G,L
HERVIER, LOUIS ADOLPHE	*100-500	
HERVIER, LOUIS ADOLPHE (1818-1879) FRENCH	300-3500	G,L,W
HERWOOD, T. (19TH C) BRITISH	100-700	X
HESS, BENEDIKT FRANZ (B. 1817) SWISS	250-11000	L,M
HESSE, ALEXANDRE JEAN BAPTISTE (1806-1879) FRENCH	*100-6000	G
HESSE, HENRI JOSEPH (1781-1849) FRENCH	*400-18000	F,W
HESSELBOM, OTTO (1848-1913) SWEDISH	900-42000	L
HESSL, GUSTAV AUGUST (1849-1926) AUSTRIAN	250-3200	G,F
HESSMERT, KARL (B. 1869) GERMAN	300-4000	L
HETZ, KARL (1828-1899) GERMAN	1000-15000	G,L
HEUSCH, JACOB DE (1657-1701) DUTCH	2000-45000	L,G,F
HEUSCH, WILLEM DE (1638-1692) DUTCH	1500-26000	G,L,W
HEUSER, CARL (19TH C) GERMAN	1000-14000	G,F
HEUVEL, THEODORE BERNARD DE (1817-1906) FLEMISH	600-10000	G
HEUZE, EDMOND AMEDEE	*100-1200	
HEUZE, EDMOND AMEDEE (1884-1967) FRENCH	350-6400	L,F,S
HEWITT, HENRY (19TH C) BRITISH	100-2100	L
HEY, PAUL (1867-1952) GERMAN	*400-8500	G,F,L
HEYDEL, PAUL (B. 1854) GERMAN	*100-2000	X
HEYDEN, JAN VAN DER (1637-1712) DUTCH	2000-132000	L
HEYDENDAHL, FRIEDRICH JOSEPH NICOLAI (1844-1906) SWEDISH	500-9000	L,F
HEYER, ARTHUR (1872-1931) GERMAN	200-14000	W
HEYERDAHL, HANS (1857-1913) SWEDISH	400-69000	L
HEYERMANS, JEAN ARNOULD (1837-1892) BELGIAN	300-4200	G
HEYLIGERS, GUSTAAF A. F. (1828-1897) DUTCH	400-6000	G,L
HEYMANS, ADRIAAN JOSEF (1839-1921) FLEMISH	500-48000	M,F,L
HEYN, AUGUST (B. 1837) GERMAN	1000-42000	G,F,W
HEYSEN, SIR HANS	*900-85000	
HEYSEN, SIR HANS (1877-1968) AUSTRALIAN	1500-203000	L,W,G
HICKEY, THOMAS (1741-1824) IRISH	1500-130000	F
HICKS, DAVID (19TH/20TH C) BRITISH	100-700	X
HICKS, GEORGE ELGAR (1824-1914) BRITISH	1000-+++	F,S
HIDDEMANN, FRIEDRICH (1829-1892) GERMAN	1000-15000	G
HIENL-MERRE, FRANZ (1870-1943) AUSTRIAN	100-1200	G,L
HIEPES, TOMAS (D. 1674) SPANISH	600-8000	S
HIERSCH-MINERBI, JOACHIM (Called VAN HIER) (1834-1905) AUSTRIAN	150-3200	L,F
HIGHMORE, JOSEPH (1692-1780) BRITISH	500-28000	F

HILAIRE, CAMILLE (B. 1916) FRENCH	400-19000	G,F,L,S
HILAIRE, JEAN BAPTISTE	*500-28000	
HILAIRE, JEAN BAPTISTE (1753-1822) FRENCH	300-7200	L,W
HILDA, E. BAILY (19TH/20TH C) AUSTRIAN	200-2500	X(W)
HILDEBRAND, ERNST	*100-700	
HILDEBRAND, ERNST (1833-1894) GERMAN	300-4500	G
HILDEBRANDT, EDUARD (1818-1869) GERMAN	600-18000	G,M,L
HILDEBRANDT, FERDINAND-THEODOR (1804-1874) GERMAN	400-3500	G
HILDER, RICHARD (1813-1848) BRITISH	300-8500	L,W
HILGERS, CARL (1818-1890) GERMAN	800-34000	L,M,G
HILL, ARTHUR (1830-1900) BRITISH	250-13000	G,F
HILL, CARL FREDERIK (1849-1911) SWEDISH	3800-+++	L,M,W
HILL, JAMES JOHN (1811-1882) BRITISH	500-14000	W,G,F
HILL, JAMES STEVENS (19TH C) BRITISH	100-1200	W,G
HILLBOM, HENRIK (B. 1863) SWEDISH	*100-600	X
HILLESTROM, PER (1732-1816) SWEDISH	1000-93000	G,F,S
HILLEVELD, ADRIANUS DAVID (B. 1838) DUTCH	500-10000	L,M
HILLIER, TRISTRAM (B. 1905) BRITISH	1200-22000	L,S
HILLINGFORD, ROBERT ALEXANDER (1825-1904) BRITISH	1500-30000	G,F
HILLS, ROBERT (1769-1844) BRITISH	*400-4800	W,L
HILLYARD, J. W. (Active 1833-1861) BRITISH	200-2800	G,W
HILLYER, D. (19TH C) BRITISH	200-2000	L
HILTON, ROGER (B. 1911) BRITISH	800-41000	A
HILVERDINK, EDUARD ALEXANDER (1846-1891) DUTCH	300-5300	L,F,W
HILVERDINK, F. H. (20TH C) DUTCH	100-800	X(L)
HILVERDINK, JOHANN JAKOB ANTON (1837-1884) DUTCH	300-4000	M
HILVERDINK, JOHANNES (1813-1902) DUTCH	500-9200	M,L
HINCHCLIFF, WOODBINE (20TH C) BRITISH	150-1500	X
HINCKLEY, ROBERT (B. 1853) BRITISH	150-1500	F
HIND, WILLIAM G. R. (1833-1888) CANADIAN	*200-1800	L,F
HINE, HENRY GEORGE (1811-1895) BRITISH	*100-2800	F,W,L
HINES, FREDERICK C.	*100-800	
HINES, FREDERICK C. (19TH C) BRITISH	150-2000	L,G,W
HINES, THEODORE (Late 19TH C) BRITISH	250-4600	G,L
HINTERREITER, HANS	*100-5300	
HINTERREITER, HANS (B. 1902) SWISS	150-2000	A
HINZ, JOHANN GEORG (D. 1670) GERMAN	900-45000	S
HIRAGA, KAMESUKE (1890-1971) JAPANESE	100-1500	X(L)
HIRD, W. (19TH C) EUROPEAN	100-1000	S

* Denotes watercolors, pastels, drawings, and/or mixed media

HIRT, HEINRICH (1727-1796) GERMAN	1500-35000	G
HIS, RENE CHARLES EDMOND (B. 1877) FRENCH	600-6500	L
HITCHENS, ALFRED (1893-1979) BRITISH	100-1500	G,F
HITCHENS, IVON (B. 1893) BRITISH	1200-82000	L,A
HITLER, ADOLF (1889-1945) GERMAN	*800-7500	F
HJERTEN, SIGRID (1885-1948) SWEDISH	6000-+ + +	F,S
HOARE, WILLIAM (OF BATH) (1706-1799) BRITISH	*400-12000	F
HOBAN, RUSSELL (B. 1925) AUSTRIAN	100-700	I
HOBBEMA, MEINDERT (1638-1709) DUTCH	5000-+ + +	L,W
HOBDAY, WILLIAM ARMSFIELD (1771-1831) BRITISH	300-2500	F
HOCH, HANNAH (B. 1889) GERMAN	600-33000	A
HOCH, JOHANN JAKOB (1750-1829) GERMAN	*300-2000	G,L,F
HOCKNEY, DAVID	*2500-+ + +	
HOCKNEY, DAVID (B. 1937) BRITISH	7000-+ + +	A
HODE, PIERRE (1889-1942) FRENCH	900-104000	L,M,S
HODGES, WILLIAM S. (1744-1797) BRITISH	700-35000	G,F,L
HODGKIN, HOWARD (B. 1932) BRITISH	7000-+ + +	A
HODGKINS, FRANCES	*800-65000	
HODGKINS, FRANCES (1869-1947) NEW ZEALAND	5000-125000	G,F,S
HODGSON, JOHN EVAN (1831-1895) BRITISH	400-7600	G,M
HODLER, FERDINAND	*600-115000	
HODLER, FERDINAND (1853-1918) SWISS	7000-+ + +	F
HOECKE, JAN VAN DEN (1611-1651) FLEMISH	900-18000	F,L
HOECKER, PAUL (1854-1910) GERMAN	200-2500	G,F
HOEFFLER, ADOLF (1826-1898) GERMAN	200-8600	L,F
HOEFNAGEL, JORIS (GEORGE) (1545-1601) FLEMISH	*6000-90000	I,L
HOENIGER, PAUL (1865-1924) GERMAN	800-20000	L,M
HOESE, JEAN DE LA (1846-1917) BELGIAN	100-3200	G,L
HOESSLIN, GEORGE VON (1851-1923) GERMAN	200-3200	G,S
HOET, GERARD (1648-1733) DUTCH	1500-20000	F,L
HOFER, HEINRICH (1825-1878) GERMAN	800-22000	G,L,W
HOFER, J. (19TH C) GERMAN	100-600	X
HOFER, KARL	*300-20000	
HOFER, KARL (1878-1955) GERMAN	2000-75000	A
HOFFMANN, ANTON (1863-1938) GERMAN	200-3400	G,F,L
HOFFMANN, CARL HEINRICH (19TH C) GERMAN	200-3200	L
HOFFMANN, JOSEF (1870-1956) AUSTRIAN	*300-5200	X(I,L)
HOFFMANN, OSCAR ADOLFOVITCH (1851-1913) RUSSIAN	900-14000	G,L
HOFFMANN, RUDOLF (19TH C) GERMAN	500-5000	X(L)

HOFLAND, THOMAS CHRISTOPHER (1777-1843) BRITISH	800-18000	L,M,W
HOFLINGER, ALBERT (1855-1936) GERMAN	250-9100	G
HOFMAN, H. (19TH C) GERMAN	100-1800	X
HOFMANN, A. (B. 1879) GERMAN	350-4500	F,W
HOFMANN, KARL (B. 1852) AUSTRIAN	150-1600	L
HOFMANN, RUDOLF (1820-1882) GERMAN	300-3000	X(L)
HOFNER, JOHANN BAPTIST (1832-1913) GERMAN	1500-22000	G,W
HOGARTH, WILLIAM (1697-1764) BRITISH	4000-+++	G,F
HOGER, RUDOLF A. (1877-1930) AUSTRIAN	200-3400	F
HOGERS, JAKOB (1614-1660) DUTCH	400-7500	F
HOGFELDT, ROBERT (B. 1894) SWEDISH	*400-6000	F
HOGGATT, WILLIAM	*200-7300	
HOGGATT, WILLIAM (1880-1961) BRITISH	300-4000	M,F
HOGUET, CHARLES (1821-1870) FRENCH	500-12000	L,M,F
HOHENSTEIN, ADOLF (1854-1917) GERMAN	150-2100	G,L,F
HOHS, LISELOTTE	*100-400	
HOHS, LISELOTTE (B. 1939) AUSTRIAN	100-700	X
HOIN, CLAUDE (1750-1817) FRENCH	*400-18000	F,L
HOKUSAI, KATSUSHIKA (1760-1849) JAPANESE	*500-55000	X(G,F,L)
HOLDER, EDWARD HENRY (19TH C) BRITISH	600-12000	L,M,W
HOLDING, HAROLD (19TH C) BRITISH	100-700	X
HOLDSTOCK, ALFRED WORSLEY (1820-1901) CANADIAN	*300-3600	L,F
HOLGATE, EDWIN HEADLEY (1892-1977) CANADIAN	500-12000	G,F,L
HOLIDAY, GILBERT (1879-1937) BRITISH	*900-23000	W
HOLIDAY, HENRY JAMES (1839-1927) BRITISH	800-16000	F,I
HOLL, FRANK (1845-1888) BRITISH	1500-95000	G,F
HOLLAMS, F MABEL (19TH C) BRITISH	400-3000	W
HOLLAND, JAMES (1799-1870) BRITISH	500-18000	G,F,L,S
HOLLAND, JOHN JOSEPH (B. 1776) BRITISH	200-1400	L
HOLLAND, JOHN SR. (1805-1880) BRITISH	400-5000	L,M,F
HOLLAND, SEBASTOPOL SAMUEL (D. 1911) BRITISH	500-15000	L,M,W
HOLLAND (JR), JOHN (1830-1886) BRITISH	*150-1200	L
HOLLANDER, HENDRIK (1823-1884) DUTCH	400-7200	G,F
HOLLAR, WENCESLAUS (1607-1677) BOHEMIAN	*500-18000	F,L
HOLLINS, WILLIAM (1763-1843) BRITISH	*400-3000	L
HOLLIS, S. (19TH C) BRITISH	100-700	L,W
HOLLOWAY, CHARLES EDWARD (1838-1897) BRITISH	*100-1200	X(L)
HOLLS, I. T. (19TH C) BRITISH	100-700	X
HOLLYER, EVA (19TH C) BRITISH	500-12000	G,F

* Denotes watercolors, pastels, drawings, and/or mixed media

HOLLYER, W. P. (19TH C) BRITISH	200-3600	W,L
HOLMAN, FRANCIS (Late 18TH C) BRITISH	2000-28000	M
HOLMAN, J. C. (18TH C) BRITISH	100-500	X
HOLMES, EDWARD (19TH C) BRITISH	200-4600	G,F
HOLMES, GEORGE AUGUSTUS (1852-1909) BRITISH	250-15500	G,L,W
HOLMES, GRACE (19TH C) BRITISH	100-900	G
HOLMES, ROBERT H. (1861-1930) CANADIAN	150-2200	X(L)
HOLMGREN, FRITZ (1777-1857) SWEDISH	300-2400	F
HOLMLUND, JOSEPHINA (1827-1905) SWEDISH	800-7000	L
HOLSOE, CARL VILHELM (1863-1935) DANISH	1000-112000	G,L,S,W
HOLST, LAURITS (1848-1934) DANISH	300-3500	L,M
HOLT, EDWIN FREDERICK (19TH C) BRITISH	500-18000	W,F,L
HOLT, EDWIN FREDERICK (Active 1850-1886) BRITISH	800-15000	G,L,W
HOLTE, A. BRANDISH (19TH C) BRITISH	200-1800	X(L)
HOLWEG, GUSTAV (1855-1890) AUSTRIAN	300-7000	G
HOLY, ADRIEN (1898-1979) SWEDISH	200-3600	G,L
HOLYOAK, ROWLAND E. (19TH C) BRITISH	400-9500	G,F
HOLZ, JOHANN DANIEL (1867-1945) GERMAN	200-4500	W
HOLZEL, ADOLF (1853-1934) GERMAN	*600-15000	A
HONDECOETER, GYSBERT DE (1604-1653) DUTCH	800-28000	L,F,W
HONDECOETER, MELCIOR DE (1636-1695) DUTCH	3000-+++	W,L,S
HONDIUS, ABRAHAM (1625-1695) DUTCH	1400-150000	F,W
HONDT, LAMBERT DE (1620-1665) FLEMISH	1000-26000	G,F
HONE, NATHANIEL (1718-1784) BRITISH	2000-65000	L,M,F,W
HONTHORST, GERRIT VAN (1590-1656) DUTCH	4000-+++	F,G
HOOCH, HORATIUS DE (D. 1686) DUTCH	400-7600	L,F
HOOCH, PIETER DE (1629-1681) DUTCH	4000-+++	G,F
HOOG, BERNARD DE	*150-3000	
HOOG, BERNARD DE (1867-1943) DUTCH	800-32000	G,F
HOOG, RUDOLF (19TH C) DUTCH	100-800	X
HOOGSTRATEN, SAMUEL VAN (1627-1678) FLEMISH	2000-200000	F,L
HOOK, JAMES CLARKE (1819-1907) BRITISH	400-9700	G,F,M
HOOM, KARL VAN (19TH/20TH C) DUTCH	100-1500	F,M
HOOPER, JOHN HORACE (Late 19TH C) BRITISH	400-8500	L,F,M
HOOPER, LUTHER (1849-1932) BRITISH	150-1200	G
HOOPER, P. SYLVESTER (19TH C) BRITISH	100-600	L
HOOY, VAN (19TH C) DUTCH	100-600	X
HOPE, ROBERT (1869-1936) BRITISH	300-4500	G,F,L,W
HOPKINS, ARTHUR (1848-1930) BRITISH	700-14000	G,F,L

HOPKINS, WILLIAM H. (D. 1892) BRITISH	800-23000	F,L,W
HOPLEY, EDWARD WILLIAM JOHN (1816-1869) BRITISH	200-15000	G,F
HOPPE, C. A. W. (1836-1860) GERMAN	150-2400	S
HOPPE, ERIK (1897-1968) DANISH	400-4500	L,F
HOPPENBROUWERS, JOHANNES FRANCISCUS (1791-1866) DUTCH	500-9500	G,F,L
HOPPNER, JOHN (1758-1810) BRITISH	3000-55000	F,L,W
HOQUET, CHARLES (1821-1870) FRENCH	400-4600	S
HORACIO, (B. 1912) MEXICAN	1600-32000	G,F,W
HORDE, F. (19TH C) DUTCH	150-1200	X
HOREMANS, JAN JOSEF (ELDER) (1682-1759) FLEMISH	800-22000	F,G
HOREMANS, PETER (B. 1714) FLEMISH	800-15000	X(G)
HOREMANS, PETER JACOB (1700-1776) FLEMISH	2000-64000	G,F
HORGNIES, NORBERT JOSEPH (19TH C) BELGIAN	1200-7000	G,F
HORLOR, GEORGE W. (Active 1849-1890) BRITISH	800-33000	W,F,L
HORLOR, JOSEPH (19TH C) BRITISH	200-3500	L,M,W
HORMANN, THEODOR VON (1840-1895) GERMAN	2000-58000	G,L
HORN, JOSEF (1902-1951) GERMAN	200-2400	X(L)
HORNEL, EDWARD ATKINSON (1864-1933) BRITISH	1500-86000	G,F,L
HORNEMANN, FRIEDRICH ADOLF (1813-1890) GERMAN	1500-32000	G
HORNUNG, PREBEN (B. 1919) DANISH	400-7700	A
HORSLEY, JOHN CALLCOTT (1817-1903) BRITISH	800-24000	G,F
HORSLEY, WALTER CHARLES	*300-4000	
HORSLEY, WALTER CHARLES (B. 1855) BRITISH	1500-39000	F
HORST, GERRIT WILLEMSZ (1612-1652) DUTCH	850-80000	G,F,S
HORST, GUSTAV AUGUST (19TH C) GERMAN	200-2400	X(L)
HORTON, ETTY (D. 1905) BRITISH	150-1600	G,L,W
HORVATH, ADORIAN (B. 1874) HUNGARIAN	150-2000	X(F)
HOSCHEDE-MONET, BLANCHE (1865-1947) FRENCH	350-18000	L,S
HOSIASSON, PHILIPPE	*100-2500	
HOSIASSON, PHILIPPE (B. 1898) FRENCH	300-16000	A
HOSSE, ADOLPH (B. 1875) GERMAN	100-800	G
HOST, OLUF (1884-1966) DANISH	800-36000	L
HOTCHKIS, ANNA MARY (20TH C) BRITISH	*100-600	X
HOUBEN, HENRI (1858-1910) BELGIAN	700-23000	G,L
HOUBRON, FREDERIC ANATOLE (1851-1908) FRENCH	*200-3400	L,F
HOUDIAKOFF, ANDREI (20TH C) RUSSIAN	*400-5000	X(I)
HOUEL, JEAN PIERRE LOUIS LAURENT (1735-1813) FRENCH	*300-4000	G,L,F
HOUGH, WILLIAM (19TH C) BRITISH	*250-6000	S

* Denotes watercolors, pastels, drawings, and/or mixed media

HOUGHTON, FRANK (19TH C) CANADIAN	*100-900	X(I)
HOUME, S. (20TH C) FRENCH	100-600	X
HOUSTON, GEORGE	*100-3100	
HOUSTON, GEORGE (1869-1947) BRITISH	500-16000	L,M
HOUSTON, JOHN ADAM (1812-1884) BRITISH	*200-3000	L,F
HOUTEN, HENRICUS L. VAN (1801-1833) DUTCH	1500-32000	L,W
HOUZE, FLORENTIN (1812-1860) BELGIAN	150-2000	G
HOVE, BARTHOLOMEUS JOHANNES VAN (1790-1880) DUTCH	1000-33000	L,F
HOVE, VICTOR VAN (1825-1891) BELGIAN	400-7000	X(G)
HOVENDEN, THOMAS (1840-1895) BRITISH/AMERICAN	900-36000	G,F,L
HOW, JULIA BEATRICE (1867-1932) BRITISH	*300-5700	F
HOWARD, J. (19TH/20TH C) BRITISH	100-800	X
HOWARTH, B. M. (19TH C) BRITISH	100-600	X
HOWE, JAMES (1780-1836) BRITISH	450-14000	W
HOWELLS, MAUD	*100-500	
HOWELLS, MAUD (19TH C) BRITISH	150-1200	G,L
HOWITT, WILLIAM SAMUEL (1765-1822) BRITISH	*200-7000	I
HOYLAND, JOHN	*150-8500	
HOYLAND, JOHN (B. 1934) BRITISH	400-6000	A
HOYLE, MARY E. (19TH/20TH C) BRITISH	100-600	X
HOYTE, JOHN BARR CLARKE (1835-1913) NEW ZEALANDER	*600-25000	L,M
HUBBUCH, KARL (B. 1891) GERMAN	*400-6600	S,G,F
HUBER, ERNST	*100-3200	
HUBER, ERNST (1895-1960) AUSTRIAN	300-6000	L,S,W
HUBER, HERMANN (1888-1968) SWISS	600-5500	L,S,A
HUBER, LEON CHARLES (1858-1928) FRENCH	500-16000	F,W,S
HUBER, WILHELM (1787-1871) GERMAN	400-5000	L
HUBERT-ROBERT, MARIUS (19TH/20TH C) FRENCH	100-900	X
HUBERTI, ANTONIO (20TH C) SPANISH	800-6000	A
HUBNER, CARL (1797-1831) GERMAN	500-8800	G
HUBNER, CARL WILHELM (1814-1879) GERMAN	800-34000	G
HUBNER, HEINRICH (B. 1869) GERMAN	700-7500	L,F
HUBNER, JULIUS (1842-1874) GERMAN	600-8600	G,F
HUBNER, ULRICH (1872-1932) GERMAN	600-10000	M,L
HUBRECHT, AMALDA BRAMINE LOUISE (1855-1913) DUTCH	300-3200	G,F
HUCHTENBURG, JACOB VAN (1639-1675) DUTCH	4000-50000	L,F
HUCHTENBURG, JAN VAN (1646-1733) DUTCH	2000-28000	L,F,W
HUDSON, HENRY JOHN (1881-1910) BRITISH	400-3500	G,F

HUDSON, THOMAS (1701-1779) BRITISH	3000-210000	F
HUE, CHARLES DESIRE (1842-1899) FRENCH	350-4600	G
HUET, CHRISTOPHE (1694-1759) FRENCH	1100-77000	L,F,W
HUET, JEAN BAPTISTE	*800-20000	
HUET, JEAN BAPTISTE (1745-1811) FRENCH	2000-52000	G,F,L,W
HUET, LEON ARMAND (19TH C) FRENCH	300-4600	X(I)
HUET, PAUL	*400-4300	
HUET, PAUL (1803-1869) FRENCH	600-12000	L
HUGGINS, WILLIAM	*400-8500	
HUGGINS, WILLIAM (1820-1884) BRITISH	900-22000	F,W,S
HUGGINS, WILLIAM JOHN (1781-1845) BRITISH	1800-40000	M,W
HUGHES, ARTHUR (1832-1915) BRITISH	1500-225000	G,F,L
HUGHES, ARTHUR FORD (1856-1914) BRITISH	400-8200	L
HUGHES, EDWARD ROBERT (1851-1914) BRITISH	*600-32000	G,F,L
HUGHES, JOHN JOSEPH (D. 1909) BRITISH	400-3600	L,M
HUGHES, TALBOT (1869-1942) BRITISH	500-17000	G,F,L,W
HUGHES, THOMAS JOHN (19TH C) BRITISH	300-8100	X
HUGHES, WILLIAM (1842-1901) BRITISH	500-16000	S
HUGHES-STANTON, SIR HERBERT (1870-1937) BRITISH	400-6200	G,W,L
HUGO, JEAN (B. 1894) FRENCH	500-20000	A
HUGO, VICTOR (1802-1885) FRENCH	*1500-62000	L,F
HUGUES, PAUL JEAN (B. 1891) FRENCH	300-3500	X(F)
HUGUET, VICTOR PIERRE (1835-1902) FRENCH	1000-22000	G,L
HUIERGLIO, MERIO (20TH C) FRENCH	100-800	X
HULBERT, LYLIAN ROOT (19TH/20TH C) FRENCH	100-600	X
HULK, ABRAHAM (JNR) (1851-1922) BRITISH	400-7000	M,W,L
HULK, ABRAHAM (SNR) (1813-1897) DUTCH	600-45000	M
HULK, F. (19TH C) DUTCH	200-2500	X(L)
HULK, HENDRIK (1842-1937) DUTCH	250-5000	M
HULK, JOHN FREDERICK (1829-1911) DUTCH	600-12000	L,M,F
HULK, WILLIAM FREDERICK (B. 1852) BRITISH	900-12000	L,W
HULL, EDWARD	*100-600	
HULL, EDWARD (19TH C) BRITISH	200-2200	X(W)
HULL, WILLIAM (1820-1880) BRITISH	*200-2500	G,L
HULLGREN, OSCAR (1869-1948) SWEDISH	500-6000	M,L
HULME, FREDERICK WILLIAM (1816-1884) BRITISH	1200-53000	L,F,W
HULSDONCK, GILLIS VAN (1626-1670) DUTCH	2000-25000	S
HULSDONCK, JACOB VAN (1582-1647) FLEMISH	3000-+++	S
HULST, FRANS DE (1610-1661) FLEMISH	1600-45000	L,M,F

* Denotes watercolors, pastels, drawings, and/or mixed media

HUMBERT, ANDRE LOUIS MAXIME (B. 1879) FRENCH	150-2000	G
HUMBERT, JACQUES FERNAND (B. 1842) FRENCH	100-1400	F,L
HUMBERT, JEAN CHARLES FERDINAND (1813-1881) SWISS	300-12000	F,W,L
HUMBLOT, ROBERT (1907-1962) FRENCH	350-22000	M,L,F
HUMBORG, ADOLF (B. 1847) AUSTRIAN	1200-36000	G,F
HUME, EDITH (19TH C) BRITISH	500-3500	G,F
HUMMEL, CARL MARIA NICOLAUS (1821-1907) GERMAN	400-5500	G,L
HUNDERTWASSER, FRITZ	*800-137000	
HUNDERTWASSER, FRITZ (B. 1928) AUSTRIAN	1500-172000	A
HUNN, THOMAS H. (19TH/20TH C) BRITISH	*100-4100	L
HUNT, ALFRED WILLIAM (1830-1896) BRITISH	*800-28000	G,F,L
HUNT, ANDREW (1790-1861) BRITISH	*200-2000	X(L)
HUNT, CECIL ARTHUR (1873-1965) BRITISH	*100-2000	L,M
HUNT, CHARLES (1803-1877) BRITISH	1500-20000	G,F
HUNT, EDGAR (1876-1953) BRITISH	1200-51000	A
HUNT, EDWARD AUBREY (1855-1922) BRITISH	700-16000	G,L,M,W
HUNT, REUBEN (19TH C) BRITISH	400-7500	W
HUNT, WALTER (1861-1941) BRITISH	1500-56000	W
HUNT, WILLIAM HENRY	*500-35000	
HUNT, WILLIAM HENRY (1790-1864) BRITISH	300-4000	G,F,L,S
HUNTEN, EMIL (1827-1902) GERMAN	700-6500	F,M
HUNTER, COLIN (1841-1904) BRITISH	200-3000	M,F
HUNTER, GEORGE LESLIE (1877-1931) BRITISH	1000-66000	M,L,S
HUNTER, GEORGE SHERWOOD (19TH C) BRITISH	500-6500	G,F
HUNTER, MARY YOUNG (1878-1936) BRITISH	700-12000	F
HUNTER, ROBERT (D. 1780) BRITISH	500-16000	F
HURENBOUT, J. (19TH C) EUROPEAN	150-1400	X
HURT, LOUIS BOSWORTH (1856-1929) BRITISH	800-43000	L,W
HUSSEY, GILES (1710-1788) BRITISH	*1000-6000	F
HUTCHISON, ROBERT GEMMELL (1855-1936) BRITISH	1000-42000	G,F,M
HUTSCHENREUTHER, ARTHUR (19TH C) AUSTRIAN	200-1600	X(F)
HUTTON, T. FAWCETT (19TH/20TH C) BRITISH	150-1800	X
HUVE, JEAN-JACQUES (1742-1808) FRENCH	*400-4600	X(L)
HUYGENS, FRANCOIS JOSEPH (1820-1908) BELGIAN	1000-18000	S
HUYGENS, JOHANNES (19TH C) DUTCH	150-1400	L,W
HUYS, MODESTE (1875-1932) BELGIAN	1000-70000	G,L
HUYSMANS, CORNELIS (1648-1727) FLEMISH	1000-20000	W,L,F
HUYSUM, JAN VAN	*400-12000	
HUYSUM, JAN VAN (1682-1749) DUTCH	5000-+++	S,L

HYDE, GEORGE (19TH C) BRITISH	150-1200	G
HYDE, HENRY JAMES (19TH C) BRITISH	100-700	X
HYNAIS, VOYTECH (1854-1925) CZECHOSLOVAKIAN	*300-5000	F
HYNCKES, RAOUL (1893-1939) DUTCH	500-9500	M,S,F
HYNER, AREND (1866-1916) DUTCH	200-2500	G,F,S
HYON, GEORGES LOUIS (B. 1855) FRENCH	200-3600	F
HYPPOLITE, HECTOR (1889-1948) HAITIAN	1200-38000	F,S
HYPPOLITE, L. (20TH C) HAITIAN	100-500	X

I

ARTIST	PRICES	SUBJECT
IACOVLEFF, ALEXANDRE	*300-13500	
IACOVLEFF, ALEXANDRE (1887-1938) FRENCH	250-7000	G,F,W
IACURTO, FRANCESCO (B. 1908) CANADIAN	300-2300	L
IANELLI, ARCANGELO (B. 1922) BRAZILIAN	500-12000	A
IARKINE, VLADIMIR (B. 1939) RUSSIAN	400-5000	L
IBANEZ, MANUEL RAMIREZ (1856-1925) SPANISH	500-8500	G,F
IBBETSON, JULIUS CAESAR	*1000-45000	
IBBETSON, JULIUS CAESAR (1759-1817) BRITISH	1000-40000	G,F,W,L
IBELS, HENRI GABRIEL (1867-1936) FRENCH	*1000-10000	L,F
ICART, LOUIS	*400-12000	
ICART, LOUIS (1888-1950) FRENCH	900-73000	F,W
ICAZA, ERNESTO (1866-1935) MEXICAN	350-7800	F,G
ICAZA, FRANCISCO DE	*100-400	
ICAZA, FRANCISCO DE (B. 1930) MEXICAN	100-800	X(F)
IGLER, GUSTAV (1842-1908) AUSTRIAN	1500-32000	G,F
IHLEE, EDUARD JOHANN (1812-1885) GERMAN	300-6500	F
IHLEE, RUDOLPH (20TH C) BRITISH	600-6000	L,F,M
IHLY, DANIEL (1854-1910) SWISS	300-8500	F,L,S
ILLES, ALADAR EDVI (1870-1911) HUNGARIAN	300-4000	W,L
ILSTED, PETER VILHELM (1861-1933) DANISH	1500-115000	F,G,L
IMMENDORF, JORG (20TH C) GERMAN?	5000-50000	X(A)
IMPENS, JOSSE (1840-1905) BELGIAN	200-2800	G,F
IMPERIALI, FRANCESCO (18TH C) ITALIAN	1000-40000	F

IMSCHOOT, JULES A. VAN (1821-1824) BELGIAN	200-2000	F
INCE, JOSEPH MURRAY (1806-1859) BRITISH	250-3500	L
INCHBOLD, JOHN WILLIAM (1830-1880) BRITISH	900-35000	L
INDONI, FILIPPO	*300-12500	
INDONI, FILIPPO (19TH C) ITALIAN	300-14000	G,F
INDONI, S. (19TH/20TH C) EUROPEAN	100-900	X
INDUNO, DOMENICO (1815-1878) ITALIAN	2500-249000	G,F
INDUNO, GIROLAMO (1827-1890) ITALIAN	2500-255000	G,F,L
INGALLS, WALTER (1805-1874) CANADIAN	150-1200	F
INGANNATI, PIETRO DEGLI (16TH C) ITALIAN	1000-20000	F
INGANNI, ANGELO (1807-1880) ITALIAN	2000-175000	L
INGEN, HENDRICK VAN (1833-1898) DUTCH	250-3200	X(W,L)
INGLIS, JANE (D. 1916) BRITISH	600-4500	M,L
INGLIS, JOHNSTONE J. (19TH C) BRITISH	150-2000	L,M
INGRES, JEAN AUGUSTE DOMINIQUE	*7500-+ + +	
INGRES, JEAN AUGUSTE DOMINIQUE (1780-1867) FRENCH	20000-+ + +	F
INNOCENTI, CAMILIO	*400-12000	
INNOCENTI, CAMILIO (1871-1961) ITALIAN	500-7000	G,F,L
INO, PIERRE (B. 1909) FRENCH	150-1600	G
IOLI, ANTONIO (1700-1777) ITALIAN	500-5000	X(L)
IRAS, ROBERTO BALDESSAR (1894-1965)	600-14000	F
IRIARTE, IGNACIO DE (1621-1685) SPANISH	600-15000	F,L,W
IRMER, CARL (1834-1900) GERMAN	300-3500	L,F
IRMINGER, VALDEMAR (1850-1938) DANISH	600-7000	G,F,L
IROLLI, VINCENZO (1860-1949) ITALIAN	2000-90000	G,F
IRONSIDE, ROBIN (20TH C) BRITISH	*100-600	X
IRWIN, BENONI (1840-1896) CANADIAN	*200-2400	G,F
IRWIN, H. J. (19TH C) BRITISH	100-700	X
ISABEY, JEAN BAPTISTE	*400-12000	
ISABEY, JEAN BAPTISTE (1767-1855) FRENCH	1200-68000	F
ISABEY, LOUIS GABRIEL EUGENE	*400-6000	
ISABEY, LOUIS GABRIEL EUGENE (1803-1886) FRENCH	1100-35000	G,F,M
ISAKSON, KARL (1878-1922) SWEDISH	3000-122000	S,F
ISAMBERT, A. (19TH C) FRENCH	150-1200	X
ISBERG, FREDRIK (1846-1904) SWEDISH	*200-2500	X(L)
ISELI, ROLF (B. 1934) SWISS	1000-24000	A
ISENBART, MARIE VICTOR EMILE (1846-1921) FRENCH	800-6500	L,F
ISENBRANDT, ADRIAEN (1490-1551) FLEMISH	7000-+ + +	F
ISENBURGER, ERIC (B. 1902) GERMAN/AMERICAN	150-3000	F

ISHIGAKI, EITARO (1893-1958) JAPANESE/AMERICAN	150-1600	G
ISMAILOVITCH, D. (Early 20TH C) RUSSIAN	100-1200	G,F
ISRAEL, DANIEL (1859-1901) AUSTRIAN	1000-24000	G,F
ISRAELS, ISAAC	*1000-78000	
ISRAELS, ISAAC (1865-1934) DUTCH	1200-129000	F
ISRAELS, JOSEF	*700-27000	
ISRAELS, JOSEF (1824-1911) DUTCH	1200-48000	G,F,W
ISSUPOFF, ALESSIO (1889-1957) RUSSIAN	700-11000	G,F,L
ISTRATI, ALEXANDRE (B. 1915) FRENCH	2500-38000	A
ISTVANFFY, GABRIELLE RAINER (B. 1877) HUNGARIAN	100-1000	X(W)
ITAYA, FOUSSA (B. 1919) FRENCH	300-4500	M,W
ITEN, HANS (1874-1930) SWISS/BRITISH	400-5000	S,L
ITTEN, JOHANNES (B. 1888) SWISS	*8000-22000	A
ITTENBACH, FRANZ (1813-1879) GERMAN	800-9000	F
IVANOFF, MICHAIL MATVEIEVITCH (1748-1823) RUSSIAN	200-2400	L
IVANOFF, MICHAIL PHILIPPOVITCH (B. 1869) RUSSIAN	*200-1500	X
IVANOVITCH, PAUL (B. 1859) AUSTRIAN	500-8000	X(G)
IVANY-GRUNWALD, BELA (1867-1940) AUSTRIAN	300-4000	F,L
IVARSON, IVAN	*400-8000	
IVARSON, IVAN (1900-1939) SWEDISH	1000-110000	F,L,M
IVERSEN, KRAESTEN (1886-1955) DANISH	400-5500	L,S
IWILL, JOSEPH	*200-4000	
IWILL, JOSEPH (1850-1923) FRENCH	250-25000	L,M
IZIDORO, JAIME (B. 1924) EUROPEAN	*100-900	X(M)
IZOYKORVSKY, F. VON (20TH C) POLISH	100-600	X
IZQUIERDO, MARIA	*900-50000	
IZQUIERDO, MARIA (1906-1950) MEXICAN	1200-99000	F

J

ARTIST	PRICES	SUBJECT
JACK, KENNETH	*400-4000	
JACK, KENNETH (B. 1924) AUSTRALIAN	600-12000	X(L)
JACK, RICHARD (1866-1952) CANADIAN/BRITISH	300-3200	F,L,S
JACKSON, ALEXANDER YOUNG	*500-5000	
JACKSON, ALEXANDER YOUNG (1882-1974) CANADIAN	2000-119000	L
JACKSON, CARLYLE (1891-1940) AUSTRALIAN	*400-2000	L

JACKSON, FREDERICK WILLIAM (1859-1918) BRITISH	700-21000	L,G,F
JACKSON, GEORGE (19TH C) BRITISH	350-4500	X(W,F)
JACKSON, JAMES R. (1886-1975) AUSTRALIAN	700-63000	M,L
JACKSON, SAMUEL (1794-1869) BRITISH	*800-30000	F,L
JACKSON, SAMUEL PHILLIPS (1830-1904) BRITISH	*300-8400	M
JACOB, ALEXANDRE LOUIS (B. 1876) FRENCH	200-3500	X(L)
JACOB, MAX	*300-4500	
JACOB, MAX (1876-1944) FRENCH	300-7500	A,G,F,S
JACOB, STEPHEN (B. 1846) FRENCH	350-9000	G,F
JACOBI, OTTO R. (1814-1901) GERMAN/CANADIAN	400-24000	L,M
JACOBS, JACOBUS ALBERTUS MICHAEL (1812-1879) BELGIAN	1100-112000	M,F
JACOBS, L. A. E. (19TH C) BELGIAN	250-2500	M
JACOBS, PAUL EMIL (1802-1866) GERMAN	1000-80000	F
JACOBSEN, DAVID (1821-1897) DANISH	300-2500	F
JACOBSEN, EGILL (B. 1910) DANISH	2000-58000	A
JACOBSEN, ROBERT (B. 1912) DANISH	*400-5300	A
JACOBSEN, SOPHUS (1833-1912) NORWEGIAN	1200-40000	L,M
JACOMB-HOOD, GEORGE PERCY (1857-1937) BRITISH	200-14000	G,W
JACOMIN, ALFRED LOUIS VIGNY (1842-1913) FRENCH	600-15000	G,F
JACOVACCI, FRANCESCO (1838-1908) ITALIAN	400-6000	X(F)
JACOVLEFF, ALEXANDRE (1887-1938) RUSSIAN	*100-800	
JACQMOTTE, GEORGES (20TH C) BELGIUM	200-2000	X(L)
JACQUAND, CLAUDIUS (1804-1878) FRENCH	400-9500	G,F
JACQUE, CHARLES EMILE	*500-5500	
JACQUE, CHARLES EMILE (1813-1894) FRENCH	2000-68500	G,W,L
JACQUE, EMILE (1848-1912) FRENCH	700-9500	W
JACQUET, ALAIN (20TH C) FRENCH	*300-4000	X
JACQUET, GUSTAVE JEAN	*100-6200	
JACQUET, GUSTAVE JEAN (1846-1909) FRENCH	1000-28000	F
JADIN, CHARLES EMMANUEL (19TH C) FRENCH	200-6400	W,L
JADIN, LOUIS GODEFROY (1805-1882) FRENCH	500-6500	G,L
JAECKEL, WILLY	*500-20000	
JAECKEL, WILLY (1888-1944) GERMAN	400-6200	F
JAEGER, CARL (1833-1887) GERMAN	200-2400	X(F)
JAHN, LOUIS (1839-1911) GERMAN	100-1300	G
JAMES, DAVID (1881-1898) BRITISH	1000-24000	L,M
JAMES, GEORGE (20TH C) BRITISH	*200-1800	L,M
JAMES, RICHARD S. (19TH C) BRITISH	250-4000	G
JAMES, WILLIAM (18TH C) BRITISH	4000-110000	F,L

JAMESON, GEORGE (1587-1644) BRITISH	600-6800	F
JAMIESON, ALEXANDER (1873-1937)	600-15000	G,F,L
JANCO, MARCEL	*300-36000	
JANCO, MARCEL (B. 1895) FRENCH	600-144000	X (A)
JANESCH, ALBERT (1889-1973) AUSTRIAN .	400-6500	G,F
JANIN, CHARLES (20TH C) FRENCH	400-2400	L
JANIN, JEAN (B. 1899) FRENCH	800-6500	X
JANKOWSKI, J. WILHEIM (Mid 19TH C) AUSTRIAN	300-4000	L,M
JANNECK, FRANZ CHRISTOPH (1703-1761) AUSTRIAN	2000-78000	G,F
JANS, EDOUARD DE (1855-1919) BELGIAN	200-5200	F
JANSEM, JEAN	*400-3500	
JANSEM, JEAN (B. 1920) FRENCH	700-75000	F,G
JANSEN, FRANZ MARIA (1885-1958) GERMAN	400-4500	F
JANSEN, HENDRIK WILLEBRORD (1867-1901) DUTCH	400-7100	X(F)
JANSEN, JOSEPH (1829-1905) GERMAN	600-11000	L
JANSEN, WILLEM GEORGE FREDERIK (1871-1949) DUTCH	400-6500	L,M,W
JANSSAUD, MATHURIN (19TH C) FRENCH	*300-10000	M,S
JANSSEN, HORST (B. 1929) DUTCH	*500-26000	X (A)
JANSSEN, LOUIS (19TH C) DUTCH	100-800	X
JANSSENS, HIERONYMUS (1624-1693) DUTCH	1000-80000	G,L
JANSSON, EUGENE (1862-1915) SWEDISH	4000-90000	L,F
JANSSON, RUNE (B. 1918) SWEDISH	400-7500	X (A)
JAPY, LOUIS AIME	*100-800	
JAPY, LOUIS AIME (1840-1916) FRENCH	400-11000	G,L,F,W
JAQUES, JEAN PIERRE (B. 1913) SWISS	700-9600	X
JARAMILLO, IGNACIO GOMEZ (20TH C) COLOMBIAN	200-2200	X
JARDINES, JOSE-MARIA (B. 1862) SPANISH	500-6500	G,F,L
JARPA, O. (20TH C) SOUTH AMERICAN	100-700	X
JARREN, M. (Early 20TH C) GERMAN	100-700	X
JARVIS, ARNOLD (19TH C) AUSTRALIAN	*100-1600	X(L)
JASCHKE, FRANZ (1775-1842) AUSTRIAN	*300-1500	L
JAULMES, GUSTAVE (1873-1959) SWISS	400-4500	X (F)
JAWLENSKY, ALEXEJ VON	*2000-182000	
JAWLENSKY, ALEXEJ VON (1864-1941) GERMAN	15000-+++	A,F
JAWLENSKY, ANDREAS (1902-1984) RUSSIAN	3000-48000	L
JEAN, FIELIX (20TH C) HAITIAN	100-600	X
JEANMAIRE, EDOUARD (1847-1916) SWISS	800-12000	L,W
JEANNIN, GEORGES (1841-1925) FRENCH	600-14000	S
JEANNIOT, PIERRE ALEXANDRE (1826-1892) FRENCH	250-3000	G

* Denotes watercolors, pastels, drawings, and/or mixed media

JEANNIOT, PIERRE GEORGES (1848-1934) FRENCH	900-9000	X(L)
JEAURAT, ETIENNE	*100-6900	
JEAURAT, ETIENNE (1699-1789) FRENCH	900-20000	G,F,L
JEFFERS, V. (19TH C) BRITISH	150-1000	X
JEFFERY, GEORGE (19TH/20TH C) BRITISH	*100-700	X
JEFFREYS, MARCEL (1872-1924) FRENCH	300-11000	L
JEGERLEHNER, HANS (1907-1974) SWISS	500-3500	L,F
JELLEY, JAMES VALENTINE (19TH C) BRITISH	700-8000	F,G,L
JENKINS, BLANCHE (19TH C) BRITISH	700-6000	G,F
JENKINS, JOSEPH JOHN (1811-1885) BRITISH	*300-2000	G,F,L
JENNER, W. (19TH C) BRITISH	200-1800	M,L
JENNY, ARNOLD (1831-1881) SWISS	500-6000	L
JENSEN, C A (1792-1870) DANISH	1500-125000	F
JENSEN, JOHANN LAURENTZ	*350-10000	
JENSEN, JOHANN LAURENTZ (1800-1856) DANISH	2500-+++	S,F
JENSEN, LOUIS ISAK NAPOLEON (1858-1908) DANISH	100-1400	L
JENSEN, THEODORE (19TH C) BRITISH	200-2000	X(S)
JENTSCH, ADOLPH (1888-1977) GERMAN	800-16000	L
JERICHAU, HOLGER H (1861-1900) DANISH	700-15000	L,M,F
JERICHAU, JENS ADOLF (1816-1883) DANISH	1000-40000	L,F
JERICHAU-BAUMANN, ELISABETH (1819-1881) POLISH	400-5000	F
JERKEN, ERIK (1898-1947) SWEDISH	200-6000	L
JERNBERG, AUGUST (1826-1896) SWEDISH	600-35000	G,F
JERVAS, CHARLES (1675-1739) BRITISH	1500-40000	F
JESPERS, FLORIS	*500-25000	
JESPERS, FLORIS (1889-1965) BELGIAN	600-96000	L,F,G
JESSEN, CARL LUDWIG (1833-1917) DANISH/GERMAN	1500-45000	G,F
JETTEL, EUGEN (1845-1901) AUSTRIAN	1800-43000	L,M,W
JEUNE, HENRY LE (1820-1904) BRITISH	1000-27000	G,F
JEYDEL, ED (19TH C) EUROPEAN	150-1500	X
JIG, FRITZ (19TH C) EUROPEAN	100-900	G,W
JIKUS, K. (19TH/20TH C) EUROPEAN	100-700	X
JIMENEZ Y ARANDA, JOSE	*300-27000	
JIMENEZ Y ARANDA, JOSE (1837-1903) SPANISH	1500-90000	G,F
JIRLOW, LENNART	*500-8000	
JIRLOW, LENNART (B. 1936) SWEDISH	2000-48000	F,L
JOBLING, ROBERT (1841-1923) BRITISH	300-5100	G,F,L
JOCHEMS, PIETER FRANS (B. 1929) DUTCH	300-12000	X(M,F)
JOCHEMSZ, P.T. (19TH C) EUROPEAN	100-800	S,M

JOCOBSEN, EGILL (B. 1910) DANISH	800-10000	A
JOENSEN-MIKINES, S (B. 1906) DANISH	400-8800	F,M,L
JOHANSEN, VIGGO (1851-1935) DANISH	500-7900	F,L,S
JOHANSSON, ALBERT (B. 1926) SWEDISH	900-8800	A
JOHANSSON, CARL (1863-1944) SWEDISH	900-61000	L,M
JOHFRA (Active 1919-1936) DUTCH	500-13000	L,F
JOHN, AUGUSTUS	*800-51000	
JOHN, AUGUSTUS (1878-1961) BRITISH	1600-49000	A
JOHN, GWEN	*250-9300	
JOHN, GWEN (1876-1939) BRITISH	1000-+++	G,F,A
JOHNSON, ALFRED GEORGE (B. 1820) BRITISH	150-1500	X(M)
JOHNSON, CHARLES EDWARD (1832-1913) BRITISH	250-3000	L,F
JOHNSON, EDWARD KILLINGWORTH (1825-1896) BRITISH	*600-18000	W,G,F
JOHNSON, HARRY JOHN	*200-3000	
JOHNSON, HARRY JOHN (1826-1884) BRITISH	400-4400	M,F
JOHNSON, NEVILL (20TH C) BRITISH	100-3800	X
JOHNSON, ROBERT (1890-1964) AUSTRALIAN	800-23000	L,M
JOHNSON, SIDNEY YATES (19TH C) BRITISH	100-1000	L,W
JOHNSTON, ALEXANDER (1815-1891) BRITISH	300-4600	G,F
JOHNSTON, CYRIL DAVID (20TH C) BRITISH	*100-2400	X(W)
JOHNSTON, FRANK HANS (1888-1949) CANADIAN	700-18000	L
JOHNSTONE, HENRY JAMES (1835-1907) BRITISH	2000-35000	L
JOLI, ANTONIO (1700-1770) ITALIAN	2000-+++	L
JOLIN, EINAR (1890-1976) SWEDISH	500-40000	G,F,M,S
JOLIN, ELLEN (1854-1939) SWEDISH	250-2800	G,L,S
JOLLY, HENRI JEAN BAPTIST (1812-1853) BELGIAN	200-4900	G,F
JOLYET, PHILIPPE (1832-1908) FRENCH	400-7500	G,F
JONAS, LUCIEN (B. 1880) FRENCH	1000-18000	X
JONES, ADOLF ROBERT (1806-1874) BRITISH	200-2600	G,L,W
JONES, ALLEN (B. 1937) BRITISH	*4000-15000	A
JONES, CHARLES (1836-1892) BRITISH	700-22000	W,L
JONES, DAVID MICHAEL (1895-1974) BRITISH	3000-15000	X
JONES, GEORGE (1786-1869) BRITISH	700-18000	G,F,L
JONES, JOSIAH CLINTON (1848-1936) BRITISH	250-5000	L
JONES, MAUD RAPHAEL (19TH/20TH C) BRITISH	100-2500	G,L
JONES, NORA (20TH C) BRITISH	*100-500	X
JONES, PAUL (1856-1879) BRITISH	300-6200	G,W,L
JONES, SAMUEL JOHN EGBERT (Active 1820-1845) BRITISH	900-24000	G,L,W
JONES, THOMAS	*1000-48000	

JONES, THOMAS (1742-1803) BRITISH	3000-80000	L
JONES, WILLIAM (18TH/19TH C) BRITISH	500-10000	G,L,S
JONG, GERM DE (B. 1886) DUTCH	600-3000	S,L
JONG, JACOBUS FREDERIK STERRE DE (1866-1920) DUTCH	350-3200	G,F
JONGE, JOHAN ANTONIO DE (1864-1927) DUTCH	400-7600	M,F,L
JONGERE, MARINUS DE (B. 1912) DUTCH	200-2700	M,L
JONGH, LUDOLFH DE (Called LIEVE DE JONGH) (1616-1679) DUTCH	1000-20000	G,F
JONGH, OENE ROMKES DE (1812-1896) DUTCH	300-5500	L,M
JONGH, TINUS DE	*300-3000	
JONGH, TINUS DE (1885-1942) DUTCH	500-5500	L,S
JONGHE, GUSTAVE LEONHARD DE (1828-1893) BELGIAN	900-56000	G
JONGHE, JAN BAPTISTE DE (1785-1844) FLEMISH	350-3800	G,L
JONGKIND, JOHAN BARTHOLD	*900-30000	
JONGKIND, JOHAN BARTHOLD (1819-1891) DUTCH	8000-165000	L,M
JONSON, CORNELIS (1593-1664) DUTCH	2000-38000	F
JONSON, SVEN (1902-1981) DANISH	4000-51000	X(A)
JOORS, EUGENE (1850-1910) BELGIAN	400-8500	G,F,S
JOOSTENS, PAUL (20TH C) BELGIAN	400-11000	X
JOPLING, LOUISE (B. 1843) BRITISH	500-2500	F
JORDAENS, HANS III (1595-1643) DUTCH	2000-49000	F
JORDAENS, JACOB	*1000-55000	
JORDAENS, JACOB (1593-1678) FLEMISH	3000-+++	G,F
JORDAN, RUDOLF (1810-1887) GERMAN	2000-33000	G,F
JORDE, LARS (B. 1865) NORWEGIAN	200-52000	G
JORIS, PIO	*400-6800	
JORIS, PIO (1843-1921) ITALIAN	800-37000	G,F,L
JORN, ASGER	*500-40000	
JORN, ASGER (1914-1973) DANISH	3000-+++	A
JOSEPHSON, ERNST (1851-1906) SWEDISH	*400-229000	F,L
JOUENNE, MICHEL (19TH C) FRENCH	300-3200	X
JOUFFROY, JEAN PIERRE (B. 1933) FRENCH	200-2000	X(G)
JOURDAIN, HENRI (1864-1931) FRENCH	*100-1500	M
JOURDAIN, ROGER JOSEPH (1845-1918) FRENCH	500-13000	G,L
JOURDAN, ADOLPHE (1825-1889) FRENCH	800-24000	G,F
JOUVE, PAUL (B. 1880) FRENCH	*400-80000	W
JOY, GEORGE WILLIAM (1844-1925) BRITISH	500-17000	G
JOY, WILLIAM (1803-1867) BRITISH	*300-17000	M
JOYANT, JULES ROMAIN (1803-1854) FRENCH	400-20000	L,M

JUAN, RONALDO DE (B. 1930) ARGENTINIAN	*300-5000	A
JUAREZ, LUIS (Early 17TH C) MEXICAN	1000-15000	F
JUDD, DON (20TH C) BRITISH	*400-4000	A
JUEL, JENS (1745-1802) DANISH	1200-62000	L,F
JUILL, A. E. (19TH C) EUROPEAN	100-700	X
JULIANA Y ALBERT, JOSE	*200-5200	
JULIANA Y ALBERT, JOSE (Active 1865-1920) SPANISH	400-11000	F
JULIEN, JOSEPH (19TH C) BELGIAN	800-12000	G,W
JULLIARD, L. (19TH C) BELGIAN	150-1800	W
JUNCKER, JUSTUS (1703-1767) GERMAN	650-26000	S,G,F
JUNGBLUT, JOHANN (1860-1912) GERMAN	900-10000	M,L
JUNGHANNS, JULIUS PAUL (1876-1953) AUSTRIAN	400-8100	F,G
JUNGLING, J. F. (19TH C) GERMAN	*100-900	X
JUNGMANN, NICO W. (1872-1935) DUTCH	*200-3600	G,F,W
JUNGNICKEL, LUDWIG HEINRICH (1881-1965) GERMAN	400-11000	W,L,M,F
JUNIPER, ROBERT (B. 1929) AUSTRALIAN	400-15000	X(A)
JURGENS, HANS PETER (B. 1924) GERMAN	*800-3500	M
JURRES, JOHANNES HENDRICUS (1875-1946) DUTCH	400-3500	F
JUSTE, JAVIER (19TH C) SPANISH	150-2000	X
JUTSUM, HENRY	*200-6000	
JUTSUM, HENRY (1816-1869) BRITISH	400-7700	L,W
JUTZ, CARL (1838-1916) GERMAN	2000-46000	L,W
JUUEL, ANDREAS (1817-1868) DANISH	700-6500	L,F
JUVELA, LENNU (1886-1979) FINNISH	500-8500	F,L

K

ARTIST	PRICES	SUBJECT
KAA, JAN VAN DER (1813-1877) DUTCH	300-4000	G,M
KABAKOV, ILYA (B. 1933) RUSSIAN	*10000-160000	A
KABELL, LUDWIG (1853-1902) DANISH	300-4500	L
KADAR, BELA	*400-16000	
KADAR, BELA (1877-1955) HUNGARIAN	900-12000	A
KADISHMAN, MENASHE (B. 1932) ISRAELI	2800-24000	X(F)
KAEMMERER, FREDERIK HENDRIK	*300-7000	
KAEMMERER, FREDERIK HENDRIK (1839-1902) DUTCH	800-75000	G,F,M
KAHANA, AHARON (20TH C) ISRAELI	900-8000	X(A)

* Denotes watercolors, pastels, drawings, and/or mixed media

KAHLER, CARL	*100-600	
KAHLER, CARL (B. 1855) AUSTRIAN	600-18000	G,F,L,W
KAHLO, FRIDA	*800-100000	
KAHLO, FRIDA (1910-1954) MEXICAN	7000-+++	G,S,W
KAIPAINEN, UNTO (1906-1971) FINNISH	400-5000	F,M
KAISER, FRIEDRICH (1815-1890) GERMAN	300-3200	F
KAISER, RICHARD (1868-1941) GERMAN	300-6500	L
KAISERMANN, FRANCOIS (1765-1833) SWISS	*400-6000	L
KAKS, OLLE (B. 1941) SWEDISH	1000-8000	A
KALBACH, F. (Late 19TH C) GERMAN	100-1600	X
KALCKREUTH, KARL WALTER LEOPOLD VON (1855-1925) GERMAN	400-11000	G,F
KALCKREUTH, PATRICK VON (19TH/20TH C) GERMAN	300-6800	M
KALCKREUTH, STANISLAS VON (1821-1894) GERMAN	400-34000	L,F
KALF, WILLEM (1622-1693) GERMAN	1500-35000	G,F,S
KALLENBERG, ANDERS (1834-1902) SWEDISH	500-6500	L
KALLMORGEN, FRIEDRICH (1856-1924) GERMAN	1000-17000	G,F,M,L
KALLOS,PAUL (B. 1928) FRENCH	1000-35000	A
KALLOS, PAUL	*800-7500	
KALLSTENIUS, GOTTFRIED (1861-1943) SWEDISH	500-85000	L
KALTENMOSER, KARL (1806-1867) GERMAN	600-12000	G,F,L
KAMEKE, OTTO VON (1826-1899) GERMAN	500-6000	L
KAMPF, ARTHUR (1864-1950) GERMAN	750-30000	G,F
KAMPF, EUGEN (1861-1933) GERMAN	500-6000	L,M,F
KAMPPURI, VAINO (1891-1972) FINNISH	1200-22000	L,F
KAN, GEORGE (B. 1870) AUSTRIAN	100-900	X
KANDINSKY, WASSILY	*3000-+++	
KANDINSKY, WASSILY (1866-1944) RUSSIAN	20000-+++	A
KANDLER, LUDWIG (B. 1856) GERMAN	200-2600	X(G)
KANERVA, AINO (B. 1909) FINNISH	*900-8500	X
KANNEMANS, CHRISTIAN CORNELIS (1812-1884) DUTCH	500-12000	M
KANOLDT, ALEXANDER (1881-1939) GERMAN	1500-29000	S,L
KANOLDT, EDMUND (1839-1904) GERMAN	200-8600	L
KAPLAN, HUBERT (B. 1932) GERMAN	1500-8000	G,F,L,W
KAPPIS, ALBERT (1836-1914) GERMAN	800-21000	M,G,L
KARFVE, FRITZ (1880-1967) SWEDISH	400-3500	L,M
KARGEL, AXEL (1896-1971) SWEDISH	500-4900	L
KARGER, CARL (1848-1913) AUSTRIAN	100-1800	G,F
KARLOVSZKY, BERTALAN (1858-1945) HUNGARIAN	800-12000	F

KARPELLUS, ADOLF (1869-1919) AUSTRIAN	*400-5500	F,L
KARPFF, JEAN JACQUES (Called CASIMIR) (1770-1829) FRENCH	*300-11000	F
KARS, GEORGE (KARPELES) (1882-1945) FRENCH	450-28000	G,L,W,F
KARSEN, KASPAR (1810-1896) DUTCH	800-12000	L
KARSKAJA, IDA (B. 1905)	*1000-4000	A
KARSSEN, ANTON (20TH C) DUTCH	300-3200	L,W
KARSTEN, LUDVIG (1876-1926) NORWEGIAN	8000-160000	F
KASPAR, PAUL (20TH C) AUSTRIAN	*400-4500	L
KASPARIDES, EDOUARD (1858-1926) GERMAN	150-6400	L,M,F
KASSAK, LAJOS (1887-1967) HUNGARIAN	*700-7600	A
KAT, ANNE-PIERRE DE (B. 1881) BELGIAN	1000-24000	L,S,F
KAUFFMAN, ANGELICA (1740-1807) SWISS	2000-42000	F,G
KAUFFMAN, HUGO (1868-1919) GERMAN	4000-103000	W,G
KAUFFMANN, HERMANN (1808-1889) GERMAN	1500-41000	L,W
KAUFFMANN, HUGO WILHELM (1844-1915) GERMAN	2000-81000	G,L
KAUFFMANN, MAX (19TH C) GERMAN	400-5600	G
KAUFMAN,, JOSEPH CLEMENS (1867-1925) SWISS	600-7500	F,L
KAUFMANN, ADOLF (1848-1916) AUSTRIAN	400-19000	L,W
KAUFMANN, ARTHUR (1888-1971) GERMAN	200-3000	L
KAUFMANN, FERDINAND (1864-1934) GERMAN/AMERICAN	350-12200	M
KAUFMANN, ISIDOR (1853-1921) AUSTRIAN	3000-82000	G,F
KAUFMANN, KARL (1843-1901) AUSTRIAN	600-11000	L
KAUFMANN, WILHELM	*100-900	
KAUFMANN, WILHELM (1895-1945) AUSTRIAN	600-18000	L,S
KAULBACH, FRIEDRICH AUGUST VON (1822-1903) GERMAN	1000-32000	F,M
KAULBACH, FRITZ AUGUST VON	*200-2700	
KAULBACH, FRITZ AUGUST VON (1850-1920) GERMAN	400-4600	F
KAULBACH, HERMANN (1846-1909) GERMAN	3000-65000	G,F
KAUS, MAX	*500-21000	
KAUS, MAX (B. 1891) GERMAN	1000-28000	S,F,L
KAUTSKY, JOHANN (1827-1896) CZECHOSLOVAKIAN	200-2000	L
KAVANAGH, JOSEPH MALACHY (1856-1918) IRISH	600-19000	G,W,L
KAVEL, MARTIN (19TH C) FRENCH	300-6000	G,F
KAVLI, ARNE TEXNES (1878-1970) NORWEGIAN	3000-95000	F,L
KAY, ARCHIBALD (1860-1935) BRITISH	400-2900	L
KAY, JAMES	*400-10000	
KAY, JAMES (1858-1942) BRITISH	500-19000	L,M
KAYSER, J. (20TH C) DUTCH	100-600	X
KEATING, SEAN	*400-16000	

* Denotes watercolors, pastels, drawings, and/or mixed media

KEATING, SEAN (B. 1889) IRISH	600-38000	M,F
KEATING, TOM	*600-11000	
KEATING, TOM (1917-1984) BRITISH	800-42000	F,L
KEATS, CHARLES JAMES (20TH C) BRITISH	*100-800	L,W
KEELING, MICHAEL (D. 1820) BRITISH	800-6500	F
KEELING, SYDNEY (19TH C) BRITISH	100-600	X
KEENE, CHARLES SAMUEL (1823-1891) BRITISH	*200-6000	I
KEIL, BERNHARDT (Called MONSU BERNARDO) (1624-1687) DANISH	2000-33000	G,F
KEINZ, E. (19TH C) GERMAN	100-700	X
KEIRINCX, ALEXANDER (1600-1652) FLEMISH	4000-110000	G,F,L
KEIRSBILCK, JULES VAN (1833-1896) BELGIAN	500-10000	G,F
KEISERMAN, FRANZ (1765-1833) SWISS	*300-40000	G,F,L
KELDER, TOON (B. 1894) DUTCH	500-6900	F,S,L
KELLER, ALBERT VON (1844-1920) SWISS	600-5100	F
KELLER, CARL (19TH C) GERMAN	250-2400	X
KELLER, FERDINAND (1842-1922) GERMAN	400-20000	F
KELLER, FRIEDRICH VON (1840-1914) GERMAN	1000-16000	G,F
KELLER, JOHANN HEINRICH (1692-1765) SWISS	1000-26000	F
KELLER-REUTLINGEN, PAUL WILHELM (1854-1920) GERMAN	2000-22000	L,G
KELLY, FELIX (B. 1916) NEW ZEALANDER	400-6500	L
KELLY, LEON (B. 1901) FRANCO/AMERICAN	*100-1500	A
KELLY, ROBERT TALBOT (1861-1934) BRITISH	*400-7200	G,L,W
KELLY, SIR GERALD FESTUS (1879-1972) BRITISH	800-35000	F,L
KEMENDY, JENO EUGEN (1860-1925) HUNGARIAN	1000-18000	G
KEMM, ROBERT F. (D. 1885) BRITISH	400-15000	G,F
KEMMEL, JULIEN VAN (B. 1834) BELGIAN	150-1000	S
KEMP-WELCH, LUCY	*400-33000	
KEMP-WELCH, LUCY (1869-1958) BRITISH	700-33000	W,L
KEMPE, ROLAND (B. 1907) SWEDISH	400-4000	X(A)
KEMPF, GOTTLIEB (1871-1964) AUSTRIAN	*500-6000	G,S
KENDRICK, SYDNEY (1874-1955) BRITISH	600-8500	G,F
KENNEDY, CECIL (B. 1905) BRITISH	700-45000	F,S
KENNEDY, EDWARD SHERARD (19TH/20TH C) BRITISH	300-3200	G,I
KENNEDY, WILLIAM (1860-1918) BRITISH	1000-15000	F,L
KENNEDY, WILLIAM DENHOLM (1813-1865) BRITISH	150-3500	G
KENNINGTON, ERIC (1888-1960) BRITISH	*400-24000	F
KENNY, JOHN T. (20TH C) BRITISH	250-4200	F,W
KENT, H. (19TH C) BRITISH	100-700	X(L)

KEPES, GYORGY (B. 1906) HUNGARIAN/AMERICAN	*400-3500	X(A)
KERKHOVE, JAN VAN DE (1822-1881) BELGIAN	150-3000	G
KERKOVIUS, IDA (1879-1970) GERMAN	*1000-8300	A
KERMADEC, EUGENE NESTOR LE (1899-1976) FRENCH	600-66000	X
KERMARREC, JOEL (20TH C) FRENCH	600-5300	A
KERN, HERMANN (1839-1912) HUNGARIAN	1000-16000	G,F,S
KERN, MELCHOIR	*100-500	
KERN, MELCHOIR (B. 1872) GERMAN	100-900	L,W
KERNER, GLAUS (20TH C) AUSTRIAN	100-900	X
KERR, HENRY WRIGHT (1857-1936) BRITISH	*200-2500	G,F
KERR, ROBERT (1823-1904) BRITISH	200-3200	X(F,G)
KERR-LAWSON, JAMES (1865-1939) BRITISH	700-18000	L,M
KESSEL, JAN VAN (I) (1626-1679) DUTCH	6000-140000	S,F
KESSEL, JAN VAN (II) (1654-1708) DUTCH	2000-56000	L,F,W
KESSEL, JAN VAN (III) (1641-1680) DUTCH	600-8000	G,L
KETTEMANN, ERWIN (B. 1897) GERMAN	300-3800	L,M,F
KETTLE, TILLY (1735-1786) BRITISH	650-37500	F
KEULEMANS, JOHANNES GERARDUS (1842-1878) DUTCH	*500-8200	W
KEVER, JACOB SIMON HENDRIK	*300-3000	
KEVER, JACOB SIMON HENDRIK (1854-1922) DUTCH	2000-24000	G,F,S
KEYSER, AUGUSTE PAUL DE (1829-1890) BELGIAN	100-2500	X(L,F)
KEYSER, EMIL (1846-1923) SWISS	500-12000	G,L,W
KEYSER, NICAISE DE (1813-1887) FLEMISH	400-3500	F,G
KEYSER, THOMAS DE (1596-1667) DUTCH	1500-36000	F
KHARLAMOV, ALEXEI (1824-1920) RUSSIAN	800-16000	X(F)
KHAYLL, A. (19TH C) EUROPEAN	100-900	X
KHITH, ROBERT (19TH C) NORWEGIAN	100-1000	X
KHNOPFF, FERNAND (1858-1921) BELGIAN	*1200-+++	F,G,I
KIAERSKOU, FREDERIK (1805-1891) DANISH	700-20000	L
KIBEL, WOLF (1903-1938) POLISH	*600-15000	F
KIEFER, ANSELM (B. 1945) GERMAN	5000-+++	A
KIELDRUP, ANTON E (1826-1869) DANISH	600-6500	L,F
KIEMLEN, EMIL (Early 20TH C) GERMAN	100-1500	X
KIESEL, CONRAD (1846-1921) GERMAN	2000-55000	F,G
KIJNO, LADISLAS	*500-25000	
KIJNO, LADISLAS (B. 1921)	700-33000	A
KIKOINE, MICHEL	*300-7400	
KIKOINE, MICHEL (1892-1968) FRENCH	1000-38000	A
KILBURNE, GEORGE GOODWIN	*200-11000	

KILBURNE, GEORGE GOODWIN (1839-1924) BRITISH	800-40000	G,W
KILLINGBECK, BENJAMIN (18TH C) BRITISH	2000-75000	W
KILPACK, SARAH LOUISE (19TH/20TH C) BRITISH	200-2000	M
KINCH, HENRY (19TH C) BRITISH	500-8600	W
KINDERMANS, JEAN BAPTISTE (1822-1876) BELGIAN	500-9200	G,L
KING, BARAGWANATH (1864-1939) BRITISH	200-2200	L
KING, EDWARD (B. 1863) BRITISH	200-2800	L,W
KING, GUNNING (1859-1940) BRITISH	100-2000	G,I
KING, HAYNES (1831-1904) BRITISH	600-11000	G,F
KING, JESSIE MARION (1875-1949) BRITISH	*400-7300	G,I,F,A
KING, JOHN YEEND	*400-4600	
KING, JOHN YEEND (1855-1924) BRITISH	500-30000	L,F,G,W
KING, W GUNNING (1859-1940) BRITISH	600-14000	F,G,L
KING, WILLIAM JOSEPH (B. 1857) BRITISH	150-2100	L,W
KINGMAN, EDUARDO (B. 1914) ECUADORIAN	400-7200	X(F)
KINGWELL, MABEL AMBER (D. 1923) BRITISH	*150-1200	X(M)
KINLEY, PETER (20TH C) BRITISH	600-6000	L,F
KINNAIRD, FREDERICK GERALD (19TH C) BRITISH	300-6100	G,F
KINNAIRD, HENRY J.	*300-6400	
KINNAIRD, HENRY J. (Active 1880-1920) BRITISH	400-8000	G,L,W
KINSON, FRANCOIS JOSEPH (1771-1839) FLEMISH	1000-88000	F
KINZEL, JOSEF (1852-1925) AUSTRIAN	1000-18000	G,L
KIRBERG, OTTO KARL (1850-1926) GERMAN	700-20000	G
KIRCHNER, ERNST LUDWIG	*800-127000	
KIRCHNER, ERNST LUDWIG (1880-1938) GERMAN	8000-+++	A,G,L,F
KIRCHNER, OTTO (1887-1960) GERMAN	300-3200	G,F,S
KIRCHNER, RAPHAEL (1867-1917) AUSTRIAN	*300-6200	G,F
KIRK, PIETR VAN (B. 1834) BELGIAN	150-1800	L
KIRKEBY, PER (B. 1938) DANISH	1000-31000	A
KIRKPATRICK, JOSEPH (B. 1872) BRITISH	*300-4900	G,L,F,A
KIRWAN, WILLIAM BURKE (Early 19TH C) IRISH	*100-1000	F
KISCHKA, ISIS (1908-1974) FRENCH	150-3800	X(L,S)
KISLING, MOISE	*800-24000	
KISLING, MOISE (1891-1953) POLISH/FRENCH	3500-+++	A
KISS, CASABA (B. 1945) HUNGARIAN	150-1600	X(F)
KIVAS, A. (19TH C) ITALIAN	100-700	X
KJARVAL, JOHANNES (1885-1972) ICELANDIC	1000-12000	L
KJERNER, ESTHER (1873-1952) SWEDISH	1000-24000	S,L
KLAPHECK, KONRAD (B. 1935) GERMAN	1500-50000	A

KLASEN, PETER (B. 1935)	*600-24000	X (A)
KLAUSS, HANS (B. 1867) GERMAN	300-3200	X(W)
KLECZYNSKI, BODHAN VON (1850-1916) POLISH	1000-17000	G,L
KLEE, PAUL	*8000-+++	
KLEE, PAUL (1879-1940) SWISS	20000-+++	A
KLEEHAAS, THEODOR (B. 1854) GERMAN	1000-18000	G,F
KLEIJN, LODEWIJK JOHANNES	*100-1200	
KLEIJN, LODEWIJK JOHANNES (1817-1897) DUTCH	400-10000	X(G)
KLEIN, CESAR (B. 1876) GERMAN	1000-9500	G,S
KLEIN, JOHANN ADAM (1792-1875) GERMAN	1000-30000	G,F,L
KLEIN, WILHELM (1821-1897) GERMAN	*200-5200	L
KLEIN, YVES	*8000-+++	
KLEIN, YVES (1928-1962) FRENCH	10000-+++	A
KLEINERT, JOSEPH (19TH C) AUSTRIAN	100-3600	G
KLEINMICHEL, FERDINAND JULIUS THEODOR (1846-1892) GERMAN	400-7000	G
KLEINSCHMIDT, PAUL	*400-8300	
KLEINSCHMIDT, PAUL (1883-1949) GERMAN	1000-31000	L,F,S
KLENE, BERN (1870-1930) DUTCH	100-1100	X
KLENGEL, JOHANN CHRISTIAN	*100-1500	
KLENGEL, JOHANN CHRISTIAN (1751-1824) GERMAN	200-2500	L,W
KLERK, WILLEM DE (1800-1876) DUTCH	700-24000	G,L,W
KLEVER, JULIUS SERGIUS VON (1850-1924) RUSSIAN	1500-26000	L
KLEYN, LODEWYK JOHANNES (1817-1897) DUTCH	900-23000	L,F,G
KLIMT, GUSTAV	*2500-+++	
KLIMT, GUSTAV (1862-1918) AUSTRIAN	10000-+++	A
KLINCKENBERG, EUGEN (B. 1858) GERMAN	750-4000	G,F
KLINGER, MAX (1857-1920) GERMAN	700-38000	G,F
KLINKENBERG, JOHANNES CHRISTIAAN KAREL	*300-10000	
KLINKENBERG, JOHANNES CHRISTIAAN KAREL (1852-1924) DUTCH	800-77000	L
KLIUN, IVAN (1873-1943) RUSSIAN	2400-+++	A
KLOMBBEK, JOHANN BERNARD (1815-1893) DUTCH	750-60000	L,F
KLOMP, ALBERT JANSZ (1618-1688) DUTCH	800-15000	L,W
KLUGE, CONSTANTINE (B. 1912) FRENCH	400-7000	L
KLUIN, IVAN	*350-6000	
KLUYVER, PIETER LODEWYK FRANCISCO (1816-1900) DUTCH	1000-39000	L,W,G
KMITT, MICHAEL (B. 1910) RUSSIAN	*700-8000	G
KNAB, FERDINAND (1834-1902) GERMAN	500-21000	L
KNAP, GEREIT WILLEM (B. 1873) DUTCH	800-3200	L,S

* Denotes watercolors, pastels, drawings, and/or mixed media

Artist	Price Range	Media
KNAPP, F. OSCAR (B.1914) GERMAN	500-3200	S
KNAPP, JOHANN (1778-1833) AUSTRIAN	2000-18000	S
KNAPP, K. (19TH/20TH C) GERMAN	300-2800	S
KNAPTON, GEORGE (1698-1778) BRITISH	1500-36000	F
KNARREN, PETRUS RENIER HUBERTUS (1826-1896) DUTCH	650-15000	F
KNAUS, F. (19TH C) GERMAN	200-2500	G,F
KNAUS, LUDWIG	*400-6500	
KNAUS, LUDWIG (1829-1910) GERMAN	2000-100000	G,F,W
KNEBEL, FRANZ (JR)	*300-5500	
KNEBEL, FRANZ (JR) (1809-1877) SWISS	700-17000	L,F
KNEBEL, LEOPOLD (B. 1810) GERMAN	300-4000	M
KNEIP, ROBERT FRANK (20TH C) GERMAN	300-2000	X(F)
KNEIPP, GEORG (1793-1862) GERMAN	200-1200	F
KNELL, WILLIAM ADOLPHUS (1805-1875) BRITISH	800-45000	M
KNELL, WILLIAM CALLCOTT (19TH C)	700-11000	M
KNELLER, SIR GODFREY (1646-1723) GERMAN/BRITISH	1300-70000	F
KNIGHT, A RONALD (19TH C) BRITISH	300-4000	W
KNIGHT, DAME LAURA	*900-30000	
KNIGHT, DAME LAURA (1877-1970) BRITISH	1500-132000	G,F,M,A
KNIGHT, GEORGE (19TH C) BRITISH	300-2800	M,L
KNIGHT, HAROLD (1878-1961) BRITISH	500-85000	L,F,W
KNIGHT, JOHN BUXTON (1843-1908) BRITISH	400-6000	L
KNIGHT, JOHN PRESCOTT (1803-1881) BRITISH	300-5400	G,F
KNIGHT, JOSEPH (1837-1909) BRITISH	*400-2800	L,F
KNIGHT, LOUIS ASTON (1873-1948) BRITISH	500-28000	F,L
KNIGHT, WILLIAM HENRY (1823-63) BRITISH	500-18000	G,F
KNIP, AUGUSTUS (1819-1852) DUTCH	700-5200	L,W
KNIP, HENRI (1819-1897) DUTCH	900-10000	L
KNIP, HENRIETTE RONNER (1821-1909) DUTCH	800-7200	W
KNIP, JOSEPHUS AUGUSTUS (1777-1847) DUTCH	750-16000	L,G
KNIP, WILLIAM ALEXANDER (1883-1967) DUTCH	500-2600	L,M
KNOBELSDORF, C. (19TH C) GERMAN	400-2600	X(M)
KNOLLER, MARTIN (1725-1804) AUSTRIAN	1000-14000	F
KNOOP, AUGUST (1856-1900) GERMAN	900-7800	G,F
KNOPFF, ADOLPH (1851-1917) GERMAN	500-5500	G,F
KNOPTON, GEORGE (18TH C) BRITISH	200-1400	F
KNOWLES, GEORGE SHERIDAN (1863-1931) BRITISH	500-15000	G,F
KNOX, JOHN (1778-1845) BRITISH	800-80000	L
KNOX, WILLIAM DUNN (1880-1945) AUSTRALIAN	600-18000	L,F

KNUPFER, NICOLAUS (1603-1660) GERMAN	2000-44000	F
KNYFF, CHEVALIER ALFRED (1819-1885) BELGIUM	400-3800	L
KNYFF, JACOB (1638-1681) DUTCH	5000-90000	M
KNYFF, LEONARD (1650-1721) DUTCH	600-6800	S
KNYFF, WOUTER (1607-1693) DUTCH	1000-34000	M,L
KOBELL, FERDINAND	*400-2200	
KOBELL, FERDINAND (1740-1799) GERMAN	600-14000	L
KOBELL, FRANZ (1749-1822) GERMAN	300-8200	L,M
KOBELL, JAN (1756-1833) DUTCH	700-14000	L,W
KOBELL, JAN BAPTIST	*200-6600	
KOBELL, JAN BAPTIST (1778-1814) DUTCH	500-7500	L,W
KOBELL, WILHELM VON	*1000-102000	
KOBELL, WILHELM VON (1766-1855) GERMAN	4000-100000	F,W
KOBKE, CHRISTEN (1810-1848) DANISH	5000-+++	L,M,F
KOCH, GEORG	*300-4200	
KOCH, GEORG (B. 1878) GERMAN	500-8200	W
KOCH, GEORGE KARL (B. 1847) GERMAN	600-10500	F
KOCH, HEINRICH (1806-1893) GERMAN	300-9800	L
KOCH, JOSEF ANTON (1768-1839) GERMAN	2000-115000	L,F
KOCH, LUDWIG (1866-1934) AUSTRIAN	500-36000	L,W
KOCKERT, JULIUS (1827-1918) GERMAN	650-28000	L
KOEDIJK, ISAAK (1616-1668) DUTCH	1500-36000	F
KOEKKOEK, BAREND CORNELIS	*400-5200	
KOEKKOEK, BAREND CORNELIS (1803-1862) DUTCH	1200-230000	L,F
KOEKKOEK, H. JR.(1836-1909) DUTCH	600-4400	M,L,F
KOEKKOEK, H. SR. (1815-1882) DUTCH	400-30000	M,L,F
KOEKKOEK, HENDRIK BAREND (1849-1909) DUTCH	700-12000	G,L
KOEKKOEK, HENDRIK PIETER (1843-1890) DUTCH	800-21000	L,W
KOEKKOEK, HERMANUS JR.(1836-1909) DUTCH	700-19000	M,L
KOEKKOEK, HERMANUS SR. (1815-1882) DUTCH	1100-51000	M,L,F
KOEKKOEK, HERMANUS WILLEM (1867-1929) DUTCH	500-60000	F,L
KOEKKOEK, JAN HERMANUS (1778-1851)	400-48000	L,M,W
KOEKKOEK, JOHANNES HERMANUS BAREND	*200-1800	
KOEKKOEK, JOHANNES HERMANUS BAREND (1840-1912) DUTCH	1400-38000	M
KOEKKOEK, MARIANUS ADRIANUS	*200-1500	
KOEKKOEK, MARIANUS ADRIANUS (1807-1870) DUTCH	800-38000	L,F,W
KOEKKOEK, WILLEM (1839-1895) DUTCH	1500-110000	L
KOENE, ISAAC (1640-1713) DUTCH	1000-34000	L,F,W
KOENIG, JOHANN (1586-1642) GERMAN	1500-40000	L,F

* Denotes watercolors, pastels, drawings, and/or mixed media

KOERLE, PANCRAZ (1823-1875) GERMAN	500-4200	G
KOERNER, ERNST (B. 1846) GERMAN	400-11000	L
KOESTER, ALEXANDER MAX	*500-21000	
KOESTER, ALEXANDER MAX (1864-1932) GERMAN	2000-240000	W,L
KOETS, ROELOF (1592-1655) DUTCH	1000-34000	F,S
KOGAN, NINA (1887-1942) RUSSIAN	*2500-17300	A
KOGL, BENEDICT (19TH C) GERMAN	300-4400	W
KOHEN, LINDA (B. ITALY 1924)	300-3000	G
KOHLER, GUSTAV (B. 1859) GERMAN	1200-5500	G,F
KOHRL, LUDWIG (B. 1858) GERMAN	400-3800	G,F
KOKEN, PAUL (B. 1853) GERMAN	300-3200	G,L
KOKO, DEMETER (1891-1929) AUSTRIAN	500-6000	W
KOKOSCHKA, OSKAR	*900-127000	
KOKOSCHKA, OSKAR (1886-1980) AUSTRIAN	5000-+++	A,F,L
KOLAR, JIRI (B. 1914) CZECHOSLOVAKIAN	*1000-15000	A
KOLBE, ERNEST (1876-1945) GERMAN	300-2800	X(F)
KOLBE, GEORG (1877-1947) GERMAN	*400-14000	F
KOLBERG, ANTON (1816-1882) POLISH	300-2400	F
KOLESSNIKOFF, SERGEI	*300-5000	
KOLESSNIKOFF, SERGEI (B. 1889) RUSSIAN	450-10000	X(L)
KOLLER, JOHANN JAKOB (1746-1805) SWISS	800-9000	L
KOLLER, RUDOLF (1828-1905) SWISS	900-45000	L,F,W
KOLLER, WILHELM (1829-1884) AUSTRIAN	300-8500	G,F
KOLLWITZ, KATHE (1867-1945) GERMAN	*800-103000	G,F
KONARSKY, JOSEF (19TH C) POLISH	400-6500	L
KONIG, FRANZ NIKLAUS (1765-1832) SWISS	*400-5500	X(F)
KONIG, FRIEDRICH (1857-1914) AUSTRIAN	*900-32000	L,S
KONIG, HUGO (1856-1899) GERMAN	300-3800	G,W,L
KONIG, JOHANN (1586-1642) GERMAN	4500-52000	F,L
KONINCK, JACOB THE ELDER (1616-1708) DUTCH	600-8500	L
KONINCK, KERSTIAEN DE (17TH C) FLEMISH	1000-65000	G,L
KONINCK, PHILIPS DE (1619-1688) DUTCH	1000-+++	G,F,L
KONINCK, SALOMON (1609-1656) DUTCH	650-42000	F
KONING, ELIZABETH JOHAN (1816-1888) DUTCH	800-4200	S
KONINGH, LEENDERT DE (1810-1887) DUTCH	800-12000	L,W
KONO, MICAO (20TH C) JAPANESE	800-25000	X(F)
KOOGH, ADRIANUS VAN DER (1796-1831) DUTCH	700-4600	L,W
KOOL, SIPKE (1836-1902) DUTCH	400-4600	G,M
KOOL, WILLEM GILLESZ (1608-1666) DUTCH	1000-28000	G,L,M

KOONING, WILLEM DE	*5000-+++	
KOONING, WILLEM DE (B. 1904) DUTCH	6000-+++	A
KOPPENOL, CORNELIS (1865-1946) DUTCH	300-12000	G,F,M
KORFF, ALEXANDER HUGO (1824-1882) DUTCH	500-13000	X
KORFF, F. DE (19TH C) GERMAN	300-2600	X(F)
KORMITE, G. ITALIAN	300-1600	X
KORN, JOHN PHILIP (1728-1796) SWEDISH	500-8500	G,M,L
KORNBECK, JULIUS (1839-1920) GERMAN	400-11000	L,W
KORNBECK, PETER (1837-1894) DANISH	400-12000	L
KOROCHANSKY, MICHEL (1866-1925) RUSSIAN	500-7500	G,F,L
KOROVINE, CONSTANTIN ALEXEIEVITCH	*400-6000	
KOROVINE, CONSTANTIN ALEXEIEVITCH (1861-1939) RUSSIAN	650-38500	G,L,I
KOSKULL, ANDERS GUSTAF (1831-1904) SWEDISH	400-11000	G,L
KOSSAK, JERZY (1890-1963) POLISH	300-3200	G,F
KOSSAK, WOICIECH VON	*200-1000	
KOSSAK, WOICIECH VON (1857-1942) POLISH	500-20000	F
KOSSOFF, LEON (B. 1926)	1200-105000	A
KOSTER, ANTONIE (1859-1937) DUTCH	*300-7200	L,S
KOSTER, EVERHARDUS (1817-1892) DUTCH	1000-18000	L,M
KOTSCHENREITER, HUGO (1854-1908) GERMAN	700-22000	G,I
KOTZEBUE, ALEXANDER VON (1815-1889) GERMAN	300-6200	F
KOUNELLIS, JANNIS	*600-63000	
KOUNELLIS, JANNIS (B. 1936)	1000-58000	A
KOWALSKI-WIERUSZ, ALFRED VON (1849-1915) POLISH	1200-75000	G,F
KOWALSKY, LEOPOLD FRANZ (B. 1856) RUSSIAN/FRENCH	600-70000	F
KOYANAGUI, SEI (B. 1896) JAPANESE	300-19000	F,S
KRABBE, HENDRIK MAARTEN (1868-1931) DUTCH	300-3300	G,F
KRAEMER, PETER (1823-1907) GERMAN	*400-4500	X
KRAEMER, PETER (1857-1941) GERMAN	*450-11000	G
KRAFFT, JAN LODEWYK (1694-1762) FLEMISH	400-4500	G,L
KRAKAUER, LEOPOLD (B. 1890) ISRAELI	*300-5400	L,F
KRATKE, CHARLES LOUIS (1848-1921) FRENCH	400-5000	G,F
KRATSCHKOWSKI, JOSSIF JEVSTATJEVICH (1854-1914) RUSSIAN	300-3600	L
KRAUS, AUGUST (1803-1864) GERMAN	500-5600	X(G)
KRAUS, AUGUST (1852-1917) GERMAN	400-5000	G,L
KRAUS, FRANZ ANTON (1705-1752) AUSTRIAN	1200-9800	F
KRAUS, FRIEDRICH (1826-1894) GERMAN	300-4300	F
KRAUS, GEORG MELCHIOR (1737-1806) GERMAN	1000-15000	G,F
KRAUSE, FELIX (B. 1873) GERMAN	300-3000	M

* Denotes watercolors, pastels, drawings, and/or mixed media

KRAUSE, FRANZ (1823-1878) GERMAN	300-3500	L
KRAUSE, FRANZ E. (1836-1900) GERMAN	400-3300	L,F
KRAUSE, LINA (B. 1857) GERMAN	200-3500	S
KRAUSE, WILHELM AUGUST (1803-1864) GERMAN	300-4200	M,F,W
KRAUSKOPF, BRUNO (1892-1962) GERMAN	300-17000	L,M,F
KRAUSZ, SIMON ANDREAS (1760-1825) DUTCH	200-3200	G,L,W
KRAY, WILHELM (1828-1889) GERMAN	600-12000	G,L,M
KREBS, WALTER	*300-2500	
KREBS, WALTER (1900-1965) SWISS	400-5500	M,L,F,G
KREGTEN, FEDOR VAN (1871-1937) DUTCH	200-1800	L,W
KREJCAR, ANTON (B. 1923) AUSTRIAN	*150-1500	X(F)
KRELING, AUGUST VON (1819-1876) GERMAN	300-3000	G
KREMEGNE, PINCHUS (B. 1890) RUSSIAN/FRENCH	*400-15000	A,S,F,L
KREMER, PETRUS (1801-1888) FLEMISH	200-3200	G,F
KREPP, FRIEDRICH (19TH C) AUSTRIAN	150-1600	X(F)
KRESTIN, LAZAR (19TH C) RUSSIAN	1200-32000	G,L
KRETSCHMER, JOHANN HEINRICH (1769-1847) GERMAN	300-3500	X(I)
KRETZSCHMER, JOHANN HERMANN (1811-1890) GERMAN	900-52000	G,L
KREUGER, NILS (1858-1930) GERMAN	650-115000	G,L,W
KREUTZER, FELIX (1835-1876) GERMAN	500-5400	L,M
KREUZER, VINZENZ (1809-1829) AUSTRIAN	300-6500	S
KREYDER, ALEXIS JOSEPH (1839-1912) FRENCH	500-22000	S
KRIEGHOFF, CORNELIUS (1815-1872) CANADIAN	3000-220000	L,F,W
KRIEHUBER, JOSEF (1800-1876) AUSTRIAN	*600-8200	G,L,F
KRIMLINDE, OLOF (1856-1945) SWEDISH	400-4600	X
KRISCHKE, FRANZ (19TH/20TH C) AUSTRIAN	300-2200	S
KROH, HEINRICH REINHARD (1841-1941) GERMAN	300-4500	F,L
KROHG, CHRISTIAN (1852-1925) NORWAY	750-147000	G,M,L
KRONBERG, JULIUS (1850-1921) SWEDISH	*300-12500	F,S,L
KRONBERGER, CARL (1841-1921) AUSTRIAN	100-20000	G,F
KRONER, CHRISTIAN JOHANN (1861-1911) GERMAN	400-16000	L,W
KROUTHEN, JOHAN (1858-1932) SWEDISH	1200-+++	F,L
KROYER, PEDER SEVERIN (1851-1909) DANISH	1500-+++	G,F,M
KROYER, MARIE (19TH/20TH C) DANISH	1000-42000	F,G,L
KRUGER, CARL (1812-1880) GERMAN	300-1800	L,W
KRUGER, FRANZ (1797-1857) GERMAN	700-28000	F
KRUGER, P. (19TH C) GERMAN	300-3500	S
KRUSEMAN, CORNELIS (1797-1857) DUTCH	400-2400	F
KRUSEMAN, FREDERIK MARIANUS (1816-1882) DUTCH	1200-127000	G,F,L,W

KRUSEMAN, JAN THEODOR (1835-1895) DUTCH	400-7800	L
KRUSEMAN VAN ELTEN, HENDRIK DIRK (1829-1904) DUTCH	500-11000	L,W
KRUYDER, HERMAN (1881-1935) DUTCH	*200-2400	F,W
KUBIERSCHKY, ERICH (1854-1944) GERMAN	*500-8200	G,L
KUBIN, ALFRED (1877-1959) AUSTRIAN	900-60000	A,F
KUBLER, LUDWIG (19TH C) AUSTRIAN	400-4200	X(W)
KUCHLER, ALBERT (1803-1886) DANISH	300-5400	G,F
KUEHL, GOTTBARDT JOHANN (1850-1915) GERMAN	750-22000	G,F
KUHN, FRIEDRICH (1926-1972) SWISS	600-11000	A
KUHNEN, PIETER LODEWYK (1812-1877) BELGIAN	400-15000	G,L,M
KUHNERT, WILHELM FRIEDRICH KARL	*300-5200	
KUHNERT, WILHELM FRIEDRICH KARL (1865-1926) GERMAN	1200-123000	L,W
KULLE, AXEL (1846-1908) SWEDISH	600-9500	L,F,S
KULLE, JAKOB (1838-1898) SWEDISH	350-12000	G,F
KULMBACH, HANS SUESS VON	*850-83000	
KULMBACH, HANS SUESS VON (1480-1522) GERMAN	5000-75000	F
KUMMER, CARL ROBERT (1810-1889) GERMAN	300-7500	L
KUMMERLI, ADRIAN (1830-1894) SWISS	200-1000	F
KUNERT, J. (19TH C) GERMAN	300-3400	L,W
KUNTZ, CARL (1770-1830) GERMAN	1000-14000	L,W
KUNZ, LUDWIG ADAM (1857-1929) AUSTRIAN	300-16000	L,S
KUPKA, FRANTISEK	*800-56000	X
KUPKA, FRANTISEK (1871-1957) CZECHOSLOVAKIAN	2000-+++	A
KURELEK, WILLIAM (1927-1977) CANADIAN	*1500-20000	X(F)
KURODA, KURODA	2500-+++	X
KURTZ, CARL VON (1817-1887) ITALIAN	800-4200	X
KURZBAUER, EDUARD (1840-1879) AUSTRIAN	900-14000	G,W
KUSS, FERDINAND (1800-1886) AUSTRIAN	300-18000	L,S
KUSTNER, CARL (B. 1861) GERMAN	300-4100	L
KUSTODIEV, BORIS MIKHAILOVICH (1878-1927) RUSSIAN	*600-9200	G
KUWASSEEG, CHARLES EUPHRASIE (JR) (1838-1904) FRENCH	800-32000	L,M
KUWASSEG, KARL-JOSEF (1802-1877) FRENCH	400-4800	L,M
KUYCK, FRANS PIETER LODEWYK VAN (1852-1915) BELGIAN	600-18000	L,W
KUYCK, JEAN LOUIS VAN (1821-1871) FLEMISH	800-9800	G,L
KUYK, LAURENS VAN (20TH C) DUTCH	500-3500	X
KUYPERS, CORNELIS (B. 1864) DUTCH	600-8000	G,L,W
KUYTEN, HARRIE (1883-1952) DUTCH	500-4000	F,G,L
KUZNETZOV, NICHOLAS DMITRIEVICH (1850-1930) RUSSIAN	400-3600	I,S
KVAPIL, CHARLES	*200-4500	

* Denotes watercolors, pastels, drawings, and/or mixed media

KVAPIL, CHARLES (1884-1958) BELGIAN	300-25000	F,L,M,S
KWIATOWSKI, JEAN (1897-1971) POLISH	800-28000	L
KYHN, VILHELM (1819-1903) POLISH	650-21000	G,L,M
KYLBERG, KARL (1878-1952) SWEDISH	1000-235000	F,L,S

L

ARTIST	PRICES	SUBJECT
L'HAY, MICHEL EUDES DE (Late 19TH C) FRENCH	650-18000	X
LA BERGE, AUGUSTE CHARLES DE (1807-1842) FRENCH	300-2700	L
LA CORTE, JUAN DE (1597-1660) SPANISH	500-7000	F
LA CROIX, GEORGES F. DE (D. 1779) FRENCH	2500-72000	L
LA FARGUE, JACOBUS ELIAS (B. 1742) DUTCH	500-25000	X
LA FARGUE, PAULUS CONSTANTIN (1732-1782) DUTCH	500-20000	G
LA FONTAINE, THOMAS SHERWOOD (B. 1915) BRITISH	400-6500	L,W
LA FOULHOUZE, GABRIEL AMABLE DE (19TH C) FRENCH	600-18500	X
LA FRESNAYE, ROGER DE	*350-21000	
LA FRESNAYE, ROGER DE (1885-1925) FRENCH	850-52000	X
LA GANDARA, ANTONIO DE (1862-1917) FRENCH	600-15000	X
LA PATELLIERE, AMEDEE DE (1890-1932) FRENCH	300-5800	X
LA ROCHENOIRE, EMILE CHARLES JULIAN DE (1825-1899) FRENCH	300-2400	X
LA ROSA, F. (19TH/20TH C) ITALIAN	200-3500	X
LA SERNA, ISMAEL GONZALEZ DE (1900-1968) SPANISH	400-9500	X
LA THANGUE, HENRY HERBERT (1859-1929) BRITISH	1500-90000	G,L
LA VILLEON, EMMANUEL DE (1858-1944) FRENCH	400-15000	G,L
LA VOLPE, ALLESANDRO (1820-1887) ITALIAN	300-2900	X
LAAN, GERARD VAN DER (1844-1915) DUTCH	200-3500	L,M
LAANEN, JASPER VAN DER (1592-1626) FLEMISH	2000-62000	G,L
LAAR, BERNARDUS VAN DE (1804-1872) DUTCH	100-1500	X
LAAR, JAN HENDRIK VAN DE (1807-1874) DUTCH	800-6000	G,F
LAAR, PIETER VAN (1582-1642) DUTCH	*600-4200	G,L,W
LABILLE-GUIARD, MADAME (1749-1803) FRENCH	1000-60000	F
LABISSE, FELIX (B. 1905) FRENCH	600-14000	A
LABO, SAVINIO (B. 1899) ITALIAN	200-3500	X
LABOUREUR, JEAN EMILE (1877-1943) FRENCH	*400-3000	X
LACASSE, JOSEPH (1894-1975) BELGIAN	300-6600	G,L
LACAZE, GERMAINE	*400-2000	

LACAZE, GERMAINE (20TH C) FRENCH	500-9500	L,S
LACH, FRITZ (1868-1933) AUSTRIAN	*800-4500	L
LACH, ANDREAS (1817-1882) AUSTRIAN	500-8200	S,W
LACH, URSULA VAN (B. 1949) BRITISH	600-3500	L,F
LACHAISE, GASTON (1882-1935) FRENCH	*400-7500	F,G,W
LACHENWITZ, F. SIGMUND (1820-1868) GERMAN	700-7600	L,W
LACHTROPIUS, NICOLAS (Active 1656-1700) DUTCH	1000-42000	S
LACOMBE, GEORGES (1868-1916) FRENCH	1200-85000	F,G,L
LACOMBLE, ADOLPHE (19TH C)	600-6500	L
LACOSTE, CHARLES (19TH-20TH C) FRENCH	500-3500	X(L,S)
LACOSTE, CHARLES (19TH/20TH C) FRENCH	800-20000	L,M
LACOUR, GEORGES (19TH C) FRENCH	400-3900	S
LACROIX, CHARLES F. DE (Called LACROIX DE MARSEILLEOR DELACROIX) (1720-1790) FRENCH	1200-195000	L,M
LACROIX, PAUL (1858-1869) FRENCH	750-14000	S
LACROIX, TRISTAN (19TH C) FRENCH	400-6500	L
LACY, CHARLES J. DE (19TH C) BRITISH	600-5800	L,M
LADBROOKE, HENRY (1800-1870) BRITISH	500-12000	L,W
LADBROOKE, JOHN BERNEY (1803-1879) BRITISH	650-18000	L,W
LADELL, EDWARD (1821-1886) BRITISH	800-57000	S
LADELL, ELLEN (19TH C) BRITISH	400-6200	S
LADUREAU, PIERRE (B. 1882) FRENCH	400-2500	X(S)
LADURNER, ADOLPH (1796-1856) RUSSIAN	800-9800	F
LAESSOE, THORALD (1816-1898) DANISH	1000-20000	L,M
LAEVERENZ, GUSTAVE (1851-1909) GERMAN	400-12000	G
LAEZZA, GUISEPPE (D. 1905) ITALIAN	1000-32000	L
LAFAGE, RAYMOND (1656-1690) FRENCH	*600-11000	F
LAFENESTRE, GASTON ERNEST (B. 1841) FRENCH	800-14000	L,W,F
LAFITE, ERNEST (1826-1885) AUSTRIAN	300-4000	L
LAFORTUNE, FELIX (B. 1933) HAITIAN	300-1200	F,G
LAFOSSE, CHARLES DE (1636-1716) FRENCH	*1200-120000	G,I
LAFRENSEN, NICOLAS (THE YOUNGER) (1737-1807) SWEDISH	*1000-70000	F,G
LAGAGE, PIERRE (1911-1977) FRENCH	4000-70000	A
LAGAR, CELSO (1891-1966) SPANISH	500-21000	X
LAGERSTAM, BERNDT (B. 1868) FINNISH	500-6000	L
LAGETSCHNIKOFF, A. L. (19TH C) RUSSIAN	200-1300	L
LAGNEAU, NICOLAS (Active 1610-1650) FRENCH	*300-28000	F,G
LAGOOR, JAN DE (17TH C) DUTCH	800-20000	G,L
LAGORIO, LEV FELIXOVICH (1827-1905) RUSSIAN	400-8500	M

* Denotes watercolors, pastels, drawings, and/or mixed media

LAGRANGE, JACQUES	*600-7000	
LAGRANGE, JACQUES (B. 1917) FRENCH	900-14000	X(A)
LAGRENEE, ANTHELME FRANCOIS (1774-1832) FRENCH	300-2000	X
LAGRENEE, JEAN JACQUES (1739-1821) FRENCH	400-75000	F,L
LAGRENEE, LOUIS JEAN FRANCOIS (Called L'AINE) (1725-1805) FRENCH	1200-65000	F,G
LAGYE, VICTOR (1825-1896) BELGIAN	400-7500	G,F
LAHALLE, CHARLES DOMINIQUE OSCAR (D. 1909) FRENCH	300-8000	X(F)
LAHENS (1836-1909) FRENCH	300-2000	X
LAHS, CURT (1893-1958) GERMAN	700-48000	A
LAIRESSE, GERARD DE (1641-1711) FLEMISH	1000-223000	F,G
LAISSEMENT, HENRI ADOLPHE (D. 1921) FRENCH	2000-25000	X
LAJOS, LUDWIG BRUCK (1846-1910) HUNGARIAN	300-5000	F,G
LAJOUE, JACQUES DE	*200-4500	
LAJOUE, JACQUES DE (1687-1761) FRENCH	500-40000	F,G,L,M
LAKHOVSKY, ARNOLD (B. 1885) RUSSIAN	400-4500	L,F
LALIQUE, RENE (1860-1945) FRENCH	*300-3500	F,I
LALLEMAND, GEORGES (1575-1635) FRENCH	500-5500	F,L
LALLEMAND, JEAN BAPTISTE	*500-18000	
LALLEMAND, JEAN BAPTISTE (1710-1805) FRENCH	3000-245000	L,M,W
LAM, WIFREDO	*1000-130000	
LAM, WIFREDO (1902-1982) CUBAN	3500-+++	A
LAMARRE, HENRI LOUIS DE (B. 1829) FRENCH	400-7600	G,I
LAMB, CHARLES VINCENT (1893-1965) IRISH	800-30000	G,F,M,L
LAMB, HENRY (1883-1960) BRITISH	800-32000	F,G,L,M
LAMBERT, CAMILLE NICHOLAS (B. 1876) BELGIAN	500-4500	F,L
LAMBERT, CLEMENT (1855-1925) BRITISH	300-4200	G,F,L
LAMBERT, EUGENE	*600-3200	
LAMBERT, EUGENE (1825-1900) FRENCH	500-18000	W
LAMBERT, FERNAND (B. 1868) FRENCH	200-1500	L,M
LAMBERT, GEORGE (1710-1765) BRITISH	1000-80000	L
LAMBERT, GEORGE WASHINGTON (1873-1930) AUSTRIAN	1000-44000	F,L
LAMBERT, LOUIS EUGENE (1825-1900) FRENCH	300-8800	G,I,S,W
LAMBERT-RUCKI, JEAN	*300-14000	
LAMBERT-RUCKI, JEAN (1888-1967) FRENCH	750-26000	A
LAMBERTS, GERRIT (1776-1850) DUTCH	800-15000	M,L
LAMBILLOTTE, GEORGE (B. 1915) BELGIAN	900-5000	L
LAMBINET, EMILE CHARLES (1815-1877) FRENCH	500-12000	L,W
LAMBRECHTS, JAN BAPTIST (1680-1731) FLEMISH	700-18500	G,I

LAMEN, CHRISTOFFEL JACOBSZ VAN DER (OR LAEMEN) (1615-1651) FLEMISH	900-14000	F,G
LAMI, EUGENE LOUIS (1800-1890) FRENCH	*500-40000	F,G
LAMOND, WILLIAM B. (1852-1925) BRITISH	400-10000	F,G,L,M
LAMONT, THOMAS R. (D. 1898) BRITISH	*500-3300	G
LAMORINIERE, JEAN PIERRE FRANCOIS (1828-1911) BELGIAN	300-8700	G,L
LAMOTTE, BERNARD	*200-800	
LAMOTTE, BERNARD (B. 1903) FRENCH	400-3500	F,L,S
LAMPI, GIOVANNI-BATTISTA (1775-1837) AUSTRIAN	400-8300	F
LAMPI, JOHANN BAPTIST (18TH-19TH C) ITALIAN	1000-72000	F
LAMPLOUGH, AUGUSTUS OSBORNE (1877-1930) BRITISH	*400-4500	L,M
LAMQUA (1825-1860) CHINESE	400-5600	F
LAMY, PIERRE DESIRE EUGENE FRANC (1855-1919) FRENCH	600-15000	L
LANCASTER, HUME (19TH C) BRITISH	500-18000	I,L,M
LANCASTER, PERCY	*300-3300	
LANCASTER, PERCY (1878-1951) BRITISH	800-15000	G,F,L
LANCE, GEORGE (1802-1864) BRITISH	1000-38000	F,L,S
LANCEROTTO, EGISTO (1848-1916)	1000-42000	F,G
LANCKOW, LUDWIG (19TH C) GERMAN	500-6500	L,G
LANCONELLI, T. (19TH C) ITALIAN	400-7500	F,G
LANCRET, NICOLAS	*1500-481000	
LANCRET, NICOLAS (1690-1743) FRENCH	5500-250000	F,G,L
LANDALUZE, VICTOR PATRICIO DE (D. 1890) SPANISH	400-4500	X
LANDELLE, CHARLES ZACHARIE (1821-1908) FRENCH	800-28000	F,G,L
LANDENBERGER, CHRISTIAN (1862-1927) GERMAN	900-12000	X(F,S)
LANDI, GASPAR (1756-1830) ITALIAN	2000-60000	F
LANDINI, A (19TH C) ITALIAN	800-11000	F
LANDINI, ANDREA (B. 1847) ITALIAN	3000-35000	G,F
LANDINO, JACOPO (Called JACOPO DEL CASENTINO) (1297-1358) ITALIAN	900-30000	X
LANDSEER, SIR EDWIN HENRY	*500-33000	
LANDSEER, SIR EDWIN HENRY (1802-1873) BRITISH	10000-+++	F,L,W
LANE, SAMUEL (1780-1859) BRITISH	400-5000	F
LANEN, JASPER VAN DER (1592-1626) FLEMISH	1000-22000	L
LANFANT, FRANCOIS LOUIS (Called LANFANT DE METZ) (1814-1892) FRENCH	700-17000	G
LANFRANCO, GIOVANNI (1582-1647) ITALIAN	2000-65000	F,G
LANG, LOUIS (1814-1893) GERMAN	800-7500	F,G
LANGE, JOHANN GUSTAV (1811-1887) GERMAN	400-13000	G,L
LANGE, JULIUS (1817-1878) GERMAN	600-13000	L

* Denotes watercolors, pastels, drawings, and/or mixed media

LANGENBERGH, DRE VAN DEN (1903-1976) BELGIAN	300-2800	F,L
LANGENDYK, DIRK (1748-1805) DUTCH	*850-28000	G,L,M
LANGENDYK, JAN ANTHONIE (1780-1818) DUTCH	*200-5800	F,G
LANGER, VIGGO (1860-1942) DANISH	600-7500	L
LANGETTI, GIOVANNI B. (1625-1676) ITALIAN	1100-42000	G
LANGEVELD, FRANS (1877-1939) DUTCH	600-8000	G,L,M
LANGEVIN, CLAUDE (B. 1942) CANADIAN	200-2000	L
LANGHAMMER, ARTHUR (1854-1901) GERMAN	27800	L
LANGKER, SIR ERIK (1898-1982) AUSTRALIAN	300-8000	M,S,L
LANGKO, DIETRICH (1819-1896) GERMAN	500-9200	F,L
LANGLET, ALEXANDER (1879-1953) SWEDISH	400-4000	G,F,L
LANGLEY, C. D. (19TH C) BRITISH	400-3300	F
LANGLEY, WALTER	*1200-79000	
LANGLEY, WALTER (1852-1922) BRITISH	900-50000	F,G,L,M
LANGLEY, WILLIAM (19TH C) BRITISH	200-2500	G,F,L
LANGLOIS, JEROME MARTIN (1779-1838) FRENCH	5000-+++	F
LANGLOIS, MARK W. (19TH C) BRITISH	400-3800	F,G,L,S
LANGMAID, ROWLAND (20TH C) BRITISH	100-3500	M
LANSKOY, ANDRE	*300-54000	
LANSKOY, ANDRE (1902-1976) RUSSIAN/FRENCH	1000-+++	F,S
LANSYER, EMMANUEL (1835-1893) FRENCH	450-41000	F,L,M
LANTARA, SIMON MATHURIN (1729-1778) FRENCH	400-5000	L
LANTOINE, FERNAND (19TH-20TH C) FRENCH	800-10500	M,L
LANTS, GERRARD (20TH C) AUSTRALIAN?	*200-2000	G,L
LANYON, PETER (1918-1964) BRITISH	*800-161000	X
LANZANI, POLIDORO (1515-1565) ITALIAN	600-15000	F,G
LAPICQUE, CHARLES	*500-37000	
LAPICQUE, CHARLES (B. 1898) FRENCH	1500-114000	A
LAPITO, AUGUSTE LOUIS (1803-1874) FRENCH	450-21000	F,L
LAPORTE, GEORGE HENRY (1799-1873) GERMAN	900-90000	F,L,W
LAPORTE, MARCELLIN (B. 1839) FRENCH	300-5500	F
LAPOSTOLET, CHARLES (1824-1890) FRENCH	500-16000	L,M
LAPRADE, PIERRE	*400-6500	
LAPRADE, PIERRE (1875-1932) FRENCH	900-79000	L,F,S
LARA, GEORGE (19TH C) BRITISH	600-7800	F,G,L,W
LARA, GEORGINA (19TH C) BRITISH	400-13000	L,F,W
LARA, WILLIAM (19TH C) BRITISH	150-2500	G,L
LARCHE, RAOUL (1860-1912) FRENCH	600-6000	X
LARD, FRANCOIS MAURICE (1864-1908) FRENCH	400-24000	F

LARGILLIERE, NICOLAS DE	*1500-35000	
LARGILLIERE, NICOLAS DE (1656-1746) FRENCH	10000-+++	F,G,S
LARIONOV, MICHEL	*800-45000	
LARIONOV, MICHEL (1881-1964) RUSSIAN	2000-135000	A
LARKIN, WILLIAM (17TH C) BRITISH	800-42000	F
LAROON, MARCELLUS (18TH C) BRITISH	650-16000	F,G
LARRAIN, EMILIO RODRIGUEZ (B. 1928) PERUVIAN	700-9000	X
LARRAZ, JULIO	*400-4300	
LARRAZ, JULIO (B. 1944) CUBAN	900-42000	G,M,S
LARSEN, ADOLPH (1856-1942) DANISH	400-5000	L
LARSEN, EMANUEL (1823-1859) DANISH	500-7000	M,L
LARSEN, JOHANNES (1867-1961) DANISH	400-5000	L
LARSSON, CARL	*4000-+++	
LARSSON, CARL (1853-1919) SWEDISH	7500-+++	F,G,L
LARSSON, HANS (1910-1973) SWEDISH	600-5000	S
LARSSON, MARCUS (1825-1864) SWEDISH	850-84000	L,M
LARWIN, HANS (B. 1873) AUSTRIAN	400-4500	G
LASAR, C. (19TH/20TH C) FRENCH	300-2100	G
LASKE, OSKAR	*400-9500	
LASKE, OSKAR (1841-1911) AUSTRIAN	300-72000	G,L,S
LASKY, L. (19TH C) FRENCH	100-1500	G
LASLETT, JOHN POTT (1837-1898) BRITISH	300-1600	X
LASSAUX, G. DE (19TH/20TH C) FRENCH	300-1200	G
LASTMAN, PIETER (1583-1633) DUTCH	10000-+++	F,G,L,W
LASZLO DE LOMBOS, PHILIP ALEXIUS DE (1869-1937) BRITISH	500-15000	F,G
LATAPIE, LOUIS	*200-3200	
LATAPIE, LOUIS (1891-1972) FRENCH	400-18000	F,G,L,S
LATASTER, GER (B. 1920) DUTCH	1000-50000	A
LATHAM, JAMES (1696-1747) BRITISH	1000-25000	F
LATHANGUE, HENRY HERBERT (1859-1929) BRITISH	3000-200000	F,L
LATOUCHE, GASTON DE	*1200-60000	
LATOUCHE, GASTON DE (1854-1913) FRENCH	1500-85000	G
LATOUR, GEORGES DE (1593-1652) FRENCH	15000-+++	G,F
LATOUR, JEAN (19TH/20TH C) FRENCH	150-1500	X
LATOUR, MAURICE QUENTIN DE	*4000-125000	
LATOUR, MAURICE QUENTIN DE (1704-1788) FRENCH	5000-95000	F
LAUB (19TH C) FRENCH	300-1600	X
LAUBSER, MAGGIE (1886-1973) SOUTH AFRICAN	900-9000	L,W,F
LAUDER, CHARLES JAMES (1841-1920) BRITISH	500-11000	L,M

* Denotes watercolors, pastels, drawings, and/or mixed media

LAUDER, JAMES ECKFORD (1811-1869) BRITISH	1000-60000	F,G
LAUDY, JEAN (1877-1956) BELGIAN	800-32000	F,S
LAUER, JOSEF (1818-1881) AUSTRIAN	1000-30000	S
LAUGE, ACHILLE	*350-4500	
LAUGE, ACHILLE (1861-1944) FRENCH	1200-55000	F,G,L,M
LAUGEE, DESIRE FRANCOIS (1823-1896) FRENCH	500-9000	F,G
LAUGEE, GEORGES (B. 1853) FRENCH	750-5200	G,L
LAUPHEIMER, ANTON (1848-1927) GERMAN	1000-14000	F,G
LAUR, MARIE YVONNE (B. 1879) FRENCH	900-24000	W,G
LAURENCIN, MARIE	*2500-+++	
LAURENCIN, MARIE (1883-1956) FRENCH	10000-+++	F,G,S,W
LAURENG, THEODOR (1879-1929) NORWEGIAN	1000-40000	F,L
LAURENS, HENRI	*1200-210000	
LAURENS, HENRI (1885-1954) FRENCH	3000-65000	F,S
LAURENS, JEAN PAUL (1838-1921) FRENCH	500-8800	G
LAURENS, JULES JOSEPH AUGUSTIN (1825-1901) FRENCH	800-16000	X(L)
LAURENT, BRUNO EMILE (20TH C) FRENCH	800-7500	L,F
LAURENT, ERNEST JOSEPH (1859-1929) FRENCH	650-22000	F,M,S
LAURENT, H. J. (1893-1976) HAITIAN	200-1000	G
LAURENT, PETERSON (Active 1940-1958) HAITIAN	500-3000	G,L,S
LAURENT, SABON (20TH C) FRENCH	200-1000	X
LAURENT-DESROUSSEAUX, HENRI ALPHONSE LOUIS (1862-1906) FRENCH	600-8400	G,M,W
LAURENTY, L. (19TH C) FRENCH	400-3600	F
LAURI, FILIPPO (1623-1694) RUMANIAN	2000-20000	F
LAUTENSCHLAGER, GUSTAV (1859-1945) AUSTRIAN	300-3000	L
LAUTERBURG, MARTIN	*400-4000	
LAUTERBURG, MARTIN (B. 1891) SWISS	500-7400	F,S,L
LAUVRAY, ABEL (1870-1950) FRENCH	2000-21000	L
LAVAGNA, GUISEPPE (1684-1724) ITALIAN	700-20000	S
LAVAL, FERNAND (B. 1895) FRENCH	400-7500	F,L,S
LAVALLEE-POUSSIN, ETIENNE DE (1733-1793) FRENCH	*100-1500	G,L
LAVERY, SIR JOHN (1856-1941) IRISH	2000-+++	F,G,M
LAVIE, RAFFI (20TH C) ISRAELI	300-3500	A
LAVIEILLE, EUGENE (1820-1899) FRENCH	400-22000	L
LAVILLE, JOY	*400-8500	
LAVILLE, JOY (B. 1923) BRITISH	800-15000	G,S
LAVOINE, L P ROBERT	*400-3000	
LAVOINE, L P ROBERT	900-6500	L

LAWRENCE, GEORGE FEATHER (1901-1981) AUSTRALIAN	1000-15000	L,M
LAWRENCE, SIR THOMAS	*1500-75000	
LAWRENCE, SIR THOMAS (1769-1830) BRITISH	10000-+++	F,L
LAWRENSON, EDWARD LOUIS (B. 1868) BRITISH	400-4700	G,M
LAWSON, ALEXANDER (19TH-20TH C) BRITISH	300-3000	L
LAWSON, CECIL GORDON (1851-1882) SCOTTISH	500-15000	G,L
LAWSON, JAMES KERR (1864-1939) BRITISH/CANADIAN	600-3200	X
LAZERGES, JEAN BAPTISTE PAUL (1845-1902) FRENCH	700-14000	G,W
LAZERGES, JEAN RAYMOND HIPPOLYTE (1817-1887) FRENCH	1000-62000	F,G
LAZO, AUGUSTIN (B. 1900) MEXICAN	400-3500	G
LE BAS, JACQUES PHILIPPE (1707-1783) FRENCH	*200-2500	F,S
LE BLANT, JULIEN (B. 1851) FRENCH	600-8000	X
LE BOULANGER (19TH C) FRENCH	300-1000	X
LE BRUN, CHARLES (1619-1690) FRENCH	1500-170000	F,G
LE CHEVALIER, PIERRE TOUSSAINT (B. 1825) FRENCH	800-5000	X
LE CORBUSIER, (CHARLES EDOUARD JEANNERET)	*5000-50000	
LE CORBUSIER, (CHARLES EDOUARD JEANNERET) (1887-1965) FRENCH	5000-+++	A
LE DRU, ALBERT FERDINAND (B. 1848) FRENCH	400-1200	X
LE FLECHE, HENRI (19TH C) FRENCH	300-2800	X
LE PARC, JULIO (B. 1928) ARGENTINIAN	400-2800	X
LE PHO (B. 1907) FRENCH	300-1800	F,G
LE SENECHAL DE KERDREORET, GUSTAVE EDOUARD (B. 1840) FRENCH	400-2800	X
LE SIDANER, HENRI	*1000-20000	
LE SIDANER, HENRI (1862-1939) FRENCH	5000-220000	X
LEADER, BENJAMIN WILLIAM (1831-1923) BRITISH	800-83000	L,M,F
LEAKEY, JAMES (1775-1865) BRITISH	500-8000	F,G,L,M
LEANDER-ENGSTROM, KJELL (B. 1914) SCANDINAVIAN	800-7500	L
LEAR, EDWARD	*1200-40000	
LEAR, EDWARD (1812-1888) BRITISH	2000-208000	G,L,W
LEAVER, NOEL HARRY	*300-6800	
LEAVER, NOEL HARRY (1889-1951) BRITISH	500-4800	G,L,M
LEBASQUE, HENRI	*900-36000	
LEBASQUE, HENRI (1865-1937) FRENCH	4500-+++	F,S,L
LEBEDJEV, VLADIMIR (1891-1967) RUSSIAN	*600-7000	X(A,F)
LEBEL, EDMUND (1834-1909) FRENCH	400-2400	F,G
LEBOURG, ALBERT CHARLES	*750-30000	
LEBOURG, ALBERT CHARLES (1849-1928) FRENCH	2500-110000	L,M
LEBRET, FRANS (1820-1909) DUTCH	500-7500	F,L

* Denotes watercolors, pastels, drawings, and/or mixed media

LEBRET, PAUL (B. 1875) FRENCH	*600-3400	X(G)
LEBSCHE, KARL-AUGUST (1800-1877) POLISH	*800-6000	L
LECADRE, ALPHONSE EUGENE FELIX (1842-1875) FRENCH	1200-36000	G
LECK, BART VAN DER (1876-1958) DUTCH	2500-175000	A
LECLAIRE, VICTOR (1830-1885) FRENCH	900-30000	G,S
LECLERC, DES GOBELINS (1734-1785) FRENCH	1200-18000	G,L
LECLERC, L. JACQUES (19TH/20TH C) FRENCH	500-5800	M
LECLERC, SEBASTIAN (1676-1763) FRENCH	800-15000	F,L
LECLERCQ, EDMUND (1817-1853) FRENCH	400-2200	G
LECOEUR, JEAN BAPTISTE (1795-1838) FRENCH	200-3500	G
LECOINDRE, EUGENE (19TH C) FRENCH	1000-15000	F,G
LECOMPTE, LOUIS (19TH C) FRENCH	400-1800	S
LECOMTE, HIPPOLYTE (1781-1857) FRENCH	500-8000	F,G,L
LECOMTE, PAUL	*200-1800	
LECOMTE, PAUL (1842-1920) FRENCH	400-15000	G,L
LECOMTE, PAUL EMILE	*200-2500	
LECOMTE, PAUL EMILE (1877-1950) FRENCH	500-19000	F,G,M,W
LECOMTE, VICTOR (1856-1920) FRENCH	300-1900	G,L,S
LECOMTE DU NOUY, JEAN JULES ANTOINE (1842-1923) FRENCH	1500-58000	G,L
LECOMTE-VERNET, CHARLES EMILE (1821-1900) FRENCH	4000-35000	X
LECOQUE, ALOIS (1891-1981) CZECH	500-5000	L
LECOURT, RAYMOND (1882-1946) FRENCH	1000-40000	L,F
LEDESMA (17TH C) SPANISH	600-12000	S
LEDIEU, PHILIPPE (19TH C) FRENCH	200-2500	X(W)
LEDOUX, JEANNE PHILBERTE (1767-1840) FRENCH	400-173000	F,G,W
LEDUC, PAUL (1876-1943) BELGIAN	800-14000	L
LEE, FREDERICK RICHARD (1798-1879) BRITISH	600-45000	F,L,W
LEE, JOHN J (19TH C) BRITISH	1500-98000	L
LEE, WILLIAM (1810-1865) BRITISH	*300-2500	F,G
LEE-HANKEY, W.	*350-17000	
LEE-HANKEY, W. (1869-1952) BRITISH	500-29000	X
LEECH, JOHN	*300-4700	
LEECH, JOHN (1817-1864) BRITISH	400-3300	G,L,W
LEECH, WILLIAM JOHN (1881-1968) BRITISH	500-62000	L,M,F
LEEKE, FERDINAND (B. 1859) GERMAN	500-7000	F
LEEMANS, JOHANNES (1633-1688) DUTCH	1000-80000	S
LEEMPUTTEN, CORNELIS VAN (1841-1902) BELGIAN	750-12000	W,F,L
LEEMPUTTEN, FRANS VAN (1850-1914) BELGIAN	500-4000	W,F,G,L
LEEMPUTTEN, JEF LOUIS VAN (1850-1914) BELGIAN	600-4400	G,L,W

LEEN, WILLEM VAN (1753-1825) DUTCH	1000-38500	S,W
LEERMANS, PIETER (1655-1706) DUTCH	500-6400	F
LEES, CHARLES (1800-1880) BRITISH	750-28000	G
LEEUW, ALEXIS DE (Late 19TH C) BRITISH	1000-18000	F,G,L,W
LEFEBRE, WILHELM ULBERT (1873-1974) GERMAN	750-6800	F,L
LEFEBVRE, CLAUDE (1632-1675) FRENCH	800-10000	F
LEFEBVRE, JULES JOSEPH (1836-1912) FRENCH	1500-50000	F,L
LEFEUBURE, KARL (1847-1911) GERMAN	800-6500	L,F
LEFEVRE, M. (19TH C) FRENCH	200-1800	F,G
LEFEVRE, ROBERT (1755-1830) FRENCH	1200-53000	X(F)
LEFFER, H. (19TH C) DUTCH	400-4000	X
LEFLER, FRANZ (1831-1898) CZECHOSLAVAKIAN	300-10000	F,G,W
LEFORT, JEAN LOUIS (1875-1954) FRENCH	500-18000	F,G
LEGA, GEORGIO (19TH C) ITALIAN	400-2600	X
LEGA, SILVESTRO (1826-1895) ITALIAN	1500-655000	F,G
LEGARDA, BERNARDO DE (B. ECUADOR Active 1730-1773)	1500-18000	X
LEGAT, LEON (B. 1829) FRENCH	1200-18000	G,L
LEGER, FERNAND	*4500-+++	
LEGER, FERNAND (1881-1955) FRENCH	10000-+++	A
LEGGETT, ALEXANDER (19TH C) BRITISH	500-17000	G,M
LEGILLON, JEAN FRANCOIS (1739-1797) FLEMISH	300-4600	G,L
LEGLER, THOMAS JOACHIM (1806-1873) FINNISH	400-2000	L
LEGLER, WILHELM (B. 1875) ITALIAN	600-5500	X(F)
LEGOUT-GERARD, FERNAND	*500-9800	
LEGOUT-GERARD, FERNAND (1856-1924) FRENCH	1000-25000	G,L,M
LEGRAND, LOUIS AUGUSTE MATHIEU (1863-1951) FRENCH	1200-30000	F
LEGRAND, PAUL EMMANUEL (B. 1860) FRENCH	400-4500	F
LEGROS, ALPHONSE	*200-4800	
LEGROS, ALPHONSE (1837-1911) FRENCH	800-24000	F,G
LEGROS, PIERRE (Called LE JEUNE) (1666-1719) FRENCH	*300-1800	F
LEGUAY, ANDRE GUERIN (B. 1872) FRENCH	200-1000	X
LEGUAY, CHARLES ETIENNE (1762-1846) FRENCH	*200-1500	F,L,W
LEGUEULT, RAYMOND JEAN	*300-7000	
LEGUEULT, RAYMOND JEAN (1898-1971) FRENCH	750-95000	A
LEHMANN, RUDOLF WILHELM AUGUST (1819-1905) GERMAN	1000-16000	F,G
LEHMDEN, ANTON	*300-2600	
LEHMDEN, ANTON (B. 1929) AUSTRIAN	1500-22000	F,L,S
LEHNER, GILBERT (19TH C) AUSTRIAN	300-3500	G
LEHTO, NIKOLAI (B. 1905) FINNISH	1000-15000	F,M

* Denotes watercolors, pastels, drawings, and/or mixed media

LEIBL, WILHELM (1844-1900) GERMAN	1000-180000	F,G
LEICKERT, CHARLES HENRI JOSEPH	*750-28000	
LEICKERT, CHARLES HENRI JOSEPH (1816-1907) BELGIAN	1600-83000	G,L,F,M
LEIGHTON, ALFRED CROCKER	*400-2500	
LEIGHTON, ALFRED CROCKER (1901-1965) BRITISH	900-15000	L
LEIGHTON, EDMUND BLAIR (1853-1922) BRITISH	2000-67000	G,S
LEIGHTON, LORD FREDERIC	*200-7000	
LEIGHTON, LORD FREDERIC (1830-1896) BRITISH	10000-+++	F,G
LEIST, FREDERICK WILLIAM (1878-1946) AUSTRIAN	1000-35000	F,G,M
LEISTIKOW, WALTER (1865-1908) GERMAN	600-10000	F,L
LEITCH, WILLIAM LEIGHTON (1804-1883) SCOTTISH	500-6500	F,L,M
LEITNER, HEINRICH (B. 1842) AUSTRIAN	800-5000	M
LEITNER, THOMAS (B. 1876) AUSTRIAN	300-5100	G,L,M
LEJEUNE, EUGENE (1818-1897) FRENCH	650-7400	G,L,W
LEJEUNE, HENRY (1881-1974) BRITISH	500-7200	F
LELEUS, ADOLPHE (1812-1891) FRENCH	400-7500	X(F,L)
LELEUX, ARMAND-HUBERT-SIMON (1818-1885) FRENCH	300-5200	F,G
LELIE, ADRIAAN DE (1755-1820) DUTCH	750-8000	F,G,L
LELIENBERGH, CORNELIS VAN AND SON, JORIS VAN (17TH C) DUTCH	5000-84000	S,W
LELLI, GIOVANNI BATTISTA (1828-1887) ITALIAN	400-7200	G,L
LELOIR, ALEXANDRE LOUIS	*150-5200	
LELOIR, ALEXANDRE LOUIS (1843-1884) FRENCH	500-20000	F
LELOIR, JEAN BAPTISTE AUGUSTE (1809-1892) FRENCH	500-15000	F,G
LELOIR, MAURICE	*200-2000	
LELOIR, MAURICE (1853-1940) FRENCH	1200-24000	F,G,L,M
LELONG, PAUL (18TH/19TH C) FRENCH	300-2000	S
LELONG	*500-14000	
LELY, SIR PETER	*500-25000	
LELY, SIR PETER (1618-1680) BRITISH	2000-116000	F
LEMAIRE, CASIMIR (19TH/20TH C) FRENCH	300-13000	F,G
LEMAIRE, CHARLES (Active 1756-1769) FRENCH	*200-1000	X
LEMAIRE, JEAN (1597-1659) FRENCH	1200-22000	G,L
LEMAIRE, MADELEINE (1845-1928) FRENCH	2500-80000	F,G,L,S
LEMAITRE, MAURICE (20TH C) FRENCH	400-6200	X
LEMAY, OLIVIER (1734-1797) FRENCH	*400-3200	X
LEMENOREL, ERNEST EMILE (B. 1848) FRENCH	300-1200	F
LEMMEN, GEORGES	*1000-15000	
LEMMEN, GEORGES (1865-1916) BELGIAN	2500-135000	F,G,L,S

LEMMENS, THEOPHILE VICTOR EMILE (1821-1867) FRENCH	500-4500	G,L,W
LEMMERS, GEORGES (1871-1944) BELGIAN	500-9400	L,F
LEMOINE, ELISABETH BOCQUET (18TH C) FRENCH	600-59000	F
LEMOINE, FRANCOIS (1688-1737) FRENCH	400-14000	F
LEMOINE, MARIE VICTOIRE (1754-1820) FRENCH	1000-26000	F
LEMORDANT, JEAN JULIEN (B. 1878) FRENCH	300-7800	F,G,L
LEMPEREUR, EDMOND (1876-1909) FRENCH	300-5000	X(F)
LEMPICKA, TAMARA DE (1898-1980) POLISH	3500-+++	F,G,S
LENBACH, FRANZ SERAPH VON	*300-5000	
LENBACH, FRANZ SERAPH VON (1836-1904) GERMAN	800-15000	F,G
LENGO Y MARTINEZ, HORACIO (B. 1890) SPANISH	300-8000	F,S,W
LENOIR, CHARLES AMABLE (B. 1861) FRENCH	800-80000	F,G
LENOIR, MARCEL (1872-1931) FRENCH	1000-38000	F,L
LENZI, LUIGI (19TH/20TH C) ITALIAN	300-1700	X
LEON, FRANCISCO DE (Early 18TH C) MEXICAN	500-10000	F
LEON, NOE	*200-1200	
LEON, NOE (B. 1907) COLUMBIAN	300-7000	G,W
LEONARD, A. (19TH C) EUROPEAN	400-3000	X
LEONARD, PATRICK	*400-6500	
LEONARD, PATRICK (B. 1918) BRITISH	300-5500	M
LEONARDO DA VINCI	*100000-+++	
LEONARDO DA VINCI (1452-1519) ITALIAN	10000-+++	F,W
LEONELLI, ANTONIO (16TH C) ITALIAN	5000-+++	F
LEONI, OTTAVIO (1587-1630) ITALIAN	*1000-36000	F
LEONTUS, ADAM (20TH C) HAITIAN	200-1400	G,W
LEOPOLD, V. (19TH/20TH C) GERMAN	300-1000	L
LEPAGE, FRANCOIS (B. 1796) FRENCH	1000-65000	S
LEPAPE, GEORGE (19TH-20TH C) FRENCH	*800-15000	X(F)
LEPELTIER, ROBERT (B. 1913) FRENCH	200-3200	X(L)
LEPICIE, NICOLAS BERNARD (1735-1784) FRENCH	2500-220000	F,G
LEPIE, FERDINAND (1824-1883) CZECHOSLOVAKIAN	400-5000	L
LEPINAY, PAUL GALLARD (1842-1903) FRENCH	500-6600	M
LEPINE, STANISLAS	*500-7000	
LEPINE, STANISLAS (1835-1892) FRENCH	1500-+++	L,M
LEPOITEVIN, EUGENE MODESTE EDMOND (1806-1870) FRENCH	700-8000	G,L,M
LEPOITTEVIN, LOUIS (1847-1909) FRENCH	300-7100	G,L
LEPPIEN, JEAN	*800-5500	A
LEPPIEN, JEAN (B. 1910) GERMAN	2000-18000	A
LEPRIN, MARCEL FRANCOIS	*300-11000	

LEPRIN, MARCEL FRANCOIS (1891-1933) FRENCH	500-160000	G,L,F,S
LEPRINCE, AUGUSTE XAVIER (1799-1826) FRENCH	1200-32000	F,G
LEPRINCE, JEAN BAPTISTE	*500-12000	
LEPRINCE, JEAN BAPTISTE (1734-1781) FRENCH	1500-142000	L,G
LERAY, PRUDENT LOUIS (1820-1879) FRENCH	500-9500	L,G
LERAY, S. (19TH C) FRENCH	400-2300	G,W
LERCHE, VINCENT STOLTENBERG (1837-1892) NORWEGIAN	400-13000	G
LERGAARD, NIELS (20TH C) SCANDINAVIAN	400-10500	F,M
LERIUS, JOSEPH HENRI FRANCOIS VAN (1823-1876) BELGIAN	650-18000	F
LEROLLE, HENRY (1848-1929) FRENCH	500-12000	G,L
LEROUX, FRANCOIS	*900-4000	
LEROUX, FRANCOIS (B. 1943) FRENCH	1000-6000	A
LEROUX, LOUIS HECTOR (1829-1900) FRENCH	300-20000	G
LEROY, CHARLES (19TH C) FRENCH	400-1800	G
LEROY, JULES (1833-1865) FRENCH	800-18000	G,S
LEROY DE LIANCOURT, FRANCOIS (1741-1835) FRENCH	400-5000	X
LERSY, ROGER (B. 1920) FRENCH	200-2800	S
LESIEUR, PIERRE (B. 1920) FRENCH	800-11000	X(S)
LESLI, R. (19TH C) BRITISH	300-1200	X
LESLIE, CHARLES (B. 1840) BRITISH	400-3200	L,F
LESLIE, CHARLES ROBERT (1794-1859) BRITISH	600-18000	L,G,F
LESLIE, GEORGE DUNLOP (1835-1921) BRITISH	1000-87000	F,G
LESREL, ADOLPHE ALEXANDRE (1839-1921) FRENCH	1200-64000	G,F
LESSER-URY	*500-50000	
LESSER-URY (1861-1931) GERMAN	1500-72000	X
LESSI, GIOVANNI (1852-1922) ITALIAN	600-7500	G,F
LESSING, KARL FRIEDRICH (1808-1880) GERMAN	800-32000	L,F
LESSING, KONRAD LUDWIG (1852-1916) GERMAN	300-4500	L
LESSORE, JULES (Late 19TH C) BRITISH	*750-18000	M,S
LESSORE, THERESE (20TH C) FRENCH	600-9500	F
LESUR, HENRI VICTOR (B. 1863) FRENCH	500-21000	G
LETH, HENDRIK DE (18TH C) DUTCH	400-4000	L
LETHABY, WILLIAM RICHARD (1857-1931) BRITISH	*800-11000	I
LETO, ANTONIO (1844-1913) ITALIAN	600-20000	L,F
LEU, AUGUST WILHELM (1819-1897) GERMAN	400-7900	L
LEU, HANS (THE YOUNGER) (1490-1531)	3500-68000	F
LEU, OSCAR (1864-1942) GERMAN	400-6400	L,W
LEUPPI, LEO PETER (1893-1972) DUTCH	300-8000	G,A
LEURS, JAN (19TH C) DUTCH	200-1600	L,W

LEURS, JOHANNES KAREL (1865-1938) DUTCH	500-4200	L
LEUTZE, EMANUEL GOTTLIEB	*300-1500	
LEUTZE, EMANUEL GOTTLIEB (1816-1868) GERMAN	600-16000	F,G
LEUUS, JESUS (20TH C) MEXICAN	200-6500	F
LEUZE-HIRSCHFELD, EMMY (B. 1884) FRENCH	500-6800	G,S
LEVANON, MORDECHAI	*400-9500	
LEVANON, MORDECHAI (20TH C) ISRAELI	1200-65000	L,F,S
LEVASSEUR, HENRI LOUIS (B. 1853) FRENCH	300-3000	F
LEVECQ, JACOB (1634-1675) DUTCH	400-2000	F
LEVEILLE, ANDRE (B. 1880) FRENCH	600-10000	G,L,F
LEVEQUE, GABRIEL (B. 1923) HAITIAN	300-4500	G
LEVERD, RENE (B. 1872) FRENCH	*200-4800	L,F
LEVERING, DOMIEN (1882-1962) BELGIAN?	200-2400	L,M
LEVESQUE (19TH/20TH C) FRENCH	150-750	X
LEVI, CARLO (1902-1975) ITALIAN	900-14000	X(S)
LEVIGNE, THEODORE (19TH C) FRENCH	400-3500	L,G,S
LEVINSEN, S. (20TH C) FRENCH	400-2200	G
LEVIS, D. (18TH C) BRITISH	200-900	X
LEVIS, MAURICE (1860-1902) FRENCH	650-12000	L,M
LEVITAN, ISAAC ILYITCH	*500-5000	
LEVITAN, ISAAC ILYITCH (1860-1900) LITHUANIAN	1500-45000	L
LEVOLI, NICOLA (1730-1801) ITALIAN	600-5500	S
LEVRAC-TOURNIERES, ROBERT (1667-1752) FRENCH	1500-65000	F
LEVY, ALEXANDER O. (1881-1947) FRENCH	200-1000	F
LEVY, EMILE (1826-1890) FRENCH	500-6000	G,F
LEVY, HENRI LEOPOLD (1840-1904) FRENCH	400-6000	G,F
LEVY, RUDOLPH (1875-1943) GERMAN	1500-41000	F,S
LEVY-DHURMER, LUCIEN	*500-55000	
LEVY-DHURMER, LUCIEN (1865-1953) FRENCH	1200-240000	X
LEWIN, STEPHEN (19TH/20TH C) BRITISH	400-5800	L,G
LEWIS, CHARLES JAMES (1830-1892) BRITISH	500-30000	L,G
LEWIS, CHARLES JAMES (1830-1892) BRITISH	1000-28000	G,L,M
LEWIS, FREDERICK CHRISTIAN	*200-1000	
LEWIS, FREDERICK CHRISTIAN (1779-1856) BRITISH	400-2000	G,W
LEWIS, HENRY (1819-1904) BRITISH/GERMAN	800-10000	L,S
LEWIS, JOHN FREDERICK	*2500-100000	
LEWIS, JOHN FREDERICK (1805-1876) BRITISH	10000-+++	F,W
LEWIS, PERCY WYNDHAM	*1000-25000	
LEWIS, PERCY WYNDHAM (1882-1957) BRITISH	1400-59000	A

* Denotes watercolors, pastels, drawings, and/or mixed media

LEWISOHN, RAFAEL (1863-1923) GERMAN	400-3400	L
LEY, VAN D (19TH C) DUTCH	400-1800	L
LEYDEN, JAN VAN (17TH C) DUTCH	1000-12000	M
LEYDEN, LUCAS VAN (1494-1538) DUTCH	5000-+++	F
LEYENDECKER, PAUL JOSEPH (B. 1842) FRENCH	500-5800	G
LEYMAN, ALFRED (1856-1933) BRITISH	*400-3500	L
LEYPOLD, KARL JULIUS (1806-1874) GERMAN	800-14000	L
LEYS, BARON HENDRIK (1815-1869) BELGIUM	1000-36000	F,G
LEYSTER, JUDITH (1600-1660) DUTCH	2400-145000	F,G
LEYTENS, GYSBRECHT (19TH C) FLEMISH	3000-115000	L
LEZCANO, CARLOS (19TH C) SPANISH	500-27000	L
LHERMITTE, LEON AUGUSTIN	*600-69000	
LHERMITTE, LEON AUGUSTIN (1844-1925) FRENCH	2200-+++	G,L,F
LHOTE, ANDRE	*650-40000	
LHOTE, ANDRE (1885-1962) FRENCH	1000-249000	A,F,L
LHUILLIER, CHARLES MARIE (1824-1898) FRENCH	200-1000	X
LIBERALE DA VERONA (1445-1526) ITALIAN	2000-112000	G,F
LIBERI, PIETRO (Called LIBERTINO) (1614-1687) ITALIAN	1200-35000	F
LIBERT, GEORG EMIL (1820-1908) DANISH	600-8800	L,G
LICATA, RICCARDO (B. 1929) ITALIAN	*900-8500	A
LICHT, HANS (B. 1876) GERMAN	200-2400	L
LICHTENHELD, WILHELM (1817-1891) AUSTRIAN	300-7000	L
LICINI, OSVALDO (1894-1958) ITALIAN	1000-61000	L,F
LICINIO, BERNARDINO (1489-1565) ITALIAN	800-15000	F
LIDDERDALE, CHARLES SILLEM	*200-5300	
LIDDERDALE, CHARLES SILLEM (1831-1895) BRITISH	500-18000	G,F,S
LIEBENWEIN, MAXIMILIAN (1869-1926) AUSTRIAN	*4000-7500	F
LIEBERMANN, ERNST (B. 1869) GERMAN	400-9000	F
LIEBERMANN, MAX	*900-57000	
LIEBERMANN, MAX (1847-1935) GERMAN	5000-+++	L,F,G
LIEBSCHER, KARL (1851-1906) POLISH	200-1000	X
LIECK, JOSEPH (B. 1849) GERMAN	500-6200	F
LIEGI, ULVI (1860-1939) ITALIAN	600-12000	L
LIENDER, PAULUS VAN (1731-1797) DUTCH	*300-5200	G,L
LIENDER, PIETER JAN VAN (1727-1779) DUTCH	800-14000	L,F
LIER, ADOLF (1826-1882) GERMAN	750-38000	L,W
LIESEGANG, HELMUT (B. 1858) GERMAN	300-7400	L,M
LIESTE, CORNELIS (1817-1861) DUTCH	500-11000	L
LIEUWEN, L. VON (19TH C) GERMAN	300-1200	X

LIEVENS, JAN	*1000-58000	
LIEVENS, JAN (1607-1672) DUTCH	5000-+++	F,L
LIEVIN, JACQUES (B. 1850) FRENCH	800-12000	L,M
LIGABUE, ANTONIO (1899-1965) SWISS	800-30000	F,L
LIGOZZI, JACAPO (1547-1632) ITALIAN	*500-24000	L,F
LIGTELIJN, EVERT JAN (1893-1974) DUTCH	200-37000	L,G
LILJEBLADH, BIRGITTA (B. 1924) SWEDISH	800-5500	S,F,M
LILJEFORS, BRUNO	*1000-+++	
LILJEFORS, BRUNO (1860-1939) SWISS	2500-+++	L,M,W
LILJEFORS, LINDORM (B. 1909) SWEDISH	800-31000	W,L
LIMBORCH, HENDRIK VAN (1681-1759) DUTCH	400-6000	F
LIMOUSE, ROGER (B. 1894) FRENCH	800-32000	X(M,S)
LIN, HERMANN VAN (17TH C) DUTCH	1000-18000	F
LIN FENGMIAN (B. 1900) CHINESE	*2000-35000	F,L,W
LINARD, JACQUES (1600-1645) FRENCH	1500-58000	S
LINDBERG, ALF (B. 1905) SWEDISH	400-18000	L
LINDBERG, HARALD (1901-1976) SWEDISH	800-8500	M,F
LINDE, JAN VAN DER	*200-1000	
LINDE, JAN VAN DER (1864-1945) DUTCH	400-2800	M,F,L
LINDELL, LAGE	*1000-40000	
LINDELL, LAGE (1920-1980) SCANDINAVIAN	2000-36000	A
LINDEN, HELGE (1897-1971) SWEDISH	900-6500	M
LINDENSCHMIT, HERMANN (1857-1939) GERMAN	500-5000	F,G
LINDENSCHMIT, WILHELM VON (1829-1895) GERMAN	300-4500	G,L
LINDER, FRANZ (1738-1809) GERMAN	400-2200	L
LINDER, LAMBERT (1841-1889) GERMAN	600-5000	G
LINDER, PHILIPPE JACQUES (Active 1857-1880) FRENCH	1000-20000	G
LINDERUM, RICHARD (B. 1851) GERMAN	1000-14000	G,F
LINDHOLM, BERNDT (1841-1914) SWEDISH	3000-210000	L,G
LINDLAR, JOHANN WILHELM (1816-1896) GERMAN	400-17000	L
LINDMAN, AXEL (1848-1930) SWEDISH	700-15000	L,M
LINDNER, ERNEST (20TH C) CANADIAN	800-7500	L
LINDNER, RICHARD	*1500-32000	
LINDNER, RICHARD (1901-1978) GERMAN	10000-+++	F
LINDQVIST, HERMAN (1868-1923) SWEDISH	800-8000	L
LINDSAY, NORMAN ALFRED WILLIAMS	*1200-25000	
LINDSAY, NORMAN ALFRED WILLIAMS	*700-	
LINDSAY, NORMAN ALFRED WILLIAMS (1879-1970) AUSTRALIAN	750-22000	G,S,F
LINDSAY, NORMAN ALFRED WILLIAMS (1879-1970) AUSTRALIAN	1000-25000	X(F)

* Denotes watercolors, pastels, drawings, and/or mixed media

LINDSTRAND, VICKE (1904-1983) SWEDISH	700-28000	X(F)
LINDSTROM, ARVID M. (1849-1923) SWEDISH	500-14000	L,F
LINDSTROM, BENGT (B. 1925) SWEDISH	1000-35000	A
LINDSTROM, FRITZ (1874-1962) SWEDISH	900-12000	L
LINDSTROM, RIKARD (1882-1943) SWEDISH	800-10000	M,L
LINER, CARL (B. 1914) SWISS	600-8500	A
LING, PAUL (19TH C) DUTCH	400-4800	G
LINGELBACH, JOHANNES	*100-600	
LINGELBACH, JOHANNES (1622-1674) DUTCH	2500-+ + +	L,F
LINGEMAN, LAMBERTUS (1829-1894) DUTCH	1000-11000	F,G
LINGNER, OTTO THEODORE GUSTAV (B. 1856) GERMAN	500-3400	G,L
LINNELL, JOHN	*200-16000	
LINNELL, JOHN (1792-1882) BRITISH	1200-71000	L,F,G
LINNELL, WILLIAM (1826-1910) BRITISH	500-12000	L,G
LINNIG, EGIDIUS (1821-1860) FLEMISH	600-9700	M
LINNIG, J. (19TH C) BELGIAN	400-3000	F
LINNIG, WILLEM (1819-1885) BELGIAN	800-15000	G
LINNOVAARA, JUHANI	*200-25000	
LINNOVAARA, JUHANI (B. 1934) FINNISH	5000-85000	X
LINNQVIST, HILDING (1891-1984) SWISS	1200-100000	S,L
LINS, ADOLF (1856-1927) GERMAN	300-3200	L
LINT, HENDRIK FRANS VAN (Called STUDIO) (1684-1763) FLEMISH	5000-165000	L,M
LINT, LOUIS VAN (B. 1909) BELGIAN	700-28000	X
LINT, PETER VAN (1609-1690) FLEMISH	1000-30000	F,L
LINTHORST, JACOBUS JOHANNES (1745-1815) DUTCH	1500-60000	S
LINTON, SIR JAMES DROMGOLE (1840-1916) BRITISH	400-3000	G,F
LINTON, WILLIAM (1791-1876) BRITISH	800-18000	L
LION, ALEXANDER LOUIS (1823-1842) BELGIAN	650-10000	G
LION, FLORA (19TH/20TH C) BRITISH	500-3400	F,L
LIONE, ANDREA DI (1596-1675) ITALIAN	900-38000	G,L
LIOTARD, JEAN ETIENNE	*5000-100000	
LIOTARD, JEAN ETIENNE (1702-1789) SWISS	10000-+ + +	G,F
LIPCHITZ, JACQUES	*450-35000	
LIPCHITZ, JACQUES (1891-1973) FRENCH	1200-51000	G,A,F,S
LIPPI, FILIPPO	*1200-+ + +	
LIPPI, FILIPPO (Called FILIPPINO) (1457-1504) ITALIAN	2000-45000	F
LIPPI, LORENZO (1606-1665) ITALIAN	750-15000	F
LIPPO DI BENIVIENI (14TH C) ITALIAN	1500-75000	X
LIS, JAN (1595-1629) DUTCH	1000-18000	G,F

LISI, DE (19TH C) ITALIAN	200-800	X
LISIEWSKA, ANNA ROSINA (18TH C) DUTCH	400-4500	F
LISIO, ARNALDO DE (19TH C) ITALIAN	*200-4200	G
LISKA, HANS (20TH C) GERMAN	500-4000	X
LISMER, ARTHUR (1885-1911) CANADIAN	650-60000	L,F,M
LISS, JAN (1570-1629) DUTCH	800-24000	F
LISSE, DIRCK VAN DER (D. 1669) DUTCH	500-73000	L
LISSITZKY, EL	*1000-+ + +	
LISSITZKY, EL (B. 1890) RUSSIAN	750-85000	A
LIST, WILHELM	*500-125000	
LIST, WILHELM (1864-1918) AUSTRIAN	1000-156000	G,F,L
LISTER, WILLIAM LISTER (1859-1943) AUSTRALIAN	*400-4900	
LITSCHAUER, KARL JOSEPH (1830-1871) AUSTRIAN	400-15000	G
LITVINOVSKY, PINCHAS (20TH C) ISRAELI	500-14000	F
LIVEMONT, PRIVAT	*200-1200	
LIVEMONT, PRIVAT (1861-1936) BELGIAN	200-2000	F
LIVENS, HENRY (1860-1885) BRITISH	300-3300	S
LIVENS, HORACE MANN (B. 1862) BRITISH	400-4500	L,S
LIVINGS, H. (19TH C) BRITISH	200-1200	L
LIVINGSTON, N.C. (19TH C) SCOTTISH	200-800	X
LIZCANO Y ESTEBAN, ANGEL (1846-1929) SPANISH	400-12000	F
LJUNGQUIST, BIRGER (1898-1965) SWEDISH	400-7000	L,F
LLINAS, GUIDO (B. CUBA 1930)	300-1200	G,F
LLONA, RAMIRO (B. 1947) PERUVIAN	*300-2000	A
LLOPIS, CARLOS RUANO (20TH C) MEXICAN	400-2400	F
LLOYD, EDWARD (Late 19TH C) BRITISH	300-8000	L,W
LLOYD, NORMAN (B. 1897) AUSTRALIAN	600-5000	M,L
LLOYD, ROBERT MALCOLM (Late 19TH C) BRITISH	*200-1500	M,L
LLOYD, T. IVESTER (19TH C) BRITISH	500-6200	G,L,W
LLOYD, THOMAS JAMES (1849-1910) BRITISH	*350-11000	F,L
LLOYD, W. STUART	*200-8000	
LLOYD, W. STUART (Active 1875-1929) BRITISH	300-7200	L
LLOYDS, F. (19TH C) BRITISH	400-4500	L
LLULL, JOSE PINELO (1861-1922) SPANISH	400-6800	G,L
LOARTE, ALEJANDRO DE (17TH C) SPANISH	700-18000	S
LOBRE, MAURICE (1862-1951) FRENCH	500-32000	F
LOBRICHON, TIMOLEON MARIE (1831-1914) FRENCH	650-87000	G
LOCATELLI, ANDREA (1693-1741) ITALIAN	2000-95000	L,F
LOCATELLI, ROMUALDO (1905-1943) ITALIAN	400-3200	G,L

LOCHER, CARL (1851-1915) DANISH	450-16000	L
LOCKHART, WILLIAM EWART (1846-1900) BRITISH	400-7800	G,L
LOCKHEAD, JOHN (B. 1866) BRITISH	400-4200	G,L
LODER, JAMES (OF BATH) (Active 1820-1857) BRITISH	750-19000	G,W
LODGE, GEORGE EDWARD	*300-15000	
LODGE, GEORGE EDWARD (1860-1954) BRITISH	500-14000	L,W
LODONE, EUSEBIO (19TH C) ITALIAN	800-6000	S
LOEBER, LOU (B. 1894) DUTCH	600-7500	X(A)
LOEFF, JACOB GERITSZ (1607-1648) DUTCH	600-32000	M
LOFFLER, AUGUST (1822-1866) GERMAN	300-4700	L,S
LOFFLER, BERTHOLD (1874-1960) AUSTRIAN	800-38000	G,F
LOFFTZ, LUDWIG VON (1845-1910) GERMAN	400-11000	L,F
LOGSDAIL, WILLIAM (1859-1944) BRITISH	700-8000	L,F
LOHR, AUGUST	*300-4500	
LOHR, AUGUST (19TH C) GERMAN	800-45000	L
LOHR, EMIL LUDWIG (1809-1876) GERMAN	400-5000	G,L
LOIR, LUIGI	*500-27000	
LOIR, LUIGI (1845-1916) FRENCH	750-67000	L,G
LOIR, MARIANNE (B. 1715) FRENCH	400-22000	F
LOIR, NICOLAS (1624-1679) FRENCH	900-16000	F
LOIRE, LEON (1821-1898) FRENCH	300-3600	G
LOISEAU, GUSTAVE	*800-35000	
LOISEAU, GUSTAVE (1865-1935) FRENCH	3000-+++	L,S
LOJACONO, FRANCESCO (1841-1915) ITALIAN	500-60000	L,M
LOKHORST, DIRK PIETER VAN (B. 1848) DUTCH	400-7500	L,W
LOKHORST, DIRK VON (1818-1893) DUTCH	400-5500	L,W
LOKHORST, JAN VAN (B. 18I37) DUTCH	400-5000	F,L
LOMAKIN, OLEG (B. 1924) RUSSIAN	800-8500	X(F)
LOMAX, JOHN ARTHUR (1857-1923) BRITISH	500-12000	G
LOMBARD, LAMBERT (1506-1566) FLEMISH	750-80000	F
LOMI, AURELIO (1556-1622) ITALIAN	650-29000	F
LOMI, GIOVANNI (1889-1969) ITALIAN	400-7400	L
LONBLAD, EMILIA (1865-1946) SCANDINAVIAN	1000-40000	G,F,M,L
LONDONIO, FRANCESCO (1723-1783) ITALIAN	500-52000	G,L,F
LONG, EDWIN (1829-1891) BRITISH	700-68000	G,F
LONG, SYDNEY (1872-1955) AUSTRALIAN	*600-25000	L
LONGANESI, R. (B. 1922) ITALIAN	200-1000	X
LONGHI, ALESSANDRO (1733-1813) ITALIAN	500-16000	F
LONGHI, BARBARA (1552-1638) ITALIAN	600-12000	F

LONGHI, LUCA (Called RAPHAEL DE RAVENNA) (1507-1580) ITALIAN	10000-60000	F
LONGHI, PIETRO (1702-1785) ITALIAN	4000-+++	G,F
LONGONI, EMILIO (1859-1933)	550-38000	F,L,S
LONGPRE, RAOUL DE	*200-33000	
LONGPRE, RAOUL DE (19TH/20TH C) FRENCH/AMERICAN	300-10000	S
LONGSTAFF, JOHN (1862-1941) AUSTRIAN	300-3000	L,G,F
LONGSTAFF, WILLIAM (1879-1953) AUSTRALIAN	300-2800	X(L)
LONGSTAFFE, EDGAR (1849-1912) BRITISH	150-2600	L,G
LONGSTAFFE, ERNEST (19TH C) BRITISH	200-2400	L
LONSDALE, JAMES (1777-1839) BRITISH	200-2500	F
LOO, ANDRE VAN (Called CARLE VAN LOO)	*400-23000	
LOO, ANDRE VAN (Called CARLE VAN LOO) (1705-1765) FRENCH	1500-90000	G,F
LOO, JACOB VAN (1614-1670) DUTCH	1000-32000	F,G
LOO, JEAN BAPTISTE VAN (1684-1745) FRENCH	1200-52000	F
LOO, LOUIS MICHAEL VAN (1707-1771) FRENCH	3000-231000	F,G
LOO, PIETER VAN (1600-1660) FLEMISH	*300-4600	X
LOO, PIETER VAN (1731-1784) DUTCH	*400-12000	S
LOON, GUSTAAF VAN (1912-1980) BELGIAN?	800-9000	L
LOOS, FRIEDRICH (1797-1890) AUSTRIAN	700-9000	L
LOOS, HENRY (19TH/20TH C) BELGIAN	400-3000	M
LOOS, JOHN F (19TH C) BELGIAN	1000-10000	M
LOOSE, BASILE DE (1809-1885) DUTCH	500-25000	G
LOOTEN, JAN (1618-1681) DUTCH	1200-211000	L,G
LOPEZ, GASPARO (1650-1732) ITALIAN	1000-42000	S,L
LOPEZ Y MARTINEZ, ENRIQUE (1853-1875) SPANISH	750-9200	F
LOPEZ-CABRERA, RICARDO (1866-1950) SPANISH	700-8000	L
LORCK, KARL JULIUS (1829-1895) NORWEGIAN	800-20000	G,F
LORENTSON, WALDEMAR (1899-1982) SWEDISH	1200-35000	F,G,L,M
LORENZ, CARL (B. 1871) AUSTRIAN	200-2400	X
LORENZ, GOTTFRIED (19TH C) GERMAN	300-1500	L
LORENZ, RICHARD (1858-1915) GERMAN	1200-34000	F,L,G
LORENZO (MONACO) (14TH C) ITALIAN	5000-+++	F
LORIA, VINCENZO	*200-1800	
LORIA, VINCENZO (B. 1850) ITALIAN	500-10000	G
LORIMER, JOHN HENRY (1856-1936) BRITISH	750-75000	F,S
LORJOU, BERNARD	*400-31000	
LORJOU, BERNARD (B. 1908) FRENCH	900-42000	A
LORRAIN, CLAUDE (CLAUDE GELEE) (1600-1682) FRENCH	*10000-+++	X

LORTET, LEBERECHT (1818-1901) FRENCH	500-7500	X
LORY, GABRIEL (18TH/19TH C) SWISS	*400-25000	L
LORY, MATTHIAS GABRIEL (1784-1846) SWISS	*300-19000	L,G
LOS, WALDEMAR (1849-1888) POLISH	500-15000	G
LOSE, JOHANN JACOB JOSEPH DE (Active 1755-1813) GERMAN	400-5000	F
LOSSOW, HEINRICH (1843-1897) GERMAN	300-6800	G
LOTH, JAN CARL (1632-1698) GERMAN	600-26500	F
LOTT, E. (19TH C) DUTCH	200-1000	X
LOTTEL, A. (19TH C) GERMAN	300-1000	X
LOTTO, LOENZO (1480-1556) ITALIAN	10000-+++	F
LOTZE, MORITZ EDUARD (1809-1890) GERMAN	400-9500	L,W
LOUND, THOMAS (1802-1861) BRITISH	300-2500	L
LOUREIRO, A. J. DE SOUZA (1862-1932) PORTUGUESE	500-6500	G,F
LOUTHER, CHARLES DRANGE (19TH/20TH C) CANADIAN	200-1000	X
LOUTHERBOURG, JACQUES PHILIPP DE	*300-3000	
LOUTHERBOURG, JACQUES PHILIPP DE (1740-1812) FRENCH	3200-+++	L,F,G
LOUTREUIL, MAURICE (1885-1925) FRENCH	300-14000	L,F,S
LOUYOT, EDMOND (B. 1861) GERMAN	400-7000	S,G,L
LOVATTI, MATTEO (B. 1861) ITALIAN	300-4400	G
LOVER, SAMUEL (1797-1868) IRISH	400-3500	L
LOVERIDGE, CLINTON (19TH C) BRITISH	400-3500	F,L
LOVMAND, CHRISTINE MARIE (1803-1872) DANISH	900-28000	S
LOWENSOHN, JULIUS (1820-1890) GERMAN	300-2000	G,F
LOWITH, WILHELM (B. 1861) AUSTRIAN	700-18500	F,G
LOWNDES, ALAN (1921-1978) BRITISH	600-15000	X
LOWRY, LAURENCE STEPHEN	*350-18000	
LOWRY, LAURENCE STEPHEN (1887-1976) BRITISH	1500-153000	A,L,F,G
LOXTON, JOHN S (B. 1903) AUSTRALIAN	400-4500	L,F
LOYE, CHARLES AUGUSTE (Called MONTBARD) (1841-1905) FRENCH	200-1500	L
LOZANO, LAZARO (B. 1906) PORTUGUESE	200-800	X
LUBBERS, ADRIAAN (B. 1892) DUTCH	500-5300	X
LUBBERS, HOLGER (1855-1928) DANISH	400-8000	M
LUBBERS, HOLGER PETER SVANE (1855-1928) DANISH	300-7500	M
LUBEN, ADOLF (1837-1905) GERMAN	300-19000	G
LUBIENIECKI, CHRISTOFEL (1660-1728) POLISH	500-11000	G
LUCA, G. DE (19TH/20TH C) ITALIAN	*200-750	X
LUCARDI, P. (19TH/20TH C) ITALIAN	200-1000	X
LUCAS, ALBERT DURER (1828-1918) BRITISH	500-7500	S,L

LUCAS, EDWARD GEORGE HANDEL (1863-1936) BRITISH	500-9500	S,F,G
LUCAS, GEORGE (19TH C) BRITISH	300-1200	G
LUCAS, HENRY FREDERICK LUCAS (D. 1943) BRITISH	750-30000	L,W
LUCAS, JOHN SEYMOUR (1849-1923) BRITISH	300-3000	G
LUCAS, JOHN TEMPLETON (1836-1880) BRITISH	300-1200	F
LUCAS, MARIE FELIX HIPPOLYTE (1854-1925) FRENCH	400-10000	X
LUCAS Y PADILLA, EUGENIO	*200-1000	
LUCAS Y PADILLA, EUGENIO (1824-1870) SPANISH	500-58000	G
LUCAS Y VILLAMIL, EUGENIO (19TH C) SPANISH	400-24000	G
LUCAS-ROBIQUET, MARIE AIMEE (B. 1864) FRENCH	400-40000	L,F
LUCCHESI, BRUNO (B. 1926) ITALIAN/AMERICAN	*500-7500	F
LUCCHESI, GIORGIO (1855-1941) ITALIAN	900-20000	S
LUCE, MAXIMILIEN	*2000-+++	
LUCE, MAXIMILIEN (1858-1941) FRENCH	5000-+++	L,F,G
LUCIONI, LUIGI (B. 1900) ITALIAN	400-8000	S,L
LUCKHARDT, K. (B. 1886) GERMAN	300-3100	G
LUCOP, THOMAS (19TH C) BRITISH	400-1800	M
LUDBY, MAX (1858-1943) BRITISH	*400-3500	M,L
LUDLOW, HAL (B. 1861) BRITISH	200-1200	F
LUDOVIC-RODO (RODO PISSARRO) (1878-1952) FRENCH	400-2500	X
LUDOVICI, ALBERT (1820-1894) BRITISH	300-7500	G
LUDWIG, AUGUSTE (B. 1834) GERMAN	500-12000	G
LUEGER, MICHAEL (1804-1883) GERMAN	300-2200	L
LUGARDON, ALBERT (1827-1909) FRENCH	500-6000	L,W
LUGO, EMIL (1840-1902) GERMAN	500-15000	L,G
LUIGARD, F. (20TH C) FRENCH	200-950	X
LUINI, BERNARDINO (1475-1532) ITALIAN	5000-+++	F
LUKA, MADELEINE (20TH C) FRENCH	300-8200	F,L
LUKER, WILLIAM (Late 19TH C) BRITISH	300-5200	G,L,W
LUKIN, SVEN (B. 1934) LATVIAN	200-850	A
LUNA, ANTONIO RODRIGUEZ	*200-1800	
LUNA, ANTONIO RODRIGUEZ (B. 1910) MEXICAN	200-2000	X
LUNA, MARIANO (19TH C) ITALIAN	*400-5000	G,F
LUND, FREDERICK CHRISTIAN (1826-1901) DANISH	500-9000	G,F
LUND, NIELS MOLLER (1863-1916) BRITISH	300-2400	L
LUNDBERG, GUSTAF (1695-1786) SWEDISH	*800-24000	F
LUNDBOHM, SIXTEN (1895-1982) SWEDISH	400-13000	L,S
LUNDBYE, JOHAN THOMAS (1818-1848) DANISH	500-36000	L,F,G
LUNDEBY, ALF (1870-1961) NORWEGIAN	200-3500	G,L,F,S

* Denotes watercolors, pastels, drawings, and/or mixed media

LUNDEGARD, JUSTUS (1860-1924) SWEDISH	650-20000	L,M
LUNDENS, GERRIT (1622-1677) DUTCH	1200-60000	G
LUNDGREN, EGRON SILLIF (1815-1875) SWEDISH	*300-5300	F,L
LUNDH, THEODOR (1812-1896) SWEDISH	400-3500	S,F
LUNDQVIST, EVART (B. 1904) SWEDISH	1800-204000	L,S,G
LUNDSTROM, VILHELM (1893-1950) DANISH	2000-75000	S
LUNTZ, ADOLF (1875-1924) GERMAN	100-2000	L
LUNY, THOMAS (1759-1837) BRITISH	1000-76000	M
LUONGO, ALDO (B. 1940) ARGENTINIAN	300-3000	X
LUONI, ROMOLO (20TH C) ITALIAN	300-2500	X
LUPO, ALESSANDRO 91876-1953) ITALIAN	500-12000	X
LUPPEN, GERARD JOSEF ADRIAN VAN (1834-1891) BELGIAN	200-6000	L
LUPTON, NEVIL OLIVER (B. 1828) BRITISH	400-4000	L
LURCAT, JEAN	*200-6200	
LURCAT, JEAN (1892-1966) FRENCH	1500-72000	A
LUSCOMBE, HENRY A (B. 1820) BRITISH	500-6500	M
LUST, ANTONI DE (17TH C) DUTCH	500-11000	S
LUSTY, OTTO (20TH C) GERMAN	400-2750	M
LUTHANDER, CARL (1879-1967) SWEDISH	200-4800	L
LUTHY, OSKAR WILHELM (1882-1945) SWISS	300-5500	L,G
LUTI, BENEDETTO (1666-1724) ITALIAN	1100-88000	F
LUTTEROTH, ASCAN (1842-1923) GERMAN	500-11000	L
LUTTICHUYS, ISAAK (1616-1673) DUTCH	600-24000	F
LUTTICHUYS, SIMON (1610-1662) DUTCH	1200-65000	S
LUYCX, FRANZ (1604-1668) FLEMISH	400-4500	G,F
LUYTEN, HENRI (1859-1945) BELGIAN	300-7500	F,L
LYALL, LAURA ADELINE (1860-1930) CANADIAN	600-14000	F,L
LYBAERT, THEOPHILE MARIE FRANCOIS (B. 1848) BELGIAN	400-3200	G,F
LYCKE, OSCAR (1877-1972) SWEDISH	100-3000	L
LYMBURNER, FRANCIS (B. 1916) AUSTRALIAN	200-5000	X(F)
LYNE, MICHAEL (B. 1912) BRITISH	300-9400	L
LYNN, JOHN (19TH C) BRITISH	800-20000	M
LYON, DAVID (Late 18TH C) BRITISH	400-6200	L
LYRE, ADOLPHE LA (B. 1850) FRENCH	300-5100	F,L
LYS, JAN VAN DER (19TH C) BELGIAN	400-2200	G,F

M

ARTIST	PRICES	SUBJECT
MAAR, CARL RITTER VON (1858-1936) GERMAN	200-1200	X
MAAR, DORA (20TH C) FRENCH	200-800	A,S
MAAREL, MARINUS VAN DER (1857-1921) DUTCH	200-1400	S,F
MAARNI, ELVI (B. 1907) FINNISH	900-15000	F
MAAS, AERT VAN (1620-1664) DUTCH	500-10000	X
MAAS, DIRCK (1659-1717) DUTCH	1000-44000	X
MAAS, JAN (1631-1699) DUTCH	300-4200	X
MAAS, PAUL (B.1936) DUTCH	400-4800	X
MAATEN, JACOB JAN VAN (1820-1879) DUTCH	400-14000	L
MABE, MANABU	*300-5000	
MABE, MANABU (B. 1910) BRAZILIAN	500-19000	G,A
MACALLUM, HAMILTON (1841-1896) BRITISH	300-17000	L,G
MACAVOY, EDOUARD (B. 1905) FRENCH	800-9500	X(L,S)
MACBETH, ROBERT WALKER (1848-1910) BRITISH	400-46000	L,G
MACCARI, MINO (B. 1898) ITALIAN	800-22000	A
MACCIO, ROMULO (B. 1931) ARGENTINIAN	1000-26000	X(A)
MACCO, GEORG (1863-1933) GERMAN	300-4000	L,G
MACDONALD, JAMES EDWARD HERVEY (1873-1932) CANADIAN	1300-125000	L,S
MACDONALD, MANLY E. (1889-1971) CANADIAN	300-16000	L
MACDOUGALL, NORMAN M (20TH C) BRITISH	800-5000	G,F,L
MACENTYRE, EDUARDO (B. 1929) ARGENTINIAN	300-2400	A
MACGEORGE, WILLIAM STEWART (1861-1931) BRITISH	950-86000	L,G
MACGOWAN, J. P. (19TH C) CANADIAN	200-1000	X
MACHADO, A. G. (20TH C) AZOREAN	200-800	X
MACHARD, JULES LOUIS	*300-6000	
MACHARD, JULES LOUIS (1839-1900) FRENCH	200-1000	G
MACK, BERNHARD KARL (19TH C) GERMAN	200-1000	X
MACKAY, FLORENCE (19TH-20TH C) BRITISH	*400-5000	G,F
MACKAY, H. (19TH/20TH C) BRITISH	200-800	X
MACKAY, JAMES M (19TH C) BRITISH	*400-3000	F,L
MACKAY, THOMAS (19TH/20TH C) BRITISH	*300-6400	F,G,L
MACKAY, WILLIAM DARLING (1844-1924) BRITISH	400-3500	G,F,L
MACKE, AUGUST	*1200-135000	
MACKE, AUGUST (1887-1914) GERMAN	5000-+++	A,L,G,F
MACKE, HELMUTH (1891-1936) GERMAN	800-11000	S
MACKEPRANG, ADOLF (1833-1911) DANISH	300-9300	L,W
MACKIE, CHARLES H (1862-1930) BRITISH	400-4500	L,G
MACLEAY, MCNEIL (19TH C) BRITISH	800-12000	L

* Denotes watercolors, pastels, drawings, and/or mixed media

MACLET, ELISEE	*200-30000	
MACLET, ELISEE (1881-1962) FRENCH	700-89000	A
MACLISE, DANIEL (1806-1870) BRITISH	700-+++	F,G,L
MACMULDROW, EDITH (19TH C) BRITISH	300-1400	G
MACNAB, MADAME MARIE (1832-1911) FRENCH	200-2400	G
MACNALLY, MATTHEW JAMES (1874-1943) AUSTRALIAN	*200-4500	F,L
MACNEE, ROBERT RUSSELL (1880-1952) BRITISH	300-6900	G,F,L
MACPHEARSON, JOHN	*200-800	
MACPHEARSON, JOHN (Late 19TH C) BRITISH	300-1800	L,G,M
MACQUEEN, KENNETH (B. 1897) AUSTRALIAN	*900-14000	L
MACREAU, MICHEL (B. 1935) FRENCH	*1000-40000	X(A)
MACWHIRTER, JOHN (1839-1911) BRITISH	800-22000	L,F
MADDERSTEG, MICHAEL (1659-1709) DUTCH	750-29000	M,L
MADELAIN, GUSTAVE (1867-1944) FRENCH	750-32000	L,F
MADELAIN, GUSTAVE (1867-1944) FRENCH	1000-35000	L,F
MADELINE, PAUL (1863-1920) FRENCH	1200-75000	L,G
MADIOL, ADRIEN JEAN (1845-1892) DUTCH	400-4800	G
MADOU, JEAN BAPTISTE	*200-4200	
MADOU, JEAN BAPTISTE (1796-1877) BELGIAN	800-38000	G,F
MADRASSI, LUCA (19TH C) ITALIAN	400-5000	F
MADRAZO, FEDERICO DE (1815-1894) SPANISH	1500-52000	X
MADRAZO Y GARRETA, RAIMUNDO DE (1841-1920) SPANISH	1500-210000	F,G,S
MADROZO Y GARRETA, RICARDO DE (1852-1917) SPANISH	2000-220000	F,G
MAELLA, MARIANO SALVADO (1739-1819) SPANISH	1500-41000	F,G
MAES, EUGENE REMY (1849-1931) BELGIAN	500-19000	S,L,W
MAES, NICOLAES	*750-16000	
MAES, NICOLAES (1632-1693) DUTCH	10000-+++	F,L,G
MAESTRI, MICHAELANGELO	*200-2400	
MAESTRI, MICHAELANGELO (D. 1812) ITALIAN	300-4500	F,G
MAFAI, MARIO (1902-1965) ITALIAN	850-67000	F,S
MAFFEI, FRANCESCO (1620-1660) ITALIAN	750-20000	F
MAGALHAES, ALOISIO (B. 1927) BRAZILIAN	300-2200	L
MAGANZA, ALESSANDRO (1556-1630) ITALIAN	*300-6000	F
MAGATTI, PIETRO ANTONIO (1687-1768) ITALIAN	400-5300	F
MAGGI, CESARE (1881-1961) ITALIAN	1100-60000	L,F
MAGGIOTTO, DOMENICO (1713-1794) ITALIAN	500-18000	F
MAGGS, JOHN CHARLES (1819-1895) BRITISH	1000-85000	F,W
MAGINI, CARLO (1720-1806) ITALIAN	1200-86000	S
MAGLAI, R. (20TH C) HUNGARIAN	500-4000	L

MAGNASCO, ALESSANDRO (Called LISSANDRINO OR ILLISSANDRO)	*800-26000	
MAGNASCO, ALESSANDRO (Called LISSANDRINO OR ILLISSANDRO) (1667-1749) ITALIAN	2000-88000	L,G
MAGNASCO, STEFANO (1635-1681) ITALIAN	1000-17000	F
MAGNELLI, ALBERTO	*500-36000	
MAGNELLI, ALBERTO (1888-1971) ITALIAN	1200-+++	A
MAGNI, GIUSEPPE (B. 1869) ITALIAN	700-65000	G
MAGNUS, CAMILLE (B. 1850) FRENCH	700-16500	L,G
MAGNUSSON, GUSTAF (1890-1957) SWEDISH	900-11000	F
MAGRATH, WILLIAM (1838-1918) IRISH	300-2000	L,G
MAGRITTE, RENE	*1400-+++	
MAGRITTE, RENE (1898-1967) BELGIAN	10000-+++	A
MAGUIRE, CECIL (20TH C) BRITISH	300-4000	L
MAGUIRE, HELENA (1860-1909) BRITISH	*400-3200	W
MAGUNA, A. (19TH/20TH C) GERMAN	*200-800	X
MAHLKNECHT, EDMUND (1820-1903) AUSTRIAN	1000-35000	L,G
MAHU, CORNELIS (1613-1689) FLEMISH	400-60000	G,M,S
MAIDMENT, HENRY (19TH/20TH C) BRITISH	300-8000	L,W
MAILLAUD, FERNAND	*350-2100	
MAILLAUD, FERNAND (1863-1948) FRENCH	450-18000	L,F
MAILLOL, ARISTIDE	*1000-75000	
MAILLOL, ARISTIDE (1861-1944) FRENCH	500-45000	A
MAINELLA, RAFFAELE	*300-2800	
MAINELLA, RAFFAELE (B. 1858) ITALIAN	200-1000	L
MAINERI, GIOVANNI	*1000-75000	
MAINERI, GIOVANNI (15TH C) ITALIAN	1200-140000	F
MAIRE, ANDRE	*400-6500	
MAIRE, ANDRE (20TH C) FRENCH 500-29000	X?	
MAIROVICH, ZVI (20TH C) ISRAELI	400-3500	X(F)
MAISTRE, ROY DE	*300-8600	
MAISTRE, ROY DE (1894-1968) BRITISH	500-50000	A
MAKART, HANS	*200-6600	
MAKART, HANS (1840-1884) AUSTRIAN	1200-85000	G,F,S,W
MAKILA, OTTO (1904-1955) FINNISH	900-9000	L,F
MAKIN, T.K. (19TH C) BRITISH	200-1000	G
MAKOVSKY, NIKOLAI (1842-1886) RUSSIAN	300-4200	L
MAKOVSKY, VLADIMIR (1846-1920) RUSSIAN	600-29000	G
MAKOWSKY, CONSTANTIN	*150-3200	
MAKOWSKY, CONSTANTIN (1839-1915) RUSSIAN	1500-78000	F,G

* Denotes watercolors, pastels, drawings, and/or mixed media

MAKS, CORNELIS JOHANNES(KEES) (1876-1967) DUTCH	400-12000	G,F
MAKUSCHENKO, CHARLES ALEXI (B. 1827) RUSSIAN	200-3800	X
MALACREA, FRANCESCO (1812-1886) ITALIAN	300-1200	S
MALAINE, JOSEPH LAURENT (1745-1809) FRENCH	500-12000	S
MALATESTA, NARCISO (B. 1835) ITALIAN	300-4500	S
MALAVAL, ROBERT (20TH C) FRENCH	900-24000	X
MALBET, AURELIE LEONTINE (19TH C) AUSTRIAN	350-7200	G
MALBON, WILLIAM (B. 1850) BRITISH	300-3200	L,W
MALECKI, WLADISLAW (1836-1900) POLISH	400-4500	X
MALER, HANS (16TH C) AUSTRIAN	5000-100000	F
MALET, ALBERT (1905-1986) FRENCH	700-25000	L
MALET, GUY (1900-1973) BRITISH	300-5000	F,S
MALEVITCH, KASIMIR (1878-1935) RUSSIAN	*3000-132000	A
MALFAIT, HUBERT (1898-1971) BELGIAN	500-46000	G,F,L,M
MALFROY, CHARLES (B. 1862) FRENCH	300-5200	L
MALFROY, HENRY (B. 1895) FRENCH	400-6000	L,M
MALHERBE, WILLIAM (19TH/20TH C) FRENCH	500-8000	F,S
MALI, CHRISTIAN FRIEDRICH (1832-1906) GERMAN	800-50000	L
MALIAVINE, PHILIPPE	*300-7800	
MALIAVINE, PHILIPPE (1869-1939) RUSSIAN	900-28000	A,F,G,L
MALINCONICO, NICOLA (1654-1721) ITALIAN	650-38000	F
MALKOWSKY, HEINER (B. 1920) GERMAN?	1000-55000	A
MALLEBRANCHE, LOUIS CLAUDE (OR MALBRANCHE) (1790-1838) FRENCH	400-8700	L,G
MALLET, JEAN BAPTISTE	*1000-22000	
MALLET, JEAN BAPTISTE (1759-1835) FRENCH	500-11000	G,F
MALLIA, RENE (1890-1948) FRENCH	300-2800	L
MALMSTROM, AKKE HUGH (1894-1968) SWEDISH	300-3000	L
MALMSTROM, AUGUST (1829-1901) SWEDISH	1600-100000	G,L
MALO, VINCENT (1600-1650) FLEMISH	300-32000	F
MALTA, EDUARDO (1900-1967) PORTUGUESE	200-1000	F
MALTON, JAMES (1761-1803) BRITISH	300-3600	G
MALTON, THOMAS (1748-1804) BRITISH	*500-46000	F
MAMBOUR, AUGUSTE (B. 1896) BELGIAN	300-5200	F
MAN, CORNELIS DE (1621-1706) DUTCH	650-48000	G
MANAGO, VINCENT (1880-1936) ITALIAN	300-5900	G,L
MANCINI, ANTONIO	*500-18000	
MANCINI, ANTONIO (1852-1930) ITALIAN	800-+++	F,L,G
MANCINI, CARLO (1829-1910) ITALIAN	800-18000	L,F

MANCINI, F. FRANCO (Late 19TH C) ITALIAN	*200-1000	X(L)
MANCINI, FRANCESCO GIOVANNI (1829-1905) ITALIAN	400-7000	L,F
MANCINI, GUALTERIO (B. 1840) ITALIAN	300-2200	L
MANDER, KAREL VAN I (1548-1606) DUTCH	1100-93000	F,G
MANDER, KAREL VAN III (1610-1672) DUTCH	650-14000	X
MANDER, WILLIAM HENRY (1850-1922) BRITISH	400-8500	L
MANDEVARE, ALPHONSE N. MICHEL (D. 1829) FRENCH	*300-1800	L
MANDRE, EMILE ALBERT DE (1869-1929) FRENCH	400-2400	F
MANDYN, JAN (1500-1560) DUTCH	1200-65000	F
MANE-KATZ	*500-55000	
MANE-KATZ (1894-1962) FRENCH	3000-195000	A
MANESSIER, ALFRED	*350-15000	
MANESSIER, ALFRED (B. 1911) FRENCH	1200-+++	A
MANET, EDOUARD	*5000-+++	
MANET, EDOUARD (1832-1883) FRENCH	15000-+++	F,L,S,G
MANFREDI, BARTOLOMEO (1580-1620) ITALIAN	2000-68000	F
MANGLARD, ADRIEN (1695-1760) FRENCH	1000-63000	F,L
MANGUIN, HENRI CHARLES	*400-3500	
MANGUIN, HENRI CHARLES (1874-1943) FRENCH	4000-+++	A,F,S
MANKES, J (1889-1920) DUTCH	650-57000	F,L
MANLY, ELEANOR E. (19TH C) BRITISH	*300-2500	L,G
MANN, ALEXANDER (1853-1908) BRITISH	1000-72000	F,L,S
MANN, CATHLEEN (1896-1959) BRITISH	200-2000	S,F
MANN, HARRINGTON (1864-1937) SCOTTISH	650-98000	F
MANNERS, WILLIAM (Active 1884-1910) BRITISH	200-5300	L,W
MANNHEIM, JEAN (1861-1945) GERMAN	400-9000	L,F
MANNI, GIANNICOLA DI PAOLO (1460-1544) ITALIAN	1200-115000	X
MANNLICH, JOHANN (1741-1822) GERMAN	500-18000	G
MANNUCCI, CIPRIANO (B. 1882) ITALIAN	400-2800	G,W
MANSCH, IGNAZ (B. 1867) AUSTRIAN	300-1200	G,F
MANSFELD, HEINRICH AUGUST (1816-1901) AUSTRIAN	400-8400	F,G
MANSFELD, JOSEF (1819-1894) AUSTRIAN	500-6000	S,F
MANSFELD, MORIZ (Late 19TH C) AUSTRIAN	300-2400	S
MANSKIRCH, BERNHARD GOTTFRIED (1736-1817) GERMAN	500-4800	G,L
MANSKIRCH, FRANZ JOSEPH (1770-1830) GERMAN	800-16000	L,F
MANSON, JAMES BOLIVAR	*350-8000	
MANSON, JAMES BOLIVAR (1879-1945) BRITISH	500-14000	S,F,G,L
MANSUROFF, PAVEL (1896-1984) RUSSIAN	10000-60000	A
MANTEGAZZA, GIACOMO (1853-1920) ITALIAN	500-10000	G,F,L

* Denotes watercolors, pastels, drawings, and/or mixed media

MANTEGNA, ANDREA	*8000-+++	
MANTEGNA, ANDREA (1431-1506) ITALIAN	5000-+++	F
MANZANA-PISSARRO, GEORGES	*400-15000	
MANZANA-PISSARRO, GEORGES (1871-1961) FRENCH	500-24000	L,G,F
MANZONI, PIERO	*500-+++	
MANZONI, PIERO (1933-1963) FRENCH	300-25000	F,G
MANZU, GIACOMO (B. 1908) ITALIAN	500-12000	F
MANZUOLI, TOMMASO (1536-1571) ITALIAN	1500-26000	F
MANZUR, DAVID	*350-16000	
MANZUR, DAVID (B. 1929) COLOMBIAN	300-4500	G
MAONTCHENU-LAIVROTTE, JANE DE (19TH C) FRENCH	300-2400	X
MAPPIN, DOUGLAS (19TH/20TH C) BRITISH	*200-1400	L
MARA, POL	*500-4000	
MARA, POL (B. 1920) BELGIAN	900-12000	A
MARAIS, ADOLPHE CHARLES (B. 1856) FRENCH	200-8500	G
MARAIS-MILTON, VICTOR (B. 1872) FRENCH	400-11500	G,F
MARASCHINI, GUISEPPE (B. 1839) ITALIAN	500-6000	F
MARASCO, ANTONIO (B. 1886) ITALIAN	750-43000	G,L
MARATTA, CARLO	*500-25000	
MARATTA, CARLO (1625-1713) ITALIAN	1100-246000	F
MARC, FRANZ	*1500-189000	
MARC, FRANZ (1880-1916) GERMAN	10000-+++	A
MARCEGLIA, F. (19TH C) ITALIAN	300-1200	C
MARCEL-BERONNEAU, PIERRE AMEDEE (1869-1937) FRENCH	2000-55000	F
MARCEL-CLEMENT, AMEDEE JULIEN (B. 1873) FRENCH	650-19000	L,G
MARCENA Y DE GHUY, ANTOINE DE (1724-1811) FRENCH	600-20000	X
MARCH, EDWARD (19TH C) BRITISH	200-850	G
MARCH, VICENTE (B. 1859) SPANISH	2000-18000	G,F
MARCHAIS, JEAN BAPTISTE ETIENNE (B. 1818) FRENCH	300-2500	X
MARCHAND, ANDRE (B. 1907) FRENCH	700-16000	X(S)
MARCHAND, JEAN (18TH C) FRENCH	1000-16000	L,S
MARCHAND, JEAN HIPPOLYTE	* 200-1800	
MARCHAND, JEAN HIPPOLYTE (1883-1940) FRENCH	400-5500	L,F
MARCHESI, GIRALAMO (1471-1550) ITALIAN	4000-+++	F
MARCHESI, GIUSEPPE (Called IL SANSONE) (1699-1771) ITALIAN	500-32000	F
MARCHESI, SALVATORE (1852-1926) ITALIAN	1000-15000	F,L
MARCHETTI, LUDOVICO	*300-6500	
MARCHETTI, LUDOVICO (1853-1909) ITALIAN	1500-110000	F
MARCHI, VINCENTE	*350-6100	

MARCHI, VINCENTE (1818-1894) ITALIAN	400-5000	F,L
MARCHIG, GIANNINO (B. 1897) ITALIAN	800-12000	X(F)
MARCHISIO, ANDREA (1850-1927) ITALIAN	300-13000	X
MARCKE, EMILE VAN (1797-1839) BELGIAN	300-4000	L
MARCKE, JEAN VAN (1875-1918) FRENCH	400-3800	G
MARCKE DE LUMMEN, EMILE VAN (1827-1890) FRENCH	600-13500	L
MARCKS, ALEXANDER (1864-1909) GERMAN	300-4000	G,M
MARCOLA, MARCO (1740-1793) ITALIAN	650-15000	F,I
MARCOUSSIS, LOUIS	*800-51000	
MARCOUSSIS, LOUIS (1883-1941) FRENCH	1500-+++	A
MARCOUX (19TH C) FRENCH	300-3400	F
MARECHAL, CHARLES (1801-1887) FRENCH	200-1800	L
MARECHAL, JEAN BAPTISTE (Late 18TH C) FRENCH	*400-8800	L
MAREES, HANS VON (1837-1887) GERMAN	500-12000	F
MAREIS, A. (Late 19TH C) DUTCH	400-1800	X
MARESCY, MARIE (20TH C) FRENCH	300-2400	G
MARFAING, ANDRE (B. 1925) FRENCH	1000-18000	A
MARGAT, ANDRE (B. 1903) FRENCH	*300-9000	G
MARGETSON, WILLIAM HENRY (1861-1940) BRITISH	2200-25000	F,G
MARGETTS, MARY (Active 1841-1886) BRITISH	*500-6200	S
MARGOTTE DE QUIVIERES, AUGUSTIN MARIE PAUL (1854-1907) FRENCH	300-2100	X
MARIA, AMRIO DE (1853-1924) ITALIAN	900-9500	M,L
MARIA, FRANCESCO DE (1845-1908) ITALIAN	200-1200	F,G
MARIANI, POMPEO	*350-28000	
MARIANI, POMPEO (1857-1927) ITALIAN	800-23000	F,L,G
MARIANO (B. 1912) CUBAN	*300-2400	G
MARIE-ALIX, ALICE (20TH C) FRENCH	400-5600	F
MARIESCHI, JACOPO (1711-1791) ITALIAN	1200-207000	L
MARIESCHI, MICHELE (1696-1743) ITALIAN	5000-+++	L,M
MARILHAT, PROSPER GEORGES ANTOINE (1811-1847) FRENCH	500-11000	L
MARIN GARCES, ISIDORO (B. 1863) SPANISH	300-1500	X
MARINI, ANTONIO (1788-1861) ITALIAN	900-8000	L
MARINI, MARINO	*800-+++	
MARINI, MARINO (1901-1980) ITALIAN	5000-+++	F,A
MARINI, MARINO (1901-1980) ITALIAN	*1500-+++	A
MARINUS VAN REYMERSWAELE (1493-1597) DUTCH	1000-25000	G
MARIOTTI, LEOPOLDO	*200-800	
MARIOTTI, LEOPOLDO (1848-1916) ITALIAN	200-1400	F

* Denotes watercolors, pastels, drawings, and/or mixed media

MARIOTTO DI NARDO (Active 1394-1424) ITALIAN	1200-35000	F
MARIS, JACOB HENRICUS (1837-1899) DUTCH	1500-88000	L,G,M
MARIS, MATTHIJS (1839-1917) DUTCH	*500-3500	W,F
MARIS, SIMON (1873-1935) DUTCH	300-2700	G,F
MARIS, WILLEM	*200-3600	
MARIS, WILLEM (1844-1910) DUTCH	400-14000	L,W
MARK, LAJOS (OR LOUIS) (1867-1942) HUNGARIAN	300-3400	X
MARKES, ALBERT ERNEST (1865-1901) BRITISH	*300-2000	M,L
MARKINO, YOSHIO (B. 1874) BRITISH	*800-6000	F,L
MARKO, ANDREAS (1824-1895) AUSTRIAN	400-16000	L,G,W
MARKO, KARL (1822-1891) HUNGARIAN	400-16000	L,G
MARKS, HENRY STACY	*200-4000	
MARKS, HENRY STACY (1829-1898) BRITISH	600-9500	F,G
MARKS, HENRY STACY (1829-1898) BRITISH	400-4000	F
MARLIER, PHILIPPE DE (1573-1668) FLEMISH	2000-75000	S,F
MARLOW, WILLIAM	*250-3600	
MARLOW, WILLIAM (1740-1813) BRITISH	800-70000	L
MARNY, PAUL (1829-1914) BRITISH	*300-3300	F,L
MAROHN, FERDINAND (19TH C) FRENCH	300-2400	G,F
MAROLD, LUDWIG (1865-1898) AUSTRIAN	*200-1000	G,L
MARON, ANTON VON (1733-1808) AUSTRIAN	1200-73000	F
MARONIEZ, GEORGES PHILIBERT CHARLES (1865-1933) FRENCH	300-7900	L,M
MAROT, DANIEL (1663-1752) FRANCO/DUTCH	*400-5000	G
MAROT, FRANCOIS (1666-1719) FRENCH	500-12000	F
MARQUET, ALBERT	*700-196000	
MARQUET, ALBERT (1875-1947) FRENCH	5000-+++	A,L,S,F
MARQUIS, EDOUARD (1812-1894) FRENCH	*400-3000	L
MARR, CARL RITTER VON (1858-1936) GERMAN	500-4500	F
MARR, J W HAMILTON (B. 1846) BRITISH	600-5000	M
MARREL, JACOB	*500-25000	
MARREL, JACOB (1614-1681) DUTCH	4000-242000	S
MARSELLA, G. (Late 19TH C) ITALIAN	300-1200	X
MARSHALL, BEN (1767-1835) BRITISH	5000-+++	F,W
MARSHALL, HERBERT MENZIES (1841-1913) BRITISH	500-10000	L
MARSHALL, HERBERT MENZIES (1841-1913) BRITISH	*500-7000	L
MARSHALL, J. FITZ (19TH C) BRITISH	400-3200	S,G
MARSHALL, JOHN (1840-1896) BRITISH	500-11000	M
MARSHALL, LAMBERT (1810-1870) BRITISH	600-17000	L,W
MARSHALL, ROBERT ANGELO KITTERMASTER (1849-1902) BRITISH	500-4000	L

MARSHALL, THOMAS FALCON (1818-1878) BRITISH	500-21000	L,G
MARSTRAND, WILHELM (1810-1873) DANISH	600-28000	G,L,F
MARTEAU, AUGUSTO (B. ARGENTINA 1890	200-1000	G
MARTEN, ELLIOT H. (Late 19TH C) BRITISH	*200-1200	L
MARTENS, CONRAD (D. 1878) BRITISH	*600-130000	L,M
MARTENS, JOHANN HEINRICH (1815-1843) GERMAN	200-2300	X
MARTENS, WILLY (1856-1927) DUTCH	300-5000	G
MARTEROSOV, L. (19TH/20TH C) RUSSIAN	300-1500	G
MARTI Y ALSINA, RAMON (1826-1894) SPANISH	500-1500	L,F
MARTIN, AGNES	*700-120000	
MARTIN, AGNES (B. 1912) CANADIAN	1200-132000	G,L
MARTIN, ANSON A. (Active 1840-1861) BRITISH	500-20000	L,G,F,W
MARTIN, DAVID (1736-1798) BRITISH	1000-50000	F,M
MARTIN, FRITZ (1859-1889) GERMAN	400-6800	F,G
MARTIN, HENRI JEAN GUILLAUME (Called HENRI MARTIN) (1860-1943) FRENCH	3500-+++	L,G,F
MARTIN, HENRY J (19TH C) CANADIAN	*400-3500	L
MARTIN, J.R. (19TH C) EUROPEAN	750-30000	X
MARTIN, JACQUES (1844-1919) FRENCH	800-9500	S,F
MARTIN, JOHN	*2000-132000	
MARTIN, JOHN (1789-1854) BRITISH	6000-+++	L,F,S
MARTIN, JULES LEON GABRIEL ALEXANDRE (19TH C) FRENCH	200-1000	G
MARTIN, PAUL (1821-1901) GERMAN	*400-2000	X
MARTIN, PIERRE (19TH C) FRENCH	500-8000	L
MARTIN, SYLVESTER (19TH C) BRITISH	800-10000	G,W
MARTIN, THOMAS MOWER (1838-1934) CANADIAN	1500-45000	L,F
MARTIN, W. (19TH C) BRITISH	300-1400	L
MARTIN-FERRIERES, JACQUES (1893-1974) FRENCH	700-30000	L,G
MARTINEAU, GERTRUDE (Late 19TH C) BRITISH	300-4200	G,F
MARTINEAU, LOUIS JOSEPH PHILADELPHE (1800-1868) FRENCH	300-3200	W
MARTINEAU, ROBERT (1826-1869) BRITISH	400-6800	F,G
MARTINEAUX, EDITH (1842-1909) BRITISH	*200-5500	L,F,S
MARTINELLI, GIOVANNI (1610-1659) ITALIAN	2000-41000	F
MARTINELLI, LUDWIG (B. 1834) AUSTRIAN	200-1800	X
MARTINET, ACHILLE LOUIS (1806-1877) FRENCH	*300-2000	X
MARTINETTI, ANGELO (19TH C) ITALIAN	400-15000	W
MARTINETTI, MARIA (B. 1864) ITALIAN	*300-6000	G,L
MARTINEZ, ALFREDO RAMOS	*200-5000	
MARTINEZ, ALFREDO RAMOS (1872-1946) MEXICAN	850-46200	F,S

MARTINEZ, FRANCISCO (Active 1718-1755) MEXICAN	500-9000	F
MARTINEZ, J. (19TH C) DUTCH	300-1500	L
MARTINEZ, JULIAN (1897-1944) AMERICAN/PUEBLO	*400-2500	F
MARTINEZ, RICARDO	*300-5500	
MARTINEZ, RICARDO (B. 1918) MEXICAN	700-32000	S,F
MARTINEZ, XAVIER	*300-1800	
MARTINEZ, XAVIER (1874-1943) MEXICAN	400-9000	L,G
MARTINEZ-PEDRO, LUIS	*250-5000	
MARTINEZ-PEDRO, LUIS (20TH C) CUBAN	300-5200	G,A
MARTINI, ALBERTO (B. 1876) ITALIAN	350-18000	F,G
MARTINI, I.R.J. (20TH C) ITALIAN	400-3000	G
MARTINI, SANDRO (B. 1941) ITALIAN	81000-20000	A
MARTINI, SIMONI (14TH C) ITALIAN	750-78000	F
MARTINO, DI BARTOLOMEO DI BIAGIO (15TH C) ITALIAN	700-62000	F
MARTINO, EDOUARDO (1838-1912) ITALIAN	200-2600	M
MARTINO, M. (19TH/20TH C) ITALIAN	*200-1200	X
MARTTINEN, VELKKO (B. 1917) FINNISH	1000-9000	X
MARUSSIG, PIERO (1879-1937) ITALIAN	4000-178000	L
MARVAL, JACQUELINE	*250-1400	
MARVAL, JACQUELINE (1866-1932) FRENCH	500-28000	S,F,L
MARX, ALPHONSE (19TH C) FRENCH	300-3800	F
MARX, ROBERTO BURLE (1909-1982) BRAZIL	400-5500	S
MARYAN, BURSTEIN PINCHAS (1927-1977) AMERICAN	2000-25000	A
MARZELLE, JEAN (B. 1916) FRENCH	300-2500	X(S,L)
MARZELLI, F. (19TH C) ITALIAN	300-1500	L
MARZOTINO, S. (19TH C) ITALIAN	300-2500	X
MAS Y FONDEVILA, ARCADIO (1852-1934) SPANISH	4000-40000	G,F,L
MAS Y FONDEVILA, ARTURO (B. 1850) SPANISH	650-33000	G,L
MASCART, GUSTAVE (Late 19TH C) FRENCH	300-7300	L
MASEREEL, FRANS	*300-11000	
MASEREEL, FRANS (1889-1972) BELGIAN	400-8800	A
MASON, FRANK H	*400-6700	
MASON, FRANK H (1876-1965) BRITISH	700-7000	M
MASON, GEORGE HEMNING (1818-1872) BRITISH	650-16000	L,W
MASQUERIER, JOHN JAMES (1778-1855) BRITISH	300-3800	F
MASSANI, POMPEO (1850-1920) ITALIAN	400-15000	G,F
MASSARI, LUCIO (1569-1633) ITALIAN	500-8500	G,F
MASSE, JEAN BAPTISTE (1687-1767) FRENCH	500-6200	F,G
MASSENET, ADELAIDE (19TH C) FRENCH	300-2500	X(S)

MASSON, ANDRE	*600-110000	
MASSON, ANDRE (B. 1896) FRENCH	3500-+++	A
MASSON, HENRI LEOPOLD (B. 1907) CANADIAN	500-7200	L,S,G
MASSON, MARCEL (20TH C) FRENCH	500-7800	M,S,L
MASSON, PAUL (1883-1970) BELGIAN	300-2400	G
MASSONI, EGISTO (1854-1929) ITALIAN	500-14000	G,M
MASSOT, FIRMIN (1766-1849) SWISS	500-157000	F
MASSYS, CORNELIS (1508-1580) FLEMISH	1500-18000	F,L
MASSYS, JAN (1505-1575) FLEMISH	650-10000	F,G
MASTENBROEK, JOHAN HENDRIK VAN	*300-4800	
MASTENBROEK, JOHAN HENDRIK VAN (1875-1945) DUTCH	700-45000	L,S,M
MASTROIANNI, UMBERTO (B. 1910) ITALIAN	800-12000	A
MASUREL, JOHANNES ENGEL (1826-1915) DUTCH	800-5000	F
MASWIENS, J. (1828-1880) BELGIAN	400-1600	F
MATANIA, FORTUNINO (B. 1881) ITALIAN	400-5000	L,F
MATHER, JOHN (1848-1916) BRITISH	*300-4000	L,M
MATHER, SYDNEY (20TH C) AUSTRALIAN	300-4000	L
MATHEWS, JOHN CHESTER (Late 19TH C) BRITISH	400-8000	X
MATHIESEN, EGON (1907-1976) DANISH	1000-10000	A
MATHIEU, ANNA ROSINA (NEE LISZEWSKA (1716-1783) GERMAN	400-4000	F
MATHIEU, GEORGES	*200-27000	
MATHIEU, GEORGES (B. 1921) FRENCH	1200-160000	A
MATHIEU, PAUL (1872-1932) BELGIAN	1000-65000	L
MATHON, EMIL LOUIS (19TH C) FRENCH	200-2100	F
MATILLA Y MARINA, SEGUNDO (1842-1923) SPANISH	1500-65000	L
MATISSE, HENRI	*5000-+++	
MATISSE, HENRI (1869-1954) FRENCH	10000-+++	A,L,F
MATSCH, FRANZ VON (1861-1942) AUSTRIAN	800-14000	S,F
MATTA, ROBERTO ECHAURREN	*2500-170000	
MATTA, ROBERTO ECHAURREN (B. 1912) CHILEAN	6000-+++	A
MATTEIS, PAOLO DI (1662-1728) ITALIAN	1000-35000	F
MATTENHEIMER, ANDREAS THEODOR (1752-1810) GERMAN	300-2600	S
MATTHEWS, JAMES (19TH C) BRITISH	*300-3000	L
MATTHEWS, MARMADUKE (1837-1913) CANADIAN	300-5000	L
MATTIOLI, CARLO (B. 1911) ITALIAN	*400-4500	X
MATULKA, JAN	*300-5400	
MATULKA, JAN (1890-1969) CZECHOSLOVAKIAN	500-8000	A
MATVEIEV, NICOLAI SERGEIEVICH (B. 1855) RUSSIAN	400-6000	X
MAUCH, RICHARD (1874-1921) AUSTRIAN	400-5000	A

* Denotes watercolors, pastels, drawings, and/or mixed media

MAUFRA, MAXIME EMILE LOUIS	*400-9800	
MAUFRA, MAXIME EMILE LOUIS (1861-1918) FRENCH	1500-95000	L,M
MAULBERTSCH, FRANZ ANTON (1742-1796) AUSTRIAN	2000-97000	F
MAURIN, CHARLES	*450-23500	
MAURIN, CHARLES (1856-1914) FRENCH	400-4800	F,G
MAURUS, HANS (1901-1942) GERMAN	200-3200	L
MAURY, FRANCOIS (1861-1933) FRENCH	300-4700	L,S
MAUVE, ANTON	*200-6500	
MAUVE, ANTON (1838-1888) DUTCH	750-32000	L,G,W
MAUVE, ANTON RUDOLF (1876-1962) DUTCH	300-6800	X
MAUZAISSE, JEAN BAPTISTE (1784-1844) FRENCH	400-4000	G,F
MAVROGORDATO, ALEXANDER J. (19TH/20TH C) RUSSIAN	*300-2200	G,L
MAVRY, F. (19TH C) FRENCH	300-1800	X
MAX, GABRIEL CORNELIUS VON (1840-1915) CZECHOSLOVAKIAN	950-88000	F,G
MAX, PETER	*200-850	
MAX, PETER (B. 1937) GERMAN/AMERICAN	300-1200	X
MAX-EHRLER, LUISE (B. 1850) ITALIAN	500-14000	F,G,S
MAXENCE, EDGARD	*1000-25000	
MAXENCE, EDGARD (1871-1954) FRENCH	1500-62000	S,F,G
MAY, EDWARD HARRISON (1824-1887) BRITISH	200-2000	F
MAY, OLIVER LE (1834-1879) FRENCH	400-4200	F
MAY, PHIL (1864-1903) BRITISH	*200-1200	I
MAY, WALTER WILLIAM (1831-1896) BRITISH	*400-2500	L,M,G
MAYER, CHRISTIAN (1812-1870) AUSTRIAN	500-6200	F
MAYER, CONSTANCE	*300-2800	
MAYER, CONSTANCE (1775-1821) FRENCH	650-8200	F,G,S
MAYER, ERICH (1876-1960) SOUTH AFRICAN	*900-8000	L,F
MAYER, FRIEDRICH CARL (1824-1903) GERMAN	900-6500	L,F
MAYER, LUIGI (19TH C) ITALIAN	*400-120 0	L
MAYER-CLEMY, E. (19TH C) GERMAN	300-1800	X
MAYES, WILLIAM EDWARD (1861-1952) BRITISH	*400-2000	L
MAYNO, JUAN BAUTISTA (1569-1649) SPANISH	900-15000	F
MAYOR, L. (19TH C) BRITISH	200-1000	X
MAYR, HEINRICH VON (1806-1871) GERMAN	500-14000	G
MAYR-GRAZ, CARL (1850-1929) GERMAN	600-5500	G,F
MAYRE, C. (19TH C) DUTCH	300-3000	G
MAYRHOFER, JOHANN NEPOMUK (1764-1832) AUSTRIAN	1500-42000	S
MAZA, FERNANDO (B. ARGENTINA 1936)	300-2400	A

MAZE, PAUL	*300-9700	
MAZE, PAUL (1887-1979) FRENCH	400-14000	L,F
MAZINI (19TH C) ITALIAN	*500-6000	X
MAZZOLA, FRANCESCO (1503-1540) ITALIAN	*4000-+++	F
MAZZOLA, GIROLAMO BEDOLI (1500-1569) ITALIAN	5000-+++	F
MAZZOLINI, GIUSEPPE (1748-1838) ITALIAN	750-13000	F,G
MAZZOLINO, LUDOVICO (1480-1528) ITALIAN	5000-205000	F,L
MAZZONI, SEBASTIANO (D. 1683) ITALIAN	2500-228000	F
MAZZOTTA, FEDERICO (19TH C) ITALIAN	1200-28000	G
MAZZUCHELLI, PIETRO F. (1571-1626) ITALIAN	1000-64000	F
MAZZUOLI, GIUSEPPE (1644-1725) ITALIAN	750-15000	F
MCALPINE, WILLIAM (19TH C) BRITISH	500-5500	M
MCAULAY, CHARLES (20TH C) BRITISH?	6700-7500	G,F,L
MCBEY, JAMES (1889-1959) BRITISH	400-8400	L,F
MCBRIDE, HENRY (19TH C) BRITISH	*200-800	X
MCCALLUM, ANDREW (1821-1902) BRITISH	400-20000	L
MCCLOY, SAMUEL (1831-1904) BRITISH 400-4500	G,F	
MCCOLVIN, JOHN (19TH C) BRITISH	200-800	X
MCCORMICK, ARTHUR DAVID	*250-3000	
MCCORMICK, ARTHUR DAVID (1860-1943) BRITISH	400-6500	F,G
MCCUBBIN, FREDERICK (1855-1917) AUSTRALIAN	5000-+++	L
MCCULLOCH, HORATIO (1805-1867) SCOTTISH	400-9400	L
MCDONALD, JOHN BLAKE (1829-1901) SCOTTISH	300-1200	F,L,G
MCDOUGAL, JOHN (1877-1941) BRITISH	*300-3300	L
MCEVOY, AMBROSE	*400-12000	
MCEVOY, AMBROSE (1878-1927) BRITISH	400-23000	F,M
MCEWAN, THOMAS (1861-1914) BRITISH	300-7100	G
MCEWEN, JEAN (B. 1923) CANADIAN	1000-25000	A
MCFARLANE, DAVID (Active 1840-1866) BRITISH	650-20000	M
MCGHIE, JOHN (1867-1941) BRITISH	800-15000	M,F,G
MCGILLIVARY, FLORENCE HELENA (B. 1864) CANADIAN	200-1000	M
MCGONIGAL, MAURICE (B. 1900) BRITISH	1000-39000	X
MCGREGOR, D. M. (19TH C) SCOTTISH	200-850	X
MCGREGOR, ROBERT (1848-1922) BRITISH	600-18000	F,L
MCGREGOR, SARAH (19TH/20TH C) BRITISH	200-2000	G,F
MCGUINNESS, NORAH (B. 1903) BRITISH	1000-27000	L,S
MCINNES, WILLIAM BECKWITH (1889-1939) AUSTRALIAN	800-4700	X
MCINTYRE, JAMES (Late 19TH C) BRITISH	300-2200	G,L
MCINTYRE, JOSEPH WRIGHTSON (19TH C) BRITISH	350-8000	L,M

MCINTYRE, PETER (B. 1910) NEW ZEALANDER	600-3500	M,F
MCKELVEY, FRANK (1895-1974) BRITISH	400-50000	L,S,M
MCKENZIE, WILLIAM (19TH C) BRITISH	200-1000	F,L
MCKEWAN, DAVID HALL (1816-1873) BRITISH	*200-3800	L,G,F
MCLEA, J. W. (19TH C) SCOTTISH	300-1000	L
MCLEAY, MACNEIL (19TH C) SCOTTISH	300-2400	L
MCMINN, WILLIAM KIMMINS (Active 1854-1880) BRITISH	400-3900	M
MCNALLY, MATTHEW (1874-1943) AUSTRALIAN	200-1800	L
MCTAGGART, SIR WILLIAM (1903-1981) BRITISH	500-25000	L,M,F
MCTAGGART, WILLIAM (1835-1910) BRITISH	800-80000	F,L,S
MEADOWS, ARTHUR JOSEPH (1843-1907) BRITISH	500-20000	L
MEADOWS, EDWIN L. (Active 1854-1872) BRITISH	650-16000	L,W
MEADOWS, JAMES (1798-1864) BRITISH	400-12000	M
MEADOWS, JAMES EDWIN (1828-1888) BRITISH	900-35000	L,G,M
MEADOWS, JASON E. (19TH C) BRITISH	200-2800	G,F
MEADOWS, WILLIAM (19TH C) BRITISH	300-5500	L,F
MEAKIN, LOUIS HENRY (1853-1917) BRITISH	500-12000	L
MEARNS, A. (Active 1855-1866) BRITISH	650-6000	W
MEARS, GEORGE (19TH C) BRITISH	500-5500	M
MECHBERG, LEV (20TH C) RUSSIAN	200-1000	X
MECKEL, ADOLPH VON (1856-1893) GERMAN	650-16000	G
MECKLENBURG, LUDWIG (1820-1882) GERMAN	300-5000	L
MEDARD, EUGENE (1847-1897) FRENCH	300-2800	F
MEDINA, SIR JOHN (1660-1711) SCOTTISH	500-75000	F
MEDIZ, KARL (B. 1868) AUSTRIAN	900-18000	F,L
MEDIZ-PELIKAN, EMILE (1861-1908) GERMAN?	1000-35000	L,F
MEDLYCOTT, THE REV. SIR HUBERT JAMES (1841-1920) BRITISH	*200-3300	L
MEDNYANSZKY, BARON LASZLO (1852-1919) AUSTRIAN	300-2200	L,M
MEEN, MARGARET (18TH/19TH C) BRITISH	300-1200	L
MEER, BAREND VAN DER (B. 1659) DUTCH	1100-69000	S
MEERHOUT, JAN (D. 1677) DUTCH	500-13000	L
MEERTENS, ABRAHAM (1757-1823) DUTCH	*300-2000	W
MEERTS, FRANZ (1836-1896) BELGIAN	400-15000	G,F
MEHEUT, MATHURIN (1882-1958) FRENCH	*400-4000	X
MEHUS, LIVIO (1630-1691) FLEMISH	1000-18000	F
MEI, BERNARDINO (1615-1676) ITALIAN	4000-65000	F
MEID, HANS (B. 1883) GERMAN	800-15000	G,F,L
MEIDE, J. L. VAN DER (20TH C) BELGIAN	200-850	L
MEIDNER, LUDWIG	*400-25000	

MEIDNER, LUDWIG (1884-1966) GERMAN	1200-48000	F,L
MEIFREN Y ROIG, ELISEO (1859-1940) SPANISH	5000-+++	G,F,L
MEIJER, ANTHONY ANDREAS (1806-1867) DUTCH	300-7400	L,F
MEIJER, GERHARDUS (1816-1875) DUTCH	200-4400	X
MEIN, ETIENNE JOSEPH (B. 1865) FRENCH	200-1200	L,F
MEINDL, ALFRED (20TH C) AUSTRIAN	200-1000	L,M
MEINERS, PIETER (1857-1903) DUTCH	200-800	L
MEINZOLT, GEORG (B. 1863) GERMAN	700-3500	M
MEIREN, JAN BAPTISTE VAN DER (1664-1708) FLEMISH	750-24000	L,G,M
MEISEL, ERNST (1838-1895) GERMAN	500-11000	G
MEISSEL (19TH C) GERMAN	400-2200	X
MEISSIONIER, JEAN CHARLES (1848-1917) FRENCH	500-50000	G,F
MEISSNER, ADOLF ERNST (1837-1902) GERMAN	800-27000	L
MEISSONIER, JEAN LOUIS ERNEST	*200-2800	
MEISSONIER, JEAN LOUIS ERNEST (1815-1891) FRENCH	2000-150000	F,G
MEISTER, ERNST (19TH C) GERMAN	400-4500	F
MEISTER, OTTO (1887-1969) SWISS	300-2500	L
MEIXNER, LUDWIG (1828-1885) GERMAN	300-5000	L,G
MELBY, F. G. (19TH C) DANISH	500-4800	M
MELBYE, ANTON (1818-1875) DANISH	600-6500	M
MELBYE, DANIEL HERMANN ANTON (1818-1875) DANISH	500-6500	L,M
MELBYE, WILHELM (1824-1882) DANISH	500-31000	M,L
MELCHER, JACOB (1816-1882) GERMAN	200-2000	X(G)
MELCHER, TILMES JAN HERMANUS (1847-1920) DUTCH	200-2400	L,G
MELDRUM DUNCAN MAX (1875-1955) AUSTRALIAN	1000-22000	L
MELENDEZ, LUIS (1716-1780) SPANISH	5000-+++	S
MELIDA Y ALINARI, DON ENRIQUE (1834-1892) SPANISH	400-3000	F
MELIN, JOSEPH HERBAIN (1814-1886) FRENCH	200-800	W
MELIS, HENRICUS JOHANNES (1845-1923) DUTCH	500-6500	G
MELLERY, XAVIER	*400-20000	
MELLERY, XAVIER (1845-1921) BELGIAN	400-11000	G
MELLING, ANTOINE IGNACE (1763-1831) FRENCH	*750-18000	L
MELLINI, PAULO (19TH/20TH C) ITALIAN	200-1000	L
MELLISH, THOMAS (Active 1740-1766) BRITISH	800-20000	M
MELLON, CAMPBELL (1876-1955) BRITISH	300-3500	M
MELLOR, EVERETT W (1878-1965) BRITISH	800-6500	M,L
MELLOR, WILLIAM (1851-1931) BRITISH	400-11000	L,W
MELLSTROM, ROLF (1896-1953) SWEDISH	400-6830	W,L
MELONI, ALTOBELLO (15TH/16TH C) ITALIAN	1200-78000	F

* Denotes watercolors, pastels, drawings, and/or mixed media

MELONI, GINO (B. 1905) ITALIAN	600-6500	X(F)
MELOTTI, FAUSTO (B. 1901) ITALIAN	*300-8200	X(A)
MELVILLE, ARTHUR	*200-45000	
MELVILLE, ARTHUR (1855-1904) BRITISH	400-7800	L,G
MELVILLE, HARLAND (19TH C) BRITISH	200-1500	L,G
MELZER, A. (19TH C) GERMAN	300-1800	L
MELZER, FRANCISCUS (B. 1808) BELGIAN	400-3200	G
MEMLING, HANS (D. 1494) FLEMISH	1200-75000	F
MEMPES, MORTIMER L. (1859-1938) BRITISH	500-6200	G,F
MEMPRES, ADRIAN LAYEUR DE (B. 1844) BELGIAN	300-2800	X
MENABONI, ATHOS (B. 1895) ITALIAN/AMERICAN	400-3700	X
MENARD, MARIE AUGUSTE EMILE RENE (1862-1930) FRENCH	400-12000	L,F
MENARD, VICTOR PIERRE (B. 1857) FRENCH	300-1400	G
MENDELSON, MARC (B. 1915) BELGIAN	1000-18000	L,S
MENDES, JULES EDUARD (1862-1920) DUTCH	400-3500	F,G
MENDJINSKY, SERGE (B. 1929) FRENCH	450-30000	L,F
MENDOZA, ESTEBAN (17TH C) SPANISH	200-850	X
MENDOZA, PEDRO (Active 1593-1597) SPANISH	300-1000	X
MENEGHINI, MATTEO (1840-1925) ITALIAN	*400-5000	F
MENESCARDI, GIUSTINO (D. 1720) ITALIAN	400-7000	F
MENGS, ANTON RAPHAEL (1728-1779) GERMAN	1200-95000	F
MENINSKY, BERNARD	*100-4900	
MENINSKY, BERNARD (1891-1950) BRITISH	200-4900	L,F
MENKES, SIGMUND (or ZYGMUNT) (B. 1896) POLISH	300-8500	G,F,S
MENN, BARTHELEMY (1815-1893) SWISS	500-15000	F,L
MENOCAL, ARMANDO (1863-1942) CUBAN	300-4000	G
MENOTTI, P. (19TH C) ITALIAN	400-2800	G,L
MENOTTI, V. A. (19TH C) ITALIAN	400-2500	X
MENSE, CARLO (1886-1965) GERMAN	650-15000	L,F
MENZEL, ADOLF FRIEDRICH ERDMANN	*1000-75000	
MENZEL, ADOLF FRIEDRICH ERDMANN (1815-1905) GERMAN	1200-60000	L,G,F
MENZLER, WILHELM (B. 1846) GERMAN	400-8900	F,G
MER, GERRET DE (17TH C) DUTCH	300-1800	X
MERA, PIETRO (16TH/17TH C) FLEMISH	300-3600	G,F
MERCIE, MARIUS JEAN ANTONIN (1845-1916) FRENCH	750-8200	L,F
MERCIER, CHARLOTTE (D. 1762) BRITISH	*850-24000	F
MERCIER, PHILIPPE (1689-1760) FRENCH	1500-85000	G,F
MERCK, JACOB FRANS VAN DER (1610-1664) DUTCH	650-12000	F,G
MERIDA, CARLOS	*750-75000	

MERIDA, CARLOS (1891-1984) MEXICAN	800-35000	A
MERINO, IGNACIO (1818-1876) PERUVIAN/FRENCH	750-16500	X
MERIOT, R. (19TH C) FRENCH	200-1000	X
MERKER, MAX (1861-1928) GERMAN	300-4800	G
MERLE, GEORGES HUGUES (19TH C) FRENCH	400-8000	G,L
MERLE, HUGUES (1823-1881) FRENCH	500-25000	F,G
MERLIN, DANIEL (1861-1933) FRENCH	300-6500	G
MERODE, CARL VON (1853-1909) AUSTRIAN	2000-10000	F,G
MERTENS, BRUNO (B. 1914) DUTCH	300-1000	X
MERTENS, CHARLES (1865-1919) BELGIAN	400-5500	G,F
MERTENS, JACOB (16TH C) BELGIAN	750-8000	X
MERTON, ERLING (1898-1967) NORWEGIAN	700-6000	M,F
MERTZ, JOHANN CORNELIS (1819-1891) DUTCH	400-3800	G,F
MERZ, MARIO (B. 1925) ITALIAN	*2000-155000	A
MESCHERSKY, ARSENII IVANOVICH (1834-1902) RUSSIAN	900-3500	L
MESDACH, SALAMON (17TH C) DUTCH	400-6000	F
MESDAG, HENDRIK WILLEM	*500-22000	
MESDAG, HENDRIK WILLEM (1831-1915) DUTCH	1000-93000	M,L,F
MESDAG, HENDRIK-WILLEM (1831-1915) DUTCH	2000-100000	M
MESENS, E. L. T. (1903-1971) BELGIAN	*300-1800	G,A
MESGRIGNY, FRANK DE	*300-1200	
MESGRIGNY, FRANK DE (1836-1884) FRENCH	500-10000	G,L
MESLE, JOSEPH PAUL (1855-1929) FRENCH	300-1200	L
MESMER, G. (19TH C) SWISS	400-2000	L
MESPLES, PAUL EUGENE (B. 1849) FRENCH	300-1500	L
MESSAGIER, JEAN	*300-16000	
MESSAGIER, JEAN (B. 1920) FRENCH	650-72000	A
MESSEL, OLIVER (20TH C) BRITISH	*300-6000	F,I
MESZOLY, GEZA VON (1844-1887) HUNGARIAN	400-3500	G,L
METEYARD, SIDNEY HAROLD	*300-9000	
METEYARD, SIDNEY HAROLD (1868-1947) BRITISH	1200-104000	F,G
METHUEN, LORD (B. 1886) BRITISH	400-3500	L
METSU, GABRIEL (1629-1667) DUTCH	1000-+++	F,G
METSYS, CORNELIS (1508-1580) FLEMISH	750-47000	L,F
METSYS, JAN (1509-1575) FLEMISH	1200-55000	F,G
METSYS, QUENTIN (1466-1530) FLEMISH	1000-+++	F
METTLING, LOUIS (1847-1904) FRENCH	750-7800	G,F,S
METVEEF, FEDOR (19TH C) RUSSIAN	300-2600	X
METZ, JOHANN MARTIN (1717-1790)GERMAN	500-14000	S,F,L

METZINGER, JEAN	*750-+++	
METZINGER, JEAN (1883-1956) FRENCH	2500-+++	A
MEUCCI, MICHELANGELO (19TH C) ITALIAN	300-3900	L,S
MEULEMANS, ADRIAN (1766-1835) DUTCH	1000-12000	F,G
MEULEN, ADAM FRANS VAN DER	*800-25000	
MEULEN, ADAM FRANS VAN DER (1632-1690) BELGIAN	1000-95000	L,F
MEULENER, PIETER (1602-1654) DUTCH	650-35000	L,F
MEUNIER, CONSTANTIN (1831-1905) BELGIAN	300-4500	G,F
MEURIS (19TH C) BELGIAN	*300-5400	L
MEURON, ALBERT DE (1823-1897) SWISS	300-5500	L
MEURON, LOUIS DE (1868-1939) SWISS	800-8500	F,L
MEURS, HARMEN (1891-1964) DUTCH	400-3200	F,M
MEYBODEN, HANS (1901-1965) GERMAN	500-3500	X
MEYER, AUGUST EDUARD NICOLAUS (1856-1919) GERMAN	400-8500	G
MEYER, CARL VILHELM (1870-1938) DANISH	1000-5000	F,G
MEYER, EMILE (19TH C) FRENCH	650-19000	G
MEYER, ERNST (17960-1861 DANISH	600-15000	L,F
MEYER, ERNST LUDOLF (B. 1848) GERMAN	400-2400	F
MEYER, GEORGE FRIEDRICH (1735-1779) GERMAN	500-4800	G
MEYER, GILLES DE (1780-1867) DUTCH	300-850	X
MEYER, GUILLAUME (19TH C) FRENCH	300-3000	X
MEYER, HENDRIK DE (II) (1737-1793) DUTCH	1000-82000	L,M
MEYER, HENDRIK DE I (1600-1690) DUTCH	5000-100000	M
MEYER, JOHANN HEINRICH LOUIS (1806-1866) DUTCH	600-33000	M
MEYER, JOHANN JAKOB (1787-1858) SWISS	*400-21000	L
MEYER, LOUIS (1809-1866) DUTCH	800-5000	M
MEYER, SAL (1877-1965) DUTCH	400-8500	L
MEYER VON BREMEN, JOHANN GEORG	*400-4200	
MEYER VON BREMEN, JOHANN GEORG (1813-1886) GERMAN	1200-45000	F
MEYER-WALDECK, KUNZ (1859-1953) GERMAN	500-4800	M
MEYER-WISMAR, FERDINAND (1833-1917) GERMAN	650-8500	G
MEYERHEIM, FRIEDRICH EDOUARD (1808-1879) GERMAN	750-28000	G,F
MEYERHEIM, HERMANN (1840-1880) GERMAN	800-24000	L,M
MEYERHEIM, PAUL FRIEDRICH (1842-1915) GERMAN	500-15000	G,L,W
MEYERHEIM, PAUL WILHELM (Late 19TH C) GERMAN	400-7800	L
MEYERHEIM, WILHELM ALEXANDER (1814-1882) GERMAN	600-16500	G,M,F
MEYERHEM, M. (19TH C) DUTCH	400-3200	G
MEYERING, ALBERT (1645-1714) DUTCH	600-18000	L,F
MEYERS, A. (19TH C) BRITISH	300-1200	F

MEYLIES, J. (19TH C) BELGIAN	200-800	X
MEZA, GUILLERMO	*300-3200	
MEZA, GUILLERMO (B. 1917) MEXICAN	400-5000	F,G
MEZA, JOSE REYES (B. 1924) MEXICAN	200-850	X
MEZZARA, FRANCOIS (19TH C) FRENCH	300-3000	X
MICALI, GUISEPPE (B. 1866) ITALIAN	*300-1200	X
MICALI, L. (19TH C) ITALIAN	400-3800	G
MICHAELS, MAX (1823-1891) GERMAN	500-8600	F
MICHALONSKI, HERMAN (19TH C) GERMAN	300-1400	F
MICHALOWSKI, PIOTR (1800-1855) POLISH	*300-2000	X
MICHAU, THEOBALD (1676-1765) FLEMISH	3500-150000	L,G
MICHAUX, HENRI (B. 1899) BELGIAN	*300-66000	X(A)
MICHEL, GEORGE	*300-5200	
MICHEL, GEORGE (1763-1843) FRENCH	950-40000	M,F,G,L
MICHEL, ROBERT (B. 1897) GERMAN	*200-7000	X(A)
MICHEL-HENRY (B. 1928) FRENCH	300-1500	L
MICHELIN, JEAN (1623-1696) FRENCH	1000-28000	G
MICHELINO, DOMENICO DI (18TH C) ITALIAN	2500-100000	X
MICHETTI, FRANCESCO PAOLO	*500-22000	
MICHETTI, FRANCESCO PAOLO (1851-1929) ITALIAN	1200-74000	G,L,F
MICHETTI, QUINTILIO (B. 1849) ITALIAN	500-8800	X
MICHIE, JOHN D. (Late 19TH C) BRITISH	400-5000	L,G,F
MICHIELI, ANDREA DEI (Called VICENTINO) (1539-1614) ITALIAN	1500-26000	F,G
MICHIS, PIETRO	*200-1000	
MICHIS, PIETRO (1836-1903) ITALIAN	600-10000	G
MICKER, JAN CHRISTIAENSZ. (17TH C) DUTCH	750-12000	F
MIDDENDORF, HELMUT (20TH C) GERMAN	*700-22000	X(A)
MIDDLETON, ALEX B.	*200-850	
MIDDLETON, ALEX B. (19TH C) BRITISH	300-4500	X
MIDDLETON, COLIN (20TH C) BRITISH	700-32000	A
MIDDLETON, JAMES GODSELL (19TH C) BRITISH	500-6000	F,G
MIDDLETON, JAMES RAEBURN (B. 1855) BRITISH	300-3000	F,G
MIDDLETON, JOHN (1828-1856) BRITISH	400-13000	L,F
MIDJO, CHRISTIAN M. S. (1880-1973) NORWEGIAN/AMERICAN	400-2200	L
MIDWOOD, WILLIAM HENRY (19TH C) BRITISH	650-12000	L,G
MIEGHEM, EUGENE VAN (B. 1875) BELGIAN	600-29000	G,F
MIEL, JAN (1599-1663) FLEMISH	1200-38000	G,F
MIEREVELT, MICHIEL JANSZOON VAN (1567-1641) DUTCH	850-34000	F
MIERIS, FRANS VAN (1689-1793) DUTCH	1200-75000	G,F

* Denotes watercolors, pastels, drawings, and/or mixed media

MIERIS, FRANS VAN (THE ELDER)(1635-1681) DUTCH	2500-+++	F,G
MIERIS, JAN VAN (1660-1690) DUTCH	800-15000	F
MIERIS, WILLEM VAN	*500-8700	
MIERIS, WILLEM VAN (1662-1747) DUTCH	1500-116000	G,F
MIETH, HUGO (B. 1865) GERMAN	400-6000	X
MIGLIARA, GIOVANNI (1785-1837) ITALIAN	750-70000	F,L
MIGLIARO, VICENZO (1858-1938) ITALIAN	800-63000	G,L,F
MIGLIORE, GUGLIELMO (B. 1922) ITALIAN	300-1000	X
MIGNARD, NICOLAS (1606-1668) FRENCH	1500-98000	F,G,L
MIGNARD, PIERRE (1612-1695) FRENCH	700-15000	F,I
MIGNECO, GIUSEPPE	*500-14000	
MIGNECO, GIUSEPPE (B. 1908) ITALIAN	800-53000	F,G,L,S
MIGNON, ABRAHAM (1640-1679) GERMAN	5000-+++	S
MIGNON, LUCIEN (1865-1944) FRENCH	300-8100	G,L,F
MIHALOVITS, MIKLOS (20TH C) HUNGARIAN	200-1000	G
MIJARES, JOSE (B. 1921) CUBAN	650-6200	G,F
MIJN, HERMAN VAN DER (17TH C) DUTCH	500-12000	F
MIKESCH, FRITZI (1853-1891) AUSTRIAN	700-9000	S
MILANE, G. (19TH C) ITALIAN	200-1000	X
MILANI, AURELIANO (1675-1749) ITALIAN	1000-20000	F
MILBOURNE, HENRI (1781-1826) FRENCH	600-16000	L,W
MILBURN, OLIVER (1883-1934) CANADIAN/AMERICAN	300-2400	L
MILES, ARTHUR (1851-1872) BRITISH	300-6000	F,L
MILES, J. R. (19TH/20TH C) AUSTRALIAN	400-3400	L
MILES, LEONIDAS CLINT (Late 19TH C) BRITISH	300-2800	L
MILES, THOMAS ROSE (Late 19TH C) BRITISH	450-12000	L,M
MILESI, ALESSANDRO (1856-1945) ITALIAN	750-47000	L,F
MILIAN, RAUL	*200-1200	
MILIAN, RAUL (B. 1914) CUBA	300-1600	S,F
MILICH, ABRAM ADOLPHE (1884-1964) POLISH	300-5300	F,S,L
MILICH, ADOLPHE (B. 1884) POLISH	400-4500	S,F,L
MILIUS, FELIX AUGUSTIN (1843-1894) FRENCH	400-6500	G
MILLAIS, H. RAOUL (Active 1928-1936) BRITISH	300-13000	L,W
MILLAIS, SIR JOHN EVERETT	*1100-110000	
MILLAIS, SIR JOHN EVERETT (1829-1896) BRITISH	5000-+++	F,G
MILLAIS, WILLIAM HENRY (1814-1899) BRITISH	*300-2000	L
MILLARD, FREDERICK (B. 1857) BRITISH	600-12000	M,F
MILLARES, MANOLO	*500-+++	
MILLARES, MANOLO (1926-1972) SPANISH	1200-+++	G

MILLER, GODFREY CLIVE (1893-1964) AUSTRALIAN	800-39000	S,F
MILLER, JOSEPH (19TH C) GERMAN	650-14000	G
MILLET, JEAN BAPTISTE (1831-1906) FRENCH	500-8500	L,M
MILLET, JEAN FRANCOIS	*1300-+++	
MILLET, JEAN FRANCOIS (1814-1875) FRENCH	5000-+++	G,L,F
MILLET, JEAN FRANCOIS (Called FRANCISQUE) (1642-1679) FLEMISH	*300-6000	F
MILLNER, KARL (1825-1894) GERMAN	1000-19000	L
MILNE, DAVID BROWN (1882-1953) CANADIAN	2500-100000	L,M
MILNE, JOHN MACLAUCHLAN (20TH C) SCOTTISH	550-30000	A,L,S
MILNE, JOSEPH (1861-1911) BRITISH	300-5600	G,M
MILO, JEAN (B. 1906) BELGIAN	600-11000	A
MILONE, ANTONIO (19TH C) ITALIAN	300-8000	L,W
MILONE, GIUSEPPE (19TH C) ITALIAN	200-2500	L,F,G
MILTON, VICTOR MARIAS (B. 1872) FRENCH	400-12000	G,F
MINARTZ, TONY (1870-1944) FRENCH	350-10000	G
MINDERHOUT, HENDRIK VAN (1632-1696) DUTCH	2800-+++	G,M
MINNE, GEORGE (1866-1941) BELGIAN	*300-32000	F
MINNIGERODE, LUDWIG (1847-1900) POLISH	300-4000	G,F
MINNS, BENJAMIN EDWARD (1864-1937) AUSTRALIAN	*600-12000	F,L,G
MINOR, FERDINAND (1814-1883) GERMAN	600-5400	G
MINOZZI, FLAMINIO INNOCENOZO (1735-1817) ITALIAN	*400-3000	I
MINTCHINE, ABRAHAM (1898-1931) RUSSIAN	500-18000	F,L,S
MINTCHINE, ISAAC (1900-1041) RUSSIAN	*400-3500	A
MINTON, JOHN (1917-1957) BRITISH	*500-7000	L
MIR, JOAQUIN (1873-1940) SPANISH	800-82000	L
MIRABENT Y CATELL, JOSE (1831-1899) SPANISH	400-2800	G
MIRADORI, LUIGI (17TH C) ITALIAN	600-17500	F
MIRALLES, FRANCISCO (B. 1850) SPANISH	1800-242000	G,F
MIRANDA, MIGUEL DE (17TH C) SPANISH	300-1600	X
MIRO, JOAN	*5000-+++	
MIRO, JOAN (1893-1983) SPANISH	10000-+++	A
MIROU, ANTOINE (1586-1661) FLEMISH	1500-104000	L,F
MITCHELL, J. CAMPBELL (1862-1922) BRITISH	300-5000	L
MITCHELL, THOMAS	*500-28000	
MITCHELL, THOMAS (18TH C) BRITISH	300-99000	G,L
MITCHELL, W. B. (19TH/20TH C) BRITISH	300-3200	L
MITTERFELLNER, ANDREAS (20TH C) GERMAN	300-4200	L
MOAL, JEAN LE (20TH C) FRENCH	1000-70000	A

MOBERLY, MARIQUITA JENNY (Late 19TH C) BRITISH	400-7200	G,S
MODENA, BARNABA DA (1361-1383) ITALIAN	1200-30000	F
MODERSOHN, OTTO (1865-1943) GERMAN	1000-38000	L,S
MODERSOHN-BECKER, PAULA (1876-1907) GERMAN	1200-116000	A,F
MODIGLIANI, AMEDEO	*2500-+++	
MODIGLIANI, AMEDEO (1884-1920) ITALIAN	10000-+++	F
MOER, JEAN BAPTISTE VAN (1819-1884) BELGIAN	500-11000	L
MOERENHOUT, JOSEPH JODOCUS (1801-1875) FLEMISH	850-54000	L,G
MOERMAN, ALBERT EDOUARD (1808-1857) FLEMISH	400-18000	L,S
MOESELAGEN, JEAN A. (B. 1827) GERMAN	400-6000	G
MOEYAERT, NICOLAES CORNELISZ (1592-1655) DUTCH	800-32000	G,F,L
MOGFORD, JOHN	*200-4200	
MOGFORD, JOHN (1821-1885) BRITISH	300-9000	L,M
MOHLER, PAUL (19TH C) GERMAN	300-1000	G
MOHOLY-NAGY, LASZLO	*1000-+++	
MOHOLY-NAGY, LASZLO (1895-1946) HUNGARIAN	1200-123000	A
MOHR, JOHANN GEORG PAUL (1808-1843) DANISH	1000-15000	M
MOIGNE, SIMONE LE (20TH C) FRENCH	200-1000	X
MOIGNIEZ, JULES (1835-1894) FRENCH	650-6000	W,F
MOILLIET, LOUIS (1880-1962) SWISS	*400-7500	F,S
MOILLON, LOUISE (1609-1696) FRENCH	1500-110000	S
MOISSET, MARTHE (20TH C) FRENCH	300-2400	S
MOJA, FREDERICO (1802-1885) ITALIAN	600-14000	L,F
MOKADI, MOSHE (20TH C) PALESTINIAN	500-24000	F,S,L
MOLA, PIER FRANCESCO (1612-1666) ITALIAN	3000-86000	F,G,L
MOLE, JOHN HENRY (1814-1886) BRITISH	*400-11000	L,G
MOLENAER, BARTHOLOMEUS (17TH C) DUTCH	500-17500	G,L
MOLENAER, CLAES (1540-1589) FLEMISH	1000-62000	L,G
MOLENAER, JAN MIENSE (1610-1668) DUTCH	850-40000	G
MOLENAER, KLAES (1630-1676) DUTCH	1200-65000	L,G
MOLESI, E. (19TH C) ITALIAN	300-1000	X
MOLIN, ORESTE DA (1856-1921) ITALIAN	500-7500	G,F
MOLINA CAMPOS, FLORENCIO	*200-3200	
MOLINA CAMPOS, FLORENCIO (1891-1959) ARGENTINIAN	550-11000	F,G
MOLINARI, ANTONIO (D. 1648) ITALIAN	1200-72000	G,F
MOLINE, A. DE (19TH C) FRENCH	650-32000	G
MOLINERI, GIOVANNI ANTONIO (1577-1645) ITALIAN	1000-12000	F
MOLITOR, FRANZ (1857-1929) GERMAN	400-5000	G
MOLL, CARL (1861-1945) AUSTRIAN	1200-148000	L,S

MOLL, EVERT (1878-1955) DUTCH	300-8500	M
MOLL, OSKAR (1875-1947) GERMAN	650-56000	L,S
MOLLBACK, CHRISTIAN (1853-1921) DANISH	2000-22000	S
MOLLEKENS, JOSEF FRANS (1702-1748) FLEMISH	500-5400	G,L,F
MOLLER, ARNOLD (B. 1884) GERMAN	400-2500	F,G,W
MOLLER, CARL (1845-1920) DANISH	500-5800	X
MOLLICA, ACHILLE (19TH C) ITALIAN	800-18000	F,G
MOLLINGER, GERRIT ALEXANDER (1836-1867) DUTCH	400-3400	L
MOLOKIN (19TH C) RUSSIAN	400-4000	I
MOLS, NIELS PEDERSEN (1859-1921) DANISH	400-16000	L,F,W
MOLS, ROBERT (1848-1903) BELGIAN	700-14000	L,M
MOLSTED, CHR (1862-1930) DANISH	500-10000	M,L
MOLTENI, GIUSEPPE (1800-1867) ITALIAN	1000-35000	F
MOLYN, PETRUS MARIUS (1819-1849) BELGIAN	650-7000	G
MOLYN, PIETER DE	*500-25000	
MOLYN, PIETER DE (THE ELDER) (1595-1661) DUTCH	1500-52000	L
MOMMERS, HENDRIK (1623-1693) DUTCH	500-45000	L,G,W
MOMPER, FRANS DE (1603-1660) FLEMISH	1200-85000	L
MOMPER, JAN DE (16TH/17TH C) FLEMISH	300-11000	L,F
MOMPER, JOOS DE (1564-1635) FLEMISH	5000-+ + +	L
MONACHESI, SANTE (B. 1910) ITALIAN	400-6600	S
MONALDI, PAOLO (18TH C) ITALIAN	1500-34000	L,G
MONAMY, PETER	*400-5000	
MONAMY, PETER (1670-1749) BRITISH	1000-48000	M
MONARI, CRISTOFORO (D. 1720) ITALIAN	650-25000	S
MONCAYO, E. (19TH/20TH C) LATIN AMERICAN	300-1200	X
MONCH, C. (19TH C) EUROPEAN	300-1400	X
MONCHABLON, EDOUARD (1879-1914) FRENCH	300-4000	X
MONCHABLON, JEAN FERDINAND (1855-1904) FRENCH	1200-40000	G,L
MONDRIAN, PIET	*1500-+ + +	
MONDRIAN, PIET (1872-1944) DUTCH	10000-+ + +	A
MONET, CLAUDE	*2000-+ + +	
MONET, CLAUDE (1840-1926) FRENCH	+ + +	L,S,F
MONFALLET, ADOLPHE FRANCOIS (1816-1900) FRENCH	300-33000	G
MONFIELD, J. (19TH C) BRITISH	300-2000	X
MONFREID, GEORGES DANIEL DE	*300-4000	
MONFREID, GEORGES DANIEL DE (1856-1929) FRENCH	1200-28000	F,S
MONGIN, ANTOINE PIERRE	*400-11000	
MONGIN, ANTOINE PIERRE (1761-1827) FRENCH	200-1000	L,F

* Denotes watercolors, pastels, drawings, and/or mixed media

MONGINOT, CHARLES (1825-1900) FRENCH	400-58000	S,G
MONI, LOUIS DE (1698-1771) DUTCH	100-26000	G,F
MONIEN, JULIUS (1842-1897) GERMAN	300-2200	X
MONIES, DAVID (1812-1894) DANISH	400-12000	G,F
MONNIER, HENRY (1805-1877) FRENCH	500-6200	G,F
MONNIER, PIERRE (B. 1870) FRENCH	300-2500	X
MONNOT, MAURICE LOUIS (B. 1869) FRENCH	300-2700	G,S
MONNOYER, ANTOINE (1670-1747) FRENCH	1000-38000	S
MONNOYER, JEAN BAPTISTE (1636-1699) FRENCH	1200-140000	S,F
MONRO, HUGH (B. 1873) BRITISH	400-3000	F
MONSTED, PEDER (1859-1941) DANISH	1100-127000	L,F
MONTAGNA, BARTOLOMMEO (1450-1523) ITALIAN	2500-62000	F
MONTAGNE, RENAUD DE LA (17TH C) ITALIAN	300-3900	L
MONTAGUE, ALFRED (Active 1832-1883) BRITISH	650-12000	L,M
MONTALANT, I. O. DE (19TH C) FRENCH	400-4000	L
MONTALBA, CLARA (1842-1929) BRITISH	300-2400	L,M
MONTALBA, ELLEN (Late 19TH C) BRITISH	400-5000	F,G,L,I
MONTAN, ANDERS (1846-1917) SWEDISH	400-4200	G
MONTANINI, PIETRO (IL PETRUCCIO) (1626-1689) ITALIAN	650-8500	L,F
MONTEGAZZA, G. (19TH C) ITALIAN	400-2800	X
MONTEMEZZO, ANTONIO (1841-1898) GERMAN	750-18000	G,L
MONTENARD, FREDERIC (1849-1926) FRENCH	350-10000	L,G,F
MONTENEGRO, ROBERTO	*300-4000	
MONTENEGRO, ROBERTO (1885-1968) MEXICAN	1200-22000	F,G,L
MONTEVERDE, LUIGI (Called RAPHAEL DES RAISINS) (B. 1843) SWISS	1200-35000	X
MONTEZIN, PIERRE EUGENE	*500-19000	
MONTEZIN, PIERRE EUGENE (1874-1946) FRENCH	3000-208000	L,G
MONTFORT, ANTOINE ALPHONSE (1802-1884) FRENCH	300-8000	G,L
MONTFORT, GUY DE (19TH/20TH C) FRENCH	300-2000	X
MONTI, FRANCESCO (1646-1712) ITALIAN	2000-60000	G,F
MONTICELLI, ADOLPHE JOSEPH THOMAS (1824-1886) FRENCH	1000-+++	L,G,F
MONTIGANI, L. (Early 20TH C) ITALIAN	300-1200	G
MONTIGNY, JENNY (1875-1937) BELGIAN	650-105000	G,L,S
MONTIGNY, JULES (1847-1899) BELGIAN	400-7200	L,G
MONTORFANO, GIOVANNI D. (1440-1510) ITALIAN	800-6500	F
MONTOYA, GUSTAVO (B. MEXICO 1905)	500-8000	F,S
MONTPEZAT, HENRI D'AINECY COMTE DE (1817-1859) FRENCH	650-22000	L,G
MONTZAIGLE, EDGAR (B. 1867) FRENCH	1100-100000	G,F

MOOR, CAREL DE (1656-1738) DUTCH	1900-65000	F,G
MOOR (or MOR) VAN DASHORST, ANTHONIS (1517-1575) DUTCH	1500-42000	F
MOORE, ALBERT JOSEPH (D. 1892) BRITISH	3500-+++	F,G,S
MOORE, BARLOW (1853-1901) BRITISH	300-9400	M
MOORE, CHALUDE T S (1853-1901) BRITISH	800-15000	M
MOORE, GEORGE BELTON (1805-1875) BRITISH	400-6300	L
MOORE, H. (19TH C) BRITISH	300-1500	L
MOORE, HENRY	*2500-155000	
MOORE, HENRY	*10000-+++	
MOORE, HENRY (1831-1895) BRITISH	400-16000	L,M
MOORE, HENRY (1898-1986) BRITISH	1200-55000	A
MOORE, JOHN (1820-1902) BRITISH	300-9500	L,M
MOORMANS, FRANZ (1831-1893) DUTCH	750-9100	G,L
MOOS, MAX VAN (B. 1903) SWISS	500-36000	A,F,S
MOOY, CORNELIS PIETERSZ (D. 1693) DUTCH	1500-24000	M
MORA, FRANCIS LUIS	*300-7000	
MORA, FRANCIS LUIS (1874-1940) URUGUAYAN/AMERICAN	1200-30000	F,L,G
MORACH, OTTO (1887-1973) SWISS	750-12000	F,S
MORADEI, A. (19TH C) ITALIAN	300-1400	G,F
MORADO, JOSE CHAVEZ (B. 1909) MEXICAN	500-12000	G,F
MORAGAS Y TORRAS, TOMAS (1837-1906) SPANISH	1500-54000	G
MORALES, ARMANDO	*400-32000	
MORALES, ARMANDO (B. 1927) NICARAGUAN	1200-61000	S,F,A
MORALES, DARIO	*500-33000	
MORALES, DARIO (B. 1944) COLUMBIAN	1200-83000	F
MORALES, EDUARDO (1868-1938) CUBAN	500-12000	G
MORALES, LUIS DE (Called EL DIVINO) (1510-1586) SPANISH	1500-65000	F
MORALT, WILLY (1884-1947) GERMAN	1000-26000	L,F
MORANDI, GIORGIO	*600-233000	
MORANDI, GIORGIO (1890-1964) ITALIAN	5000-+++	A,L,S
MORANI, VINCENZO (19TH C) ITALIAN	300-1500	F
MORAS, WALTER (1856-1925) GERMAN	300-3600	L
MORAZZONE, (or MARAZZONE) PIER FRANCESCO	*300-5000	
MORAZZONE, (or MARAZZONE) PIER FRANCESCO (1573-1626) ITALIAN	500-7500	F
MORBELLI, ANGELO (1853-1919) ITALIAN	1500-85000	G,L,F,M
MORCHAIN, PAUL-BERNARD (B. 1876) FRENCH	300-3400	X
MOREAU, ADRIEN (1843-1906) FRENCH	1200-127000	G
MOREAU, CHARLES (B. 1830) FRENCH	800-16500	G,L,W

* Denotes watercolors, pastels, drawings, and/or mixed media

MOREAU, GUSTAVE	*1500-+++	
MOREAU, GUSTAVE (1826-1898) FRENCH	5000-+++	F
MOREAU, JEAN MICHEL	*1500-88000	
MOREAU, JEAN MICHEL (Called MOREAU LE JEUNE) (1741-1814) FRENCH	300-4500	G,L,F
MOREAU, LOUIS GABRIEL	*500-42000	
MOREAU, LOUIS GABRIEL (Called L'AINE) (1740-1806) FRENCH	1000-28000	L,G
MOREELSE, PAULUS (1571-1638) DUTCH	800-45000	F,L
MOREL, ANTON (20TH C) DUTCH	200-1400	F
MOREL, JAN BAPTIST (17TH/18TH C) FLEMISH	750-18000	S
MOREL, JAN EVERT (1766-1808) DUTCH	1000-54000	L,S
MOREL, JAN EVERT (THE YOUNGER) (1835-1905) DUTCH	800-20000	L
MORELAND, GEORGE (1763-1804) BRITISH	900-20000	L
MORELLI, DOMENICO (1823-1901) ITALIAN	400-9000	F,G
MORELLI, FRANCESCO (1768-1830) FRENCH	100-1500	G
MORELLO, LEANDRO (19TH C) ITALIAN	*400-2200	G
MORENI, MATTIA (B. 1920) ITALIAN	800-55000	L,A
MORENO, MATIAS (B. 1840) SPANISH	600-10000	G
MORERE, RENE (1907-1942) FRENCH	200-3900	X(L)
MORET, HENRY (1856-1913) FRENCH	2000-170000	L,M
MORETTI, LUCIEN PHILIPPE	*600-15000	
MORETTI, LUCIEN PHILIPPE (20TH C) FRENCH	400-32000	A,F,G
MORETTI, RAYMOND	*250-8400	
MORETTI, RAYMOND (B. 1931) ITALIAN	300-11000	G,M
MORGAN, ALFRED (1868-1928) BRITISH	1500-156000	S,G
MORGAN, EVELYN DE (1850-1919) BRITISH	650-203000	G,L,F
MORGAN, FREDERICK	*200-29000	
MORGAN, FREDERICK (1856-1927) BRITISH	1200-55000	F,G
MORGAN, JOHN (1823-1886) BRITISH	500-35000	L,F
MORGAND, MADAME CECILE (19TH C) FRENCH	400-2000	X
MORGARI, RODOLFO (1827-1909) ITALIAN	700-12000	G
MORGENSTERN, CARL (1811-1893) GERMAN	400-20000	L
MORGENSTERN, CHRISTIAN ERNST BERNHARD (1805-1867) GERMAN	1200-80000	L,G
MORGENSTERN, JOHANN L E (1738-1819) GERMAN	650-12000	G,F
MORGENSTERN, KARL ERNST (1847-1928) GERMAN	400-6500	L,F
MORGENTHALER, ERNST (1887-1962) SWISS	600-15000	G,F,L,S
MORGNER, WILHELM (1891-1917) GERMAN	*300-4500	F
MORIANI, A. (19TH/20TH C) ITALIAN	300-2500	X
MORIER, DAVID (1705-1770) SWISS	1500-58000	F

MORIN, G. (19TH C) EUROPEAN	300-1200	L
MORIN, LOUIS (B. 1855) FRENCH	400-3600	G
MORIS, J. (1837-1899) DUTCH	300-1000	X
MORISEA, S. (19TH/20TH C) ITALIAN	300-1400	G
MORISOT, BERTHE	*1500-+++	
MORISOT, BERTHE (1841-1895) FRENCH	5000-+++	G,F,L
MORISSET, FRANCOIS HENRI (B. 1870) FRENCH	800-20000	G,F
MORITZ, WILLIAM (1816-1860) SWISS	700-8100	G
MORLAND, GEORGE (1763-1804) BRITISH	1000-85000	G,L,F
MORLAND, HENRY (1730-1797) BRITISH	400-8800	G,F
MORLEY, E. (19TH C) BRITISH	300-1000	S
MORLEY, HENRY (1869-1937) BRITISH	650-24000	F,L
MORLEY, ROBERT (1857-1941) BRITISH	500-12000	G
MORLEY, T W (1859-1925) BRITISH	*200-2800	L
MORLON, PAUL EMILE ANTONY (19TH C) FRENCH	750-15000	G,L
MORLOTTI, ENNIO (B. 1910) ITALIAN	4000-114000	X
MORMILE, GAETANO (1839-1890) ITALIAN	500-6400	G,F
MORNER, STELLAN (1896-1979) SWEDISH	800-98000	A
MORO, (or ANGOLO) BATTISTA DEL	*350-5000	
MORO, (or ANGOLO) BATTISTA DEL (1514-1575) ITALIAN	1500-75000	F
MORONE, DOMENICO (1442-1517) ITALIAN	1500-28000	F
MORONI, GIOVANNI BATTISTA (1525-1578) ITALIAN	5000-+++	G,F
MORREN, GEORGES (B. 1868) BELGIAN	4000-65000	X(F)
MORRICE, JAMES WILSON (1865-1924) CANADIAN	1200-95000	L,M
MORRIS, CEDRIC (B. 1889) BRITISH	700-21000	X
MORRIS, JACOB (B. 1837) DUTCH	300-1200	X
MORRIS, JOHN (19TH C) BRITISH	400-8800	L,W
MORRIS, KATHLEEN MOIR (B. 1893) CANADIAN	800-20000	G,L
MORRIS, PHILIP RICHARD (1833-1902) BRITISH	500-23000	G,W
MORTEL, JAN (1650-1719) DUTCH	1000-91000	S
MORTELMANS, FRANS (1865-1936) BELGIAN	1500-31000	G,S
MORTENSEN, RICHARD	*300-13000	
MORTENSEN, RICHARD (B. 1910) DANISH	2000-170000	S,A
MORTIMER, JOHN HAMILTON (1740-1779) BRITISH	1000-78000	F,L
MOSCHER, JACOB VAN (17TH C) DUTCH	1200-32000	L
MOSCOSO, LUIS (B. 1915) ECUADORIAN	300-1400	X
MOSER, JULIUS (B. 1808) GERMAN	300-2400	G,L
MOSER, KOLO	*400-10000	
MOSER, KOLO (1868-1918) AUSTRIAN	5000-125000	F,L

MOSER, RICHARD (B. 1874) AUSTRIAN	*500-6500	G,F
MOSNIER, JEAN LAURENT (1743-1808) FRENCH	1200-36000	F
MOSSA, GUSTAVE ADOLF (1883-1971) FRENCH	*500-42000	X
MOSTAERT, GILLIS (16TH C) FLEMISH	1500-68000	G,L
MOSTAERT, JAN (1475-1555) DUTCH	1800-22000	F,G
MOSTYN, TOM EDWIN (1864-1930) BRITISH	600-14000	G,F,L
MOTE, GEORGE WILLIAM (1832-1909) BRITISH	300-4300	L,W
MOTTA, RAPHAEL (Called RAFAELLINO DE REGGIO) (1550-1578) ITALIAN	1000-15000	F
MOTTE, HENRI PAUL (1846-1922) FRENCH	300-1200	X
MOTTEZ, HENRY (B. 1855) FRENCH	400-3800	G
MOTTRAM, CHARLES SIM (Late 19TH C) BRITISH	*300-4500	L,M
MOTTU, LUC-HENRI (1815-1859) SWISS	500-15000	L
MOUALLA, FIKRET (1905-1968) FRENCH	*500-12000	X(A)
MOUCHERON, FREDERICK DE (1633-1686) DUTCH	2000-44000	L,G
MOUCHERON, ISAAC DE	*400-29000	
MOUCHERON, ISAAC DE (1667-1744) DUTCH	500-24000	G,L,F
MOUCHOT, LOUIS CLAUDE (1830-1891) FRENCH	700-18000	G,F
MOULINET, ANTOINE EDOUARD JOSEPH (1833-1891) FRENCH	400-6200	G,S
MOYNAN, RICHARD THOMAS (1856-1906) BRITISH	700-26000	G,F
MOYNE, FRANCOIS LE (18TH C) FRENCH	1200-+++	F
MOZIN, CHARLES LOUIS (1806-1862) FRENCH	600-9500	G,L,F
MUCHA, ALPHONSE MARIA	*1200-85000	
MUCHA, ALPHONSE MARIA (1860-1939) CZECHOSLOVAKIAN	1000-105000	F
MUCKE, CARL EMIL (1847-1923) GERMAN	500-10000	G,F
MUCKLEY, WILLIAM JABEZ (1837-1905) BRITISH	*300-3800	G,S
MUELLER, FRITZ (B. 1865) GERMAN	300-1200	G,L,F
MUELLER, MORITZ (1841-1899) GERMAN	200-1000	L,W
MUELLER, OTTO	*1800-+++	
MUELLER, OTTO (1874-1930) GERMAN	2500-+++	F,L
MUENIER, JULES ALEXIS (1863-1942) FRENCH	650-24000	L
MUHL, ROGER (B. 1929) FRENCH	400-9000	L,S
MUHLENEN, MAX VON (1903-1971) SWISS	600-7500	L,F
MUHLFELD, JOSEPH MOLITOR VON (1856-1890) GERMAN	500-2500	X
MUHLIG, BERNARD (1829-1910) GERMAN	300-10000	L,G
MUHLIG, HUGO (1854-1929) GERMAN	1200-40000	L,F,W
MUHLIG, MENO (1823-1873) GERMAN	400-9000	G,L
MUHRMANN, LUDWIG (B. 1886) GERMAN	300-6100	S
MULIER, PIETER (1637-1701) DUTCH	1000-41000	M,L

MULLER, ADOLPH EWALD (B. 1853) GERMAN	400-3200	G,F
MULLER, ALBERT (1897-1926) SWISS	1000-36000	L,F
MULLER, ANTON (1853-1897) AUSTRIAN	650-24000	G
MULLER, AUGUST (1836-1885) GERMAN	400-11500	G,F
MULLER, CARL FRIEDRICH MORITZ (Called FEUERMULLER) (1807-1865) GERMAN	500-12000	G
MULLER, CHARLES LOUIS LUCIEN (1815-1892) FRENCH	500-24000	G,F
MULLER, CORNELIUS (19TH C) GERMAN	400-5000	X
MULLER, EDMUND GUSTAVAS (1816-1888) BRITISH	300-4800	L
MULLER, EMMA VON (B. 1859) AUSTRIAN	300-7500	G,F
MULLER, ERNST (1823-1875) GERMAN	500-16500	F,G
MULLER, ERNST EMMANUEL (B. 1844) GERMAN	400-15000	G
MULLER, FRANS HUBERT (1784-1835) GERMAN	300-4500	X
MULLER, FRANZ (1843-1929) GERMAN	500-8000	F
MULLER, FRITZ (B. 1818) GERMAN	300-1400	X
MULLER, FRITZ (B. 1879) GERMAN	400-3000	X
MULLER, FRITZ (B. 1913) GERMAN	400-3800	X
MULLER, GERARD (1861-1923) DUTCH	300-5600	G,F
MULLER, HEINRICH EDOUARD (1823-1853) GERMAN	650-25000	L,F
MULLER, JAN	*400-3200	
MULLER, JAN (1922-1958) GERMAN/AMERICAN	600-20000	L,F
MULLER, JAN HARMENSZ (1571-1628) DUTCH	*900-45000	F
MULLER, KARL (19TH C) GERMAN	300-1400	F,L
MULLER, LEOPOLD CARL (1834-1892) AUSTRIAN	1000-95000	G,F,S
MULLER, LUDWIG CORNELIUS (19TH C) GERMAN	500-6000	L,G
MULLER, MAX (19TH C) GERMAN	300-3400	G
MULLER, MORITZ (1841-1899) GERMAN	500-21000	W,L
MULLER, MORITZ (Called KINDERMULLER) (1825-1894) GERMAN	300-2000	X
MULLER, MORITZ KARL FRIEDRICH (1807-1865) GERMAN	500-29000	X
MULLER, MORTEN (1828-1911) GERMAN	400-20000	L
MULLER, OTTO	*1500-+++	
MULLER, OTTO (1874-1930)	1200-60000	F
MULLER, PAUL JAKOB (B. 1894) SWISS	300-2500	F,G
MULLER, PETER PAUL (B. 1853) GERMAN	300-5000	L,G,W
MULLER, RICHARD (1874-1930) AUSTRIAN	400-9400	W
MULLER, ROBERT ANTOINE (19TH C) BRITISH	300-9400	G,F
MULLER, ROSA (19TH C) GERMAN	300-9400	F
MULLER, RUDOLPH GUSTAVE (1858-1888) GERMAN	650-14000	F
MULLER, WILLIAM JAMES (1812-1845) BRITISH	800-30000	L,G

MULLER-LINGKE, ALBERT (B. 1844) GERMAN	500-6500	G,L
MULLEY, OSKAR (B. 1891) AUSTRIAN	700-17700	L
MULREADY, AUGUSTUS E. (1863-1905) BRITISH	700-25000	F
MULREADY, WILLIAM (1786-1863) IRISH	1200-62000	L,F
MUNARI, CRISTOFORO (1667-1720) ITALIAN	2500-210000	S
MUNCH, EDVARD	*1500-110000	
MUNCH, EDVARD (1863-1944) NORWEGIAN	5000-+++	A,L,F,G
MUNCHEN, LAZAR BINENBAUM (Early 20TH C) GERMAN	300-1500	X
MUNDELL, J. (1818-1875) BRITISH	300-1800	F
MUNDUAAN, G. Y. (19TH C) DUTCH	400-2000	X
MUNIER, EMILE (1810-1885) FRENCH	1500-42000	F,G
MUNK, JACOB (D. 1885) BRITISH	300-2200	G
MUNKACSY, MICHAEL VON LEIB (Called MIHALY) (1844-1900) HUNGARIAN	1200-88000	F,G,S
MUNN, PAUL SANDBY (1773-1845) BRITISH	*300-2700	L,F
MUNNINGS, SIR ALFRED J.	*1200-68000	
MUNNINGS, SIR ALFRED J. (1878-1959) BRITISH	5000-+++	L,F,G
MUNNS, HENRY TURNER (1832-1898) BRITISH	400-5200	L
MUNOZ, OSCAR (B. 1951) COLUMBIAN	*400-3000	G
MUNOZ Y CUESTA, DOMINGO (1850-1912) SPANISH	600-24000	G,F
MUNRO, HUGH (1873-1928) BRITISH	800-12000	L,F
MUNSCH, JOSEPH (1832-1896) AUSTRIAN	500-16000	G,F
MUNSCH, LEOPOLD (1826-1888) AUSTRIAN	300-5400	L,G
MUNTER, GABRIELE (1877-1962) GERMAN	1500-100000	A,G,F,L
MUNTHE, GERHARD ARIJ MORGENSTJERNE (1875-1950) DUTCH	400-7000	L,G
MUNTHE, LUDWIG (1841-1896) NORWEGIAN	700-22000	L,G
MURA, ANGELO DELLA (B. 1867) ITALIAN	400-2800	L,M
MURA, FRANCESCO DE (1696-1782) ITALIAN	2000-139000	F
MURA, FRANK (B. 1861) FRENCH	500-3200	L,F
MURANT, EMILE (17TH C) DUTCH	400-14000	L
MURATORI, DOMENICO ANTONIO (1661-1744) ITALIAN	500-10000	F
MURILLO, BARTOLOME ESTEBAN	*750-25000	
MURILLO, BARTOLOME ESTEBAN (1618-1682) SPANISH	2500-+++	F,G
MURRAY, CHARLES FAIRFAX (1849-1919) BRITISH	550-20000	L,F
MURRAY, H. (Active 1850-1860) BRITISH	*400-5300	G
MURRAY, LILIAN (19TH C) BRITISH	300-1800	S
MURRAY, SIR DAVID (1849-1933) BRITISH	500-30000	G,L
MUSCART, GUSTAVE (19TH C) FRENCH	300-2400	X
MUSCHAMP, F. SYDNEY (D. 1929) BRITISH	1500-35000	G,L

MUSCRAFT, E. G. (19TH C) BRITISH	300-1500	X
MUSIC, ZORAN ANTONIO	*500-43000	
MUSIC, ZORAN ANTONIO (1909-1952) ITALIAN	2500-+++	L,G,F
MUSIN, AUGUSTE HENRI (1852-1920) BELGIAN	650-11000	L
MUSIN, FRANCOIS ETIENNE (1820-1888) BELGIAN	700-89000	M
MUSITELLI, GIULIO VITO (B. 1901) ITALIAN	600-7500	X(F)
MUSSCHER, MICHIEL VAN (1645-1705) DUTCH	1000-64000	G,F
MUTER, MELA	*200-2100	
MUTER, MELA (1886-1967) FRENCH	300-33000	L,F
MUTRIE, ANNIE FERAY (1826-1893) BRITISH	500-8200	S
MUTRIE, MARTHA DARLAY (1824-1885) BRITISH	300-9100	S
MUTTONI, PIETRO DE (Called PIETRO DELLA VECCHI) (1605-1678) ITALIAN	1500-22000	F,G
MUZIANI, GIRALAMO (1528-1592) ITALIAN	1500-51000	F
MUZZIOLI, GIOVANNI (1854-1894) ITALIAN	500-97000	G,F
MY, HIERONYMUS VAN DER (1687-1761) DUTCH	300-7500	F
MYN, AGATHA VAN DER (18TH C) DUTCH	400-4800	X
MYN, FRANCES VAN DER (1719-1783) DUTCH	500-14000	G,F
MYN, HERMAN VAN DER (1684-1741)	600-21000	F,G,S
MYTENS, DANIEL (17TH C) DUTCH	600-66000	F
MYTENS, JAN (1614-1670) DUTCH	1200-78000	F,L
MYTENS, MARTIN (1648-1736) SWEDISH	400-8500	F
MYTENS, MARTIN II (1695-1770) SWEDISH	750-61000	F

N

ARTIST	PRICES	SUBJECT
NADLER, ROBERT (B. 1938) HUNGARIAN	300-2000	X
NAFTEL, PAUL JACOB (1817-1891) BRITISH	*300-12000	L
NAGEL, PAT (20TH C) GERMAN	300-1600	A
NAGEL, WILHELM (B. 1866) GERMAN	800-4000	F
NAGELE, REINHOLD (B. 1884) GERMAN	1000-18000	L,F
NAGY, EMO (19TH/20TH C) HUNGARIAN	300-2000	S
NAGY, ERNEST DE (20TH C) GERMAN	300-1200	S
NAIRN, GEORGE (1799-1850) IRISH	400-3800	L,W
NAIRN, JAMES McCLACHLAN (1859-1904) BRITISH	300-11000	L,F
NAISH, JOHN GEORGE (1824-1905) BRITISH	*400-2400	G,M
NAIVEU, MATTYS (1647-1721) DUTCH	500-30000	G,I

* Denotes watercolors, pastels, drawings, and/or mixed media

NAKAGAWA, HACHIRO (1877-1922) JAPANESE	*300-1500	G,L
NAKKEN, WILLEM CAREL (1835-1926) DUTCH	600-13000	L,G
NALDINI, GIOVANNI BATTISTA	*3000-55000	
NALDINI, GIOVANNI BATTISTA (1537-1591) ITALIAN	5000-25000	F,G
NAMATJIRA, ALBERT (1902-1959) AUSTRALIAN	*800-14000	L
NANI, JACOPO (OR GIACOMO) (1701-1770) ITALIAN	900-55000	S
NANNINGA, JAAP (1904-1962) DUTCH	800-21000	A
NAPIER, GEORGE (19TH C) BRITISH	500-25000	F
NAPOLITANO, FILIPPO (18TH C) ITALIAN	3000-42000	L,W
NARAY, AUREL (B. 1883) HUNGARIAN	400-4000	F,L
NARDEUX, HENRI (19TH C) FRENCH	500-6200	S
NARDO, MARIOTTO DI	*650-16500	
NARDO, MARIOTTO DI (14TH/15TH C) ITALIAN	4000-141000	F
NARIMANBEKOV, TOGRUL (B. 1930) RUSSIAN	1000-15000	X(S,L)
NARJOT, ERNESTE (1826-1898) FRENCH	750-20000	L,F,G
NASH, FREDERICK (1782-1856) BRITISH	*500-15000	L
NASH, JOHN	*350-6400	
NASH, JOHN (1895-1977) BRITISH	300-14000	L,F
NASH, JOSEPH	*600-32000	
NASH, JOSEPH (1808-1878) BRITISH	400-4200	G,F
NASH, PAUL (1889-1946) BRITISH	1000-98000	L,F
NASMITH, JAMES (1808-1890) BRITISH	700-6500	L
NASMYTH, ALEXANDER (1758-1840) SCOTTISH	1200-35000	L
NASMYTH, ANNE (B. 1793) BRITISH	1000-13000	L
NASMYTH, CHARLOTTE (1804-1884) BRITISH	500-5600	L
NASMYTH, JANE (1778-1866) BRITISH	400-12000	L,F
NASMYTH, MARGARET (1791-1869) BRITISH	400-10500	G,L
NASMYTH, PATRICK (1787-1831) BRITISH	650-31000	L,W
NASON, PIETER (1612-1688) DUTCH	400-49000	F
NAT, WILLEM HENDRIK VAN DER (1864-1929) DUTCH	300-1500	G,W
NATALI, RENATO (B. 1883) ITALIAN	200-6500	L,S,G
NATHAN, ARTURO (1891-1944) ITALIAN	300-15400	L
NATINGUERRA, AMERIGO BARTOLI (1890-1971) ITALIAN	100-4500	X
NATOIRE, CHARLES JOSEPH (1700-1777) FRENCH	*750-34000	F,L,G
NATTIER, JEAN MARC	*750-35000	
NATTIER, JEAN MARC (1685-1766) FRENCH	2000-+++	F
NATTIER, JEAN-BAPTISTE (1678-1726) FRENCH	1200-58000	G,F
NATTONIER, C. (19TH/20TH C) FRENCH	300-1000	L
NAUDE, HUGO (1869-1941) SOUTH AFRICAN	900-22000	L

NAUEN, HEINRICH (1880-1941) GERMAN	900-63000	L,F
NAUER, ADOLF (B. 1886) GERMAN	300-1500	G,F
NAUMANN, CARL (18TH/19TH C) GERMAN	600-15000	X
NAUWINCX, HERMANN (1624-1651) FLEMISH	300-2400	X
NAVARRA, PIETRO (17TH/18TH C) ITALIAN	800-25000	S
NAVARRO LLORENS, JOSE (1867-1923) SPANISH	4000-+++	G,F,M
NAVEZ, ARTHUR (1881-1931) FLEMISH	300-2400	G,L,S
NAVEZ, FRANCOIS JOSEPH (1787-1869) BELGIAN	400-31000	F
NAVLET, JOSEPH (1821-1889) FRENCH	500-7500	G,F
NAVONE, EDUARDO (19TH C) ITALIAN	400-11000	F
NAY, ERNST WILHELM	*500-41000	
NAY, ERNST WILHELM (1902-1968) GERMAN	1000-+++	A
NAZZARI, BARTOLOMEO (1699-1758) ITALIAN	750-69000	F
NAZZARI, GUISEPPE (19TH C) ITALIAN	500-20000	F
NEALE, GEORGE HALL (19TH/20TH C) BRITISH	800-5500	F,G
NEBEL, OTTO (B. 1892) GERMAN	*400-11000	A
NECK, JAN VAN (1635-1714) DUTCH	500-18000	F,L
NEDER, JOHANN MICHAEL (1807-1882) AUSTRIAN	650-26000	G,F
NEEDHAM, WILLIAM (19TH C) BRITISH	500-11000	L,F
NEEFFS, PEETER (THE YOUNGER) (1620-1675) FLEMISH	1000-46000	G,L
NEEFS, PEETER (THE ELDER) (1578-1658) FLEMISH	2000-76000	G
NEER, AERT VAN DER (1603-1677) DUTCH	5000-+++	L,F
NEER, EGLON H. VAN DER (1634-1703) DUTCH	5000-+++	G,F
NEER, JAN VAN DER (1637-1665) DUTCH	300-9000	L
NEERGAARD, HERMANIA (1799-1874) DANISH	2000-70000	S,L
NEGELY, R. (19TH/20TH C) HUNGARIAN	400-3600	X
NEGRET, EDGAR (B. 1920) COLUMBIAN	300-2400	A
NEHLIG, VICTOR (1830-1910) FRENCH	300-4400	F,G
NEILLOT, LOUIS (1898-1973) FRENCH	400-12000	L,G,S
NEIMANN, EDMOND JOHN (19TH C) BRITISH	300-3700	X
NELIMARKKA, EERO (1919-1941) FINNISH	2000-40000	L,G,F
NELLIUS, MARTINUS (Active 1674-1706) DUTCH	500-15000	S
NEMES, ENDRE (1909-1985) HUNGARIAN	1500-14000	A
NEMETH, GYORGY (19TH/20TH C) HUNGARIAN	300-1400	L,W
NEOGRADY, ANTAL (OR LASZLO) (1861-1942) HUNGARIAN	300-3000	L,G
NEOGRADY, LASZLO (B. 1900) HUNGARIAN	300-4000	L,G
NERENZ, WILHELM (1804-1871) GERMAN	300-7200	F
NERLI, MARCHESE GIROLAMO (1863-1926) ITALIAN	800-131000	F,L,G
NERLY, FRIEDRICH (1807-1878) ITALIAN	400-17000	L

* Denotes watercolors, pastels, drawings, and/or mixed media

NERMAN, EINAR (1888-1983) SCANDINAVIAN	400-2000	S
NERONI, BARTOLOMMEO (1500-1573) ITALIAN	1000-18000	F
NESBITT, JOHN (1831-1904) BRITISH	400-2700	L
NESTEROVA, NATALIA (B. 1944) RUSSIAN	2000-15000	X(F)
NETSCHER, CASPAR (1639-1684) DUTCH	1000-92000	G,F,L
NETSCHER, CONSTANTIN	*200-7200	
NETSCHER, CONSTANTIN (1668-1723) DUTCH	750-18000	F,G
NETTER, BENJAMIN (1811-1881) FRENCH	300-3000	L,G
NETTI, FRANCESCO (1834-1894) ITALIAN	400-4800	G
NEUBERT, LUDWIG ((OR LOUIS)) (1846-1892) GERMAN	500-5200	L,M
NEUENSCHWANDER, ALBERT (B. 1902) SWISS	500-3000	A
NEUFCHATEL, NICOLAS (1527-1590) FLEMISH	2000-28000	F
NEUHAUS, TRUDE (20TH C) GERMAN	300-1000	F
NEUHAUS, WERNER (1897-1934) SWISS	200-1600	L,G,F
NEUHUYS, ALBERT (OR JOHAN ALBERTUS)	*400-1300	
NEUHUYS, ALBERT (OR JOHAN ALBERTUS) (1844-1914) DUTCH	500-18000	G,F
NEUMANN, CARL (1833-1891) DANISH	500-22000	L,M
NEUMANN, EMIL (1842-1903) GERMAN	300-2300	X
NEUMANN, JOHAN CARL (1833-1891) DANISH	300-3800	X
NEUMANN, JOHAN J. (1860-1940) DANISH/GERMAN	400-4800	L,M
NEUMANS, ALPHONSE (19TH C) DUTCH	400-2500	G
NEUQUELMAN, LUCIEN (B. 1909) FRENCH	950-22000	G,L,M
NEUSTATTER, LUDWIG (1829-1899) GERMAN	750-12000	G
NEUSTEIN, JOSHUA (B. 1940) POLISH/AMERICAN	500-5200	A
NEUSTUCK, MAXIMILIAN (1756-1834) SWISS	300-5900	G
NEUVILLE, ALPHONSE MARIE DE	*300-2400	
NEUVILLE, ALPHONSE MARIE DE (1835-1885) FRENCH	1200-74000	G,F
NEUVILLE, BRUNO DE (19TH/20TH C) FRENCH	300-5900	W
NEVELSON, LOUISE (B. 1900) AMERICAN		
NEVINSON, CHRISTOPHER RICHARD WYNNE	*400-3500	
NEVINSON, CHRISTOPHER RICHARD WYNNE (1889-1946) BRITISH	1200-70000	L,S,F
NEWBOLT, JOHN (1805-1867) BRITISH	300-4100	L
NEWELL, HUGH (B. 1830) BRITISH	1000-28000	F,S
NEWHOUSE, C. B. (19TH C) BRITISH	*300-1200	W
NEWMARCH, STRAFFORD (19TH C) BRITISH	300-1800	G,L
NEWNHAM, J. (19TH C) BRITISH	200-1000	X
NEWTON, ALGERNON (1880-1968) BRITISH	300-7000	L
NEWTON, JOHN EDWARD (19TH C) BRITISH	700-48000	L,S

NEWTON, RICHARD (1777-1798) BRITISH	400-3200	L,W
NEYN, PIETER DE (1597-1639) DUTCH	1500-60000	G,L,F
NEYTS, GILLIS (1623-1687) FLEMISH	500-58000	G,L,F
NIBBRIG, FERDINAND HART (1866-1915) DUTCH	650-13000	L,G,F
NIBBS, RICHARD HENRY (1816-1893) BRITISH	500-6900	L,M
NICCOLO, ANDREA DI (1395-1462) ITALIAN	1200-65000	F
NICCOLO, LORENZO DI (15TH?/16TH C?) ITALIAN	2000-54000	F
NICCOLO DA VOLTRI (1385-1417) ITALIAN	1200-28000	X
NICCOLO DI TOMMASO (14TH/15TH C) ITALIAN	1500-100000	F
NICHOL, JOHN WATSON (Late 19TH C) BRITISH	300-2600	G
NICHOLL, ANDREW (1804-1886) IRISH	*550-33000	L,M,S
NICHOLLS, GEORGE F (1885-1937) BRITISH	*400-2500	F,G,L
NICHOLS, C. C. (19TH C) ENGLSIH	400-3600	X
NICHOLS, JOSEPH (18TH C) BRITISH	400-55000	L
NICHOLSON, BEN	*1200-+++	
NICHOLSON, BEN (1894-1982) BRITISH	5000-+++	A
NICHOLSON, FRANCIS (1753-1844) BRITISH	*500-7500	G,F,M
NICHOLSON, SIR WILLIAM (1872-1949) BRITISH	1200-139000	L,F,S
NICHOLSON, WINIFRED (B. 1893) BRITISH	2000-62000	A
NICKELE, ISAAK VAN (1660-1703) DUTCH	850-42000	F,G
NICOL, ERSKINE (1825-1904) BRITISH	750-30000	G
NICOLETE, GABRIEL (1856-1921) SWISS	600-18000	F,G
NICOLLE, VICTOR JEAN (1754-1826) FRENCH	*300-15000	G,L
NICOLO, DA BOLOGNA (14TH C) ITALIAN	500-9000	X
NICZKY, EDUARD (B. 1850) GERMAN	500-12000	G,L
NIEDMANN, AUGUST HEINRICH (1826-1910) GERMAN	400-7200	X
NIEHAUS, KASPAR (1889-1974) DUTCH	900-18000	F,L
NIELSEN, AMALDUS CLARIN (1838-1932) NORWEGIAN	2000-35000	M,L
NIELSEN, JAIS (1885-1961) DANISH	800-15000	F,S
NIELSEN, KAY (1886-1957) DANISH	*500-20000	A,G,F
NIEMANN, EDMUND JOHN (1813-1876) BRITISH	750-18000	L
NIEMANN, EDWARD H (19TH C) BRITISH	700-7000	L
NIERMAN, LEONARDO (20TH C) MEXICAN	300-3000	A,M
NIEULANDT, ADRIAEN VAN (1587-1658) FLEMISH	1500-28000	F
NIEUWENHOVEN, WILLEM VAN (B. 1879) DUTCH	500-4800	G
NIGG, JOSEPH	*300-26000	
NIGG, JOSEPH (1782-1863) AUSTRIAN	1200-54000	S
NIGHTINGALE, BASIL	*150-1100	
NIGHTINGALE, BASIL (19TH C) BRITISH	400-5000	G,F

NIGHTINGALE, LEONARD CHARLES (19TH/20TH C) BRITISH	300-3500	F,G
NIGHTINGALE, ROBERT (1815-1895) BRITISH	500-11000	G,W
NIGRO, MARIO (B. 1917) ITALIAN	1000-28000	A
NIJMEGEN, GERARD VAN (1735-1808) DUTCH	400-8800	L,F
NIKEL, LEA (20TH C) ISRAELI	300-10000	A
NIKUTOWSKI, ARTHUR JOHANN SEVERIN (1830-1888) GERMAN	1500-62000	G,L
NILSON, SEVERIN (1846-1918) SWEDISH	600-75000	G,L,F
NILSSON, AXEL (B. 1887) SWEDISH	600-38000	L,F,S
NILSSON, NILS (1901-1949) SWEDISH	300-34000	L,F,S
NILSSON, OLOF (1868-1956) SWEDISH	1200-76000	L
NILSSON, VERA (1888-1979) SWEDISH	550-41000	L,F,S
NISBET, NOEL LAURA (1887-1956) BRITISH	300-4900	X
NISBET, POLLOCK (1848-1922) BRITISH	1000-22000	M,L
NISBET, ROBERT BUCHAN (1857-1942) BRITISH	300-2500	M,L
NISS, THORVALD (1842-1905) DANISH	300-7800	L,M
NITSCH, RICHARD (B. 1866) GERMAN	300-2600	G
NITTIS, GIUSEPPE DE	*500-55000	
NITTIS, GIUSEPPE DE (1846-1884) ITALIAN	1500-+++	F,L,G
NIVERVILLE, LOUIS DE (B. 1933) CANADIAN	300-3600	A
NIXON, JAMES HENRY (17TH/18TH C) BRITISH	400-6400	F
NIXON, JOHN (1760-1818) BRITISH	*400-2400	L
NIXON, W. R. (19TH C) BRITISH	300-2600	X
NOBLE, CHARLES F. (20TH C) BRITISH	300-1800	G,F
NOBLE, JAMES CAMPBELL (1846-1913) BRITISH	500-5000	M
NOBLE, JOHN SARGEANT (1848-1896) BRITISH	900-30000	G,F
NOBLE, ROBERT (1857-1917) BRITISH	300-3300	L
NOBREGA, NELSON (B. BRAZIL 1900)	300-1600	F
NOCCHI, BERNARDINO (1741-1812) ITALIAN	750-77000	X
NOCI, ARTURO (B. 1875) ITALIAN	500-12000	X(S)
NOE, LUIS FELIPE (B. 1933) ARGENTINIAN	500-20000	G
NOEH, ANNA T (B. 1903) CANADIAN	*400-2800	G,L,F
NOEL, ALEXANDRE JEAN	*200-2500	
NOEL, ALEXANDRE JEAN (1752-1834) FRENCH	400-8200	G,L,M
NOEL, GEORGES	*300-63000	
NOEL, GEORGES (B. 1924) FRENCH	400-11800	A
NOEL, JOHN BATES (19TH/20TH C) BRITISH	300-3700	G,L
NOEL, JULES ACHILLE	*250-3500	
NOEL, JULES ACHILLE (1813-1881) FRENCH	550-53500	G,L,M
NOEL, PETER PAUL JOSEPH (1789-1822) BELGIAN	350-13000	L,F

NOERR, JULIUS (1827-1897) GERMAN	500-12700	G,L
NOGARI, GIUSEPPE (1699-1763) ITALIAN	450-24000	F
NOIRE, MAXIME (19TH C) FRENCH	1000-12000	L
NOIROT, EMILE (1853-1924) FRENCH	700-6500	L
NOLAN, SIDNEY	*400-+++	
NOLAN, SIDNEY (B. 1917) AUSTRALIAN	800-69000	A
NOLDE, EMIL	*1200-234000	
NOLDE, EMIL (1867-1956) GERMAN	3000-+++	A
NOLLEKENS, JEAN BAPTIST (18TH C) FLEMISH	300-3200	X
NOLLEKENS, PIETER (17TH/18TH C) FLEMISH	300-2400	X
NOLPE, PIETER (1613-1652) DUTCH	650-25000	L,M
NOLTEE, CORNELIS (1903-1967) DUTCH	400-3600	G,L
NOME, FRANCESCO DE (Called MONSU DESIDERIO) (1593-1618) ITALIAN	1200-67000	F,G
NOMELLINI, PLINIO (1866-1943) ITALIAN	700-42000	G,F
NONELL Y MONTIROL, ISIDRO (1873-1911) SPANISH	1200-+++	F,L
NONNENBRUCH, MAX (1857-1922) GERMAN	500-27500	L,F
NONNOTTE, DONAT (1708-1785) FRENCH	850-59000	F
NONO, LUIGI (1850-1918) ITALIAN	650-41000	G,L,F
NOOMS, RENIER (Called ZEEMAN) (1623-1667) DUTCH	750-43000	L,F,M
NOORT, ADRIANUS CORNELIS VAN (B. 1914) DUTCH	300-5000	L,F
NOORT, JAN VAN (16TH-18TH C) DUTCH	2000-50000	F
NOORT, PIETER VAN (1602-1648) DUTCH	400-13000	L,W
NOOTEBOOM, J.H.J. (1811-1878) DUTCH	600-26000	L,M
NORBLIN DE LA GOURDAINE, JEAN PIERRE (1745-1830) FRENCH	400-3200	G,L
NORDBERG, OLLE (B. 1905) SWEDISH	650-11000	G,L,F
NORDENBERG, BENGT (1822-1902) SWEDISH	1500-58000	G,F,L
NORDENBERG, C. HENDRICK (1857-1928) SWEDISH	1000-44000	G
NORDFELDT, BROR JULIUS OLSSON	*300-3400	
NORDFELDT, BROR JULIUS OLSSON (1878-1955) SWEDISH	600-30000	L,F,S
NORDGREN, ANNA (1847-1916) SWEDISH	500-12000	G,L
NORDGREN, AXEL (1828-1888) SWEDISH	400-9600	L,M
NORDHAGEN, OLAF (19TH C) NORWEGIAN	300-2600	X
NORDSTROM, KARL F. (1855-1923) SWEDISH	650-49000	L,S
NORIE, ORLANDO (1832-1901) SCOTTISH	*300-3200	F
NORLIND, ERNST (1877-1952) SWEDISH	300-4000	W
NORMAND, ADELSTEEN (OR NORMANN) (1848-1918) NORWEGIAN	750-24000	L,M
NORMAND, ERNEST (1857-1923) BRITISH	800-24000	G
NORMIL, ANDRE (B. 1934) HAITIAN	400-3800	G,L

* Denotes watercolors, pastels, drawings, and/or mixed media

NORRETRANDERS, JOHANNES (B. 1871) DANISH	700-9500	X
NORTH, JOHN WILLIAM (1842-1924) BRITISH	*500-40000	L
NORTHCOTE, H. B. (19TH C) BRITISH	300-1200	X
NORTHCOTE, JAMES (OR THOMAS JAMES) (1746-1831) BRITISH	1500-94000	F
NORTHEN, ADOLF (1828-1876) GERMAN	300-4300	M
NORTON, BENJAMIN CAM (1835-1900) BRITISH	400-26000	W
NORWELL, GRAHAM NOBLE (1901-1967) CANADIAN	500-4500	L
NOTER, DAVID EMIL JOSEPH DE (1825-1912) BELGIAN	850-34000	G,L,S
NOTER, PIERRE FRANCOIS DE (1779-1843) BELGIAN	1200-60000	G,L
NOTER, RAPHAEL DAVID MARIE DE (19TH C) BELGIAN	300-2200	L
NOTERMANN, ZACHERIE (19TH C) GERMAN	300-6200	G
NOTTERMAN, EMMANUEL (1808-1863) BELGIAN	250-8000	X
NOURT, ANDRIANUS CORNELIUS VAN (B. 1914) DUTCH	300-2600	X
NOUVILLE, B. (20TH C) FRENCH	300-2000	X
NOVELLI, PIETRO ANTONIO	*400-17500	
NOVELLI, PIETRO ANTONIO (1729-1804) ITALIAN	1000-18000	F
NOVO, STEFANO (B. 1862) ITALIAN	500-48000	G
NOWAK, FRANZ (19TH/20TH C) AUSTRIAN	300-2800	S
NOWAK, OTTO (1874-1945) AUSTRIAN	300-1800	G,F
NOYER, DENIS PAUL (B. 1940) FRENCH	150-2500	L,M
NOYER, PHILIPPE HENRI	*300-5000	
NOYER, PHILIPPE HENRI (B. 1917) FRENCH	400-7500	G
NOYES, GEORGE LOFTUS (1864-1951) CANADIAN	400-28000	L
NOYES, ROBERT (1780-1843) BRITISH	*300-3200	L
NOZAL, ALEXANDRE (1852-1929) FRENCH	500-17000	G,L
NUNEZ, FERNANDO (19TH/20TH C) MEXICAN	300-2200	G
NUNEZ DE VILLAVICENZIO, PEDRO (1644-1700) SPANISH	400-4000	X
NUVOLONE, CARLO FRANCES (1608-1665) ITALIAN	1200-68000	F
NUVOLONE, GIUSEPPE (Called PANFILO) (1619-1703) ITALIAN	1200-58000	G
NUYEN, WIJBRAND JOHANNE (1813-1839)	750-30000	L,G
NUZZIO, MARIO (Called MARIO DA FIORI) (1603-1673) ITALIAN	700-43000	G,S
NYBERG, IVAR (1855-1925) SWEDISH	400-4500	F
NYBLOM, LENNART (1872-1947) SWEDISH	400-5000	L,M
NYILASY, SANDOR (B. 1873) HUNGARIAN	300-5600	G
NYMAN, OLLE (B. 1909) SWEDISH	500-6900	L,F,S
NYSTROM, JENNY (1857-1946) SWEDISH	*1200-147000	G,L,F,S

O

ARTIST	PRICES	SUBJECT
O'BRIEN, DERMOD (1865-1945) BRITISH	800-5500	L
O'BRIEN, JUSTIN MAURICE (B. 1917) AUSTRALIAN	550-21000	S,F
O'BRIEN, LUCIUS RICHARD (1832-1899) CANADIAN	300-3500	L,M,F
O'CONNOR, JAMES ARTHUR (1792-1841) IRISH	500-27000	L
O'CONNOR, JOHN (1830-1889) BRITISH	400-26000	G,L
O'CONOR, RODERICK (1860-1940) IRISH	1100-240000	X
O'GORMAN, JUAN	*600-44000	
O'GORMAN, JUAN (1905-1982) MEXICAN	2800-+++	L
O'HIGGINS, PABLO	*200-2000	
O'HIGGINS, PABLO (B. 1905) MEXICAN	500-12200	G,L,S
O'KELLY, ALOYSIUS (B. 1853) IRISH	500-17000	G,L,W,M
O'LYNCH OF TOWN, KARL (1869-1942) GERMAN	300-3500	L
O'NEILL, DANIEL (20TH C) BRITISH	800-25000	X(F)
O'NEILL, GEORGE BERNARD (1828-1917) BRITISH	650-26500	G
O'NEILL, HENRY NELSON (1817-1880) BRITISH	2500-+++	F
O'REILLY, JOSEPH (D. 1893) IRISH	300-3200	F
O'RYAN, FERGUS (1911-1989) BRITISH	400-4500	L
OAKES, JOHN WRIGHT (1820-1887) BRITISH	300-5500	L
OAKES, JOHN WRIGHT (1820-1887) BRITISH	400-5000	L
OAKLEY, OCTAVIUS (1800-1867) BRITISH	*300-4500	G,F
OBERHAUSER, E. (19TH C) GERMAN	300-14000	F
OBERHUBER, OSWALD (B. 1931) AUSTRIAN	*500-3000	A
OBERMAN, ANTHONY (1781-1845) DUTCH	400-15000	F,S
OBERMULLER, FRANZ (1869-1917) AUSTRIAN	300-2800	F
OBERMULLNER, ADOLF (1833-1898) AUSTRIAN	300-4500	G,L
OBERSTEINER, LUDWIG (B. 1857) AUSTRIAN	400-5500	G
OBIN, ANTOINE (B. 1929) HAITIAN	300-2400	G,F
OBIN, PHILOME (B. 1892) HAITIAN	1000-42000	L,F
OBIN, SENEQUE (1893-1977) HAITIAN	500-18000	G,L,F,S
OBREGON, ALEJANDRO	*300-12000	
OBREGON, ALEJANDRO (B. 1920) SPANISH/COLOMBIAN	2000-65000	G,F,S
OCAMPO, ISIDORO (20TH C) MEXICAN	300-2000	G,F
OCAMPO, MIGUEL (B. 1922) ARGENTINEAN	300-3400	A
OCHTERVELT, JACOB (1635-1682) DUTCH	2000-+++	G,F
OCKEL, EDUARD (1834-1910) GERMAN	300-3600	X
OCKERT, CARL (1825-1899) GERMAN	200-1400	L,G

* Denotes watercolors, pastels, drawings, and/or mixed media

OCTAVIEN, FRANCOIS (1695-1736) FRENCH	650-16000	G,L
ODAZZI, GIOVANNI (1663-1731) ITALIAN	1000-7000	F
ODELMARK, FRANS WILHELM	*300-5200	
ODELMARK, FRANS WILHELM (1849-1937) SWEDISH	500-24000	G,L,F
ODIERNA, GUIDO (19TH/20TH C) ITALIAN	200-1200	L
OEDER, GEORG (1846-1931) GERMAN	650-15000	L,G
OEHMICHEN, HUGO (1843-1933) GERMAN	850-59000	G,F
OEHRING, HEDWIG (B. 1855) GERMAN	400-6500	G,F
OER, THEOBALD REINHOLD VON (1807-1885) GERMAN	*200-4500	F
OERDER, FRANS DAVID (1866-1944) DUTCH	300-7500	G,L,F,S
OESTERLEY, CARL AUGUST (1839-1930) GERMAN	300-10000	L,F
OFFERMANS, ANTONY JACOB (1796-1872) DUTCH	300-7800	L
OFFERMANS, TONY LODEWIJK GEORGE (1854-1911) DUTCH	300-4500	G,F
OFFORD, JOHN S. (19TH C) BRITISH	400-4200	G
OGUISS, TAKANARI (B.1900) JAPANESE	1800-+++	L,S
OHTAKE, TOMIE (B. 1913) JAPANESE/BRAZILIAN	300-10000	A
OJA, ONNI (B. 1909) FINNISH	1000-15000	L
OKUN, EDWARD (1872-1945) POLISH	600-22000	G
OLDEMAN, HENDRIK (19TH/20TH C) DUTCH	300-1000	L,F
OLIBECK, JACOBUS (17TH C) DUTCH	400-4500	M
OLIS, JAN (1610-1676) DUTCH	1200-85000	G,S
OLIVA, FELIX (B. 1936) PERUVIAN	400-4200	F
OLIVE, JEAN BAPTISTE (1848-1936) FRENCH	800-85000	L,S,M
OLIVER, ISAAC (1550-1617) BRITISH	900-10000	F
OLIVER, JEAN (20TH C) FRENCH	400-1800	X
OLIVER, WILLIAM (1805-1853) BRITISH	500-9500	G,F,L
OLIVER, WILLIAM (Active 1867-1882) BRITISH	400-4500	F,G
OLIVERO, PIETRO DOMENICO (17TH/18TH C) ITALIAN	750-62000	G,L
OLIVETTI, LUIGI (16TH C) ITALIAN	*300-2500	G,L,F
OLIVIER, MICHEL BARTHELEMY (1712-1784) FRENCH	600-6000	X
OLLAGUE, BOLIVAR (20TH C) ECUADORIAN	300-3600	G
OLLER, EDVIN (1888-1959) SWEDISH	400-3500	L,S
OLLEROS Y QUINTANA, BLAS (1851-1919) ITALIAN	600-7000	G,L
OLLEY, MARGARET HANNAH (B. 1923) AUSTRALIAN	600-8000	L,S
OLLIVARY, ANNETTE (20TH C) FRENCH	200-1600	X
OLOFSSON, PIERRE	*400-5000	
OLOFSSON, PIERRE (B. 1921)	600-22000	A
OLSEN, ALFRED (1854-1932) DANISH	200-3200	M
OLSEN, CHRISTOPHER BENJAMIN (1875-1935) DANISH	400-5600	M

OLSON, AXEL	*250-5500	
OLSON, AXEL (1899-1986) SWEDISH	1100-49000	G,L,M
OLSON, BENGT (B. 1930) SWEDISH	800-11000	A
OLSON, ERIK (1901-1986) SWEDISH	2600-63000	A
OLSSON, JULIUS (1864-1942) BRITISH	400-5500	L
OLSSON, OLLE (1904-1972) SWEDISH	800-67000	G,L,F,S
OLSTED, PETER (1824-1887) DANISH	300-2800	L
OMICCIOLI, GIOVANNI (B. 1901) ITALIAN	500-6500	X
OMMEGANCK, BALTHASAR PAUL (1755-1826) FLEMISH	500-15000	L,W
ONSAGER, SOREN (1878-1946) NORWEGIAN	1000-55000	G,F,L
OOLEN, ADRIAEN VAN (D. 1694) DUTCH	800-30000	L
OOMS, KAREL (1845-1900) BELGIAN	400-4500	G
OORT, HENDRIK VAN (1775-1847) DUTCH	300-4200	L
OOSTEN, FRANS VAN (D. 1679) FLEMISH	300-5200	F
OOSTEN, IZAAK VAN (1613-1661) FLEMISH	1000-70000	G,F,L
OOSTERWYCK, MARIA VAN (1630-1693) DUTCH	1000-62000	S
OOSTSANEN, JACOB C. (1477-1533) DUTCH	3000-95000	F
OPAZO, RODOLFO (B. CHILE 1925)	300-2200	F
OPDENHOFF, GEORG WILLEM (1807-1873) DUTCH	750-15000	M
OPHEY, WALTER (1882-1930) GERMAN	600-15000	L,S
OPIE, JOHN (1761-1807) BRITISH	500-33000	G,F
OPITZ, GEORG EMANUEL	*200-7700	
OPITZ, GEORG EMANUEL (1775-1841) GERMAN	750-54000	G,F
OPPEL, LISEL (1897-1960) GERMAN	800-6500	F,L,S
OPPENHEIMER, CHARLES (1875-1961) BRITISH	900-20000	M
OPPENHEIMER, JOSEF (B. 1876) GERMAN	1000-80000	F
OPPENHEIMER, MAX (Called MOPP) (1880-1954) GERMAN	800-71000	G,F,S
OPPLER, ERNST (B. 1869) GERMAN	*300-6500	G
OPSOMER, ISIDORE (1878-1967) FLEMISH	500-9800	G,S
ORANGE, MAURICE HENRI	*150-1500	
ORANGE, MAURICE HENRI (1868-1916) FRENCH	300-3200	G,F
ORANT, MARTHE	*400-7200	
ORANT, MARTHE (1874-1953) FRENCH	800-11000	F,S,L
ORBAN, DESIDERIUS (B. 1884) HUNGARIAN	300-6500	L,F,S
ORCHARDSON, SIR WILLIAM (1835-1910) BRITISH	500-21000	G,F
ORCZY, EMMA BARONNE DE (B. HUNGARY 1865) BRITISH	300-2000	F
ORFEI, ORFEO (19TH C) ITALIAN	400-8500	G
ORIANI, PIPPO (1909-1972) ITALIAN	400-9400	G,A,S
ORIZANTI (17TH C) DUTCH	400-2000	X

ORLEY, BAREND VAN(1492-1542) FLEMISH	5000-+++	F
ORLIK, EMIL (1870-1932) GERMAN	400-24000	G,F,L,S
ORLOFF, NICOLAS WASSILIEVITCH (B. 1863) RUSSIAN	650-11000	G
ORLOWSKI, ALEXANDER (1777-1832) POLISH	*600-3000	F
OROZCO, JOSE CLEMENTE	*1200-28000	
OROZCO, JOSE CLEMENTE (1883-1949) MEXICAN	1200-96000	A
OROZCO ROMERO, CARLOS	*300-6400	
OROZCO ROMERO, CARLOS (B. 1898) MEXICAN	600-12000	L,F,G
ORPEN, SIR WILLIAM	*300-16000	
ORPEN, SIR WILLIAM (1878-1931) IRISH	2000-+++	F,G,L
ORROCK, JAMES (1829-1913) BRITISH	*400-2900	M,L
ORSELLI, ARTURO (19TH C) ITALIAN	400-4000	G
ORTIZ, EMILIO (B. MEXICO 1936)	500-13500	W
ORTIZ DE ZARATE, MANUEL (1886-1946) FRENCH	900-9500	S,F
ORTLIEB, FRIEDRICH (1839-1909) GERMAN	700-25000	G
ORTMANS, FRANCOIS AUGUSTE (1827-1884) FRENCH	300-4600	L,W
ORTUZAR, CARLOS (B. 1935) CHILEAN	300-2400	A
OS, GEORGIUS JACOBUS JOHANNES VAN	*300-19000	
OS, GEORGIUS JACOBUS JOHANNES VAN (1782-1861) DUTCH	1200-50000	L,S,W
OS, JAN VAN (1744-1808) DUTCH	3500-+++	S,L
OS, MARIA MAGRITA VAN (1780-1862) DUTCH	300-5400	S
OS, PIETER FREDERIK VAN (1808-1860) DUTCH	400-3200	W,G,L
OS, PIETER GERARDUS VAN	*200-1800	
OS, PIETER GERARDUS VAN (1776-1839) DUTCH	500-24000	L,S
OSBERT, ALPHONSE (1857-1939) FRENCH	600-122000	L
OSBORNE, EMILY MARY (1834-1913) BRITISH	400-9600	G,F,L
OSBORNE, WALTER	*850-25000	
OSBORNE, WALTER (1859-1903) BRITISH	2000-130000	L,G,F
OSBORNE, WILLIAM (1823-1901) BRITISH	300-9000	G,W
OSCARSSON, BERNHARD (1894-1971) SWEDISH	500-6000	M,F,L
OSNAGHI, JOSEPHINE (19TH C) AUSTRIAN	300-4000	S
OSSANI, ALESSANDRO (19TH C) BRITISH	300-3800	G,F
OSSENBEECK, JAN VAN (1624-1674) DUTCH	400-6200	L
OSSLUND, HELMER	*250-11000	
OSSLUND, HELMER (1866-1938) SWEDISH	1000-76000	F,L
OSSWALD, EUGEN (B. 1879) GERMAN	400-3000	W,G,L
OSTADE, ADRIAEN VAN	*750-25000	
OSTADE, ADRIAEN VAN (1610-1684) DUTCH	1500-+++	G,F
OSTADE, ISAAC VAN	*500-25000	

OSTADE, ISAAC VAN (1621-1649) DUTCH	2400-+++	G,L
OSTERLIND, ANDERS (1887-1960) FRENCH	500-9100	L,S
OSTERLUND, HERMAN (1873-1964) SWEDISH		
OSTERSETZER, CARL (19TH/20TH C) GERMAN	300-6200	G,F
OSTHAUS, EDMUND HENRY	*300-17000	
OSTHAUS, EDMUND HENRY (1858-1928) GERMAN	650-18000	L,S
OTERO, ALEJANDRO (B. 1921) VENEZUELAN	500-10000	A
OTT, LUCIEN (D. 1927) FRENCH	300-1200	X
OTTENFELD, RUDOLF RITTER VON (1856-1913) ITALIAN	800-12000	G,L
OTTESEN, OTTO DIDERICH (1816-1892) DANISH	650-69000	S
OTTINI, PASQUALE (1580-1630) ITALIAN	1500-12000	F
OTTMANN, HENRI (1877-1927) FRENCH	350-48000	G,L,F
OTTO, CARL (1830-1902) GERMAN	400-4200	G,S
OUDENHAVEN, JOSEPH VAN (19TH C) BELGIAN	400-9200	G
OUDENROGGE, JOHANNES DIRCKSZ VAN (1622-1653) DUTCH	500-14000	G
OUDINOT, ACHILLE FRANCOIS (1820-1891) FRENCH	400-9200	L
OUDOT, ROLAND	*300-4400	
OUDOT, ROLAND (1897-1981) FRENCH	650-14500	L,F,S
OUDRY, JACQUES CHARLES (1720-1778) FRENCH	1000-75000	G,F,S
OUDRY, JEAN BAPTISTE	*1500-185000	
OUDRY, JEAN BAPTISTE (1686-1755) FRENCH	5000-+++	F,S
OUTIN, PIERRE (1840-1899) FRENCH	750-20000	G,F
OUVRIE, PIERRE JUSTIN	*300-3000	
OUVRIE, PIERRE JUSTIN (1806-1879) FRENCH	650-24000	L,F
OUWATER, ISAAK (1750-1793) DUTCH	1500-87000	L
OVADYAHU, SAMUEL (20TH C) ISRAELI	500-5500	L,S,M
OVENS, JURGEN (1623-1678) GERMAN	1000-60000	F,G
OVERBECK, FRITZ (1869-1909) GERMAN	700-56000	L
OVERHOFF, R. (19TH C) FRENCH	300-1200	X
OVERSTRAETEN, WAR VAN (20TH C) BELGIAN	400-3500	F,G
OVTCHINNIKOV, VLADIMIR (1911-1978) RUSSIAN	300-5200	X
OWEN, SAMUEL (1768-1857) BRITISH	300-6000	M
OWEN, WILLIAM (1765-1829) BRITISH	*500-8800	L,F
OZANNE, NICOLAS (17TH C) FRENCH	*500-5300	M,L
OZENFANT, AMEDEE	*500-40000	
OZENFANT, AMEDEE (1886-1966) FRENCH	2400-220000	A

P

ARTIST	PRICES	SUBJECT
PAAL, LADISLAS DE (1846-1879) HUNGARIAN	300-3200	L
PAALEN, WOLFGANG (1905-1959) MEXICAN	1000-61000	G
PACCHIA, GIROLAMO DEL (1477-1533) ITALIAN	3000-32000	F
PACCHIAROTTI, GIACOMO (1474-1540) ITALIAN	1000-20000	X
PACE, RAINERI DEL (18TH C) ITALIAN	400-5200	F
PACETTI, MICHAELANGELO (1793-1855) ITALIAN	500-9800	L,S
PACHECO, MARIA LUISA	*200-1500	
PACHECO, MARIA LUISA (B. 1919) BOLIVIAN	500-10000	F
PACHER, FERDINAND (1852-1911) GERMAN	750-22000	G,F
PADDAY, CHARLES (20TH C) BRITISH	1500-30000	M
PADILLA, EUGENIO LUCAS (1824-1870) SPANISH	650-28500	G,F
PADUA, PAUL MATTHIAS (1903-1981) AUSTRIAN	300-10000	G,F
PAEDE, PAUL (1868-1929) GERMAN	300-8000	G,L,F
PAELINCK, JOSEPH (1781-1839) BELGIAN	500-73000	G
PAERELS, WILLEM (1878-1962) BELGIAN	1400-45000	G,L
PAEZ, JOSEPH DE (18TH C) MEXICAN	300-12000	F
PAGANI, PAOLO (1661-1716) ITALIAN	1000-80000	F
PAGANO, MICHELE (1697-1732) ITALIAN	500-28000	L
PAGE, EVELYN (B. 1899) NEW ZEALANDER	500-6000	M,L
PAGE, HENRI MAURICE (Late 19TH C) BRITISH	300-4500	G,L,S
PAGI, GIORGIO (B. 1913) ITALIAN	300-2400	A
PAGLIANO, ELEUTERIO (1826-1903) ITALIAN	200-3900	F,G
PAICE, GEORGE (19TH C) BRITISH	400-4500	W
PAIL, EDOUARD (B. 1851) FRENCH	200-19000	L
PAILES, ISAAC (B. 1895) FRENCH	300-7000	G,L,S
PAJOU, AUGUSTIN (1730-1809) FRENCH	*400-4000	G,F
PAKOUN, FILARET (B. 1912) RUSSIAN	1000-12000	X(L,F)
PALACIOS, ALIRIO (1897-1968) CUBAN	3000-15000	X
PALACIOS, FRANCISCO DE (1640-1676) SPANISH	800-55000	S
PALADINO, MIMMO (B. 1948) ITALIAN	*850-118000	L,F
PALAGI, PELAGIO (1775-1860) ITALIAN	1000-20000	X(F)
PALAMEDES, ANTHONIE (Called STEVERS) (1601-1673) DUTCH	900-118000	G,F
PALAMEDES, PALAMEDESZ (17TH C) DUTCH	2500-45000	F,G
PALENCIA, BENJAMIN (1902-1980) SPANISH	400-82100	L
PALEZZANO, MARCO (1458-1539) ITALIAN	1500-32000	X
PALIN, WILLIAM MAINWARING (1862-1947) BRITISH	400-19000	G,L,F

PALING, JOHANNES JACOBUS (1844-1892) DUTCH	400-5200	F,L
PALIZZA, GIUSEPPE (1812-1888) ITALIAN	400-66000	F,G,L
PALIZZI, FILIPPO (1818-1889) ITALIAN	1000-115000	G,L
PALIZZI, NICOLA (1820-1870) ITALIAN	400-8400	L
PALLARES Y ALLUSTANTE, JOAQUIN (19TH C) SPANISH	400-6400	G
PALLIERE, JEAN LEON (B. 1823) FRENCH	500-13500	G,L
PALLIK, BELA (1845-1908) HUNGARIAN	650-15000	L
PALLMANN, GOTZ (1908-1966) GERMAN	300-8200	L,F
PALM, ANNA (1854-1924) NORWEGIAN	*400-34000	L,M
PALM, GUSTAF WILHELM (1810-1890) SWEDISH	1000-55000	L
PALM, TORSTEN (1875-1934) SWEDISH	400-7500	L,M
PALMA, JACOPO (Called IL GIOVANE)	*900-25000	
PALMA, JACOPO (Called IL GIOVANE) (1544-1628) ITALIAN	1500-54000	G,F
PALMAROLI Y GONZALEZ, VICENTE (1834-1896) SPANISH	1200-33000	F,G
PALMEIRO, JOSE (B. 1903) SPANISH	500-8500	L,S,M
PALMER, HARRY SUTTON (1854-1933) BRITISH	*500-7900	L,G
PALMER, HERBERT SIDNEY (1881-1970) CANADIAN	200-3500	L
PALMER, JAMES LYNWOOD (1865-1941) BRITISH	800-24000	L,F
PALMER, SAMUEL	*800-170000	
PALMER, SAMUEL (1805-1881) BRITISH	1000-220000	L
PALMER, WILLIAM (1763-1790) BRITISH	200-1200	X
PALMIER, CHARLES (1863-1911) GERMAN	400-26000	L,F
PALMIERI, PIETRO	*200-6800	
PALMIERI, PIETRO (19TH C) ITALIAN	300-1400	L,F
PANABAKER, FRANK S (B. 1904) CANADIAN	300-4500	L,S
PANINI, FRANCESCO (18TH C) ITALIAN	750-32000	L
PANINI, GIOVANNI PAOLO	*450-27000	
PANINI, GIOVANNI PAOLO (1691-1765) ITALIAN	10000-+++	L,F
PANKOK, BERNHARD (1872-1943) GERMAN	900-12000	G,F,L
PAOLETTI, ANTONIO ERMOLAO (1834-1912) ITALIAN	1000-38000	G,L,M
PAOLETTI, RODOLFO (1866-1940) ITALIAN	400-7600	L
PAOLETTI, SYLVIUS D. (1864-1921) ITALIAN	300-9900	G,L
PAOLINI, PIETRO (1605-1682) ITALIAN	2000-207000	F
PAOLINO, PAOLO (1490-1547) ITALIAN	2000-65000	F
PAOLO (VENEZIANO) (1333-1358) ITALIAN	850-75000	F
PAOLO DI GIOVANNI FEI (14TH/15TH C) ITALIAN	1200-120000	F
PAOLOZZI, EDUARDO (B. 1924) BRITISH	*300-2000	G,F
PAON, JEAN BAPTISTE LOUIS LE (1735-1785) FRENCH	*750-28000	F,G
PAPALUCA, L. (19TH/20TH C) ITALIAN	200-3500	M

PAPART, MAX (B. 1911) FRENCH	200-75000	G,F,S
PAPAZOFF, GEORGES (1894-1972) BULGARIAN	700-35000	X
PAPE, ABRAHAM DE (1620-1666) DUTCH	400-14000	G,F
PAPE, FRIEDRICH EDUARD (1817-1905) GERMAN	600-6500	L
PAPELEN, VICTOR DE (1810-1881) FRENCH	400-5000	L
PAPETY, DOMINIQUE LOUIS (1815-1849) FRENCH	*300-10000	F,L
PAREDES, VICENTA DE (19TH C) SPANISH	500-15000	G,F
PARESCE, RENATO (1886-1937) ITALIAN	1000-25000	X
PARET Y ALCAZAR, LUIS (1746-1799) SPANISH	650-90000	F,L
PARIS, ALFRED (1846-1908) FRENCH	800-18000	X
PARIS, GEORGE DE (1829-1911) BRITISH	*300-2500	X
PARIZEAU, PHILIPPE-LOUIS (1740-1801) FRENCH	*800-5000	G,F
PARK, JOHN ANTHONY (1888-1962) BRITISH	800-7000	M,L
PARK, STUART (1862-1933) BRITISH	300-16000	F,S
PARKER, HENRY H.	*200-2500	
PARKER, HENRY H. (1858-1930) BRITISH	600-32000	L
PARKER, HENRY PERLE (1795-1873) BRITISH	800-22000	G,F,L
PARKER, JOHN (17TH C) BRITISH	500-15500	X
PARKER, JOHN (B. 1827) BRITISH	300-3200	L
PARMEGGIANI, TANCREDI (1927-1964) ITALIAN	300-4200	X
PARMIGIANINO, (GIROLOMO FRANCESCO MAZZOLA) (1503-1540) ITALIAN	*3500-+++	F,L
PARMIGIANINO, (MICHELE ROCCA) (1670-1751) ITALIAN	500-14000	X
PARPETTE, PHILIPPE (1738-1739) FRENCH	750-22000	S
PARRIS, EDMOND THOMAS (1793-1873) BRITISH	300-5400	G,L,F
PARROCEL, CHARLES (1688-1752) FRENCH	700-16000	F,G
PARROCEL, IGNACE JACQUES (1667-1722) FRENCH	650-60000	F
PARROCEL, JOSEPH (1646-1704) FRENCH	400-45000	G,F
PARROCEL, JOSEPH FRANCOIS (1704-1781) FRENCH	*400-12000	F
PARROT, PHILIPPE (1831-1894) FRENCH	500-4400	G
PARROTT, WILLIAM (1742-1782) BRITISH	300-13000	L,M
PARROW, KARIN (1900-1984) SWEDISH	1000-10000	F,S,L,M
PARRY, JOSEPH (1744-1826) BRITISH	500-15000	G,L
PARS, WILLIAM (1742-1782) BRITISH	*400-6000	L
PARSONS, ALFRED WILLIAM	*250-15000	
PARSONS, ALFRED WILLIAM (1847-1920) BRITISH	400-7600	L
PARSONS, BEATRICE (1870-1955) BRITISH	300-7900	F,L
PARTON, ERNEST (1845-1933) BRITISH	400-8400	L
PARTRIDGE, ALFRED (19TH/20TH C) BRITISH	300-1500	L

PARTRIDGE, JOHN (1790-1872) BRITISH	1000-10000	F
PASCAL, PAUL (1832-1903) FRENCH	*300-2200	L,F
PASCAL, PAUL B. (B. 1867) FRENCH	*300-4400	L
PASCH, ULRIKA (1735-1796) SWEDISH	400-8600	F
PASCUTTI, ANTONIO (19TH C) AUSTRIAN	300-4000	G
PASINELLI, LORENZO	*500-25000	
PASINELLI, LORENZO (1629-1700) ITALIAN	1000-25000	F
PASINI, ALBERTO	*300-7600	
PASINI, ALBERTO (1826-1899) ITALIAN	1200-180000	G,L
PASINI, LUDWIG (1832-1903) AUSTRIAN	*1500-55000	L,F
PASMORE, DANIEL (Late 19TH C) BRITISH	300-5000	G,F
PASMORE, JOHN F. (19TH C) BRITISH	300-5800	G,F
PASMORE, VICTOR (B. 1908) BRITISH	1200-55000	A
PASMORE, VICTOR (B. 1908) BRITISH	2000-50000	A,F
PASSANTE, BARTOLOMEO (1614-1656) ITALIAN	500-20000	F
PASSAROTTI, BARTOLOMEO	*1500-36000	
PASSAROTTI, BARTOLOMEO (1529-1592) ITALIAN	5000-+ + +	F
PASSERI, GIUSEPPE (1654-1714) ITALIAN	900-10000	G,F
PASSEY, CHARLES HENRY (Late 19TH C) BRITISH	400-4500	L
PASSMORE, JOHN FREDERICK (1820-1881) BRITISH	300-8800	G,L,F
PASSMORE, JOHN RICHARD (B. 1904) AUSTRALIAN	1000-24000	F,G,L,M
PASTEGA, LUIGI (1858-1927) ITALIAN	400-13000	G
PASTERNAK, LEONID OSSIPOVITSCH (1862-1945) RUSSIAN	200-2000	G,F,S
PATAKY VON SOSPATAK, LASZLO (1857-1912) HUNGARIAN	300-4500	G
PATALANO, ENRICO (19TH C) BRITISH	300-2600	I
PATCH, THOMAS (1720-1782) BRITISH	1200-69000	L
PATEL, ANTOINE PIERRE (1648-1707) FRENCH	500-21000	L
PATEL, PIERRE (1605-1676) FRENCH	600-24000	L
PATELLIERE, AMEDEE DE LA (1890-1932) FRENCH	500-26000	X(L,F)
PATENIER, JOACHIM (1485-1524) FLEMISH	3000-93000	L,F
PATEO, KAROLY (1895-1941) HUNGARIAN	900-15000	L
PATER, JEAN BAPTISTE	*500-27000	
PATER, JEAN BAPTISTE (1695-1736) FRENCH	5500-225000	G,F
PATERSON, JAMES	*600-6000	
PATERSON, JAMES (1854-1932) BRITISH	800-24000	S,G,L
PATON, FRANK (1856-1909) BRITISH	950-49000	G,L,W
PATON, RICHARD (1717-1791) BRITISH	500-32000	M
PATON, SIR JOSEPH NOEL	*200-47000	
PATON, SIR JOSEPH NOEL (1821-1901) BRITISH	600-203000	F

PATON, W. HUBERT (1853-1927) SCOTTISH	*300-1800	F
PATON, WALLER HUGH (1828-1895) BRITISH	300-9100	L,G
PATRICK, JAMES MCINTOSH (B. 1907) BRITISH	400-42000	L
PATTEIN, CESAR (Active 1882-1914) FRENCH	500-17000	G,L
PAU DE SAINT MARTIN, ALEXANDRE (18TH C) FRENCH	500-15000	L
PAUDISS, CHRISTOPH (1618-1666) GERMAN	400-7200	G,F
PAUL, JOHN (19TH C) BRITISH	800-15000	L
PAUL, JOSEPH H. (1804-1887) BRITISH	400-7300	L
PAULI, ADOLPH (1820-1895) BELGIAN	*300-1500	L
PAULI, GEORG (1855-1935) SWEDISH	600-+++	F,M,L
PAULI, HANNA (1864-1940) SWEDISH	500-93000	F,L
PAULSEN, FRITZ (1838-1898) GERMAN	650-7000	G
PAULSEN, JULIUS (1860-1940) DANISH	550-21000	G,L,F
PAULUCCI, ENRICO (B. 1901) ITALIAN	600-10000	X
PAULUS, PIERRE (1881-1959) BELGIAN	400-13000	L
PAUSINGER, CLEMENS VON (1855-1936) AUSTRIAN	*300-5600	G,F
PAUSINGER, FRANZ VON (1839-1915) AUSTRIAN	300-4500	L,W
PAUW, JEF DE (1888-1930) BELGIAN	300-4500	L,M,F
PAVESI, P. (19TH C) ITALIAN	*300-6200	G,F
PAVIL, ELIE ANATOLE (1873-1948) FRENCH	300-37000	L
PAVY, PHILIPPE (19TH C) FRENCH	1000-26000	G,L
PAWLEY, JAMES (19TH C) BRITISH	1000-20000	W,G,F
PAYNE, DAVID (19TH C) BRITISH	300-7300	L
PAYNE, WILLIAM (1760-1830) BRITISH	*300-5000	L,F
PAYNE, WILLIAM (17TH C) BRITISH	*800-3500	M,F
PEACOCK, GEORGE EDWARD (19TH/20TH C) AUSTRALIAN	400-22000	L
PEACOCK, RALPH (1868-1946) BRITISH	800-15000	X(F)
PEAKE, ROBERT (16TH/17TH C) BRITISH	1200-84000	F
PEAKE, ROBERT (THE ELDER) (1592-1667) BRITISH	1000-10000	F
PEARS, CHARLES (1873-1958) BRITISH	300-9000	F,L
PEARSON, CORNELIUS (1805-1891) BRITISH	*300-3200	L,F
PECHAUBES, EUGENE (B. 1890) FRENCH	600-6000	X
PECHEUX, LAURENT (1729-1821) FRENCH	1200-26000	F
PECHSTEIN, MAX HERMANN M.	*850-76000	
PECHSTEIN, MAX HERMANN M. (1881-1955) GERMAN	5000-+++	A
PECRUS, CHARLES FRANCOIS (1826-1907) FRENCH	400-14000	G,F,L
PEDDER, JOHN (19TH-20TH C) BRITISH	*300-3000	L,F
PEDERSEN, CARL HENNING	*800-55000	
PEDERSEN, CARL HENNING (B. 1913) DANISH	2000-98000	F,S

PEDERSEN, FINN (20TH C) DANISH	800-4000	A
PEDERSEN, VIGGO (1854-1926) DANISH	500-7500	L,F,W
PEDIETTI, F. (19TH/20TH C) ITALIAN	300-2000	X
PEDON, BARTOLOMEO (1665-1732) ITALIAN	400-15000	L,M
PEDRETTI, ARTURO (1896-1964) ITALIAN	400-14000	G,L,S
PEDRINI, GIOVANNI (15TH C) ITALIAN	1200-230000	F
PEDRO, LUIS MARTINEZ (B. 1910) CUBAN	*300-3000	X
PEEL, JAMES (1811-1906) BRITISH	400-9100	L,W
PEEL, PAUL (1861-1892) CANADIAN	600-+++	G,F
PEELE, JOHN THOMAS (1822-1897) BRITISH	650-15000	F
PEETERS, BONAVENTURA (17TH/18TH C) FLEMISH	500-29000	M
PEETERS, CLARA (1594-1657) FLEMISH	8000-175000	S
PEETERS, GILLISA (1612-1653) FLEMISH	650-15000	L
PEETERS, JACOB (17TH C) FLEMISH	500-8800	G,L
PEGOT-OGIER, JEAN BERTRAND (1877-1915) FRENCH	1000-32000	X(F)
PEGURIER, AUGUSTE (1856-1936) FRENCH	300-4000	L,M
PEHRSON, KARL AXEL	*500-6000	
PEHRSON, KARL AXEL (B. 1921) SWEDISH	900-33000	A
PEIFFER-WATENPHUL, MAX (B. 1896) GERMAN	*700-15000	S,L
PEINADO, JOAQUIN (1898-1975) SPANISH	300-2400	A,S
PEISER, KURT (19TH/20TH C) BELGIAN	300-5200	F
PELAEZ, AMELIA	*300-20000	
PELAEZ, AMELIA (1897-1968) MEXICAN	800-25000	A,S
PELEZ, FERNAND (1843-1913) FRENCH	300-1500	F
PELGROM, JACOBUS (1811-1861) DUTCH	400-4200	G,L
PELHAM, JAMES (II) (1800-1874) BRITISH	300-2900	G
PELHAM, THOMAS KENT (Late 19TH C) BRITISH	300-6200	G
PELLEGRIN, HONORE (1800-1870) FRENCH	*500-15000	G,F,M
PELLEGRINI, GIOVANNI ANTONIO (1675-1741) ITALIAN	5000-198000	F
PELLEGRINI, RICCARDO (1863-1934) ITALIAN	400-9000	G,L,S
PELLETIER, CLAUDE (20TH C) FRENCH	300-1800	X
PELLICCIOTTI, TITO (1872-1943) ITALIAN	400-6800	X
PELLIZZA DA VOLPEDO, GIUSEPPE (1868-1907) ITALIAN	3000-+++	G,F,L
PELLON, GINA (B. 1925) CUBAN	300-2400	X
PELOUSE, LEON GERMAIN (1838-1891) FRENCH	500-36000	G,L
PELUSO, FRANCESCO (B. 1836) ITALIAN	300-6800	G,M
PENCK, A. R.	*900-220000	
PENCK, A. R. (B. 1939) GERMAN	1200-143000	G,A
PENDL, ERWIN (B. 1875) AUSTRIAN	*300-3400	L,F

* Denotes watercolors, pastels, drawings, and/or mixed media

PENLEY, AARON EDWIN (1807-1870) BRITISH	*200-4400	L
PENN, WILLIAM CHARLES (1877-1968) BRITISH	900-48000	F,S
PENNACCHINI, DOMENICO (1860-1928) ITALIAN	300-13000	G,F
PENNE, CHARLES OLIVIER DE	*300-2800	
PENNE, CHARLES OLIVIER DE (1831-1897) FRENCH	500-60000	G,W
PENNELL, HARRY (19TH C) BRITISH	500-4000	L
PENNETHORNE, SIR JAMES (1801-1871) BRITISH	*3000-36000	X(L)
PENNY, W. D. (19TH C) BRITISH	200-1200	M
PENOT, ALBERT JOSEPH (Early 20TH C) FRENCH	300-4600	F,G
PENOT, JEAN VALLETTE (1710-1777) FRENCH	300-80000	S
PEPLOE, SAMUEL JOHN (1871-1935) BRITISH	1400-217000	L,F,S
PERAIRE, PAUL EMMANUEL (1829-1893) FRENCH	500-21000	L
PERALTA DEL CAMPO, FRANCISCO	*200-2000	
PERALTA DEL CAMPO, FRANCISCO (D. 1897) SPANISH	750-30000	G,L
PERAUX, LIONEL (B. 1871) FRENCH	300-2000	X
PERBOYRE, PAUL EMILE LEON (1826-1907) FRENCH	300-9500	F
PERCIER, CHARLES (18TH/19TH C)	*2000-35000	L,F
PERCIVAL, H. (19TH C) BRITISH	*300-2400	M
PERCY, SIDNEY RICHARD WILLIAMS (1821-1886) BRITISH	1100-74000	L,W
PEREDA, ANTONIO DE (1599-1669) SPANISH	1500-60000	S,F
PEREHUDOFF, WILLIAM W. (B. 1919) CANADIAN	300-2800	A
PERELLE, NICOLAS (1631-1695) FRENCH	400-6000	L
PEREZ, ALONZO (B. 1858) SPANISH	900-43000	G
PEREZ, BARTOLOME (1634-1693) SPANISH	850-95000	S
PEREZ, CARLOS ALONZO (B. 1858) SPANISH	300-3400	G
PEREZ-SENET, RAFAEL (B. 1856) SPANISH	*300-16000	G
PERIGAL, ARTHUR (1816-1884) BRITISH	350-17000	L
PERIN, LOUIS JULES (B. 1871) FRENCH	*400-5500	X
PERK, W. D. (19TH C) BRITISH	300-2500	G
PERLBERG, FRIEDRICH (1848-1921) GERMAN	300-3400	L
PERLBERG, GEORG (1807-1884) GERMAN	400-7200	G
PERMAN, LOUISE E (D. 1921) BRITISH	500-3200	S
PERMEKE, CONSTANT	*500-48000	
PERMEKE, CONSTANT (1886-1952) BELGIAN	1100-175000	A
PERNET, JEAN HENRY ALEXANDRE (B. 1763) FRENCH	400-7000	G
PEROV, VASILI (1833-1882) RUSSIAN	200-1800	X
PERRAULT, LEON JEAN BASILE (1832-1908) FRENCH	1200-50000	G,F
PERRET, AIME (1847-1927) FRENCH	800-16000	G,L,S
PERRET, EDOUARD (B. 1864) FRENCH	300-2000	X

PERREY, LOUIS (B. 1856) FRENCH	300-7600	G
PERRIER, EMILIO SANCHEZ (1853-1907) SPANISH	700-50000	G,L
PERRIN, G. (19TH C) FRENCH	600-5800	G
PERRONEAU, JEAN BAPTIST	*500-25000	
PERRONEAU, JEAN BAPTIST (1715-1783) FRENCH	1200-79000	F
PERRY, WILLIAM (19TH C) BRITISH	300-3400	G,L
PERSOGLIA, FRANZ VON (B. 1852) AUSTRIAN	400-5200	F,G
PERSON, HENRI	*350-5000	
PERSON, HENRI (1876-1926) FRENCH	600-14000	L,G
PERSSON, FOLKE (1905-1964) SWEDISH	400-3000	M,L
PERSSON, PETER ADOLF (1862-1914) SWEDISH	300-10000	L
PERSSON, RAGNAR (B. 1905) SWEDISH	650-79000	G,L,F
PERUGINI, CHARLES EDWARD (1839-1918) BRITISH	600-22000	G,F
PERUZZI, BALDASSARE	*1200-226000	
PERUZZI, BALDASSARE (1481-1536) ITALIAN	2000-70000	F
PESCE, GIROLAMO (1684-1759) ITALIAN	500-6400	F
PESENTI, DOMENICO (1843-1918) ITALIAN	300-2200	G
PESKE, GEZA (B. 1859) HUNGARIAN	300-2800	G,L
PESKE, JEAN	*500-18000	
PESKE, JEAN (1880-1949) FRENCH	400-11000	L,G,S
PESNE, ANTOINE (1683-1757) FRENCH	1000-77000	F
PESNE, ANTOINE (1683-1757) FRENCH	700-42000	F
PESSENTI, D. (19TH C) ITALIAN	300-2700	X
PETER, WENCESLAUS (1742-1829) AUSTRIAN	300-6500	W
PETERELLE, ADOLPHE (1874-1947) FRENCH	500-4500	F
PETERS, ANNA (1843-1926) GERMAN	400-25000	S
PETERS, PIETER FRANCIS (THE YOUNGER) (1818-1903) DUTCH	700-63000	L
PETERS, REV. MATTHEW WILLIAM (1741-1814) IRISH	400-24000	F
PETERS, WILHELM OTTO (1851-1935) NORWEGIAN	1200-86000	L,G
PETERSEN, EDVARD (1841-1911) DANISH	900-32000	G,L
PETERSEN, ROBERT STORM (1882-1949) DANISH	400-6000	L,G
PETHER, ABRAHAM (1756-1812) BRITISH	650-12000	L,G
PETHER, HENRY (19TH C) BRITISH	750-25000	L
PETHER, SEBASTIAN (1790-1844) BRITISH	300-4800	L
PETILLION, JULES (1845-1899) FRENCH	800-30000	G
PETIT, CORNEILLE (19TH C) BELGIAN	300-6000	X
PETIT, EUGENE (1839-1886) FRENCH	400-8500	G,S
PETIT, FRANCOIS CONSTANT (19TH C) BELGIAN	500-6000	G
PETIT, JEAN LOUIS (1795-1876) FRENCH	300-2800	L,M

PETITI, FILIBERTO (1845-1924) ITALIAN	500-6400	X(L)
PETITJEAN, EDMOND MARIE (1844-1925) FRENCH	1100-125000	M,F,G,L
PETITJEAN, HIPPOLYTE	*500-24500	
PETITJEAN, HIPPOLYTE (1854-1929) FRENCH	1500-130000	G,L,F,S
PETRIDES, KONRAD (1864-1943) AUSTRIAN	300-4000	L
PETROCELLI, ARTURO (B. 1856) ITALIAN	300-4200	G
PETROCELLI, VINCENZO (1823-1896) ITALIAN	300-2000	G,L
PETRUOLO, SALVATORE (1857-1946) ITALIAN	400-6200	L,M
PETTENKOFEN, AUGUST CARL RITTER VON (1822-1889) AUSTRIAN	850-54000	G,L,F
PETTER, FRANZ (1791-1866) AUSTRIAN	400-15500	S,L
PETTER, THEODOR (1822-1872) AUSTRIAN	300-4000	L,S
PETTIE, SIR JOHN (1839-1893) SCOTTISH	400-9200	F,G
PETTITT, CHARLES (19TH C) BRITISH	400-11000	L
PETTITT, EDWIN ALFRED (1840-1912) BRITISH	300-1800	L
PETTITT, JOSEPH PAUL (1812-1882) BRITISH	500-14000	F,L,M
PETTORUTI, EMILIO	*750-105000	
PETTORUTI, EMILIO (1892-1971) ARGENTINIAN	2500-245000	A
PETZHOLDT, FRITZ (1805-1838) DANISH	400-5000	L
PEURSE, ADAM VAN (B. 1814) DUTCH	300-2400	G
PEYRISSAC, JEAN (B. 1895) FRENCH	*400-3000	X
PEYROL, RENE (19TH C) FRENCH	300-3000	L
PEYRON, JEAN FRANCOIS PIERRE (1744-1814) FRENCH	*300-7800	F
PEZANT, AYMAR (1846-1914) FRENCH	300-3400	L
PEZENBURG, E. (19TH C) GERMAN	500-8900	G
PEZOUS, JEAN (1815-1885) FRENCH	400-3000	F,G
PFEIFFER, WILHELM (1822-1891) GERMAN	400-11000	G
PFEILER, MAXMILLIAN (18TH C) GERMAN	650-23000	S
PFISTER, ALBERT (B. 1884) SWISS	400-5000	L,F
PFLUG, JOHAN BAPTIST	*500-68000	
PFLUG, JOHAN BAPTIST (1785-1866) GERMAN	1000-130000	G,F
PFORR, JOHAN GEORG (1745-1798) GERMAN	650-47000	L,M
PFYFFER VON ALTISHOFEN, NIKLAUS (1836-1908) SWISS	800-8000	L
PHILIPPE-AUGUSTE, SALNAVE (B. 1908) HAITIAN	500-10000	G
PHILIPPEAU, KAREL FRANS (1825-1897) DUTCH	800-20000	G,L,F
PHILIPPOTEAUX, HENRI FELIX EMMANUEL (1815-1884) FRENCH	700-14000	F,L
PHILIPPOTEAUX, PAUL DOMINIQUE (19TH C) FRENCH	300-5000	L,F
PHILIPS, FRANK ALBERT (19TH C) BRITISH	300-2800	G
PHILIPSEN, THEODOR (1840-1920) DANISH	500-16000	L

PHILIPSON, ROBIN (B. 1916) BRITISH	600-12000	X
PHILLIP, JOHN (1817-1867) BRITISH	500-12000	G,F
PHILLIPS, CHARLES (1708-1747) BRITISH	750-26000	F
PHILLIPS, CHARLES (18TH/19TH C) BRITISH	300-8000	F,G
PHILLIPS, PETER (B. 1939) BRITISH	400-14000	A
PHILLIPS, THOMAS (1770-1845) BRITISH	350-28000	F
PHILPOT, GLYN	*500-25000	
PHILPOT, GLYN (1884-1937) BRITISH	1200-156000	G,F,L
PHOENIX, GEORGE (1863-1935) BRITISH	650-11000	F,G
PIACENZA, CARLO (1814-1887) ITALIAN	300-7000	L
PIANA, GIUSEPPE FERDINANDO (1864-1958) ITALIAN	500-4000	X
PIATKOWSKI, HENRYK (1853-1932) POLISH	300-2400	X
PIAUBERT, JEAN (B. 1900) FRENCH	500-27000	A
PIAZZETTA, GIAMBATTISTA (1682-1754) ITALIAN	*1500-+++	F
PICABIA, FRANCIS	*5000-+++	
PICABIA, FRANCIS (1878-1953) FRENCH	5000-+++	A
PICARD, GUSTAVE (19TH C) FRENCH	300-4000	F
PICART, JEAN MICHEL (1600-1682) FLEMISH	1200-85000	S
PICASSO, PABLO	*5000-+++	
PICASSO, PABLO (1881-1973) SPANISH	198000-+++	A
PICAULT, C. E. (19TH C) FRENCH	300-3600	L
PICK, ANTON (B. 1840) AUSTRIAN	300-3800	L,G
PICKARD, LOUISE (1865-1928) BRITISH	300-2600	G
PICKARDT, ERNST (1876-1931) GERMAN	300-3000	L,F
PICKENOY, NICOLAES ELIAS (1590-1656) DUTCH	1000-60000	F
PICKERING, HENRY (Active 1745-1776) BRITISH	400-25000	G,F
PICKERSGILL, FREDERICK (1820-1900) BRITISH	500-15000	F,G
PICKERSGILL, HENRY (1782-1875) BRITISH	400-11000	F,G
PICOLO Y LOPEZ, MANUEL (1850-1892) SPANISH	300-10000	G
PICOU, HENRI PIERRE (1824-1895) FRENCH	300-18500	F
PIELER, FRANZ XAVIER (1879-1952) AUSTRIAN	700-21000	S
PIEMONT, NICOLAS (1644-1709) DUTCH	500-24000	X(L)
PIENNE, GEORGES (Late 19TH C) BRITISH	300-2000	M
PIEPENHAGEN, AUGUST (1791-1868) POLISH	400-9000	L
PIERCY, FREDERICK (Active 1848-1880) BRITISH	*400-3400	F,L
PIERE, LUC (B. 1916) BELGIAN	600-15000	X
PIERNEEF, JACOB HENDRIK	*400-12000	
PIERNEEF, JACOB HENDRIK (1886-1957) SOUTH AFRICAN	600-25000	L
PIERO DI COSIMO (1492-1521) ITALIAN	1500-55000	F

* Denotes watercolors, pastels, drawings, and/or mixed media

PIERRE, ANDRE (B. 1914) HAITIAN	300-3200	G,F
PIERRE, EDGAR DE MONTZAIGLE DE SAINT (B. 1867) FRENCH	300-3400	X
PIERRE, JEAN BAPTISTE MARIE	*400-19000	
PIERRE, JEAN BAPTISTE MARIE (1713-1789) FRENCH	1100-58000	L,F
PIETERS, EVERT (1856-1932) DUTCH	950-42000	G,F,L,S
PIETERSZ, AERT (1550-1612) DUTCH	1200-20000	F
PIETERSZ, PIETERS (1550-1611) ITALIAN	1500-18000	G,F
PIETERSZEN, ABRAHAM VAN DER WAYDEN (1817-1880) DUTCH	4000-32000	L,F
PIETRO, A. (19TH C) DUTCH	300-1800	F
PIETRO DI DOMENICO (1457-1506) ITALIAN	3000-55000	F
PIETTE, LUDOVIC (1826-1877) FRENCH	650-28000	L,G
PIFFARD, HAROLD H. (Late 19TH C) BRITISH	500-33000	G,S
PIGNON, EDOUARD	*350-12000	
PIGNON, EDOUARD (B. 1905) FRENCH	350-78000	A
PIGNONI, SIMONE (1614-1698) ITALIAN	700-27000	F
PIGUET, RODOLPHE (1840-1915) SWISS	*300-1200	F,L
PIKE, SIDNEY (19TH/20TH C) BRITISH	300-8500	L
PILICHOWSKI, LEOPOLD	*200-3600	
PILICHOWSKI, LEOPOLD (1869-1933) POLISH	400-5000	X
PILLEMENT, JEAN BAPTISTE	*300-24000	
PILLEMENT, JEAN BAPTISTE (1728-1808) FRENCH	1000-40000	L,G
PILLET, EDGAR (B. 1912) FRENCH	1000-20000	A
PILNY, OTTO (B. 1866) SWISS	2000-32000	L,G,F
PILO, CARL GUSTAF (1712-1792) SWEDISH	650-39000	F
PILOT, ROBERT WAKEHAM (1898-1967) CANADIAN	500-35000	L,F
PILOTY, CARL THEODOR VON (1826-1886) GERMAN	800-34000	F,G
PILOTY, FERDINAND (1828-1895) GERMAN	300-2400	X
PILS, ISIDORE ALEXANDRE AUGUSTIN	*400-28000	
PILS, ISIDORE ALEXANDRE AUGUSTIN (1813-1875) FRENCH	500-17000	F,L
PILSBURY, WILMOT (1840-1908) BRITISH	*300-3900	L
PILTZ, OTTO (1846-1910) GERMAN	850-45000	F
PINAL, FERDINAND (1881-1958) FRENCH	1000-30000	L,S
PINCEMIN, JEAN PIERRE	*1000-28000	
PINCEMIN, JEAN-PIERRE (B. 1944) FRENCH	7000-85000	A
PINCHART, EMILE AUGUSTE (1842-1930) FRENCH	400-11000	G,F
PINCHON, ROBERT	*300-7600	
PINCHON, ROBERT (1886-1943) FRENCH	500-97000	L
PINE, ROBERT EDGE (1730-1788) BRITISH	400-+++	F
PINEL DE GRANDCHAMP, LOUIS EMILE (D. 1894) FRENCH	500-8400	L

PINELLI, BARTOLOMEO	*500-40000	
PINELLI, BARTOLOMEO (1781-1835) ITALIAN	1000-24000	G,L
PINELO, JOSE (19TH/20TH C) SPANISH	300-4000	L
PINGGERA, H. (19TH C) ITALIAN	400-4800	G
PINGRET, EDOUARD HENRI THEOPHILE	*200-2500	
PINGRET, EDOUARD HENRI THEOPHILE (1788-1875) FRENCH	1200-49000	G,F
PINIO, ANTONIO (19TH C) ITALIAN	200-1500	X
PINTURICCHIO, BERNARDINO BETTI	*25000-175000	
PINTURICCHIO, BERNARDINO BETTI (1454-1513) ITALIAN	3000-25000	F
PIOLA, DOMENICO (17TH/18TH C) ITALIAN	*500-63000	F
PIOLA, PAOLO GIROLAMO (1666-1724) ITALIAN	*300-2800	A,I
PIOMBO, SEBASTIANO DEL	*10000-200000	
PIOMBO, SEBASTIANO DEL (1485-1547) ITALIAN	15000-+++	F
PIOT, ADOLPHE (1850-1910) FRENCH	1000-46000	G,F
PIOTROWSKI, ANTONI (1853-1924) POLISH	500-10000	G
PIPER, JOHN	*350-17000	
PIPER, JOHN (B. 1903) BRITISH	900-29000	A
PIPPEL, OTTO EDUARD (1878-1960) GERMAN	650-33000	G,L
PIRANDELLO, FAUSTO (B. 1899) ITALIAN	1000-45000	X(S)
PIRANESI, GIOVAN BATTISTA (1720-1778) ITALIAN	9500-150000	L,F
PIRIE, SIR GEORGE (1863-1946) BRITISH	400-5500	G,F
PISA, ALBERTO (1864-1931) ITALIAN	300-3400	F
PISANI, ALBERTO (1826-1899) ITALIAN	300-1500	X
PISANI, GUSTAVO (B. 1877) ITALIAN	300-2000	G
PISANO, NICCOLO (1484-1538) ITALIAN	650-42000	F
PISEMSKY, ALEXEI A. (1859-1909) RUSSIAN	200-1800	L
PISIS, FILIPPO DE	*500-25000	
PISIS, FILIPPO DE (1896-1956) ITALIAN	1200-81000	G,L,F,S
PISSARRO, CAMILLE	*2500-+++	
PISSARRO, CAMILLE (1830-1903) FRENCH	10000-+++	G,L,F
PISSARRO, CLAUDE	*800-3200	
PISSARRO, CLAUDE (B. 1935) FRENCH	1000-25000	L,S,M
PISSARRO, LUCIEN (1863-1944) FRENCH	1500-82000	L,F,S
PISSARRO, LUDOVIC RODO (1878-1952) FRENCH	600-8000	X
PISSARRO, PAUL EMILE	*800-7600	
PISSARRO, PAUL EMILE (1884-1972) FRENCH	400-7500	L
PISTOLETTO, MICHELANGELO	*300-28000	
PISTOLETTO, MICHELANGELO (B. 1933) ITALIAN	1000-20000	F
PISTOR, HERMANN (B. 1832) GERMAN	300-3600	G,F

* Denotes watercolors, pastels, drawings, and/or mixed media

PISTORIO, GIACOPI DE (15TH C) ITALIAN	500-50000	X
PITATI, BONIFAZIO DE (Called BONIFAZIO VERONESE) (1487-1553) ITALIAN	1000-12000	L,F
PITLOO, ANTONIO SMINCK (1791-1837) DUTCH	500-30000	G,L
PITMAN, JOHN (Active 1820-1832) BRITISH	400-8000	F,L
PITOCCHI, MATTEO DE (17TH C) ITALIAN	400-7200	L,F
PITT, WILLIAM (Late 19TH C) BRITISH	400-34000	L
PITTARA, CARLO (1836-1890) ITALIAN	400-14000	L,W
PITTONI, GIOVANNI BATTISTA (1687-1767) ITALIAN	3000-+++	F
PITZNER, MAX JOSEPH (1855-1912) GERMAN	400-12000	G,L
PLANELLA, GABRIEL (1780-1850) SPANISH	300-2350	X
PLANK, JOSEF (1815-1901) AUSTRIAN	300-2400	G,L
PLANQUETTE, FELIX (B. 1873) FRENCH	300-6700	F,G,L
PLANSON, ANDRE (B. 1898) FRENCH	700-13000	L
PLANSON, JOSEPH ALPHONSE (B. 1799) FRENCH	300-2800	S
PLAS, LOURENTIUS (1828-1888) DUTCH	500-4500	L,W
PLASCHKE, MORITZ (1818-1888) GERMAN	400-3800	G
PLASKETT, JOE (B. 1918) CANADIAN	200-3000	G,F,S
PLATHNER, HERMANN (1831-1902) GERMAN	300-9500	G
PLATONOV, CHARITON PLATONOVICH (1842-1907) RUSSIAN	300-3000	G,F
PLATTEEL, JEAN (1839-1867) BELGIAN	400-14000	G
PLATZER, JOHANN GEORG (1704-1761) AUSTRIAN	5000-+++	F,G
PLATZER, JOSEF (1751-1806) AUSTRIAN	300-6200	G
PLAY GALLARDO, CECILIO (B. 1860) SPANISH	4000-48000	G,F
PLAY RUBIO, ALBERTO (B. 1867) SPANISH	4000-32000	F,G,L
PLEUER, HERMANN (1863-1911) GERMAN	900-10000	L
PLEYSIER, ARY (1809-1879) DUTCH	400-5500	L,M
PLIMPTON, W. E. (19TH C) BRITISH	300-1800	F
PLUMOT, ANDRE (1829-1906) BELGIAN	600-21500	L,G
PLYASHNIKOV, IVAN (19TH C) RUSSIAN	300-3600	F
PO, GIACOMO DE (1652-1726) ITALIAN	650-12000	F
PO, PIETRO DEL (1610-1692) ITALIAN	800-14000	F
POCCETTI, BERNARDINO (1542-1612) ITALIAN	*1000-12000	F
POCOCK, NICHOLAS (1740-1821) BRITISH	1000-35000	M,L,G
PODCHERNIKOFF, A. M. (1886-1931) RUSSIAN	300-4800	G,L,F
PODESTI, VINCENZO (1812-1897) ITALIAN	*500-4500	F
PODLIASKI, YURI (1923-1987) RUSSIAN	400-5000	F
POEL, ADRIAEN LIEVENSZ (1626-1685) DUTCH	700-8500	L
POEL, EGBERT VAN DER (1621-1664) DUTCH	750-38000	G,F

POELENBURGH, CORNELIS VAN (1586-1667) DUTCH	1000-160000	F,G,L
POGANY, WILLIAM ANDREW (OR WILLY)	300-1850	F,I
POGGENBEEK, GEO (1853-1903) DUTCH	400-14000	L,W
POGGI, P. (19TH C) ITALIAN	300-3500	F
POHLE, HERMANN (1831-1901) GERMAN	400-12000	L,G
POIDEVIN, F. (19TH C) FRENCH	400-4200	X
POILPOT, THEOPHILE (1848-1915) FRENCH	1000-34000	G
POINGDESTRE, CHARLES H (D. 1905) BRITISH	500-12000	L,W
POINT, ARMAND	*500-25000	
POINT, ARMAND (1860-1932) FRENCH	1200-220000	F,L
POIRSON, MAURICE (1850-1882) FRENCH	1000-45000	G
POISSON, LOUVERATURE (1914-1985) HAITIAN	500-14000	G
POKITONOV, IVAN (1851-1924) RUSSIAN	350-9000	L,G
POKORNY, RICHARD (20TH C) AUSTRIAN	*200-2200	L
POL, CHRISTIAN VAN (1752-1813) DUTCH	800-82000	S
POL, LOUIS VAN DER (1896-1982) DUTCH	300-3000	G,F,S
POLA, HENDRICK (1676-1748) DUTCH	300-2300	X
POLAZZO, FRANCESCO (1683-1753) ITALIAN	500-41000	X
POLEO, HECTOR	*300-12000	
POLEO, HECTOR (B. 1918) VENEZUELAN	1500-110000	G,F
POLESELLO, ROGELIO (B. 1939) SOUTH AMERICAN	300-5000	A
POLGARY, GEZA (B. 1862) HUNGARIAN	300-2800	F,G
POLIAKOFF, SERGE	*400-110000	
POLIAKOFF, SERGE (1906-1969) FRENCH	4000-+++	A
POLIDORI, C.	*200-2000	
POLIDORI, C. (19TH/20TH C) ITALIAN	200-1000	G
POLIDORO, DA CARVAGGIO (1492-1543) ITALIAN	*1200-30000	F,G
POLLAK, AUGUST (B. 1838) AUSTRIAN	500-6200	S
POLLAK, LEOPOLD (1816-1880) AUSTRIAN	400-9500	G,F
POLLARD, JAMES (1797-1859) BRITISH	5000-+++	G,W
POLLENTINE, ALFRED (Late 19TH C) BRITISH	300-12000	L
POLLITT, ALBERT (19TH-20TH C) BRITISH	*600-4000	M,F,L
POMA, SILVIO (1840-1932) ITALIAN	600-15000	X
POMERENKE, HEINRICH (19TH C) EUROPEAN	500-5200	F
POMEY, LOUIS EDMOND (1831-1891) FRENCH	750-25000	F,G
POMPIGNOLI, LUIGI (19TH C) ITALIAN	200-1750	X
PONCE DE LEON, FIDELIO (1895-1949) CUBAN	500-30000	G,F,S
POND, ARTHUR (1705-1758) BRITISH	300-9700	F
PONS, JEAN (B. 1913) FRENCH	900-7500	A

PONSE, JORIS (1723-1783) DUTCH	750-55000	S
PONTE, GIOVANNI DA (1385-1437) ITALIAN	950-145000	F
POOLE, JAMES (1804-1886) BRITISH	300-3000	L,F
POOLE, L. (19TH C) EUROPEAN	1200-55000	L
POOLE, PAUL FALCONER (1807-1879) BRITISH	400-8200	L,G,F
POORTEN, JACOBUS JOHANNES VAN (1841-1914) GERMAN	300-2500	L,S
POORTER, WILLEM DE (1608-1648) DUTCH	650-48000	F,G
POOSCH, MAX VON (B. 1872) AUSTRIAN	300-3000	G,L
POOTER, FRANS DE (B. 1898) BELGIAN	400-7000	W
POPEC, DURO (B. 1943) YUGOSLAVIAN	400-2500	X
POPIEL, THADDEUS (1862-1913) POLISH	400-7200	L,G
POPOVA, LIUBOV	*500-139000	
POPOVA, LIUBOV (1889-1924) RUSSIAN	3200-+++	A,I
PORCELLIS, JAN (1584-1632) DUTCH	2500-45000	M
PORCELLIS, JULIUS (1610-1645) DUTCH	1000-32000	M
PORDENONE, GIOVANNI ANTONIO	*2500-+++	
PORDENONE, GIOVANNI ANTONIO (1483-1576) ITALIAN	900-18000	F
PORO, A. (19TH C) CUBAN	300-2000	G
PORPORA, PAOLO (1617-1673) ITALIAN	1500-80000	S
PORTA, GIUSEPPE (IL SALVIATI) (1520-1585) ITALIAN	*5000-75000	F,I
PORTAELS, JEAN FRANCOIS (1818-1895) BELGIAN	600-14000	F,L
PORTAIL, JACQUES ANDRE (1695-1759) FRENCH	*500-75000	F
PORTENGEN, PETRUS (D. 1643) DUTCH	500-9000	G
PORTER, ALFRED THOMAS (Late 19TH C) BRITISH	300-3200	G
PORTER, FREDERICK (19TH-20TH C) BRITISH	400-3000	F,L
PORTIELJE, EDWARD ANTOON (1861-1949) BELGIAN	650-17000	G,F,M
PORTIELJE, GERARD (1856-1929) BELGIAN	750-45000	G
PORTIELJE, JAN FREDERIK PIETER (1829-1895) DUTCH	400-20000	G,F
PORTINARI, CANDIDO	*400-24000	
PORTINARI, CANDIDO (1903-1962) BRAZILIAN	1800-+++	G,S
PORTMANN, CARL (1837-1894) GERMAN	300-4000	F,G
PORTMANN, WILHELM (1819-1893) GERMAN	300-8800	L
PORTOCARRERO, RENE	*300-16000	
PORTOCARRERO, RENE (B. 1912) CUBAN	500-28000	G,F
POST, EDUARD C (1827-1882) GERMAN	800-7000	M
POST, FRANS (1612-1680) DUTCH	5000-+++	L
POSTIGLIONE, LUCA (1876-1936) ITALIAN	300-3000	F
POSTIGLIONE, LUIGI (1812-1881) ITALIAN	300-4200	G,F
POSTIGLIONE, SALVATORE (1861-1906) ITALIAN	800-15000	G,F,S

POSTOLLE, VICTOR (B. 1836) FRENCH	*400-4800	I
POT, HENDRICK GERRITSZ (1585-1657) DUTCH	1500-30000	G,F
POTAGE, MICHEL (20TH C) FRENCH	1000-12000	A
POTEMONT, ADOLPHE THEODORE JULES MARTIAL (1828-1883) FRENCH	300-3700	G
POTHAST, BERNARD (1882-1966) DUTCH	1500-27000	G,F
POTRONAT, L (20TH C) FRENCH	700-4000	X(L)
POTT, LASLETT JOHN (1837-1898) BRITISH	900-61000	F,G,M
POTTER, MARY (B. 1900) BRITISH	900-13000	L,F
POTTER, PAULUS (1625-1654) DUTCH	2000-+++	L
POTTER, PIETER SYMONSZ (1597-1652) DUTCH	1500-24000	G,L,S
POUGHEON, EUGENE ROBERT (B. 1886) FRENCH	300-1800	F,I
POUGNY, JEAN	*250-33000	
POUGNY, JEAN (1894-1956) FRENCH	750-75000	G,L,F,S
POULBOT, FRANCISQUE (1879-1946) FRENCH	*500-7000	X
POULTON, JAMES (Active 1844-1859) BRITISH	300-8000	G,S
POURBUS, FRANS (THE ELDER) (1545-1581) FLEMISH	2000-35000	F
POURBUS, FRANS (THE YOUNGER) (1570-1622) FLEMISH	2000-40000	F
POURBUS, PEETER JANSZ (1523-1584) FLEMISH	3000-30000	F
POURTAU, LEON (B. 1872) FRENCH	1500-+++	L
POUSSIN, NICOLAS	*1200-82000	
POUSSIN, NICOLAS (1594-1665) FRENCH	5000-+++	G,L,F
POWELL, CHARLES MARTIN (D. 1824) BRITISH	750-18500	M
POWELL, JOSEPH RUBENS (Active 1835-1871) BRITISH	300-3600	G,F
POWELL, WILLIAM E (19TH C) BRITISH	*400-3500	W
POWER, HAROLD SEPTIMUS	(400-4000	
POWER, HAROLD SEPTIMUS (1878-1951) NEW ZEALANDER	500-25000	W,L,S
POWNALL, GEORGE HYDE (20TH C) AUSTRALIAN?	800-3500	L
POYNTER, SIR EDWARD JOHN (1836-1919) BRITISH	3000-+++	G,F
POZZI, ANDREA (1778-1833) ITALIAN	650-20000	X
PRACHENSKY, MARKUS (20TH C) AUSTRIAN	*600-4000	A
PRACHENSKY, WILHELM NIKOLAUS (1898-1956) AUSTRIAN	400-4500	L
PRADES, ALFRED FRANK DE (Late 19TH C) BRITISH	750-55000	L,W
PRADILLA Y ORTIZ, FRANCISCO	*750-32000	
PRADILLA Y ORTIZ, FRANCISCO (1848-1921) SPANISH	1000-20000	G,F,L
PRAGA, EMILIO (1839-1875) ITALIAN	900-15000	L
PRAMPOLINI, ENRICO	*500-200000*	
PRAMPOLINI, ENRICO (1894-1956) ITALIAN	1000-48000	X
PRANISHNIKOFF, IVAN P. (19TH C) RUSSIAN	300-3600	F,W

* Denotes watercolors, pastels, drawings, and/or mixed media

PRASCH, MAGNUS (1731-1787) GERMAN	500-10000	G
PRASSINOS, MARIO (1916-1985) TURKISH	1000-30000	A
PRATELLA, ATTILIO (1856-1932) ITALIAN	900-66000	G,L,M
PRATELLA, FAUSTO (1888-1964) ITALIAN	400-15000	L
PRATERE, EDMOND JOSEPH DE (1826-1888) BELGIAN	300-11000	G,W
PRAX, VALENTINE (B. 1899) FRENCH	700-41000	X(A)
PREDIS, AMBROGIO DA (1460-1520) ITALIAN	400-8500	F
PRELL, WALTER (B. 1857) FRENCH	500-12000	L
PRELLER, FRIEDRICH (1838-1901) GERMAN	400-6500	L,F
PREMAZZI, LUIGI OSSIPOVICH (1814-1891) RUSSIAN	*300-2200	G
PRESSMANE, JOSEPH (1904-1967) FRENCH	300-17000	L,S
PRESTON, MARGARET ROSE (B. 1883) AUSTRALIAN	1000-52000	S
PRETI, MATTIA (1613-1699) ITALIAN	5000-+++	F
PREUDHOMME, JEROME (18TH C) FRENCH	*200-1200	L
PREVAL, CHRISTIANE DE (B. 1876) FRENCH	400-5000	G
PREVIATI, GAETANO (1852-1920) ITALIAN	1000-114000	F
PREVITALI, ANDREA	*500-25000	
PREVITALI, ANDREA (1470-1528) ITALIAN	1200-80000	F
PREYER, EMILIE (1849-1930) GERMAN	2000-60000	S
PREYER, JOHANN WILHELM (1803-1889) GERMAN	1200-110000	S
PREZIOSI, AMADEO (1816-1882) ITALIAN	*600-28000	F,L
PRIECHENFRIED, ALOIS HEINRICH (1867-1953) AUSTRIAN	1500-26000	G,F
PRIECHENFRIED, G. KALLA (20TH C) GERMAN	300-2400	G,W
PRIEST, THOMAS (18TH C) BRITISH	300-7800	X
PRIESTLEY, PHILIP COLLINGWOOD (B. 1901) BRITISH	300-4500	L
PRIESTMAN, BERTRAM (1868-1951) BRITISH	400-16000	L
PRIETO, MANUEL JIMENEZ (19TH C) SPANISH	400-6500	G
PRIETO, MANUEL TOMMASO (19TH C) SPANISH	500-10000	X
PRIKING, FRANTZ (B. 1927) GERMAN	300-70000	A
PRIMATICCIO, FRANCESCO (1504-1570) FRENCH	*25000-85000	F
PRINCE, LEONADO DE (18TH/19TH C) FRENCH	300-2400	X
PRINCETEAU, RENE (1844-1914) FRENCH	850-65000	G,F
PRINET, RENE-XAVIER (1861-1946) FRENCH	1000-50000	L
PRINGLE, WILLIAM (Active 1840-1858) BRITISH	500-8500	G,W,S
PRINS, JOHANNES HUIBERT (1757-1806) DUTCH	700-15000	L,G
PRINS, PIERRE (1838-1913) FRENCH	400-4500	X(L)
PRINSEP, VALENTINE CAMERON (1836-1904) BRITISH	700-41000	G,F
PRITCHETT, EDWARD (Active 1828-1864) BRITISH	750-55000	G,L
PROBST, CARL (1854-1924) AUSTRIAN	900-20000	G,L

PROCACCINI, CAMILLO	*1000-32000	
PROCACCINI, CAMILLO (1546-1629) ITALIAN	1000-63000	L,F
PROCACCINI, ERCOLE (THE YOUNGER) (1515-1595) ITALIAN	1000-12000	F
PROCACCINI, GUILIO CESARE	*2000-28000	
PROCACCINI, GUILIO CESARE (1570-1625) ITALIAN	4000-+++	F
PROCTER, DOD (1892-1972) BRITISH	1500-83000	G,F,S
PROCTER, ERNEST (1886-1935) BRITISH	800-45000	L
PROOYEN, ALBERT JURARDUS VAN (1834-1898) DUTCH	300-5200	L,G
PROSDOCINI, ALBERTO (B. 1852) ITALIAN	*300-5700	G
PROTAIS, ALEXANDRE (1826-1890) FRENCH	200-3300	F
PROUHO, PAUL (1849-1931) FRENCH	400-5000	F
PROUT, JOHN SKINNER (1806-1876) BRITISH	2000-105000	L,M
PROUT, SAMUEL	*300-25000	
PROUT, SAMUEL (1783-1852) BRITISH	200-2500	G,M
PROUVE, VICTOR (1858-1943) FRENCH	*400-13000	X(F)
PROVIS, ALFRED (Active 1843-1886) BRITISH	300-6300	G,F
PROVOST, JAN (1462-1529) FLEMISH	5000-+++	F
PRUCHA, GUSTAV (B. 1875) AUSTRIAN	400-6600	G,L,F
PRUD'HON, PIERRE PAUL	*1000-+++	
PRUD'HON, PIERRE PAUL (1758-1823) FRENCH	1500-100000	F,G
PRUNA O'CERANS, PEDRO	*450-22000	
PRUNA O'CERANS, PEDRO (1904-1977) SPANISH	650-106000	F,S
PRYDE, JAMES	*600-5000	
PRYDE, JAMES (1869-1941) BRITISH	1000-35000	X(F)
PUCCINELLI, ANTONIO (1822-1897) ITALIAN	300-3800	F,G
PUCCINI, BIAGIO (1675-1721) ITALIAN	700-20000	F
PUCCINI, MARIO (1869-1920) ITALIAN	550-34000	G,M
PUCCIO DI SIMONE (Active 1320-1358) ITALIAN	1000-84000	F
PUGA, ANTONIO (17TH C) SPANISH	500-12000	X
PUGET, PIERRE (1622-1694) FRENCH	500-21000	M,F
PUGH, CLIFTON ERNEST (B. 1924) AUSTRALIAN	800-25000	X
PUHONNY, VICTOR (1838-1909) POLISH	500-4500	L,F
PUIGAUDEAU, FERNAND DE (1864-1930) FRENCH	950-140000	L,F
PUJOL DE GUASTAVINO, CLEMENT (19TH C) FRENCH	700-38000	G
PULIGO, DOMENICO (1492-1527) ITALIAN	2500-25000	F
PULINCKX, LOUIS (B. 1843) BELGIAN	300-7500	L
PULLER, JOHN ANTHONY (19TH C) BRITISH	400-7200	G,L,F
PUPINI, BIAGIO	*1500-55000	
PUPINI, BIAGIO (Called DELLA LAME) (Active 1530-1540) ITALIAN	1000-20000	F

* Denotes watercolors, pastels, drawings, and/or mixed media

PURRMANN, HANS (1880-1966) GERMAN	2500-+++	F,L,S
PURY, EDMOND-JEAN DE (1845-1911) SWISS	1500-30000	F
PUTEANI, EMIL MAXIMILIAN JOSEPH VON (1805-1856) GERMAN	*200-1000	X
PUTTER, PIETER DE (1500-1659) DUTCH	1500-18000	S
PUTTNER, JOSEF CARL (1821-1881) AUSTRIAN	300-3600	L,M
PUTZ, LEO	*250-3800	
PUTZ, LEO (1869-1940) GERMAN	700-84000	G,L,F
PUTZEYS, G. (19TH C) BELGIAN	*300-4000	G
PUVIS DE CHAVANNES, PIERRE	*500-25000	
PUVIS DE CHAVANNES, PIERRE (1824-1898) FRENCH	1400-+++	L,F,S
PUY, JEAN (1876-1960) FRENCH	600-88000	A
PUYL, LOUIS FRANCOIS (1750-1824) DUTCH	300-5300	G,F
PYCKE, FRANCOIS (1890-1970) BELGIAN	400-9600	F,L
PYNACKER, ADAM (1622-1673) DUTCH	5000-+++	L
PYNAS, JACOB (1585-1648) DUTCH	2000-40000	L,F
PYNAS, JAN (1583-1631) DUTCH	1500-10000	F
PYNE, GEORGE (1800-1884) BRITISH	*300-3200	G
PYNE, JAMES BAKER	*200-5200	
PYNE, JAMES BAKER (1800-1870) BRITISH	600-12000	L
PYNE, THOMAS (1843-1935) BRITISH	*200-3200	L
PYNE, WILLIAM HENRY (1769-1843) BRITISH	300-1600	G
PYYKONEN, KALEVI (B. 1934) FINNISH	200-2500	A

Q

ARTIST	PRICES	SUBJECT
QI BAISHI (1863-1957) CHINESE	*5000-60000	L,W
QUA, SUN (19TH C) CHINESE	400-5500	X
QUAEDVLIEG, CAREL MAX GERLACH ANTON (1823-1874) DUTCH	400-16000	G,W
QUAGLIA, CARLO (1907-1970) ITALIAN	600-3000	X
QUAGLIO, DOMENICO (1787-1837) GERMAN	1000-63000	L
QUAGLIO, FRANZ (1844-1920) GERMAN	400-16000	G,F
QUARENGHI, GIACOMO (1744-1817) ITALIAN	*500-3500	I
QUAST, PIETER JANSZ	*200-2800	
QUAST, PIETER JANSZ (1605-1647) DUTCH	300-8000	G,F
QUELLINUS, JAN ERASMUS (1634-1715) FLEMISH	350-9500	F
QUENTIN, BERNARD (B. 1923) FRENCH	500-19000	A

QUERCI, DARIO (B. 1831) ITALIAN	300-28000	F
QUERENA, LUIGI (1860-1890) ITALIAN	300-51000	G,L
QUERFURT, AUGUST (1696-1761) GERMAN	400-16000	G,L,F
QUERNER, CURT (1904-1976) GERMAN	*600-2500	F
QUESNE, FERNAND LE (19TH C) FRENCH	300-8500	F
QUESTA, FRANCESCO DELLA (1652-1723) ITALIAN	900-9000	S
QUIGLEY, DANIEL (18TH C) BRITISH	2000-58000	G,F,L
QUIGNON, FERNAND JUST	*200-2000	
QUIGNON, FERNAND JUST (B. 1854) FRENCH	300-13000	L
QUINN, JAMES PETER (1870-1951) AUSTRALIAN	800-8000	F,L
QUINQUELA MARTIN, BENITO (1870-1977) ARGENTINIAN	500-26000	L
QUINTLIN, H J (19TH C) BRITISH	800-7500	W,F
QUIROS, CESAREO BERNALDO DE (1881-1968) ARGENTINIAN	400-9800	L
QUISPEL, MATTHYS (1805-1858) DUTCH	300-3300	L,W
QUITTON, EDOUARD (B. 1842) BELGIAN	300-7000	S,W
QUIZET, ALPHONSE LEON	*200-2500	
QUIZET, ALPHONSE LEON (1885-1955) FRENCH	800-74000	L,M
QUZAIRMOFF (19TH C) FRENCH	*300-3600	X

R

ARTIST	PRICES	SUBJECT
RAADSIG, PETER (1806-1882) DANISH	300-5000	L,G
RAAPHORST, CORNELIS (1875-1974) DUTCH	300-16000	W
RABE, EDMUND FRIEDRICH THEODOR (1815-1902) GERMAN	400-5500	F
RABES, MAX (1868-1944) AUSTRIAN	1000-16000	L,F
RACKHAM, ARTHUR	*500-32000	
RACKHAM, ARTHUR (1867-1939) BRITISH	400-14000	F,G,I
RADEMAKER, ABRAHAM (1675-1735) DUTCH	*400-20000	L
RADERSCHEIDT, ANTON (1892-1970) GERMAN	900-7500	X(S)
RADICE, MARIO (B. 1900) ITALIAN	1000-32000	X
RADZIEJOWSKI, STANISLAW (19TH C) POLISH	200-1200	L
RADZIWILL, FRANZ (B. 1895) GERMAN	1000-136000	A,L,G,S
RAEBURN, SIR HENRY (1756-1823) SCOTTISH	2500-+++	F
RAEMAEKERS, LOUIS	*200-800	
RAEMAEKERS, LOUIS (1869-1956) DUTCH	300-2800	M,L
RAFFAELLI, JEAN FRANCOIS	*250-13000	

* Denotes watercolors, pastels, drawings, and/or mixed media

RAFFAELLI, JEAN FRANCOIS (1850-1924) FRENCH	2200-104000	G,F,L
RAFFALT, IGNAZ (1800-1857) AUSTRIAN	400-15000	L,G
RAFFET, AUGUSTE (1804-1860) FRENCH	500-8500	F,G,I
RAFFY LE PERSAN (B. 1919) FRENCH	400-45000	L,M
RAGGI, G. (19TH C) ITALIAN	300-3000	F
RAGGIO, GIUSEPPE (1823-1916) ITALIAN	300-12000	L,G,W
RAGLESS, MAXWELL RICHARD (1901-1981) AUSTRALIAN	400-7500	L,G
RAIMONDI, R. (19TH C) ITALIAN	*300-2000	G
RAINE, THOMAS SURTEES (19TH C) BRITISH	200-1500	X
RAINER, JOHANN JOSEPH (19TH C) AUSTRIAN	400-8000	G,F
RAINEY, WILLIAM (1852-1936) BRITISH	300-5500	G,L
RALLI, THEODORE (1852-1909) GREEK	1000-44000	G,L
RAMAH, HENRI	*500-25000	
RAMAH, HENRI (1887-1947) BELGIAN	300-10000	L,F
RAMBERG, JOHANN HEINRICH	*300-25000	
RAMBERG, JOHANN HEINRICH (1763-1840) GERMAN	300-4000	F,G,L
RAME, ACHILLE ALEXIS (19TH C) FRENCH	300-2500	W
RAMENGHI, BARTOLOMEO (16TH C) ITALIAN	500-22000	F
RAMIREZ, SATURNINO	*200-3000	
RAMIREZ, SATURNINO (B. 1946) COLOMBIAN	400-5200	F
RAMIREZ IBANEZ, MANUEL (1856-1925) SPANISH	300-3500	G,F
RAMOS, JOSE GARCIA (1852-1912) SPANISH	550-30000)	G
RAMOS CATALAN, B. (20TH C) CHILEAN	300-2000	L
RAMOS PRIDA, FERNANDO (B. 1937) MEXICAN	300-3500	A
RAMPOLLO, J. (19TH C) ITALIAN	300-2000	F,G
RAMSAY, ALLAN (1713-1784) BRITISH	1500-90000	F,L
RANC, JEAN (1674-1735) FRENCH	300-39000	G,F
RANCILLAC, BERNARD	*600-15000	
RANCILLAC, BERNARD (B. 1931) FRENCH	1000-24000	A
RANDANINI, CARLO (Late 19TH C) ITALIAN	*300-3200	G
RANFTL, JOHANN MATTIAS (1805-1854) AUSTRIAN	600-35000	G,W
RANKEN, WILLIAM BRUCE ELLIS	*200-2500	
RANKEN, WILLIAM BRUCE ELLIS (1881-1941) BRITISH	300-8100	G,F,L
RANKLEY, ALFRED (1819-1872) BRITISH	500-4500	X(F)
RANSON, PAUL (1864-1909) FRENCH	1500-234000	L,F
RANZONI, DANIELE (1843-1889) ITALIAN	600-50000	F,L
RANZONI, GUSTAV (1826-1900) AUSTRIAN	. 300-3800	L,W
RAOUX, JEAN (1677-1734) FRENCH	500-19000	F,G
RAPHAEL, MARY F. (19TH C) BRITISH	300-12000	L,F

RAPHAEL, WILLIAM (1833- 1914) BRITISH	300-12000	G,F,L
RAPIN, ALEXANDRE (1839-1889) FRENCH	500-5200	L
RAPISARDI, MICHELE (1822-1886) ITALIAN	300-3000	G,F
RAPOPORT, ALEK (B. 1933) RUSSIAN	1000-22000	F
RAQUIN, IRIS MICHELLE (B. 1933) FRENCH	800-6500	A,L
RASCH, HEINRICH (1840-1913) GERMAN	400-17000	L,G
RASCH, OTTO (1862-1932) GERMAN	300-7000	X
RASMUSSEN, I E C (1841-1893) DANISH	800-7000	M,L,F
RASMUSSEN, GEORG ANTON (1842-1914) NORWEGIAN	700-21000	L
RASSENFOSSE, ANDRE (1862-1934) DUTCH	400-3600	X(F,S)
RATCLIFFE, WILLIAM (1870-1955) BRITISH	550-40000	L
RATHBONE, JOHN (1750-1807) BRITISH	300-11000	L,M
RAU, EMIL KARL (B. 1858) GERMAN	500-16000	G,F,L
RAUBER, WILHELM CARL (1849-1926) GERMAN	800-14000	G
RAUPP, CARL (1837-1918) GERMAN	400-26000	G,L,F
RAVEEL, ROGER (20TH C) BELGIAN?	900-12000	A
RAVEL, EDOUARD-JOHN (1847-1920) SWISS	300-6000	F,G,L
RAVEN, JOHN SAMUEL (1829-1877) BRITISH	1000-88000	G
RAVENSWAAY, JAN VAN (1789-1869) DUTCH	800-7500	G,F
RAVENZWAAY, HENDRIKJE ADRIANA VAN (1816-1872) DUTCH	600-40000	S
RAVESTEYN, HUBERT VAN (D. 1670) DUTCH	1500-185000	F,S
RAVESTEYN, JAN ANTHONISZ VAN (1570-1657) DUTCH	1500-78000	F
RAVESTEYN, NICOLAS VAN (1661-1750)	500-24000	F
RAVET, VICTOR (1840-1895) FRENCH	300-3000	G
RAVIER, FRANCOIS AUGUSTE	*400-12000	
RAVIER, FRANCOIS AUGUSTE (1814-1895) FRENCH	300-33000	L
RAY, JULES LE (19TH-20TH C) FRENCH	800-7500	L,M
RAYMAL-AMOUROUX, BLANCHE (19TH C) FRENCH	300-1500	X
RAYMOND, MARIE (B. 1908) FRENCH	2000-32000	A
RAYNAUD, AUGUSTE (19TH C) FRENCH	300-5000	G,L
RAYNER, LOUISE J. (1829-1924) BRITISH	*400-37000	G
RAYSKI, FERDINAND VON (1807-1890) GERMAN	400-20000	F
RAYSSE, MARTIAL (B. 1936) FRENCH	*350-27000	A,F
RAZZIER, G. (19TH C) FRENCH	200-1000	X
RE, VINCENZO DAL (D. 1762) ITALIAN	*300-2500	I,G
READ, RICHARD (1745-1800) BRITISH	*300-40000	F
REALFONSO, TOMMASO (Called MASILLO) (Early 18TH C) ITALIAN	1000-23200	S
REATTU, JACQUES (1760-1833) FRENCH	400-6500	F

REBELL, JOSEPH	*200-2000	
REBELL, JOSEPH (1787-1828) AUSTRIAN	500-30000	L,M
REBOLLEDO CORREA, BENITO (1880-1964) CHILEAN	1000-35000	F,M
REBULL, SANTIAGO (1829-1902) MEXICAN	1200-85000	G
RECCO, GIOVANI BATTISTA (1630-1675) ITALIAN	3500-90000	S
RECCO, GIUSEPPE (1634-1695) ITALIAN	800-32000	S
RECCO, NICOLA (18TH C) ITALIAN	800-40000	S
RECKNAGEL, JOHN (19TH/20TH C) GERMAN	*300-2000	F
REDER, CHRISTIAN (1656-1729) GERMAN	400-9600	G,F
REDGATE, ARTHUR W (19TH/20TH C) BRITISH	400-4900	W,L,M
REDGRAVE, RICHARD (1804-1888) BRITISH	600-40000	F,G,L
REDMORE, EDWARD KING (1860-1941) BRITISH	500-4500	M
REDMORE, HENRY (1820-1887) BRITISH	500-26000	M
REDON, ODILON	*1200-+++	
REDON, ODILON (1840-1916) FRENCH	5000-+++	A
REDOUTE, PIERRE JOSEPH	*500-126000	
REDOUTE, PIERRE JOSEPH (1759-1840) FRENCH	1000-25000	F,S
REDPATH, ANNE	*500-23000	
REDPATH, ANNE (1895-1965) BRITISH	1000-32000	S
REE, ANITA (1885-1933) GERMAN	500-7500	G,F
REED, JOSEPH (1822-1877) BRITISH	*300-2000	G
REED, R. H. (19TH C) BRITISH	300-1200	X
REEKERS, HENDRIK (1815-1854) DUTCH	650-42000	S
REEKERS, JOHANNES (1790-1858) DUTCH	400-9500	S
REES, LLOYD FREDERICK (B. 1895) AUSTRALIAN	850-55000	L,M
REGEMORTER, IGNATIUS J (1785-1873) FLEMISH	350-21000	G,L
REGEMORTER, PETRUS J VAN (1755-1830) FLEMISH	400-6000	L,G
REGGIANI, MAURO (B. 1897) ITALIAN	450-75000	A
REGGIANINI, VITTORIO (B. 1858) ITALIAN	750-93000	G
REGNAULT, BARON JEAN (1754-1829) FRENCH	3500-+++	F
REGNAULT, HENRI ALEXANDRE GEORGES (1843-1871) FRENCH	300-6500	G,L,F
REGNIER, NICOLAS (1590-1667) FLEMISH	2500-116000	F,G
REGOYOS, DARIO DE (1845-1913) SPANISH	1200-85000	G
REGTERS, TIEBOUT (1710-1768) DUTCH	500-23000	F
REHDER, JULIUS CHRISTIAN (B. 1861) GERMAN	300-3600	L,F
REHFISCH, ALISON (B. 1900) AUSTRALIAN	400-16000	X
REHS, THEODORE (19TH C) BELGIAN	300-1500	F
REICH, ALBERT (B. 1881) GERMAN	400-7200	G,L
REICHE, HANS (1892-1958) GERMAN	5000-60000	A

* Denotes watercolors, pastels, drawings, and/or mixed media 373

REICHEL, HANS	*700-12000	
REICHERT, KARL (1836-1918) AUSTRIAN	300-6700	G,L,W
REICHLICH, MARX (1460-1525) AUSTRIAN	3500-65000	F
REID, FLORA MACDONALD (Active 1879-1929) BRITISH	600-42000	G
REID, GEORGE OGILVY (1851-1928) BRITISH	800-12000	G,M
REID, JOHN ROBERTSON (1851-1926) SCOTTISH	400-9400	G,M
REID, ROBERT PAYTON (B. 1859) BRITISH	300-26000	G,L
REIGNIER, JEAN MARIE (1815-1886) FRENCH	900-19000	S
REINAGLE, PHILIP (1749-1833) BRITISH	1800-147000	L,W
REINAGLE, RAMSAY RICHARD	*200-4500	
REINAGLE, RAMSAY RICHARD (1775-1862) BRITISH	1000-66000	F,L,S
REINHART, JOHANN CHRISTIAN	*300-10000	
REINHART, JOHANN CHRISTIAN (1761-1847) GERMAN	500-25000	L,W
REINIGER, OTTO (1863-1909) GERMAN	300-16000	L
REITER, JOHANN BAPTIST (1813-1890) AUSTRIAN	800-14000	G,F
REMBRANDT, (REMBRANDT HARMENSZ VAN RIJN)	*6500-+++	
REMBRANDT, (REMBRANDT HARMENSZ VAN RIJN) (1606-1669) DUTCH	+++	F,L
REMISOFF, NICOLAI (1894-1975) RUSSIAN/AMERICAN	300-2400	I
RENARD, H. (20TH C) FRENCH	300-1200	L
RENARD, JEAN AUGUSTIN (1744-1807) FRENCH	*300-4200	F,L
RENAUDIN, ALFRED (B. 1866) FRENCH	300-16000	L
RENAULI, L. M. (19TH C) FRENCH	300-3400	X
RENAULT, LEX DE (19TH C) FRENCH	300-2800	G
RENAULT-DES-GRAVIERS, VICTOR J. (D. 1905) FRENCH	300-4000	L
RENAVO (19TH C) ITALIAN	300-2000	X
RENE, JEAN JACQUES (20TH C) FRENCH	700-16000	X
RENE-HIS, E. (19TH C) FRENCH	300-3300	L
RENESSE, CONSTANTIJN A. (1626-1680) DUTCH	*300-4600	F
RENI, GUIDO	*600-16000	
RENI, GUIDO (1575-1642) ITALIAN	10000-+++	F
RENOIR, PIERRE AUGUSTE	*10000-+++	
RENOIR, PIERRE AUGUSTE (1841-1919) FRENCH	20000-+++	G,F,L
RENOUF, EDDA (B. 1943) MEXICAN/AMERICAN	*300-1500	X
RENOUF, EMILE (1845-1894) FRENCH	750-38000	L
RENOUX, JULES ERNEST (1863-1932) FRENCH	400-9200	L
REPIN, ILYA YEFIMOVICH	*200-14000	
REPIN, ILYA YEFIMOVICH (1844-1930) RUSSIAN	1400-52000	G,F
RESCH, ERNST (1807-1864) GERMAN	200-1800	L

* Denotes watercolors, pastels, drawings, and/or mixed media

RESCHI, PANDOLFO (1643-1699) POLISH	1000-28000	L,F
RESTOUT, JEAN (THE YOUNGER)	*500-30000	
RESTOUT, JEAN (THE YOUNGER) (1692-1768) FRENCH	2000-70000	F
RESTOUT, JEAN BERNARD (1732-1797) FRENCH	300-3600	F,I
RESZO, BURGHARDT (1884-1968) HUNGARIAN	200-1200	L,F
RETH, ALFRED	*250-17000	
RETH, ALFRED (1884-1966) HUNGARIAN/FRENCH	500-48000	L,F,A
RETTIG, HEINRICH (1859-1921) GERMAN	400-14000	G,F,L
REVERON, ARMANDO	*500-+++	
REVERON, ARMANDO (1890-1954) VENEZUELAN	1200-143000	G,F
REVESZ, IMRE EMERICH (1859-1945) HUNGARIAN	300-4000	X
REVUELTAS, FERMIN (B. 1903) MEXICAN	400-8200	G
REYCEND, ENRICO (1855-1928) ITALIAN	1000-67000	G
REYMERSWAELE, MARINUS VAN (1493-1567) DUTCH	4000-75000	F
REYNA MANESCAU, ANTONIO MARIA (19TH/20TH C) SPANISH	750-44000	G,L
REYNOLDS, ALAN	*400-6900	
REYNOLDS, ALAN (20TH C) BRITISH	500-25000	X(A)
REYNOLDS, SIR JOSHUA (1723-1790) BRITISH	5000-+++	L,F
REYNTJENS, HENRICH ENGELBERT (1817-1859) DUTCH	400-7800	G,F
REZIA, FELICE A (19TH/20TH C) FRENCH	400-2000	L,F
RHEAM, HENRY MEYNELL (1859-1920) BRITISH	*200-4550	F
RHODES, JOSEPH (1782-1854) BRITISH	800-15000	L,S
RHOMBERG, HANNO (1820-1869) GERMAN	500-28000	G
RHYS, OLIVER (19TH C) GERMAN	300-8700	G,F
RIBALTA, FRANCESCO (1551-1628) SPANISH	3000-55000	F
RIBARZ, RUDOLF (1848-1904) AUSTRIAN	800-31200	L,M
RIBERA, JIUSEPE DE (Called LO SPAGNOLETTO) (1589-1652) SPANISH	10000-+++	F
RIBERA, PIERRE (1867-1932) FRENCH	1200-125000	F,L
RIBERA CIRERA, ROMAN (1848-1935) SPANISH	1200-60000	F,G
RIBONI, GIACINTO (D. 1838) ITALIAN/AMERICAN	300-1500	F
RIBOT, GERMAIN THEODORE (1825-1893) FRENCH	500-110000	G,F,S
RIBOT, THEODULE AUGUSTIN	*500-20000	
RIBOT, THEODULE AUGUSTIN (1823-1891) FRENCH	500-82000	G,F,M
RICCI, ALFREDO (1864-1889) ITALIAN	300-3000	G
RICCI, ARTURO (B. 1854) ITALIAN	700-28000	G
RICCI, DANTI (B. 1879) ITALIAN	*300-1200	G
RICCI, GIAN PIETRO (16TH C) ITALIAN	400-14000	X
RICCI, GUIDO (1836-1897) ITALIAN	300-4500	L,M

RICCI, MARCO	*1500-58000	
RICCI, MARCO (1676-1729) ITALIAN	5000-+ + +	G,L,F
RICCI, PIO (D. 1919) ITALIAN	600-13000	G
RICCI, SEBASTIANO (1659-1734) ITALIAN	3000-+ + +	G,F
RICCIARDELLI, GABRIELLE (18TH C) ITALIAN	500-20000	X
RICCIARDI, OSCAR (1864-1935) ITALIAN	300-7000	G,L,M
RICHARD, RENE (1895-1982) CANADIAN	800-12000	L,M
RICHARD, THEODORE (1782-1859) FRENCH	300-7500	G,F
RICHARD-PUTZ, MICHEL (B. 1868) FRENCH	550-18000	M
RICHARDE, LUDVIG (1862-1929) SWEDISH	600-6200	M
RICHARDS, CERI (1903-1971) BRITISH	300-7500	A
RICHARDS, JOHN INIGO (18TH/19TH C) BRITISH	1500-75000	G,L,F
RICHARDS, L. (19TH C) BRITISH	300-2600	G,L
RICHARDSON, CHARLES DOUGLAS (1853-1932) BRITISH	400-18000	G
RICHARDSON, FREDERICK STUART	*200-3500	
RICHARDSON, FREDERICK STUART (1855-1934) BRITISH	200-2500	L
RICHARDSON, JONATHAN (17TH/18TH C) BRITISH	1400-25000	F
RICHARDSON, THOMAS MILES (JR.) (1813-1890) BRITISH	*400-12500	G,L
RICHARDSON, THOMAS MILES (SR.) (1784-1848) BRITISH	700-27000	L
RICHARDSON, WILLIAM (19TH C) BRITISH	300-5000	L
RICHARDT, FERDINAND (1819-1895) DANISH	700-24000	L
RICHE, ADELE (B. 1791) FRENCH	900-22000	X(S)
RICHET, LEON (1847-1907) FRENCH	400-16500	G,L,S
RICHIR, HERMAN JEAN (B. 1866) BELGIAN	600-14000	G,F
RICHMOND, GEORGE (1809-1896) BRITISH	1000-55000	F
RICHMOND, SIR WILLIAM BLAKE (1842-1921) BRITISH	800-39000	F
RICHMOND, THOMAS (JR.) (1802-1874) BRITISH	300-4500	F
RICHOMME, JULES (1818-1903) FRENCH	300-3600	G,F
RICHTER, ADRIAN LUDWIG	*300-25000	
RICHTER, ADRIAN LUDWIG (1803-1884) GERMAN	300-3000	G,F
RICHTER, EDOUARD FREDERIC WILHELM (1844-1913) FRENCH	400-33000	G,L,S
RICHTER, GERHARD (B. 1932) GERMAN	1500-+ + +	F,L,A
RICHTER, HERBERT DAVIS (1874-1955) BRITISH	300-17000	S,F,G
RICHTER, JOHANN (1665-1745) SWEDISH	700-+ + +	L,F
RICHTER, JOHANN HEINRICH (1803-1845) GERMAN	300-10000	L
RICHTER, LUDWIG (1803-1884) GERMAN	*800-20000	F,L
RICHTER, M. J. (B. 1860) GERMAN	500-7200	L,F
RICHTER, WILHELM M. (1824-1892) AUSTRIAN	300-8100	G,W
RICKMAN, PHILIP (B. 1891) BRITISH	*300-9000	W,L

RICKS, JAMES (19TH C) BRITISH	300-3200	G,L,W
RICO Y CEJUDO, JOSE (B. 1864) SPANISH	400-6800	F
RICO Y ORTEGA, MARTIN	*400-10000	
RICO Y ORTEGA, MARTIN (1833-1908) SPANISH	2000-117000	G,F,L,M
RICOIS, FRANCOIS EDME (1795-1881) FRENCH	1000-12000	L
RIDDEL, JAMES (1858-1928) BRITISH	2000-30000	G,F
RIDE, G. F. (19TH C) BRITISH	300-2500	F
RIDEOUT, PHILIP H. (20TH C) BRITISH	300-7400	G
RIDOLFO, MICHELE DI (1795-1854) ITALIAN	900-30000	F
RIECHARD, B. C. (19TH C) AUSTRIAN	200-1200	L
RIEDEL, AUGUST (1799-1883) GERMAN	300-6500	G
RIEDEL, H. (19TH C) GERMAN	300-2400	G
RIEDER, MARCEL (B. 1852) FRENCH	400-7000	G,F,L
RIEFSTAHL, WILHELM LUDWIG FRIEDRICH (1827-1888) GERMAN	600-24000	G
RIEGEN, NICOLAAS (1827-1889) DUTCH	500-11000	M
RIEGER, ALBERT (1834-1905) AUSTRIAN	350-21000	L,M
RIEPER, AUGUST (B. 1865) GERMAN	300-2400	L
RIESNER, HENRI FRANCOIS (1767-1828) FRENCH	400-10000	G,F
RIET, WILLEM VAN (19TH/20TH C) BELGIAN	200-1400	F
RIETSCHOOF, HENDRIK (1687-1746) DUTCH	400-9000	M
RIETSCHOOF, JAN CLAES (1652-1719) DUTCH	1000-22000	M
RIGAUD, HYACINTHE (1659-1743) FRENCH	2500-100000	F
RIGAUD, JOHN FRANCIS (1742-1810) BRITISH	1200-115000	G,F
RIGAUD, PIERRE GASTON (B. 1874) FRENCH	300-1500	X
RIGNANO, V. (19TH C) ITALIAN	300-2100	X
RIGOLOT, ALBERT GABRIEL (1862-1932) FRENCH	450-36000	G,L
RIJKELLIJKHUYSEN, HERMANUS JAN HENDRIK (1813-1883) DUTCH	500-3000	G,F
RIJSBRUCK, G. (19TH C) EUROPEAN	300-4200	X
RIKKERS, WILLEM (1812-1873) DUTCH	400-6500	X
RILEY, BRIDGET (B. 1931) BRITISH	*900-85000	A
RILEY, JOHN (1646-1691) BRITISH	400-5500	F
RILEY, THOMAS (Late 19TH C) BRITISH	300-2800	F
RINALDI, CLAUDIO (19TH/20TH C) ITALIAN	400-5000	G
RING, L A (1854-1933) DANISH	1000-30000	L,F
RING, LUDGER TOM (THE ELDER) (1496-1547) GERMAN	4000-50000	F
RING, LUDGER TOM (THE YOUNGER) (1522-1584) GERMAN	6000-95000	F
RING, OLE (1902-1972) DANISH	900-25000	L
RING, PIETER DE (1615-1660) DUTCH	9000-+++	S

RIOPELLE, JEAN PAUL	*350-21000	
RIOPELLE, JEAN PAUL (B. 1924) CANADIAN	2500-+++	A
RIORDAN, ERIC (1906-1948) CANADIAN	200-2800	L
RIOS, L. DA (1844-1892) ITALIAN	*300-4000	G,F
RIP, WILLEM CORNELIS	*300-12000	
RIP, WILLEM CORNELIS (1856-1922) DUTCH	400-5000	L,M
RIPARI, VIRGILIO (1843-1902) ITALIAN	300-3000	G,F,S
RISSON, CHARLES (19TH C) FRENCH	200-1000	X
RITCHIE, JOHN (19TH C) BRITISH	300-29000	G,F,L
RITSCHER, MORITZ (1827-1875) GERMAN	300-3000	L
RITSCHL, OTTO (20TH C) GERMAN	450-12000	I
RITTER, EDUARD (1820-1892) GERMAN	500-14000	G,L
RITZ, RAPHAEL (1829-1894) SWISS	1500-32000	G,F
RITZBERGER, ALBERT (1853-1915) AUSTRIAN	300-5500	G,F
RITZENHOFER, HUBERT (B. 1879) GERMAN	300-2400	G,M
RIVAS, ANTONIO (B. 1840) SPANISH	300-12000	G,F
RIVE, PIERRE LOUIS DE LA (1753-1817) SWISS	800-10000	L,F
RIVERA, DIEGO	*1100-230000	
RIVERA, DIEGO (1886-1957) MEXICAN	10000-+++	G,F,L
RIVERON, ENRIQUE (B. 1902) CUBAN	*300-2000	A
RIVERS, LEOPOLD (1850-1905) BRITISH	500-8500	G,L
RIVIERE, BRITON (1840-1920) BRITISH	300-130000	G,L,W
RIVIERE, HENRI (1864-1951) FRENCH	*500-9000	L
RIVIERE, HENRY PARSONS (1811-1888) BRITISH	*200-6000	G
RIVOIRE, FRANCOIS (1842-1919) FRENCH	*350-11000	S
RIVOIRE, RAYMOND LEON (B. 1884) FRENCH	*300-1500	F,L,S
RIXENS, JEAN ANDRE (1846-1924) FRENCH	750-35000	F,S
RIZZO, EDUARDO (1881-1952) ITALIAN	200-1000	X
ROBBE, HENRI (1807-1899) BELGIAN	1000-50000	S
ROBBE, LOUIS (1806-1887) BELGIAN	400-15000	L,W
ROBELLAZ, EMILE (1844-1882) SWISS	300-3100	G,L
ROBERT, AURELE (1805-1871) SWISS	300-3500	F,L
ROBERT, HENRI (B. 1881) FRENCH	300-12000	L
ROBERT, HUBERT	*750-52000	
ROBERT, HUBERT (1733-1808) FRENCH	10000-+++	G,L,F
ROBERT, LEOPOLD LOUIS	*150-2200	
ROBERT, LEOPOLD LOUIS (1794-1835) FRENCH	1000-18000	G,F
ROBERT, MARIUS HUBERT (19TH/20TH C) FRENCH	200-1000	G,F
ROBERT, THEOPHILE PAUL (1879-1954) SWISS	300-11100	G,S

* Denotes watercolors, pastels, drawings, and/or mixed media

ROBERT-FLEURY, TONY (1837-1912) FRENCH	300-15000	F,G
ROBERTI, M. (19TH C) ITALIAN	*200-1000	X
ROBERTS, DAVID	*500-80000	
ROBERTS, DAVID (1796-1864) SCOTTISH	5000-+++	F,L
ROBERTS, EDWIN THOMAS (1840-1917) BRITISH	750-27000	G,F
ROBERTS, G. (19TH C) BRITISH	300-3600	X
ROBERTS, GOODRIDGE (1904-1974) CANADIAN	500-43000	X
ROBERTS, HENRY BENJAMIN (1831-1915) BRITISH	300-9800	G,L,S
ROBERTS, JAMES (19TH C) BRITISH	600-18000	G,L
ROBERTS, THOMAS (1749-1778) BRITISH	2400-230000	L,W
ROBERTS, THOMAS EDWARD (1820-1902) BRITISH	400-7500	G,F
ROBERTS, THOMAS SAUTELL (1760-1826) IRISH	700-21000	L,G
ROBERTS, THOMAS WILLIAM	*800-42000	
ROBERTS, THOMAS WILLIAM (1856-1931) AUSTRALIAN	5000-+++	L,F
ROBERTS, WILLIAM	*700-32000	
ROBERTS, WILLIAM (1895-1981) BRITISH	750-36000	A
ROBERTSON, CHARLES	*500-75000	
ROBERTSON, CHARLES (19TH/20TH C) BRITISH	1200-68000	G,L
ROBERTSON, GEORGE EDWARD (B. 1864) BRITISH	700-26000	G,M
ROBERTSON, SUZE (1856-1922) DUTCH	500-15000	G,F,L
ROBERTY, ANDRE FELIX (B. 1877) FRENCH	*300-4900	X
ROBICHON, JULES PAUL VICTOR (19TH/20TH C) FRENCH	400-9000	X
ROBIE, JEAN BAPTISTE (1821-1910) BELGIAN	600-34000	L,S
ROBIN, GEORGES (D. 1590) BELGIAN	300-1800	L,I
ROBIN, LOUIS (B. 1845) FRENCH	300-9500	X
ROBINS, H. (19TH C) BRITISH	300-3000	X
ROBINS, THOMAS SEWELL	*300-5500	
ROBINS, THOMAS SEWELL (1814-1880) BRITISH	300-19000	M
ROBINSON, ALBERT HENRY (1881-1956) CANADIAN	450-41000	L,M
ROBINSON, FREDERIC CAYLEY (1862-1927) BRITISH	1200-65000	G,L
ROBINSON, WILLIAM HEATH (1872-1944) BRITISH	600-15000	I,G,L
ROBSON, FORSTER (19TH/20TH C) BRITISH	*300-4000	G,F
ROBSON, GEORGE FENNEL (1788-1833) BRITISH	300-12000	L,F
ROCCA, J. DELLA (19TH C) ITALIAN	300-5000	G
ROCCA, MICHELE (1670-1751) ITALIAN	3000-+++	F
ROCCHI, FRANCESCO DE (B. 1902) ITALIAN	1000-16000	X
ROCCO, GIOVANNI LUIGI (Early 18TH C) ITALIAN	400-17000	F
ROCHE, ALEXANDER (1863-1921) BRITISH	800-20000	X(F)
ROCHE, C. A. LA (19TH C) FRENCH	300-2400	W

ROCHE, ODILON (1868-1947) FRENCH	*200-11000	G,L
ROCHEGROSSE, GEORGES ANTOINE (1859-1938) FRENCH	500-53000	F,G
ROCHUSSEN, CHARLES (1814-1894) DUTCH	300-10000	G,L
ROCKBURNE, DOROTHEA	*500-46000	
ROCKBURNE, DOROTHEA (20TH C) CANADIAN	2000-25000	A
RODA, G. PUIG	*300-8800	
RODA, G. PUIG (19TH C) ITALIAN	700-32000	L
RODCHENKO, ALEXANDER	*1000-+++	
RODCHENKO, ALEXANDER (1891-1956) RUSSIAN	2500-+++	F
RODE, CHRISTIAN BERNHARD (1727-1797) GERMAN	500-18000	X
RODECK, KARL (1841-1909) DUTCH	300-2800	L
RODIN, AUGUSTE	*500-95000	
RODIN, AUGUSTE (1840-1917) FRENCH	400-14000	F
RODRIGUEZ DE GUZMAN, MANUEL (1818-1867) SPANISH	300-4000	X
RODRIQUEZ JUAREZ, NICOLAS (1667-1734) MEXICAN	400-14000	X
ROE, CLARENCE (D. 1909) BRITISH	400-3800	L,W
ROE, COLIN GRAEME (19TH C) BRITISH	600-20000	W
ROE, FRED (B. 1887) BRITISH	400-8000	G,F
ROE, ROBERT ERNEST (19TH C) BRITISH	300-4000	M
ROED, JORGEN (1808-1888) DANISH	650-60000	F,L,M
ROEDER, MAX (1866-1947) GERMAN	300-2600	L
ROEDIG, JOHANN CHRISTIAN (1751-1802) DUTCH	400-24000	S
ROEGGE, WILHELM (1829-1908) GERMAN	500-6500	G,F
ROEJMERSWAELEN, MARINUS (1493-1567) DUTCH	2000-20000	F,G
ROELANT, E. (19TH C) FRENCH	200-1200	S
ROELOFS, ALBERT (1877-1920) BELGIAN	300-7400	G,L,F
ROELOFS, WILLEM (1822-1897) DUTCH	500-37000	L,W
ROELOFS, WILLEM ELIZA (1874-1940) DUTCH	300-6500	F,S
ROEPEL, CONRAET (1678-1748) DUTCH	4000-122000	S
ROERICH, NIKOLAI	*200-6000	
ROERICH, NIKOLAI (1874-1947) RUSSIAN	400-14300	L,F,M
ROESELER, AUGUST (1866-1934) GERMAN	300-3600	G,L
ROESLER FRANZ, ETTORE (1845-1907) ITALIAN	*300-4200	G,L
ROESSLER, WALTER R. (19TH/20TH C) RUSSIAN	300-2500	G,F
ROESTRATEN, PIETER GERRITSZ VAN (1630-1700) DUTCH	2000-55000	G,S
ROFFIAEN, JEAN FRANCOIS XAVIER (1820-1898) BELGIAN	300-6000	L,G
ROGERS, G. (20TH C) BRITISH	300-4000	M
ROGHMAN, ROELAND	*300-30000	
ROGHMAN, ROELAND (1597-1686) DUTCH	3000-115000	L,G

* Denotes watercolors, pastels, drawings, and/or mixed media

ROHDE, FREDERIK NIELS MARTIN (1816-1886) DANISH	200-12000	G,L,F
ROHDE, LENNART (B. 1916) SWEDISH	1000-20000	X(L)
ROHLFS, CHRISTIAN	*1000-55000	
ROHLFS, CHRISTIAN (1849-1938) GERMAN	1000-111000	A
ROHLING, CARL (1849-1922) GERMAN	300-2500	F
ROHNER, GEORGES (B. 1913) FRENCH	400-17000	F,L,S
ROHRHIRSCH, RICHARD (1833-1892) AUSTRIAN	300-2000	G,L
ROJAS, CARLOS (20TH C) LATIN AMERICAN	300-2400	A
ROJAS, ELMAR (B. 1938) GUATEMALAN	300-18000	F
ROLANDO, CHARLES (B. 1842) AUSTRALIAN	900-14000	L,M,W
ROLFE, A. F. (19TH C) BRITISH	500-15000	G,L
ROLFE, ALEXANDER T. (19TH C) BRITISH	300-1800	X
ROLFE, HENRY LEONIDAS (1847-1881) BRITISH	300-9000	L,S
ROLL, ALFRED PHILIPPE (1846-1919) FRENCH	900-10000	F
ROLLMAN, JULIUS (1827-1865) GERMAN	400-15500	L
ROLYAT, V. (19TH C) BRITISH	200-1800	X
ROMAGNOLI, ANGIOLO (Late 19TH C) ITALIAN	300-2000	G,F
ROMAGNOLI, GIOVANNI (B. 1883) ITALIAN	200-1800	S
ROMAKO, ANTON (1832-1889) AUSTRIAN	500-28000	G,F
ROMANACH, LEOPOLDO (1862-1951) A. CUBAN	500-14000	G,F
ROMANELLI, GIOVANNI FRANCESCO (1610-1662) ITALIAN	2800-165000	F
ROMANI, JUANA (1869-1924) ITALIAN	300-12500	F
ROMANINO, GIROLAMO DI ROMANO (1484-1562) ITALIAN	3000-25000	F
ROMANO, GIULIO	*2000-80000	
ROMANO, GIULIO (GIULIO DI PIETRO DE GIANUZZI PIPPI) (1499-1546) ITALIAN	4000-45000	G,F
ROMANY, ADELE (1769-1846) FRENCH	300-7500	F
ROMBOUTS, GILLIS AEGIDIUS (1630-1678) DUTCH	800-12000	G,L
ROMBOUTS, SALOMON (Late 17TH C) DUTCH	2200-75000	L,F
ROMBOUTS, THEODOR (1597-1637) FLEMISH	2000-84000	G,L,F
ROMEIN, BERNARD (1894-1957) DUTCH	600-4200	A
ROMERO DE TORRES, JULIO (1880-1930) SPANISH	850-156000	G
ROMEYN, WILLEM (1624-1694) DUTCH	300-13000	L,W
ROMHOFF, O. (19TH/20TH C) GERMAN	*200-1200	X
ROMITI, GINO (B. 1881) ITALIAN	300-11000	G,L,M
ROMNEY, GEORGE	*1000-15000	
ROMNEY, GEORGE (1734-1802) BRITISH	5000-+++	F
RONCALLI, CRISTOFORO (1552-1627) ITALIAN	1800-78000	F
RONCARD, P. (19TH/20TH C) FRENCH	300-1800	L

RONDEL, HENRI (1857-1919) FRENCH	350-18000	F
RONGIER, JEANNE (Active 1869-1900) FRENCH	300-12000	G,L
RONNER-KNIP, HENRIETTE (1821-1909) DUTCH	1200-169000	L,W
RONTINI, ALESSANDRO (B. 1854) ITALIAN	1000-18000	F
ROOKE, THOMAS MATTHEWS (1842-1942) BRITISH	400-43000	G,F,L
ROOKER, MICHAEL ANGELO	*500-25000	
ROOKER, MICHAEL ANGELO (1743-1801) BRITISH	300-8100	L,F
ROOS, CAJETAN (1690-1770) ITALIAN	300-5400	X
ROOS, JOHANN HEINRICH (1631-1685) GERMAN	700-23000	L,W
ROOS, JOHANN MELCHIOR (1659-1731) GERMAN	400-24000	L,F,W
ROOS, PHILIPP PETER (Called ROSA DA TIVOLI) (1657-1706) GERMAN	1000-30000	L,G
ROOSDORP, FREDERIK (1839-1865) DUTCH	300-2400	L,G
ROOSENBOOM, ALBERT (1845-1875) BELGIAN	600-19000	G,L
ROOSENBOOM, MARGARETE (1843-1896) DUTCH	600-21000	S
ROOSENBOOM, NICOLAAS JOHANNES (1808-1880) DUTCH	700-24000	L,M,W
ROOSKENS, ANTON	*300-12000	
ROOSKENS, ANTON (B. 1906) DUTCH	900-80000	G,F,W
ROOTIUS, JAKOBUS (1644-1681) DUTCH	500-18000	S
ROOTIUS, JAN ALBERTSZ (1615-1674) DUTCH	1500-26000	F,S
ROPS, FELICIEN JOSEPH VICTOR	*500-75000	
ROPS, FELICIEN JOSEPH VICTOR (1833-1898) BELGIAN	600-57000	G,F,L
ROQUEPLAN, CAMILLE JOSEPH ETIENNE (1803-1855) FRENCH	800-15000	G,L,M
RORBYE, MARTINUS (1803-1848) NORWEGIAN	1500-139000	G,L,F
ROSA, FRANCESCO DE (Called PACECCO DE ROSA) (1500-1654) ITALIAN	1500-55000	F
ROSA, SALVATOR	*1500-87000	
ROSA, SALVATOR (1615-1673) ITALIAN	1900-195000	F,L,M
ROSAI, OTTONE (1895-1957) ITALIAN	600-138000	G,L,F
ROSATI, GIULIO	*500-20000	
ROSATI, GIULIO (1858-1917) ITALIAN	800-40000	G,F
ROSATI, GUILIO (1675-1757) ITALIAN	750-30000	G,F
ROSE, ALEXANDRE AUGUSTE (Active 1866-1878) FRENCH	300-15000	G
ROSE, GIOVANNI LUIGI (19TH C) ITALIAN	300-3600	G
ROSE, JULIUS (1828-1911) GERMAN	300-9000	L
ROSE, WILLIAM S. (1810-1873) BRITISH	300-6000	L
ROSENBERG, EDWARD (1858-1934) SWEDISH	600-18000	L
ROSENBOOM, NICHOLAS JOHANNES (19TH C) DUTCH	1200-30000	F
ROSENHOF, FRANZ (1626-1700) AUSTRIAN	500-10000	X
ROSENSTAND, VILHELM (1838-1915) DANISH	300-12000	G,F

ROSIER, AMEDEE (B. 1831) FRENCH	800-21000	L,S
ROSIER, JEAN GUILLAUME (1858-1931) BELGIAN	300-4000	G,F
ROSIERSE, JOHANNES (1818-1901) DUTCH	400-14000	G,F
ROSLIN, ALEXANDER (1718-1793) SWEDISH	1200-+++	F
ROSS, JAMES (18TH/19TH C) BRITISH	400-31000	G,L
ROSS, KARL or CHARLES (1816-1858) GERMAN	300-1800	L,S
ROSS, ROBERT THORBURN (1816-1876) BRITISH	300-3000	G,L
ROSSANO, FREDERICO (1835-1912) ITALIAN	500-17000	L,G
ROSSEELS, JACOB CORNELIS (1828-1912) BELGIAN	300-4300	G,L
ROSSELLI, COSIMO (1439-1507) ITALIAN	1000-55000	F
ROSSELLI, MATTEO	*900-5500	
ROSSELLI, MATTEO (1578-1650) ITALIAN	1500-22000	F
ROSSETTI, DANTE GABRIEL	*800-234000	
ROSSETTI, DANTE GABRIEL (1828-1882) BRITISH	5000-+++	F,G
ROSSI, ALBERTO (1858-1936) ITALIAN	300-3200	F,L
ROSSI, ALEXANDER M. (Active 1870-1903) BRITISH	1200-35000	G,F
ROSSI, GINO (1884-1947) ITALIAN	2000-150000	X(F)
ROSSI, LUCIUS (1846-1913) FRENCH	550-40000	G
ROSSI, LUCUIS	*250-4000	
ROSSI, LUIGI (1853-1923) SWISS	1500-65000	G,L
ROSSI, PASQUALE (B. 1861) ITALIAN	300-8800	F
ROSSITER, CHARLES (B. 1827) BRITISH	1000-25000	G,F
ROSSLER, GEORG (B. 1861) GERMAN	300-3800	G,F
ROSSUM DU CHATTEL, FREDERICUS JACOBUS VAN (1856-1917) DUTCH	300-4500	G,L,M
ROSTEL, AGATHE (Active 1871-1893) GERMAN	400-6000	L
ROTARI, PIETRO ANTONIO	*500-22000	
ROTARI, PIETRO ANTONIO (1707-1762) ITALIAN	600-38000	F,G
ROTELLA, MIMMO (B. 1918) ITALIAN	*200-21000	F,I
ROTH, C. (19TH C) FRENCH	*300-2000	S
ROTH, PHILIPP (1841-1921) GERMAN	700-19000	L,W
ROTHAUG, ALEXANDER (B. 1870) AUSTRIAN	1000-36000	G,F
ROTHAUG, LEOPOLD (B. 1868) AUSTRIAN	450-12000	L
ROTHENSTEIN, SIR WILLIAM	*500-32000	
ROTHENSTEIN, SIR WILLIAM (1872-1945) BRITISH	750-66000	G,F
ROTIG, GEORGES FREDERIC (1873-1961) FRENCH	300-18000	L,W
ROTTA, ANTONIO (1828-1903) ITALIAN	600-21500	L
ROTTENHAMMER, JOHANN (1564-1625) GERMAN	1500-75000	L,F
ROTTERDAM, PAUL Z. (B. 1939) AUSTRIAN/AMERICAN	500-6500	A

ROTTMANN, CARL (1798-1850) GERMAN	400-9500	L
ROTTMANN, MOZART (B. 1874) AUSTRIAN	750-24000	G,F
ROUAULT, GEORGES	*5000-+++	
ROUAULT, GEORGES (1871-1958) FRENCH	10000-+++	A,F
ROUBAUD, FRANZ (1856-1928) RUSSIAN	700-28000	L,F
ROUBY, ALFRED (B. 1849) FRENCH	500-5000	S
ROUFFET, JULES (1862-1931) FRENCH	300-2800	X
ROUGE, FREDERIC (1867-1950) FRENCH	300-4500	X
ROUGERON, JULES (1841-1880) FRENCH	300-4000	G
ROULLET, GASTON (1847-1925) FRENCH	300-4200	L,M
ROUMEGOUS, AUGUSTE FRANCOIS (19TH C) FRENCH	300-2200	F,G
ROUSE, H. L. (19TH C) BRITISH	300-2800	L,M
ROUSSEAU, ADRIEN (19TH C) FRENCH	300-2800	L
ROUSSEAU, HENRI (Called LE DOUANIER) (1844-1910) FRENCH	5000-+++	G,L,F
ROUSSEAU, HENRI EMILIEN (1875-1933) FRENCH	1000-24000	F,S
ROUSSEAU, MAURICE (19TH C) FRENCH	200-1800	L
ROUSSEAU, PHILIPPE (1816-1887) FRENCH	650-19000	G,M,S
ROUSSEAU, T. T. (18TH/19TH C) FRENCH	*300-3400	X
ROUSSEAU, THEODORE ETIENNE PIERRE	*300-26000	
ROUSSEAU, THEODORE ETIENNE PIERRE (1812-1867) FRENCH	3500-+++	L,S,W
ROUSSEAU-DECELLE, RENE (1881-1964) FRENCH	300-15000	L
ROUSSEL, KER XAVIER	*400-30000	
ROUSSEL, KER XAVIER (1867-1944) FRENCH	500-21000	G,L,F
ROUSSEL, PIERRE (B. 1927) FRENCH	300-9800	S,L
ROUSSEL, THEODORE (1847-1926) BRITISH	900-20000	F,L
ROUSSLEY, G. J. (Late 19TH C) SWISS	200-1400	X
ROUX, ANTOINE	*350-6000	
ROUX, ANTOINE (1765-1835) FRENCH	*400-8300	X
ROUX, ANTOINE (1799-1872) FRENCH	400-16000	L,M
ROUX, FRANCOIS (1811-1882) FRENCH	*1000-6000	X
ROUX, KARL (1826-1894) GERMAN	300-7000	L
ROUX, LOUIS (1817-1903) FRENCH	*300-6500	M
ROVERE, GIOVANNI MAURO DELLA (1575-1640) ITALIAN	*800-10000	F
ROWBOTHAM, CHARLES (1823-1895) BRITISH	*300-5000	L,G,M
ROWBOTHAM, THOMAS LEESON (1823-1875) BRITISH	*300-10000	L
ROWE, E ARTHUR (D. 1922) BRITISH	*400-8500	L
ROWE, SIDNEY GRANT (1861-1928) BRITISH	300-2200	L,F
ROWLAND, WILLIAM (20TH C) BRITISH	200-1200	W
ROWLANDSON, GEORGE DERVILLE	*200-8500	

* Denotes watercolors, pastels, drawings, and/or mixed media

ROWLANDSON, GEORGE DERVILLE (B. 1861) BRITISH	400-13000	G
ROWLANDSON, THOMAS (1756-1827) BRITISH	*900-75000	G,F,I
ROWLES, STANLEY CHARLES (B. 1887) BRITISH	300-3000	L,F
ROY, JEAN BAPTISTE DE (1759-1839) BELGIAN	500-11000	L,W
ROY, LOUIS (1862-1907) FRENCH	750-55000	G,L
ROY, MARIUS (B. 1833) FRENCH	400-4000	G,F
ROYBET, FERDINAND (1840-1920) FRENCH	600-58000	G,F
ROYEN, WILLEM FRANS VAN (1645-1723) GERMAN	400-87000	L,F
ROYER, CHARLES (19TH C) FRENCH	300-5700	G,S
ROYLE, HERBERT (1870-1958) BRITISH	300-9900	L
ROYLE, STANLEY	*450-26500	
ROYLE, STANLEY (1888-1962) BRITISH/CANADIAN	600-12000	G,L
ROZIER, DOMINIQUE (1840-1901) FRENCH	300-5000	S
ROZIER, JULES CHARLES (1821-1882) FRENCH	300-5500	L
ROZIER, PROSPER ROCH (19TH C) FRENCH	300-2000	X
RUBBO, ANTHONY DATTILO (1870-1955) AUSTRALIAN	400-3000	G,L
RUBELLI, LUDWIG DE (1841-1905) AUSTRIAN	300-2400	L
RUBEN, FRANZ LEO (1843-1920) AUSTRIAN/CZECH	350-23000	G,L
RUBENS, SIR PETER PAUL	*1500-+++	
RUBENS, SIR PETER PAUL (1577-1640) FLEMISH	2000-+++	F
RUBIN, REUVEN	*200-8000	
RUBIN, REUVEN (1893-1974) ISRAELI	750-88000	L,F,S
RUBIO, LOUIS (18TH/19TH C) ITALIAN	200-4500	F
RUDE, OLAF	*150-800	
RUDE, OLAF (1886-1957) DANISH	1300-35000	L,F,S
RUDELL, CARL (1852-1920) GERMAN	*400-8700	L,G
RUDISUHLI, HERMANN (1864-1945) SWISS	300-8500	L
RUDOLPHI, JOHANNES (B. 1877) GERMAN	300-2000	G,F
RUGENDAS, GEORGE PHILIPP (1666-1742) GERMAN	300-8000	L,F
RUGENDAS, JOHANN G.L. (1730-1799) GERMAN	400-8500	F
RUGENDAS, JOHANN MORITZ	*300-14000	
RUGENDAS, JOHANN MORITZ (1802-1858) GERMAN	1400-80000	G,L
RUGGIERO, PASQUALE (1851-1916) ITALIAN	350-6900	G,F
RUISDAEL, JACOB SALOMONSZ VAN (1630-1681) DUTCH	7500-+++	L
RUIZ, JUAN (16TH C) SPANISH	400-8500	M
RUIZ, TOMMASO (17TH C) ITALIAN	500-13000	M
RUMMELSPACHER, JOSEPH (1852-1921) GERMAN	300-3200	L
RUMONATO, E. (19TH C) SPANISH	200-1500	X
RUMPF, PHILIPP (1821-1896) GERMAN	300-3400	G,F

RUOPPOLO, GIOVANNI BATTISTA (1629-1693) ITALIAN	950-62000	S,W
RUOPPOLO, GIUSEPPE (1639-1710) ITALIAN	1100-176000	L,S
RUPPERT, OTTO VON (B. 1841) GERMAN	500-12000	G,L
RUPPRECHT, TINI (B. 1868) GERMAN	*300-3000	G,F
RUPRECHT, ADELE (Active 1839-1845) AUSTRIAN	400-6500	F
RUSCHI, FRANCESCO (Active 1643-1656) ITALIAN	600-17000	F
RUSINOL, SANTIAGO (1861-1931) SPANISH	1500-+++	L
RUSKIN, JOHN	*300-25000	
RUSKIN, JOHN (1819-1900) BRITISH	300-2800	L
RUSS, FRANZ (1844-1906) AUSTRIAN	300-4600	F,G
RUSS, ROBERT	*200-5000	
RUSS, ROBERT (1847-1922) AUSTRIAN	1500-63000	L,M
RUSSELL, CHARLES (1852-1910) BRITISH	200-4500	G
RUSSELL, GEORGE WILLIAM (1867-1935) IRISH	300-8400	G,F,L
RUSSELL, JOHN	*500-25000	
RUSSELL, JOHN (1745-1806) BRITISH	300-11000	G,F,L,S
RUSSELL, JOHN PETER	*400-25000	
RUSSELL, JOHN PETER (1859-1930) AUSTRALIAN	500-52000	L,M
RUST, JOHAN ADOLPH (1828-1915) DUTCH	400-13000	L,M
RUSTON, C. (Late 19TH C) FRENCH	200-1200	X
RUTGERS, ABRAHAM (Late 17TH C) DUTCH	400-8000	L
RUTS, F. (19TH C) GERMAN	200-2000	X
RUTTEN, JOHANNES (1809-1884) DUTCH	700-19000	G
RUYS, THEODORE VAN (18TH C) DUTCH	300-2500	L,W
RUYSCH, RACHEL (1664-1750) DUTCH	3500-+++	S
RUYSDAEL, JACOB SALOMONSZ VAN (1630-1681) DUTCH	3000-+++	L,W
RUYSDAEL, JACOB VAN (1628-1682) DUTCH	2500-200000	L
RUYSDAEL, SALOMON VAN (1500-1670) DUTCH	5000-+++	L,M
RUYTEN, JAN MICHAEL (1813-1881) BELGIAN	500-14000	L,F
RYALL, HARRY THOMAS (1811-1867) BRITISH	200-1500	G
RYBACK, ISSACHAR (B. 1897) RUSSIAN	300-13000	G,F,L
RYBKOVSKI, THADEUSZ (1848-1926) POLISH	300-2800	G,F
RYCKAERT, DAVID (16TH/17TH C) FLEMISH	3000-20000	G
RYCKAERT, DAVID (THE YOUNGER) (1596-1642) FLEMISH	2500-20000	G,F
RYCKAERT, DAVID III (1612-1661) FLEMISH	1500-27000	G
RYCKAERT, MARTIN (1587-1638) FLEMISH	4700-205000	G,L,F
RYCKHALS, FRANS (1500-1647) DUTCH	1500-18000	S,G
RYDBERG, GUSTAF (1835-1933) SWEDISH	500-48000	L
RYLAND, HENRY (1856-1924) BRITISH	300-4500	F,L

RYSBRACK, PETER ANDREAS (1690-1748) FLEMISH	900-68000	L,S
RYSBRAECK, LODOVICSUS (18TH C) FLEMISH	300-13000	L
RYSSELBERGHE, THEO VAN	*550-87000	
RYSSELBERGHE, THEO VAN (1862-1926) BELGIAN	3000-+++	L,F,S
RZEPINSKI, CZESLAV (B. 1905) POLISH	300-2200	L,F

S

ARTIST	PRICES	SUBJECT
SAAL, GEORG EDUARD OTTO (1818-1870) GERMAN	600-14000	G,L
SABATELLI, LUIGI (1772-1850) ITALIAN	*400-600	F,G
SABBAGH, GEORGES (1887-1951) EGYPTIAN	500-6500	X(L)
SABBATINI, ANDREA (Called ANDREA DE SALERNO) (1487-1530) ITALIAN	2000-48000	F,G
SABBATINI, LORENZO (1530-1576) ITALIAN	2000-16000	F
SABLET, FRANCOIS JEAN (1745-1819) FRENCH	400-25000	F,G
SABOGAL, JOSE (1888-1935) PERUVIAN	200-2200	F
SABOURAUD, EMILE (B. 1900) FRENCH	300-4200	L,S
SACCHETTI, LORENZO (15TH C) ITALIAN	*200-1200	X
SACCHI, ANDREA (1599-1661) ITALIAN	1500-10000	F
SADEE, PHILIP LODOWYCK JACOB FREDERIK (1837-1904) DUTCH	500-25000	G,F,L
SADELER, GILLIS (1570-1629) FLEMISH	1500-18000	L,F
SADKOWSKI, ALEX	*800-8500	
SADKOWSKI, ALEX (B. 1934) SWISS	400-7000	F
SADKOWSKI (19TH/20TH C) AUSTRIAN	300-4000	G,S
SADLER, GEORGE (Late 19TH C) BRITISH	300-2000	X
SADLER, WALTER DENDY (1854-1923) BRITISH	800-22000	G,L
SADLER, WILLIAM (18TH/19TH C) BRITISH	400-12000	G
SADLER, WILLIAM (JR.) (1782-1839) BRITISH	300-8500	G,L
SADOLETTI, ALFREDO (B. 1866) ITALIAN	300-2200	W
SAEDELEER, VALERIUS DE (1867-1941) BELGIAN	700-38200	L
SAENZ Y SAENZ, PEDRO (19TH C) SPANISH	300-2800	G,F
SAETTI, BRUNO (1902-1984) ITALIAN	*1000-15000	X
SAEYS, JAKOB FERDINAND (1658-1725) FLEMISH	400-9500	G,L
SAFTLEVEN, CORNELIS (1607-1681) DUTCH	2000-79000	G,L,F
SAFTLEVEN, HERMAN (II)	*350-36000	
SAFTLEVEN, HERMAN (II) (1609-1685) DUTCH	750-110000	G,L

SAGRADO, LUIGI (19TH C) ITALIAN	300-2000	X
SAGRESTANI, GIOVANNI C. (1660-1731) ITALIAN	400-7800	F
SAHULA-DYCKE, IGNATZ (B. 1900) CZECHOSLOVAKIAN	300-1800	L
SAIN, EDOUARD ALEXANDRE (1830-1910) FRENCH	600-24000	G,F
SAIN, PAUL JEAN MARIE (1853-1908) FRENCH	300-11000	L,G
SAINT AUBIN, GABRIEL DE	*500-25000	
SAINT AUBIN, GABRIEL DE (1724-1780) FRENCH	3000-+++	G,F,I
SAINT JAQUES, R. (18TH/19TH C) FRENCH	200-1200	G
SAINT PHALLE, NIKI DE (B. 1930) FRENCH	*600-48000	A
SAINT-ANDRE, SIMON RENARD DE (1614-1677) FRENCH	2000-91000	G,S
SAINT-AUBIN, AUGUSTIN DE (1736-1807) FRENCH	*300-9200	G,F
SAINT-DELIS, HENRI RENE DE LA	*200-6500	
SAINT-DELIS, HENRI RENE DE LA (1879-1949) FRENCH	350-25000	L,S
SAINT-GERMIER, JOSEPH (1860-1925) FRENCH	300-4000	L
SAINT-JEAN, SIMON (1808-1860) FRENCH	2000-36000	S
SAINT-MEMIN, CHARLES BALTHAZAR JULIEN FEVRET DE	*200-9000	
SAINT-MEMIN, CHARLES BALTHAZAR JULIEN FEVRET DE (1770-1852) FRENCH/AMERICAN	400-5200	F,L
SAINT-NON, JEAN CLAUDE RICHARD, ABBE DE (1727-1791) FRENCH	*300-2000	X
SAINT-PIERRE, GASTON CASIMIR (1833-1916) FRENCH	1500-45000	G,F
SAINTHILL, LOUDON (1918-1969) AUSTRALIAN	200-2500	X(S)
SAINTHILL, LOUDON (1918-1969) AUSTRALIAN	200-2500	X(S)
SAINTIN, JULES EMILE (1829-1894) FRENCH	500-9000	G,F
SAITO, KIKUO (20TH C) JAPANESE	*500-1800	X
SALA, PAOLO	*350-13000	
SALA, PAOLO (1859-1924) ITALIAN	600-28000	G,L,F
SALA Y FRANCES, EMILIO (1850-1910) SPANISH	650-33000	G,F
SALENTIN, HUBERT (1822-1910) GERMAN	750-48000	G,F,L
SALENTIN, K. (19TH C) ITALIAN	200-1800	G,F
SALINAS Y TERUEL, AUGUSTIN (B. 1862) SPANISH	300-8500	G,L
SALINAS Y TERUEL, JUAN PABLO (1871-1946) SPANISH	600-54000	G,L,F
SALINI, TOMASO (1575-1625) ITALIAN	1000-30000	F,S
SALISBURY, FRANK O (1874-1962) BRITISH	800-29100	X(F)
SALKELD, CECIL (1908-1968) BRITISH	1000-6000	G,F
SALLES WAGNER, JULES (1814-1898) FRENCH	200-1200	F
SALM, ADAM VAN (16TH/17TH C) DUTCH	1500-30000	M
SALM, ADRIAAN (18TH C) DUTCH	300-55000	L,M
SALMEGGIA, ENEA (ENEA TALPINO) (1558-1626) ITALIAN	1000-8500	F
SALMSON, HUGO (1844-1894) SWEDISH	400-30000	G,F,L

SALOKIVI, SANTERI (1886-1940) FINNISH	4000-70000	F,L,M
SALOME, EMILE (1833-1881) FRENCH	300-4000	G,F
SALOSMAA, AARNO (B. 1941) FINNISH	1000-15000	A
SALT, JAMES (19TH C) BRITISH	300-8800	L
SALT, JOHN (B. 1937) BRITISH	600-43000	L
SALTINI, PIETRO (1839-1908) ITALIAN	500-21000	G,F
SALTMER, FLORENCE A. (Active 1882-1908) BRITISH	350-12000	L
SALTZMANN, CARL (1847-1923) GERMAN	400-8600	L,M
SALVI, GIOVANNI BATTISTA (Called IL SASSOFERRATO) (1609-1685) ITALIAN	500-34000	F
SALVIATI, FRANCESCO	*2000-155000	
SALVIATI, FRANCESCO (1510-1563) ITALIAN	2000-25000	F
SALVIN, M. DE (19TH/20TH C) FRENCH	300-4000	F,L
SAMACHCHINI, ORAZIO (1532-1577) ITALIAN	1500-138000	G,F
SAMARAN, U. M. (19TH C) FRENCH	400-8000	G
SAMBACH, FRANZ (1715-1795) GERMAN	300-3300	X
SAMOKICH, NICOLAI SEMIONOVITCH	*200-2000	
SAMOKICH, NICOLAI SEMIONOVITCH (B. 1860) RUSSIAN	400-8800	L,F
SAMPSON, A. (19TH C) EUROPEAN	200-2000	X
SANCHEZ, EMILIO	*200-3000	
SANCHEZ, EMILIO (B. 1921) CUBAN	400-12000	L
SANCHEZ COTAN, JUAN (1560-1627) SPANISH	3000-60000	S
SANCHEZ-PERRIER, EMILIO	*200-3200	
SANCHEZ-PERRIER, EMILIO (1855-1907) SPANISH	700-32000	G,L,M
SANDBERG, RAGNAR (1902-1972) SWEDISH	1500-195000	G,L,F
SANDBY, PAUL	*450-80000	
SANDBY, PAUL (1725-1809) BRITISH	1200-52000	L
SANDELS, GOSTA	*250-2700	
SANDELS, GOSTA (1877-1919) SWEDISH	2000-145000	F,L,S
SANDERS, CHRISTOPHER (B. 1905) BRITISH	200-3500	L,S
SANDERS, HERCULES (1606-1663) DUTCH	300-4500	I
SANDERS, T. HALE (19TH C) BRITISH	300-2500	G
SANDERSON-WELLS, JOHN (20TH C) BRITISH	300-13000	G,L
SANDONA, MATTEO (B. 1883) ITALIAN/AMERICAN	300-2000	F,S
SANDORHAZE, W. B. (20TH C) HUNGARIAN	200-1800	X
SANDRART, JOHANN JAKOB VON (1655-1698) GERMAN	500-7000	F
SANDRINI, A. (19TH C) ITALIAN	200-1200	F
SANDYS, EMMA (19TH C) BRITISH	300-6000	L,F
SANDYS, FREDERICK ANTHONY AUGUSTUS (1832-1904) BRITISH	400-35000	G,F

SANGIOVANNI, A (18TH C) ITALIAN	7000-100000	S
SANGLOIS, EUSTACHE N. (19TH C) FRENCH	*300-2400	X
SANI, ALESSANDRO (19TH C) ITALIAN	400-9000	G,F
SANI, DAVID (19TH C) ITALIAN	300-3600	G,L,F
SANO DI PIETRO (1406-1481) ITALIAN	15000-117000	F
SANT, JAMES (1820-1916) BRITISH	450-30000	G,F
SANTA MARIA, ANDRES DE (1869-1945) COLOMBIAN	300-2600	F
SANTA MARINA, JOSE MARIA (20TH C) SPANISH	1000-8000	X(S)
SANTACROCE, FRANCESCO (15TH C) ITALIAN	1200-38500	F
SANTACROCE, GIROLAMO (16TH C) ITALIAN	1500-44000	F
SANTERNE, ROBERT (B. 1903) FRENCH	200-1500	L
SANTERRE, JEAN BAPTISTE (1658-1771) FRENCH	1500-34000	F,G
SANTIAGO, FILEMON (B. 1958) MEXICAN	*200-1400	G
SANTINI, ANTELMA (B. 1896) ITALIAN	300-2800	S
SANTOMASO, GIUSEPPE	*300-34000	
SANTOMASO, GIUSEPPE (B. 1907) ITALIAN	1500-141000	A,S
SANTORO, FRANCESCO RAFFAELLO (B. 1844) ITALIAN	300-3000	G
SANTORO, RUBENS (1843-1942) ITALIAN	1200-92000	G,F,L
SANTRY, TERENCE JOHN (B. 1910) AUSTRALIAN	*600-6500	M,F
SANTVOORT, DIRCK VAN (1610-1680) DUTCH	1500-50000	F
SANTVOORT, PIETER VAN (1604-1635) DUTCH	500-24000	L,F
SARACENI, CARLO (1585-1620) ITALIAN	1000-30000	F
SARESTONIEMI, REIDAR (1925-1981) FINNISH	10000-95000	X(L)
SARIAN, MARTIROS SEGUEEVITCH (B. 1880) RUSSIAN	*200-1200	L
SARLUIS, LEONARD (1874-1949) FRENCH	300-4500	F
SARTO, ANDREA DEL	*1200-165000	
SARTO, ANDREA DEL (1487-1530) ITALIAN	2000-25000	F
SARTORELLI, FRANCESCO (1856-1939) ITALIAN	300-2800	X
SARTORIO, ARISTIDE (1860-1932) ITALIAN	300-15000	G,F,L
SARTORIUS, FRANCIS (1734-1804) BRITISH	1000-58000	F,L,G,W
SARTORIUS, JOHN FRANCIS (1775-1831) BRITISH	400-12000	L,G,W
SARTORIUS, JOHN NOST (1759-1828) BRITISH	1300-85000	L,F,G
SARTORIUS, WILLIAM (18TH C) BRITISH	400-16000	S,W
SASSENBROUCK, ACHILLE VAN (1886-1979) BELGIAN	600-7500	L,S
SASSO, A. (19TH C) ITALIAN	200-1500	G
SASSOFERRATO (1609-1685) ITALIAN	1500-65000	F
SASSONE, MARCO (20TH C) ITALIAN	300-11000	M
SASSU, ALIGI (B. 1912) ITALIAN	1500-105000	G,L
SATTLER, HUBERT (1817-1904) AUSTRIAN	750-58000	L

* Denotes watercolors, pastels, drawings, and/or mixed media

SAUBER, ROBERT (B. 1868) BRITISH	300-2000	G,F
SAUER, WALTER (1889-1972) BELGIAN	*600-15100	X(F)
SAUNDERS, JOSEPH II (1773-1875) BRITISH	200-1500	X
SAUNIER, NOEL (1847-1890) FRENCH	300-8000	F,W
SAURA, ANTONIO	*300-72000	
SAURA, ANTONIO (B. 1930) SPANISH	1000-+ + +	G,F,A
SAUREZ, ARTURO (B. 1923) SPANISH	200-2000	A
SAURFELT, LEONARD (19TH C) FRENCH	300-7600	G,L
SAUTIN, RENE (1881-1968) FRENCH	800-4200	L
SAUVAGE, PHILIPPE FRANCOIS (B. 19TH C) FRENCH	400-6000	G,F,S
SAUVAGE, PIAT JOSEPH (1744-1818) FLEMISH	500-12000	F,S
SAUZAY, ADRIEN JACQUES (1841-1928) FRENCH	400-21000	G,L
SAVAIN, PETION (20TH C) HAITIAN	300-4000	G
SAVERY, JACOB I (1545-1602) DUTCH	3000-+ + +	G,L
SAVERY, JACOB II (1593-1627) DUTCH	3000-66000	F
SAVERY, ROELAND	*900-25000	
SAVERY, ROELAND (1576-1639) FLEMISH	6000-249000	G,L,S
SAVERYS, ALBERT (1886-1964) BELGIAN	400-19000	L,S,W
SAVIN, MAURICE (1894-1973) FRENCH	700-22000	X(L)
SAVINI, ALFONSO (1836-1908) ITALIAN	300-4500	G
SAVINIO, ALBERTO (1891-1952) ITALIAN	1200-+ + +	F
SAVINOV, GLEB (B. 1915) RUSSIAN	600-6500	F,L
SAVRASOV, ALEKSEI KONDRATIEVITCH (1830-1897) RUSSIAN	300-2800	L
SAVRY, HENDRICK (1823-1907) DUTCH	400-5800	L
SAWREY, HUGH (B. 1923) AUSTRALIAN	500-9500	G
SAY, FREDERICK RICHARD (1827-1860) BRITISH	500-8200	F
SAY, WILLIAM (1768-1834) BRITISH	300-2400	F
SAYERS, REUBEN (1814-1888) BRITISH	200-2000	F
SCACCIATI, ANDREA (1642-1710) ITALIAN	800-16000	S,W
SCAFFAI, LUIGI (B. 1837) ITALIAN	500-20000	G
SCALBERGE, PIERRE (1592-1640) FRENCH	400-9000	G
SCALBERT, JULES (B. 1851) FRENCH	500-12000	G,F
SCANAVINO, EMILIO	*200-11000	
SCANAVINO, EMILIO (B. 1922) ITALIAN	300-46000	A
SCANDRETT, THOMAS (1797-1870) BRITISH	*200-2000	G
SCARAMUCCIA, GIOVANNI ANTONIO (1580-1633) ITALIAN	*400-7000	F
SCARBOROUGH, FRANK WILLIAM (19TH-20TH C) BRITISH	*500-6000	M
SCARBOROUGH, FREDERICK W (19TH/20TH C) BRITISH	*400-5000	L,M
SCARCELLINO, IPPOLITO (1551-1620) ITALIAN	800-44300	G,L,F

SCARVELLI, S (19TH-20TH C) GREEK	*500-7500	M
SCATIZZI, SERGIO (B. 1918) ITALIAN	400-3500	L
SCHAAK, J C (18TH C) BRITISH	4000-35000	F
SCHAAN, PAUL (19TH/20TH C) FRENCH	300-4200	W,G
SCHAAP, HENRI (1778-1850) DUTCH	300-2500	X
SCHACHINGER, GABRIEL	*200-5000	
SCHACHINGER, GABRIEL (1850-1912) GERMAN	400-7500	G,F
SCHAD, CHRISTIAN (B. 1894) GERMAN	500-133000	F,G
SCHADE, KARL MARTIN (1862-1954) AUSTRIAN	300-3000	L,W
SCHADOW, WILHELM VON (1788-1862) GERMAN	300-4800	F
SCHAEFELS, HENDRIK FRANS (1827-1904) BELGIAN	600-35000	G,M
SCHAEFELS, LUCAS (1824-1885) BELGIAN	400-30000	S
SCHAEFER, HENRY THOMAS (B. 1854) BRITISH	300-4800	G,F,S
SCHAEFER, MAXIMILIAN (1851-1916) GERMAN	*200-1500	I
SCHAEFFER, AUGUST (1833-1916) AUSTRIAN	650-42000	L,S
SCHAEP, HENRI ADOLPHE (1826-1870) DUTCH	300-15000	L,M
SCHAFER, FREDERICK FERDINAND (1841-1917) GERMAN/AMERICAN	300-8500	L
SCHAFER, HEINRICH (OR HERMANN)	*200-3400	
SCHAFER, HEINRICH (OR HERMANN) (19TH C) GERMAN	300-6200	L
SCHAFER, HENRY (19TH C) BRITISH/FRENCH	300-3600	L
SCHAFER, HENRY THOMAS (19TH-20TH C) BRITISH	400-5000	L,F
SCHAFER, LAURENZ (1840-1904) GERMAN	300-2200	G,W
SCHAFFER, ADALBERT (1815-1871) HUNGARIAN	300-6000	S
SCHAFFER, FRITZ (19TH C) GERMAN	200-2000	X
SCHAFFNER, MARTIN (1478-1549) GERMAN	1500-15000	F
SCHALCH, JOHANN JACOB (1723-1789) SWISS	400-5500	L,W
SCHALCKE, CORNELIS SIMON (1611-1671) DUTCH	400-24000	L
SCHALCKEN, GODFRIED (1643-1706) DUTCH	2000-107000	F,G
SCHALL, JEAN FREDERIC (1752-1825) FRENCH	750-135000	L,F,G
SCHAMPHELEER, EDMUND DE (1824-1899) BELGIAN	400-4800	L
SCHANTZ, PHILIP VON (B. 1928) SWEDISH	800-15000	X(S)
SCHAPER, HERMAN (1853-1911) GERMAN	300-6700	L
SCHARFF, WILLIAM (1866-1959) DANISH	300-4000	L,F
SCHARL, JOSEF (1896-1954) GERMAN/AMERICAN	600-19000	G,F,S
SCHATTENSTEIN, NIKOL (1877-1954) RUSSIAN/AMERICAN	350-11000	G
SCHAUFFELEIN, HANS LEONARD	*1500-75000	
SCHAUFFELEIN, HANS LEONARD (1480-1540) GERMAN	5000-200000	F
SCHAWINSKY, XANTI (1904-1979) ITALIAN	1500-190000	A

* Denotes watercolors, pastels, drawings, and/or mixed media

SCHEBEK, FERDINAND (1875-1949) AUSTRIAN	300-8000	G
SCHEERBOOM, ANDRIES (1832-1880) DUTCH	1000-18000	G,F,L
SCHEFFER, ARY	*200-3600	
SCHEFFER, ARY (1795-1858) FRENCH	300-212000	F
SCHEFFER, HENRI (1798-1862) FRENCH	200-3700	G
SCHEIBER, HUGO	*500-16000	
SCHEIBER, HUGO (1873-1950) HUNGARIAN	800-22000	A,F,G
SCHEIDEL, FRANZ ANTON VON (1731-1801) AUSTRIAN	*500-12000	W
SCHEINS, KARL LUDWIG (1808-1879) GERMAN	300-5500	G,L
SCHELFHOUT, ANDREAS (1787-1870) DUTCH	1200-225000	L,M
SCHELFHOUT, J. (19TH C) DUTCH	750-52000	G
SCHELLINKS, WILLEM (1627-1678) DUTCH	400-10000	G,L,W
SCHELTEMA, JAN HENDRIK (1861-1938) DUTCH	400-24000	G,L,W
SCHENAU, JOHANN ELEAZAR (1737-1806) GERMAN	400-49000	G
SCHENCK, AUGUST FRIEDRICH ALBRECHT (1828-1901) DANISH	300-5000	L
SCHENCK, AUGUST FRIEDRICH ALBRECHT (1828-1901) DANISH	1000-14000	F,W,L
SCHENDEL, BERNARDUS VAN (1649-1709) DUTCH	400-9900	G
SCHENDEL, PETRUS VAN (1806-1870) BELGIAN	650-130000	G,L,F
SCHENK, KARL (1780-1827) GERMAN	700-7500	F,G
SCHENKER, JACQUES (1854-1927) GERMAN	300-5500	L
SCHENNIS, HANS FRIEDRICH (1852-1918) GERMAN	100-2500	L,W
SCHEPP, AUGUSTE (1846-1905) GERMAN	400-3000	X(S)
SCHERFIG, HANS (20TH C) DANISH	1000-7000	X
SCHERMER, CORNELIS (1824-1915) DUTCH	300-4800	F,L
SCHERREWITZ, JOHAN (1868-1951) DUTCH	500-22000	L,M
SCHETKY, JOHN CHRISTIAN (1778-1874) BRITISH	300-15000	F,M
SCHEUBEL, JOHANN J. III (1733-1801) GERMAN	400-6000	X
SCHEUCHZER, WILHELM (1803-1866) SWISS	400-5600	L
SCHEUERER, JULIUS (1859-1913) GERMAN	400-11000	L,W
SCHEUERER, OTTO (1862-1934) GERMAN	300-5200	L,W
SCHEUREN, CASPAR JOHANN NEPOMUK (1810-1887) GERMAN	650-21000	L,F
SCHEURENBERG, JOSEPH (1846-1914) GERMAN	300-3200	G,F
SCHGOER, JULIUS (1847-1885) GERMAN	300-2000	G
SCHIAVONE, ANDREA (1522-1563) ITALIAN	1200-55000	G,F
SCHICK, CARL (1826-1923) GERMAN	300-3800	L
SCHICKHARDT, KARL (1866-1933) GERMAN	300-2000	L
SCHIDER, FRITZ (1846-1907) AUSTRIAN	*400-2500	X(S)
SCHIEDGES, PETER PAUL (1812-1876) DUTCH	300-4500	L,G,M
SCHIELE, EGON	*5000-+++	

SCHIELE, EGON (1890-1918) GERMAN	7000-+ + +	A
SCHIERTZ, FRANZ WILHELM (1813-1887) GERMAN	400-11000	L
SCHIESS, TRAUGOTT (1834-1869) SWISS	300-6300	L
SCHIFANO, MARIO (B. 1934) ITALIAN	300-22000	L
SCHIFFER, ANTON (1811-1876) AUSTRIAN	400-13000	L
SCHIFFERLE, CLAUDIA (20TH C) SWISS	*1000-12000	A
SCHIKKINGER, FRANS (1838-1902) DUTCH	1000-6000	L
SCHILDER, ANDREI NICOLOIVICH (B. 1861) RUSSIAN	300-8600	L
SCHILL, ADRIAAN (1849-1902) DUTCH	300-2800	G
SCHINDLER, CARL (1821-1842) GERMAN	750-54000	F
SCHINDLER, EMILE JACOB (1842-1892) AUSTRIAN	900-36000	G,L
SCHINNAGL, MAXMILLIAN (1697-1792) GERMAN	300-7800	L,M
SCHIOETTZ-JENSEN, NIELS FREDERIK (1855-1941) DANISH	300-4500	G,L,M
SCHIOLER, INGE (1908-1971) SWEDISH	1500-78000	G
SCHIOTT, AUGUST (1823-1895) DANISH	600-5500	F,G
SCHIOTTZ-JENSEN, NIELS F (1855-1941) DANISH	1000-26000	F,G
SCHIPPERUS, PIETER ADRIANUS (1840-1929) DUTCH	300-4800	L,G,W
SCHIRFEN, JOHANNES (19TH C) EUROPEAN	200-1500	S
SCHIRMER, JOHANN WILHELM (1807-1863) GERMAN	1000-19000	L
SCHIRREN, FERDINAND (B. 1872) BELGIAN	*500-7800	X(S,L)
SCHISCHKIN, IVAN IVANOVITCH (1831-1898) RUSSIAN	*350-42000	L
SCHIVERT, VIKTOR (B. 1863) ROMANIAN	400-4800	G
SCHJERFBECK, HELENE	*1800-+ + +	
SCHJERFBECK, HELENE (1862-1946) FINNISH	3000-+ + +	G,L,F
SCHLEH, ANNA (1833-1879) GERMAN	300-2400	X
SCHLEICH, EDUARD (THE ELDER) (1812-1874) GERMAN	1200-55000	L
SCHLEICH, EDUARD (THE YOUNGER) (1853-1893) GERMAN	300-13000	L
SCHLEICH, ROBERT	*200-2400	
SCHLEICH, ROBERT (1845-1934) GERMAN	500-17000	G,L
SCHLEICHER, CARL (Active 1859-1871) AUSTRIAN	300-4300	F,G
SCHLEICHON, J. (19TH C) EASTERN EUROPEAN	200-1800	X
SCHLEISNER, C A (1810-1882) DANISH	500-4500	F,L
SCHLEMMER, OSKAR	*500-156000	
SCHLEMMER, OSKAR (1888-1943) GERMAN	700-54000	G,F
SCHLESINGER, FELIX (1833-1910) GERMAN	1000-75000	G,W
SCHLESINGER, JOHANN (1768-1848) GERMAN	1000-4000	S
SCHLESINGER, KARL (1825-1893) SWISS	400-19000	L,F
SCHLICK, BENJAMIN (1796-1872) DANISH	*1000-12000	I
SCHLIER, MICHAEL (1744-1807) GERMAN	300-2000	X

* Denotes watercolors, pastels, drawings, and/or mixed media

SCHLOESSER, CARL BERNHARD (1832-1914) GERMAN	500-19000	G,F,L
SCHLOESSER, G. (19TH C) GERMAN	300-2500	X
SCHLOGL, JOSEF VON (B. 1851) AUSTRIAN	300-3800	L
SCHLOMER, RICHARD (B. 1921) GERMAN	200-2000	X
SCHMAEDEL, MAX VON (B. 1856) GERMAN	300-4500	F
SCHMALZIGAUG, FRIEDERICH FERDINAND (1847-1902) GERMAN	350-8500	W
SCHMALZIGAUG, JULES (1886-1917) BELGIAN	*300-48000	A
SCHMID, FRANZ (1796-1851) SWISS	300-9800	G,L
SCHMID, J. (19TH C) GERMAN OR AUSTRIAN	300-2000	X
SCHMID-BREITENBACH, FRANZ (1857-1927) GERMAN	300-4400	G
SCHMIDT, ADOLPHE (19TH C) GERMAN	750-83000	L,F,G
SCHMIDT, ALBERT (1883-1970) SWISS	500-6300	X(L)
SCHMIDT, CARL (19TH C) GERMAN	300-10000	F,G,L
SCHMIDT, EDUARD ALLAN (B. 1809) GERMAN	400-7800	G
SCHMIDT, FREDERIC ALBERT (1846-1916) FRENCH	300-3000	L
SCHMIDT, HANS (B. 1877) GERMAN	300-2200	L
SCHMIDT, JOHANN MARTIN (1718-1801) GERMAN	1400-116000	F
SCHMIDT, MAX (1818-1901) GERMAN	300-7500	L
SCHMIDT, THEODOR (B. 1855) GERMAN	400-9800	X
SCHMIDT-HAMBURG, R. (1885-1963) GERMAN	300-2800	X
SCHMIDT-ROTTLUFF, KARL	*800-125000	
SCHMIDT-ROTTLUFF, KARL (B. 1884) GERMAN	3000-+++	A
SCHMITT, GUIDO (1834-1922) GERMAN	400-8000	G
SCHMITZ, ERNST (1859-1917) GERMAN	300-6200	F,G
SCHMITZ, PHILIPP (1824-1887) GERMAN	300-4500	G
SCHMITZBERGER, JOSEF (B. 1851) GERMAN	300-11000	L,W
SCHMUTZER, FERDINAND (1833-1915) AUSTRIAN	300-5500	G
SCHMUTZLER, LEOPOLD (1864-1941) GERMAN	1000-22000	F,G
SCHNEE, HERMAN (1840-1926) GERMAN	300-4200	L
SCHNEIDER, FELICIE FOURNIER (1831-1888) FRENCH	300-2000	G
SCHNEIDER, GEORG (1759-1842) GERMAN	300-13000	L
SCHNEIDER, GEORGE (19TH C) GERMAN	300-4500	X
SCHNEIDER, GERARD ERNEST	*350-180000	
SCHNEIDER, GERARD ERNEST (1896-1986) FRENCH	1500-211000	A
SCHNEIDER, H. (20TH C) GERMAN	300-2800	G
SCHNORR, FRANZ (1794-1859) GERMAN	300-4200	G,F
SCHNORR VON CAROLSFELD, JULIUS	*400-25000	
SCHNORR VON CAROLSFELD, JULIUS (1794-1872) GERMAN	300-5600	F,G,L

SCHNYDER, ALBERT (B. 1898) GERMAN	900-24500	L,S
SCHODL, MAX (1834-1921) AUSTRIAN	550-18000	S
SCHODLBERGER, JOHANN (1779-1853) AUSTRIAN	300-9800	G,L
SCHOEFF, JOHANNES (1608-1666) DUTCH	500-25000	L
SCHOEVAERDTS, MATHYS (1665-1694) FLEMISH	1200-55000	L,G
SCHOFREN, H. J. (B. 1817) GERMAN	300-4000	G
SCHOLTEN, HENDRIK JACOBUS (1824-1907) DUTCH	350-10000	L
SCHOLZ, MAX (B. 1855) GERMAN	400-11000	G
SCHOMMER, FRANCOIS (1850-1935) FRENCH	200-1500	F
SCHONBRUNNER, IGNAZ (B. 1835) AUSTRIAN	200-1400	X
SCHONFELD, HEINRICH (1809-1845) GERMAN	400-9000	F
SCHONFELD, JOHANN HEINRICH (1609-1682) GERMAN	1000-50000	F
SCHONGAUER, MARTIN (1445-1491) GERMAN	2000-35000	F
SCHONIAN, ALFRED (B. 1856) GERMAN	200-2800	L,W
SCHONLEBER, GUSTAV (1851-1917) GERMAN	500-26000	L,M
SCHONN, ALOIS (1826-1897) AUSTRIAN	700-26000	G,L
SCHOOTEN, FLORIS GERRITSZ VAN (17TH C) DUTCH	4000-150000	S
SCHOPIN, HENRI-FREDERICK (1804-1880) GERMAN	500-115000	L,W
SCHOTEL, JAN CHRISTIANUS (1787-1838) DUTCH	500-37000	L,M
SCHOUBROECK, PIETER (1570-1607) FLEMISH	4200-100000	G,L,F
SCHOUMAN, AERT (1710-1792) DUTCH	400-6800	F,L,S
SCHOUMAN, MARTINUS (1770-1840) DUTCH	500-18000	M
SCHOUTEN, HENRY (1864-1927) BELGIAN	250-4800	L,W
SCHOUTEN, HUBERT PIETER (1747-1822) DUTCH	*200-10000	L
SCHOVELIN, AXEL THORSEN (1827-1893) DANISH	600-6800	L
SCHOYERER, JOSEF (1844-1923) GERMAN	400-13000	L
SCHRADER, JULIUS (1815-1900) GERMAN	400-43000	F,G
SCHRAM, ALOIS HANS (1864-1919) AUSTRIAN	600-22000	F,G,L
SCHRAMM-ZITTAU, RUDOLPH (1874-1929) GERMAN	300-12000	L,G
SCHRANZ, ANTON (19TH C) GERMAN	300-37000	M
SCHRANZ, JOSEPH (B. 1803) GERMAN	600-23000	L
SCHRAUDOLPH, JOHANN (1808-1917) GERMAN	400-5200	F
SCHREIBER, CHARLES BAPTISTE (D. 1903) FRENCH	450-12000	F,G
SCHREIBER, CONRAD PETER (1816-1894) GERMAN	200-2000	L
SCHRENK, JOSEPH (19TH C) AUSTRIAN	300-3400	L
SCHREUER, WILHELM (1866-1933) GERMAN	600-11000	G,F
SCHREYER, ADOLF	*300-10000	
SCHREYER, ADOLF (1828-1899) GERMAN	2100-150000	F,W
SCHREYER, FRANZ (B. 1858) GERMAN	200-4300	L

* Denotes watercolors, pastels, drawings, and/or mixed media

SCHRICK, J. E. (20TH C) GERMAN	300-2400	X
SCHRIECK, OTTO M. VAN (1619-1678) DUTCH	2000-104000	L,S,W
SCHRIMPF, GEORG (1889-1938) GERMAN	3000-128000	A
SCHRODER, ALBERT FRIEDRICH (B. 1854) GERMAN	400-14000	G
SCHRODER, JUSTIN (19TH/20TH C) GERMAN	300-4000	G
SCHROTTER, ALFRED VON (1856-1935) AUSTRIAN	500-10000	G,F
SCHRYVER, LOUIS MARIE DE (1863-1942) FRENCH	2500-190000	G,F,S
SCHUBACK, EMIL GOTTLIEB (1820-1902) GERMAN	400-11000	G
SCHUCH, CARL (1846-1903) AUSTRIAN	2000-110000	L,S
SCHUFFENECKER, CLAUDE EMILE	*400-12000	
SCHUFFENECKER, CLAUDE EMILE (1851-1934) FRENCH	1200-120000	L,F,S
SCHUFRIED, DOMINIK (B. 1810) AUSTRIAN	300-5200	L
SCHUIZ, CHRISTIAN GEORG (1718-1791) GERMAN	600-18000	X
SCHULDT, FRITIOF (1891-1978) SWEDISH	300-8400	F,S
SCHULER, HEINRICH (1857-1885) GERMAN	200-1500	L
SCHULMAN, DAVID (1881-1966) DUTCH	300-3100	L
SCHULTEN, ARNOLD (1809-1874) GERMAN	300-9800	L
SCHULTHEISS, KARL (1852-1944) GERMAN	300-4500	L
SCHULTHEISS, NATALIE (1865-1932) AUSTRIAN	200-2000	S
SCHULTZ-STRADTMANN, OTTO (Early 20TH C) GERMAN	200-3000	X
SCHULTZBERG, ANSHELM (1862-1945) SWEDISH	850-155000	L,S
SCHULTZE, BERNARD (B. 1915) GERMAN	800-5500	A
SCHULTZE, CARL (B. 1856) GERMAN	300-3400	L,G
SCHULTZE, JEAN (19TH/20TH C) RUSSIAN	300-2400	X
SCHULTZE, ROBERT (B. 1828) GERMAN	200-12000	L
SCHUMACHER, EMIL	*650-78000	
SCHUMACHER, EMIL (B. 1912) GERMAN	700-104000	S,A
SCHUMACHER, WILLEM (B. 1891) DUTCH	300-3400	L,S
SCHUMACHER, WIM (B. 1894) DUTCH	900-12000	F,L
SCHUMANN, LUDWIG (19TH/20TH C) GERMAN	200-1500	X
SCHUPPEN, JAKOB VAN (1670-1751) GERMAN	450-16000	F
SCHURCH, JOHANN ROBERT	*400-12000	
SCHURCH, JOHANN ROBERT (1895-1941) SWISS	600-7500	F,G
SCHUSSELE, CHRISTIAN	*200-3000	
SCHUSSELE, CHRISTIAN (1826-1879) FRENCH/AMERICAN	500-20000	F
SCHUSTER, HEINRICH RUDOLF (1848-1902) GERMAN	400-6000	G,L
SCHUSTER, JOSEF (1812-1896) AUSTRIAN	900-28000	S
SCHUSTER, LUDWIG (1820-1873) AUSTRIAN	300-2600	W
SCHUT, CORNELIS (17TH C) FLEMISH	1500-36000	F

SCHUTSMANS, T. (19TH C) DUTCH	300-3000	X
SCHUTZ, CHRISTIAN GEORGE (1758-1823) GERMAN	2200-105000	L,F
SCHUTZ, JAN FREDERICK (1817-1888) DUTCH	300-7700	L,M
SCHUTZ, JOHANN GEORG (1755-1813) GERMAN	300-18000	L
SCHUTZE, WILHELM (1840-1898) GERMAN	1200-58000	G
SCHUTZENBERG, LOUIS FREDERIC (1825-1903) FRENCH	400-4000	G,L
SCHUZ, FRANZ (1751-1781) GERMAN	400-10000	L
SCHUZ, THEODOR (1830-1900) GERMAN	1500-38000	F
SCHWABE, CARLOS	*200-132000	
SCHWABE, CARLOS (1866-1926) SWISS	500-18000	F,G
SCHWALBE, OLE (B. 1929) DANISH	500-2200	X(A)
SCHWANFELDER, HENRY (1773-1837) BRITISH	900-13000	L
SCHWAR, WILHELM (B. 1860) GERMAN	300-3600	G
SCHWARTZ, WILLIAM S	*200-2000	
SCHWARTZ, WILLIAM S. (20TH C) RUSSIAN/AMERICAN	300-6500	F,S,L
SCHWARZ, CHRISTOPH (1545-1592) GERMAN	1200-30000	F
SCHWARZENFELD, ADOLPH FRANZ CHRISTIAN SCHREITTER VON (B. 1854) BOHEMIAN	300-4500	G,F
SCHWEGLER, XAVIER (1832-1902) SWISS	750-20000	L,S
SCHWEICH, CARL (1823-1898) GERMAN	300-3000	X
SCHWEICKARDT, HENDRIK WILLEM (1746-1797) GERMAN	1800-60000	L,W
SCHWEITZER, ADOLF GUSTAV (1847-1914) GERMAN	300-6800	L,G
SCHWEITZER, R. (19TH/20TH C) GERMAN	300-3500	S
SCHWENDY, ALBERT (1820-1902) GERMAN	300-8800	L
SCHWENINGER, KARL (THE ELDER) (1818-1887) AUSTRIAN	300-14000	G,W,L
SCHWENINGER, KARL (THE YOUNGER) (1854-1903) AUSTRIAN	800-12000	G,F
SCHWERIN, AMELIE VON (1819-1897) SWEDISH	600-4400	L,G
SCHWIND, MORITZ VON (1804-1871) AUSTRIAN	600-59000	F,G
SCHWINGE, FRIEDRICH (1852-1913) GERMAN	300-2700	X
SCHWINGEN, PETER (1813-1863) GERMAN	300-10000	X
SCHWITTERS, KURT	*1500-+ + +	
SCHWITTERS, KURT (1887-1948) GERMAN	1200-170000	A
SCKELL, LUDWIG (1833-1912) GERMAN	500-18000	L
SCOPPA, GIUSEPPE (19TH C) ITALIAN	*400-7700	L
SCOPPA, RAIMONDO (B. 1820) ITALIAN	300-3800	L
SCOPPETTA, PIETRO (1863-1920) ITALIAN	600-31000	G,F,L
SCOREL, JAN VAN	*1000-50000	
SCOREL, JAN VAN (1475-1562) DUTCH	2500-35000	F
SCORZA, SINIBALDO (18 ?)	*1200-22000	X

* Denotes watercolors, pastels, drawings, and/or mixed media

SCORZELLI, EUGENIO (1890-1958) ITALIAN	600-6000	L
SCOTT, ADAM SHERRIFF (1887-1980) CANADIAN	400-5500	L,F
SCOTT, COLIN A. (20TH C) CANADIAN	200-1200	S
SCOTT, GEORGES (B. 1873) FRENCH	600-15000	X(F)
SCOTT, JAMES R. (Late 19TH C) BRITISH	300-2800	M
SCOTT, JOHN (1802-1882) BRITISH	1000-26000	M
SCOTT, SAMUEL (1703-1772) BRITISH	2400-250000	L,M
SCOTT, SIR PETER (B. 1909) BRITISH	500-15000	L,W
SCOTT, TOM (1859-1927) BRITISH	*400-5000	L
SCOTT, WILLIAM	*400-8500	
SCOTT, WILLIAM (B. 1913) BRITISH	600-29000	A
SCOTT, WILLIAM BELL (1811-1890) BRITISH	500-40000	L,G
SCRAGGS, JAMES (19TH C) BRITISH	300-3600	X
SCULLY, SEAN (B. 1946) BRITISH	400-9500	A
SEAGO, EDWARD BRIAN (1910-1974) BRITISH	800-77000	L,F
SEBEN, HENRI VAN (1825-1913) BELGIAN	400-13000	F,L,G
SEBIRE, GASTON (B. 1920) FRENCH	300-11000	L,S
SECKENDORF, GOTZ VON (19TH C) GERMAN	300-2800	L,G
SEDDON, THOMAS (1821-1856) BRITISH	600-44000	L
SEDLACEK, STEPHEN (19TH/20TH C) GERMAN	450-25000	G
SEDLINER, STEPHAN (19TH C) EUROPEAN	300-3400	X
SEEBACH, LOTHAR HANS EMMANUEL VON (1853-1930) GERMAN	200-4000	F
SEEKATZ, JOHANN CONRAD (1719-1768) GERMAN	1100-99000	G,F
SEEL, ADOLF (1829-1907) GERMAN	300-25000	F,G
SEELE, JOHANN BAPTIST (1774-1814) GERMAN	300-14100	G
SEGAL, ARTHUR (1875-1944) RUMANIAN	1500-68000	F,L
SEGANTINI, GIOVANNI	*400-28000	
SEGANTINI, GIOVANNI (1858-1899) ITALIAN	3000-240000	W,G,F
SEGANTINI, GOTTARDO (B. 1882) ITALIAN	800-36000	L,S
SEGAR, WILLIAM (16TH/17TH C) BRITISH	2000-30000	S
SEGHERS, CORNEILLE (1814-1875) BELGIAN	300-2800	X
SEGHERS, DANIEL (1590-1661) FLEMISH	1000-55000	F,S
SEGHERS, GERARD (1591-1651) FLEMISH	1500-78000	F
SEGHERS, HERCULES (1590-1638) DUTCH	1200-50000	L
SEGNA, NICCOLO DI (14TH C) ITALIAN	2000-115000	F
SEGOVIA, ANDRES (B. 1929) SPANISH	300-3800	F,S
SEGUI, ANTONIO	*200-21000	
SEGUI, ANTONIO (B. 1934) ARGENTINIAN	400-15000	A
SEIDEL, AUGUST (1820-1904) GERMAN	300-11000	L

SEIFERT, ALFRED (1850-1901) CZECHOSLOVAKIAN	600-35000	F,G
SEIGNAC, GUILLAUME (19TH/20TH C) FRENCH	1200-90000	F,G
SEIGNAC, PAUL (1826-1904) FRENCH	500-30000	G
SEILER, CARL WILHELM ANTON (1846-1921) GERMAN	300-15000	G,F
SEISENEGGER, JAKOB (1505-1567) AUSTRIAN	1400-36000	F
SEITZ, ANTON (1829-1900) GERMAN	600-28000	G
SEITZ, GEORG (1810-1870) GERMAN	700-15000	S
SEITZ, OTTO (1846-1912) GERMAN	300-2000	L
SEIWERT, FRANZ WILHELM (1894-1933) GERMAN	400-3500	X
SELIGMAN, ADALBERT FRANZ (1862-1945) GERMAN	750-18000	G
SELIGMANN, KURT	*350-11000	
SELIGMANN, KURT (1900-1962) SWISS	600-67000	G
SELL, CHRISTIAN (1831-1883) GERMAN	300-7000	L,F
SELLAER, VINCENT (Called GELDERSMANN) (B. 1539) FLEMISH	2000-28000	F
SELLAIO, JACOPO DEL (1441-1493) ITALIAN	8000-245000	F
SELMY, EUGENE BENJAMIN (B. 1874) FRENCH	200-1200	G
SELMYHR, CONRAD (19TH C) SCANDINAVIAN	300-1500	M
SELVATICO, LINO (1872-1924) ITALIAN	300-4000	G,F
SEMEGHINI, PIO (B. 1878) ITALIAN	800-21000	G,L,S
SEMENOWSKY, EISMAN (19TH C) FRENCH	400-7800	G,F
SEMINO, ANDREA (Called SEMINO IL VECCHIO) (1525-1595) ITALIAN	1200-8500	F
SENAVE, JACQUES ALBERT (1758-1829) BELGIAN	300-14000	G,S
SENET, RAFAEL PEREZ	*300-4500	
SENET, RAFAEL PEREZ (B. 1856) SPANISH	1000-42000	L,M
SENIOR, MARK (1864-1927) BRITISH	900-17000	L,F
SEPESHY, ZOLTAN L. (1898-1934) HUNGARIAN/AMERICAN	200-3500	F
SEPHTON, GEORGE HARCOURT (19TH C) BRITISH	200-1800	G,F
SERENA, LUIGI (1855-1911) ITALIAN	300-7500	G,F
SERGENT, LUCIEN PIERRE (1849-1904) FRENCH	400-8800	G,L
SERGER, FREDERICK B. (1889-1965) CZECH/AMERICAN	200-1400	G
SERIEZ, AUGUSTE (19TH C) FRENCH	200-1500	G
SERNA, ISMAEL DE LA (B. 1887) SPANISH	450-87000	L,F,S
SERNESI, RAFFAELLO (1838-1866) ITALIAN	800-19000	G,F,L
SERNICOLI, N. G. (19TH C) ITALIAN	200-2000	X
SERRA Y AUGUE, ENRIQUE (1859-1918) SPANISH	350-22000	X
SERRA Y PORSON, JOSE (1824-1910) SPANISH	300-8000	G,F
SERRA-BADUE, DANIEL (B. 1914) CUBAN/AMERICAN	300-2600	X
SERRALUNGA, LUIGI (B. 1880) ITALIAN	500-14000	S,F

SERRES, ANTONY (1828-1898) FRENCH	300-6200	G,F
SERRES, DOMINIC (THE ELDER) (1722-1793) BRITISH	500-66000	L,M
SERRES, JOHN THOMAS (1759-1825) BRITISH	600-24000	L,M
SERRI, ALFREDO (1897-1972) ITALIAN	400-7000	F,S
SERRURE, AUGUSTE (1825-1903) FLEMISH	600-21000	G,L
SERT Y BADIA, JOSE MARIA (1876-1945) SPANISH	1500-78000	I
SERUSIER, LOUIS PAUL HENRI	*500-27000	
SERUSIER, LOUIS PAUL HENRI (1863-1927) FRENCH	3000-+++	A
SERVAES, ALBERT	*300-88000	
SERVAES, ALBERT (1883-1966) BELGIAN	700-35000	L,F
SERVEAU, CLEMENT (1886-1972) FRENCH	300-28000	G,F,L,S
SERVRANCKX, VICTOR (B. 1897) BELGIAN	1000-61000	X(A)
SEURAT, GEORGES	*1000-+++	
SEURAT, GEORGES (1859-1891) FRENCH	5000-+++	G,F,L
SEVERDONCK, FRANZ VAN (1809-1889) BELGIAN	400-9600	L,W
SEVERDONCK, JOSEPH VAN (1819-1905) BELGIAN	300-2500	L,F
SEVERINI, GINO	*1200-+++	
SEVERINI, GINO (1883-1966) ITALIAN	2000-+++	A
SEVESTRE, JULES MARIE (1834-1901) FRENCH	300-2200	F
SEVIN, PIERRE PAUL (1650-1710) FRENCH	350-24000	F
SEYDEL, EDWARD GUSTAV (1822-1881) FRENCH	400-9800	G
SEYLER, JULIUS (1873-1958) GERMAN	600-7500	L,S,F
SEYMOUR, GEORGE L (19TH C) BRITISH	400-5100	F
SEYMOUR, JAMES (1702-1752) BRITISH	1200-235000	G,F,W
SEYPPEL, CARL MARIA (1847-1913) GERMAN	400-10000	G,L
SEYSSAUD, RENE (1867-1952) FRENCH	500-19000	X(L)
SHALDERS, GEORGE	*200-8200	
SHALDERS, GEORGE (1826-1873) BRITISH	300-6000	G,L,W
SHALOM OF SAFED, (SHALOM MOSKOVITZ) (B. 1892) ISRAELI	*300-4500	F
SHANKS, WILLIAM SOMERVILLE (1864-1951) BRITISH	600-15000	X
SHANNON, CHARLES HASLEWOOD (1865-1937) BRITISH	500-27000	G,L,F
SHANNON, SIR JAMES (1862-1923) BRITISH	1000-75000	F
SHARP, DOROTHEA (1874-1955) BRITISH	1500-105000	F
SHAW, JOHN BYAM (1872-1919) BRITISH	1500-215000	G,F
SHAW, JOSHUA (1776-1861) BRITISH	1400-37000	F,L
SHAW, WILLIAM (18TH C) BRITISH	1000-64000	G,L
SHAYER, CHARLES (19TH C) BRITISH	300-2000	G,L
SHAYER, HENRY (19TH C) BRITISH	300-6000	G,L
SHAYER, WILLIAM (JR.) (1811-1892) BRITISH	600-45000	G,L,W

SHAYER, WILLIAM (SR.) (1787-1879) BRITISH	500-90000	L,M,F
SHEARBORN, ANDREW (19TH C) BRITISH	300-7000	L
SHEARD, THOMAS F M (1866-1921) BRITISH	500-6100	L,G
SHEE, SIR MARTIN ARCHER (1769-1850) IRISH	3000-200000	F
SHEERBOOM, ANDRIES (1832-1880) DUTCH	300-3100	G
SHEERBORN, ANDREW (19TH C) BRITISH	200-1200	G
SHELTON, SIDNEY (19TH C) BRITISH	*400-2000	G,F
SHEPARD, ERNEST HOWARD (1879-1976) BRITISH	300-6200	G,L,W
SHEPHERD, DAVID (20TH C) BRITISH	400-24000	W,L
SHEPHERD, GEORGE (1782-1830) BRITISH	300-2000	W
SHEPHERD, GEORGE SYDNEY (D. 1858) BRITISH	*900-16000	L,F
SHEPHERD, THOMAS HOSMER (1792-1864) BRITISH	*200-1200	G,L
SHERLOCK, W. P. (B. 1780) BRITISH	200-1400	L
SHERMAN, ALBERT J (B. 1882) AUSTRALIAN	600-13000	S
SHERRIFF-SCOTT, ADAM (1880-1980) CANADIAN	400-4500	G,F
SHERRIN, DANIEL	*200-2000	
SHERRIN, DANIEL (Active 1895-1915) BRITISH	300-7800	L
SHERRIN, DAVID (B. 1868) BRITISH	200-1000	L
SHERRIN, JOHN (1819-1896) BRITISH	300-2800	L,S
SHERWOOD, WILLIAM A. (1875-1951) CANADIAN/AMERICAN	200-2500	L
SHIELS, WILLIAM (1785-1857) BRITISH	300-8000	L,F
SHIERE, W. (19TH C) EUROPEAN	300-1500	X
SHISHKIN, IVAN IVANOVICH (1821-1898) RUSSIAN	1600-55000	G,L
SHRAPNIL, EDWARD SCOPE (19TH/20TH C) CANADIAN	400-7000	G,L
SHUKAYEV, STEPHAN GRIGORIEVICH (1830-1888) RUSSIAN	300-2800	F
SHUKHAEV, VASILII IVANOVICH (1887-1972) RUSSIAN	300-2000	X
SIBERDT, EUGENE (1851-1931) BELGIAN	200-4500	F,L
SIBERECHTS, JAN (1627-1703) FLEMISH	700-75000	G,L
SICARD, PIERRE (B. 1900) FRENCH	300-2400	L
SICCIOLANTE, GEROLAMO	*1000-25000	
SICCIOLANTE, GEROLAMO (Called IL SERMONETA) (1521-1580) ITALIAN	1500-8000	F
SICHEL, NATHANIEL (1843-1907) GERMAN	500-9500	X(F)
SICKERT, WALTER RICHARD	*500-75000	
SICKERT, WALTER RICHARD (1860-1942) BRITISH	2000-150000	G,F
SIDANER, HENRI LE	*1000-+++	
SIDANER, HENRI LE (1862-1939) FRENCH	5000-+++	L,G
SIDLER, ALFRED (B. 1905) SWISS	400-3000	M,L
SIDLEY, SAMUEL (1829-1896) BRITISH	650-27500	G,F,L

* Denotes watercolors, pastels, drawings, and/or mixed media

SIEFFERT, PAUL (B. 1874) FRENCH	300-7600	F
SIEGEN, AUGUSTE (19TH C) GERMAN	400-7900	L
SIEGEN, J. VAN DE (19TH C) AUSTRIAN	200-2000	X
SIEGER, VICTOR (1843-1905) GERMAN	300-2200	F
SIEGERT, AUGUST (1786-1869) GERMAN	300-5500	G,F
SIEGERT, AUGUST FRIEDRICH (1820-1883) GERMAN	300-4700	G,F
SIGMUND, BENJAMIN D (19TH/20TH C) BRITISH	*600-11000	L,W
SIGNAC, PAUL	*700-57000	
SIGNAC, PAUL (1863-1935) FRENCH	10000-+++	L,G,S
SIGNORELLI, FRANCESCO (D. 1559) ITALIAN	300-4500	X
SIGNORELLI, LUCA (1441-1523) ITALIAN	4000-95000	F
SIGNORET, CHARLES LOUIS (1867-1932) FRENCH	600-28000	F
SIGNORINI, GIOVANNI (1808-1858)ITALIAN	900-52500	G,L
SIGNORINI, GIUSEPPE (1857-1932) ITALIAN	500-44000	G,F
SIGNORINI, TELEMACO (1835-1901) ITALIAN	2500-180000	G,L
SIGRIST, FRANZ (1727-1803) AUSTRIAN	400-7500	F
SIGRISTE, GUIDO (1864-1915) SWISS	300-8400	F,G
SIL, J. VAN (19TH C) DUTCH	200-1200	X
SILBERT, MAX (B. 1871) FRENCH	350-22000	G,F
SILLEN, HERMAN (1857-1908) SWEDISH	800-24000	L,M
SILLETT, JAMES (1764-1840) BRITISH	400-12000	S
SILO, ADAM (1674-1772) DUTCH	400-26000	M
SILVA-BRUHNS, IVAN (D. 1980) FRENCH	*300-2000	X
SILVEN, JAKOB (1851-1924) SWEDISH	300-14000	L
SILVESTRE, ALBERT (B. 1869) SWISS	300-2800	L
SILVESTRE, LOUIS DE	*200-2500	
SILVESTRE, LOUIS DE (1675-1760) FRENCH	1500-28000	F
SILVESTRE, NICOLAS CHARLES DE (1699-1767) FRENCH	*300-2200	L
SIMBARI, NICOLA (B. 1927) ITALIAN	500-20000	G,L
SIMKIN, RICHARD (1840-1926) BRITISH	*400-2200	F,G
SIMMLER, FRIEDRICH KARL (1801-1872) GERMAN	300-4500	X
SIMMONDS, JULIUS (1843-1924) GERMAN	300-3400	G
SIMMONS, JOHN	*300-25000	
SIMMONS, JOHN (1715-1780) BRITISH	300-3200	G,F
SIMON, LUCIEN	*200-2400	
SIMON, LUCIEN (1861-1945) FRENCH	800-13000	G,F,L
SIMONE, NICOLO DE (17TH C) ITALIAN	300-6800	F
SIMONE, TOMMASO DE (Active 1852-1857) ITALIAN	800-20000	M,L
SIMONELLI, GIUSEPPE (1650-1710) ITALIAN	450-20000	X

SIMONETTI, AMEDEO (1874-1922) ITALIAN	*300-4000	G
SIMONETTI, ATTILIO	*200-5000	
SIMONETTI, ATTILIO (1843-1925) ITALIAN	300-5600	G,F
SIMONETTI, ETTORE	*300-28000	
SIMONETTI, ETTORE (19TH C) ITALIAN	650-30000	G
SIMONI, ALFREDO DE (19TH C) ITALIAN	300-5500	L
SIMONI, GUSTAVO	*400-25000	
SIMONI, GUSTAVO (B. 1846) ITALIAN	400-15500	G,F
SIMONI, SCIPIONE (19TH C) ITALIAN	*300-2400	G,L
SIMONI (19TH C) ITALIAN	*200-1200	X
SIMONINI, FRANCESCO (1686-1753) ITALIAN	600-65000	L,F
SIMONS, FRANS (1855-1919) BELGIAN	300-15000	L,S
SIMONS, MICHIEL (D. 1673) DUTCH	1500-105000	S
SIMONSEN, NIELS (1807-1885) DANISH	600-29000	G,L,F
SIMONSEN, SIMON (1841-1928) DANISH	300-11000	L,F,G
SIMONSSON, BIRGER (1883-1938) SWEDISH	600-16000	L,S
SIMPSON, A. B. (Early 20TH C) BRITISH	300-1800	G,F
SIMPSON, CHARLES	*500-40000	
SIMPSON, CHARLES (19TH C) BRITISH	600-14000	L,W,G
SIMPSON, WILLIAM	*900-28000	
SIMPSON, WILLIAM (1823-1899) BRITISH	400-6200	L,F
SIMS, CHARLES	*250-11000	
SIMS, CHARLES (1873-1928) BRITISH	500-19000	G,L,F
SIMSON, WILLIAM (1800-1847) BRITISH	300-12600	G
SINCLAIR, ALFREDO (B. PANAMA 1915)	300-4000	S,L
SINCLAIR, G. (19TH C) BRITISH	200-2400	L
SINCLAIR, JOHN (1872-1922) BRITISH	600-22000	L,W
SINCLAIR, MAX (19TH C) BRITISH	300-4200	L,M
SINDING, OTTO (1842-1909) NORWEGIAN	300-13000	G,L
SINGIER, GUSTAVE	*500-15200	
SINGIER, GUSTAVE (B. 1909) FRENCH	800-127000	X(A)
SINGLETON, HENRY (1766-1839) BRITISH	400-5000	F,G
SINIBALDI, JEAN PAUL (1857-1909) FRENCH	500-19000	G,W,L
SINNOT, J. (19TH C) FRENCH	200-1200	X
SION, PETER (16TH C) FLEMISH	400-15000	S
SIQUEIROS, DAVID ALFARO (1896-1964) MEXICAN	*900-+++	
SIQUEIROS, DAVID ALFARO (1896-1964) MEXICAN	1000-84000	A,G,F
SIRANI, ELISABETTA	*200-1800	
SIRANI, ELISABETTA (1638-1665) ITALIAN	1500-87000	F

* Denotes watercolors, pastels, drawings, and/or mixed media

SIRANI, GIOVANNI ANDREA (1610-1670) ITALIAN	900-15000	F
SIRONI, MARIO	*500-+ + +	
SIRONI, MARIO (1885-1961) ITALIAN	1500-+ + +	G,L
SISLEY, ALFRED	*1200-+ + +	
SISLEY, ALFRED (1839-1899) FRENCH	7500-+ + +	L,F
SJAMAAR, PIETER GEERARD (1819-1876) DUTCH	500-6400	G
SJOBERG, AXEL (B. 1866) SWEDISH	300-34000	G,L,M
SJOLANDER, WALDEMAR (B. 1906) SWEDISH	400-3800	F,L
SKANBERG, KARL (1850-1883) SWEDISH	300-8300	L,S
SKARBINA, FRANZ (1849-1910) GERMAN	900-73000	G,F
SKEAPING, JOHN (B. 1901) BRITISH	*400-5600	F,G
SKELTON, LESLIE JAMES (1848-1929) CANADIAN	300-3600	L
SKILLING, WILLIAM (20TH C) SCOTTISH/AMERICAN	300-6500	W
SKIRMUNT, SZYMON (1835-1902) POLISH	300-2400	G
SKOLD, OTTE (1894-1958) SWEDISH	500-48000	L,F,S
SKOU, SIGURD (D. 1929) NORWEGIAN/AMERICAN	200-2000	L
SKOVGAARD, JOAKIM (1856-1933) DANISH	300-12000	L
SKOVGAARD, NIELS (1858-1938) DANISH	300-3400	X
SKOVGAARD, PETER CHRISTIAN (1817-1875) DANISH	600-17000	L,F,W
SKRAMLICK, JAN (B. 1860) CZECHOSLOVAKIAN	300-4200	G
SKRAMSTAD, LUDWIG (1855-1912) NORWEGIAN	600-11000	L,F
SKREDSVIG, CHRISTIAN (1854-1924) DANISH	1500-102000	L
SKUM, NILS NILSSON (1872-1951) SWEDISH	*800-2500	L
SLABBINCK, RIK (20TH C) BELGIAN	500-6500	S,F
SLADE, SYDNEY (20TH C) BRITISH	200-1200	G
SLADER, SAMUEL M. (B. 1861) BRITISH	300-3200	F
SLATER, JOHN FALCONER (1857-1937) BRITISH	300-5800	L,W
SLAUGHTER, STEPHEN (D. 1765) BRITISH	1500-62000	F
SLEVOGT, MAX	*250-8000	
SLEVOGT, MAX (1868-1932) GERMAN	2000-+ + +	G,L,F
SLINGELANDT, PIETER VAN (1640-1691) DUTCH	600-78000	G,F
SLINGENEYER, ERNEST (1820-1894) BELGIAN	200-2000	F
SLOANE, GEORGE (19TH/20TH C) BRITISH	300-5800	G,F
SLOCOMBE, FREDERICK ALBERT (1847-1920) BRITISH	*400-5800	F,L
SLOTH, W. R. (19TH C) BRITISH	200-1200	G,L
SLOTT-MOLLER, HAROLD (B. 1864) DANISH	700-24000	F
SLUITER, WILLY	*200-4000	
SLUITER, WILLY (B. 1873) DUTCH	350-10000	G,F
SLUYS, JACOB VAN DER (1660-1732) DUTCH	300-11000	G

SLUYS, THEO VAN (19TH C) BELGIAN	300-5200	L,W
SLUYTERS, JAN (1881-1957) DUTCH	650-149000	F,L
SMARGIASSI, GABRIELE (1798-1882) ITALIAN	2000-28000	L,F
SMART, EDMUND HODGSON (B. 1873) BRITISH	300-9000	F
SMART, JEFFREY (B. 1921) AUSTRALIAN	2000-70000	X(G)
SMART, JOHN (IV) (1838-1899) BRITISH	200-3000	G,L,F
SMART, R. BRUCE (20TH C) BRITISH	200-1000	L
SMEERS, FRANZ (1873-1960) BELGIAN	700-23000	F,L
SMET, GUSTAVE DE (1877-1943) BELGIAN	800-+++	A
SMET, LEON DE (B. 1881) BELGIAN	1600-91000	L,F,S
SMETHAM, JAMES (1821-1889) BRITISH	400-14000	G,L
SMETS, LOUIS (B. 1918) DUTCH	300-9500	L,S
SMIDTH, HANS (1839-1917) DANISH	500-14000	G,L
SMIRKE, ROBERT (1752-1845) BRITISH	500-8000	G,I,S
SMIRNOV, NIKOLAI (B. 1938) RUSSIAN	5000-35000	F,L
SMIRSCH, JOHANN (1801-1869) AUSTRIAN	300-3800	X
SMISSEN, L. VAN DER (19TH/20TH C) DUTCH	300-2200	F
SMIT, AERNOUT (1641-1710) DUTCH	400-29100	M
SMITH, BARTHOLOMEW (19TH C) BRITISH	300-2400	X
SMITH, CAPTAIN ROBERT (19TH C) BRITISH	900-91000	L
SMITH, CARL FRITHJOF (1859-1917) NORWEGIAN	600-18000	L
SMITH, CARLTON ALFRED	*200-25000	
SMITH, CARLTON ALFRED (1853-1946) BRITISH	1000-28000	G,F,L
SMITH, DAN W. (Early 20TH C) BRITISH	*200-3000	F,L
SMITH, F. HOLLIN (19TH C) BRITISH	300-3000	L
SMITH, FRANCIS (19TH-20TH C) FRENCH/BRITISH	1500-20000	G,F,L
SMITH, FRED THOMAS (19TH C) BRITISH	200-1200	G
SMITH, FREDERICK FORD (19TH C) BRITISH	200-1000	G,L
SMITH, FRITHJOF (1859-1917) NORWEGIAN/GERMAN	*500-7500	F
SMITH, GEORGE (1829-1901) BRITISH	1000-25000	G,F
SMITH, GEORGE (OF CHICHESTER) (1714-1776) BRITISH	800-43000	L,S
SMITH, GEORGE ARMFIELD (Active 1840-1875) BRITISH	200-1500	G,L
SMITH, GRACE COSSINGTON (B. 1892) AUSTRALIAN	2500-115000	L,S
SMITH, HERBERT LUTHER (1809-1869) BRITISH	300-4000	F
SMITH, HOBBE (1862-1942) DUTCH	300-4500	L,M
SMITH, J. WELLS (Active 1870-1875) BRITISH	300-5400	G,F
SMITH, JAMES BURRELL (1822-1897) BRITISH	300-3600	L
SMITH, JOHN BRANDON (1848-1884) BRITISH	300-14500	L,F
SMITH, JOHN RAPHAEL (1752-1812) BRITISH	2000-28000	G,F

* Denotes watercolors, pastels, drawings, and/or mixed media

SMITH, JOHN WARWICK (1749-1831) BRITISH	300-4500	L
SMITH, REGINALD	*200-1200	
SMITH, REGINALD (1870-1925) BRITISH	300-3000	M,L,S
SMITH, RICHARD (B.1931) BRITISH	700-15000	F,I
SMITH, SIR MATTHEW (1879-1959) BRITISH	1000-64000	L,F,S
SMITH, WILLIAM COLLINGWOOD (1815-1887) BRITISH	*300-6800	G,L
SMITH, WILLIAM HARDING (1848-1922) BRITISH	800-5000	S
SMITH-HALD, FRITHJOF (1846-1903) NORWEGIAN	600-45000	L,M
SMITHE, GEORGE (19TH C) BRITISH	200-1500	L,F
SMITS, JAKOB (1856-1928) BELGIAN	1500-50000	G,L,F
SMITS, JAN GERARD (1823-1910) DUTCH	300-2800	G,L
SMOUT, DOMINICUS (1700-1733) DUTCH	400-6800	G
SMYTH, ADMIRAL (19TH C) SCOTTISH	200-1200	X
SMYTH, HENRY (19TH C) BRITISH	300-5000	L
SMYTHE, EDWARD ROBERT (1810-1899) BRITISH	1000-12000	G,L
SMYTHE, LIONEL PERCY (1839-1913) BRITISH	*600-14000	G,F
SMYTHE, THOMAS (1825-1906) BRITISH	600-17000	G,L,W
SNAYERS, PIETER (1592-1667) FLEMISH	1200-74000	L,F
SNELL, JAMES HERBERT (1861-1935) BRITISH	300-3000	L
SNELLINCK, GEERAERT (B. 1577) FLEMISH	300-2000	G,L
SNOECK, JACQUES (1881-1921) DUTCH	300-2200	G
SNOW, JAMES WRAY (19TH C) BRITISH	300-3500	W
SNOWMAN, ISAAC (B. 1874) ISRAELI	800-28000	G,F
SNYDERS, FRANS	*1500-35000	
SNYDERS, FRANS (1579-1657) FLEMISH	2500-175000	S,W,L
SNYERS, PIETER (1681-1752) FLEMISH	600-50000	G,S
SOBLE, JOHN JACOB (B. 1893) RUSSIAN/AMERICAN	300-4800	L
SODOMA, IL, (GIOVANNI ANTONIO BAZZI) (1477-1549) ITALIAN	*1500-25000	F
SOENS, JAN (1547-1611) DUTCH	1200-55000	F
SOEST, GERARD VAN (1500-1681) BRITISH	500-8200	F
SOEST, LOUIS WILLEM VAN (B. 1867) DUTCH	400-8800	L
SOEUR, S. (19TH C) FRENCH	200-1200	X
SOFFICI, ARDENGO (1879-1964) ITALIAN	2000-+++	L,F
SOGLIARI, GIOVANNI ANTONIO	*1500-50000	
SOGLIARI, GIOVANNI ANTONIO (1492-1544) ITALIAN	1500-15000	F
SOKOLOV, PIOTR PETROVICH	*400-19000	
SOKOLOV, PIOTR PETROVICH (1821-1899) RUSSIAN	300-5600	G
SOLANA, JOSE GUTIERREZ (1885-1945) SPANISH	2500-96000	A
SOLARIO, ANDREA (1460-1522) ITALIAN	1500-15000	F

SOLARIO, ANTONIO (16TH C) ITALIAN	300-9800	F
SOLDAN-BROFELDT, VENNY (1863-1945) FINNISH	2000-32000	M,G
SOLDATI, ATANSIO (1896-1953) ITALIAN	1500-69000	L,M,S
SOLDENHOFF, ALEXANDER LEO (1882-1951) SWISS	400-3600	X(S,F)
SOLDI, ANDREA (1703-1771) ITALIAN	850-76000	F
SOLDI, RAUL (B. 1905) ARGENTINIAN	300-2000	L
SOLE, GIOVAN GIOSEFFO DAL (1654-1719) ITALIAN	1000-10000	F
SOLENGHI, GIUSEPPE (1879-1944) ITALIAN	400-6400	X
SOLIMENA, FRANCESCO (1657-1747) ITALIAN	1500-+ + +	F
SOLIN, SUZANNE DAYNES GRASSOT (B. 1884) FRENCH	300-2400	X
SOLLIER, HENRI (1886-1966) FRENCH	300-5500	L
SOLOMON, ABRAHAM (1824-1862) BRITISH	1200-145000	G,F
SOLOMON, J SOLOMON (1860-1927) BRITISH	1200-50000	F
SOLOMON, SIMEON	*400-15000	
SOLOMON, SIMEON (1840-1905) BRITISH	800-49000	G,F
SOMER, HENDRICK VAN (1615- 1684) DUTCH	750-72000	F
SOMER, PAULUS VAN (1570-1621) DUTCH	1200-21000	F,L
SOMERS, H. (B. 1922) ALSATIAN	200-2000	X
SOMERSCALES, THOMAS (1842-1927) BRITISH	1000-30000	L,M
SOMERSET, CHEDDER (19TH C) EUROPEAN	200-1200	X
SOMERVILLE, HOWARD (B. 1873) BRITISH	300-3000	F
SOMERVILLE, STURAT (1908-1983) BRITISH	1000-6000	S,L
SOMM, HENRI (1844-1907) FRENCH	*300-4200	G,F,I
SOMME, JACOB (1862-1940) NORWEGIAN	800-15000	L,F
SOMMER, FERDINAND (1822-1901) SWISS	800-6500	L
SOMMER, GEORG (19TH C) GERMAN	200-2000	L,M,S
SOMMER, OTTO (19TH C) GERMAN	300-5000	L
SOMMER, RICHARD (19TH C) GERMAN	400-6000	L
SOMN, DAVID S. (19TH C) BRITISH	300-1200	M
SOMOV, CONSTANTIN ANDREIEVICH (B. 1869) RUSSIAN	300-41000	G,L
SOMVILLE, ROGER (B. 1923) BELGIAN	500-5100	X
SON, JAN VAN (1658-1718) FLEMISH	400-42000	F,S
SON, JORIS VAN (1623-1667) FLEMISH	1800-220000	S
SONDERBORG, KURT R HOFMANN (B. 1923) GERMAN	*900-4200	A
SONDERGAARD, JENS (B. 1895) DANISH	600-18000	L,M,F
SONDERLAND, FRITZ (1836-1896) GERMAN	500-24000	G
SONDERMAN, HERMANN (1832-1901) GERMAN	600-22000	G,F,L
SONIER, J. (19TH C) FRENCH	300-2200	G
SONJE, JAN (D. 1691) DUTCH	300-2500	L

* Denotes watercolors, pastels, drawings, and/or mixed media

SONJE, JAN GABRIELSZ (1625-1707) DUTCH	400-18000	L,W
SONNE, JORGEN (1771-1833) DANISH	1000-36000	L,F
SONREL, ELIZABETH (1874-1953) FRENCH	400-33000	G,F
SOOLMAKER, JAN FRANS (1635-1685) FLEMISH	400-10000	L,F
SORBI, RAFFAELO (1844-1931) ITALIAN	700-202000	G,L,F
SOREAU, JAN (17TH C) DUTCH	1200-95000	S
SOREE, L. (19TH C) BRITISH	300-2000	G
SORENSEN, CARL FREDRICK (1818-1879) DANISH	1000-31000	L,M
SORENSEN, EILER (B. 1869) DANISH	400-5000	G,F
SORENSEN, HENRIK (1882-1962) SWEDISH/NORWEGIAN	600-12100	L
SORENSEN, JACOBUS LORENZ (1812-1857) DUTCH	500-4500	L,F
SORGH, HENDRICK MAARTENSZ ROKES (1611-1670) DUTCH	3500-+++	G
SORIANO, JUAN (20TH C) MEXICAN	550-35000	G,L
SORKAU, ALBERT (B. 1874) FRENCH	200-2500	G
SOROLLA Y BASTIDA, JOAQUIN	*600-68000	
SOROLLA Y BASTIDA, JOAQUIN (1863-1923) SPANISH	4500-+++	G,L,F
SOTO, CARLOS (19TH C) ITALIAN	300-2800	G,L
SOTO, JESUS RAPHAEL	*450-45000	
SOTO, JESUS RAPHAEL (20TH C) SPANISH	1000-18000	I,A
SOTTOCORNOLA, GIOVANNI (1855-1917) ITALIAN	450-70000	G,L,S
SOUBRIN, JEAN DE (19TH C) FRENCH	200-1000	G
SOUDEIKINE, SERGEI	*200-7500	
SOUDEIKINE, SERGEI (1883-1946) RUSSIAN/AMERICAN	300-4200	G,L,S
SOUKENS, HENDRIK (1680-1711) DUTCH	300-4000	L
SOULACROIX, FREDERIC (B. 1825) FRENCH	1200-105000	G,F
SOULAGES, PIERRE	*350-189000	
SOULAGES, PIERRE (B. 1919) FRENCH	800-+++	A
SOULES, EUGENE EDOUARD (D. 1876) FRENCH	*500-9000	L
SOULIKIAS, PAUL (B. 19226) CANADIAN	400-3500	L,G,F
SOUTHALL, JOSEPH EDWARD (1861-1944) BRITISH	*800-18000	M,L
SOUTHGATE, FRANK (1872-1916) BRITISH	*500-3000	W
SOUTINE, CHAIM (1894-1943) RUSSIAN	3500-+++	A
SOUTMAN, PIETER CLAESZ (1580-1657) DUTCH	500-11000	G,L,F
SOUTTER, LOUIS	*400-54000	
SOUTTER, LOUIS (B. 1871) SWISS	400-10000	G,F,L
SOUVERBIE, JEAN	*200-4400	
SOUVERBIE, JEAN (1891-1981) FRENCH	600-35000	F,G,S
SOYER, MOSES	*200-1200	
SOYER, MOSES (1898-1974) RUSSIAN/AMERICAN	500-15000	F,G

SOYER, PAUL (1823-1903) FRENCH	1000-11000	G,L,S
SPADA, LIONELLO (1576-1622) ITALIAN	600-60000	F
SPADARO, MICCO (1612-1675) ITALIAN	300-6400	G,F
SPADINI, ARMANDO (1883-1925) ITALIAN	450-107000	G,F,S
SPADINO, BARTOLOMEO (18TH C) ITALIAN	400-50000	S
SPADINO, GIOVANNI PAOLO (17TH C) ITALIAN	2000-90000	S
SPAENDONCK, CORNELIS VAN (1756-1840) FRENCH	3000-+ + +	S
SPAENDONCK, GERARD VAN (1746-1822) FRENCH	3000-+ + +	S,W
SPALA, VACLAV (1885-1946) CZECHOSLOVAKIAN	900-11000	L,F,S
SPALDING, C. B. (19TH C) BRITISH	200-7200	L,G
SPALTHOFF, JAN PHILIP (Early 18TH C) FLEMISH	400-8800	G,L
SPANGENBERG, PAUL (1843-1918) GERMAN	300-2400	G
SPARRE, LOUIS (1863-1964) SWEDISH	900-15000	M,L
SPAT, GABRIEL (19TH/20TH C) FRENCH	450-11000	L
SPEAR, RUSKIN (B. 1911) BRITISH	800-27000	X(L)
SPEED, HAROLD (1872-1957) BRITISH	1000-69000	G,F,L
SPENCE, HARRY (1860-1928) BRITISH	300-6100	G,F
SPENCE, THOMAS RALPH (B. 1855) BRITISH	500-11000	F
SPENCELAYH, CHARLES (1865-1958) BRITISH	600-167000	G,L,F
SPENCER, FREDERICK (19TH C) BRITISH	300-2800	F
SPENCER, GILBERT (B. 1892) BRITISH	300-13000	G,F,L
SPENCER, J. A. (19TH C) BRITISH	300-2200	F
SPENCER, R. B. (Active 1805-1870) BRITISH	400-8400	M
SPENCER, RICHARD (19TH C) BRITISH	300-19000	M
SPENCER, SIR STANLEY	*250-91000	
SPENCER, SIR STANLEY (1891-1959) BRITISH	2000-+ + +	F,G,L
SPENCER, THOMAS (18TH C) BRITISH	500-92000	W
SPERANZA, GIOVANNI (1480-1532) ITALIAN	4000-50000	F
SPERL, JOHANN (1840-1914) GERMAN	750-78000	G,L
SPERLICH, SOPHIE (19TH C) GERMAN	300-6800	F,W
SPERLING, HEINRICH (1844-1924) GERMAN	300-12000	W
SPEYER, CHRISTIAN GEORG (1855-1929) GERMAN	600-20000	F
SPICUZZA, FRANCESCO J. (1883-1962) ITALIAN/AMERICAN	200-1500	G,L
SPIELTER, CARL JOHANN (1851-1922) GERMAN	600-19000	G
SPIERS, BENJAMIN WALTER (Late 19TH C) BRITISH	*300-5700	G,S
SPILHAUS, NITA (1878-1967) GERMAN	600-5200	X(M,L)
SPILIMBERGO, ADRIANO (B. 1908) ITALIAN	900-8800	X(S)
SPILIMBERGO, LINO ENEAS (1896-1964) ARGENTINIAN	500-22000	L
SPILLIAERT, LEON	*500-159000	

* Denotes watercolors, pastels, drawings, and/or mixed media

SPILLIAERT, LEON (1881-1948) BELGIAN	400-31000	L,F,M
SPINETTI, MARIO (19TH/20TH C) ITALIAN	400-11000	G,W
SPINKS, THOMAS (Active 1872-1907) BRITISH	300-5300	L
SPIRIDON, IGNACE (Late 19TH C) ITALIAN	400-22000	G,F
SPIRO, EUGEN (B. 1874) GERMAN	900-12000	F,M,L
SPIRO, GEORGES (1909-1948) FRENCH	300-7800	G,L,S
SPITZER, EMANUEL (1844-1919) GERMAN	400-6500	G
SPITZER, WALTER (B. 1927) POLISH	1000-25000	G,F
SPITZWEG, CARL	*500-14000	
SPITZWEG, CARL (1808-1885) GERMAN	1800-+++	G,L,F
SPLITGERBER, AUGUST KARL MARTIN (1844-1918) GERMAN	400-6000	G,L
SPODE, JOHN (19TH C) BRITISH	400-5400	F,W
SPODE, SAMUEL (19TH C) BRITISH	500-9500	G,L,W
SPOEDE, JEAN JACQUES (1680-1757) DUTCH	350-28000	X
SPOHLER, JACOB JAN COENRAAD (1837-1923) DUTCH	600-34000	L
SPOHLER, JAN JACOB (1811-1879) DUTCH	700-50000	L,F
SPOHLER, JOHANNES FRANCISCUS (1853-1894) DUTCH	600-18000	L
SPOONER, ARTHUR (20TH C) BRITISH	1000-125000	G,L,F
SPRANGER, BARTHOLOMAEUS	*300-56000	
SPRANGER, BARTHOLOMAEUS (1546-1611) FLEMISH	1000-85000	F
SPREUWEN, JACOB VAN (B. 1611) DUTCH	300-4300	G,F
SPRING, ALFONS (1843-1908) GERMAN	500-18000	G,F
SPRINGER, CORNELIS	*400-16000	
SPRINGER, CORNELIS (1817-1891) DUTCH	1000-129000	G,L
SPRINKMANN, MAX CHRISTIAN (B. 1876) GERMAN	400-3500	G,F
SPRUYT, JAN (1627-1671) DUTCH	400-14000	G,W
SQUIRRELL, LEONARD (B. 1893) BRITISH	*400-4500	L
STAAL, GUSTAVE PIERRE EUGENE (1817-1882) FRENCH	300-3200	F
STAATEN, LOUIS VAN (19TH/20TH C) DUTCH	*200-1900	L
STABLI, JOHANN ADOLF (1842-1901) SWISS	300-16500	L
STACK, JOSEF MAGNUS (1812-1868) SWEDISH	350-15000	G,L,M
STACQUET, HENRY (1838-1907) BELGIAN	*300-2200	L
STADELMANN, HANS (B. 1876) GERMAN	300-2400	F
STADEMANN, ADOLF (1824-1895) GERMAN	700-35000	G,L,W
STADLER, TONI (OR ANTON VAN) (1850-1917) GERMAN	300-5800	F,L
STAEL, NICOLAS DE	*2000-116000	
STAEL, NICOLAS DE (1913-1955) FRENCH	8000-+++	A
STAGER, BALZ (B. 1861) SWISS	600-7500	L,F
STAGURA, ALBERT	*500-4500	

STAGURA, ALBERT (1866-1947) GERMAN	600-9000	F,L
STAHL, FRIEDRICH (1863-1940) GERMAN	800-60000	G,F
STAINTON, GEORGE	*200-1600	
STAINTON, GEORGE (19TH C) BRITISH	300-6900	L
STAINTON, GEORGE (19TH C) BRITISH	500-7000	M
STALBEMT, ADRIAEN VAN (1580-1662) FLEMISH	1500-64000	G,L,F
STALLER, GERARD JOHAN (1880-1956) DUTCH	300-5000	G
STAMMBACH, EUGEN (1876-1966) GERMAN	600-4500	L
STAMMEL, EBERHARD (1832-1906) GERMAN	400-8000	G
STANDING, H. W. (19TH/20TH C) BRITISH	*300-2800	L,W
STANEK, EMMANUEL (1862-1920) AUSTRIAN	300-3200	M
STANESBY, ALEXANDER (Active 1845-1854) BRITISH	*300-2800	S
STANFIELD, GEORGE CLARKSON (1828-1878) BRITISH	550-35000	G,L
STANFIELD, WILLIAM CLARKSON	*200-3000	
STANFIELD, WILLIAM CLARKSON (1793-1867) BRITISH	500-16000	L,M
STANGERUS, CORNELIS (1616-1667) DUTCH	300-8000	G,F
STANHOPE, JOHN RODDAM SPENCER (1829-1908) DUTCH	1500-110000	F
STANILAND, CHARLES (1838-1911) BRITISH	300-5500	G,F
STANLEY, CALEB ROBERT (1795-1868) BRITISH	500-18000	G,L
STANNARD, ALFRED (1806-1889) BRITISH	650-50000	L,M
STANNARD, ALFRED GEORGE (1828-1885) BRITISH	*200-2000	L,M
STANNARD, ELOISE HARRIET (1829-1915) BRITISH	500-45000	S
STANNARD, EMILY (1803-1885) BRITISH	600-24000	L,S
STANNARD, HENRY (1844-1920) BRITISH	*300-3000	L,W
STANNARD, HENRY SYLVESTER (1870-1951) BRITISH	*300-15000	G,L
STANNARD, JOSEPH (1797-1830) BRITISH	300-9000	M
STANNARD, LILIAN (B. 1884) BRITISH	*900-18000	L
STANNARD, SYLVESTER (1898-1947) BRITISH	*500-6500	L,F
STANNUS, ANTHONY CAREY (1862-1903) BRITISH	200-1200	L,G
STANZIONE, MASSIMO (Called CAVALIERRE MASSIMO) (1585-1656) ITALIAN	3000-220000	F
STARK, JAMES (1794-1859) BRITISH	1500-56000	L,W
STARKENBORGH, JACOBUS NICOLAS BARON TJARDA VAN (1822-1895) DUTCH	300-5000	L
STARKENBORGH STACHOUWER, WILLEM TJARDA VAN (1823-1885) DUTCH	200-4000	L,W
STAUFFER, FRED	*600-3000	
STAUFFER, FRED (B. 1892) SWISS	400-11000	L,S
STAUFFER, KARL (1857-1891) SWISS	900-8500	F
STAVERDEN, JACOB VAN (17TH C) DUTCH	300-5600	L,F

* Denotes watercolors, pastels, drawings, and/or mixed media

STEAD, FRED (1863-1940) BRITISH	2000-60000	G,F
STEADMAN, J. T. (Late 19TH C) BRITISH	200-5000	G,F
STEELE, EDWIN (19TH C) BRITISH	200-2500	L,S
STEELINK, WILLEM (1826-1913) DUTCH	300-2600	L
STEELINK, WILLEM (THE YOUNGER) (1856-1928) DUTCH	300-4800	G,L
STEELL, DAVID GEORGE (1856-1930) BRITISH	400-6200	F,W
STEELL, GOURLAY (1819-1894) BRITISH	700-49000	W,G,L,F
STEEN, JAN HAVICKSZ (1626-1679) DUTCH	2000-+++	L,F
STEENWYCK, HARMEN VAN (1612-1656) DUTCH	400-26000	G,F,S
STEENWYCK, HENDRIK VAN (1550-1603) DUTCH	1000-20000	F,G
STEENWYCK, HENDRIK VAN (THE YOUNGER)	*300-25000	
STEENWYCK, HENDRIK VAN (THE YOUNGER) (1580-1649)	1000-84000	G,L
STEEPLE, JOHN (Active 1846-1852) BRITISH	300-3200	L,F
STEER, PHILIP WILSON	*250-2100	
STEER, PHILIP WILSON (1860-1942) BRITISH	500-78000	G,F,L
STEFANO, DA FOSSANO (1455-1535) ITALIAN	3000-85000	F
STEFANORI, ATTILLIO (1860-1941) ITALIAN	200-1400	X
STEFANSSEN, JON (1881-1962) ICELANDIC	1000-16000	S
STEFFAN, JOHANN (1815-1905) SWISS	600-42000	G,L
STEFFEK, CARL CONSTANTINE HEINRICH (1818-1890) GERMAN	500-85000	W
STEFFENSEN, PAUL (1866-1923) DANISH	300-6000	L,W
STEGMANN, FRANZ (1831-1892) GERMAN	300-4500	G,L
STEIGER, I. DE (19TH C) GERMAN	200-1400	F
STEIN, GEORGES	*250-10000	
STEIN, GEORGES (20TH C) FRENCH	600-28000	L
STEINACKER, ALFRED (B. 1838) AUSTRIAN	200-3000	G,L,W
STEINER, AGNES (1845-1925) GERMAN	200-2400	X
STEINER, ANTON (19TH C) GERMAN	400-8400	S
STEINER, JOSEF (B. 1898) AUSTRIAN	300-8500	S
STEINFELD, FRANZ (1787-1868) AUSTRIAN	500-9200	L
STEINFELD, WILHELM (1816-1854) AUSTRIAN	300-5000	L
STEINHARDT, FRIEDRICH KARL (B. 1844) GERMAN	300-3000	G
STEINHARDT, JAKOB (1887-1968) ISRAELI	200-4600	G,L,F
STEINHEIL, CARL FRIEDRICH (1860-1917) GERMAN	300-2400	G,F
STEINLE, JOHANN EDWARD VON (1810-1886) AUSTRIAN	*400-5600	F
STEINLEN, THEOPHILE ALEXANDRE	*400-32000	
STEINLEN, THEOPHILE ALEXANDRE (1859-1923) SWISS/FRENCH	1200-38000	G,L,F
STEINTHAL, TRAUTE TOMINE (1868-1906) GERMAN	200-1300	G,F
STELLA, IGNAZ STERN (Called IGNAZ STERN) (1680-1748) GERMAN	800-35000	F

STELLA, JACQUES (1596-1657) FRENCH	500-58000	F
STELZNER, HEINRICH (1833-1910) GERMAN	300-12000	G
STEN, JOHN (1879-1922) SWEDISH	*300-5000	L,F
STENBERG, EMERIK (1873-1972) SWEDISH	300-3600	G,F
STEPHAN, JOSEPH (1709-1786) GERMAN	200-2400	X
STEPHANE, MICIUS (B. 1912) HAITIAN	400-11000	G,L
STEPHANOFF, FRANCIS PHILIP (1788-1860) BRITISH	300-8800	G,F
STEPHENSON, LIONEL MCDONALD (1854-1907) CANADIAN	200-2100	G,F
STEPHENSON, W. (1893-1938) BRITISH	*100-3000	L
STERKENBURG, PIETER (19TH/20TH C) DUTCH	200-1000	M
STERN, IRMA (B. 1894) BRITISH	600-46000	L,F
STERN, LUDOVICO (1709-1777) ITALIAN	400-11000	F,S
STERN, MAX (1872-1943) GERMAN	200-15000	F,L
STERNE, SIDNEY C. (19TH C) BRITISH	300-2800	W
STEUBEN, CARL VON (1788-1856) GERMAN	800-55000	F
STEVENS, AGAPIT (19TH C) BELGIAN	350-14000	F,L
STEVENS, ALFRED	*350-15000	
STEVENS, ALFRED (1823-1906) BELGIAN	1200-+++	G,F,M
STEVENS, JOSEPH EDOUARD (1819-1892) BELGIAN	200-2600	G,W
STEVENS, PIETER (1567-1624) FLEMISH	1000-122000	L,F
STEVER, JORG (B. 1940) GERMAN	200-2000	A
STEWART, CHARLES EDWARD (1887-1938) BRITISH	350-30000	F,G
STEWART, FRANK ALGERNON (1877-1945) BRITISH	*200-7300	L,G
STICKS, GEORGE BLACKIE (1843-1938) BRITISH	200-16000	L,M
STICKS, HARRY (1894-1938) BRITISH	200-1400	L
STIELER, JOSEPH KARL (1781-1858) GERMAN	400-78000	F
STIEPEVICH, VINCENT G. (1841-1910) RUSSIAN	600-36000	F,L
STIFTER, MORITZ (1857-1905) AUSTRIAN	200-18000	G,F
STILLERICH, JOHANN (1802-1843) AUSTRIAN	200-1200	L
STILLMANN, MARIA SPARTALI (1844-1927) BRITISH	*400-12000	F,L
STOBBAERTS, JAN (1838-1914) BELGIAN	300-5900	G
STOBBAERTS, MARCEL (B. 1899) BELGIAN	450-11000	G,F
STOCK, HENRI CHARLES (1826-1885) FRENCH	300-5500	X
STOCK, IGNATIUS VAN DER (17TH C) DUTCH	300-14000	L,W
STOCK, JACOBUS VAN DER (1794-1864) DUTCH	400-10000	L,G
STOCKLEIN, CHRISTIAN (1741-1795) SWISS	300-6000	G
STOCKLER, EMMANUEL (1819-1893) AUSTRIAN	*200-7500	G,M
STOCKMANN, ANTON (B. 1868) SWISS	200-2600	X
STOCKMANN, HERMANN (1867-1939) GERMAN	300-7200	G,L

* Denotes watercolors, pastels, drawings, and/or mixed media

STOCKT, VRANCKE VAN DER (1424-1495) FLEMISH	2000-75000	F
STOCKUM, HILDA VAN (B. 1908) DUTCH	700-3500	S
STOECKLIN, NIKLAUS (B. 1896) SWISS	400-34100	G,L,S
STOFFE, JAN JACOBSZ VAN DER (1611-1682) DUTCH	300-11000	L
STOILOFF-BAUMGARTNER, CONSTANTIN (1850-1924) RUSSIAN/AUSTRIAN	400-16000	G,L
STOITZNER, JOSEF (B. 1884) AUSTRIAN	500-15000	L
STOITZNER, KONSTANTIN (1863-1934) AUSTRIAN	300-7200	G,S
STOITZNER, RUDOLF (1873-1933) AUSTRIAN	200-2200	S
STOITZNER, WALTER (1890-1921) AUSTRIAN	300-2800	L,G
STOJANOW, CONSTANTINE (19TH C) RUSSIAN	300-5000	G
STOK, JACOBUS VAN DER (1795-1864) DUTCH	1000-9100	F,L
STOKELD, JAMES (1827-1877) BRITISH	200-4800	G,L
STOKES, ADRIAN (1854-1935) BRITISH	200-14000	L,S
STOKES, GEORGE VERNON	*400-2000	
STOKES, GEORGE VERNON (1873-1954) BRITISH	800-8000	W
STOKES, MARIANNE (1855-1927) BRITISH	550-70000	F,G
STOL, DOMINICUS VAN (1635-1676) DUTCH	200-2200	G
STOLL, LEOPOLD (D. 1869) GERMAN	600-10000	S
STOLTENBERG-LERCHE, V. (1837-1892) NORWEGIAN	300-10000	G
STOM, ANTONIO (18TH C) ITALIAN	500-6000	L
STOMER, MATTHIAS (17TH C) FLEMISH	1200-180000	G,F,S
STOMME, JAN JANSZ DE (Active 1643-1657) DUTCH	200-4500	F
STONE, FRANK (1800-1859) BRITISH	300-17000	G,F
STONE, MARCUS (1840-1921) BRITISH	500-90000	G,L
STONE, ROBERT (20TH C) AUSTRALIAN	500-15000	G
STONE, TOM (1897-1978) CANADIAN	200-1800	L
STONE, WILLIAM (JR.) (19TH C) BRITISH	300-2800	L,F
STOOP, DIRK (1610-1681) DUTCH	600-52000	F,L
STOOP, MAERTEN (1620-1647) DUTCH	400-10000	G
STOOPENDAAL, GEORG (1866-1953) SWEDISH	300-6000	L,W
STOOPENDAAL, MOSSE (1901-1948) SWEDISH	500-46000	L,W
STOPPOLONI, AUGUSTO (B. 1855) ITALIAN	300-4600	G,F,L
STORCK, ABRAHAM (1635-1710) DUTCH	1500-+++	M,L
STORCK, JACOBUS (1610-1686) DUTCH	600-30000	M,L
STOREY, GEORGE ADOLPHUS (1834-1919) BRITISH	700-35000	G,F
STORTENBEKER, PIETER (1828-1898) DUTCH	300-6800	L,W
STOTHARD, THOMAS (1755-1834) BRITISH	300-4000	G,F
STOTT, EDWARD WILLIAM (1859-1918) BRITISH	2000-130000	G,F,L

STOUF, JEAN BAPTISTE (19TH C) FRENCH	300-8000	F
STOWER, WILLY (1864-1931) GERMAN	*800-6000	M,L
STRAATEN, LAMBERT VAN DER (1631-1712) DUTCH	400-15000	L
STRACHAN, ARTHUR CLAUDE (1865-1929) SCOTTISH	*350-17000	L
STRACHEY, HENRY (B. 1863) BRITISH	400-5200	L,F
STRAET, JAN VAN DER	*1500-56000	
STRAET, JAN VAN DER (1523-1605) FLEMISH	900-7500	F,G
STRALEN, ANTONI VAN (1594-1641) DUTCH	2000-28000	L
STRANG, WILLIAM (1859-1921) SCOTTISH	300-8600	G,F
STRANOVER, TOBIAS (1684-1724) CZECHOSLOVAKIAN	750-56000	L,S,W
STRAUCH, LORENZ (1554-1630) GERMAN	400-10000	F,L
STRECKER, EMIL (1841-1925) GERMAN	300-4000	G,L
STREECK, JURRIAEN VAN (1632-1687) DUTCH	1500-80000	S
STREETON, SIR ARTHUR ERNEST (1867-1943) AUSTRALIAN	3000-+++	L,F
STREITT, FRANCISZEK (1839-1890) POLISH	300-7200	G
STRETTON, PHILIP EUSTACE (18TH/20TH C) BRITISH	700-9900	W
STREUTZEL, OTTO (19TH/20TH C) GERMAN	200-1000	X
STREVENS, JOHN (Called FREDERICK JOHN LLOYD) (B. 1902) BRITISH	200-1500	G,F,L
STRIEP, CHRISTIAN (1634-1693) DUTCH	600-26000	S
STRIGEL, BERNHARD (1460-1528) GERMAN	3500-+++	F
STRIJ, ABRAHAM VAN (1753-1826) GERMAN	300-2400	X
STRINDBERG, AUGUST	*600-25000	
STRINDBERG, AUGUST (1849-1912) SWEDISH	1800-+++	L
STROEBEL, JOHANN ANTHONIE BALTHASAR (1821-1905) DUTCH	500-15000	G
STROMEYER, HELEN MARIE (1834-1924) GERMAN	500-11000	L
STROOBANT, FRANCOIS (1819-1916) BELGIAN	400-5800	L
STROZZI, BERNARDO	*500-33000	
STROZZI, BERNARDO (1581-1644) ITALIAN	2000-+++	G,F
STRUDWICK, JOHN MELHUISH (1849-1935) BRITISH	5000-+++	G,F
STRUTT, ALFRED WILLIAM (1856-1924) BRITISH	500-15000	G,L
STRUTT, ARTHUR JOHN (1819-1888) BRITISH	300-7000	L,F
STRUTT, WILLIAM (1826-1915) BRITISH	400-29000	G,F,W
STRUTZEL, LEOPOLD OTTO (1855-1930) GERMAN	400-17000	L,W
STRY, ABRAHAM VAN (1753-1826) DUTCH	600-28000	G,L,F
STRY, ABRAHAM VAN (THE YOUNGER) (1790-1840) DUTCH	300-7700	G,L,F
STRY, JACOB VAN (1756-1815) DUTCH	300-18500	G,F,L
STRYDONK, GUILLAUME VAN (1861-1937) BELGIAN	450-24000	G,F
STUART, CHARLES (Late 19TH C) BRITISH	300-12000	L,S

STUART, W. (19TH C) BRITISH	300-4500	L,S
STUBBS, GEORGE (1724-1806) BRITISH	10000-+++	W,F,L
STUBNER, ROBERT (1874-1931) GERMAN	450-50000	G
STUCK, FRANZ VON	*300-12000	
STUCK, FRANZ VON (1863-1928) GERMAN	600-71000	F
STUHLMULLER, KARL (1858-1930) FRENCH	700-45000	G,L
STUHR, JOHANN GEORG (1640-1721) GERMAN	400-9000	M
STURGESS, JOHN (Late 19TH C) BRITISH	600-16000	G,W
STURM, FRITZ LUDWIG CHRISTIAN (1834-1906) GERMAN	300-4500	F
STUVEN, ERNST (1660-1712) GERMAN	400-43000	S
STYKA, ADAM (1890-1959) FRENCH	800-20000	L,G
STYKA, JAN (1858-1925) POLISH/FRENCH	300-4800	F,G
SUBA, MIKLOS (1880-1944) HUNGARIAN/AMERICAN	*200-1800	A
SUBOWSKY, B. (19TH C) RUSSIAN	200-1200	X
SUGAI, KUMI (B. 1919) JAPANESE	900-176000	A
SUHRLANDT, CARL (1828-1919) GERMAN	300-25000	G,W
SUNOL, ALVAR	*200-3000	
SUNOL, ALVAR (B. 1935) SPANISH	200-1000	X
SUNYER, JOAQUIN S. Y MYRO	*400-15000	
SUNYER, JOAQUIN S. Y MYRO (B. 1875) SPANISH	550-60000	G,L,F
SUPPANTSCHITSCH, MAX (1865-1953) AUSTRIAN	300-6000	G,L
SURBEK, VICTOR	*300-2400	
SURBEK, VICTOR (B. 1885) SWISS	1000-12000	L,F
SUREDA, ANDRE (1872-1930) FRENCH	300-3000	L,F,G
SURTEES, JOHN (1817-1915) BRITISH	*300-3000	G,L
SURVAGE, LEOPOLD	*400-21000	
SURVAGE, LEOPOLD (1879-1968) FRENCH	1200-145000	A
SUS, GUSTAV KONRAD (1823-1881) GERMAN	300-3200	X
SUTCLIFFE, HARRIETTE (Late 19TH C) BRITISH	300-9500	G,S
SUTHERLAND, GRAHAM	*400-63000	
SUTHERLAND, GRAHAM (1903-1980) BRITISH	1500-162000	A
SUTIL, FRANCISCA (B. CHILE 1952)	*400-5500	L
SUZOR-COTI, MARC AURELE	*200-3700	
SUZOR-COTI, MARC AURELE (19TH C) CANADIAN	1800-+++	L,F,S
SVEINSDOTTIR, JULIANA (B. 1889) ICELANDIC	400-5000	L,S
SVENSSON, CHRISTIAN FREDRIK (1834-1909) SWEDISH	600-13000	M
SVENSSON, GUNNAR (1892-1977) SWEDISH	400-4200	S,L
SVENSSON, ROLAND (B. 1910) SWEDISH	*400-3800	L
SWAGERS, FRANS (1756-1836) DUTCH	800-5000	G,L,F

SWAINE, FRANCIS (1740-1782) BRITISH	1000-30100	M
SWAN, CUTHBERT EDMUND (1870-1931) IRISH	200-4400	W
SWANE, CHRISTINE (B. 1876) DANISH	600-10000	S,L
SWANE, SIGURD (B. 1879) DANISH	500-5200	L,S
SWANEBURGH, JACOB ISAACSZ (1571-1638) FLEMISH	2000-55000	F,M
SWANEVELT, HERMAN VAN (1600-1655) DUTCH	800-56000	L
SWANWICK, HAROLD (1866-1929) BRITISH	*500-10000	G,F
SWEBACH, BERNARD EDOUARD (1800-1870) FRENCH	600-15000	G,F
SWEBACH-DESFONTAINES, JACQUES FRANCOIS (1769-1823) FRENCH	1500-20000	L,F
SWEDLUND, PELLE (B. 1865) SWEDISH	2000-30000	L
SWEERTS, JERONIMUS (1603-1636) DUTCH	600-38000	S
SWEERTS, MICHAEL (1624-1664) DUTCH	5000-+++	L,F,G
SWENSSON, CHRISTIAN FREDRIK (1834-1909) SWEDISH	300-3500	L,M
SWIESZEWSKI, ALEXANDER (1839-1895) POLISH	300-5800	L,M
SWINSTEAD, GEORGE HILLYARD (1860-1926) BRITISH	1000-10000	X(G)
SWOBODA, EDUARD (1814-1902) AUSTRIAN	1000-25000	F
SWOBODA, RUDOLF (1859-1914) AUSTRIAN	600-30000	F
SWYNNERTON, JOSEPH WILLIAM (1844-1933) BRITISH	800-10000	F
SYBERG, FRITZ (1862-1939) DANISH	400-6500	S,L,M
SYER, JOHN (1815-1885) BRITISH	400-16000	L,M
SYLVESTRE, JULES N. (19TH C) FRENCH	300-2800	G,F
SYMONDS, WILLIAM ROBERT (1851-1934) BRITISH	500-13000	G,L
SZANTHO, MARIA (B. 1898) HUNGARIAN	200-5500	F,G
SZERNER, VLADYSLAV (JR.) (1870-1936) POLISH	200-1200	G,W
SZULE, PETER (1886-1944) HUNGARIAN	200-1000	X
SZYSZLO, FERNANDO DE (B. 1925) PERUVIAN	600-24000	G,A

T

ARTIST	PRICES	SUBJECT
TAANMAN, JACOB (1836-1923) DUTCH	300-8000	G
TADINI, EMILIO (B. 1927) ITALIAN	*300-8000	X
TAFURI, CLEMENTE (1903-1971) ITALIAN	300-11000	G
TAFURI, RAFFAELE (1857-1929) ITALIAN	300-5800	G,L
TAGLINI, V. (19TH C) ITALIAN	200-1000	X
TAILLE, EDOUARD DE (1848-1912) FRENCH	*300-1500	X
TAL COAT, PIERRE	*300-6000	

TAL COAT, PIERRE (1905-1985) FRENCH	500-60000	A
TALBOYS, AGNES AUGUSTA (19TH C) BRITISH	200-2300	G,W
TALLONE, CESARE (1853-1919) ITALIAN	450-54000	F,L
TALLONE, GUIDO (B. 1894) ITALIAN	500-5200	X(S)
TALMAGE, ALGERNON (1871-1939) BRITISH	2200-25000	G,W,F
TAMAYO, RUFINO	*1500-120000	
TAMAYO, RUFINO (B. 1899) MEXICAN	3500-+++	A
TAMBURI, ORFEO (B. 1910) ITALIAN	600-12000	X
TAMBURINI, ARNALDO (B. 1843) ITALIAN	300-9000	G,L
TAMBURINI, ARONNE (20TH C) ITALIAN	200-2500	X(L)
TAMLIN, JOHN (19TH C) BRITISH	200-2800	G
TAMM, FRANZ WERNER (1658-1724) GERMAN	3000-95000	S
TANCREDI, PARMEGGIANI	*450-32000	
TANCREDI, PARMEGGIANI (1927-1964) ITALIAN	600-142000	L
TANGO, GIUSEPPE (19TH C) BRITISH	200-1000	X
TANGUY, YVES	*2400-198000	
TANGUY, YVES (1900-1955) FRENCH/AMERICAN	3000-+++	A
TANNING, PHILIPPE (1795-1878) FRENCH 400-6000	M,L	
TANOUX, ADRIEN HENRI (1865-1923) FRENCH	300-13000	G,F
TANZI, LEON LOUIS ANTOINE (1846-1913) FRENCH	300-12000	F,L
TANZIO DA VARALLO, ANTONIO D'ENRICO	*1500-62000	
TANZIO DA VARALLO, ANTONIO D'ENRICO (Called II TANZIO) (1575-1635) ITALIAN	600-48000	F
TAPIES, ANTONIO	*1500-+++	
TAPIES, ANTONIO (B. 1923) SPANISH	950-+++	A
TAPPERT, GEORG (1880-1957) GERMAN	3000-+++	A,S
TARAVAL, HUGUES (1729-1785) FRENCH	400-36000	F,G
TARENGHI, ENRICO	*200-10000	
TARENGHI, ENRICO (B. 1848) ITALIAN	300-8500	G,F
TARKHOFF, NICOLAS	*200-15000	
TARKHOFF, NICOLAS (1871-1930) RUSSIAN	300-42000	G,L,S
TARRANT, PERCY (19TH/20TH C) BRITISH	1000-25000	X(W)
TASKER, WILLIAM (1808-1852) BRITISH	300-7500	L,W
TASSAERT, OCTAVE (1800-1874) FRENCH	300-9500	F,G
TASSEL, JEAN (1608-1667) FRENCH	10000-+++	F
TASSI, AGOSTINO (BUONAMICO)	*200-3500	
TASSI, AGOSTINO (BUONAMICO) (1565-1644) ITALIAN	2000-173000	L,F
TATLIN, VLADIMIR (20TH C) RUSSIAN	*700-30000	I
TATO (1896-1968) ITALIAN	400-24000	X

TAUBE, EUGEN (1860-1913) FINNISH	3000-30000	M,L
TAUNAY, NICOLAS ANTOINE (1755-1830) FRENCH	750-68000	L,G
TAUREL, HENRI (B. 1843) FRENCH	600-15000	L,W
TAVELLA, CARLO ANTONIO (Called IL SOLTAROLA) (1668-1738) ITALIAN	600-30000	L,F
TAVERNIER, ANDREA (1858-1932) ITALIAN	300-17000	G,L
TAVERNIER, JULES (1844-1889) FRENCH/AMERICAN	500-60000	G,L
TAVERNIER, JULIEN LOUIS (B. 1879) FRENCH	700-7000	X(G)
TAVERNIER, PAUL (B. 1852) FRENCH	600-25000	G
TAYLER, ALBERT CHEVALLIER (1862-1925) BRITISH	1200-39000	F,G,L
TAYLER, EDWARD (1828-1906)	*800-5600	F
TAYLER, JOHN FREDERICK (1802-1889) BRITISH	*300-3600	G,W,F
TAYLOR, FREDERICK (1875-1963) BRITISH	*500-4200	F,S
TAYLOR, HENRY KING (19TH C) BRITISH	1000-10000	M
TAYLOR, LEONARD CAMPBELL (B. 1874) BRITISH	300-23000	G,F,S
TAYLOR, STEPHEN (Active 1817-1849) BRITISH	300-8500	L,W
TAYMANS, LOUIS (19TH C) BELGIAN	300-2000	G,L
TCHELITCHEV, PAVEL	*300-31000	
TCHELITCHEV, PAVEL (1898-1957) RUSSIAN	700-49300	A
TCHERPINE, ALEXANDER (19TH C) RUSSIAN	*300-4000	G,F
TEJEIRO, C. (19TH C) CUBAN	*300-1500	L
TELEMAQUE, HERVE	*1000-15000	
TELEMAQUE, HERVE (B. 1937) HAITIAN	2000-35000	X(A,F)
TELLES, SERGIO BARCELLOS (B. 1936) PORTUGUESE	300-3000	G
TELLIER, RAYMOND (B. 1897) FRENCH	300-4000	F
TEMPEL, ABRAHAM VAN DEN (1622-1672) DUTCH	2000-75000	F,W
TEMPESTA, ANTONIO (16TH/17TH C) ITALIAN	400-14000	L,G
TEMPLE, HANS (1857-1931) AUSTRIAN	300-4900	G,S
TEN CATE, SIEBE JOHANNES (1858-1908) DUTCH	*700-8500	L,F,M
TEN KATE, HERMAN FREDERIK CAREL	*200-3000	
TEN KATE, HERMAN FREDERIK CAREL (1822-1891) DUTCH	300-30000	G,L
TEN KATE, JOHAN MARI HENRI	*200-7800	
TEN KATE, JOHAN MARI HENRI (1831-1910) DUTCH	600-39000	G,L
TEN KATE, JOHANNES MARINUS (1859-1896) DUTCH	*300-5300	L,M
TEN KOMPE, JAN (1713-1761) DUTCH	500-24000	L,M
TEN OEVER, HENDRIK (17TH/18TH C) DUTCH	600-5500	L,F
TENGGREN, GUSTAF ADOLF (1896-1981) SWEDISH	*600-3000	I
TENIERS, ABRAHAM (1629-1670) FLEMISH	500-20000	G,W
TENIERS, DAVID (THE ELDER) (1582-1649) FLEMISH	2000-55000	G

* Denotes watercolors, pastels, drawings, and/or mixed media

TENIERS, DAVID (THE YOUNGER) (1610-1690) FLEMISH	3000-+++	G,F,L
TENNANT, JOHN F (1796-1872) BRITISH	1000-13000	L
TENRE, HENRY (1864-1924) FRENCH	900-21000	G,L
TEPA, FRANZ (1828-1889) POLISH	300-2500	G
TER BORCH, GERARD (1617-1681) DUTCH	3500-+++	G,F
TER MEULEN, FRANS PIETER (1843-1927) DUTCH	300-6000	L,W
TERA, TEPPO (B. 1935) FINNISH	2500-28000	L
TERBRUGGHEN, HENDRICK (1587-1629) DUTCH	2000-+++	G,F
TERECHKOVITCH, KONSTANTIN (KOSTIA)	*250-25000	
TERECHKOVITCH, KONSTANTIN (KOSTIA) (1902-1978) RUSSIAN/FRENCH	600-72000	L,F,S
TERLOUW, KEES (1890-1948) DUTCH	6700-4500	L,F
TERWESTEN, MATTHAUS (1670-1757) DUTCH	300-10000	L,F
TESSON, LOUIS (19TH C) FRENCH	300-7000	G,L
TETAR VAN ELVEN, PIERRE HENRI THEODORE	*200-2500	
TETAR VAN ELVEN, PIERRE HENRI THEODORE (1828-1908) DUTCH	1200-50000	L
TETAR VAN ELVEN, PIERRE HENRI THEODORE (1831-1908) DUTCH	500-15000	L,G
TETAR VON ELVEN, JAN BAPTIST (1805-1879) DUTCH	200-2400	G
TETMAYER, WLODZIMIERZ (1862-1923) POLISH	300-6000	G
TEUPKEN, DIRK ANTOON (1828-1859) DUTCH	*500-3700	M
TEYE, TERESA CUELLAR (19TH C) COLOMBIAN	*400-9800	L,S
THARRATS, JUAN JOSE (B. 1918) SPANISH	*600-2500	A
THAULOW, FRITZ	*1500-48000	
THAULOW, FRITZ (1847-1906) NORWEGIAN	1000-153000	L,G
THEGERSTROM, ROBERT (1857-1919) SWEDISH	1000-35000	F,L
THERKILDSEN, MICHAEL (1850-1925) DANISH	600-6000	F,W
THERKILDSEN, MICHAEL (1850-1925) DANISH	900-9000	F,W,L
THERY, MADELEINE (20TH C) FRENCH	*300-2200	L
THESLEFF, ELLEN (1869-1954) FINNISH	5000-85000	L,S
THEVENET, LOUIS (1874-1930) BELGIAN	600-33000	G,S
THEVENET, PIERRE (1870-1937) BELGIAN	700-4200	X(S,L)
THEVENIN, CHARLES (1764-1838) FRENCH	750-80000	L
THIBAULT, JEAN THOMAS (1757-1826) FRENCH	400-9000	L
THIELE, ALEXANDER (B. 1924) GERMAN	600-3000	L,W
THIELE, J F ALEXANDER (1747-1803) GERMAN	500-28000	L
THIELEMANN, ALFRED RUDOLPH (1851-1927) DANISH	300-3400	G,S
THIELER, FRED (20TH C) GERMAN	3000-33100	A
THIEMANN, HANS (B. 1910) GERMAN	200-1200	G

THIER, BAREND HENDRIK (1751-1814) DUTCH	500-4500	F,L
THIERSCH, LUDWIG (1825-1909) GERMAN	400-6200	G,L
THIRION, CHARLES VICTOR (1833-1878) FRENCH	500-18000	G
THIVET, ANTOINE AUGUST (19TH C) FRENCH	300-10000	F,L
THOL, HENDRICK OTTO VON (1859-1902) DUTCH	200-1200	X
THOLEN, WILLEM BASTIAAN (1860-1931) DUTCH	500-23000	F,L,S
THOLER, RAYMOND (B. 1859) FRENCH	300-3200	S
THOMA, HANS (1839-1924) GERMAN	1200-101000	G,F,L
THOMA, JOSEF (1828-1899) AUSTRIAN	350-25000	L,M
THOMAS, FRANCIS WYNNE (B. 1907) BRITISH	400-5000	M
THOMAS, GERARD (1663-1720) FLEMISH	400-15000	G
THOMAS, HENRI JOSEPH (1878-1972) BELGIAN	700-24300	X(F)
THOMAS, JAN (1617-1678) FLEMISH	300-4500	F,L
THOMAS, PAUL (B. 1859) FRENCH	300-3000	L,W
THOMAS, PIETER HENDRIK (1814-1866) DUTCH	500-4000	M,F
THOMAS, RICHARD STRICKLAND (1787-1853) BRITISH	1000-12000	M
THOMAS, THOMAS (19TH C) BRITISH	500-6000	L
THOMASSIN, DESIRE (1858-1933) GERMAN	500-17000	G,L,F
THOMASSIN, LOUIS (18TH C) FRENCH	600-28000	G,F
THOMPSON, EDWARD H (1866-1949) BRITISH	*800-12000	L
THOMPSON, HARRY (D. 1901) BRITISH	300-2200	G
THOMPSON, SYDNEY LOUGH (1877-1973) BRITISH	1000-35000	L,F,M
THOMSEN, CARL (1813-1886) DANISH	1000-20000	F
THOMSON, ADAM BRUCE (B. 1885) BRITISH	900-10000	L,S
THOMSON, CLIFTON (1775-1843) BRITISH	300-2500	L,W
THOMSON, FRANCES INGRAM DALRYMPLE (D. 1845) BRITISH	200-1000	X
THOMSON, HUGH (1860-1920) BRITISH	*300-3400	G
THOMSON, JOHN MURRAY (B. 1885) BRITISH	*500-2200	W
THOMSON, TOM (1877-1917) CANADIAN	1400-110000	L,W
THONE, FRANZ (1851-1906) GERMAN	200-7000	G
THONY, EDUARD (1866-1950) GERMAN	*300-2200	X(G,F)
THONY, WILHELM (B. 1888) AUSTRIAN	*700-8000	F,M
THORBURN, ARCHIBALD	*800-63000	
THORBURN, ARCHIBALD (1860-1935) SCOTTISH	1000-25000	L,W
THORBURN, ROBERT (1818-1885) BRITISH	2000-10000	F
THORELL, HILDEGARD (1850-1930) SWEDISH	300-4000	F
THOREN, ESAIAS (1901-1981) SWEDISH	1200-50000	A
THOREN, OTTO VON (1828-1889) AUSTRIAN	400-9000	L,G,W
THORNE, ALFRED (1850-1916) SWEDISH	800-20000	L,M

THORNHILL, SIR JAMES (1675-1734) BRITISH	1000-20000	F
THORNLEY, HUBERT (19TH C) BRITISH	500-4800	M
THORNLEY, WILLIAM (OR GEORGES WILLIAM) (B. 1857) FRENCH	300-9500	L,M
THORNLEY, WILLIAM A. (19TH/20TH C) BRITISH	300-7000	L,M
THORNTON, HERBERT (19TH C) BRITISH	400-11000	L,G
THORS, JOSEPH (1835-1884) BRITISH	300-11000	W,G,L
THULDEN, THEODOOR VAN (1606-1669) FLEMISH	800-49500	F
THURNER, GABRIEL EDOUARD (1840-1907) FRENCH	200-1500	G
TIBBLE, GEOFFREY ARTHUR (1909-1952) BRITISH	200-11000	G,L,S
TIDEMAND, ADOLPHE (1841-1876) NORWEGIAN	2200-+++	G
TIDEY, ALFRED (1808-1892) BRITISH	300-8000	F
TIELEMANNS, LODEWYK (1826-1856) BELGIAN	600-18000	G,L
TIEPOLO, GIOVANNI BATTISTA	*3000-198000	
TIEPOLO, GIOVANNI BATTISTA (1696-1770) ITALIAN	5000-+++	F
TIEPOLO, GIOVANNI DOMENICO	*1000-75000	
TIEPOLO, GIOVANNI DOMENICO (1727-1804) ITALIAN	1500-+++	G,F
TIEPOLO, LORENZO (1736-1776) ITALIAN	*200-75600	F
TILBORG, GILLIS VAN (OR TILBORCH) (1625-1678) FLEMISH	1200-110000	G,L,F
TILL, LEOPOLD (1830-1893) AUSTRIAN	300-12000	G,F
TILLBERG, HARALD (B. 1877) GERMAN	200-1000	G
TILLEMANS, PETER (1684-1734) FLEMISH 1200-30000		F,L
TIMMERMANS, LOUIS ETIENNE	*200-1800	
TIMMERMANS, LOUIS ETIENNE (1846-1910) FRENCH	300-9900	G,M
TINGUELY, JEAN (B. 1925) SWISS	*300-32000	A
TINTORE, SIMONE DEL (Late 17TH C) ITALIAN	1500-245000	S
TINTORETTO, DOMENICO ROBUSTI (Called IL) (1560-1635) ITALIAN	1500-45000	F
TINTORETTO, JACOPO ROBUSTI (IL FURIOSO) (1518-1594) ITALIAN	2500-+++	F
TIRATELLI, AURELIO (1842-1900) ITALIAN	700-28000	G,L
TIRATELLI, CESARE (B. 1864) ITALIAN	400-38000	F,L
TIREN, JOHAN (1853-1911) SWEDISH	700-59000	L
TIRONI, FRANCESCO (18TH/19TH C) ITALIAN	600-55000	L
TISCHBEIN, JOHANN HEINRICH (1722-1789) GERMAN	850-50000	F,G
TISCHLER, VICTOR (1890-1951) AUSTRIAN/AMERICAN	200-3400	F
TISI, BENVENTO (CALLED GASOFALO) (?)	5000-90000	F
TISSOT, JAMES JACQUES JOSEPH	*1800-+++	
TISSOT, JAMES JACQUES JOSEPH (1836-1902) FRENCH	5000-+++	G,F,L
TITCOMB, WILLIAM HOLT YATES (1858-1930) BRITISH	500-17000	G

TITIAN (1477-1576) ITALIAN	3000-+++	F
TITO, ETTORE (1859-1941) ITALIAN	2000-105000	F,G
TITO, SANTI DI (1536-1603) ITALIAN	4000-170000	F
TIVOLI, P. (19TH C) ITALIAN	*300-2000	X
TIVOLI, SERAFINO DE (1826-1892) ITALIAN	350-27000	L
TOBER, K. (19TH C) GERMAN	200-2400	F
TOBIASSE, THEO	*200-17000	
TOBIASSE, THEO (B. 1927) ISRAELI/FRENCH	500-42000	A
TOCQUE, LOUIS (1696-1772) FRENCH	1500-64000	F
TODARO, V. (19TH C) ITALIAN	200-4500	G
TODD, HENRY GEORGE (1847-1898) BRITISH	700-12000	L,S
TODD, ROBERT CLOW (19TH C) BRITISH/CANADIAN	5000-125000	L
TODT, MAX (1847-1890) GERMAN	300-4800	G
TOEPUT, LODEWYK (1550-1603) FLEMISH	5000-48000	G,F,L
TOESCHI, G. (19TH C) ITALIAN	200-8000	X
TOFANO, EDOUARD (1838-1920) ITALIAN	400-9900	G,F
TOFFOLI, LOUIS (B. 1907) FRENCH	1000-38000	X
TOJETTI, VIRGILIO (1851-1901) ITALIAN	400-14000	G,L
TOL, DOMINICUS VAN (1635-1676) DUTCH	500-22000	G,F
TOLDT, A. (19TH/20TH C) GERMAN	200-1800	L
TOLEDO, FRANCISCO	*1000-85000	
TOLEDO, FRANCISCO (B. 1940) MEXICAN	1200-+++	A,F
TOM, JAN BEDYS (1813-1894) DUTCH	300-8500	L,W
TOMA, GIOACCHINO (1836-1891) ITALIAN	900-32000	X
TOMANEK, JOSEPH (B. 1899) CZECH	200-1500	F
TOMBA, ALDINI CASIMIRO (1857-1929) ITALIAN	*200-3000	G
TOMEA, FIORENZO (1910-1960) ITALIAN	900-9300	X
TOMINZ, ALFREDO (1854-1936) AUSTRIAN	300-9600	W
TOMMASI, ADOLFO (1851-1933) ITALIAN	400-38500	L,F
TOMMASI, LUDIVICO (1866-1941) ITALIAN	300-9500	G,L,F
TOMME, LUCA DI (1330-1389) ITALIAN	1200-75000	F
TOMSON, CLIFTON (1775-1828) BRITISH	800-42000	L,W
TOMSON, J. (19TH C) BRITISH	200-1000	X
TONGEN, LOUIS VAN DE (1871-1937) DUTCH	300-4000	G,F
TOORENVLIET, JACOB (1635-1719) DUTCH	2300-40000	F,G
TOOROP, CHARLEY (1881-1955) DUTCH	200-9500	A,F
TOOROP, JAN (1858-1928) DUTCH	1500-95000	A
TOPFFER, WOLFGANG ADAM (1766-1847) SWISS	5000-40000	G,F
TOPHAM, FRANCIS WILLIAM	*400-9000	

* Denotes watercolors, pastels, drawings, and/or mixed media

TOPHAM, FRANCIS WILLIAM (1808-1877) BRITISH	800-19000	L,G,F
TOPHAM, FRANK WILLIAM WARWICK (1838-1924) BRITISH	700-20000	G,L
TOPOLSKI, FELIKS	*200-1200	
TOPOLSKI, FELIKS (B. 1907) POLISH	*250-5600	G,F
TORAL, MARIO (B. 1934) CHILEAN	300-2400	F
TORDI, SINIBALDO (1876-1955) ITALIAN	1000-9500	X(G)
TORHAMN, GUNNAR (1894-1955) SWEDISH	1000-11000	M,L
TORNA, OSCAR (1842-1894) SWEDISH	800-58000	L,F,W
TORNAI, GYULA (1861-1928) HUNGARIAN	400-15000	F,G
TORNOE, WENZEL ULRIK (1844-1907) DANISH	600-83000	G,F
TORRES, ANTONIO (B. 1851) SPANISH	200-2700	F,L
TORRES, JULIO ROMERO DE (1879-1930) SPANISH	400-11000	G,F
TORRES-GARCIA, JOAQUIN	*200-230000	
TORRES-GARCIA, JOAQUIN (1874-1949) URUGUAYAN	1500-+++	A
TORRIGLIA, GIOVANNI BATTISTA (1858-1937) ITALIAN	850-156000	G
TORRINI, E. (19TH C) ITALIAN	800-27000	G,F
TORTEZ, VICTOR (D. 1890) FRENCH	200-6000	G
TOSI, ARTURO (1871-1956) ITALIAN	600-23000	L,S
TOSINI, MICHELE (1503-1577) ITALIAN	6300-65000	F
TOUDOUZE, EDOUARD (1848-1907) FRENCH	750-30000	G
TOULMOUCHE, AUGUSTE (1829-1890) FRENCH	1500-40000	G,F
TOULOUSE-LAUTREC, HENRI DE	*5000-+++	
TOULOUSE-LAUTREC, HENRI DE (1864-1901) FRENCH	10000-+++	G,F
TOUR-DONAS, MARTHE (1885-1967) BELGIAN	300-7000	S
TOURNEMINE, CHARLES (1812-1872) FRENCH	400-10000	G,L,F
TOURNIER, NICOLAS (1590-1657) FRENCH	3000-70000	G,F
TOUSSAINT, AUGUSTE (20TH C) HAITIAN	400-9000	X
TOUSSAINT, FERNAND (1873-1955) BELGIAN	2000-95000	L,F,S
TOUSSAINT, LOUIS (19TH C) EUROPEAN	400-8800	G,L
TOUSSAINT, PIERRE (19TH C) FRENCH	300-7000	X
TOUSSAINT, PIERRE JOSEPH (1822-1888) BELGIAN	300-4500	G
TOVAR, IVAN (20TH C) CZECHOSLOVAKIAN	400-7200	G
TOVAR Y TOVAR, MARTIN (1827-1902) VENEZUELAN	500-23000	F
TOWNE, CHARLES (18TH/19TH C) BRITISH	1200-72000	L,W
TOWNE, CHARLES (OF LIVERPOOL) (1763-1840) BRITISH	650-88000	L
TOWNE, CHARLES (OF LONDON) (1781-1854) BRITISH	900-58000	L,G
TOWNE, FRANCIS (1740-1816) BRITISH	*1000-48000	L
TOWNSHEND, ARTHUR LOUIS (19TH/20TH C) BRITISH	200-1400	L,W
TOZZI, MARIO (B. 1895) ITALIAN	500-50000	L,F,S

TRACHE, RUDOLPH (B. 1866) GERMAN	200-1200	F
TRAFFELET, FRIEDRICH EDUARD (1897-1954) SWISS	700-6000	L,F,S
TRAIES, WILLIAM (1789-1872) BRITISH	300-21000	G,L
TRAMANEO, GIANNI (19TH/20TH C) ITALIAN	200-2000	G,F
TRAPPES, FRANCIS M. (Late 19TH C) BRITISH	300-5500	G,L
TRAUTMANN, JOHANN (1713-1769) GERMAN	700-10000	G,F
TRAVERSI, GASPARE (D. 1769) ITALIAN	2000-35000	G,F
TRAYER, JEAN BAPTISTE JULES (1824-1908) FRENCH	2800-246000	G
TRECCANI, ERNESTO (B. 1920) ITALIAN	400-5000	X
TRECK, JAN JANSSEN (1606-1652) HUNGARIAN	1200-170000	S
TREPOLO, GIOVANNI DOMENICO (1727-1804) ITALIAN	*200-2200	X
TRETCHIKOFF, VLADIMIR (20TH C) RUSSIAN	200-3000	F,W,S
TREVISANI, FRANCESCO (1656-1746) ITALIAN	1500-28000	G,F
TRIER, HANN (B. 1915) GERMAN	2000-38000	A
TRINQUESSE, LOUIS ROLLAND	*300-41000	
TRINQUESSE, LOUIS ROLLAND (1746-1800) FRENCH	1500-42000	G,F
TRIONFI, EMANUELE (1832-1900) ITALIAN	200-1000	X
TRIOSON, GIRODET DE ROUCY (18TH C) FRENCH	550-23000	X
TRIPET, ALFRED (Late 19TH C) FRENCH	300-15000	G
TRIPPEL, ALBERT LUDWIG (1813-1854) GERMAN	300-2000	L
TROGER, PAUL (1698-1762) AUSTRIAN	400-13000	F
TROKES, HEINZ (B. 1913) GERMAN	900-7000	X(A)
TROMP, JAN ZOETELIEF	*200-14000	
TROMP, JAN ZOETELIEF (1872-1947) DUTCH	1200-52000	G,F
TROOD, WILLIAM HENRY HAMILTON (1848-1899) BRITISH	1500-30000	G,W
TROOST, CORNELIS (1697-1750) DUTCH	500-15000	F,L,G
TROUILLEBERT, PAUL DESIRE	*200-3400	
TROUILLEBERT, PAUL DESIRE (1829-1900) FRENCH	1200-114000	F,L
TROUTOVSKY, KONSTANTIN ALEXANDROVITCH (1826-1893) RUSSIAN	300-3100	G,L
TROY, FRANCOIS DE (1645-1730) FRENCH	650-132000	F,G
TROY, JEAN FRANCOIS DE (1697-1752) FRENCH	1200-110000	F
TROYON, CONSTANT	*700-22000	
TROYON, CONSTANT (1810-1865) FRENCH	2000-709000	G,L,W
TRUBNER, WILHELM (1851-1917) GERMAN	300-62000	G,F,L
TRUDY, MILNE (1842-1900) FRENCH	200-1000	G
TRUJILLO, GUILLERMO (B. 1927) PANAMANIAN	300-4800	A
TRUPHEME, AUGUSTE JOSEPH (1836-1898) FRENCH	300-42400	S,F
TRUPHEMUS, JACQUES (20TH C) FRENCH	500-4700	X

* Denotes watercolors, pastels, drawings, and/or mixed media

TSCHEGGENY, CHARLES (1815-1894) BELGIAN	300-6200	G,W
TSCHELAN, HANS (B. 1873) VIENNESE	200-6500	G
TUBBECKE, PAUL W. (1848-1924) GERMAN	300-2500	G,L
TUERENHOUT, JEF VAN	*400-5500	
TUERENHOUT, JEF VAN (20TH C) BELGIAN	800-10000	X(F)
TUKE, HENRY SCOTT	*150-12100	
TUKE, HENRY SCOTT (1858-1929) BRITISH	550-198000	G,F,M
TUNNARD, JOHN	*200-6500	
TUNNARD, JOHN (B. 1900) BRITISH	400-23000	L,W
TUNNICLIFFE, CHARLES FREDERICK (B. 1901) BRITISH	*400-12000	W
TURCATO, GIULIO	*500-19000	
TURCATO, GIULIO (B. 1912) ITALIAN	1000-65000	X(A)
TURCHI, ALESSANDRO (1578-1649) ITALIAN	3000-80000	F
TURINA, CARLO (B. 1885) ITALIAN	200-2000	F
TURNER, ALFRED M. (1852-1932) BRITISH	*200-2000	G,F
TURNER, DANIEL (18TH C) BRITISH	500-12000	L
TURNER, FRANCIS CALCRAFT (1782-1846) BRITISH	1400-76000	G,F
TURNER, GEORGE (1843-1910) BRITISH	1000-31000	L,W
TURNER, GEORGE (JR.) (19TH C) BRITISH	300-2800	X
TURNER, JAMES ALFRED (20TH C) EUROPEAN	3000-156000	L,F,G
TURNER, JOSEPH MALLORD WILLIAM	*2000-+++	
TURNER, JOSEPH MALLORD WILLIAM (1775-1851) BRITISH	15000-+++	L
TURNER, L. (19TH C) BRITISH	200-1200	M
TURNER, WILLIAM EDDOWES (19TH C) BRITISH	200-3000	L,W
TURNER, WILLIAM H. (Active 1840-1887) BRITISH	300-6000	W
TURNER, WILLIAM L. (1867-1936) BRITISH	200-2200	L
TURNER OF OXFORD, WILLIAM (1789-1862) BRITISH	*500-15000	L
TURSHANSKY, LEONID VIKTOROVICH (1875-1945) RUSSIAN	200-2300	X
TUSHAUS, FRITZ (1832-1885) GERMAN	400-6800	X
TUSQUETS Y MAIGNON, RAMON (D. 1904) ITALIAN	300-6500	G
TUTUNDJIAN, LEON ARTHUR	*600-19000	
TUTUNDJIAN, LEON ARTHUR (1906-1968) FRENCH	1000-60000	F
TUXEN, LAURITS (1853-1927) DANISH	1000-30000	F,L
TYNDALE, THOMAS NICHOLSON (19TH-20TH C) BRITISH	*500-1800	L,W
TYNDALE, WALTER (1855-1943) BRITISH	*400-6000	L,F,G
TYTGAT, EDGARD (1879-1957) BELGIAN	1000-17000	X(F)
TYTGAT, MEDARD (B. 1871) BELGIAN	400-24000	G,F

U

ARTIST	PRICES	SUBJECT
UBAC, RAOUL	*2000-15000	
UBAC, RAOUL (B. 1911) BELGIAN	10000-150000	A
UDEN, LUCAS VAN	*1000-34000	
UDEN, LUCAS VAN (1595-1672) FLEMISH	1000-51000	G,L
UHDE, FRIEDRICH KARL HERMANN VON (OR FRITZ) (1848-1911) GERMAN	600-34000	F,L,G
UHRDIN, SAM (1886-1964) SWEDISH	600-24000	L,F
ULFSTEN, NICOLAY (B. 1855) DUTCH	200-14000	L,G
ULFT, JACOB VAN DER (1627-1689) DUTCH	750-51000	L,F
ULMANN, CH. (19TH C) GERMAN OR SWEDISH	200-1500	G
ULMANN, JANS (20TH C) GERMAN	200-1500	X
ULRICH, JOHANN JAKOB HANS (1798-1877) SWISS	850-40000	L,M
ULVING, EVEN (1863-1952) NORWEGIAN	900-14000	G,F,L,M
UNDERHILL, FREDERICK CHARLES (Late 19TH C) BRITISH	300-4700	G,L
UNDERHILL, WILLIAM (Late 19TH C) BRITISH	400-7400	G,L
UNGER, HANS (1872-1936) GERMAN	400-4200	F,S,L
UNGEWITTER, HUGO (B. 1869) GERMAN	500-12000	L,G,W
UNKER, CARL HENRIK (1828-1866) SWEDISH	300-2000	X
UNOLD, MAX (B. 1885) GERMAN	200-4000	L,G,S
UNTERBERGER, FRANZ RICHARD (1838-1902) BELGIAN	1800-58000	L,M
URBANI, LUDIVICO (15TH C) ITALIAN	600-45000	F
URDAL, ATLE (B. 1913) NORWEGIAN	300-5500	L,F,M
URIBURU, NICHOLAS GARCIA (B. 1937) ARGENTINIAN	300-3400	F,G
URILLIOT, P. (19TH C) BELGIAN	200-2400	F,G
URLASS, LOUIS (B. 1804) FRENCH	200-1200	G,F
URQUHART, MURRAY (1880-1972) BRITISH	800-12000	L,M,F
URY, LESSER	*1500-115000	
URY, LESSER (1861-1931) GERMAN	1800-190000	G,L,F
USSI, STEFANO (1822-1901) ITALIAN	400-16000	F,L
UTRECHT, ADRIAEN VAN (1599-1653) FLEMISH	1500-49200	G,L,S
UTRILLO, MAURICE	*1200-210000	
UTRILLO, MAURICE (1883-1955) FRENCH	5000-+ + +	A
UTTER, ANDRE (1886-1948) FRENCH	400-6200	L,F
UYTEWAEL, JOACHIM	*300-10000	
UYTEWAEL, JOACHIM (1566-1638) DUTCH	2000-+ + +	L,F
UYTTENBROECH, MOSES VAN (1590-1648) DUTCH	2500-100000	L,F

* Denotes watercolors, pastels, drawings, and/or mixed media

V

ARTIST	PRICES	SUBJECT
VAARBERG, JOHANNES CHRISTOFFEL (1825-1871) DUTCH	500-8100	F
VACCA, ALESSANDRO (B. 1836) ITALIAN	200-1400	G
VACCARO, ANDREA (1598-1670) ITALIAN	2000-67000	F
VACCARO, NICOLA (1634-1709) ITALIAN	550-21000	X
VACHER, CHARLES (1818-1883) BRITISH	*200-2700	G
VADDER, LODEWYK DE (1605-1655) FLEMISH	1000-22000	L
VAES, WALTER (B. 1882) BELGIAN	600-18500	S
VAGH, ALBERT (B. 1831) FRENCH	400-7500	L
VAGH WEINMANN, ELEMER (B. 1906) HUNGARIAN	600-4200	F,L
VAGH WEINMANN, NANDOR (B. 1897) FRENCH	500-3500	L,S,F
VAGNETTI, GIANNI (B. 1898) ITALIAN	200-2000	G,S
VAGO, PAUL (1853-1928) HUNGARIAN	200-1800	X
VAGO, SANDOR (B. 1887) HUNGARIAN	200-2800	X
VAGO, VALENTINO (B. 1931) HUNGARIAN	700-4000	A
VAILLANT, PIERRE HENRI (1878-1939) FRENCH	300-2400	G,F
VAILLANT, WALLERANT (1623-1677) DUTCH	2000-+++	F,S
VALADE, JEAN (1709-1787) FRENCH	700-+++	F
VALADON, SUZANNE	*1000-52000	
VALADON, SUZANNE (1865-1938) FRENCH	1200-170000	A,F
VALCIN, GERARD (B. 1923) HAITIAN	300-6200	G,L
VALDES LEAL, JUAN DE (1622-1690) SPANISH	5000-80000	F
VALENCIENNES, PIERRE HENRI DE (1750-1819) FRENCH	500-24000	L,F
VALENSI, HENRY (1883-1960) FRENCH	500-35000	G,F
VALENTI, ITALO (B. 1912) ITALIAN	*800-16000	X
VALENTINI, GOTTARDO (1820-1884) ITALIAN	200-1000	G,S
VALENTINI, VALENTINO (B. 1858) ITALIAN	200-2000	G
VALENTINO, GIAN DOMENICO (17TH C) ITALIAN	2000-32000	S
VALERO, D. C. (19TH/20TH C) ITALIAN	300-2400	M
VALERO, J. PIO (1830-1911) SPANISH	300-4600	G
VALK, HENDRIK DE (17TH C) DUTCH	500-14000	G
VALKENBORCH, FREDERICK VAN (1570-1623) FLEMISH	1000-81000	F
VALKENBORCH, GILLIS VAN (1570-1622) FLEMISH	600-13000	F,L
VALKENBORCH, LUCAS VAN	*1200-75000	
VALKENBORCH, LUCAS VAN (1530-1597) FLEMISH	3000-+++	L
VALKENBORCH, MARTIN VAN (1535-1612) FLEMISH	1500-84000	L
VALKENBURG, DIRK (1675-1727) DUTCH	650-74000	S,W

VALKENBURG, HENDRIK	*200-1700	
VALKENBURG, HENDRIK (1826-1896) DUTCH	400-11000	G,L
VALLAYER-COSTER, ANNE (1744-1818) FRENCH	2000-+++	F,S
VALLAYER-MOUTET, PAULINE (19TH C) FRENCH	400-4600	G
VALLEE, ETIENNE MAXIME (Late 19TH C) FRENCH	300-5900	G,L
VALLES, LORENZO (1830-1910) SPANISH	400-14000	G,F
VALLET, EDOUARD (1876-1929) SWISS	3000-40000	F,L
VALLET, EMILE (D. 1899) FRENCH	300-2500	X
VALLETTE-FALGORES, JEAN (Called PENOT) (1710-1777) FRENCH	600-38000	S
VALLGREN, VILLE (1855-1940) SCANDINAVIAN	900-5000	L,S
VALLIN, JACQUES ANTOINE (1760-1831) FRENCH	1000-18000	F
VALLMAN, UNO (B. 1913) SWEDISH	600-7500	L,S
VALLOIS, PAUL FELIX (Late 19TH C) FRENCH	200-2400	L
VALLOTTON, FELIX	*200-5500	
VALLOTTON, FELIX (1865-1925) SWISS	1500-130000	F,S,A
VALMIER, GEORGES	*600-110000	
VALMIER, GEORGES (1885-1937) FRENCH	1200-+++	S
VALORE-UTRILLO, LUCIE (1878-1965) FRENCH	200-2000	S
VALTAT, LOUIS	*700-52000	
VALTAT, LOUIS (1869-1952) FRENCH	2600-+++	A,F,S
VANAISE, GUSTAAF (1854-1902) BELGIAN	600-12000	X
VANDENBRANDEN, GUY (20TH C) BELGIAN	800-2500	A
VANDERBANK, JOHN (1694-1739) BRITISH	400-15000	G,F
VANDERLICK, ARMAND (B. 1897) BELGIAN	700-12000	F,S,L
VANDERMAN, E. (18TH/19TH C) DUTCH	200-2000	S
VANDEVERDONCK, FRANIS (19TH C) BELGIAN	300-3800	L,W
VANLIER, B. (19TH C) DUTCH	200-1800	X
VANMEBLAERT, G. (19TH C) DUTCH	200-1400	X
VANMOUR, JEAN BAPTISTE (1671-1737) FLEMISH	800-140000	F
VANNI, SAM (B. 1908) FINNISH	4000-50000	A
VANNUCCIO, FRANCESCO DI (1361-1388) ITALIAN	600-32000	X
VANNUTELLI, SCIPIONE (1834-1894) ITALIAN	800-3500	X(F)
VANTONGERLOO, GEORGES	*300-22000	
VANTONGERLOO, GEORGES (1886-1965) BELGIAN	1000-64000	A
VARLEY, FREDERICK HORSMAN (1881-1969) BRITISH	950-+++	L,F
VARLEY, JOHN (I) (1778-1842) BRITISH	300-7500	L,F
VARLEY, JOHN (II) (Late 19TH C) BRITISH	500-19000	F
VARLIN, WILLY GUGGENHEIM (B. 1900) SWISS	1000-24000	F,L
VARO, REMEDIOS (1908-1963) SPANISH	8000-+++	G,F

* Denotes watercolors, pastels, drawings, and/or mixed media

VARRELON (19TH C) FRENCH	200-1000	X
VASARELY, VICTOR	*300-46000	
VASARELY, VICTOR (B. 1908) FRENCH	500-196000	F,A
VASARI, GIORGIO	*1000-130000	
VASARI, GIORGIO (1511-1574) ITALIAN	8000-232000	F,G
VASARRI, EMILIO (19TH C) ITALIAN	1200-42000	G,F
VASI, GIUSEPPE (1710-1782) ITALIAN	700-55000	L
VASNETSNOV, VICTOR MIKAILOVICH (1848-1919) RUSSIAN	200-1800	X
VASSE, LOUIS CLAUDE (1716-1772) FRENCH	*200-23000	F
VASSILIEFF, DANILA (1899-1958) AUSTRALIAN	900-21000	X(A)
VASSILIEFF, MARIE (1884-1957) RUSSIAN	500-19000	A
VASTAGH, GEZA (1866-1919) HUNGARIAN	1000-25000	L,W
VAUGHAN, KEITH	*500-20000	
VAUGHAN, KEITH (B. 1912) BRITISH	500-28000	A
VAULIER, J. C. (19TH C) FRENCH	300-2400	G
VAUMOUSSE, MAURICE (1876-1961) FRENCH	600-7000	L
VAUTHIER, PIERRE LOUIS LEGER (1845-1916) FRENCH	200-6900	G,L
VAUTIER, BENJAMIN (1829-1898) GERMAN	1000-50000	G,L,F
VAUTIER, OTTO (1863-1919) SWISS	800-12000	F
VEAL, GEORGE (19TH C) BRITISH	300-9000	W
VECCHIA, PIETRO DELLA (1605-1678) ITALIAN	1200-76000	F,G
VEDEL, HERMAN (1875-1948) DANISH	800-7000	F,S,L
VEDOVA, EMILIO	*800-45000	
VEDOVA, EMILIO (B. 1919) ITALIAN	1200-199000	G,F
VEEN, OTTO VAN (1556-1629) FLEMISH	700-6000	F
VEEN, PIETER VAN (1563-1629) DUTCH	300-7000	F
VEERENDAEL, NICOLAES VAN (1640-1691) FLEMISH	1500-200000	F,S
VEGA, JORGE DE LA (B. 1930) ARGENTINIAN	400-18000	G
VEGAS Y MUNOZ, PEDRO DE (19TH C) SPANISH	250-5000	G
VEILLON, AUGUSTE-LOUIS (1834-1890) SWISS	800-18000	M,L
VEIT, PHILIPP (1793-1877) GERMAN	*200-3200	G,F
VEITH, EDOUARD (1856-1925) AUSTRIAN	600-15000	G,F,L
VELASCO, JOSE MARIA	*300-10000	
VELASCO, JOSE MARIA (1840-1912) MEXICAN	2400-+++	L
VELASCO, LEANDRO (B. 1933) COLOMBIAN	200-2000	G
VELASQUEZ, JOSE ANTONIO (1906-1985) HONDURAN	900-42000	L,G
VELASQUEZ, JUAN RAMON	*200-2400	
VELASQUEZ, JUAN RAMON (B. 1950) PUERTO RICAN	200-1800	G
VELDE, ADRIAEN VAN DE (1636-1672) DUTCH	750-64000	G,L,F

VELDE, BRAM VAN	*900-52000	
VELDE, BRAM VAN (B. 1910) DUTCH	1800-86000	L,S
VELDE, CORNELIS VAN DE (Active 1710-1729) BRITISH	650-30000	M
VELDE, ESAIAS VAN DE (THE ELDER) (1590-1630) DUTCH	2500-115000	L,F
VELDE, GEER VAN	*200-14000	
VELDE, GEER VAN (B. 1898) DUTCH	700-155000	G,F,S
VELDE, PIETER VAN DE (1634-1687) FLEMISH	400-30000	M
VELDE, WILLEM VAN DER (THE ELDER)	*400-25000	
VELDE, WILLEM VAN DER (THE ELDER)(1611-1693) DUTCH	3600-+++	M
VELDE, WILLEM VAN DER (THE YOUNGER)	*200-9500	
VELDE, WILLEM VAN DER (THE YOUNGER)(1633-1707) DUTCH	3500-+++	L,M
VELDEN, PETRUS VAN DER (1837-1915) DUTCH	350-20000	G,L,F
VELICKOVIC, VLADIMIR (B. 1935) YUGOSLAVIAN	1000-8500	A
VELTEN, WILHELM (1847-1929) RUSSIAN	1000-25000	G,L,W
VELZEN, GERARD VAN (19TH C) DUTCH	200-1800	L
VENANT, FRANCOIS (1592-1636) DUTCH	500-4500	F
VENARD, CLAUDE (B. 1913) FRENCH	300-48000	A
VENETO, BARTOLOMEO (Active 1502-1555) ITALIAN	400-15000	F
VENEZIANO, LORENZO (14TH C) ITALIAN	1300-72000	F
VENNE, ADOLF VAN DER (1828-1911) AUSTRIAN	400-15000	G,L,W
VENNE, ADRIAEN VAN DE (1589-1662) DUTCH	2200-95000	G,F
VENNE, FRITZ VAN DER (B. 1900) GERMAN	400-14000	G,L
VENNEMAN, CHARLES FERDINAND (1802-1875) FLEMISH	500-18000	G
VENNEMAN, ROSA (19TH C) BELGIAN	400-9500	L
VENTURI, ROBERTO (1846-1883) ITALIAN	200-2000	L
VENUSTI, MARCELLO (1512-1579) ITALIAN	450-16000	F
VERBEECK, CORNELIS (1590-1631) DUTCH	2000-92000	M
VERBEET, GIGSBERTA (1838-1916) DUTCH	300-14000	S
VERBOECKHOVEN, CHARLES LOUIS (1802-1889) BELGIAN	400-17000	M
VERBOECKHOVEN, EUGENE JOSEPH	*200-3000	
VERBOECKHOVEN, EUGENE JOSEPH (1798-1881) BELGIAN	1000-81000	L,W
VERBOECKHOVEN, LOUIS (1802-1889) BELGIAN	600-18000	M
VERBOOM, ADRIAEN FRANS (1628-1670) DUTCH	400-22000	L,W
VERBRUGGE, EMILE (1856-1936) FLEMISH	200-2000	G
VERBRUGGEN, GASPAR PIETER II (1664-1730) FLEMISH	3000-59100	S
VERBRUGGHE, CHARLES (B. 1877) DUTCH	200-4200	G,L,S
VERBURG, HARRIE (B. 1914) DUTCH	600-3500	A
VERBURGH, DIONYS (18TH C) DUTCH	600-51000	G,L
VERDIER, FRANCOIS (1651-1730) FRENCH	300-9500	F

* Denotes watercolors, pastels, drawings, and/or mixed media

VERDIER, JULES VICTOR (B. 1862) FRENCH	300-5800	G,F
VERELST, CORNELIS (1667-1734) DUTCH	300-16000	F,S
VERELST, HERMAN (1641-1690) DUTCH	600-34000	F
VERELST, MARIA (1680-1744) DUTCH	300-4000	F
VERELST, PIETER HARMENSZ (1618-1668) DUTCH	300-25000	G,F,S
VERELST, SIMON (1644-1721) DUTCH	2500-+++	F,S
VERENDAEL, NICOLAES VAN (1640-1691) FLEMISH	1800-214000	F,S
VEREY, ARTHUR (19TH C) BRITISH	200-2000	G,L
VERGIN, DENIS HAITIAN	500-4200	F
VERHAECHT, TOBIAS (1561-1631) FLEMISH	3000-125000	L,F
VERHAERT, PIETER (Called PIET VERHAERT) (1852-1908) FLEMISH	200-5000	G
VERHAS, FRANS (1827-1897) BELGIAN	400-20000	F
VERHAS, THEODOR (1811-1872) GERMAN	200-2000	G,L
VERHEYDEN, FRANCOIS (1806-1890) BELGIAN	300-86000	G,L
VERHEYDEN, ISIDOOR (1846-1905) BELGIAN	300-16000	L,M
VERHEYEN, JAN HENDRIK (1778-1846) DUTCH	500-58000	G,L
VERHOESEN, ALBERTUS (1806-1881) DUTCH	400-8800	L,S
VERHOEVEN-BALL, ADRIEN JOSEPH (1824-1882) BELGIAN	1000-17000	G,F,S
VERKOLJE, NICHOLAAS (1673-1746) DUTCH	500-10000	G,F
VERLAT, CHARLES MICHEL MARIA (1824-1890) BELGIAN	200-12000	G,L
VERLINDE, PIERRE ANTOINE AUGUSTIN (1801-1877) BELGIAN	300-2400	F
VERMEER, (JAN VERMEER DE HAARLEM) (1628-1691) DUTCH	700-64000	L
VERMEIR, ALFONS (20TH C) BELGIAN	300-4500	L
VERMERSCH, AMBROS (1810-1852) FLEMISH	300-4200	X
VERMEULEN, ANDREAS FRANCISCUS (1821-1884) DUTCH	400-9200	G
VERMEULEN, ANDRIES (1763-1814) DUTCH	500-39000	G,L
VERMEYEN, JAN CORNELISZ (Called JUAN DE MAYO) (1500-1559) DUTCH	2000-103000	F,G
VERNER, FREDERICK ARTHUR	*300-25000	
VERNER, FREDERICK ARTHUR (1836-1928) CANADIAN	1700-78000	G,L,W
VERNET, ANTOINE CHARLES HORACE (Called CHARLOT OR CARLE)	*400-30000	
VERNET, ANTOINE CHARLES HORACE (Called CHARLOT OR CARLE) (1758-1836) FRENCH	900-47000	L,F
VERNET, CLAUDE JOSEPH	*300-15000	
VERNET, CLAUDE JOSEPH (1712-1789) FRENCH	2000-+++	G,L,M
VERNET, EMILE JEAN HORACE (Called HORACE)	*200-5000	
VERNET, EMILE JEAN HORACE (Called HORACE) (1789-1863) FRENCH	1500-+++	F,W
VERNET, HORACE (1789-1863) FRENCH	2500-+++	F

VERNIER, EMILE LOUIS (1829-1887) FRENCH	300-4800	L,M
VERNON, ARTHUR LANGLEY (Active 1871-1922) BRITISH	300-8400	G,L
VERNON, EMILE (19TH C) BRITISH	1000-63000	G,F
VERNON, PAUL (19TH C) FRENCH	300-3300	L,F
VERNON, WILLIAM H. (B. 1820) BRITISH	200-2200	L
VERON, A. L. (19TH C) FRENCH	300-3800	G
VERON, ALEXANDRE RENE (1826-1897) FRENCH	550-60000	G,L
VERON-FARE, JULES HENRI (Late 19TH C) FRENCH	300-3600	G
VERONESE, BONIFAZIO (1487-1553) ITALIAN	2500-46000	L,F
VERONESE, PAOLO	*2500-+++	
VERONESE, PAOLO (1528-1588) ITALIAN	7500-+++	F,I
VERSAILLE, E. (19TH C) FRENCH	200-1200	M
VERSCHUIER, LIEVE (1630-1686) DUTCH	1200-+++	M
VERSCHUUR, WOUTERUS (1812-1874) DUTCH	1800-168000	L,G,W
VERSPRONCK, JAN (1597-1662) DUTCH	1000-79000	F
VERSTER, FLORIS (1861-1927) DUTCH	600-13000	L,S
VERSTRALEN, ANTHONIE (1594-1641) DUTCH	4000-124000	L
VERTANGEN, DANIEL (1598-1684) DUTCH	1000-18000	L,F
VERTES, MARCEL	*200-3400	
VERTES, MARCEL (1895-1961) FRENCH	300-12000	A,F
VERTIN, PIETER GERARDUS (1819-1893) DUTCH	650-30200	L,M
VERTUNNI, ACHILLE (1826-1897) ITALIAN	300-13000	L
VERVEER, ELANCHON (1826-1900) DUTCH	400-7800	G
VERVEER, SALOMON LEONARDUS (1813-1876) DUTCH	900-40000	L,M,G
VERVLOET, FRANS (1795-1872) DUTCH	1000-10000	L,F
VERVOORT, MICHAEL (19TH C) DUTCH	300-7000	L
VERWEE, LOUIS CHARLES (D. 1882) BELGIAN	200-3400	F
VERWEE, LOUIS PIERRE (1807-1877) BELGIAN	600-20000	G,L,W
VERWER, JUSTUS DE (1626-1688) DUTCH	400-12000	M
VERWEY, KEES (B. 1900) DUTCH	*500-7000	S
VERWILT, FRANCOIS (1620-1691) DUTCH	800-9500	L,F
VESIN, JAROSLAV FR. JULIUS (1859-1915) BULGARIAN	500-18000	G,L
VESNIN, ALEXANDER (1883-1959) RUSSIAN	*2000-16000	A
VESPIGNANI, RENZO (B. 1924) ITALIAN	600-16000	G,L,M
VESTER, WILLEM (1824-1871) DUTCH	400-33000	L
VESTIER, ANTOINE (1740-1824) FRENCH	350-85100	G,F
VETTER, CHARLES FRIEDRICH ALFRED (B. 1858) GERMAN	400-17000	G
VEYRASSAT, JULES JACQUES (1828-1893) FRENCH	500-30000	G,L,F
VIANELLI, ACHILLE (1803-1894) ITALIAN	*200-5000	G

VIANEN, PAULUS WILLEMSZ VAN (1570-1614) DUTCH	*1000-15000	F
VIANI, LORENZO (1882-1936) ITALIAN	1000-25000	X
VIBERT, JEAN GEORGES	*750-205000	
VIBERT, JEAN GEORGES (1840-1902) FRENCH	600-45000	G
VICENTE, ESTEBAN (B. 1904) SPANISH	700-8500	A
VICENTINO, ANDREA (16TH C) ITALIAN	2000-7500	F
VICKERS, ALFRED (1786-1868) BRITISH	400-20000	L
VICKERS, ALFRED H. (Late 19TH C) BRITISH	300-13000	L
VICKERS, HENRY HAROLD (1851-1919) CANADIAN	200-1800	L,W
VICTORS, JAN (1620-1676) DUTCH	1500-58000	L,F
VICTORYNS, ANTHONIE (D. 1655) FLEMISH	1000-7000	G
VIDAL, EMERIC ESSEX	*500-25000	
VIDAL, EMERIC ESSEX (1791-1861) BRITISH	300-4600	L
VIDAL, LOUIS (B. 1754) FRENCH	600-52000	S
VIDAL, MIGUEL ANGEL (B. 1928) ARGENTINIAN	200-1000	X
VIEIRA DA SILVA, MARIA ELENA	*1000-95000	
VIEIRA DA SILVA, MARIA ELENA (B. 1908) FRENCH	1500-+++	A
VIELLARD, ROBERT (19TH C) FRENCH	200-1200	X
VIELLEVOYE, JOSEF BARTHOLOMEUS (1788-1855) BELGIAN	200-5200	G
VIEN, JOSEPH MARIE (1716-1809) FRENCH	600-52000	F
VIGAS, OSWALDO (B. 1926) VENEZUELAN	*200-3000	F
VIGEE, LOUIS (1715-1767) FRENCH	500-35000	F
VIGEE-LEBRUN, MARIE LOUISE ELISABETH (1755-1842) FRENCH	4500-+++	G,F
VIGNE, EDOUARD DE (1808-1866) BELGIAN	400-6000	L
VIGNON, CLAUDE	*600-38000	
VIGNON, CLAUDE (1593-1670) FRENCH	1500-178000	F
VIGNON, VICTOR (1847-1909) FRENCH	800-58000	L,S
VILLA, EMILE (19TH C) FRENCH	400-12000	G,F
VILLACRES, CESAR A. (B. 1880) ECUADORIAN	300-5000	L
VILLARD, ANTOINE (1867-1934) FRENCH	200-3500	L
VILLEGAS Y CORDERO, JOSE (1848-1922) SPANISH	1200-140000	G,F,L
VILLEGAS Y CORDERO, RICARDO (B. 1852) SPANISH	800-28000	G
VILLEGLE, JACQUES DE LA (B. 1926) FRENCH	*600-29000	A
VILLEMSENS, JEAN BLAISE (1806-1859) FRENCH	300-6000	G
VILLEON, EMMANUEL DE LA (1858-1944) FRENCH	800-36000	G,L,S
VILLON, JACQUES	*700-50000	
VILLON, JACQUES (1875-1963) FRENCH	1000-173000	A
VIN, PAUL VAN DER (1823-1887) BELGIAN	200-15000	G,W
VINCENT, FRANCOIS ANDRE (1746-1816) FRENCH	1500-+++	G,L,F

VINCENT, RENE (1879-1936) FRENCH	400-7200	G
VINCK, FRANZ (1827-1903) BELGIAN	200-6900	G,F
VINCKBOONS, DAVID (1576-1629) FRENCH	2000-88000	G,F,L
VINEA, FRANCESCO (1845-1902) ITALIAN	600-7500	X(G)
VINEA, FRANCESCO (1846-1904) ITALIAN	400-14000	G,F
VINNE, VINCENT JANS VAN DER (1736-1811) DUTCH	1400-24000	F,L
VINNE, VINCENT LAURENSZ VAN DER (1629-1702) DUTCH	500-37000	G,S
VINNEN, CARL (1863-1922) GERMAN	400-5900	M
VINOGRADOFF, M. (19TH C) RUSSIAN	400-5000	F,L
VINOGRADOV, SERGEI ARSSENIEVICH	*200-2400	
VINOGRADOV, SERGEI ARSSENIEVICH (B. 1869) RUSSIAN	450-16000	F,L
VIOLLET-LE-DUC, EUGENE EMMANUEL (1814-1879) FRENCH	*200-2000	G,F
VIOLLET-LE-DUC, VICTOR (1848-1901) FRENCH	300-4000	G,L
VIOLLIER, JEAN	*400-3000	
VIOLLIER, JEAN (B. 1896)	600-8000	A
VIRANO, A. J. (19TH C) ITALIAN	200-2400	X
VIRY, PAUL ALPHONSE (1861-1881) FRENCH	500-42000	G,S
VISCHER, AUGUST (1821-1898) GERMAN	200-3000	G
VISCONTI, F. (1850-1924) ITALIAN	300-13000	G
VISO, ANDREA (1658-1740) ITALIAN	300-8000	F
VISSOTSKY, KONSTANTIN (20TH C) RUSSIAN	300-3600	L
VITTORI, F. (19TH C) ITALIAN	200-2200	G,F
VIVANCOS, MIGUEL GARCIA (1895-1972) SPANISH	200-3200	M,S
VIVARINI, ANTONIO (1445-1503) ITALIAN	4000-85000	F
VIVARINI, BARTOLOMMEO (1432-1499) ITALIAN	500-32000	F
VIVIAN, GEORGE (1798-1873) BRITISH	350-10000	G
VIVIAN, JOSEPH (1657-1735) BRITISH	200-2000	L
VIVIEN, NARCISSE (19TH C) FRENCH	300-4200	F
VIVIN, LOUIS (1861-1936) FRENCH	300-9000	G,L,S
VIZZOTTO-ALBERTI, GIUSEPPE (1862-1931) ITALIAN	*200-2200	G
VLAMINCK, MAURICE DE	*1500-113000	
VLAMINCK, MAURICE DE (1876-1958) FRENCH	10000-+++	L,F,S
VLETTER, SAMUEL DE (1816-1844) DUTCH	400-8500	G
VLIEGER, SIMON DE	*300-24000	
VLIEGER, SIMON DE (B. 1500) DUTCH	600-+++	M
VLIET, HENDRICK CORNELISZ VAN DER	*200-10000	
VLIET, HENDRICK CORNELISZ VAN DER (1611-1675) DUTCH	750-135000	M,G
VOERMAN, JAN (1857-1941) DUTCH	300-6000	G,L,S
VOESCHER, LEOPOLD HEINRICH (1830-1877) AUSTRIAN	300-4800	X

Name	Price	Media
VOET, FERDINAND (1639-1700) FLEMISH	300-26000	F
VOGEL, CORNELIS JOHANN DE (1824-1879) FLEMISH	300-3000	L
VOGEL, JOHANNES GIJSBERT (1828-1915) DUTCH	200-3200	G
VOGELAER, KAREL VAN (Called CARLO DEI FIORI) (1653-1695) DUTCH	1500-46000	S
VOGLER, PAUL (1852-1904) FRENCH	300-11000	L
VOGT, GUNDO (1852-1939) GERMAN	200-1200	G,W
VOIGT, AUGUST (19TH C) GERMAN	200-1500	L
VOILLEMOT, ANDRE CHARLES (1823-1893) FRENCH	300-4200	G,L,F
VOINIER, ANTOINE (Active 1795-1810) FRENCH	*500-25000	I
VOIRIN, JULES ANTOINE (1833-1898) FRENCH	500-6500	G
VOIS, ARIE DE (1631-1680) FLEMISH	400-10000	G,F
VOLAIRE, JACQUES ANTOINE (OR PIERRE JACQUES) (1729-1802) FRENCH	600-18000	F,L
VOLCKER, ROBERT (1854-1924) GERMAN	300-3000	G
VOLKER, G. (19TH C) GERMAN	200-1000	X
VOLKERS, EMIL (1831-1905) GERMAN	300-15000	F,W
VOLKHART, MAX (1848-1924) GERMAN	1200-42000	G
VOLKOV, E. (19TH C) RUSSIAN	200-1000	L
VOLLERDT, JAN CHRISTIAN (1708-1769) GERMAN	400-35000	G,L,F
VOLLON, ALEXIS (B. 1865) FRENCH	500-28000	G,F,S
VOLLON, ANTOINE (1833-1900) FRENCH	600-32000	F,S,L
VOLLWEIDER, AUGUST (B. 1835) GERMAN	300-4000	X
VOLLWEIDER, JOHANN JACOB (1834-1891) GERMAN	500-8000	L
VOLPEDO, PELIZZA DA (19TH/20TH C) ITALIAN	5000-+++	X
VOLTZ, FRIEDRICH JOHANN	*200-3000	
VOLTZ, FRIEDRICH JOHANN (1817-1886) GERMAN	1200-90000	L,W
VOLTZ, LUDWIG (1825-1911) GERMAN	300-4000	G,L
VONCK, ELIAS (1605-1652) DUTCH	400-33000	S,F
VOORDEN, AUGUST WILLEM VAN (1881-1921) DUTCH	300-4100	M,L,F
VORDEMBERGE-GILDEWART, FRIEDRICH (1899-1963) GERMAN/DUTCH	400-13000	L
VOS, CORNELIS DE (1585-1651) FLEMISH	4000-80000	F
VOS, HUBERT	*200-2000	
VOS, HUBERT (1855-1935) DUTCH	300-3500	G,F,S
VOS, J. C. J. DE (19TH/20TH C) DUTCH	500-8500	S
VOS, LEON DE (20TH C) BELGIAN	200-8600	F,W
VOS, MARTIN DE (1532-1603) FLEMISH	1200-65000	F
VOS, PAUL DE (1596-1678) FLEMISH	300-13000	L,S,W
VOS, SIMON DE (1603-1676) FLEMISH	850-45000	G,F,L

VOS, VINCENT DE (1829-1875) BELGIAN	450-15000	G
VOSCHER, LEOPOLD HEINRICH (1830-1877) AUSTRIAN	900-10000	L,F
VOSS, KARL LEOPOLD (1856-1921) GERMAN	200-3400	G,F,L
VOUET, SIMON (1590-1649) FRENCH	5000-+++	F
VOUTIER, J. C. (19TH C) FRENCH	300-2800	G
VOYET, JACQUES (B. 1927) FRENCH	200-2000	X
VRANCX, SEBASTIAN (1573-1647) FLEMISH	1500-96000	G,L,F
VREEDENBURGH, CORNELIS (1880-1946) DUTCH	300-16000	L,M
VREELAND, F. VAN (19TH C) DUTCH	200-1000	G
VRIENDT, JULIAAN DE (1842-1935) BELGIAN	300-2500	G
VRIES, ANTHONI DE (1841-1872) DUTCH	200-2400	G,L
VRIES, HANS VREDEMAN DE (1527-1604) FLEMISH	400-56000	F
VRIES, JOGH. DE (18TH C) DUTCH	300-9000	L
VRIES, PAUL VREDEMAN DE (1567-1630) FLEMISH	900-52500	G
VRIES, ROELOF JANSZ DE (1631-1681) DUTCH	1000-24000	L,G,F
VROLYK, ADRIANUS JACOBUS (1834-1862) DUTCH	300-6000	G,L
VROLYK, JAN MARTINUS (1845-1894) DUTCH	200-3500	L
VROOM, HENDRIK CORNELISZ	*200-5500	
VROOM, HENDRIK CORNELISZ (1566-1640) DUTCH	400-9000	L
VUCHT, GERRIT VAN (1610-1699) DUTCH	1000-20000	S
VUILLARD, EDOUARD	*1500-+++	
VUILLARD, EDOUARD (1868-1940) FRENCH	4000-+++	G,F,M

ARTIST	PRICES	SUBJECT
WAAGEN, ADALBERT (1833-1898) GERMAN	600-5000	L
WAAY, NICHOLAS VAN DER (1855-1936) DUTCH	350-19000	G
WACH, ALOYS (OR WACHLMAYR) (1892-1940) AUSTRIAN	*200-1800	F
WACHSMUTH, MAXIMILIAN (B. 1859) GERMAN	500-6000	G
WACIK, FRANZ (1883-1938) AUSTRIAN	*300-2500	X
WACKER, RUDOLF (1893-1939) AUSTRIAN	*400-3500	F
WADSWORTH, EDWARD	*300-8000	
WADSWORTH, EDWARD (B. 1889) BRITISH	950-125000	G,S
WAEL, CORNELIS DE (1592-1667) FLEMISH	1200-36000	G,F
WAENERBERG, THORSTEN (1846-1917) SCANDINAVIAN	2000-45000	L,M
WAGEMAKER, JAAP (B. 1906) DUTCH	*700-3800	A

WAGEMANS, P. J. A.(1879-1955) DUTCH	200-2700	L
WAGNER, ALEXANDER VON (1838-1919) HUNGARIAN	1500-36000	L,W
WAGNER, ELYSE PUYROCHE (1828-1895) GERMAN	200-1500	S
WAGNER, FRITZ (1896-1939) GERMAN	300-11000	G,F,L
WAGNER, FRITZ (1896-1939) GERMAN	1000-9000	G,F
WAGNER, KARL (19TH/20TH C) AUSTRIAN/GERMAN	300-5000	L,M
WAGNER, PAUL (B. 1852) GERMAN	500-8500	F,G
WAGNER, WOLFGANG (19TH C) GERMAN	200-1500	G
WAGNER-HOHENBERG, JOSEF (B. 1870) GERMAN	300-9000	G,F
WAGREZ, JACQUES CLEMENT (1846-1908) FRENCH	850-17000	G,F
WAHLBERG, ALFRED (1834-1906) SWEDISH	1500-101000	L,M
WAHLQVIST, EHRNFRIED (1815-1895) SWEDISH	600-9000	L
WAHLSTROM, CHARLOTTE (1849-1924) SWEDISH	600-8200	G,F,L
WAIN, LOUIS (1860-1939) BRITISH	800-10000	W
WAINEWRIGHT, THOMAS FRANCIS (19TH C) BRITISH	300-8900	W,L,S
WAINEWRIGHT, THOMAS GRIFFITHS (1796-1847) BRITISH	*500-40000	F
WAINWRIGHT, JOHN (Active 1859-1869) BRITISH	600-40000	L,S
WAINWRIGHT, WILLIAM JOHN	*200-8500	
WAINWRIGHT, WILLIAM JOHN (1855-1931) BRITISH	500-6500	S,G,F
WAITE, EDWARD WILKINS (1880-1920) BRITISH	900-93000	G,L
WAITE, JAMES CLARKE (19TH C) BRITISH	600-10000	G,L
WAITE, ROBERT THORNE (1842-1935) BRITISH	*300-8200	L,G
WAKELIN, ROLAND SHAKESPEARE (B. 1887) AUSTRALIAN	500-19000	F,L,S
WALBOURN, ERNEST (Active 1895-1920) BRITISH	300-23000	G,L
WALCH, CHARLES	*250-4700	
WALCH, CHARLES (1898-1948) FRENCH	300-7900	G,L
WALCKIERS, GUSTAVE (1831-1891) BELGIAN	400-6800	G
WALCOT, WILLIAM (1874-1943) BRITISH	*200-12000	L,G
WALDE, ALFONS	*300-5200	
WALDE, ALFONS (B. 1891) AUSTRIAN	1500-73000	A
WALDEGG, F. (19TH C) GERMAN	300-2000	L
WALDMULLER, FERDINAND (1816-1885) AUSTRIAN	500-48000	X
WALDMULLER, FERDINAND GEORG (1793-1865) AUSTRIAN	3500-+++	G,F,L
WALDORF, ANTOINE (1803-1866) DUTCH	600-14000	L,M
WALE, SAMUEL (1721-1786) BRITISH	300-17000	G,F
WALKER, ADA H. (19TH/20TH C) BRITISH	*300-35000	X
WALKER, DAME ETHEL (B. 1867) BRITISH	600-15000	S,L,F
WALKER, FREDERICK (1840-1875) BRITISH	300-5400	G,L
WALKER, HORATIO	*200-3700	

WALKER, HORATIO (1858-1938) CANADIAN	300-12000	G,L
WALKER, JOHN (B. 1939) BRITISH	900-33000	A,L
WALKER, R. HOLLANDS (Active 1892-1920) BRITISH	200-2800	G,L
WALKER, ROBERT (1607-1658) BRITISH	450-20000	F
WALKER, WILLIAM EYRE (1847-1930) BRITISH	*600-5000	L
WALL, WILLIAM ARCHIBALD (1828-1875) BRITISH	300-2800	L,M
WALLACE, DONALD (20TH C) BRITISH	200-1000	W
WALLACE, HARRY (19TH C) BRITISH	200-2300	L
WALLACE, JAMES (D. 1911) BRITISH	350-18000	L
WALLANDER, ALF (1862-1914) SWEDISH	500-6000	F,G
WALLER, JOHANNES (D. 1945) GERMAN	200-800	X
WALLER, SAMUEL EDMUND (1850-1903) BRITISH	800-15000	G,W
WALLET, TAF (20TH C) BELGIAN	*1000-7000	S
WALLIS, ALFRED (1855-1924) BRITISH	200-12000	M
WALLIS, HENRY (1830-1916) BRITISH	300-10000	F
WALLNER, THURE (1883-1965) SWEDISH	600-55000	W
WALMSLEY, THOMAS (1763-1805) IRISH	*200-2300	L
WALRAVEN, JAN (1827-1874) DUTCH	300-8100	G,W
WALSER, KARL (1877-1943) SWISS	*800-9500	X(F)
WALTER, F. (19TH C) BRITISH	200-1000	X
WALTER, HENRY (1786-1849) BRITISH	*200-3000	G,W
WALTER, JOSEPH (1783-1856) BRITISH	3000-35000	M
WALTER, W. J. (1818-1894) DUTCH	400-4800	L,F
WALTERS, GEORGE STANFIELD	*200-4700	
WALTERS, GEORGE STANFIELD (1838-1924) BRITISH	400-10000	G,L
WALTERS, JOSEPH (1783-1865) BRITISH	2500-29000	M
WALTERS, SAMUEL (1811-1882) BRITISH	1000-73000	M
WALTON, CECILE (1891-1956) BRITISH	300-3600	G,F
WALTON, EDWARD ARTHUR	*500-20000	
WALTON, EDWARD ARTHUR (1860-1922) BRITISH	1500-32000	G,L,F
WALTON, FRANK (1840-1928) BRITISH	600-7800	L,W
WANING, CORNELIS VAN (1861-1929) DUTCH	200-9800	M
WANKOWSKI (19TH C) POLISH	300-3500	X
WAPPERS, BARON DE GUSTAVE (1803-1874) BELGIAN	300-7000	G,F
WARD, CAMILLE (19TH C) BRITISH	200-1000	X
WARD, EDWIN ARTHUR (19TH C) BRITISH	200-1200	G,F
WARD, JAMES (1769-1859) BRITISH	1500-65000	G,L,W
WARD, JAMES CHARLES (19TH C) BRITISH	300-5000	L,S
WARD, JOHN (1798-1849) BRITISH	700-105000	X(L)

* Denotes watercolors, pastels, drawings, and/or mixed media

WARD, MARTIN THEODORE (1799-1874) BRITISH	600-39000	G,L,W
WARD, MATTHEW EDWARD (1816-1879) BRITISH	200-30000	G
WARD, STEPHEN (20TH C) BRITISH	*400-3200	X(F)
WARD, THOMAS (19TH C) BRITISH	700-10000	S
WARD, VERNON (B. 1905) BRITISH	400-5800	F,S
WARDLE, ARTHUR	*300-6600	
WARDLE, ARTHUR (1864-1949) BRITISH	1000-65000	W,F
WARDLEWORTH, J.L. (19TH C) BRITISH	300-3000	G,L
WAROQUIER, HENRY DE (1881-1970) FRENCH	600-14000	X(L)
WARREN, EDMUND GEORGE	*800-16000	
WARREN, EDMUND GEORGE (1834-1909) BRITISH	1000-12000	L,F,W
WARREN, HENRY (1794-1879) BRITISH	200-1200	G,L
WARREN, JOSEPH (19TH/20TH C) BRITISH	200-2000	G,S
WASHINGTON, GEORGES	*200-5300	
WASHINGTON, GEORGES (1827-1910) FRENCH	1000-35000	L,G,W
WATELET, CHARLES JOSEPH (1867-1954) BELGIAN	1000-26000	G,F
WATELET, LOUIS ETIENNE	*200-1200	
WATELET, LOUIS ETIENNE (1780-1866) FRENCH	700-30000	G,L
WATELIN, LOUIS FRANCOIS VICTOR (1838-1905) FRENCH	300-3800	L
WATERHOUSE, ALFRED (1830-1905) BRITISH	300-4000	F
WATERHOUSE, JOHN WILLIAM (1849-1917) BRITISH	1800-+++	F,G
WATERHOUSE, W. (19TH C) BRITISH	200-1000	G,F
WATERLOO, ANTHONIE (1610-1690) FLEMISH	*500-58000	G,F,L
WATERLOO, DENIS (19TH C) DUTCH	300-16000	M
WATERS, BILLIE (B. 1896) BRITISH	600-6500	L
WATKINS, B. COLLES (1833-1891) IRISH	*200-4200	L
WATKINS, JOHN SAMUEL (1886-1942) AUSTRALIAN	500-4500	F
WATSON, CARI E. (20TH C) BRITISH	200-4700	W
WATSON, CHARLES EDWARD (19TH C) BRITISH	300-2400	L,G
WATSON, HAMLIN (20TH C) BRITISH	200-1000	X
WATSON, HARRY (1871-1936) BRITISH	1500-36000	G,F,L
WATSON, HOMER RANSFORD	*200-1500	
WATSON, HOMER RANSFORD (1855-1936) CANADIAN	300-22000	L
WATSON, JOHN DAWSON (1832-1892) BRITISH	300-5500	G,L,S
WATSON, ROBERT (19TH/20TH C) BRITISH	300-6000	L,F,W
WATSON, WALTER J (B. 1879) BRITISH	400-11000	L,W
WATSON, WILLIAM (JR.) (D. 1921) BRITISH	300-8000	L,W
WATT, LINNIE (1875-1908) BRITISH	500-9500	G
WATTEAU, JEAN ANTOINE	*1500-+++	

WATTEAU, JEAN ANTOINE (1684-1721) FRENCH	2500-+++	G,F
WATTEAU DE LILLE, LOUIS JOSEPH (1731-1798) FRENCH	3000-65000	F
WATTER, JOSEPH (1838-1913) GERMAN	300-5500	G
WATTS, FREDERICK WATERS (1800-1862) BRITISH	1200-86000	L,W
WATTS, GEORGE FREDERICK (1817-1904) BRITISH	2000-+++	G,F
WATTS, JAMES T (1853-1930) BRITISH	*300-4100	L
WAY, CHARLES JONES (1834-1919) BRITISH	*200-3000	L
WEATHERILL, GEORGE (1810-1890) BRITISH	*300-8700	M
WEATHERSTONE, ALFRED C. (Late 19TH C) BRITISH	300-4000	G
WEAVER, THOMAS (1774-1844) BRITISH	700-31000	L,F,W
WEBB, CHARLES MEER (1830-1895) BRITISH	850-40000	G
WEBB, JAMES (1825-1895) BRITISH	1000-28000	M
WEBB, WILLIAM EDWARD (1850-1925) BRITISH	600-15000	M,G
WEBBE, WILLIAM J (19TH C) BRITISH	600-10000	G,F
WEBBER, JOHN (1750-1793) BRITISH	1500-+++	L,M
WEBER, ALFRED CHARLES	*200-1000	
WEBER, ALFRED CHARLES (1862-1922) FRENCH	300-8000	G
WEBER, ANDREAS (1893-1980) GERMAN	*200-1800	G,L
WEBER, GOTTLIEB DANIEL PAUL (1823-1916) GERMAN	750-39000	L
WEBER, HEINRICH (1843-1913) GERMAN	300-5000	G
WEBER, MARIE PHILIPS (19TH C) GERMAN	200-2200	G,F
WEBER, OTTO (1832-1888) GERMAN	400-10000	G,L
WEBER, RUDOLF (B. 1872) AUSTRIAN	200-5200	G,L
WEBER, THEODORE (1838-1907) FRENCH	400-18000	M
WEBER, TYROL HANS JOSEF (1874-1957) GERMAN	400-9600	G,L
WEBSTER, GEORGE (19TH C) BRITISH	2000-18000	M
WEBSTER, THOMAS (1800-1886) BRITISH	600-12000	G,F,L
WEBSTER, WALTER ERNEST (B. 1878) BRITISH	400-9500	F
WEEDON, AUGUSTUS WALFORD	*200-3500	
WEEDON, AUGUSTUS WALFORD (1838-1908) BRITISH	200-2000	G,L
WEEKES, HENRY (Late 19TH C) BRITISH	300-8000	G,L,F
WEEKES, HERBERT WILLIAM (1864-1904) BRITISH	300-10000	G,W
WEEKES, WILLIAM (19TH C) BRITISH	800-12000	W
WEELE, HERMAN JOHANNES VAN DER	*200-1000	
WEELE, HERMAN JOHANNES VAN DER (1852-1930) DUTCH	200-10000	L,W
WEENIX, JAN (THE YOUNGER) (1640-1719) DUTCH	5000-+++	S
WEENIX, JAN BAPTIST (THE ELDER) (1621-1663) DUTCH	1000-110000	F,L,M,S
WEERT, ANNA DE (1867-1950) BELGIAN	1200-20000	X
WEERTS, JEAN JOSEPH (1847-1927) FRENCH	200-5500	G

* Denotes watercolors, pastels, drawings, and/or mixed media

WEGENER, GERDA (1883-1931) DANISH	900-35000	F
WEGMAN, BERTHA (1847-1926) DANISH	900-35000	G,F
WEGNER, ERICH (B. 1899) GERMAN	*500-2000	X
WEHRLIN, SCHMIDT (19TH C) GERMAN	200-2500	G
WEICHBERGER, EDUARD (1843-1913) GERMAN	300-6600	L
WEIE, EDVARD (1879-1943) DANISH	400-8300	L,M
WEIGHT, CAREL (B. 1908) BRITISH	600-49000	G,F,L
WEILAND, JOHANNES	*200-2400	
WEILAND, JOHANNES (1856-1909) DUTCH	400-13000	G
WEILER, MAX C. (B. 1910) AUSTRIAN	*400-10000	L
WEILUC (19TH C) FRENCH	200-800	X
WEIN, KONG (19TH C) CHINESE	200-3000	M
WEIR, WILLIAM (D. 1865) BRITISH	200-1800	F
WEISBUCH, CLAUDE (B. 1927) FRENCH	1000-27000	X(F)
WEISER, JOSEPH EMMANUEL (1847-1911) GERMAN	300-3600	G,F
WEISGERBER, ALBERT (1878-1915) GERMAN	300-18000	G,L
WEISHAUPT, VICTOR (1848-1925) GERMAN	400-6000	X(W)
WEISS, ANTON (1801-1851) AUSTRIAN	300-17000	S
WEISS, EMILE GEORGES (B. 1861) FRENCH	350-20000	G,S
WEISS, JOHANN BAPTIST (1812-1879) GERMAN	200-5600	M
WEISS, JOSE (1859-1929) BRITISH	300-5600	L,W
WEISSE, RUDOLPH (B. 1846) CZECHOSLOVAKIAN	550-44000	G
WEISSENBRUCH, JAN (OR JOHANNES) (1824-1880) DUTCH	600-31000	L
WEISSENBRUCH, JAN HENDRIK (OR HENDRIK JOHANNES)	*200-21000	
WEISSENBRUCH, JAN HENDRIK (OR HENDRIK JOHANNES) (1824-1903) DUTCH	500-35000	G,L,W
WEISSENBRUCH, WILLEM (1864-1941) DUTCH	300-5500	L,M
WEISZ, ADOLF (B. 1838) AUSTRIAN	300-4000	G
WEISZ, ADOLPHE (B. 1868) FRENCH	400-28000	G,F,L
WELCH, DENTON (20TH C) BRITISH	*800-12000	X(F,S,L)
WELLS, DENNIS G (B. 1881-1973) BRITISH	500-8000	F
WELLS, GEORGE (1842-1888) BRITISH	200-1200	G,L,F
WELLS, JOHN SANDERSON	*200-1500	
WELLS, JOHN SANDERSON (B. 1872) BRITISH	300-16000	G
WELLS, WILLIAM PAGE ATKINSON (1871-1923) BRITISH	500-18000	F,L
WELSCH, FEODOR CHARLES (Late 19TH C) GERMAN	300-3600	L
WELVAERT, ERNEST (1880-1946) BELGIAN	1000-15000	G,F
WELZ, JEAN (B. 1900) SOUTH AFRICA	600-12000	X(F,L)
WENDEL, KARL (19TH C) GERMAN	200-1300	G

WENDLER, FRIEDRICH MARIZ (1814-1872) GERMAN	*200-3000	F
WENGLEIN, JOSEPH (1845-1919) GERMAN	600-65000	L,G
WENNING, PIETER (1873-1921) SOUTH AFRICAN	850-65000	L,S,F
WERBEL, ADOLF (B. 1848) AUSTRIAN	300-4000	G
WEREFKIN, MARION VON	*800-37000	
WEREFKIN, MARION VON (1870-1938) RUSSIAN	300-34000	G,L
WERENSKIOLD, ERIK THOEDOR (1855-1938) NORWEGIAN	1500-+++	G,F
WERETSCHAGIN, VASSILIJ (1842-1904) RUSSIAN	200-1800	F
WERFF, ADRIAEN VAN DER (1659-1722) DUTCH	900-110000	G,F,L
WERNER, ANTON ALEXANDER (1843-1915) GERMAN	1200-23000	F
WERNER, CARL FRIEDRICH HEINRICH	*400-35000	
WERNER, CARL FRIEDRICH HEINRICH (1808-1894) GERMAN	300-11500	L,F
WERNER, JOSEPH (1637-1710) SWISS	900-12000	F
WERNER, THEODOR (1886-1969) GERMAN	800-15000	A
WESELY, A. (Late 19TH C) AMERICAN/BRITISH	200-1200	X
WESSLER, O. (19TH C) GERMAN	200-1500	G
WEST, BENJAMIN	*750-80000	
WEST, BENJAMIN (1738-1820) BRITISH	3000-+++	F
WESTALL, JOHN (19TH C) BRITISH	400-4500	L
WESTALL, RICHARD	*200-2400	
WESTALL, RICHARD (1765-1836) BRITISH	500-17000	G,F
WESTALL, WILLIAM (1781-1850) BRITISH	1200-100000	L,G
WESTCHILOFF, CONSTANTIN (1880-1945) RUSSIAN	300-5600	L,F
WESTERBEEK, CORNELIS (1844-1903) DUTCH	300-5800	F,G,L,W
WESTPHALL, FRIEDRICH (1804-1844) DANISH	200-2000	X
WESTROTT, F. (19TH C) EUROPEAN	200-1800	X
WET, JACOB WILLEMSZ DE (1610-1671) DUTCH	500-52000	F
WETERING DE ROOY, JOHANNES EMBROSIUS VAN DE (B. 1877) DUTCH	200-2000	M
WEYDEN, GOSWYN VAN DER (1465-1538) FLEMISH	2000-35000	F
WEYDEN, ROGIER VAN DER (1399-1464) FLEMISH	1500-+++	G,F
WEYER, GABRIEL (1850-1640) GERMAN	200-1400	F,L
WEYL, HANS (20TH C) GERMAN	*300-3600	F
WEYMANN, R. (19TH C) GERMAN OR SWISS	*300-3000	L
WEYTS, CAROLUS LUDOVICUS (1828-1875) BELGIAN	400-5500	X
WEYTS, PETRUS (1799-1855) BELGIAN	400-6600	M
WHAITE, JAMES (Late 19TH C) BRITISH	200-1500	L,W
WHALEN, JAMES T. (19TH C) BRITISH	200-800	X
WHEATLEY, FRANCIS	*300-15000	

WHEATLEY, FRANCIS (1747-1801) BRITISH	3000-+++	G,F,L
WHEELER, ALFRED (1851-1932) BRITISH	800-18000	G,W
WHEELER, CHARLES ARTHUR (B. 1881) AUSTRALIAN	500-15000	X(L)
WHEELER, JAMES T. (19TH C) BRITISH	500-8000	L,W
WHEELER, JOHN (OF BATH) (1821-1903) BRITISH	350-25000	G,F,W
WHEELER, JOHN ARNOLD (1821-1877) BRITISH	600-48000	W
WHEELRIGHT, W. H. (19TH C) BRITISH	400-8800	G,W
WHEELWRIGHT, ROLAND (B. 1870) BRITISH	700-29100	F
WHELDON, JAMES (19TH C) BRITISH	500-6500	M
WHITCOMBE, THOMAS (1760-1824) BRITISH	1500-75000	M
WHITE, ETHELBERT (1891-1972) BRITISH	400-8400	L,F
WHITE, JOHN (1851-1933) BRITISH	*300-5300	L,F
WHITING, FREDERICK (1874-1962) BRITISH	800-24000	G,F
WHITLEY, THOMAS W. (Active 1835-1863) ANGLO/AMERICAN	300-3800	X
WHITTLE, H. A. (19TH C) BRITISH	200-2000	L
WHITTLE, THOMAS (JR.) (Late 19TH C) BRITISH	300-3400	L,S
WHITTLE, THOMAS (SR.) (Late 19TH C) BRITISH	300-5000	L,S
WHYTE, DUNCAN MCGREGOR (20TH C) BRITISH	500-8000	X(L,M)
WICHERA, RAIMUND R. V. (1862-1925) AUSTRIAN	300-4000	G,F,S
WIDDAS, RICHARD DODD	*200-2000	
WIDDAS, RICHARD DODD (1826-1885) BRITISH	700-14000	L,G
WIDFORSS, GUNNAR MAURITZ (1879-1934) SWEDISH	*300-9000	L
WIDGERY, FREDERICK JOHN (1861-1942) BRITISH	200-3000	L
WIDGERY, WILLIAM (1822-1893) BRITISH	400-6500	L,M
WIEGERS, JAN (B. 1893) DUTCH	400-10000	S,L
WIELAND, HANS BEAT (1867-1945) SWISS	400-6000	L,F
WIELANDT, MANUEL (1863-1922) GERMAN	200-1000	X
WIENGAREDT, A. B. DE (19TH C) DUTCH	200-2800	X
WIERINGA, FRANCISCUS GERARDUS (1758-1817) DUTCH	500-24000	X
WIERUSZ-KOWALSKI, ALFRED VON (1849-1915) POLISH	3000-40000	W,F
WIGAND, BALTHASAR (1771-1846) AUSTRIAN	*400-33000	L,F
WIJNGAERDT, PIET THEODORUS VAN (B. 1873) DUTCH	300-3000	X
WIJNVELD, BAREND (1820-1902) DUTCH	400-11000	X
WIKSTROM, BROR ANDERS (1840-1909) SWEDISH	200-2000	L
WILATCH, MICHA (B. 1905) FRENCH	200-1400	L
WILD, FRANK PERCY (B. 1861) BRITISH	300-16000	G,L
WILDA, CHARLES	*300-3000	
WILDA, CHARLES (1854-1907) AUSTRIAN	400-46000	G
WILDE, SAMUEL DE (1748-1832) BRITISH	300-7500	G,F

WILDENS, JAN (1586-1653) FLEMISH	1200-64000	L,W
WILDENS, JEREMIAS (1621-1653) FLEMISH	400-13000	G
WILDER, ANDRE (1871-1965) FRENCH	300-27000	L
WILDSTOSSER, A. (19TH C) GERMAN	300-2800	X
WILHELM, HEINRICH (D. 1902) GERMAN	500-4000	G
WILHELMSON, CARL	*200-34000	
WILHELMSON, CARL (1866-1928) SWEDISH	2000-+++	G,F,L
WILKIE, SIR DAVID	*800-29000	
WILKIE, SIR DAVID (1785-1841) BRITISH	3000-106000	G,L,F
WILKINSON, ARTHUR STANLEY (19TH/20TH C) BRITISH	*200-3000	L,F
WILKINSON, NORMAN (1878-1934) BRITISH	600-20000	G,L,M
WILKINSON, R. (19TH C) BRITISH	200-1200	L
WILKS, W. (19TH C) BRITISH	200-2500	S
WILLAERTS, ABRAHAM (1603-1669) DUTCH	600-82000	G,M
WILLAERTS, ADAM (1577-1664) FLEMISH	1600-153200	G,F,M
WILLAERTS, ISAAC (1620-1693) DUTCH	400-35000	M
WILLARD, HARRIET (19TH C) BRITISH	*200-1800	F
WILLE, FRITZ JULIUS VON (1860-1941) GERMAN	500-49000	L
WILLE, JOHANN GEORG (1715-1808) GERMAN	*200-5700	L,F
WILLE, PIERRE ALEXANDRE (1748-1821) FRENCH	500-34000	G,F,L
WILLEBEECK, PEETER (Active 1632-1647) FLEMISH	4000-49000	S
WILLEMS, FLORENT (1823-1905) BELGIAN	1500-20000	G,F
WILLIAMS, ALEXANDER (1846-1930) BRITISH	*200-4600	M
WILLIAMS, ALFRED W. (1824-1905) BRITISH	300-38000	L,W
WILLIAMS, BENJAMIN (1831-1923) BRITISH	800-38000	L,M,F
WILLIAMS, EDWARD (JR.) (1782-1855) BRITISH	300-9400	L,W,G
WILLIAMS, EDWARD CHARLES (1807-1881) BRITISH	500-38000	L,W
WILLIAMS, FREDERICK (B. 1927) AUSTRALIAN	1000-103000	L,M
WILLIAMS, GEORGE AUGUSTUS (1814-1901) BRITISH	500-14000	L,W
WILLIAMS, H. P. (19TH C) BRITISH	200-1700	G,L
WILLIAMS, JAMES W. (1797-1868) BRITISH	200-1200	M
WILLIAMS, JOHN HAYNES (1836-1908) BRITISH	350-11000	G,F
WILLIAMS, PENRY (1798-1885) BRITISH	450-32000	G,L,F
WILLIAMS, TERRICK	*250-6000	
WILLIAMS, TERRICK (1860-1936) BRITISH	1000-31000	G,L,M
WILLIAMS, W. (19TH C) BRITISH	200-1500	G
WILLIAMS, W. M. (19TH C) BRITISH	200-1000	G
WILLIAMS, WALTER (1835-1906) BRITISH	500-12500	G,L
WILLIAMS, WALTER HEATH (19TH C) BRITISH	400-4900	L,F,G

* Denotes watercolors, pastels, drawings, and/or mixed media

WILLIAMSON, DANIEL ALEXANDER	*300-3600	
WILLIAMSON, DANIEL ALEXANDER (1822-1903) BRITISH	350-8800	L,W
WILLIAMSON, FRANCIS JOHN (1833-1920) BRITISH	300-2800	L
WILLIAMSON, WILLIAM H. (1820-1883) BRITISH	200-4000	G,L,M
WILLIGEN, CLAESZ JANS VAN DER (1630-1676) DUTCH	300-11000	L
WILLINK, CAREL (B. 1900) DUTCH	5000-55000	X
WILLIOT, P. (19TH C) BELGIAN	300-4800	L
WILLIS, HENRY BRITTAN (1810-1884) BRITISH	300-12500	L,G
WILLIS, J. (19TH C) FRENCH	200-1600	F
WILLMORE, JAMES TILBITTS (1800-1863) BRITISH	200-2400	X
WILLOUGHBY, ROBERT (1768-1843) BRITISH	300-2500	M
WILLOUGHBY, WILLIAM H. (19TH C) BRITISH	300-5600	W
WILLROIDER, JOSEF (1838-1915) AUSTRIAN	900-15000	L,F
WILLROIDER, LUDWIG (1845-1910) GERMAN	800-18000	L,G,F
WILMS, PETER JOSEF (1814-1892) GERMAN	300-6000	S
WILS, JAN (1600-1666) DUTCH	400-12000	G,L
WILSON, ANDREW (1780-1848) SCOTTISH	300-6000	L,S
WILSON, BENJAMIN (1721-1788) BRITISH	500-48000	F
WILSON, CHARLES EDWARD (19TH C) BRITISH	*400-19600	G
WILSON, DORA LYNELL (1883-1946) AUSTRALIAN	*600-7500	X(F)
WILSON, G. B. (19TH C) BRITISH	400-13000	L
WILSON, JOHN (1774-1855) BRITISH	400-5000	M
WILSON, JOHN JAMES (1818-1875) SCOTTISH	750-112000	G,L
WILSON, OSCAR (1867-1930) BRITISH	600-5000	F
WILSON, RICHARD (1714-1782) BRITISH	3000-+++	L,F
WILSON, SOLOMON (1896-1974) POLISH	200-800	G
WILSON, THOMAS FAIRBAIRN (19TH C) BRITISH	450-32000	L,W
WILSON, W. (19TH C) BRITISH	200-1500	F,W
WILT, HANS (1867-1917) AUSTRIAN	*300-3000	L
WILT, THOMAS VAN DER (1659-1733) DUTCH	400-17000	G
WIMPERIS, EDMUND MORISON (1835-1900) BRITISH	550-110000	G,L
WINCK, JOHANN AMANDUS (1748-1817) GERMAN	3000-61000	S
WINCK, JOHANN CHRISTIAN THOMAS (1738-1797) GERMAN	300-17000	F
WINDMAYER, ANTON (1840-1896) GERMAN	500-11000	L,G
WINDMAYER, WILHELM THEODOR (1828-1883) GERMAN	200-2400	G
WINDT, CHRIS VAN DER (B. 1877) DUTCH	200-3600	G,L
WINDT, LAURENT VAN DER (1878-1916) DUTCH	200-3000	X
WINGATE, SIR JAMES LAWTON (1846-1924) SCOTTISH	300-16000	L
WINGFIELD, JAMES DIGMAN (1800-1872) BRITISH	300-47000	G,L,F

WINKLER, FRITZ (1894-1964) GERMAN	200-3000	L
WINKLER, OLOF (B. 1843) GERMAN	200-2000	L
WINOGRADOFF, ARSSENIEVITCH (1869-1938) RUSSIAN	300-6600	X
WINS, E. (19TH C) BRITISH	200-1200	X
WINSTANLEY, HAMLET (18TH C) BRITISH	400-7000	F
WINT, PETER DE	*1000-40000	
WINT, PETER DE (1784-1849) BRITISH	1000-15000	L,F,S
WINTER, FRITZ (1905-1978) GERMAN	400-76200	A
WINTER, HEINRICH (B. 1843) GERMAN	300-3500	G
WINTERHALTER, FRANZ XAVIER	*400-75000	
WINTERHALTER, FRANZ XAVIER (1806-1873) GERMAN	1500-+++	G,F
WINTERLIN, ANTON (1805-1894) SWISS	800-15000	L
WINTHER, FREDERIK JULIUS AUGUST (1853-1916) DANISH	300-3600	L
WISINGER, OLGA FLORIAN (1844-1926) AUSTRIAN	800-130000	L,S
WISSING, WILLIAM (1653-1687) DUTCH	1500-12000	L,F
WIT, JAKOB DE (1695-1754) DUTCH	2000-35000	G,L,F
WITHAM, JAMES (19TH C) BRITISH	800-9500	M
WITHERINGTON, WILLIAM FREDERICK (1785-1865) BRITISH	400-27000	G,L,F
WITHERS, M. N. (Early 20TH C) BRITISH	200-1000	S
WITHERS, WALTER	*300-6000	
WITHERS, WALTER (1854-1914) AUSTRALIAN	1000-132000	G,L
WITHOOS, MATTHIAS (1627-1703) DUTCH	400-20000	L,S
WITSEN, WILLEM (1860-1923) DUTCH	400-5000	L,S
WITTE, EMANUEL DE (1617-1692) DUTCH	1500-+++	L,G
WITTEL, GASPARD VAN (1653-1736) DUTCH	2200-+++	G,L
WITTKAMP, JOHANN BERNHARD (1820-1885) GERMAN	300-6000	L,I
WITTMER, JOHANN MICHAEL	*400-25000	
WITTMER, JOHANN MICHAEL (1802-1885) GERMAN	300-4500	F
WOHNER, LOUIS (B. 1888) GERMAN	200-1000	G
WOLF, CASPAR (1735-1798) SWISS	4100-50000	L
WOLF, FRANZ (1795-1859) AUSTRIAN	200-2500	F,L
WOLF, FRANZ XAVIER (B. 1896) AUSTRIAN	300-17000	F,L,S
WOLF, GEORG (1882-1962) GERMAN	600-6500	F,G,L
WOLF, J. (19TH C) BRITISH	300-7000	W
WOLFE, EDWARD (1897-1982) BRITISH	600-38000	X(A)
WOLFE, GEORGE (1834-1890) BRITISH	300-4800	L,M
WOLFLE, INGE (B. 1928) GERMAN	200-2000	G
WOLFLI, ADOLF (1864-1930) SWISS	2000-12000	A
WOLFROM, FRIEDRICH ERNST (B. 1857) GERMAN	300-3800	G,L

* Denotes watercolors, pastels, drawings, and/or mixed media

WOLMARK, ALFRED (1877-1961) BRITISH	700-60000	F,L,S
WOLS, (ALFRED O WOLFGANG SCHULTZEBATTMAN)	*300-78000	
WOLS, (ALFRED O WOLFGANG SCHULTZEBATTMAN) (1913-1951) GERMAN	1500-+++	L,A
WOLSKI, STANISLAW POMIAN (1859-1894) POLISH	300-6000	L,F
WOLSTENHOLME, DEAN (JR.) (1798-1882) BRITISH	1000-100000	G,L,W
WOLSTENHOLME, DEAN (SR.) (1757-1837) BRITISH	1200-32000	L,G
WOLTER, HENDRIK JAN (1873-1952) DUTCH	400-27000	M
WOLVECAMP, THEO (B. 1925) DUTCH	1000-14000	A
WOLVENS, HENRI VICTOR (1896-1977) BELGIAN	800-12000	X
WONTNER, WILLIAM (Active 1879-1922) BRITISH	500-34000	F
WOOD, CARLOS C. (1772-1856) BRITISH	400-14000	F
WOOD, CHRISTOPHER	*400-8000	
WOOD, CHRISTOPHER (1901-1930) BRITISH	1200-54000	S,M,F
WOOD, FRANK	*200-2600	
WOOD, FRANK (1862-1953) BRITISH	200-2000	F,M
WOOD, JOHN (1801-1870) BRITISH	200-16000	G,F
WOOD, LEWIS JOHN (1813-1901) BRITISH	300-5200	L
WOOD, THOMAS P. (19TH C) BRITISH	200-1000	X
WOODHOUSE, FREDERICK (1820-1909) AUSTRALIAN	1000-8500	W
WOODHOUSE, FREDERICK (JNR) (19TH/20TH C) AUSTRALIAN	2000-20000	W
WOODHOUSE, WILLIAM (1857-1939) BRITISH	900-23000	W,G
WOODLOCK, DAVID (1842-1929) BRITISH	*300-9500	F,L
WOODS, HENRY (1846-1921) BRITISH	700-9700	G,L
WOODVILLE, RICHARD CATON (JR.) (1856-1927) BRITISH	750-14000	F
WOODWARD, THOMAS (1801-1852) BRITISH	1400-93000	L,W
WOOG, RAYMOND (B. 1875) FRENCH	300-5000	F
WOOLLETT, HENRY CHARLES (Late 19TH C) BRITISH	400-5400	W,F,G
WOOLMER, ALFRED JOSEPH (1805-1892) BRITISH	1000-12000	F,L
WOOLMER, W. (19TH C) BRITISH	200-2200	L
WOOTTON, FRANK (20TH C) BRITISH	200-1300	L
WOOTTON, JOHN (1686-1765) BRITISH	5000-+++	L,F,G
WOPFNER, JOSEPH (1843-1927) AUSTRIAN	1500-60000	L,M
WORLIDGE, THOMAS (1700-1766) BRITISH	300-11000	X
WORMORWALD, E. (19TH/20TH C) DANISH	200-2000	X
WORMS, JULES	*200-4000	
WORMS, JULES (1832-1924) FRENCH	500-38000	G,F
WORRELL, ABRAHAM BRUININGH VAN (1787-1823) DUTCH	1200-59000	L,S
WORSDALE, JAMES (D. 1767) BRITISH	300-4200	G,F

WORTLEY, ARCHIBALD JAMES STUART (1849-1905) BRITISH	750-19200	F
WOSTRY, CARLO (B. 1865) ITALIAN	1000-60000	X
WOTRUBA, FRITZ (1907-1975) GERMAN	*200-3600	F
WOU, CLAES CLAESZ (1592-1665) DUTCH	1500-40000	M
WOUTERMAERTENS, EDOUARD (1819-1897) BELGIAN	300-3400	L,W
WOUTERS, G. J. (19TH C) DUTCH	200-800	L
WOUTERS, RIK (1882-1916) BELGIAN	*800-42000	F
WOUWERMAN, PHILIPS (1619-1668) DUTCH	3500-+++	G,L
WOUWERMAN, PIETER (1623-1682) DUTCH	850-22000	G,L,F
WOUWERMANS, JAN (1629-1666) DUTCH	1000-26000	L,G
WRIGHT, (OF LIVERPOOL) (1735-1774) BRITISH	200-3000	X
WRIGHT, GEORGE (1860-1942) BRITISH	500-41000	W,F
WRIGHT, GILBERT SCOTT (Active 1896-1900) BRITISH	1000-29000	W,F
WRIGHT, JOHN MICHAEL (1623-1700) BRITISH	800-54000	F
WRIGHT, JOSEPH (OF DERBY) (1734-1797) BRITISH	10000-+++	F,L
WRIGHT, ROBERT WILLIAM (Late 19TH C) BRITISH	300-14000	G,L
WSSEL, MANUEL (19TH C) SPANISH	400-12100	X
WUCHERER, FRITZ (B. 1873) SWISS	300-5000	G,L
WULFFAERT, ANDRIANUS (1804-1873) BELGIAN	300-3800	L,F
WUNDERLICH, PAUL	*500-44000	
WUNDERLICH, PAUL (B. 1927) GERMAN	850-27000	G,L,F
WUNNENBERG, CARL (1850-1929) GERMAN	400-10000	G,F
WUNSCH, MARIE (1860-1898) GERMAN	500-8000	G
WUTTKE, CARL (1849-1927) GERMAN	600-10000	L
WYATT, SAMUEL (18TH C) BRITISH	*500-4500	L
WYCK, JAN (1640-1702) DUTCH	1500-+++	L,G,F
WYCK, THOMAS (1616-1677) DUTCH	1300-71000	G,L
WYDOOGEN, N. M. (19TH C) DUTCH	300-4000	L,M
WYK, HENRI VAN (B. 1883) DUTCH	300-4800	G,L,S
WYLD, WILLIAM (1806-1889) BRITISH	*300-33000	G,L
WYLIE, ROBERT (1839-1877) BRITISH	400-6500	G,F
WYLLIE, CHARLES WILLIAM (1853-1923) BRITISH	1000-32000	M
WYLLIE, WILLIAM LIONEL	*300-5600	
WYLLIE, WILLIAM LIONEL (1851-1931) BRITISH	300-97000	L,M
WYNANTS, JAN (1630-1684) DUTCH	1200-66000	L,W
WYNANTSZ, AUGUST (1795-1848) DUTCH	800-7000	L
WYNGAERDT, ANTHONIE JACOBUS VAN (1808-1887) DUTCH	300-7500	G,L
WYNGAERDT, PIET VAN (1875-1964) DUTCH	200-1000	F,L,S
WYNNE, ARTHUR (19TH C) BRITISH	200-800	L

* Denotes watercolors, pastels, drawings, and/or mixed media

WYSMULLER, JOHAN HILLEBRAND (1855-1925) DUTCH	300-7000	L,M
WYSOCKI, M. (19TH/20TH C) POLISH	200-1000	X
WYTSMAN, RODOLPHE (1860-1927) BELGIAN	500-14100	L
WYWIORSKI, MICHAL GORSTKIN (1861-1926) POLISH	800-13000	L

X

ARTIST	PRICES	SUBJECT
XICARA, IXQUIAC GUATEMALAN	200-1400	S
XUAREZ, NICOLAS RODRIGUEZ (1667-1734) MEXICAN	400-22000	F

Y

ARTIST	PRICES	SUBJECT
YAOUANC, ALAIN LE (20TH C) BELGIAN	*800-3500	X(A)
YARNOLD, GEORGE B. (19TH C) BRITISH	300-8000	L
YARNOLD, JOSEPH W. (19TH C) BRITISH	300-3000	M
YATES, FREDERICK (D. 1920) BRITISH	200-2400	G,F
YATES, GIDEON (19TH C) BRITISH	*400-7500	L
YATES, H. J. (20TH C) BRITISH	200-800	G
YATES, LIEUTENANT THOMAS (19TH C) BRITISH	200-1800	M
YDEMA, EGNATIUS (1876-1937) DUTCH	300-3000	M
YEAMES, WILLIAM FREDERICK (1835-1918) BRITISH	900-12000	X(G)
YEATS, JACK BUTLER	*800-29000	
YEATS, JACK BUTLER (1871-1957) IRISH	2900-+++	G,L
YEEND-KING, HENRY JOHN (1855-1924) BRITISH	400-15000	X
YEKTAI, MANOUCHER (B. 1922) IRANIAN/AMERICAN	200-2000	A
YEPES, TOMAS (1600-1674) SPANISH	3600-+++	S
YKENS, FRANS (1601-1693) FLEMISH	800-120000	S
YORKE, GEORGE HOWARD (19TH C) BRITISH	1000-24000	X(G)
YORKE, WILLIAM HOWARD (Active 1858-1913) BRITISH	400-28000	M
YOSHIDA, MATSUGORO (B. 1900) JAPANESE	200-800	L
YOUNG, EDWARD (1823-1882) AUSTRIAN	300-2800	L
YOUNG, J. B. (19TH C) BRITISH	300-3300	X
YOUNG, TOBIAS (D. 1824) BRITISH	300-8800	G,L
YOUNG, WILLIAM (19TH C) BRITISH	*150-26000	L

YOUNG, WILLIAM BLAMIRE (20TH C) AUSTRALIAN	*300-11000	L,F
YOUNGMAN, ANNIE MARY (1860-1919) BRITISH	*200-1500	L,S
YRRARAZAVAL, RICARDO (B. 1940) CHILEAN	200-1800	G
YUNKERS, ADJA (B. 1900) LATVIAN/AMERICAN	200-800	A
YVARAL, JEAN PIERRE (JEAN PIERRE VASARELY)	*200-1500	
YVARAL, JEAN PIERRE (JEAN PIERRE VASARELY) (B. 1934) FRENCH	300-3800	A
YVON, ADOLPHE (1817-1893) FRENCH	400-28000	G,F

Z

ARTIST	PRICES	SUBJECT
ZAALBERG, K. A. (20TH C) DUTCH	200-800	L
ZABEHLICKY, A. (19TH C) GERMAN	200-1500	L,S
ZABEHLICKY, FRANZ (19TH C) GERMAN	200-1800	L
ZABEHLICKY, L. (19TH/20TH C) EUROPEAN	200-800	X
ZACHIA, PAOLO (15TH C) ITALIAN	500-45000	X
ZACHO, CHRISTIAN (1843-1913) DANISH	400-19000	G
ZACK, LEON (B. 1892) RUSSIAN	900-55100	A
ZADKINE, OSSIP	*300-40000	
ZADKINE, OSSIP (1890-1967) RUSSIAN/FRENCH	400-12000	G,L,F
ZAHND, JOHANN (1854-1934) SWISS	300-6300	G,L
ZAHRTMANN, KRISTIAN (1843-1917) DANISH	500-48000	G,F
ZAIS, GIUSEPPE	*200-15000	
ZAIS, GIUSEPPE (1709-1784) ITALIAN	600-48000	L,F
ZAJICEK, CARL WENZEL (1860-1923) AUSTRIAN	*600-3500	L
ZAK, EUGENE	*200-1800	
ZAK, EUGENE (1884-1926) POLISH	300-11000	G,F
ZALCE, ALFREDO	*150-1500	
ZALCE, ALFREDO (B. 1908) MEXICAN	200-2400	G,F
ZAMACOIS Y ZABALA, EDUARDO	*200-2500	
ZAMACOIS Y ZABALA, EDUARDO (1842-1871) SPANISH	1200-105000	G,F
ZAMAZAL, JAROSLAV (Called VERIS) (B. 1900) CZECHOSLOVAKIAN	200-800	X
ZAMORA, JESUS MARIA (1875-1949) COLOMBIAN	500-7000	L
ZAMORA, JOSE DE	*900-86000	
ZAMORA, JOSE DE (16TH C) SPANISH	600-32000	I,S
ZAMPIGHI, EUGENIO EDUARDO (1859-1944) ITALIAN	900-35000	G,L,F

ZANAZIO, G. (19TH/20TH C) ITALIAN	200-1400	X
ZANDOMENEGHI, FEDERICO	*2000-+++	
ZANDOMENEGHI, FEDERIGO (1841-1917) ITALIAN	5000-+++	G,L
ZANETTI, GIUSEPPE MITI (1859-1929) ITALIAN	1000-26000	M,L
ZANETTI (19TH/20TH C) ITALIAN	200-1000	L
ZANETTI-ZELLA, VETTORE	*500-26000	
ZANETTI-ZELLA, VETTORE (1864-1946) ITALIAN	300-8000	L,M
ZANGUIDI, JACOPO (1544-1574) ITALIAN	*2000-35000	G,F
ZANIERI, ARTURO (B. 1870) ITALIAN	1000-12000	G,L
ZAO-WOU-KI (1921-1964) CHINESE/FRENCH	1100-195000	L
ZAPKUS, KESTUTIS (B. 1938) LITHUANIAN/AMER.	200-3000	I
ZARITSKY, JOSEPH	*600-8500	
ZARITSKY, JOSEPH (20TH C) ISRAELI	1000-24000	X
ZAROUBIN, VIKTOR IVANOVICH (1866-1928) RUSSIAN	900-14000	F,L
ZARRAGA, ANGEL (1886-1946) MEXICAN	450-80000	L,F,S
ZATZKA, HANS (B. 1859) AUSTRIAN	400-17000	L,F,S
ZAWISKI, EDOUARD (19TH-20TH C) FRENCH	1000-35000	W,G,L
ZBAUER, F. F. (19TH C) GERMAN	200-2000	X
ZDANEVITCH, KIRIL (1892-1970) RUSSIAN	*500-10000	A,F
ZEECK, J. (19TH/20TH C) PORTUGESE	200-800	X
ZEELANDER, PIETER DE (17TH C) DUTCH	400-16000	X
ZEFFIRELLI, FRANCO (B. 1923) ITALIAN	*200-1500	I
ZEHENDER, JOHANN CASPAR (1742-1805) GERMAN	400-6200	M,L,F
ZEITTER, JOHN CHRISTIAN (D. 1862) BRITISH	200-1400	G,L
ZELECHOWSKI, GASPARD (B. 1863) POLISH	200-800	X
ZELGER, JAKOB JOSEPH (1812-1885) SWISS	1000-25000	L
ZELLER, MAGNUS (B. 1888) POLISH	1000-45000	F,L
ZELONI, R. (19TH C) ITALIAN	200-2200	G,F
ZENAZOO, G. (20TH C) EUROPEAN	200-1000	X
ZENDEL, GABRIEL (B. 1906) FRENCH	1000-7500	X(F)
ZENDER, RUDOLF (20TH C) SWISS	200-13000	L,S
ZEPPENFELD, VICTOR (1834-1871) GERMAN	150-2700	X
ZERBE, KARL (1903-1972) GERMAN/AMERICAN	200-1800	F,L,S
ZERMATI, JULES (19TH/20TH C) ITALIAN	200-3000	G
ZETSCHE, EDUARD (1844-1927) AUSTRIAN	800-7500	L,F
ZETTERBERG, NISSE (1910-1986) SWEDISH	600-5000	S
ZEWY, KARL (1855-1929) AUSTRIAN	900-12000	G,F
ZEYER, ERICH (20TH C) GERMAN	400-3000	L,F
ZHANG DAQIAN (1899-1983) CHINESE	*2000-165000	L,S,F

ZHANG SHANZI (1882-1940) CHINESE	*1000-16000	W,L
ZHAO SHAOANG (B. 1904) CHINESE	2000-15000	L,W
ZICK, JANUARIUS JOHANN RASSO (1730-1797) GERMAN	1000-52000	G,F
ZIEGLER, RICHARD (B. 1901) GERMAN	400-5000	G,F
ZIEM, FELIX	*200-8000	
ZIEM, FELIX (1821-1911) FRENCH	1000-95000	G,L
ZIER, FRANCOIS EDOUARD (1856-1924) FRENCH	350-18000	G,F
ZIESENIS, JOHANN GEORG (1716-1776) GERMAN	300-6600	F
ZIGLIARA, EUGENE LOUIS (1873-1918) FRENCH	300-4200	G,F,L
ZILLA, VETTORE ZANETTI (1866-1945) ITALIAN	1000-30000	M,L,F
ZILLE, HEINRICH	*900-55000	
ZILLE, HEINRICH (1858-1929) GERMAN	500-22000	G,F,L
ZIMMER, BERND	*900-9600	
ZIMMER, BERND (20TH C) GERMAN	1000-15000	X
ZIMMER, WILHELM CARL AUGUST (1853-1937) GERMAN	400-30000	G,L,F
ZIMMERMAN, ALBERT AUGUST (1808-1888) GERMAN	300-20000	L
ZIMMERMAN, ERNST KARL GEORG (1852-1901) GERMAN	300-6000	G,F,S
ZIMMERMAN, THEODORE (20TH C) BRITISH	*500-3500	L,F
ZIMMERMANN, ALFRED (1854-1910) GERMAN	300-8000	G
ZIMMERMANN, AUGUST RICHARDC (1820-1872) GERMAN	1000-15000	L
ZIMMERMANN, CARL (1863-1930) GERMAN	300-30000	L
ZIMMERMANN, REINHARD SEBASTIAN (1815-1893) GERMAN	1000-51000	G,F
ZIMMERMANN, RENE (20TH C) FRENCH	800-3500	X(L)
ZINGG, JULES	*400-4500	
ZINGG, JULES (1882-1942) FRENCH	800-36000	L
ZINGONI, AURELIO (1853-1922) ITALIAN	600-18100	G
ZINI, UMBERTO (1878-1964) ITALIAN	150-700	L
ZINK, R. FRENCH	400-10000	G
ZINKEISEN, ANNA (B. 1901) BRITISH	500-9500	A
ZINKEISEN, DORIS (20TH C) BRITISH	800-13000	A,F,L
ZINNOGGER, LEOPOLD (1811-1872) AUSTRIAN	500-94000	X(L)
ZIVERI, ALBERTO (B. 1908) ITALIAN	1000-25000	X(L,F)
ZLOTNIKOV, YURI (B. 1930) RUSSIAN	800-3000	A
ZO, HENRI (1873-1933) FRENCH	800-22000	X(G)
ZOBEL, FERNANDO (B. 1924) SPANISH	200-59000	L
ZOCCHI, EMILIO (1835-1920) ITALIAN	300-3400	G
ZOCCHI, GIUSEPPE	*600-18000	
ZOCCHI, GIUSEPPE (1711-1767) ITALIAN	1000-143000	L,F
ZOCCHI, GUGLIELMO (B. 1874) ITALIAN	400-15000	G,F

454 * Denotes watercolors, pastels, drawings, and/or mixed media

ZOCCHI, SILVIO (19TH C) ITALIAN	200-2800	F
ZOFF, ALFRED (1852-1927) AUSTRIAN	300-3000	L,M
ZOFFANY, JOHANN (1733-1810) BRITISH	5000-+++	G,L,F
ZOFFOLI, A. (19TH C) ITALIAN	700-14000	G
ZOLL, KILIAN (1818-1860) SWEDISH	2500-36000	F,L
ZOLLER, JOSEF ANTON (1730-1791) AUSTRIAN	*200-1400	L
ZOMPINI, GAETANO (1700-1778) ITALIAN	500-6500	L,F
ZONA, ANTONIO (1813-1892) ITALIAN	300-10000	G
ZONARO, FAUSTO (1854-1929) ITALIAN	1800-16000	X(M)
ZOPF, CARL (B. 1858) GERMAN	200-2200	F
ZOPF, JULIUS (1838-1897) AUSTRIAN	200-3000	L
ZOPPI, ANTONIO (1860-1926) ITALIAN	350-15000	G
ZORN, ANDERS	*1500-+++	
ZORN, ANDERS (1860-1920) SWEDISH	3500-+++	L,F,S
ZRZAVY, JAN (B. 1890) CZECHOSLOVAKIAN	200-1500	S
ZUBER, HENRI (1844-1909) FRENCH	800-16000	L,M
ZUBER BUHLER, FRITZ (1822-1896) SWISS	1000-64000	G,F
ZUBIAURRE, RAMON DE (B. 1882) SPANISH	1000-20000	G,F,M
ZUBIAURRE, VALENTIN DE (B. 1879) SPANISH	1200-82000	G,F
ZUBRITZKY, LORAND DE (B. 1869) HUNGARIAN	500-20000	G,L
ZUCCARELLI, FRANCESCO (1701-1788) ITALIAN	1000-+++	L
ZUCCARO, FEDERICO	*500-+++	
ZUCCARO, FEDERICO (1543-1609) ITALIAN	1500-+++	F
ZUCCARO, TADDEO (1529-1566) ITALIAN	*900-+++	L,F
ZUCCHI, ANTONIO (1726-1795) ITALIAN	300-15000	G,L
ZUCCO, FRANCESCO (1570-1627) ITALIAN	400-9000	F
ZUGEL, HEINRICH JOHANN (1850-1941) GERMAN	1200-175000	F,L,S
ZUGNO, FRANCESCO (1709-1787) ITALIAN	2000-34000	F
ZUHR, HUGO (1895-1971) SWEDISH	600-14100	L,S
ZULOAGA Y ZABALETA, IGNACIO	*200-5500	
ZULOAGA Y ZABALETA, IGNACIO (1870-1945) SPANISH	1200-+++	F,L
ZULOW, FRANZ VON (1883-1963) AUSTRIAN	*400-4000	L,F
ZUND, ROBERT (1827-1909) SWISS	1000-138000	L
ZUNIGA, FRANCISCO	*300-20000	
ZUNIGA, FRANCISCO (B. 1913) MEXICAN	400-2000	F
ZURBARAN, FRANCISCO (1598-1664) SPANISH	5000-+++	F,S
ZURKINDEN, IRENE	*400-5000	
ZURKINDEN, IRENE (B. 1909) SWISS	800-11000	F,L,S
ZUSTERS, REINIS (B. 1918) AUSTRALIAN	500-7500	L,M

ZWADO, (JAN WACLAW ZOWADOWSKI) (B. 1891) POLISH	200-2000	L
ZWANN, CORNELISZ C. (1882-1964) DUTCH	300-5000	G,S
ZWART, PETRUS ANTONIUS DE (1880-1967) DUTCH	200-1000	L
ZWART, WILLEM DE	*200-3500	
ZWART, WILLEM DE (1862-1931) DUTCH	300-14000	L,F
ZWENGAUER, ANTON (1810-1884) GERMAN	300-4200	L
ZWENGAUER, ANTON (THE YOUNGER) (1850-1928) GERMAN	300-5400	L
ZWILLER, MARIE AUGUSTIN (1850-1939) FRENCH	300-5500	L,F
ZYL, GERARD PIETERSZ VAN (1607-1665) DUTCH	300-11000	G

APPENDIX

RESOURCES FOR PRICING

Reference Books

Prices for books which are a compilation of the results of actual art auction sales can be very high - from $40 to $195. Unless you plan to buy and sell art regularly, you should check with a large public library, or art museum library for the titles you will need (see next page.)

For a complete list of the references available, write or call the following book dealers and request their catalog. You should become familiar with all of the art price guides and art reference books available to you, before you start buying art. One note: I do not believe these guides are available in any familiar chain bookstores.

Here is a list of book dealers specializing in fine art who have elected to advertise in this third edition. Immediately following this advertising section you will find a list of those price guides which contain important listings of auction results of the sale of American and European paintings. You can look ahead, under *Biographical Resources* for a list of the important art dictionaries and specialized artists' biographies.

Fine Art Books

NEW ENGLAND GALLERY
RR 2 BOX 959
WOLFEBORO, NH 03894

(603) 569-3501 (NH)
(305) 733-9237 (FL)

Dealer's Choice Books, Inc.
P. O. Box 710
Land O'Lakes, FL 34639
(please see Display Ad)

In Fla.:(813) 996-6599
(800) 238-8288 (toll free)

Fine Art Books: Rare & Out of Print

JOSLIN HALL RARE BOOKS
P.O. BOX 516
CONCORD, MA 01742
(508) 371-3101

Important Art Price Sources
(check each dealer - prices vary)

1. *Art Sales Index 1990/91,* by Richard Hislop, Art Sales Index Ltd.,England.

 Two volumes (hardcover) containing the worldwide auction results of the previous auction season (August to July). Over 2,700 pages and over 90,000 sales results for artists worldwide - includes sculptors. Price $198 (two volumes).

2. *McKittrick's Art Price Guide 1989/90,* by Michael & Rosemary McKittrick

 Lists the art sold at 51 auction houses across the U. S. from July 1, 1989 thru June 30, 1990 - American and European. Price $85 (hardcover). Much like *Leonard's* (below), but much less expensive. *Note:* Weak on reporting important European auction sales results covered by *Art Sales Index.*

3. *Leonard's Annual Price Index of Art Auctions,* by Auction Index, Inc., 30 Valentine Park, West Newton, MA 02165

 Complete listing of sales results, American and European, during 1989-90. Compiled *only* from American auction sales. Past volumes available. Price $195 (hardcover). *Note:* Weak on reporting important European auction sales results covered by *Art Sales Index.*

4. *E. Mayer 1991 International Auction Records,* by Editions Publisol

 A very thick (1,618 pages), illustrated, international price guide to paintings, prints, drawings, and sculptures. Covers auction results for preceding year. Present price is $199 (hardcover).

"On-Line" Database

For the serious art dealer, collector, appraiser, and auctioneer, the "on-line" database described below is essential. You go to your terminal, touch a few keys, and you quickly have access to the world's most complete coverage of international auction sales.

Artquest, a subscription computer service, was compiled by Richard Hislop, editor of *Art Sales Index* (ASI). This database contains the international sales results of the past 21 years. Presently on the database are the results from the sale of the work of over 85,000 artists, worldwide, and over 500,000 works of art, worldwide.

You can retrieve information in innumerable ways: by artist, title, size, medium, nationality, price (i.e., descending or ascending order), most recent sales, and much more. *Artquest* can also give you an analysis of each artist's auction record during the past 21 years, year by year. Information can be accessed in seconds; important when you are paying over $2.00 per minute for "connect" time. It is worth the expense, though, because you can glean information in seconds from *Artquest*, which you could not gather from guide books, after weeks of investigation.

I subscribe to *Artquest*, and wholeheartedly recommend it to any active art dealer, collector, appraiser, or auctioneer. Any novice to computers can learn to use *Artquest* successfully in a very short time. For more information call or write:

<div align="center">

Artquest
Art Sales Index, Ltd.
1 Thames Street
Weybridge, Surrey KT13 8JG, UK

TELEPHONE: (0932) 856426
FAX: (0932) 842482

</div>

Note: Although the *Artquest* database is located in London, you can access it easily by using a local packet switching network. The literature you receive from *Artquest* will explain it more thoroughly.

ART AUCTION HOUSES

Here is a list, by state, of those auction houses which sell a large volume of artwork each year and have elected to advertise in this third edition. A good number have in-house art specialists who do the research on each consignment and see that it is properly catalogued.

Please keep in mind, most *major* auction houses today will not accept a single consignment unless it is valued at over $500. Check the policies of each, when you initially contact them. In general, the commission rate charged the consignor will fall between 6% and 20%. The more valuable your piece, the lower the commission should be.

If you own, or operate, an auction house and wish to advertise in the next edition, please call or write: **Currier Publications**, PO Box 2098, Brockton, MA 02405, tel: (508) 588-4509.

CONNECTICUT

Mystic Fine Arts
47 Holmes Street
Mystic, CT 06355
(203) 572-8873
(please see Display Ad)

MASSACHUSETTS

James R. Bakker Antiques, Inc.
370 Broadway
Cambridge, MA 02139
(617) 864-7067
(please see Display Ad)

Shute Auction Gallery
50 Turnpike Street
West Bridgewater, MA 02379
(508) 588-0022
(please see Display Ad)

Skinner, Inc.
357 Main Street
Bolton, MA 01740
(508) 779-5528
(please see Display Ad)

MAINE

Young Fine Arts Gallery, Inc.
P.O. Box 313
North Berwick, ME 03906
(207) 676-3104
(please see Display Ad)

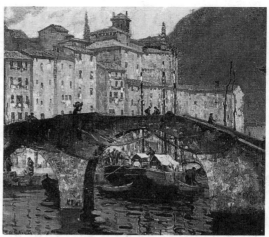

ART DEALERS

The following is a list of art dealers who have elected to advertise in this third edition. If you are a painting dealer and have an interest in placing an ad in the next edition, please call or write: **Currier Publications**, PO Box 2098, Brockton, MA 02405, tel: (508) 588-4509.

CALIFORNIA

Summit Gallery
2608 Adams Avenue
San Diego, CA 92116
(619) 299-5353

DISTRICT OF COLUMBIA

Antique Art Galleries, Inc.
3760 Howard Avenue
Washington, DC 20895
(301) 946-2152

MASSACHUSETTS

Rebecca Hoffmann
P.O. Box 269
Hudson, MA 01749
(508) 562-4716

NEW YORK

Ronald L. Manson Antiques
1638 Hillside Avenue
New Hyde Park, NY 11040
(516) 328-1556

NORTH CAROLINA

Seaside Art Gallery
Box 1 - Mile Post 11
Nags Head, NC 27959
(919) 441-5418
(800) 828-2444
Fax: (919) 441-8563

(please see Display Ad)

APPRAISAL ORGANIZATIONS

If you have need of an art appraiser, be sure he or she is a member in good standing of one of the respected appraisal organizations, nationally. Here are your leading sources for qualified appraisers. Always ask for references.

The Appraisers Assoc.
of America (suite 2505)
60 E 42nd St
New York, NY 10165

(212) 867-9775

The American Society
of Appraisers
Box 17265
Washington, DC 20041

(703) 478-2228

The Art Dealers Association
575 Madison Avenue
New York, NY 10022

(212) 940-8590

The New England
Appraisers Assoc.
5 Gill Terrace
Ludlow, VT 05149

(802) 228-7444

The Intr'nl Society
of Appraisers
Box 280
River Forest, IL 60305

(312) 848-3340

United States Appr. Assoc.,Inc.
1041 Tower Road
Winnetka, IL 60093

(312) 446-3434

In addition to the list above, the *major* auction houses also provide appraisal services.

AUTHENTICATION SERVICES:

The Art Dealers Association will be helpful when you need an expert to authenticate a valuable work of art.

The International Foundation for Art Research (IFAR) provides an authentication service for valuable works of art. For more information on all their services, write or call:

IFAR
Executive Director
46 East 70th Street
New York, NY 10021

(212) 879-1780

PAINTING CONSERVATORS

Because of limitations of space, only a representative sample of conservators has been compiled from the United States. Only telephone numbers are given. Please remember, the simplest and safest approach to take in finding a competent conservator is to get a referral from a reputable art gallery or museum.

CALIFORNIA

Greaves, James L.	(213) 857-6161
Lohnert, Andrej	(213) 436-1341
Lorenz, Richard	(415) 929-1240
Minguillon, Emilio	(619) 726-4665

CONNECTICUT

Goring, Ruth Walker	(203) 572-8873
Hindermann, Andrea	(203) 535-2124
Kimball, David	(203) 653-5465
McElroy, Richard	(203) 928-6114

DISTRICT OF COLUMBIA

Page, Arthur H. IV	(202) 333-6269

FLORIDA

Putnam, Harold	(305) 567-5870

INDIANA

Phegley, Monica Radecki (219) 287-0266

LOUISIANA

Bessor, Louise C. (504) 241-2587

MARYLAND

Archer-Shee, Audrey Z.	(301) 822-0703
Caraher, Josepha	(301) 435-7275
Dennis, Alexandra	(301) 986-1296
Jones, Sian B.	(301) 433-0038
Klatzo, Cornelia	(301) 530-0880

MASSACHUSETTS

Abrams, Linda M.	(617) 272-8391
Brink, Elise	(617) 566-5252
Coren, Simon	(617) 394-1416
Kostoulakos, Peter	(508) 453-8888

MICHIGAN

Plaggemars, Howard O. (616) 396-6607

MISSOURI

Larson, Sidney (314) 445-2058

NEW JERSEY

Duff, Suzanne	(201) 228-9701
DeFlorio, Dante	(201) 744-2640

NEW MEXICO

Munzenrider, Claire (505) 982-4300

NEW YORK

Bronold & Winnicke	(212) 982-3416
Farancz, Alan M.	(212) 563-5550
Katlan, Alexander	(718) 445-7458
Scott Jr., John C.	(212) 714-0620
Van Gelder, Mark E.	(607) 547-5585
VoorHees, Alan Lee	(607) 739-7898
West Lake Conservators, Ltd.	(315) 685-8534

RHODE ISLAND

Bosworth, David (401) 789-1306

SOUTH CAROLINA

Dibble, Ginny Newell (803) 254-1640

TEXAS

Kennedy, Ellen D.	(713) 520-1808
Rajer, Anton	(806) 655-7191
Van Slyke, Angelo	(713) 520-1808

VIRGINIA

Clover, Cecile (804) 973-8126

WASHINGTON

Harrison, Alexander (604) 732-5217

WISCONSIN

Rajer, Anton (414) 457-3056

OIL PAINTINGS CLEANED AND RESTORED

BEFORE

AFTER

 Peter Kostoulakos
Artist/Conservator
15 Sayles Street
Lowell, MA 01851
(508) 453-8888

BIOGRAPHICAL RESOURCES

The following is a selective list of those references, available from most art reference book dealers, which the author feels are important in researching artists outside the United States. Please contact one or more of the art book dealers listed in *Resources for Pricing* in this *Appendix* for further details on each title listed below.

Artist Dictionaries:

- *A Dictionary of Artists / Who Have Exhibited Works in the Principal London Exhibitions from 1760-1893*, Algernon Graves
- *A Dictionary of British Miniature Painters*, Daphne Foskett
- *A Dictionary of British Sporting Painters*, Sydney H. Paviere
- *A Dictionary of Canadian Artists*, Colin S. MacDonald, (6 volumes)
- *A Dictionary of Contemporary British Artists - 1929*, Bernard Dolman
- *A Dictionary of Japanese Artists / Painting, Sculptor, Ceramics, Prints, and Laquer*, Laurance P. Roberts
- *A Dictionary of Women Artists: An International Dictionary of Women Artists Born Before 1900*, Chris Petteys
- *Allgemeines Lexikon der Bildenden Kunstler von der Antike bis zur Gegenwart; unter Mitwirkung von 300 Fachgelehrten des In-und Auslandes,* (called "Theime-Becker"), Ulrich Theime and Felix Becker (37 Volumes in German)
- *Allgemines Lexicon der Bildenden Kunstler des XX. Jahrhunderts*, (called "The Vollmer"), Dr. Hans Vollmer, (6 volumes in German)
- *Dictionary of British Equestrian Artists*, Sally Mitchell
- *Dictionary of Marine Painters*, Dorothy E.R. Brewington
- *Dictionary of Sea Painters*, E. Archibald
- *Dictionnaire Critique et Documentaire des Paintres, Sculpteurs, Dessinateurs et Graveurs*, (called "Benezit"), Emmanuel Benezit (10 Volumes in French)
- *Die Niederlandische Maler und Zeichner des 17 Jahrunderts*, (Old Masters), Walther Bernt, (3 volumes in German)

- *Dizionario Enciclopedico Bolaffi dei Pittori e Degli Incisori Italiani: Dall' XI al XX Secolo*, Giulio Bolaffi, (11 volumes in Italian)
- *Les Petits Maitres de la Peinture*, Gerald Schurr, (6 volumes in French)
- *Lexicon of the Belgian Romantic Painters*, William G. Flippo
- *Munich Painters of the 19th Century*, F. Bruckman, (4 volumes in German)
- *Popular 19th Century European Painting: A Dictionary of Subject Matter*, Philip Hook and Mark Poltimore
- *Popular 19th Century Painting: A Dictionary of European Genre Painters*, Philip Hook and Mark Poltimore
- *The Dictionary of British 18th Century Painters*, Ellie Waterhouse
- *The Dictionary of British Artists 1880-1940*, J. Johnson and A. Greutzner
- *The Dictionary of British Watercolor Painters Up to 1920*, H.L. Mallilieu
- *The Dictionary of Victorian Painters*, Christopher Wood

Artist Indexes:

- *Index to Artistic Biography*, Patricia Havlice, (2 volumes)
- *International Directory of Painters and Sculptors of the 19th Century*, (called Busse-Index), Joachim Busse, (Published in five languages)
- *Mallet's Index of Artists*, Daniel Mallett, (1 volume plus supplement)
- *World Painting Index*, Patricia Havlice, (2 volumes plus 2 supplements)

Additional References

PAINTING CONSERVATION:

- *The Care of Pictures*, George L. Stout

- *The Cleaning of Pictures*, Helmut Ruhemann

- *Conservation and Scientific Analysis of Paintings*, Madelaine Hours

- *The Restorer's Handbook of Easel Painting*, Gilberte Emile-Male

- *A Handbook on the Care of Paintings*, Caroline K. Keck

AID IN DATING PAINTINGS:

- *Antique Picture Frame Guide*, Richard A. Maryanski

- *Book of Picture Frames*, Grimm

- *Costume and Fashion: A Concise History*, James Laver

IDENTIFYING SIGNATURES AND MONOGRAMS:

- *Classified Directory of Artists Signatures, Symbols and Monograms*, H.H. Caplan

- *Monogram Lexicon 1964*, Goldstein, (German text)

- *Die Monogramisten*, George K. Nagler, (German text)

PERIOD FRAMES

Below is a bibliography of titles pertaining to frame history.

Frame Bibliography

Adair, William. *Frames in America, 1700-1900: Survey of Fabrication, Technique and Style*, The American Institute of Architects Foundation, 1983.

Brettell, Richard R. and Starling, Steven. *The Art of the Edge: European Frames 1300 - 1900*. Art Institute of Chicago, IL, 1986

Grimm, Claus. *The Book of Picture Frames*. Abaris Books, NY, 1981

Grimm, Claus. *Alte Bilderrahmen*. Munich: Georg D.W. Callwey, 1978.

Heydenryk, Henry. *The Art and History of Frames.. An Inquiry into the Enhancement of paintings*. New York: James H. Heineman, 1963.

Jones, Harvey L. *Mathews. Masterpieces of the California Decorative Style*. Santa Barbara and Salt Lake City: Peregrine Smith, 1980.

Mitchell, Paul. *Italian Picture Frames 1500-1825: A Brief Survey*. Furniture History: The Journal of the Furniture History Society 20 (1984), pp. 18-47.

Maryanski, Richard A.. *Antique Picture Frame Guide*. Cedar Forest, NY, 1973.

Van Hoist, Niels. *Creators, Collectors, and Connoisseurs*. London: Thames and Hudson, 1967.

Wilner, Eli. *The Art of the Frame: American Frames of the Arts and Crafts Period*. Eli Wilner & Co. (catalog), NY, 1988

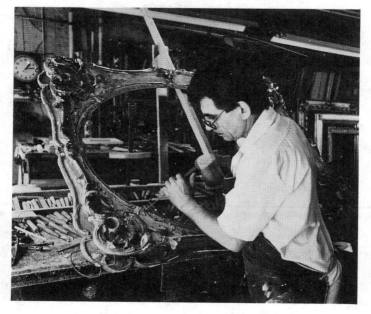

Important Notes

Important Notes

Important Notes

Important Notes

Important Notes

Introducing:

BIRCHES, *pastel, "18x24", by* Anatoly

Author, William Currier, invites you to share in the excitement of a newly discovered artist. Russian born, Anatoly Dverin certainly deserves a large appreciative audience during his lifetime. This fall, as his exclusive representative, I will supervise an international promotion on his behalf.

For more details on his accomplishments,
his life, and his versatility as an artist.
Please call, or write:

William Currier
P.O. Box 2098, Brockton, MA 02405
Tel: (508) 588-4509 • Fax: (508) 643-1197